JOURNEYS IN THE
DREAMTIME

KEYS TO UNDERSTANDING THE 'NATURE' OF REALITY, ASTRAL WORLDS - EXPLORING THE OCCULT HISTORY OF ART

JOURNEYS IN THE
DREAMTIME

KEYS TO UNDERSTANDING THE 'NATURE' OF REALITY, ASTRAL WORLDS - EXPLORING THE OCCULT HISTORY OF ART

NEIL HAGUE

First published in May 2006
by
Quester Publications
New Edition December 2022

Printed and bound by Lightning Source

**CoBritish Library Cataloguing in Publication Data
A catalogue record for this book is
available from the British Library**

ISBN 978-1-8381363-4-5

DEDICATION

To my family, both here in the physical, and otherworldly loved ones. I will see you again when the time comes.

ACKNOWLEDGEMENTS

I would like to thank the following people who over the years have been influential to my work. They are:

Dan Budnik, Pierre Sabak & Ellis C. Taylor.

I also wish to acknowledge Matthew Hurley, Giuliana Conforto and Susan Reed for their books. Along with authors who tirelessly work to unveil the subjects covered in this book.

A huge thank you to Wendy Salter for her commitment to my work.

I'd like to thank the *Artisan Magazine* and their work to promote visionary art both here in the UK and the USA.

Kind regards to Tate Britain, the National Gallery and the British Museum in London, for when I've felt the need to immerse myself in both ancient and modern archetypes. The Whitworth Art Gallery, University of Manchester for their permission to use *Europe, plate 1, Ancient of Days*, by William Blake. Thanks to the Museo Nacional del Prado in Madrid for their permission to use part of the *Garden of Earthly Delights* by Hieronymus Bosch.

To Peter Gabriel: You are a true visionary.

I wish to acknowledge all artists and authors whose works are briefly quoted or referred to in the text and in the notes and references.
If I have inadvertently overlooked anyone I hope I will have used their work appropriately and that they will accept my thanks.

Neil Hague

Other books by Neil Hague

Orion's Door - *Symbols of Consciousness & Blueprints of Control - The Story of Orion's Influence Over Humanity*

Through Ancient Eyes - *Seeing Hidden Dimensions, Exploring Art & Soul Connections*

Kokoro - *The New Jerusalem & the Rise of the True Human Being*

Moon Slayer - *The Return of the Lions of Durga*

Aeon Rising - *Battle for Atlantis Earth*

Eye of the Heart - *A Book of Postcards*

For more information please visit:

www.neilhague.com

www.neilhaguebooks.com

CONTENTS

PART THREE: *Beyond Night & Day*

PART FOUR: *Beyond Heaven & Earth*

PART FIVE: *The Dreaming*
& Becoming Multi-dimensional

All men dream, but not all equally.

Those who dream by night,

in the dusty recesses of their minds,

wake to find it was all vanity.

But the dreamers of the day are dangerous,

for they may act their dreams with open eyes,

and make things happen.

T.E. Lawrence

The prophets describe what they saw in visions

as real and existing men,

whom they saw with their imaginative

and immortal organs ...

William Blake

Beyond the threshold of consciousness lies
the infinite heart of awaiting dream.
To touch that sacred part of the mystery
is to know the eternal aspect of being.

Joaquin Muriel Espinosa

A culture without its storytellers will eventually cease to be a culture

Ari Ma'ayan

Muskogee Creek Native American

Those that lose the dream are lost

Aboriginal saying

Nothing happens unless first a dream.

Carl Sandburg

A person is guided into a particular state which is
halfway between being asleep and being awake...
All his senses are alert as when he is fully awake physically.
In this state, spirits and angels have been seen,
heard and, remarkably, touched.
Then nothing of the body intervenes.

Emanuel Swedenborg

Reality has boundaries.
Imagination is limitless.

Jean-Jacques Rousseau

This life's dim windows of the soul
Distorts the heavens from pole to pole
And leads you to believe a Lie
When you see with not thro' the eye.

William Blake
The Everlasting Gospel

something we must have ...

Love is something you and I must have.
We must have it because our spirit feeds upon it.
We must have it because without it we become weak and faint.
Without love our self-esteem weakens.
Without it our courage fails.
Without love we can no longer look confidently
at the world.
We turn inward and begin to feed upon
our own personalities,
and little by little we destroy ourselves.
With love we are creative
With it we march tirelessly
With it, and with it alone,
we are able to love others.

Chief Dan George
Coast Salish Tribe, British Columbia (1899-1981)

Journeys in the Dreamtime

He walks ancient paths across space and time and is the misfit of our modern world. Like Pan of Arcadia he follows the free flow of his heart, for contemporary society dislikes the shepherd wanderer, because he cannot be herded. Making treks he finds 'journeys' in the dreamtime and armed with imagination he rejects stagnation of the mind.

The Sun is his ally, it fires his passion for the truth.
The Earth is his mother and all that live here, the birds,
trees and animals are his relations.
If he stands in silence he becomes a tree person.
When he runs he turns into a four legged creature.
But when he dances in the light he is a bird on the winds.

In the modern world we sometimes catch a glimpse of him in the cities where he now lives. He moves amongst the crowds and can be seen if we 'look twice' at the world. He's the one who's not caring where he's going. His destination is the heart and where spirit takes him. He moves through time, neither in the past or the future, but loves the moment in motion.

I once found him and walked alongside, talking and playing as we went.
I decided to ask him who he really was.
Turning to look at me, a twinkle of light in his eye, he produced a gift.
A magical box made of all the things of the Earth.
He then placed it in my hands: "Now go inside it," he said softly.
I carefully unwrapped my gift noticing every detail, facet and form. Inside was a shiny mirror, sparkling like a star. He then asked me to look into the mirror, saying: "Now you will know who I am, and who we always are."

Neil Hague

visions from beyond the matrix

unlocking the imagination

Love is a canvas furnished by nature and embroidered by imagination.

Voltaire

I t's been over eighteen years since I wrote this book, and since then, so much has changed in our world; therefore parts have been updated to reflect the times in which we live. The book you are about to read attempts to explore myths, symbols and the nature of reality, while also sharing an alternative history within art. It's a story as such, told in five parts, that is still relevant today, especially in the midst of a new reality emerging for those who have the vision to truly see all-that-there-is to see.

In today's society we are encouraged to believe that art must imitate material appearances; yet for the shaman artist painting our dreams and visions is a way of opening the portals within the imagination. Our intuition, apparitions and experiences, which are not always of this ordinary reality, are considered by the ancients to carry substance that could be made visible *through* art. My art, illustrations and books over the past thirty years have taken me into areas exploring 'alternative realities', a practice that has provided a window into worlds within worlds. Every living soul on this planet has their own unique connection to the 'dreamtime' and subtle worlds that formulate our personal reality. It is the visionary within us all that harnesses our imagination, intuition and creativity, so to enter the dreamtime. Through these vehicles we can change our reality.

The role of the visionary throughout history is to unveil the hidden realms of the imagination. More so, the visionary within, is our connection to our multidimensional self. We are truly multifaceted and exist in many worlds simultaneously, as I shall explore throughout the book. To appreciate alternative ways of 'seeing' our world we need to stop speaking of reality as if it were ordinary. We need to de-automate consciousness in order to cleanse our perceptions, especially in terms of how we see art and life. From my own experience of making pictures, a natural ability to 'see through' the appearance of everyday reality occurs, when we refocus the mind's eye and turn it inwards to look at who we really are. Much of my art and illustration is about

15

seeing and depicting forms that unlock the imagination. My imagery represents an alternative vision of the world: one that finds parity with philosophies expounded throughout indigenous myths and a science that considers the true nature of human consciousness. I feel at home painting spiritual scientific concepts, just as much as I do illustrating themes found in 'science fiction'. We are in an era today where Science Fiction has become science fact. Therefore, reality and fiction are often entwined in my art and carry concepts relating to alchemy, ancient wisdom, philosophy, and worlds that exist beyond our physical reality. The book unfolds the truth about non-physical realities, our history and myths that speak of dualistic forces, to unravel part of a formula humanity is desperate to know and understand. The 'out there' five-sense world is becoming more dystopian by the year, yet our inner world, or our non-local realities, is crying out for communication. Whether we know it or not, humanity speaks a universal language, and like music, art and other forms of creativity, is a language that reminds us of our deeper connections to Infinite Consciousness. A consciousness that can be accessed through *journeying* in what I call the *Dreamtime*. Accessing worlds occupied by interstellar forces, microbes, invertebrates and other natural phenomena, as captured by visionaries since ancient times, comes from an ability to *see* through the façade of our virtual reality, three-dimensional-world. I call this type of seeing, accessing our "ancient eyes" (see my book of the same name), or seeing the next layer of the illusion. Therefore, much of my art and writing is focused on 'esoteric' concepts and the 'nature of reality'. Both areas I will endeavour to unravel throughout the course of this book. Seeing in this way has been symbolic of putting my head above the mundane surface reality and noticing that there are many worlds teeming with life forms, shapes, and characteristics that can seem alien to the consensus reality. The book you are about to read is dedicated to expanding the mind *beyond* the immediate five senses - the matrix world. But the true mission behind this work, is to unlock the imagination, ignite our soul's purpose, and move us into worlds unique to who we are as individual co-creators operating in an infinite universe.

Neil Hague

The Wentworth Estate 2022

The Power of the Visionary

The cave paintings are no more truthful than the moving image,
the artist sees the truth behind the truth.
George Lucas

Since ancient times the movement of the stars, planets and other celestial bodies has fascinated humanity. Myths and their associated imagery relate directly to the multidimensional aspects of our world. Our ancestors have built temples, belief systems and even personified these bodies so to gain a greater understanding of the mysterious connections between inner and outer realities. Guided by unseen forces our ancestors were pioneers, wanderers, storytellers and stargazers who undertook many quests into these unseen worlds. In doing so many native civilisations, through their stories and myths, claim to have been in contact with strange entities across other planets and stars. The mythology and associated imagery of our ancient ancestors is absolutely packed full of gods, super heroes and fantastic worlds where, quite often, good fights a continuous battle against evil. There are as many stars in the universe as there are grains of sand on all the beaches of the world and yet we still close our minds to the possibility of alternative realities and other life forms that stretch the imagination beyond the five senses of the physical world. This book sets out to explore the connections between the stars and the ancient myths that speak of extraterrestrial contact, parallel worlds, the *Dreamtime* and our ability to reshape reality. Through the art and myths of the ancient shaman artists, to the great scientific minds of the Renaissance, this book will attempt to uncover the hidden forces that influence our reality. More so, it is a guide to those who are ready to use their imagination and creativity towards shaping a new vision of themselves. As always, it has been the visionary in all eras and through all media who seeks—and continually seeks—communication with the unseen, eternal and divine aspects of life.

MYTH MAKERS

Humanity as a whole is a powerful myth maker where natural language holds ancient memories, symbols and hidden meanings deep within its cells. Our DNA not only shapes the life patterns and structure of what we call

physical reality, it is our link to what aboriginal cultures call the *ancestors*. Our creative life force is what enables us to expand our consciousness beyond the parameters of conditioned thought and belief. We are also natural communicators with invisible worlds and our multidimensional persona is often captured in the myths and archetypes recorded by the ancient cultures. According to many sages, geniuses, philosophers and visionaries since ancient times, this myth-making capability is part of our human multidimensional consciousness. I would also say that forces, which exist on the different wavelengths we call creation, massively influence our everyday reality. I emphasise 'forces' here because it seems that from the overwhelming amount of texts and images in the ancient world, through to more modern accounts of extraterrestrials, that a variety of 'strange entities' have indeed influenced what we call history. What the ancients describe as gods and folk-lore across many continents telling of gnomes, elves, little people and dragons, for example, often correlates with experiences now termed extraterrestrial. The knowledge of different worlds populated by animal gods and alien races is a common theme in much mythology, art, and religious belief because of the memories tucked away inside our DNA. These memories are also an attribute of the human creative imagination which also expresses itself through modern literature and cinema. Therefore, when we are searching for threads of truth, common themes and information around any myth, ancient or modern, it is important to understand how this book is only one version, or one branch, of reality on the infinite tree of possibilities.

Various hero gods and celestial figures found in ancient myths, art and religious texts have also shaped our reality for many thousands of years because they too are part of a collective human memory of worlds beyond time. This world *is* the *Dreamtime*. In this book, I will delve into the symbols, archetypes, and forces that weave their way through many myths and artworks. In many ways, this book is dedicated to individuals, throughout history, who have attempted to share their knowledge of the Dreamtime. Quite often they have been persecuted, ridiculed and condemned by forces who want humanity to 'sleep' but not to 'dream' of alternative realities.

DREAMING OF DUALITY

Ancient knowledge of the Dreamtime is very much alive in our collective consciousness of humanity. It's in our ability to re-define our patterns (or programming), within our DNA, as I shall explore later in the book. Perceptions of a Dreamtime reality, captured in myths and legends, relate to a very ancient struggle between *opposing forces* and the duality that 'constructs' the reality our consciousness is born into. Our struggle for freedom over tyranny is encapsulated in a storyline found time after time in *all* myths and religions, even more blatantly in the movies. In most cases one force seeks to 'enlighten' and 'liberate' humanity, the other seeks to 'dominate' and 'control', and this struggle exists on many levels and worlds. However, when one views opposites from a higher perspective, what we often realise is that both sides are 'projections' of the same source, knowledge, or *force*. Even the

word 'evil' when reversed, yields the word 'live', implying that 'life force' can be used for both good and evil purposes. What we call past, present, and future, are all existing at the same time and how we perceive the past and the future, as always, depends on what knowledge or information is available to us in the present. As we shall see throughout this book, many truths and memories pertaining to be 'just myths' are still alive in our collective consciousness. On the other hand, many myths bound up in religious belief are presented as facts, when they are nothing more than stories created by ancient brotherhoods (cults) to suit their own agendas.

OPENING THE HEART

Myths are actual history as 'remembered' by the indigenous peoples of our planet. Many threads of truth embedded in symbols and mythological themes, which 'experts' call the 'fantasies of primitive people', are found to co-exist in art, texts and stories of very different advanced cultures all over the ancient world. As I will show, we have created a 'designer history', one that accepts the literal translation of ancient myths, while denying the more symbolic content of religions and belief systems that came out of various myths. For example, over the best part of 2000 years, billions of lives on earth have been controlled and manipulated by 'belief systems' founded on hero-saviour gods, or an omnipotent God. Quite often, the 'super gods' and 'saviour figures' come from the literal translations of astrological symbols, celestial objects and so-called supernatural forces. Such forces are very real and can be shown to connect to the stars.

Throughout the book I will explore the creative human imagination and its ability to digest and recycle the myths of our ancestors. This means that 'myth making' is a powerful and natural human ability. It is a tool that can provide inner knowing and vision, even offering a 'mirror' to reveal the source of our true aspirations in this illusionary dualistic world. All art, especially from a metaphysical point of view, allows any civilisation to contemplate itself and change both the individual and collective perception of the world. The ability to 'unlock our imagination' and tap into our creative inner source of power, frees us to see alternative visions of reality. When we acknowledge our visionary and creative power, then **no external force** can influence our perception of what reality is supposed to be. In our true form, we are all artists, poets, extraterrestrials, angels and earth stars rolled into one. When we open our hearts and minds we start to remember who we are and through our dreams and imagination (our higher senses), we recognise our 'infinite personas'. Being multidimensional, painting and dancing across different levels of our consciousness can only bring us joy and love for ourselves. The book you are about to read will scatter seeds that hopefully take root in the imagination of all those who are ready to enter the *Dreamtime* and reshape reality with an open heart.

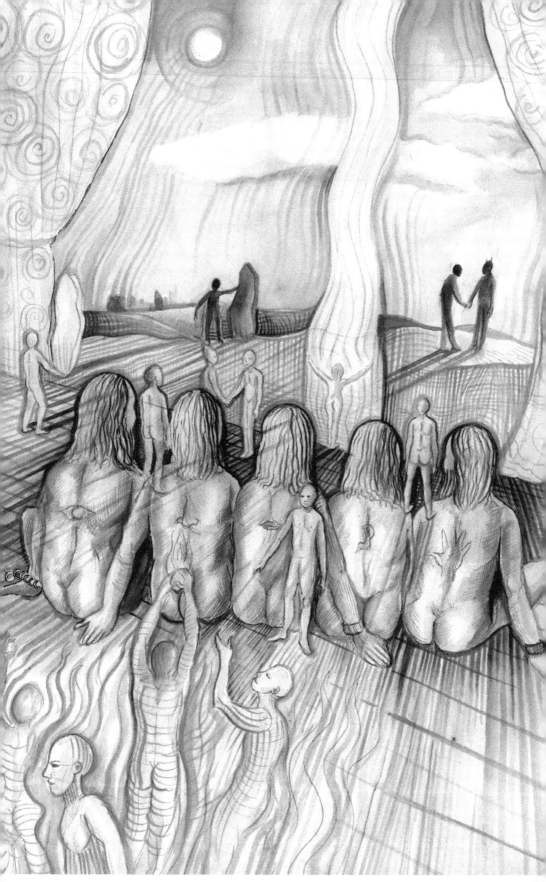

PART ONE
SEEING
THE UNSEEN

*The imagination sees through a thing to the
cluster of possibilities which shroud it.*

John O'Donohue

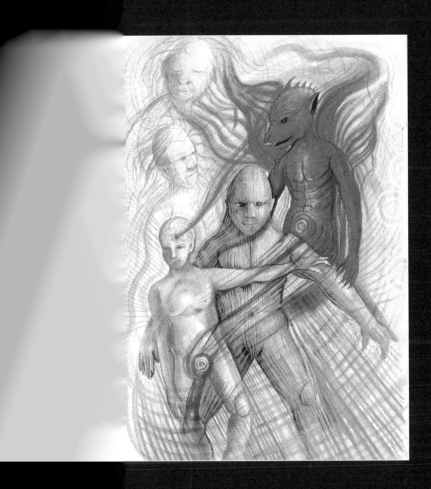

What we don't see!

Images of alternative realities

The real voyage of discovery lies not in seeking new lands.
But in seeing with new eyes
Marcel Proust

What has interested me over the years is how the search for higher dimensions and spirituality has inspired artists, writers, musicians and scientists of every millennia. Since ancient times humans have reached out and longed for communication with unseen forces. Our ancestors went as far as crawling into the deepest recesses of the earth to paint and scrape their innermost thoughts, only for their paintings to be uncovered tens of thousands of years later by minds that still, today, do not fully understand why some of these images were made. Artists and poets throughout history have also shown a natural fascination for what we call the 'supernatural', or the 'mysteries' of life. Artists from all eras choose the esoteric nature and the 'science of symbols' as a source of inspiration to invoke the mysteries. Many visionary artists were traditionally priests or shamans—our ancestors, who through their own art forms explored the idea of multidimensional realms through our greatest tool—the imagination.

Art from the Upper Palaeolithic (45,000 years ago) onwards gives us a glimpse of the shaman at work as he or she travelled into alternative, non-physical realities. On this matter, I speak purely as an artist (an image-maker), whose imagination and ancient memories, seem to connect my work to many archetypes found in the type of ancient art I will be discussing. Of course artists or shamans from indigenous cultures, through to the modern world, have made art through use of natural hallucinogenics. Shamanic art and music have been influenced, in some shape or form, by the ability to *see* through the physical world—to look *beyond* the mundane, five-sense reality. This was the primal reason for shamans using the Ayahuasca (soul vine) hallucinogenic so they could see into the *Dreamtime*. Too often, art history is presented in a one-dimensional manner. Yet, as we find throughout history, var-

ious artists, visionaries, musicians, and scientists have striven to remind us that many worlds exist beyond the parameters of the five senses and our too-often 'firewalled' thoughts.

MIND POWER

What has become apparent through the work of astrophysicists, studying parallel realities, is that the majority of what exists in our Universe is undetected by the five senses. *Ninety five percent* of *all* 'matter' is unseen to be precise.[1] What we *cannot* see, touch, taste, smell, or hear therefore belongs to our thoughts and emotions as they manifest in the physical world in the form of people, places, and experiences. Our imagination and memories are also harnessed through thought, and it is through our *imagination* and *intuition* that we can uncover our *sixth-sense* ability. The imagination is *our* unique tool for transforming *our* world, and by the same token, it is the most suppressed part of our psyche, as are our deepest feelings associated with love and creativity, which can provide us with a higher directional purpose in life.[2] These, too, are frequently suppressed by the five-sense world's day-to-day drudgery. By *drudgery* I mean paying bills, often going to jobs we hate and existing in 'survival mode'. Our reason for being, our visions and deep-rooted knowledge of our true state of being, is, in my view, the path to real wisdom and peace. Loving ourselves and trusting our creativity connects us to the centre of all life. Therefore, if we do not know ourselves as individuals, how can we truly know others? We are taught from an early age that the physical world is made up of three dimensions, which are governed by the predictable laws of physics and chemistry. Our failure to admit how limited our knowledge of those specific sciences is, combined with a common human arrogance that pretends mastery of those same sciences, only dooms future generations to the same limited set of choices that previous generations deliberated on. As always, it has been the visionary, the individual, the maverick, the artist, or the scientist, through their genius, who constantly remind us that we use only a fraction of our true universal power. As Sir Francis Bacon once said:

Ipsa scientia postestas est – Knowledge itself is power.

As I say, it is accepted by mainstream science that 95% of what is understood as 'matter' is undetectable by our five senses. In other words, what we see, touch, taste, hear, and smell is only a fraction of what exists within the universe. This ratio corresponds with human brain capacity and how we are only using around 5% of our brain's capacity. In astrophysical terms, the larger portion of life (or matter) that we *don't see* is referred to as 'dark matter' or

'dark light'. The notion of dark matter or the weak electromagnetic force, as physicists describe it, first became evident about sixty years ago.[3] The term 'dark matter' was concocted to get around the disturbing fact that galaxies spin so fast that they should have twirled apart aeons ago. Scientists concluded that something else is holding together the oscillations of galaxies and atoms. Science is also coming to the inescapable conclusion that there isn't nearly enough gravity to hold the whole conglomeration of stars together. However, what is becoming more obvious to science is that 'interference waves', 'subatomic particles', and 'higher dimensional space' are the keys to understanding the nature of what we call reality. Our perception of *anything* (our reality) is how we really see. Yet, our perception can easily be manipulated (even denied) through mind dogmas to the point of being blind to such knowledge (information).

The mind is unknown territory for conventional mainstream science and is confused with the physical brain. The mind is not the brain, just as our spiritual heart is not the physical heart. The so-called 'mysteries' are not hidden from any human who sees through the physical world/reality. The Nobel laureate Isidor Isaac Rabi was once asked what event in his life first set him on the long journey to discover the secrets of nature. He replied that it was when he checked out some library books about the planets. What fascinated him was the fact that our human mind is capable of *knowing* such cosmic truths. He said:

> *The planets and stars are so much larger than humans, yet the human mind is able to understand them.*[4]

From the earliest pictographs depicting stars (constellations), to Van Gogh's 19th century painting *Starry Night*, we can see how the human mind is capable of perceiving a vast 'ocean of forms', both dark and light subatomic particles. So much art conveys the 'unseen', 'deeper' concepts relating to stellar forces and worlds within worlds, as we shall see.

STAR SYSTEMS & THE UNSEEN

In recent years, astrophysicists have recorded giant vacuums between stars, which they say are full of living particles that we *cannot see*. Just as any substance placed under a microscope reveals forms that would normally be undetected by the naked eye, various star systems are revealing interesting 'energetic forms' that can be detected (and in some cases 'felt') here on earth. In my book *Orion's Door* (2020) I write about the deeper mysteries connected to Orion, its stars, and the 'unseen'. Back in March 2000, *The New York Times* reported that the Orion nebula revealed the existence of some kind of

'unworldly' dark matter influencing our solar system. The same article went on to state that:

> *Empty space is pervaded by a mysterious dark energy, a kind of antigravitational humph that is accelerating cosmic expansion.*[5]

Scientists at the University of Rome, mentioned in the same article, named this otherworldly energy *quintessence*, something already understood by the great philosophers and scientists of ancient Greece. Namely, Aristotle (384 - 222 BC) who went as far as saying:

> *The Heavens are more alien and wondrous than meets the earthly eye.*

On a 32,500 year-old piece of Mammoth tusk, found in 1979 in Asch Valley in the outskirts of the German City of Ulm, a human figure is pictured, its arms and legs situated in the same way as the Orion constellation. The tablet is said to have been left by a mysterious nation, the Auriniaks (ancient train spotters?). However, there is little information about them, except that they came to Europe from the East about 40,000 years ago and forced out the native population of the Netherlands. This artefact, as with many others from the same period, suggests whoever created it was 'tuning into' specific constellations (in this case Orion) as either *a)* a sort of calendar for tracking time; or *b)* direct attempts to recognise the influence of stellar intelligence on Earth (see *Orion's Door*). I am inclined to believe that many of the ancient art forms pointing to, or depicting, specific constellations were made by shamanic emissaries who had direct genetic ties to these constellations and the types of life forms connected to specific stars.

DELVING IN THE DARK

Science suggests that 5% of *all* matter in the Universe is constructed of 'luminous matter' and electromagnetic forces that shape our reality. You could say these are the *measurable* particles lighting up our world, or the codes constructing our matrix. However, ordinary light is only *one* type, according to scientists who have discovered other worldly substances. To appreciate the necessity of light in 'shaping' what we see, we only have to put ourselves in a *totally* dark room (at night) with no light source, to realise that *everything* we 'see' only takes form due to light hitting the retina in our eyes. Colour is also another aspect of how light makes objects seem real. The same understanding relates to the holographic universe and how scientists studied irregularities in radiation and coupled them with existing quantum theory to try and work out the unexplained nature of microwave radiation. Such complex findings give ground to what we call 'holographic universe' theory, more on

this later.

The spectrum we call colour, through light, even disappears when saturated by darkness. However, what we *feel*, our emotions, our love, our fears and the deeper sensations *beyond* the five senses, also dwell in the spaces unseen by the eye, unless they manifest through physical forms. Even in that darkened room we 'sense' forms, we 'imagine scenarios' and 'feel emotions' which also have a life of their own. The darkened room scenario also applies to the majority of Palaeolithic art and is probably one reason why such art was made in caves that simulated the dark place of birth. Cave paintings were an attempt to reach into the 'darker invisible regions of the cosmos' and extract these emotions, feelings, and other hidden, alien-like forms. Amongst the more common images of animals found in caves all over the world, there are many other seemingly unexplainable images scattered around. Many of these images seem to speak of 'luminous waves', geometric sunbursts and spiral formations, which uncannily suggest celestial cycles, suns and stars. Interestingly, prehistoric portable art from the upper Palaeolithic period (30,000 BC), shows that our ancestors had their eyes 'fixed on the stars' and their cycles marked through time, or calendars. Imagery made by Aborigines in Australia, through to the African Dogon tribes of Mali, often refer to *invisible* creative forces that 'formed', or shaped our world. The Aborigines called this level of creation the 'Dreamtime' or 'Tjukuba', a *timeless* epoch when all life was shaped into existence by totemic forces emerging from the sky and earth.

THE SCIENCE OF ASTROLOGY

Science today measures unseen rhythms found in all life. They are tiny particles of light called 'neutrinos' and have almost *no* mass. According to scientists researching the strange world of neutrinos, over one trillion of these particles pass through our bodies *every second*.[6] They are also said to be one of the pervasive forms of matter in the Universe and are created in the Sun and within supernovas (stars) by cosmic rays crashing into the upper atmosphere. Neutrinos explain the interactive dynamic bond between our human psyche and the movement of stars – otherwise known as astrology. We are essentially 'star stuff', and astrology on one level shows there is more to humanity than flesh and bone. Conventional science scoffs at astrology, but in ancient Egypt, for example, both astronomy *and* astrology were united inside the priesthoods and secret orders that maintained the pyramids and other temples. Artist priests, who in some shape or form, using an advanced knowledge to construct these temples, also cultivated a deeper knowledge of the stars; something scientists and engineers would struggle to replicate today! However, what a growing number of physicists are now coming to terms with is that invisible matter, thought only to exist in outer space as

'photons' (sub atomic particles), can also be detected on Earth. In terms of measuring our life-force, which includes the 'rhythms and cycles' of *every-thing* from a solar system to an atom, every spoonful of what we perceive to be space is teeming with invisible energy.

Sages, philosophers, and seers of the past, sought to understand how all matter can be perceived as invisible particles. The Greek philosopher Democritus (460BC-370 BC) went so far as saying: *Nothing exists except atoms and empty space: everything else is opinion.* Later in the book I will consider the holographic nature of our Universe as shown in art and movies over the years. Yet, suffice to say, that over two thousand years ago it was the Greek philosophers, the Gnostics (along with earlier shamanic cultures), who ascribed our unconscious, automatic heartbeats (all-that-exists *within* us), to invisible forces or 'perceived' empty space.

A CITY AT NIGHT – LIMITED PERCEPTION

To try and explain further the scientific concepts behind unseen worlds, we could picture ourselves thousands of feet in the air, looking down on a major city at night. We can see hundreds and thousands of tiny lights, orange, white, some red, scattered throughout the city. From this perspective we only see the luminous parts of the city and therefore take that to be the only recognisable life forms in existence. However, hidden away behind the 'light-ed' rooms, all sorts of activity continues. In the dark areas of the city, in the sewers and cellars, etc., other life forms 'move' (live). From our limited per-spective, nothing is in the darkness, unless we personally visit those parts of the city and see the types of life (or creatures) for ourselves (see figure 1).

Just as science moves nearer to accepting the existence of undetected parti-cles, we know that other life dwells in the darker areas of the city, moving unseen to the eyes. If our birds-eye view of the city in this analogy is symbol-

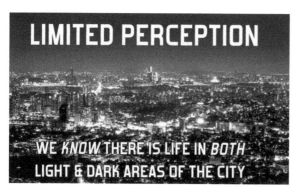

ic of our reality, the five senses (our physical world), then what else dwells undetected in the shadows (the darker frequencies/matter) within our universe? How many other cities (or worlds) also exist beyond the vibrational walls of the one we think we know so well? The human imagi-nation, for example, houses many forms that

Figure 1: Perceptions - Deceptions.
Even though we *know* there is life in *all* areas of the city, the light and the dark, our perception is limited by what we say we can see! (CC0 Public Domain)

are not easily recognised through ordinary five sense perception. This doesn't mean these forms don't exist! As an image maker, as with other artists, what we call fairies, angels, demons, unicorns, or now aliens, are not only part of our dreams but *are* elements of a complex human reality diffused in lots of worlds (cities). These strange and fabulous creatures do not exist to the consensus reality 'dominated' by the five senses, but for the visionary or dreamer who *sees with the imagination,* they *are* visible forms just the same. For the visionary-sighted, multiple worlds are open to the mind's eye. Especially when one looks 'outside' of the window of the world, and beyond its illusionary façade. In relation to the subjects covered in this book, how have artists/shamans from all over the ancient world tried to record their journeys into these dark luminous realms of the 'city'? Just as nightfall in any city brings sleep and *dreams,* so our ancestors sought out the Dreamtime, the place where the subconscious mind and the imagination formulated multiple realities. Many ceremonies performed by native cultures, including religious esoteric rituals of secret societies were, and still are, an attempt to interact with these Dreamtime worlds. Often, the visionary artist's images are memories of time spent in these worlds, and the purpose of the shaman or visionary artist is to show what dwells beyond the illusion. As you'll see, this is one of the driving forces behind my work; to go beyond the veil that separates us from the *Dreamtime.*

Science accepts we only use between *five* and *ten percent* of our brain capacity. Yet, many artists tap into the realms that exist within the *95 percent* of brain capacity we don't use. It's the same with our DNA. Scientists call some *95 percent* of our DNA 'junk DNA' because they don't know what it does! Could it be that the *95 percent* of DNA and brain activity relates to the *95 percent* of energy (or realities) that we *can't see* via *our* five senses? Throughout history artists have tried to paint, scrape, make and tell stories about those journeys into the darker areas of that city, or the *95 percent* of untapped human brain capacity. How these visionaries get into these 'unseen' realms is often through chant, music, hallucinogenic drugs, dance, painting and ceremony. Some journey through meditation or sometimes through using several combinations, but the most important factor is the 'imagination'. What the shaman artist brings back are the clear memories, feelings, and 'visions' borne out of taking a closer look at the once 'invisible' but now 'detectable' avenues of that universal city.

What I'm exploring in the first part of this book, are connected themes relating to mythology, religion and *unseen* forces detected by science and visionary artists today. The book also draws on the works of artists, shamans and other visionaries who have visited *their* city/world/reality, as such, through higher senses, stretching the imagination beyond the mundane.

BEING COSMIC

There are many different kinds of energies at work in our world. Some are visible through light, others appear and disappear, like the rainbow, and others cannot be seen, only sensed. Music is another perfect example of the type of force that generates feelings and vibrations through sound. Astrology in effect is the harmony of the 'music of the spheres' (planets and stars) and how they effect the 'rhythms' translated as emotions: Eros, love, life and *dreams* from our human perspective. In all cases it's the visionary who taps into the sounds of the universe and then gives these forces 'form' through art, poetry or music.

Sound is said to be a major force behind creation. Words create sounds, and it is sound that gives us 'vibration', which manifests as form. The psychologist and scientist Itzhak Bentov, in his book *Stalking the Wild Pendulum: On the Mechanics of Consciousness* (1988), said of vibration:

> ... *our reality is a vibratory reality, and there is nothing static in it. Our senses can only appreciate the differences in vibrations.*

Bentov explains how matter, being made of 'quanta of energy', is the vibrating, changing component of pure consciousness. The absolute is fixed, manifest, *and* invisible - everything is producing sound. This point is echoed in the *Gospel of St John*, part of which reads:

> *In the Beginning there was the Word, and the Word was with God, and the Word was God...*[7]

The *95 percent* of the invisible Universe, according to science, constitutes a *weak* electromagnetic frequency, which is one of four forces formulating life, or matter. This larger weak force is said to be composed of sound and vibrates along a 'cosmic wind', undetected by our finer senses but made available to us through our thoughts, intuition, our feelings and creativity. The other three forces are said to be composed of a strong electromagnetic force, a nuclear force, and gravity. The latter binds our physical mass (which is condensed to a slow vibration) to the earth's surface. The four forces are actually three, as the *weak* and *electromagnetic* compose *one* 'electro-weak force' – or what is referred to as dark matter by astrophysicists. As I will come to in the next chapter, it is the knowledge of *how* these forces operate, especially through initiates, priests and brotherhoods (cults) going back to ancient Egypt and Atlantis. The same cults have provided us with visions and religious templates, archetypes and beliefs. For example, the idea behind the *Trinity* is one archetype showing how *three* forces (gravity, nuclear and

electromagnetics) compose the physical world we call reality! The Trinity (Trinitas in Latin) could be an understanding of how *two* forces (one direct and the other indirect) produce a *third* frequency (vibration) that is much slower than the other two. The holographic nature of reality, revealed in books by scientists Michael Talbot and Karl Pribram, could also connect to the notion of a third frequency (a trinity) creating the super hologram we call life.

As I show in *Through Ancient Eyes* (2018), four forces, linked through a *fifth* element (love/light), make up what many visionaries call the 'cosmic being'. Our creativity, or destructiveness, is our response to energies not always visible in the physical world. They become visible through art forms when we tune into and respond to the forces at work *within* and *outside* of us. Great minds such as Plato, through to Artists like William Blake, along with other philosophers, poets, painters and writers, have all tried to communicate this basic understanding of humans, being *more* than just a physical body. In films such as *Star Wars*, George Lucas, actually uses the term the 'Force' to describe a hidden knowledge that can be used to do good or bad. In my eyes Lucas is a modern day equivalent of the mediaeval alchemist or priest, revelling in archetypes and using the latest technology to sell many an ancient myth in today's world. Whether we are watching the latest science fiction blockbuster, or musing over ancient art in a museum, *all* archetypes provide a glimpse of a hidden knowledge, often suppressed by the Church and State in times past.

THE FIFTH ELEMENT

The heretical scientist, poet, philosopher, and proponent of alien worlds, Giordano Bruno of 16th-century Italy, explains in great detail how a higher cosmic energy holds all four forces together. Bruno was burnt at the stake by the Catholic Church for insisting that humans can emit and absorb what he termed 'Cosmic love or fire', or what physicists now refer to as the 'fifth element', a force that connects all four substances. The fifth element is also referred to as 'heavy light', an energy that exists in all life. Some say this is fifth element is infinite love. The movie, *The Fifth Element* (1998) starring Bruce Willis and Milla Jovovich also touches on similar concepts regarding the true power of love. Great thinkers like Bruno refer to this fifth substance as a *divine force*, one that creates all life and, crucially, makes all in its own image. Visionary artist William Blake (1757 - 1827) also strives to explain what he calls *'The Divine Image'* in his poem of the same name. For Blake, the human 'spiritual form' is at once a projection of 'God in human form', and the imagination is the true form present in humanity.[8]

As with many ancient cosmogonies, both Bruno and Blake, considered the

real human form to be a 'cosmic cell', a particle of divine consciousness and a projection of the whole - or *Oneness*. This inherent natural divinity we all hold, is playing its part in infinite worlds, all peopled by different aspects/stages of evolution within the universe at large. A perfect example of this would be the main sequence of stars, all of which are made of the same substance, but pass through hot and cold phases. Their evolutionary cycles from blue/white super giants through to the cooler red dwarfs, illustrate how matter *changes* in relation to the distance it travels from its original source, its birth. We too are travellers (or aspects) of the original source, and our cells are a microcosm of the parts we play in the organic structure of our planet, the solar system, and universe. The Sun surrounded by circling planets provides a central point, which is just a magnification of the atom, with its neutrons and electrons centred on its hot spot. *We are all One substance*, every atom, cell, sun and star is an image of *One* consciousness. The common theme linking our cell structure and DNA, through to the spiralling of our galaxy, etc., is *infinite* consciousness. How we perceive the infinite (in our-mind) depends on our own individual visionary capabilities. The energies constituting all aspects of the *infinite* are inherent in all life forms, dimensions, and levels of being.

Some artists, like physicists, strive to absorb, explain and communicate feelings of a higher consciousness. Ancient artists (priests) developed esoteric systems to try and contain 'knowledge' of such cosmic forces through alchemy. In many religious orders and earlier shamanic cultures, the use of herbs and mushrooms (like the Aminita muscaria mushroom), along with other plants, was used to communicate with forces or dimensions. Sometimes these were 'higher levels of consciousness', sometimes lower dimensions. Many symbols were often given through dreams or altered states by shamans as they journeyed into these realms. What they witnessed may have been copied on cave walls, or transcribed on temples in the ancient world. Art and symbols can tell of encounters with strange entities, possibly extraterrestrials; others speak of sacred geometry and the forces providing blueprints for all life - our DNA. Interestingly, imagery that has appeared as 'crop circles' over the years (not the ones that are hoaxed), looks very similar to fractals and geometric forms seen in our microcosmic natural world. The only connection between imagery such as archetypal cave art, through to crop circles, is that the artists or shamans (and later alchemists) desired to understand the force that interpenetrates and influences our physical world. The same force is both 'spirit and matter', 'alpha and omega', 'male and female', 'night and day, and so on. It's the *infinite* sea of consciousness, expansive and ever-flowing, beyond the limits of separation we experience in the physical world. The need to understand and express this knowledge by humanity is as old as humanity itself; and as I will show later in the book,

many myths, religious deities, 'themes' behind modern art and movies, have inspired our desire to understand 'consciousness'. The evolution of the human form, from less dense matter, to the biological body we have today, is also part of this process of moving (or falling) through frequencies. You could say it is a fall from non-physical to physical matter, too. As always, it's the intent behind how knowledge is used which decides the outcome of any action. The energy I am trying to describe both enthrals and fascinates us. It's the *power of love*, *life* and *death* and our *infinite* creativity. All of these have moved many a poet, artist or sage for millennia. How such forces connect, as understood by science, is through the weaker electromagnetic energy, expressed through music, art (as emotions), but made visible (tangible) through the imagination.

What is often described as the 'soul' also operates and interacts with invisible worlds, or forces. The name often given to the soul's relationship with powerful invisible forces was that of 'daemons' or 'guardian angels'. The concept of 'genius' also relates to our connection to wavelengths and vibrations, which house a cornucopia of ideas that can manifest in physical form. Accessing our creative power automatically means we are calling on unseen forces that are as much a part of who we are as our fingers and toes.

FIVE GIANTS FALLING

We live in a world dominated by the five senses. Sight, especially our *perception*, can be the most deceptive of them all. However, we are also inspired by the concept of "extrasensory" perception in the forms of clairvoyance, fortune telling, healing, channeling, and so on. These natural human abilities can be traced back to the oracles, prophets and shamans of the ancient world, and all are forms of communication relating to our interactions with invisible frequencies interpenetrating our physical world.

Our world is a mirror of the five senses. It's a world dominated by the number *five*. We have five fingers, five vowels and five continents. The classic Olympic Games symbol of the five circles relates to the five continents of the earth. As does the star (and pentagram) symbol, which can be found as far back as ancient Egypt, and used in the architecture of many prominent buildings and city plans to this day. The US Military headquarters, the 'Pentagon' for example, is housed in the body of a pentagram. The number five is also evident in certain geometric expressions in nature, mainly through pentagonal shapes common to many flowers. Five also manifests in the name given to the first five books of the Old Testament—the Pentateuch—and in the pentathlon and pentatonic scale found in music. However, as many shamans or sages confirm, we also operate through higher numbers or levels of perception, too. Hexagonal symmetry found in snowflakes, honeycombs, pollen and Uranium atoms, for example, speaks of sixth-dimensional structures and

symbols that are finely tuned to our senses. This type of "seeing" takes us out of our everyday world and into one powered by our imagination. Art, therefore, could be seen as a psychic tool. An instrument through which we allow ourselves to venture *beyond* the five senses. Obviously we need sight to 'see' art, but it is the content, vision and energy behind the imagery that speaks to the higher mind of the viewer, and more often than not, higher dimensional art (through symbols) speaks to our heart! We go beyond everyday reality of the five senses when we start to realise that the world of dreams, the imagination, memory and thought are all realities that structure and reflect our physical world. In other words, we can see ourselves as explorers, operators and 'viewers 'of many different realities, just as gamers can see themselves in many different roles based on the games they play. Our thoughts and our imagination, which *are* our non-physical aspects of being, need our physical vehicles to express the deeper levels of who we are. They move us beyond the mundane, physical, and obsessively controlled reality!

Palaeolithic artists (shamans) marked rocks with handprints, a form of standard five-fingered stencilling; and much rock art, especially handprints, holds a special ritualistic significance. Handprints are considered 'signatures' of the human souls that live on after the passing of the physical body, and so the 'hand shadows' became part of an ancestor cult for our ancient relatives. In most cases the hands are shown to emit photonic light, or energy, which is not too dissimilar to the 20th-century photographs made by the Russian engineer, Semyon Kirlian (see figure 2). Kirlian's work has been discredited over the years; however, the notion of energy encircling and emanating from organic objects *is* an ancient understanding, whether we agree or not with Kirlian's photographs. In a recent study at the Central Research Laboratory at Hiramatsu Photonics in Japan, it was shown hands do emit light (energy). Scientist Mitsuo Hiramatsu said: "The presence of photons means our hands are producing light all of the time." The detector used at Hiramatsu Photonics found that human fingernails release 60 photons, and fingers emit 40 with the palms being the dimmest area of the hand.[9]

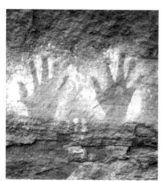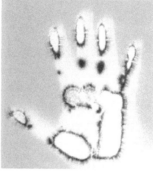

Figure 2: Five Senses & Hand Shadows.
(Left) 20,000 year-old cave art showing a natural interest by the artists in energy, creativity and the soul. **(Right)** A Kirlian photograph depicting similar energy fields. (CC0 Public Domain)

It was as if the artists who made

these rock art forms were trying to convey the notion of higher energies or frequencies surrounding our physical body. The same understanding of our human form being connected to lighter (ethereal) bodies, or frequencies, alongside the physical one, has been captured by visionaries and shamans in all eras. A common name for the energy that surrounds our physical body is the aura, or egg, and this energy can usually only be sensed or seen through our sixth sense or our natural psychic abilities.

SIX-FINGERED – SIXTH SENSE?

Along with the more common images of hand stencils amongst rock art, I have often read about 'six-fingered' handprints and seen them for myself in recent years at a 29,000-year-old cave called Grotte Mervielles in the Lot department of France. Also, among the cave paintings of Garnet Glen Mann Ranges in Central Australia, there are images that show six-fingered hands and six-toed feet. Egyptian and Indian dwarf gods, such as 'Khnumhotpu' and 'Kubera', are often depicted in art and sculpture as having six toes. Certain deities, such as the hunchback flute player, Kokopelli, of Native American legend, are also said to be six-fingered. All these examples could relate to physical characteristics, just as some animals like pandas have six toes. Hands are frequently associated with Aboriginal Dreamtime symbols, implying that the bearers of the hands were said to have walked the earth *before* the physical world took shape and form. Do the six-fingered marks also relate to a higher, more *lucid* frequency range that *continues* to shape the physical (five sense) world? More on this later.

In Eucolo Creek of Pimba, South Australia there are other symbolic representations of six-fingered hands and in Central and South America there are also images of strange beings with six-fingered hands, some dating back thousands of years. Again in Peru, at Cerro Sechin, Casma Valley in the north, there are huge slabs of stone where there are carved similar figures

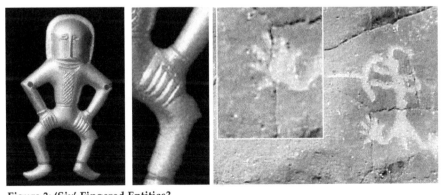

Figure 3: 'Six'-Fingered Entities?
(Left) A 4000 year old statue found in Kyiv. **(Right)** Bronze Age petroglpyphs depicting strange six-fingered creatures. See *The Alien Chronicles* (2003) by Matthew Hurley.

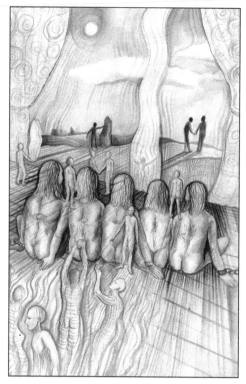

Figure 4: Plato's Cave.
Five giants are facing an illusionary façade, shackled and limited in perception, they represent the five senses. The spirits dancing behind and around the giants are symbols of *unseen* forces that constitute multidimensions and unlimited potential. (© Neil Hague)

with six-fingered hands. Artefacts discovered in Kyiv (formely Kiev) dated 2,000 BC, also show a strange 'cyberman-like' entity with six fingers (see figure 3). In some cases the prehistoric artist would suggest a missing finger through exaggerating the gap between the third and fourth fingers. Again could this have been a code for dimensional frequencies? Perhaps there is a connection between five fingers and five senses, and artists, from prehistoric times on, have sought to remind us of our sixth sense and other realities (reached through higher senses) beyond the physical world. What visionaries have tried to do, in my view, is to make visible the archetypes, which are parts of our subconsciousness, and non-physical levels of being. In Blake's illustrations for Danté's *Divine Comedy*, for example, he clearly depicts in one of the realms of Hell, 'five giants', symbolic of the five senses. In this image,

Blake shows the giants 'fixed' in perspective, part of the landscape, 'unable to move' beyond the constraints of the physical realm. Plato's Allegory of the Cave tells the same story. In my version of Blake's image, I show non-physical forms creating the reality dominated by the five giants/senses (see Figure 4).

DENYING THE WORLDS BEYOND THE FIVE SENSES

In order to attune to frequencies that are not clearly visible through the five senses, we have to appreciate feelings, intuition, vibrations, our dreams, and our imagination. All of these subtle vehicles of the human psyche hint at an internal and eternal device that places us in worlds beyond the physical world. As always, it was the shaman, or priest of the past (embodied in the government-approved religions of today), who claimed exclusive rights to

these different worlds. In other words, the priest or shaman became a 'door-keeper' (an agent) too often shutting off the true nature of reality to the masses and only letting in the chosen initiate.

In truth, the Holy Inquisition was created purposely to take out of circulation the knowledge of our natural and individual divine right to access different levels of creation. Policing our thoughts, calling people heretics, denouncing individuals as crazy, dangerous or bad, is the natural response from any civilisation that fears its own creativity and individuality. The imagination is the key to the door marked 'freedom of thought' and it is through this door in the mind that we access the multidimensional aspects of ourselves. In short, the knowledge that was murdered, tortured and burnt out of circulation over the last fifteen hundred years, is basically this:

1) The five senses are only the outer controls for consciousness, which functions through a physical vehicle (administered by the brain) within this reality. We exist on multidimensional levels of creation.

2) We are much 'bigger' than we think we are! The forces structuring the universe are the same invisible 'threads of life' that inspire our thoughts, fire our imagination, and *shape* our reality. We are the whole universe and *all-that-exists* is a part of us.

3) We are in this world but not of it. Our bodies (from the physical to the invisible light structures), from an atom to a star, expand into infinity.

What religion, politics, and mainstream science have most feared over the last 1500 years is people having the freedom to think as well as the realisation that they are in control of their own reality. Not good news for the hierarchies that desire control of the 'systems' enslaving the human spirit! All religions and orthodox mainstream scientific ideology have had one thing in common: they foster the 'ultimate belief' that power is out there in the world around us. When in truth, it is and always has been *within us*! Knowing that the IMAGINATION of ourselves is the key for reshaping our individual and collective reality is a liberating feeling in itself. As the book unfolds, I will explore this idea of liberation through art and creativity. When we *rethink* our world (our personal universe), through opening our minds and utilising our visionary powers—our creativity, then we are less likely to feel the need to 'defend' any belief system. Instead we become individual pioneers with a unique vision of our own. We also realise that we don't need any priest, politician, teacher, media pundit, guru or doctor telling us what to do with our infinite power!

I believe we are kept locked into the 'five sense' frequency range, by allowing ourselves to forget that we are capable of expanding our sight beyond the reality that binds us and, in many ways, controls our sense of self. Powers that are seeking to limit true human potential, which I believe are not of this physical world, as I will expand on later, are no more than 'programmed' states of mind, almost like 'software' programmes. Every aspect of society is governed by these states of mind, and almost all are based on how the five senses dominate our *perception* of reality. The analogy of the 'matrix', which I will come to in a later chapter, is a perfect example of how difficult it is for us to define what is real, or what creates our reality. Yet through our imagination, creativity and the feelings we experience when we are in altered states brought on by day dreaming and meditation, we can sense there is 'something else' beyond the physical. I feel that much art, going back to the earliest rock paintings, is hinting at these finer levels of reality beyond the physical. Accessing our multi-dimensional persona, can be seen in Palaeolithic art showing human and animal fusion, sacred geometry and many symbols (forms) that hint at lucid dream states shared by every culture. Our emotions also form part of subtle sensory systems that can expand us beyond the physical world, and it is the emotion of *fear* that has been harnessed by a force that literally feeds off that fear. Fear is not our natural divine state of being. We are conditioned to be fearful and in extreme cases this fear manifests as war, division and separation on a collective level. Look at the world around us, from Covid to other endless wars and tell me fear isn't the driving force behind so much of what we believe and do? The switch from being in a state of fear, which is more often than not a manufactured state of being, to feeling empowered through love is going to create another reality on this planet, one that respects all life, no matter what we choose to believe as individuals. The visionary within us all wants to knock down the walls of fear and limitation to offer us a new reality and a new way of seeing.

THE VEIL OF ILLUSION

The ancients understood creation consists of infinite dimensions of life vibrating at different speeds and that everything had its opposite nature. This philosophy is evident in all of the myths and artworks, symbols and stories that talk of the 'web of life', the 'matrix' and references to more than *three* perspectives or dimensions. Creation is simply different frequencies sharing the same space as each other and when we move the frequency dial, or access our 'ancient eyes', then we see many interdimensional forms (beings) operating from other levels of creation. What we see can be entities, gods, giants and other strange creatures found in folklore across every continent. In more common instances they have been the "now-you-see them, now-you-don't" ghosts, UFO and mysterious beings like Bigfoot and Loch Ness Monster-

types. I believe that when people witness any of these phenomena, they don't actually disappear, instead they move into another frequency range and so become invisible to the viewer. Those frequency ranges, which cannot be easily seen from a denser one-dimensional perspective, are mainly due to the effects of ordinary light—the five percent that formulates our reality. This 'ordinary' light is what astrophysicists today, including the so-called heretical scientists throughout history, describe as 'luminous matter', which is accessed through the five senses' frequency band. Ordinary luminous light is merely the shadow of our 'inner light', which consists of many finer frequencies and parallel worlds.

The notion of a shadow world, peopled by the shadows cast by a cosmic fire (their true selves), is found in the art, myths and texts of various sages and philosophers from Plato through to Giordano Bruno.[10] In other words, the physical world we think we know so well, according to modern science and mystics of the past, is merely one of many 'stage shows' – a *projection* of a higher consciousness. Bruno proposed that the universe is only an image; an interactive movie on a peculiar screen. The earthly state (physical reality) we participate in, according to the likes of Bruno, is a virtual movie and each 'life game' unique to the individual.

THE SHADOW WORLD

According to Bruno, true light (the cosmic force), which includes all dark matter and involves infinite universes, is what many people attempt to call God. However, forces that have separated themselves from the infinite, do not want humanity to open their hearts and minds to the true nature of life, or to contemplate the many worlds beyond the illusion. It is fear of the divine within us that has created religions and orthodox science. Priests and shamans since ancient times have been the authority, the middlemen for their own gods and, today, new religions in the form of brand names, sport, political saviours, big Pharma, Hollywood film stars, pop idols and the great god of money takes precedence in the minds of people who are mesmerised by the shadows of a world. But what is real? All separation promotes a world out of balance, especially in a world that continues to foster beliefs that ask us to look 'outside of ourselves' for answers to the mysteries of life.

In a more modern context, using the term *Science Fiction*, killing scientists like Giordano Bruno, or hiding the truth from the masses is part of this separation that maintains the illusions we call everyday life. The perpetrators of the veil of illusion are ancient forces dwelling in parallel worlds that can be accessed via portals or doorways in our space-time fabric. Ceremonies performed by *elite* 'secret' societies are also designed to form a 'vibrational pact' with forces that fuel our fears and the separation we experience in our world. From time to time we see in art and sculpture (historically speaking), these

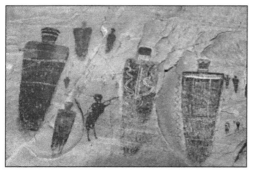

Figure 5: Coming out of another dimension?
Anasazi petroglyphs of anthropomorphs found in Utah and Arizona. These strange figures seem to be *appearing* out of nowhere just like ghosts or spectres are often shown to do in modern film.

parallel frequencies. Some of the North American Anasazi Rock Art also seems as though the ancient artists were trying to portray strange entities coming out of nowhere—or another dimension (see Figure 5)!

OUTSIDE LOOKING IN

In William Blake's art we often find subjects hinting at parallel realities. In one illustration *The Ancient of Days* (see figure 6), we are shown a figure leaning out of a parallel world or through a portal of some kind. Lots of Christians view their God in this manner, mainly thanks to how Renaissance artists, such as Michelangelo, and the 13th-century *Bible Moralisée* depicted God. However, in Blake's mythology this character is named 'Urizen', a Greek word meaning to 'bind'. Blake sees Urizen as the creator of all the restrictions of the world, written down in religious laws, dogma and the restrictions that limit our true potential. With Blake's image we have another

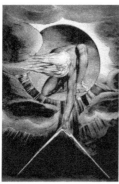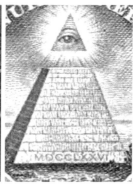

Figure 6: Outside looking in!
(Left) *The Ancient of Days*. This image represents a deity leaning out of one world,
while measuring and influencing the very structure of the world he is detached from.
(Right) The All-seeing-eye floating above the pyramid offers the same symbolism showing a supreme deity (Lucifer) dwelling 'outside' of the 'structure of the world' it oversees.

vision that illustrates the separation of humanity from God by orthodox science, the hierarchy of the State and the restraining powers (laws) set out by Urizen! The Masonic-style compass he places on the reality he is leaning into is symbolic of the structure (hierarchy) that constructs our physical reality. I would go as far as saying that the systems in place today, the institutions and 'official' authorities, *are* the body of this Urizen archetype. It's also a symbol for the duality and the separation of mind from heart. What animates Urizen's authority is a more

subliminal force, one that we as co-creators help fuel through fear of what others will say, think or do, if we dare to break free of Urizen's control mechanisms. Blake's Urizen figure is the archetype for the Father God figure and a beacon for the 'Age of Reason', a subject I'll explore further in a later part of the book. In some of my art, I show Urizen as the Puppet Master who is also an archetype for the 'hidden' control across politics, the mainstream media, global finance, religion and the military industrial complex. In his book *Urizen*, Blake describes his archetypal character:

> *As supreme deity, as ruler of consciousness, Urizen creates those "isms" which close the doors of perception, and enslave people into myopic "ists". Then Urizen (Reason) will trample creativity and imagination, ban his books, censor his thoughts, and bind his aspirations. In chains of the mind locked up | Like fetters of ice shrinking together* [11]

The second *Matrix* film (*Matrix Reloaded* 2003), a highly symbolic production in my view, also features the creator or Father God of the 'world matrix' as the 'Architect', a white-haired old man! In the *Matrix* this figure clicks a pen to change hundreds of television monitors, symbolic of God's giant artificially intelligent 'notebook' recording our every move. In the classic story the *Wizard of Oz* (1939), we find identical symbolism along with a depiction of a white-haired, all-knowing God (Oz), who when the veil is drawn back, he is revealed as just another 'man-myth' desperate to control and have authority over his minions. Both these stories hint at our human desire to free our minds and hearts from the limitations of a grand illusion and return home (like Dorothy from Oz) to our true domain. The Old Testament God, in my view, is man's creation, and many people, over thousands of years, have taken religious symbolism literally, while denying their *true* natural state. Scientists are also put on pedestals as the 'gods' of our 'nuclear age' which was heavily reinforced during COVID 19, via the constant mantra "trust the science," a subject I will come back to later in the book.

The 'All-seeing eye (see figure 6), is also symbolic of an interdimensional force from 'outside' of our world. One that looks into our reality and views all of humanity. It could also be symbolic of an ancient deity worshipped by brotherhoods in temples dating back to Atlantis. Some say the force the eye represents has controlled our 'five sense world' via an ancient priestly cult for many thousands of years. According to numerous myths and legends, immense battles took place in the skies (across the earth) to keep this 'force' (represented by the All-seeing eye) from taking over. Legendary tussles between 'heroes', 'gods' and a 'predator force' seem to be narratives embedded in the human psyche. Similar themes appear in art history and in movies today, which are especially potent due to the fact that moving images reach

a greater audience than any historical painting can. Images of a predatory force can also be found in modern literature and films; see the *Lord of the Rings Trilogy* (2000-2003); it is often depicted as a great evil overshadowing humanity. The main point here is that such a predator force or intelligence, whether it sits atop the Black Tower of Mordor, or on the back of the one dollar bill, represents something very much influencing our reality.

It's recorded in the art and texts of ancient Babylon (now Iraq), that fantastic hybrid creatures known as 'guardians' and 'doorkeepers' dwelt unseen at sacred sites. The same 'entities' are found at ancient sites in places like Tiwanaku, Bolivia, Peru and at many Templar church cloisters built in medieval France (see figure 7). Such sites are aligned with the stars, the

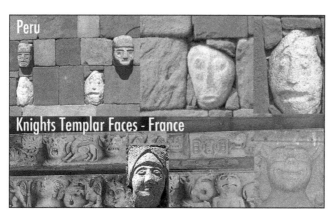

Figure 7: Stone faces from another dimension?
Otherworldly stone faces at temples all over the world. These visages seem to be *appearing* 'out of nowhere' watching our reality.

sun and the moon all across the world. I have visited many of these sites over the past twenty years and it is obvious that the ancients were calling on such forces. It's also true that many of these 'creatures' (faces) were carved by priests into the walls of palaces and temples so to keep unseen forces from entering into our physical reality. The same understanding is applied to the coffins and tombs of the Egyptians, masks of the shamans and the totem poles of the North Western tribes of North America. The carvings made by many native artists are said to represent allies, aspects, and non-physical forces connected to a specific clan or tribe. All of these examples hint at the metaphysical attributes of art and the power of symbolic effigies to speak with unseen forces (often through portals) dwelling on parallel dimensions!

I feel that visionary artists, like William Blake, were massively aware of these portals and parallel worlds from where alternative dimensions could be accessed. While illustrating Danté's *Divine Comedy*, depicting Hell, Purgatory and Paradise, which is a monumental project and left unfinished on his death bed, Blake wrote: *Where Danté sees only Devils, I see Angels.* Despite the obvious religious symbolism, Danté, a 13th-century Knight

Templar was speaking symbolically of different worlds where ancient-future forces dwell within the realms of our mind. Paradise *or* hell *are* just states of mind! Close encounters, premonitions, vivid dreams and experiences that put our minds into multiple realities are as natural to our species as drinking water. It's only our conditioned sense of self and opinions moulded by external forces that limit our ability to see beyond the five senses. Astrophysicist Giuliana Conforto explains in her fantastic book, *Giordano Bruno's Future Science and the Birth of the New Human Being* (2002), that in relation to parallel worlds:

> *Contacts of the 1st, 2nd, 3rd type, crop circles, premonitory dreams and visions of different worlds are on the increase. The existence of infinite worlds that are all one explains why the dead are not dead and aliens are not aliens. Many different or alternative cultures considered heretical from the standpoint of academic conformity are full of genius, high culture and consciousness of cosmic oneness in tune with some of the great thinkers of history who have hitherto only been understood in fragmentary and very often distorted ways.*[12]

PARALLEL REALITIES AND TIME TRAVEL

Parallel worlds and interdimensional travel have fascinated scientists and artists alike. Great thinkers from Plato to Einstein sought to prove their existence. Einstein's theories of 'worm holes' are just one example, while visionaries such as William Blake also gave us imagery of mythological characters that seemed to exist in parallel realities; so do the works of Gustav Moreau (1826–1898) and the Symbolist Movement, whose subject matter hints at 'invisible worlds' peopled by gods, devils, angels, and spirits. Apparitions, dreams and mythological characters are transported into the mind of the beholder through the art of the visionary. Our perception is the 'key' to the door marked 'alternative realities', but our imagination is the hand that 'turns the key'. We are able to walk *through* worlds, especially when in nature, or in a silent place, or even listening to certain music (usually 432 hz). We are beings *animating* a 'flesh and bone body', but our *spirit* comes from 'source' connected to infinite realities (see figure 8).

Figure 8: We are natural time travellers.
Moving through parallel realities should be a natural ability for humanity.

The easiest example of how parallel realities co-exist, is through our ability

to comprehend the past, present and future simultaneously! Through our thoughts, memories and imagination we are able to transcend the boundaries of time. Our perspective on any sequence of events, be they what we believe to be the past or the typing of this sentence, only exists because of how we live within linear time. In truth, time does not exist. We transcend time when we 'create' and forget about the structures surrounding us and controling our lives. Simply turning off the television (especially the news) for weeks will create that feeling of 'no time'.

All particles of energy (neutrinos) that exist in our universe, according to physicists, are passing through each other all of the time. Just as different radio frequencies and television station broadcasts occupy the same space at the same time. Radio and television stations are a perfect analogy of how parallel worlds exist: none are 'physical', and depending on what frequency we are tuning into, depends on what 'reality' we perceive. Many films, literature and art, especially in recent years, are littered with concepts that relate to parallel realities. Movies, like *Sliding Doors* (1998) by Peter Howitt, show the possibility of how one person can bend time and live in two separate realities in any one instance. Also in the 1990 film *Jacob's Ladder*, actor Tim Robbins plays a Vietnam War veteran caught up in parallel realities, peopled by demonic hosts and what he sees as friends and angels. Films such as *Donnie Darko* (2001) and *The Butterfly Effect* (2004) also touch on similar themes. So do classic books such as *The lion, the Witch and the Wardrobe* (1950) by C.S. Lewis and *Alice in Wonderland* (1865) by Lewis Carroll. Again, the concept of parallel worlds peopled by fantastic creatures and hidden doorways leading to different realities is at the heart of the human imagination.

Since the 1960s Ufologists and Science Fiction writers have documented similar themes showing how forces, outside of our space-time dimension, can manipulate our thoughts and influence our view of reality. The Ufologist John Keel shows in his books, *Operation Trojan Horse* (1970) and the *Eighth Tower* (1975), how forces, which can take on multiforms, use 'electromagnetic symbols' to affect our thoughts. Something that is getting more obvious by the year, as I will return to later in the book. In his book the *Eighth Tower*, Keel talks of energies coming through a black hole from another space-time-world. Jacque Vallées talks of similar themes in his book *Dark Satellite* (1962) which highlights the concept of strange beings operating in a subspace, and how they can impress certain imagery on the minds of contactees.[13] I feel certain that this is how, what we call, 'extraterrestrial' or 'inter-dimensional' forms communicate with people within this frequency range. These so-called ETs could also be linked to untapped levels of our DNA and our untapped brain capacity. In other words, both ancient and futuristic intelligences, which use symbols and telepathy to communicate with humans from higher

levels of creation, also have amongst their ranks malevolent intelligences that wish to dominate through possession. The Wachoskis' 2015 movie *Jupiter Ascending* brilliantly illustrates how ETs enter our world and interact with humans through the use of advanced technology to affect consciousness. Another Ufologist, Jenny Randles, also argues that consciousness can be a medium of interstellar communication.[14] According to Randles, a council member of the British UFO Research Association, our consciousness can act as a radio telescope beaming messages into the complex electro chemical computer that is our human mind. This is another way of describing the process of the 'matrix mind' and how it interacts with our imagination to select imagery, thoughts and inspiration.

George Lucas's *Star Wars* illustrates how in a parallel world, either somewhere in the distant future, or in a distant galaxy, there are governments, senates and empires waging war and vying for power. Themes in movies and stories such as *The Lord of the Rings* and *Star Wars*, could easily relate to memories of an ancient epoch on Middle Earth, peopled by alien creatures or interdimensional forces; they are littered with themes that are timeless. At the time of releasing *Lord of the Rings*, British and American forces were invading Afghanistan (2001) and later Iraq in 2003. Such films were almost as a reflection of our collective desire to continually see a world painted black and white, polarised, and at war. The 'mirroring' continues today, with endless other dualistic themes in movies and dramas on platforms like Netflix, etc. Yet, films like *Star Wars* and books such as the *Lord of the Rings* speak of our past-future-worlds *through* the use of archetypal myths. Films, art and stories of this calibre offer us a glimpse of the possibility of parallel realities and ancient memories of another time somewhere in the deepest chasms of human evolution.

DWELLING IN DIFFERENT WORLDS

In terms of parallel worlds we also have to consider Mescaline influence and natural psychotropics. Aldous Huxley's inspired 1956 essay detailed the vivid, mind-expanding, multisensory insights of his own mescaline adventures. By altering his brain chemistry with natural psychotropics, Huxley tapped into a rich and fluid world of shimmering, indescribable beauty and power. Huxley was very connected to the 'elite circles' of his day so he would have had access to knowledge not available to the masses at that time. Whether by hallucination or epiphany, Huxley sought to remove all controls, all filters, all cultural conditioning from his perceptions and to confront Nature or the World (reality) first-hand, in its unedited infinite rawness. What physicists have learnt since Huxley's time is what the mystics of the past always understood – that *particles of energy have the ability to be in two dif-*

ferent places at the same time. In times gone by many a seer, sage, witch, shaman and mystic have been ridiculed and burned at the stake for sharing this kind of information. It was a threat to the status quo of whatever period they spoke out in. As I said earlier, Giordano Bruno was one of many geniuses who believed in the possibility of time travel and parallel realities peopled by other versions of ourselves. According to Bruno, humanity and the universe came into being at exactly the same time! The energy that makes up who we are in all our forms was present at the birth of the universe. Every bit of what mystics call the 'etheric', 'energy', 'spirit' or what scientists now understand as vibrating particles, exists at different states of speed or vibration. Allusions to time travel also relate to how particles can vibrate at a faster speed (future, or ascending), or can become denser and more solid (the past, or descending). The present moment is from where all this movement is perceived. So, time in this sense, is our experience of movement, not just in its physical sense, but how we move from past, present and future through our thoughts, memories and, importantly, our dreams. We are dwelling in different worlds simultaneously and this gives us our memory and the mind capability to traverse time. When we look at ourselves from the *outside looking in* as human beings, I believe we are natural time travellers who can exist in parallel realities simultaneously. This is why our creative imagination is so important; it's our personal time key or individual set of codes designed to transport us (through our imagination) into other worlds.

Galactic time is also connected to many interplanetary forces (symbolised through Astrology) and can relate to the ageing of our bodies, or the movement of cells. But in truth, if time does not really exist then neither does death! Only the dense physical vibration (flesh and bone) can die, the soul, our imagination and our spirit lives *forever*. Much scientific evidence proves that life after death exists.[15] We have divided daylight and darkness into segments called hours, which comes from the Egyptian word for their solar god 'Horus'. We also have calendars inspired by Babylon and 'religious reordering' of time. From this perspective we *believe* time to be something that is actually physical or linear, when it only exists in our minds! Our perception of time only relates to the five senses outlined earlier, whether a clock ticking, or a flower growing, we are still locked into the vibration of this physical dimension. While I am typing this text into the computer, our planet is travelling within the solar system and other planets are moving at different speeds, all producing different rates of time passage. Our Sun is moving with a wider arm of the Galaxy, and all this is happening from a physical view point. Galaxies are also turning and spinning and the microcosm and macrocosm of creation (as I will delve into towards the end of the book), takes us beyond the boundaries of the illusion of time. But, in essence, it's our ability

to 'imagine' ourselves at any place *in* time (as part of the *infinite*) that moves us out of this physical dimension—out of our minds. It's our ability to 'day-dream' and use our creative imagination that creates non-local (non-physical) states of being. William Blake expressed this concept of existing simultaneously within *and* beyond time, when he wrote: *"To see a world in a grain of sand, And a Heaven in a wild flower. Hold infinity in the palm of your hand, And Eternity in an hour."* [16]

By the very nature of our artistic abilities, through a combination of art and science, we can enter into multirealities, subconscious realms where archetypes speak through symbols, colour, forms, sacred shapes, music, and our own unique imagery—an ancient form of communication. In the next few chapters, I intend to explore some of the art and themes used by the ancients, to understand the many 'unseen levels' or 'forms' interpenetrating our world.

NOTES:

1) Conforto, Giuliana: *Giordano Bruno's Future Science*, 2002 Edizioni Noesis. p106
2) Hague, Neil. *Through Ancient Eyes*. 2018. Quester p203
3) Conforto, Giuliana: *Giordano Bruno's Future Science and the Birth of the New Human Being*. 2002 Edizioni Noesis. p107
4) Kaku, Michio: *Hyperspace*. Oxford University Press, 2000. p333
5) Johnson, George: The *New York Times Week in Review* Sunday March 5 2000 Section 4 *Dark matters afloat in the cosmic hall of mirrors*.
6) Close, Frank: *The New Scientist*, December 2002
7) Beginning of the *Gospel of St John* – and St John is probably not the same John who wrote the Revelation of St John the Divine.
8) Bellin F, Harvey & Ruhl, Darrell; *Blake & Swedenborg, Opposition Is True Friendship* Swedenborg Foundation 1985.
9) https://www.carlagoldenwellness.com/2012/10/05/hands-shown-to-emit-light/
10) I write in more detail about the effects of the shadow world, Plato's Cave and how we perceive reality, (established beliefs and dogmas) in *Through Ancient Eyes*.
11) Blake, William: *Urizen* 10:25-26; E.75.
12) Conforto, Giuliana: *Giordano Bruno's Future Science and the Birth of the New Human Being*. Edizioni Noesis. 2002. p50
13) Story, Ronald D (Edited by): *The Mammoth Encyclopaedia of Extraterrestrial Encounters*, Robinson Books, p436
14) Ibid. p44
15) *http://www.SurvivalAfterDeath.org*
16) Blake, William: *Auguries of Innocence*. 1803

symbols of consciousness

Worlds of form & secrets of matter

Art does not reproduce the visible;
rather it makes visible the inward vision
Paul Klee

A lot of art from prehistoric times is not art for art's sake! In fact it may well be more scientific in content than we have ever realised. Much of what we call 'prehistoric art' was made by humans who show signs of 'seeing' the world through subconscious levels of the mind. Palaeolithic art is some of the most intriguing imagery the world has ever seen, and the 'artists' behind it insinuate interest in the movement, energy forms, animal and various geometric symbols. To appreciate the minds of our ancestors one only has to see the more lucid, or fluid, images of lions and bison in places such as the caves of Chauvet and Lascaux in France, to realise they are not visualising reality in the same way. In these places, artists seem to be concerned with the 'spirit of the animal' rather than a phys-ical interpretation. But isn't this the real reason for art? Other prehistoric imagery found in caves is totally abstract and executed in a way that 'sug-gests' the artist is focusing on imagery within the subconscious mind.

The mind operates through two distinct levels: the conscious and subcon-scious, or the world behind the conscious one that we all accept as reality. These two areas can be seen as chaotic and ordered or imaginative and ratio-nal and, when we look back at art made by prehistoric artists, it is focused more on the subconscious levels of the mind and phosphenes (hypnagogic) imagery. A phosphene is an entoptic phenomenon characterized by the expe-rience of seeing light *without* light actually entering the eye. The word phosphene comes from the Greek words phos (light) and phainein (to show). Phosphenes can be directly induced by mechanical, electrical, or magnetic stimulation of the retina or visual cortex, as well as by random firing of cells in the visual system. Children have this natural ability to 'see without light', utilise their imagination, or dwell in the subconscious when it comes to mak-

ing imagery. In some cases the oldest cave art found to date (Chauvet, in France) may have been made by very gifted children![1]

EVERYTHING COMES FROM THE WORLD OF FORMS

For the ancients, the physical world was brought into existence through archetypes and symbols. The Greek philosopher, Plato, went as far as saying the physical world, the one we see, touch, smell, hear and taste was governed by what he called: *the world of forms*. Today science recognises these 'forms' through wavelengths, particles and, notably strings, but for the ancients they were part of an invisible, eternal 'substance' that provided the energy fields and blueprints behind life. In the Egyptian papyri, for example, this substance was given the name 'Nun', the infinite ocean from which all forms and structures emerge. For the ancient Greeks it was the goddess 'Chaos' that provided the energetic substance permeating all life. The concept of a world of invisible forms, that give structure to the world (our reality), is one that can aid us in our understanding of why various marks were made by prehistoric artists.

For the philosophers and scientists of ancient Greece, a non-physical world was thought to be the 'morphic essence' behind the Universe – a level of reality made up of archetypal forms, waves and shapes. Rupert Sheldrake postulated in his book *A New Science Of Life: The Hypothesis of Formative Causation* (1981) the existence of morphic resonances. A morphic field is a *field* of *pattern, order, form* or *structure* organising forms *behind* the development of living organisms, atoms and molecules. According to physicists, 'fields' actually influence and organise everything in our universe. Sheldrake likens it to the field around a magnet which causes iron filings to arrange themselves in predetermined patterns. The same imagery is seen in 'cymatics', a subset of modal vibrational phenomena, pioneered by Swiss medical doctor and natural scientist, Hans Jenny (1904-1972). Certain images found in prehistoric cave art, on tombs and in the temples of the ancient world, seem to be attempts to understand such forms. When such vibrational shapes and forms are viewed from a metaphysical viewpoint they can tell us more about the nature of reality and the forces that shape it. If we are going to fully understand deeper meanings behind prehistoric rock art, then art historians and scientists working within the field of astrophysics and the holographic nature of the universe, need to come together.

A SEA OF SPIRALS – THE MOTHER SUBSTANCE

In prehistoric art we find amazing examples of spirals, waves and symbols that seem to be conveying *energy* and *movement*. Spirals in particular are found in art across most cultures and of course the spiral will have different meanings for different people. Even the spiral form itself can vary, as seen in

the different types of galaxies photographed by NASA over the years. However, there is a common belief in its message of migration, movement, and, as an archetype for energy not yet formed into something solid. The principles behind holograms, as understood by scientists today, also show a layer of reality that is not solid and this can be depicted as waves, circles and spirals.[2] Even the composite nature of archetypal images can be modeled on the holographic universe theory. Stanislav Grof, chief of psychiatric research at the Maryland Psychiatric Research Center, and author of the *Holotropic Mind*, even suggests that holography makes it possible to build up a sequence of exposures such as pictures of every member of a large archetypal family in one image.[3]

Similiar concepts are seen in the idea of the 'web of life'. The ancients used terms like the 'web of life', or 'maya' to suggest that all life is connected to the invisible strands that construct what is often called 'Mat' in Egypt and in modern terms, the '*Mat*rix'. For the ancients these names were given to a goddess, who like Grandmother Spider, was said to have woven the threads and forms of the universe. What the ancients and open minded scientists working within quantum physics are alluding to, is a world 'woven' by invisible wave patterns - a reality that is holographic by nature.

One fascinating aspect of prehistoric art is the use of wave forms and spirals to cover sacred tombs and shrines. Could it be the artist/shaman was conveying the idea of a 'lucid world', one that constructs our solid three-dimensional one? According to world-renowned quantum physicist, David Bohm, at the University of London, 'two sets' of wave patterns caused by diverting a coherent light source create what we call a hologram. The patterns caused by this process can be likened to two stones thrown into still water and if light is directed to where these waves (ripples) interfere, then a holographic image, of any original source, can be seen. From a metaphysical viewpoint, the subconscious mind creates *thought waves* that the conscious mind *observes* in 3D holographic form as *thought waves*. Therefore, artists concentrating on subconscious aspects of the mind would predominately produce lucid, spiral-type rings and waveforms. Going inside the earth, into wombs or caves, while taking mind-altering drugs, would have easily aided the ancient artist in 'seeing beyond' the veil of conscious thought. In fact, the world would have seemed very different for the shamans who broke down the doors of perception, and moved their sight towards internal realms of the archetypes. The entrances to the Holy of Holies in places such as New Grange, Ireland and at Hal Tarxien in Malta, are just two of thousands of examples where the use of spiral forms on stone represents the 'borders' between this reality and the invisible world of archetypes (see Figure 9).

In later epochs, many artists made extensive use of spiral forms, too. Vincent Van Gogh made use of such forms within his paintings and he was

an artist who used his visionary sight while focusing on forms in nature. As I will show in a later chapter, the lucid world of forms (archetypes) encompass both the 'microcosm and macrocosm' (no telescope or microscope necessarily required) and it is within this level of perception that the artist realises 'reality' is in effect a holographic projection of our mind, or the mind of God for the more religious folk. From the holographic understanding of reality, an atom *is* a solar system, and a galaxy takes the form of our DNA! Both big and small are the same. It's only the obsession with the 'physicalness' of everything that has led to the making of powerful lenses to see such connections, and, even then, not all that there is to see is available through the most powerful microscopes. Shamans from South America to Australia, through the use of hallucinogenic plants and mushrooms, could actually *see* the rhythms in all life – the DNA, as symbolised through images of cosmic ser-

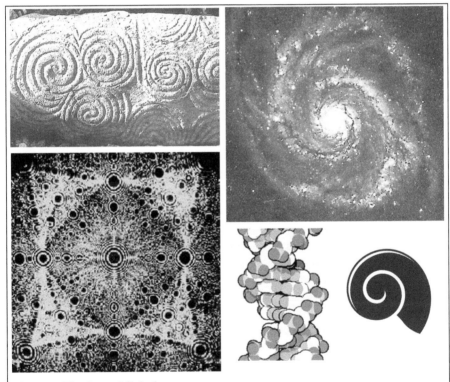

Figure 9: The Sacred Spiral.
(Upper Left) The Entrance to the 'holy of holies' at New Grange, Ireland gives the impression of wave patterns caused by lasers hitting holographic film. Raindrops falling on water also give the same effects of interference patterns.
(Left) Atoms dancing also create interference patterns, which look like holographic film. **(Upper Right)** The galaxy is also a spiral and this symbol speaks of our 'dreamtime'. **(Middle & Right)** Our DNA, when magnified, takes on a spiral formation, just as many forms in nature replicate the spiral coding.

Figure 10: Shamanic journeying.
One of many sketches I've made showing the 'astral body' of the shaman/priest/initiate (as the stick figures), at places like the Pyramid of Cheops, flying through worlds beyond the physical. The astral world *is* the Dreamtime. © Neil Hague 1995

pents and spirals found in their art. For more on this strand of subject I can recommend an excellent book called *The Cosmic Serpent: DNA and the Origins of Knowledge* (1998) by anthropologist Jeremy Narby.

Archetypes, such as spirals and circles found in ancient art, are reminders of a universal language, a 'computer pro-gramme' if you like, that formulates our perception of reality. In many cases prehistoric images were made by seers that had taken their sight beyond the veil of the physical world.

Imagine if the real world is purely moving waves, patterns or numbers as shown through the work of astrophysicists and seen in *The Matrix* movies. To be able to *see* the world from the 'outside looking in', the *seer*, or shaman, would have to go into the darkness of the womb and be reborn. The positions of key ancient ritual sites, such as pyramids, the Holy of Holies, and earth mounds all over the world, were built for this purpose. Many caves from Palaeolithic times were also used to enter a state of mind (or being) from where archetypal imagery would emerge. Many of the sacred sites, like New Grange, Pyramids at Giza, etc., were *not* burial sites, but places of initiation, where the shaman/priest would be taken through levels of consciousness into worlds beyond the physical one (see figure 10)! Art therefore is the per-fect tool for expressing the lucid dream imagery and symbols that appear under these circumstances.

SACRED GEOMETRY

Sacred geometry and platonic forms found in nature are also an expression of an unseen language. Nature is a world teeming with invisible structures, patterns and mathematical data that underpins the physical or solid one. From Egyptian artist priests to Leonardo da Vinci and on to Odilon Redon (a French Symbolist painter), all made use of geometric forms in their work. The same geometric patterns are found in flower shapes, honeycombs, spi-

derwebs and such, and express a higher dimensional language that includes *Numbers, Music, Geometry* and *Cosmology* (the four great Liberal Arts of the ancient world). Similar geometric shapes are also found in the designs of walls and floors of places like the Palace of Tell el-Amarna in Ancient Egypt and in the design of many gothic cathedrals. Several 20th century artists, especially the Surrealist work of Paul Klee and Wassily Kandinsky, also used archetypal geometric forms as a basis for their art. Platonic and Archimedean solids, along with the Fibonacci sequence are all examples of 'invisible' numbers creating forms that give structure to the so-called physical world.

Artists and image-makers (whether consciously or not), have used the 'world of forms' in their art, to remind us of our connection to 'unseen forces' formulating our reality. It's the use of such archetypal images within all art that provides us with aspects of an alternative history of art; and therefore, an alternative version of reality. In the next few pages I want to highlight some of what I call 'power symbols' found in the archetypal world of forms, as painted, scraped and studied by our ancestors. Here are the most common symbols underpinning the ancient language of the archetypes.

THE CIRCLE

Obvious examples of archetypal forms are the circle and spiral, which appear throughout much Native art. The circle is a symbol of oneness, unity and represents the wholeness inherent in all life. To indigenous cultures the circle was more than just a pattern or shape, it also represented 'balanced power' and knowledge of how the universe creates, evolves and changes. The circle reminds us of patterns in nature, and the life patterns *within* us. But more so, the circle reminds us of more scientific principles explaining how *all* life is part of an immense 'mind' – expressed as 'images' in the mind of God. *We are all circles.* The world (Earth) is also a circle (flat or otherwise) and constantly reflects our collective state of being. In its simplest form, the circle is made up of *two* parts, the 'inner', which is who we are, and the 'outer', which is the world around us. It's our job as both spirit and matter to expand our consciousness beyond the thin rim separating us from the rest of creation.

Circles, domes, ovals, spirals, squares, labyrinths and pyramids are just a few examples of symbols containing a knowledge that was (still is) used to create the foundations of communities, religious beliefs and even governments. All our modern councils, including the more clandestine global think tanks, are modelled on the use of ancient archetypal symbols like the circle. However, these symbols held a deeper, mysterious and more spiritual significance to our native ancestors. Throughout history and over many thousands of years cultures grew and evolved through the use of their creative energy and the development of profound symbolic knowledge in its variety of forms. Direct inspiration was sought from the worlds of archetypes and the

universe in its many forms through the use of symbols. This is how all religions and belief systems were originally conceived and created. Through dreams and inspiration our ancestors forged links with either positive or negative versions of the original archetypes, many of which became represented as hero gods and goddess figures *through* religion. For example, the priesthoods of ancient civilisations such as Babylon, through their ceremonies and rituals designed to forge links with beings from other dimensions, knowing our fears and weaknesses, proclaimed themselves the 'fathers' of what became modern (organised) religion. These founding fathers then set rules, drew up calendars and twisted the true meanings of certain symbols so to assert control over the populace. Such 'control' of the archetypes is still with us today in the so-called civilised world, especially in the way 'time' is measured. On the other hand, native tribal people from Alaska to Australia maintain within their lives the perception of universal symbols and how they are intricately woven into the structure of all life forms. The circle as an archetype for life in this reality is summed up beautifully by Black Elk, an Oglala Sioux Medicine Man, when he said:

> *You have noticed that everything an Indian does is in a circle, and that is because the power of the world always works in circles, and everything tries to be round....The sky is round, and I have heard the earth is round like a ball, so are the stars. The wind in its greatest power, whirls. Birds make their nests in circles, for theirs is the same religion as ours....Even the seasons form a great circle in their changing, and always come back again to where they were. The life of a man is a circle from childhood to childhood, and so it is in everything where power moves.* [4]

Celebrating the circle by seeing it expressed through the natural world gives humanity a deep sense of its own creativity and community. People use the circle to heal, tell stories and inform community. The circle inspires us while asking us to value the more mysterious side of what we term 'reality'.

SPIRALS *EVERYWHERE*

The spiral is also a circle to which the dimension of time has been added. It is a symbol that embodies the movement of galaxies, stars, moons and suns, (captured brilliantly by Van Gogh in his work *Starry Night*), to the life force in our DNA. For many ancient cultures, like the Native American Hopi, the spiral represents both a spiritual and physical journey and it is a migration symbol, which explains the migration of tribal clans across the earth. The spiral can also be used to describe the microcosm for our individual soul movement or our personal creativity as we journey through life. For artists like Vincent Van Gogh it was how he saw the stars move, while accessing his

inner sight, and only in recent times have scientists discovered that some stars do form spirals of light in space. The spiral represents the motion and evolution of the universe, our consciousness, the movements of cells, and even hair growth. From a wider perspective the spiral can symbolise eternity, as it turns forever experiencing itself.

As a mythological symbol the mystical spiral appears as the protecting 'Cosmic Serpent' (or dragon) which coils around the 'World Tree' or 'World Mountain'. This is the same mountain that any initiate has to climb to penetrate different levels of awareness which, as you will see, is a constant theme throughout this book. The dragon coil or spiral can also be seen carved and painted into many ancient works of art, not least the images on page 51. One particular Indian myth illustrates how the Sun god 'Vishnu' devises a plan to preserve cosmic order by insisting on the cooperation of demons to activate universally opposing *spiralling* forces—a story about dualism that I will return to in more detail later in the book. The demons and gods, through Vishnu's initiation, haul the Cosmic Serpent, which is coiled around the world axis, turning thus creating the 'Milky Ocean' (the sea of spirals) to produce immortality. On another level this act can also be seen as the creation of opposite forces, the 'duality of being'. It's also the concept of our world as an illusion, created by two osculating forces to create a third reality—our earth matrix. For the ancients, the spiral was a symbol for the 'coils of manifestation', the veil itself, which must be *seen through* to gain one's truth, or inner self.

THE LABYRINTH

In a painting I made in 2011, titled *Placing the Stone*, I show both the spiral and the labyrinth coming together to symbolise two different hemispheres of the brain. In the canvas I show the spiral as a labyrinth 'opposing' what appears to be a 'maze', which forms the right side of the brain. Both symbols are found in much ancient art, from cave paintings to the landscape gardening of our elite royal bloodlines. The latter I will be focusing on in *Part Two*.

The spiral is also represented as a labyrinth by many ancient cultures; the earliest known is said to be in Egypt, dated to the 19th century BC. However, labyrinths can be seen on the plains of Nazca in Peru and, according to authors like Maurice Cotterell, they are Sun symbols, and represent its light. labyrinth and spiral designs appeared in ancient Crete through the Minoan civilisation (2000-1000BC), especially in places like Knossos and Phaistos. The use of such symbols is a reminder of our human preoccupation with the hidden order of the cosmos. The symbolism of the spiral and labyrinth is one of our 'inner cosmos', which also translates as an individual life, a temple, a town, the womb of the mother, or the 'journey of our consciousness' through

the maze called life. In cathedrals, like Chartres in France which was a major Druid site dedicated to the Sun (before Christianity), depictions of the labyrinth are found built into its floor. Such symbolsim represents the spiralling development of our own consciousness, the 'revealer and concealer' of the cosmos. On a higher level, the labyrinth is also a two-dimensional vortex that can represent our windings through space and time or our journey into many different worlds.

The whole idea of initiation *within* inner temple chambers or secret forest groves, which is still carried on in the secret societies today, is symbolic of that hidden knowledge contained within the labyrinth. The labyrinth is a symbol for the living cosmos and is a major mother goddess archetype used by the ancients, in their art, to symbolise 'forms that shape worlds', or 'thoughts' that brought our world into existence.

KEYS TO THE COSMIC STAIRWAY

Another theme relating to the spiral in art, is what I call the 'cosmic stairway'. It, too, is an archetype found woven into ancient myths, scripture and cultures. The cosmic stairway, or 'star-way' is one that was said to be the path along which we travelled (as multidimensional beings) through rime. The 'stairway' can descend (travel into the past) or ascend (journey into the future). It's also the 'dream ladder', or the golden thread left by Ariadne for Thesius to follow so to escape the beast within (Minatour) and the labyrinth of the underworld (our reality). The Aboriginal tribes of Australia depict the same knowledge behind the cosmic stairway as a 'Cosmic Serpent' or the 'Rainbow Serpent'. As I already mentioned, anthropologist, Jeremy Narby illustrates the connection between shamanic images of cosmic stairways and serpents and the double helix structure of DNA in his book *The Cosmic Serpent* (1999). In fact the use of the double-headed flying serpent symbols, or a serpent eating its own tail in aboriginal art and alchemical drawings, seems to relate to the confines of our DNA and how the physical world is structured.

The Cosmic Serpent is a creature referred to by the ancients as a symbol for the force constructing space and time. Beyond the limits of time was the state that shamans of both Peruvian and Mayan cultures of South America would journey to. As mentioned earlier, several plants, like the Banisteriopsis caapi (ayahuasca) and tobacco, were used for their mind-altering capabilities. To journey to the centre of the Milky Way, or to ride the Axis Mundi, the Cosmic Serpent, the mind had to be freed from the limits of the illusory physical world. As Narby points out in *The Cosmic Serpent*, the shaman was journeying along, or *going beyond the double helix of the DNA* (the snake and ladder programme), to obtain knowledge of transformation and healing powers of

specific plants. At this level the shaman was accessing knowledge contained within, what microbiologists call, the crystalline aperidoic codes, as transmitted by all living matter. As Narby says in his book: "...The message was crystal clear: we are made of the same fabric as the vegetal world." [5]

SNAKES & LADDERS

The classic image of 'snakes and ladders' comes from the knowledge received by indigenous shamans prior to conventional science's discovery of the double helix by James Watson in 1953. In Australia, Tibet, Nepal, Ancient Egypt, Africa, and North and South America, the symbolism of the ladder, rope, bridge, chain, and thread—by which the gods descended to earth and men went up to the sky—can be shown to speak of knowledge contained within our DNA. Alchemists from the 14th century onwards refer to this same knowledge of the DNA as the 'Axis Mundi', or the 'sky ladder', which is climbed to 'see' into the molecular worlds of microbes and multidimensional information contained within our DNA. The indigenous peoples of the world knew nature talked in signs and through mental images brought on by accessing our DNA. This was often achieved by taking hallucinogenic infusions to break down the mental barriers so humans could converse with the mind of a plant, or the consciousness of an animal. As I will get to in the third part of the book, our DNA *is* the programme (blueprint), a 'web' connecting us to our past holographic forms and to the matrix shaping our perception of reality. The same understanding is conveyed in Native American teachings relating to the 'Web of Life', described as invisible threads holding all worlds (realities) in place through a centrifugal point. This point, or place, is a timeless zone beyond the realm of the Cosmic Serpent. It's our DNA that holds us in 'time and space' while our higher self exists beyond its programme. The worlds 'enclosed' by the Cosmic Serpent can be understood as different vibrations of matter, ranging from solid to more lucid forms. It is across this 'solid to lucid' *spectrum* that the shaman/artist journeys so to receive knowledge. Much shamanic art is derived from this journey.

Ancient calendar systems, from Egypt to the Americas, fixed themselves on time as measured by the movement of the Milky Way, in relation to the constellations in its 'arm', the Sun and the Earth. In truth, the calendar systems, both ancient and modern, are based on the syncronicity between time and our DNA. No matter where we live in the world, it is our culture, language, and, more importantly, our 'beliefs' that bind us to this time-frame structure. References to 'Grandmother Spider' in ancient myths (the weaver of space and time) also relate to the structure of this stairway and the cosmic threads said to create the energy fields and realities of which we are a part. Another name, for Grandmother Spider, was 'Thinking Woman', which hints at the

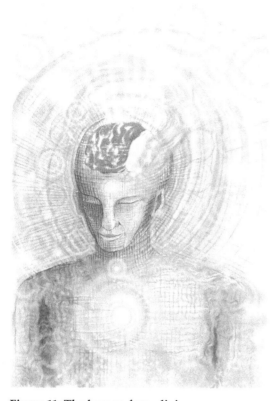

Figure 11: The human form divine.
The spiritual heart is our connection to the infinite ocean of love. It is both *within us* and *surrounds us*. We are a sea of energy fields or wave forms, which are decoded by our visual cortex in the brain. In truth, we are actually 'seeing with the brain' *not* our eyes. The world outside us is an illusion created as a 'reflection' of our subconscious mind.

power of the mind to weave and create reality.

The ancient world matrix, the web of life, *is* the archetype for how we formulate reality and, according to indigenous beliefs, it has been rewired (woven) or erased several times before, hence the legends of different worlds ending in much mythology. Each time the matrix or grid is reprogrammed by human consciousness, we are given the opportunity to return to oneness – our infinite form! Even the term 'Web of Life' also comes from the same understanding which suggests we *are all one* – all connected to the *one source*. When we, as a collective mind, realise and truly feel this notion of oneness within our being, all of the smaller programmes designed to keep life polarised naturally come to an end! The internal conflict ceases to exist when inner peace replaces inner chaos.

The world around us is either at peace or in chaos because of this understanding. Our spiritual heart is where we find our strongest connection to the infinite ocean of love (see figure 11). The earth matrix, like a web, holds our human form in a form of bondage, confined by the five senses, through the mind, yet the heart is the place connecting us to infinite awareness!

So much mythology, which by the way has inspired modern day filmmakers and writers to produce works such as *Star Wars* and write books like the *Lord of the Rings*, contains concepts of parallel worlds and invisible forces. Truths about the nature of life and the illusion we believe to be the real world are contained within a lot of science fiction topics (see *Orion's Door*). In fact, I often think that *Star Wars* should be renamed 'Stair-wars'– the battle for our right to travel into different dimensions. There are obviously more general

themes relating to archetypal 'good guys' and 'bad guys' thrashing it out for eternity, many of which are dual aspects of the same 'force'. Various religious doctrines, from the so-called cradles of civilisation in Sumeria and Egypt to Catholicism and to the worship of the 'triad or trinity', can also be found embedded in more ancient beliefs and scientific theory.

It's my view that this Cosmic Stairway allows higher dimensional messages to descend to the earthly realms and travel inwards (or upwards) to the cosmic centre. Artists tapping into such knowledge are aware of our duality and 'messages' from source as they descend to earth. William Blake expressed such a sentiment in his letter to Thomas Butts (1802), when he wrote:

> *I am under the direction of Messengers from Heaven, Daily & Nightly; but the nature of such things is not, as some suppose, without trouble or care. Temptations are on the right hand & left; behind, the sea of time & space roars & follows swiftly; he who keeps not right onward is lost ... I write when commanded by the spirits, and the moment I have written I see the words fly about the room in all directions, it is then published and the spirits can read it, and my manuscript is of no further use.*[6]

What Blake wrote relates to all who connect to the light within - our cosmic centre. This connection is our spiritual heart at the centre of who we truly are! I will come back to Blake and the Divine towards the end of the book.

SPIRALS OF LIGHT WITHIN US

According to great visionaries such as the aforementioned Giordano Bruno, the stairway is a structure that spans all dimensions and is held in place by particles that he calls the *Mother Substance*. Bruno also called her the Mother, the 'Abyssal Styx', the divine substance or eternal companion of matter.[7] According to Bruno this divine light, or crystaline energy, connects us to the original source, the divine infinite consciousness and awareness beyond mind. The crystaline is actually '*Chryst*aline' and it's our heart connection to the source of all-that-exists beyond mind, body and spirit. It's the power behind the 'genetic message' carried within our non-physical light bodies, and it is this level of being, where our light expands beyond the illusion of the physical world! Even though DNA is claimed by conventional science to have the laser power of only a single candle, its light is coherent, focused, concentrated and far more powerful than a single candle. Its real potential is highly symbolised in George Lucas's *Star Wars* movies as the weapon of the Jedi – the light sabre, and the Force they command so to use it.

For more Eastern traditions, the body is made of non-luminous matter centred upon seven energy fields (vortices) that run along the spinal cord. These spiralling vortices are called chakras, which in the Sanskrit translates as

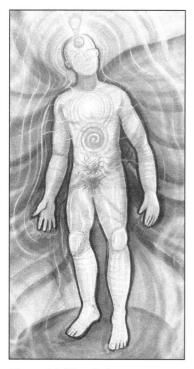

Figure 12: The chakra system.
If we were to see beyond the physical, humans are a myriad of energy fields connected to the ancient chakra system.

'wheel of light'. They are centres where various frequencies and energy fields interact with the physical body. According to ancient cultures we have several of these energy centres in the body and some outside the body connecting us with other realms of consciousness. According to the Hopi Indians and ancient Egyptians, the living body of mankind and the living body of the Earth *are* constructed in the same way. Through each body runs an axis; a human's axis being the backbone, the vertebral column, which controls the equilibrium of his movements and his functions. Along this axis are ten vibratory centres that are said to echo primordial sounds of life and the stars (see Figure 12).

The chakra system is our own personal rainbow of energy, colour, and sound. They act as a warning system if anything within our body starts to go wrong. All illness, from a higher perspective, is merely an imbalance on the unseen levels of the body, which then becomes physical 'dis-ease', or 'dis-harmony'. The ten body chakras are situated: below the feet; the feet, bottom of the spine (base or root); above the navel (sacral or spleen); above navel (solar plexus); chest (the heart; throat, base of the brain; centre of the forehead (third eye chakra); the top of the head (crown chakra). The chakra energy centres are connected to the glandular system, and through the glands disease can be transmitted to the physical body when one or more centres becomes imbalanced. The energy centres beneath our feet are said to connect us with the earth and the ones above our crown are of the spirit, or the stars and the cosmos. In many ancient cultures the crown chakra (where the mind interacts with the body) is seen as the open door, the portal by which a person receives his or her life force. It is also said that all inspiration comes through this door and, like a beam of light striking a single nerve cell in the brain, the seed (idea) is placed in our mind. Out of these vibratory centres are said to be the roots and branches on the tree of life symbolic of our connection with unseen levels of creation. In the Kaballah similar centres are also linked to the chakra system and the crown, or Kether, which is the highest location connected to the stars (see my book *Orion's Door* for more detail).

What visionaries, scientists and artists, from Democratus to the likes of Giordano Bruno, have striven to communicate through their work is that we are all made of the same substance that stars are made from. Giuliana Conforto, the Italian physicist, in her book *Giordano Bruno's Future Science*, describes this 'substance' as a 'crystaline genetic message' or the whole fantastic, emotional, cybernetic supercosmos composed of infinite worlds.[8] As individual souls we are a memory unit of the collective cosmic message or 'Christos' and we are 'carriers' of the original light that formulates all matter! Even though our bodies are made of all the elements of earth, fire, water and air, from a physical (alchemical) perspective, we have many other *finer* bodies composed of 'bright fire' (Christ light). The real Us – our higher state of consciousness, one that exists both here and beyond space and time, *is* Christ-like, for want of a better word. The energy waves, patterns and forms creating the physical world, are the same invisible particles manifesting *infinite* forms, both seen and unseen. Just as every individual grain of sand is the desert, we as individuals are aspects of Oneness – *we are all One.*

BRUNO & THE SECRET OF MATTER

Giordano Bruno in his work *De la Causa, Principio et Uno*: said, "*All particles, which constitute all life, are divine.*" He even went so far as saying that if there were other planets with intelligent beings, then where did that leave Jesus Christ? Did those other planets need their own Jesus? You can appreciate why he was jailed and murdered by the Roman Catholic Inquisition! Two of his alleged scientific heretical errors were his belief in an infinite universe and in planets circling other stars, much of which is proved to exist today.[9] He also went on to explain that divine matter constitutes *three* aspects: it *acts*, it has *form* and it has *power*. All three come *through* thought and matter, which defines and creates our reality! This 'trinity' can also be described as 'particle', 'light' and 'wave'. At a human level, these three correspond to: *body, image,* and *thought,* or *past, present,* and *future.* All three are connected to many religious notions of the Father, the Son and the Holy Spirit. Even the particles known to science as 'neutrinos', are said to fit into three specific categories depending on their electromagnetic charge.

According to the likes of Bruno, matter and spirit are just two different speeds of thought. We don't 'see' but 'feel' faster than light speed! All matter is the slowest state of being, and all spirit is the fiery aeriform one. How matter solidifies, becoming denser in vibration depends on how we relate to the three levels of matter (particle, light and wave). In other words, our ideas can appear in a flash, striking our nervous system, inspiring a thought. Yet, that idea (or thought) would become solid (real), in terms of its vibration, if it became an actual object, or experience in the physical world.

The same threefold knowledge is found in the ideas around creativity, and

relates to what Arthur Koestler describes as *humour*, *discovery* and *art*. All patterns of creativity are 'trivalent', according to writers like Koestler, and they enter the service of any of these three forms.[10] I feel certain that the three-pronged hat of the jester relates to this understanding of an ancient 'trivalent' threefold knowledge. Duality (twos) and triplicity (threes) can be found in all our social structures from sports, through to political heirarchies, or parties. Duality and triplicity are aspects of human nature and are rooted in deeper symbolism as I will explore later in the book. Through our DNA (deoxyribonucleic acid) we are quite naturally both dualistic, by the very nature of having 'pairs' of almost everything, not forgetting the brain is also left and right-sided. All nature, from a human being, to a reptile, fish, bird, tree, insect and flower, shares the same genetic codes known as A, D, C and T (adenine, thymine, guanine and cytosine) through DNA.

As I have already speculated there could be connections between both ancient and modern scientific understanding of how the universe evolved. Alchemy, myths and mystical systems found in places like the Kaballah also inform us and try to explain the nature or structure of the cosmos. The Cosmic *spiral* Staircase, mentioned earlier, is seen by mystics as 'mini-rings' or 'cosmological stairways'; according to astrophysicists, these 'rings' span the mother substance's or its creator's 'hottest phase' to the 'coolest' (solid one) we observe in the physical world. All stars, making up the life of our galaxy and the universe, are said to evolve through heat, from white-hot dwarfs to cool red ones, along what astronomers and cosmologists refer to as the 'Main Sequence'. The phases and sequences of the stars and planets are part of the cosmology attributed to gods, heroes and often 'historical' people. Those portrayed as gods within the religions of the world, are, in my view, analogies of the movements and birth of stars, suns and planets. Other interpretations of unseen forces, often described as gods, could relate to out-of-body experiences caused by using sacred plants, such as SOMA and hallucinogenic mushrooms.[11] For example, according to the late James Arthur, Father Christmas, in his red and white costume pulled by his flying reindeer, is a 'symbolic code' for the red and white Amanita muscaria mushroom, which grows at the foot of the evergreen pine tree across Siberia. In some traditions the 'PINEal gland' is thought to be the seat of the human soul and it is shaped exactly like a pine cone (see the court of the Pine Cone in the Vatican). The effect on the shamans' minds after eating a mushroom (as part of their ceremonies) would open the 'doors of perception' to many versions of realityrelated to flying and astral travel. Moving through galaxies or flying amongst the stars would have been possible for the shaman or druid after digesting hallucinogenic plants and mushrooms. The art and symbols placed on cave walls, or on temple tablets, etc., once the shaman had returned, would have 'reflected' what they had *seen* or 'encountered' while journeying

into alternative dimensions. Parallel worlds would have been as real to the mind of the shaman as the dreams we quite naturally embark on every night. From that perspective, the so-called 'real world' is no more than a dream world for those who can see beyond the window separating us from alternative realities. I was not surprised to see a similar concept illustrated in the Peter Jackson movie *The Two Towers* (2002). In this film we see Gandalf lying down on a mountain top after defeating his opposite, the Balroc. Here Gandalf passes into timelessness and drifts through space into the centre of the Milky Way. In this wonderful piece of cinema we are shown the eye of Gandalf *becoming* the centre of the galaxy as Tolkien's text explains 'how time and space merge, so a second becomes a lifetime'. Obviously the film and this character have many more attributes and meanings, but I felt the imagery posed in this scene was a classic example of how the artist/shaman, or druid/priest would journey into 'unseen realms' to obtain the secrets of matter, a higher knowledge and wisdom.

In reality nothing is separate and all stages of evolution, phases, explosions, chaotic and ordered movements of stars, down to the movement of people, *all* hold memories of each passing stage. Early phases of evolution are still present in our memory banks, locked deep within our cells. Just as stars give birth to planets, I feel somewhere back in our distant past, our universe was 'thought into existence' (no Big Banging required) by a divine consciousness, **One**, which in my view, is the 'creator' within us all!

In the next chapter, I want to explore the 'personification' of stars, suns, planets, and the 'phases or forces' aligned with ancient gods.

NOTES:

1) Berger, John: *Past & Present*, *The Guardian Review* 12th October 2002, p18

2) The *Scientific American Magazine* 2003. Also Talbot, Michael; *The Holographic Universe*.

3) Grof, Stanislav: *Beyond the Brain*, Albany, N.Y., State University of New York Press 1985, p31

4) *Native American Wisdom*. Running Press, pp20-21

5) Narby, Jeremy: *The Cosmic Serpent*, 1998. pp74-75

6) E. B. Murray. *Blake/An Illustrated Quarterly*, Volume 13, Issue 3, Winter 1979-1980, pp148-151

7) Conforto, Giuliana: *Giordano Bruno's Future Science*. Edizioni Noesis 2002, p97

8) Ibid: p119

9) Ibid: pp31-33

10) Koestler, Arthur: *Acts of Creation*, p27

11) Authur, James; *Mushrooms & Mankind*. The Book Tree 2000. pp11- 13

Personifying the planets

symbols of the mythic mind

Archetypes are systems of readiness for action, and at the same time images and emotions. They are inherited with the brain structure; indeed, they are its psychic aspect.

Carl Jung

Through mythology, we experience a multidimensional perception of the world. For example, the phenomenon of birth can be understood as a 'physical process' but that does not exclude it also being regarded as a 'supernatural' event such as reincarnation or an emergence from one world to the next. All myths are tales (often traditions) that seek to explain our place in the universe; they are a way of understanding many levels of reality. There are common themes in myths associated with ancient civilisations found all over the world, and the archetypal knowledge contained within myths through art forms are 'timeless'. Some of the commonalities found in mythology relate to a natural 'dream language', one that was superseded by a more linguistic form of communication. Such a dream language is purely connected to subconscious levels of our mind, one that often speaks through our imagination. It is also what indigenous cultures call 'oral tradition', or 'visual storytelling'. Carl Jung called this dream language the 'collective unconsciousness' when he said:

> *The creative process, so far as we are able to follow it at all, consists in the unconscious activation of an archetypal image and elaborating and shaping the image into the finished work. By giving it shape, the artist translates it into the language of the present and so makes it possible for us to find our way back to the deepest springs of life.*[1]

From the myths and art forms of our ancestors, especially from 8,000 BC to 4,000 BC (the late Neolithic period), we can *see* that the world, as they perceived it, was one that combined knowledge of 'heavenly cycles' with 'nature's cycles' through life on earth. The artistic level achieved by many Neolithic cultures is extraordinary, especially in places like the Karanovo and

the Cucuteni–Trypillia culture, also known as the Tripolye culture of the Western Ukraine (4,700 BC). Many symbols used on pottery from this period tell of various cults (focused on planets and stars) that had access to higher knowledge. We call this knowledge the 'occult', which is simply knowledge of hidden forces, and these cults also practiced a science *not* separate from nature. Across the ancient world the same gods were chosen by different native tribes and civilisations to represent archetypes evident in nature and the celestials above the earth. All life forms, from a rock to a planet, provided the 'prehistoric mind' with imagery and narratives that spoke of powerful forces animating nature. Palaeolithic art is a testimony to the understanding of 'invisible forms', 'energies' and 'archetypes' taking shape through our physical world. For psychologists, like Carl Jung, our human 'mythmaking' capability was a natural language (constructed through archetypes) expressed by our 'collective human unconscious'. Our ancestors' art, from the period officially labelled 'Stone Age' and 'Bronze Age', in some parts of the world, is adundant with symbols or archetypal forms. Archaeological discoveries in places like Germany show Bronze Age shamans, for example, had a unique understanding of the heavens. The 'Nebra Sky Disc' is considered one of the oldest depictions of the stars, the sun, and the moon.[2] It even seems to represent a face and some experts claim that it shows the Pleiades constellation. Other Upper Palaeolithic artifacts, such as a carved piece of a mammoth tusk found in 1979 at the Geißenklösterle Cave in the Ach Valley of southern Germany, clearly shows a 'figure' which is said to be the Orion constellation. Sculptures of the voluptuous goddess known as the Venus of Dusseldorf, from the same Upper Palaeolithic period, may also be an artistic impression of celestial cycles involving Venus, Mars and the Earth. The famous image of the 'Squatter Man' found all over the world from America to China, seems to be a Shamanic rendition of what our ancestors witnessed in the skies at the time of major upheavals (in the ancient world). Such a global personification in one image could have related to celestial events, along with the appearance of comets, or a global phenomenon (a Vela Supernova) seen at the same time 'everywhere' on earth.

In fact, when we look at the art of the ancients, it's as though we are being reminded of a prelinguistic dream language, one that speaks *through* symbolism pertaining to *unseen* forces personified. Whether celestial bodies, constellations, suns or planets, art and writings from the ancient temple cultures, such as Egypt, are coded with a dream language. In this chapter, I want to concentrate on strands of 'esoteric' knowledge that seemingly influenced art and writings of 'advanced civilisations' going back 5,000 years. What the ancients had in common, through imagery and certain religious beliefs, was a constant 'personification' of celestial bodies (planets, suns and stars) turned into gods and goddesses passed on through antiquity.

PERSONIFYING THE PLANETS

In classical mythology, at the height of ancient Greece, the names of the planets in our solar system, along with the sun and other stars, were given human qualities so as to describe the attributes of various gods. One reason for this anthropomorphism was mainly because, from our earthly perspective, *planets* outshine every other celestial object, except the Sun and the Moon, and therefore they were considered gods by our ancient ancestors. The giants of our solar system, Jupiter and Saturn, were also considered suns (stars) by the ancients. Various religions or 'cults', incorporating pagan beliefs, were founded through Saturn and Jupiter worship. Other celestial bodies, especially comets-turned-planets, such as Venus, which was once said to have been a comet, would have also made a massive impression on ancient people who observed the movements of wandering gods in the Heavens. Planets such as Venus and Mars appear *twenty times* brighter than Sirius (the brightest star in the night sky), and the way in which planets look in terms of colour and their position from the sun, aided our ancestors in personifying them. For example, Pluto, the most distant planet from the Sun's light, became the ruler of Hades the legendary *dark* Underworld of Tartarus. Pluto is associated with volcanic eruptions, firestorms, earthquakes and underground water systems, all of which relate to prehistoric evolutionary phases on earth. The Romans called this deity, 'Janus' (the two faced), and he was also known as 'Isimud' by the ancient Sumerians or as 'Usmu' by the Akkadian civilisation (see Figure 13). The Sumerian Tablets say Usmu was born with a dual face due to a genetic aberration. According to writers and astronomers, this double-headed description fits perfectly with Pluto's oddly inclined orbit, which takes it outward beyond Neptune for 248 earth years and brings it inside the orbit of Neptune for the remainder of its journey around the Sun.

The double-headed phoenix, of ancient Egyptian myth, also relates to death and resurrection associated with stories of the Underworld. Greek and

Figure 13: Double heads (or two-faced). (**Left**) Janus as a masonic double-headed eagle. (**Middle**) Usmu, or Isimud, the Sumerian deity. (**Right**) My version of the two-faced god – the 'Puppet Master'.

Roman deities such as 'Vulcan' and the 'Cyclops' race, were also said to be connected to the Underworld and to elite priesthoods that created (and, according to some researchers, still control) the secret society networks today. According to the Masonic author Manly Palmer Hall:

> *The Phoenix is one sign of the secret orders of the ancient world and of the initiate of those orders, one who had been accepted into the temples of man twice born, or reborn.*[2]

The fire-breathing hundred-armed Titans recorded in an ancient epoch, as depicted in Hindu-Asian art and Greek myths, are also symbols of unseen forces wreaking havoc, both on Earth and amongst our solar system. In Celtic mythology for example, the Titans were called 'Norns' and considered the 'shapers of destiny'. Flying Sun Discs, dragon slayers and Sun gods, are symbolic depictions of the relationships between people and their perceptions of space and time (more on this in the next chapter). The expansion and often cataclysmic movement of planets, including the impact of rogue visiting bodies such as comets (within the confines of our solar system) have also provided many a myth-maker with inspiration for battles and duels, sometimes in space, between different gods or opposing forces. In fact, the word 'planet' comes from the Greek word 'wanderer', which also adds weight to the personification of celestial objects and could relate directly to the 'migration of peoples', most of which followed the stars and made calendars while worshipping the gods and goddesses (archetypes) embodied in the earth, moon, and sun.

OMNIPOTENT DEITIES & DOORWAYS

The most common deities or archetypes worshipped by shamans or priesthoods going back to the rise of the great civilisation are the Sun, Moon, Earth and the planets. Images of the Sun and Moon 'personified' can be seen in Egyptian art, Bronze Age petroglyphs and in Akkadian cuneiform tablets found in what is now Iraq. From a physical point of view, the Sun and associated planets (wanderers) were personified and given human or animal attributes by priests and shamans because of our inherent human ability to 'personalise' the omnipotent, so as to make unseen forces much more comprehensible. For example, Genesis in the Bible can be viewed as a story of how the solar system was created by a higher mind (consciousness), one that seeded space, just as a gardener plants seeds and nurtures his garden. As I was finalising this chapter, I was sent an intriguing synopsis that proposed how the creation of the solar system can be related to the work of a celestial gardener or an 'intelligence' operating from other star systems. What inter-

ested me the most was that many years ago I also wrote a synopsis for a children's book called *The Garden in the Stars*, before I knew about any of these themes. The children's book (not published) also considered the personification of celestial bodies and a presence *behind* the creation of our solar system; one that 'threw comets', 'placed planets' and satellites sown like seeds in a garden. Creation *through* imagination, rather than random expansion or copying, was the theme of this particular book project. Many of my paintings over the years also hint at similar themes, and I think there is so much more to know about the true nature of our moon and the planets within the solar system (see *Orion's Door* for more a more detailed understanding).

In many ancient civilisations, for example, the Sun was regarded as a shepherd, a warrior, an archer, a hunter, a giant and a horse, along with many other archetypes. The power of the Sun became the power of a god or animal-hybrid creature on Earth. Many of these personas also related to the stars and as I have shown in *Orion's Door*, the Sun is hugely connected to both Sirius and Orion, not least through its position in the Orion spur of the Milky Way. Other reasons for direct personification, related to the worship of real men and women who stood out amongst tribal populations in ancient times, were the "auras" of these perceived gods and goddesses. Could these god-men and women have been extraterrestrials portrayed as other aspects of our human gene pool, or just purely mythic creatures of the imagination? However, so many seemingly different cultures, now oceans apart, carry the same legends of humans possessing godlike powers, albeit names changed due to language. What our ancestors had in common was the ability to perceive heavenly bodies, like the Sun, and represent their 'hidden powers', their *electro*magnetic power (such as sunspot activity). Such phenomena, or powers, can be seen in art and religious iconography, some of which have only been discovered by scientists in recent decades. It was quite natural for a Bronze Age artist to symbolise the Sun as both a human and a circle, because *both* Sun and man can be seen to 'move in circles'. The Sun (son) of Man figure known as Adam, Ptah (Egypt), or Jesus are all personfications of the Sun and its connection to a higher power. For the temple orders of Egypt, and their likes in South America, the Sun's powers were seen to reach beyond space and time and into unseen dimensions. In many cultures the Sun was a 'portal', known as the grandfather or grandmother; the 'door' to higher wisdom or consciousness. Such knowledge inspired the ancients to seek or *see* beyond the realms of the solar spectrum – or the illusionary façade presented by the five senses. Many references to solar insect deities found in cave art refer to different types of gods said to dwell beyond the rainbow (the solar spectrum) on a higher dimension; more on this later in the book.

GATES OF THE GODS & THE IMAGINATION

Another name for the Sun is the 'Golden Door' the portal to other levels of our imagination (*Super Consciousness*) and our link with stellar consciousness. William Blake's epic poem *Jerusalem* (1804) is dedicated to the 'awakening of minds' to the possibilities of what lies *beyond* the solar spectrum. The frontispiece for Blake's illuminated book shows a man, possibly Blake himself, passing through a doorway carrying a fire or sun symbolic of the fire and the imagination. The illuminated door or gate also refers to the knowledge of star-gates and the ability to transport humanity into parallel worlds, to the place where our gods reside. A huge mysterious door-like structure discovered in the Hayu Marca mountain region of Southern Peru, called 'The Gate of the Gods', hints at the possibility of operational star-gates. The Hayu Marca region (35 kilometres from the city of Puno), a place I visited in 2012, has long been revered by local Indians as the 'City of the Gods'. Over twenty people, including myself, witnessed the appearance of a genie-like 'extraterrestrial face' through a rainbow and cloud formation as we gathered to focus energy on the stargate (see my other books for more on this subject). Many other portals exist around the world and can be found at ancient sites. Some are stone circles like Avebury and others are hidden within chambers inside places like the Pyramid of Cheops at Giza, Egypt. Other sites are 'natural' landscapes (like Hayu Marca) where villages (or Mesas) at ancient sites form terrestrial 'markers' creating a portal into other dimensions and the stars.

So much ancient art, through to themes in science fiction books and films, contains images associated with portals and doorways that access different space-time worlds. I am convinced that much of what we call extraterrestrial exists in the higher dimensional worlds, or microbiological world of plants, insects and DNA. Both microbes *and* nebulas can be seen as parallel realities often tapped into by visionaries and shamans throughout history. This is why vertebrates can seem to take on an alien-like appearance when magnified, as I shall come to in more detail later. It's from these microcosmic levels of creation that some visionaries had communication with various insect-reptile-microbe figures, including phantoms and spirits. In the case of some magicians, artists or priests, knowledge and insights were gleaned from communication with such entities. William Blake's drawing of *The Man Who Taught Blake Painting in His Dreams (1819-20)* is a wonderful example of genius and creative imagery that speaks of his ability to see multidimensional personas. The power of the imagination, or the 'fire of inspiration' was also considered an attribute of our *inner* sun. What I am driving towards here is that omnipotent imagery, often created by sun (and star) worshipping shamans and priests in the ancient world, seemed to reflect a higher understanding of how everything is composed of luminous matter. The worship of

Atun (the source-light) by the Egyptians under Akhenaten is one example of such knowledge.

ANIMAL-PEOPLE & THE DREAMTIME

The Sun and the Moon also came to represent dualistic elements of life on earth and many symbols found in cave art, through to Egyptian hieroglyphs, show celestial objects personified. On a more invisible level, the Sun became a symbol for the 'inner light' revered by alchemists. Other interpretations of our inner light include battles between a Solar god and a Luna deity; quite often depicted in heraldry as the lion and the unicorn, eagles, serpents and humans. Animals were often used as icons for planets due to the influence of nature's cycles in accordance with the movement of the heavens. In my graphic novel *Moon Slayer* (2015), I show Jupiter as a giant plasma-like eagle called Altair, and Saturn as a giant red dragon, opposing each other. The animal wheel, or zodiac, is one perfect example of personification through imagery found in nature. Clearly, different cultures attribute different animals to the astrological wheel according to their perception of the heavens. Other reasons for the use of key animals in astrological and religious art relates to ancient knowledge of how *all* life, both animal and human, is connected, not least through DNA. The correlation between animal-gods, often considered the 'first people' in some indigenous people's traditions, and 'humans' is that both were seen as 'separate species'. The bear and the monkey were said to be two ancient tribes of people living alongside humans in an ancient era (age). In numerous accounts from all over the world, these ages ended abruptly through changes, due not least to the topology of the planet, caused by an infamous flood of biblical proportions.

Strange animal-people, or hybrids, are ubiquitous throughout all world mythologies. Identical hybrids can be found in some of the oldest art on earth, and the reason for such phenonema must lean towards the fact that *some* of these animal-human creatures actually existed. On a physical level, they could have been part of some sort of genetic experiment that took place after the flood, using the various strands of DNA available on the planet. In countries like India, for example, children born with horns or tails suggests that our modern DNA is capable of remembering certain 'ancient' codes. On a more metaphysical level, I feel that ancient references to the flood and animal-human hybrid gods found in world myths, relate to 'untapped' levels of our DNA, or what scientists call 'junk DNA', more on this later. Other myths and legends seem to be telling us about 'aspects' of our consciousness that dwell in what the ancients call the *Dreamtime*. Artists and shamans (of interchangeable roles) going within themselves to explore their visionary capabilities, often depict animal-human deities and dream landscapes. All of these art forms speak of a time 'before time' and the places where reality is imag-

ined into existence before it manifests as physical form. As one Native American belief states:

> *In the beginning of all things, wisdom and knowledge were with the animals, for Tirawa, the One Above, did not speak directly to man. He sent certain animals to tell men that he showed himself through the beasts, and that from them, and from the stars and the sun and the moon should man learn ...*

THE UNIVERSE AS A MAN-ANIMAL

There are many representations in art of the human form depicted as the Universe. Saviour figures and avatars of Hindu and Buddhist belief are just a few examples of the human form illustrating omnipotence. In Sanskrit, 'avatara' means 'the descent of God', or simply 'incarnation'. North American tribes, like the Hopi, also have similar beliefs in avatars, which is merely a belief in a 'Supreme Being' taking form in the physical world. When a *persona* form of God descends from a higher dimensional realm, into the material world, He (or She) is known as an incarnation, or Avatar. The Eastern mindset regards the avatar, or incarnation, as a *non-physical* one, whereas the western mindset concept of divine incarnation relates to a *physical* incarnation. In fact, the Latin root 'carnis' means flesh, hence the personi-fication. I feel there are many layers of dogmatic nonsense expounded within both old and new age religions regarding avatars, ascended masters and supreme beings. But what is interesting, from an artistic viewpoint, is the need to per-sonify 'invisible' (or visible) forces from planets, to energy, has come out of human percep-tion. Shamans, priests and artists from 30,000 to 5,000 BC helped symbolise or formalise the concept of an omnipotent persona constructed of many layers or dimensions through using both human and animal forms to illustrate these connec-

Figure 14: Half-animal, half humans.
(Left) Was portable art found in Germany over 30,000 years ago made by artists who were quite possibly making statements about their higher spiritual selves? **(Right)** The half-ante-lope, half-human figure on the right was made by the African San tribe.

tions (see figure 14 on previous page).

In Northern Europe during the Upper Paleolithic era (between 50,000 and 12,000 years ago), the two most common forms used in cave art were those of a human figure and the elk, and both are connected to the shaman. Images of humans with antlers relate to the legends of a genetic stream, or 'deer people,' encountered by shamans when they journeyed into Dreamtime. In Native American legends these 'deer people' were animal-human ancestors. Much cave art from the Stone Age period (4,000 BC) onwards constantly refers to ritualistic hunts, markers and migration records. Other images seem like prophetic narratives that attempt to explain various legends of changing worlds, 'time' and the types of gods/goddesses that influenced the ancients. However, many images relate to the rational formalisation of forces extending beyond the five senses—to the visionary powers of the shaman accessing the Dreamtime.

OMNIPRESENT DEITIES

'Vishnu', the omnipresent deity of ancient India, was depicted as almost everything! The most common image of Vishnu is a blue-skinned male, which was considered a representation of the creative vastness and more 'eternal' aspects of the universe. His consort and female counterpart, 'Lashmiti', was the embodiment of wealth, fortune, power, beauty and prosperity. Interestingly, Vishnu, according to Indian belief, was said to incarnate ten times, which I feel is more symbolic of 'ten dimensions' (realms) as recorded in ancient myth and also referred to as hyperspace by quantum physicists (see *Through Ancient Eyes* for more information on the ten dimensions). According to the Holy Hindu Upanishads, there have been *nine* avatars, two in the form of Krishna, Rama, and the *tenth* one, named 'Kalki' has been compared to the concepts of the return of the Messiah, the Apocalypse, etc. My own take on these mythological characters and the themes relating to incarnations of an 'omnipotent being', relate to the 'emergence' of different ages or shifts in consciousness, a subject I will return to later. The different forms Vishnu takes are also connected to the types of gods, possibly extraterrestrials, that have interacted with humanity since ancient times. In fact, the avatars of Hindu belief, more than likely, relate to forces existing in 'hidden' dimensions undetected by the five senses. Similar myths associated with Vishnu and the avatars themes, with artworks often depicting strange beings, seem to illustrate the idea of invisible forces both 'restoring' and wreaking havoc on earth. The incarnations of Vishnu show these forces as the fish, tortoise, wild boar, man-lion, the dwarf, the axe-man, Rama the Gentile, Krishna, Buddha and finally Kalkin, the White Horse. All of these animal-human deities can be found in theme in other ancient myths and artworks relating to 'Earth Changes' recorded in anciet texts. Variations

of such deities can be seen in Upper Palaeolithic art, not least the lion-headed humans made over 30,000 years ago by artists who were quite possibly making statements about their higher spiritual selves, and aspects of humanity existing in the Dreamtime.

Scattered star bodies of Nut (pronounced Noot) in the Egyptian pantheon, are also examples of the heavens and space personified. The stars depicted on Nut relate to the passage of the Sun through the ecliptic and the four stages of the Sun (mid-morning, noon, early afternoon and late afternoon). The last stage was when the Sun *leaves her body* at sunset and enters the Underworld. The twelve signs of the zodiac circling the ecliptic around the Sun also became the twelve disciples or knights, who aid their master, the Sun, in his mission on Earth (the annual cycle). Mithra, the Roman/Persian pre-Christian version of Jesus can be found depicted with the signs of the zodiac (animal wheel) circling him. He is often depicted as a lion-headed human and said to be 'Lord of Time'. Mithra, like Vishnu, also assumes different forms – symbolic of the key phases of the Sun passing through the stars (Milky Way) as seen from Earth. These key phases (or ages) of the evolution, form a cosmological viewpoint, relating to how our ancestors viewed the skies.

The Milky Way and its galactic centre was observed in relation to the precession of the equinoxes (the wobble of the Earth's axis) by ancient skywatchers, some of whom built detailed calendar systems based on this knowledge. In truth, the mythic language of astronomy eventually became religious doctrines, still taken literally to this day by millions of people. The ancient 'myth-makers' who invented religious heroes and saviours, did so with a far greater knowledge of the skies, astronomy and astrology than the masses. In the book *Hamlet's Mill* (1969) the co-authors, anthropologist Hertha Von Dechend with Giorgio de Santillana, proposed several core principles in relation to mythic language and astronomy. These were that animals, gods, hybrid creatures and goddesses frequently represented planets, stars, or other celestial bodies, and that battles and adventures taking place on the surface of the earth (possibly Middle Earth of Tolkien's stories) were metaphors for events actually taking place in the sky. Hence the ancient teachings of synchronised action between Heaven and Earth. One other astronomical feature relates to the ancient dualistic saviour figure, who represents the movement of time rather than celestial objects. The story of Jesus, which has other symbolic attachments, that we shall touch on briefly a little later, can, on one level, be shown to be stellar and Sun mythology.

BOTH BIG AND SMALL IN ONE IMAGE
How ancient civilisations of Egypt, Sumeria, the Maya and the Dogon of Mali in Africa came to have technology, knowledge and skills that expressed

their understanding of certain stars, remains a mystery to the Western mind-set. What the academics seem not to want to face in all interrelated areas is that alien life or interdimensional intelligence could have taught the ancients the arts and sciences that made these civilisations advanced for their time. On the other hand, much evidence suggests that the ancient Egyptians and the Olmec of Central America, for example, were inspired by gods that could travel great distances via modes of flight, rendering stone weightless, and performing miracles. Could the quest for extraterrestrial life, according to physicists today, may come through the unity of all particles, forces and phases which constitute our Universe? Could dark matter (which makes up 95% of our Universe) as recorded by astrophysics in recent years, also house what we would describe as alien intelligence?

From a more spiritual viewpoint, the reunification of all matter in the universe, luminous and dark, could be seen as 'returning to the source of all life' - to the centre of our being. Mystics, seers and visionaries of all epochs have tried to explain the *truth* that we are all a microcosm of our Universe – everything that exists also exists within us, too (see Figure 15). Hence the constant use of spirals and other original archetypes in ancient art to express more spiritual concepts. We are both a macrocosm and microcosm of all-that exists. In the next few pages I want to examine some of the more visible links between myth, religion and the formation of our physical Universe

Figure 15: We are made of stars.
(Left) A human fetus compared to a nebula © Science Photo Library.
(Right). Heaven and Earth are one and the same. © David Malin.

WHERE BIG BANG MEETS RELIGION

From my own study of ancient myths, more often than not, *three* deities form a trinity relating to Sun, Moon and Earth worship. From a more metaphysical perspective, could the 'Father', 'Mother', 'Son' (which includes the 'Holy Spirit'), relate to *three* key stages of our evolving universe? There are some striking similarities between religious doctrine, key deities recorded in myths and scientific understanding of how our universe supposedly 'Big Banged' itself into existence. Both mainstream religious and scientific understanding

of creation could well be contrived, yet much can be gleaned from musing over similarities found in both areas of thought.

According to science, about 15 billion years ago a tremendous explosion started the expansion of the Universe and from this cataclysmic event came what astrophysicists call the 'mother substance', part of the 'divine substance' found in the first atoms. According to conventional physics the 'secret of matter' is contained within *three* clearly recognised stages of evolution, all of which include the notion of a 'Big Bang'. The origin of the Big Bang theory is credited to Edwin Hubble who made the observation that our universe is continuously expanding. These stages, or 'phases' are described as *final, efficient* and *formal*. The first two phases, according to Renaissance scientists such as Giordano Bruno, carry out the will of the 'source of all life'. You could say they provide the opposite forces that construct our chromosomes (man and woman), so to birth the new life, the child, as found symbolised in all ancient cosmogonies. The formal cause (the new life) has also been likened to the 'crystalline light force', the 'Christ', which is pure love and an integral part of the first two phases. The first Bang was said to have led to a cosmic gestation period which gave birth to a second explosion (primordial chaos), quantified by what some physicists call the mother substance. This 'phase' (the virgin mother) gave birth to stars and our Sun, which is said to be 4.5 billion years old, along with other stars that form our galaxy and what astronomers describe through the four astronomical ingredients of life.[3] These phases have also been captured in the oral traditions of native cultures and ancient civilisations since Egypt and possibly much, much earlier. For example, such scientific narratives are not dissimilar to Gnostic creation myths found in the two thousand year old *Dead Sea Scrolls* which tell of a goddess, 'Sophia', giving birth to a creator god called 'Yaldabaoth' - the God of the Old Testament (see my book *Orion's Door* for more information). The concept of the great queen or virgin goddess birthing a Sun, or a divine male saviour, could directly relate to the phases outlined in theories expounded by physicists in recent decades.

Many esoteric symbols found in ancient beliefs and mainstream religions of the world also relate to 'dual forces' of 'life and death' birthing a third force or a 'new life'. The obsession with the Trinity within Christianity, I would suggest, comes from the knowledge of two forces interacting to create a third one. Both conventional science and early hermetic (alchemical) studies also describe a three-stage process, which can also be found in symbolism relating to the Trinity (see figure 16 overleaf). The alchemical trinity illustration shows the 'three' phases depicted as a goat, eagle and lion in the upper circle, but also in the overall composition we have *three* globes (two pendulums) hanging from the top circle. This symbolic image alludes to reality being a 'construct', the important part to focus on here is the 'hand' holding

Figure 16: Trinity.
Alchemical imagery depicting the construct of reality – the interaction between the subconscious and the conscious minds. The two come together to create our reality.

the overall structure. Similar concepts can be seen in 13th-century illuminations, and in the work of William Blake (see page 40) which was based on the *Bible moralisée* eleventh Century image of God as the architect of the world with his masonic compass. Imagery of this kind relates to the 'construct of reality' and the interactions between the subconscious and the conscious minds. The two points come together to create what we *perceive* to be our physical reality.

Creation myths from all over the world also tell of three clearly defined stages, or 'creators' of life, and quite often the forces involved are personified. The second stage or efficient phase of the Big Bang, according to conventional science, saw giants being born from the original mother substance; these were said to be the Suns (sons) which also gave birth to giants and titans via copulation as the Galaxy cooled down. Many of the giants, titans, gods and sons of the gods found in myth and religion can be related to planets, stars and their changing orbits and evolution. Other gods and goddess figures could represent stages of the Earth's evolution, from fire and brimstone deities, to gods of the sea and air. Personifying these phases, or depicting a planet as a person was a natural human attempt to define the powers at work behind the Universe. From this artistic need to personify cosmic forces, often using a mixture of animal, symbolic and human forms, came the foundations for religious doctrine found in all ancient civilisation. Therefore in Egypt, for example, it was said that Tum created Shu and Tefnut, who birthed Isis and Osiris whose son Horus (Sun) became the new light of the world. The Hopi of the American Southwest share a similar legend that talks of 'Tiaowo' creating 'Sokotang' and 'Spider Woman' who had twins that created the light of the world. Each *birth* or *phase* was said to be connected through an organic divine substance, one, which vibrates at different speeds and is now known as matter by conventional science. The 16th century sage and scientist, Giordano Bruno, writes of this connection between the 'three stages' in his work *De Umbris Idearum* (1582). He says: *"There are Three cases of evolution that relate to one source, from which everything originates. Everything is God and God is everything."* [4]

Physicists also refer to the 'Higgs Boson Theory' which attempts to explain how a *second* explosion, after the initial Big Bang, generated a 'primordial sea' of energy measured through various particles, namely 'quarks' and 'leptons'. It's said this 'outburst' birthed *both* the 'chaos' and 'order' as the Universe evolved. Opposing forces also propagate creating centrifugal and centripetal waves, which are the world of forms I touched on in the last chapter. It's these waves and 'forms' (spirals/circles) that have inspired shamanic artists since prehistoric times.

Knowledge of 'oscillating forces' could have also provided concepts personifying dualistic gods and heroes found in myth and religion. The imagery associated with the 'god of life' and 'god of death' (opposites) is a key aspect of this knowledge, something I will return to in more detail later on in the book. According to physicists the second phase (or explosion) saw the birth of what we regard as the giants of our solar system. Many creation myths also convey an 'evolutionary process' narrating how invisible particles have expanded to formulate the visible universe. Beliefs and theories in the existence of pre-historic 'advanced' ancient civilisations on Earth, such as Atlantis and Lemuria, could also be a reference to higher states of evolution peopled by giants or eternals. The latter is a term often used in myth to describe the time when humanity operated on higher levels of consciousness. The fall of man described in religious texts could easily be telling of a 'fall in frequency' from multidimensional vision, to mundane five-sense perception. The Dogon people of Mali, Africa, who had an advanced understanding of stars, especially Sirius, claim that the Earth had a twin called the Sixth Earth – a parallel planet, possibly in another nearby star system. The beings that occupy the Sixth Earth, according to the Dogon, are said to have wings. This parallel world (or reality) could be the source of our obsession with angels, both good and bad (see the Gnostic Archons) and specific aliens. The Dogon say that we, in our current level of evolution, live on the 'Fourth Earth' (Middle Earth?) and beings with horns live on the 'Third Earth'. Horned gods are hugely significant to our plight and our connection to unseen forces, as I will come to. The Third Earth or *plane* (reality) could be a reference to what certain physicists see as the 'inter-space planes' and creatures that dwell in what the ancients also referred to as parallel realities, or mirror worlds.

EGGS IN SPACE

There are theories that the Universe existed *before* the Big Bang and some scientists believe it was made up of *ten* dimensions. These alternative worlds are fluid, constructed of light, and interdimensional. In Chinese creation myths it is said that in the beginning the Universe was contained within an egg, inside which the forces of Yin (dark, female and cool) and Yang (light,

male and hot) interacted with each other. The same theme is told in ancient Egypt as 'Ptah of Memphis' shaping the world in the form of an egg on a potter's wheel. However, it was said that this egg and its yoke, representing the ten-dimensional world, became unstable and eventually cracked so creating two separate universes of *four* and *six* dimensions. Our Universe was born in that cosmic cataclysm and the cracking of the egg could also relate to the creation of the Dreamtime, a theme the aboriginal tribes of Australia refer to in their creation stories. The egg symbol also relates to how we see the world and how we interpret primordial waves and light-codes, or 'forms' mentioned in the last chapter. In recent years, scientists at the Russian National Academy of Sciences and the Rutherford Appleton National Laboratories in California have observed how the 'photonic plasma' or 'light' creating our solar system appears to be egg-like.

From a scientific viewpoint, various levels of evolution all housed within a spiralling vortex (the Milky Way), could have easily birthed other stars, suns and their planets. Other forms, which we interpret as 'alien' could also exist on frequency ranges undetected by the five senses. The solar spectrum is a frequency range, but there must be others running parallel, or further afield, to the one we call reality. If we were to liken reality (life on Earth) to a cosmic television, then what other channels could we pick up if we moved beyond the standard (solar spectrum) satellite dish? What types of realities, programmes or actors would we tune into if we switched solar systems (cosmic televisions)? Too many researchers over the years, in various scientific fields, (including Ufology) are obsessed with the 'physical proof' of something alien; when, in truth, nothing is really solid. As Democritus (460 BC-370 BC) said: *"Nothing exists except atoms and empty space, everything else is opinion."* Pythagoras of Samos, the famous Greek mathematician, also said: *"The ultimate nature of reality is number."* A concept that scientists have only really started to fully understand in the last century.

STARS & SOLAR SYSTEMS

The Dogon claim that there are five or six solar systems with intelligent life in the vicinity of our system.[5] This they said was explained to them by the visiting 'Nommos', also called 'Annedoti', a race of subterranean amphibious beings (fish-gnomes) from the star system Sirius. These creatures, according to the Dogon, were hermaphroditic creatures and provided their ancestors with the science of letters and numbers (language) and art (symbols) of civilisation. These gods were also called 'Masters of the Water', 'The Monitors' and 'The Teachers' and the Dogon oral tradition recalls how these beings became saviours and spiritual guardians. As their beliefs state:

The Nommo divided his body among men to feed them; that is why it is also said

that the universe "had drunk of his body". The Nommo also made men drink. He gave all his life principles to human beings." The Nommo was crucified and resurrected and will again visit the Earth in the future but this time in human form. Later he will assume his amphibious form and will rule the world from the waters.[6]

The Dogon knowledge of the Sirius constellation was also way ahead of the official discoveries made in the 1970s, when Sirius B was photographed for the first time.[7] Scientists today now face the real possibility that we are definitely *not* alone and that our Universe contains an infinite number of other Universes.[8] Scientists at the University of California at Berkeley have reported finding two giant planets orbiting the star Ursa Major about 51 years from Earth in the Big Dipper constellation.[9] The acclaimed American physicist Michio Kaku, in his book *Hyperspace - A Scientific Odyssey through Parallel Universes, Time Warps, and the Tenth Dimension* (1995), also presents theories surrounding parallel worlds (other star systems), in relation to our universe. He writes:

The theory predicts that our universe still has a dwarf twin, a companion universe that has curled up into a small six-dimensional ball that is too small to be observed. This six-dimensional universe, far from being a useless appendage to our world, may ultimately be our salvation.[10]

Subjects relating to parallel realities and the fall of ancient epochs populated by 'god-people' can also be found in numerous science fiction novels and films. Angels and the 'fiery forms' (Archons) that the likes of Bruno believed to dwell in dark light, or dark matter (now recognised by science) constitute these multidimensional levels of consciousness. We are like fallen angels and our light bodies, which are our eternal aspects, illuminate our physical bodies, yet we also exist *beyond* the limits of space and time.

As I have already mentioned, the Big Bang Theory and the Higgs Boson Theory make no real attempt to explain how structures like stars, nebulas and galaxies came to exist in the Universe, they only focus on the 'expansion' aspects, this is because they are merely theories and belief systems, no different to other belief systems. Both science and religion are more connected through the fact they can foster dogmatic beliefs about the 'nature of life' and defend those beliefs without looking further.

THE ETERNALS

One *Marvel Comic* series created by Jack Kirby in 1976, features godlike beings called 'Celestials', angelic-like 'Eternals' and *fallen* 'Deviants', who, along with humanity, constitute different evolutionary levels of 'beings' on Earth and within the Solar system. The movie, *The Eternals* (2021), based on the Kirby comic, depicts an ongoing conflict between forces on earth, over-

shadowed by what seem like alien creatures caught up in human prehistory. In the comic, Kirby imagines huge armored alien Celestials who come to Earth and use 'proto-humans' to bring forth two other species, the Eternals and 'Deviants'. The former are generally beautiful, immune to natural death, and possessed of superhuman powers. The 'Deviants', whose inability to breed in a consistent form, according to the comic and movie, produce generations of varied, grotesque monsters, like the dinosaurs and alien alpha predator creatures. I'll come back to the alien predator in a the next few chapters. In my view, the Celestials are reimagined interpretations of the biblical Elohim - the same plural interpretation of a group of 'Lords' (see the Old Testament) who create the earthly Adam and shape the 'eternal Adam' also existing in celestial form. He is Orion, the heavenly star man, the 'eternal one', see my book *Orion's Door* for more symbolism on the 'Heavenly Adam'.

The Celestials are the creators *of the* Eternals in the story, and along with the Deviants form the basis for human ancient myths and legends about various gods, angels and monsters, as portrayed in the film. One Celestial called 'Arishem' seems to appear as a 'tyrannical' god resembling a cyborg 'demiurge' figure, almost straight out of Gnostic myth! In fact, Gnostic concepts seem to appear in so many movies ove the past thirty years, a topic I address later in the book. In the *Eternals* comic, Arishem is a 'seed planter', who for millions of years, has been planting the seeds of 'Celestials *inside* planets' where the energy from large human populations allows the Celestials to be born, or emerge from the core of a planet. One Celestial called 'Tiamat' is considered a 'Dreaming Celestial', a Babylonian goddess of the ocean, and the creator of every Tsunami. In *Part Two*, I inquire into what types of forces inspire movie scripts, so to 'programme' the minds of humanity? An ET arrival on earth? Something celestial emerging from the sea (see the book of Revelation), and an 'awakening' to our higher purpose? According to the comic and movie, the ancient civilisations of 'Mu' and 'Atlantis' were destroyed by the Celestials, creating five epochs or what Kirby calls 'Hosts' on earth.

Figure 17: Celestials.
Could the Carina nebula, like many others, be seen as a personified Celestial?

Celestials, Eternals, and Deviants seem to represent extraterrestrial intelligence (whom

the ancients called gods) whose implanted DNA structure reveals an extraordinary ability to select random human beings to develop superpowers following exposure to dangerous environmental catalysts, thus enabling the development of benevolent mutations and creating the 'X-Men', or 'mutants'. The Eternals are both angels *and* demons at the same time (see the Gnostic Archons), and they are also stars and planets personified.

Another character created by Jack Kirby is *The Lord of the Rings*, a Saturn-like figure called 'Galactus' whose origin within the stories concerns an ancient planet called 'Taa'. In the story, Taa is a 'dead' zone, prompting one Taa scientist to mount a final space expedition into the 'heart of a star', to go out in a last blaze of glory, as it were. A fictional narrative concerning Celestials could easily be seen in the formation of stars and nebulas (see Figure 17). In Kirby's story, the radiation of the star kills everyone aboard the craft except for that 'one scientist', who somehow survives and evolves into a new form of life. One could say he is a kind of 'otherworldly' immense Celestial figure, who after incubating for eons (within a colossal spaceship), eventually emerges as the 'godlike', 'control-hungry', Galactus!

From 'the gods' to 'God' the heavens have been personified through myth, religion, art and dreams since ancient times.

NOTES:

1) Jung, Carl: *The Collected Works, Volume 10: Civilisation in Transition*, Princeton University Press 1956. p 31

2) Harding, Luke: *Ancient Sky Map or Fake?* The Guardian. 1st March 2005 p15

3) Garriga, Jaume and Vilenkin, Alexander: Article to be found at
http://www.unknowncountry.com/news/?id=417)

4) Giuliana, Conforto: *Giordano Bruno's Future Science & the Birth of the New Human Being.* Noesis 2002, p200

5) Temple, Robert: *The Sirius Mystery*. Arrow 1999. p278

6 & 7) For more information on the Sirian/Dogon connection see the work of Robert Temple and *The Masters of the Water* by John Meluch

8) Moore, Patrick: *Phillips Guide to the Stars and Planets*. Chencellor Press 2001, pp 86-7

9) Perlman, David: *The San Francisco Chronicle*, 16th August 2001

10) Kaku, Michio: *Hyperspace*, Oxford University Press, 2000. p27

Ruled by the stars

Making myths, creating religions

*From the same food and the same circumstances
the hornet produces poison whereas the bee produces honey*

Buddha

The ancient world is no different to our modern society when it comes to creating 'belief systems' out of stories, legends or myths. Ancient memories of battles between immense forces or powerful gods seem common through myth. Our appetite for 'beliefs' and the need to form imagery that speaks of forces *beyond* our physical sight is a natural human trait. Memories of who we were and how we have survived continuously shifting epochs on earth are hugely associated to our relationship with the skies, stars, planets and the other worlds. The birth of celestial bodies and the so-called expansion of our Universe, seem to echo in theme the birth of the gods and Titans as described in much world mythology. Science fiction has also opened up the human imagination to the possibility of otherworldly gods, goddesses and super-humans ruling over the earth. But this level of imagination is part of our ancestry, our 'ancient memory' of the dreamtime - a place where the future merges with the past.

TITANS, SUNS AND FATHER GODS

Myths that tell of the great father planets Uranus, Saturn, and Jupiter relate in some ways to the creation of giant gaseous forms and their effect on other planets, not least Earth. In Egyptian, Greek and Roman myth, Osirus, Ouranus or Uranus, were considered the fathers of the giants and similar themes can be found in numerous texts and ancient legends. Uranus, for the ancients, was said to rule the invisible, *unseen* forces affecting crop growth and the cycles of life and death. Often referred to as the Titans, Uranus and Saturn influenced Earth's prehistoric civilisations, (probably Atlantis) until they were replaced by the reverence of Jupiter and a 'new age' of gods. Myths involving the battles between the gods can relate to cataclysmic movement of planetary bodies and the possibility that the giant planets like Saturn and

Jupiter were worshipped as suns (dwarf stars). The solar lord Jupiter (Jove or Zeus), according to classical myth, became the 'father of the gods and men', a title given to Zeus after a great mythological battle where he defeated the old Sun, his father Saturn or 'Kronos'. Jupiter was said to have been born of the same 'substance' that formed the Titans (the old order of gods) of whom his mother 'Rhea' (Ops) and his father Saturn, 'Satanaku' (Satan /Set) also belonged. The common theme here was a constant reverence of a father god, a title that became God in the Old Testament. The theme of gods 'fighting for supremacy' could relate to the movement of giant gaseous bodies such as Jupiter, causing other planets like Saturn to change orbit, hence the narrative of the 'clash of the Titans'. Such narratives can be seen in the work of Russian-Jewish psychiatrist and writer, Immanuel Velikovsky. If Velikovsky's work in the 1950s is anything to go by, then Saturn and Venus have massively influenced life on Earth, through their movements. According to mainstream science, space is extremely cold and planets such as Venus, according to the likes of Velikovsky's work, was a comet with an ionised (ice-frozen) surface. Saturn, Venus and the Sun, as archetypal gods, can be found in religious structures and ancient cults stretching back thousands of years. Some writers have pointed out that they also live on in themes found in science fiction epics such as *Star Wars*. George Lucas's movies are especially telling in relation to the 'symbolic' tussle between Saturn/'Satanaku' (Vader) and the Sun (Son/Skywalker), with Venus as the Princess (goddess). The Sith in Lucas's epics are especially intriguing, as they represent what I see as a 'Predator Consciousness', something I will look at more closely in the next chapter.

In Egyptian myth it is said Satanaku was one of three sons born to the creator-god named 'Ptah'. This creator was interchangable with Orion/Osirus in ancient Egyptian religious symbolism, a topic I explore in great detail in *Orion's Door*. Satanaku's two sons were 'Osiris' and 'Poseidon' and both represent an ancient epoch on earth; a time I have referred to as the 'Age of Orion'. In Greek/Roman myth these sons (suns) became Uranus and Neptune. Ptah or the 'Great Developer' was said to have handed rule of Egypt over to his son 'Ra' (the bright One), just as Saturn handed over rule to his son Jupiter (The Return of the King), also seen as Osirus handing rule over to Horus in Egyptian myth. The passing of ages, often symbolised by 'suns' in indigenous cultures, also relates to the reverence of specific planets over other celestial bodies in our solar system. Conventional astronomy hints at the possibility that our sun was once *thirty percent dimmer* than it is now. With this in mind, other large bodies like Saturn and Jupiter may have also seemed like suns in the ancient world.[1] I believe they were suns and I show their mythological emergence in my graphic novels, *Moon Slayer* (2015) and *Aeon Rising* (2017).

In numerous myths, Saturn or Satanaku was the brother of Yahweh (Jehovah/Jupiter), who would battle with, and kill, his brother Osiris. Another name for Satanaku was 'Seth' or 'Set', a deity who was also called 'Masau'u' by the Hopi Indians. Masau'u was a 'dualistic' desert god or and another version of Orion (Osiris) for the Hopi. In Egyptian myth, Set was described as a red-haired creature, often depicted as a crocodile with the ears of an ass (see Figure 18). Set was portrayed in this way for no other reason than the Egyptian belief that anything evil must be ugly. In many esoteric writings, Set was compared with 'Lucifer' and considered a benevolent God *before* the slaying of his brother, Osiris. For some writers, Set is the Greek god Prometheus (a Saturn-Orion figure) who defies Zeus by bringing fire (light) to humanity. I go into much more depth regarding these subjects in my book *Orion's Door*. Set was also worshipped by the Hyksos invaders in the Egyptian pre-dynastic period (6000-3150 BC), when Pharaohs called themselves the 'beloved

Figure 18: Set / Satanaku.
Set or Typhon – the god of death was worshipped by the Egyptian brotherhood. Set was also known as 'Lord of the Rings'.

of Set' until as recently as the 16th Dynasty (1640-1580 BC). Ramses II, along with the later emperors of Rome, would align himself with Set or Saturn as the ruler of a much more ancient global civilisation, possibly Atlantis. Some researchers have even speculated that Atlantis was attacked by Set. For the Egyptians, the Titans, whom Set was said to belong to, were part of an old age of gods that influenced major advanced civilisations of Earth. Their influence seems to refer to an epoch when earth people were influenced by the gods (the stars) that aided in the building of the great wonders, such as the Pyramids.

TRANSFORMING FORCES

Both Earth (Gaia) and the billions of celestial bodies making up our galaxy, were said to have *emerged* from a cosmic primordial soup - the 'mother substance', recorded as a great goddess, a figure who births *all* life forms. Much symbolism for the 'great mother', across endless beliefs, relates to the symbolism of the 'Wheel, Web and Mirror', all of which try to explain the invisible energy structuring our Universe. A web-like field providing multirealities. In other creation accounts, Erebus and Eros (love) were the first deities to be born to the mother substance and it is said that they issued from the

'Egg of Night'.[2] Eros, in my view, relates to what astrophysicists describe as the Weak electromagnetic force, one that is invisible and permeates (penetrates) all bodies in our Universe. In truth, this vibration is anything but weak; instead, it's an all-powerful, creative, 'love vibration' that can be utilised to reshape and *heal* our world. In Hindu and Buddhist creation stories, the same source, or 'elixir of life', was churned to create the 'Milky Ocean' (Milky Way or Galaxy). According to Hindu legend the supreme deity Vishnu oversaw this churning, and instructed both gods and demons to pull the giant Naga serpent 'Vasouki', in a tug of war, around what is described as the celestial mountain. Many of the themes within myths of this nature relate to the oscillation of forces (duality) brought about by separation. This mountain is also symbolic of the 'glory hole' at the centre of the galaxy and was considered the highest state by the Mayan shamans. In *The Lord of the Rings: The Two Towers* (2001), directed by Peter Jackson, Gandalf is shown at the highest peak and at the centre of the Galaxy simultaneously after battling with the giant fire-demon, Balroc. From this point in Tolkien's masterpiece, Gandalf is transformed, like the ancient shaman, and returns to Middle Earth (physical reality) operating from a higher state of knowledge. There are many similarities between key figures in Tolkien's book and the myths of ancient Near and Middle East, especially between Gandalf and Vishnu, the preserver. Tolkien was a mythmaker in my view. He obviously had access to ancient texts and knowledge enabling him to produce work with many correlations between mysticism, ancient myth and otherworldly forces vying for power over our 'middle-earthly' world.

EYES IN SPACE

According to Indian legend, *fifty* gods and *fifty* demons pull the serpent Vasouki back and forth to create the Milky Way. This act of 'churning', described through literal forms, represents the spiralling motion of our galaxy and the tussle between ancient forces opposing one another. The 'Yin and Yang' is the most common symbol illustrating the churning dual forces effecting our reality. The symbolism behind the number *fifty* also relates to the goddess 'Hecate' and the orbit of Sirius B around Sirius (the Goddess 'Isis' or 'Ino'), which takes *fifty* of our Earth years. In Greek myth, Ino was transformed into a heifer

Figure 19: Argus.
The eyes on the body of Argus are symbolic of the holographic nature of reality.

(cow) and was considered the ancestress of the Egyptian civilisation.[3] The god Argus (nothing to do with the chain of shops in the UK) was said to have 100 eyes and was given the task of watching Ino by Zeus's jealous wife, Hera. According to the myth, Isis (the star Sirius) also had *fifty* sons, while 'Dannaus' (Argus in Greece) had *fifty* daughters; the sons married the daughters, thus constituting the one hundred eyes on Argus's body (see figure 19 on previous page). After Argus's death, which was commanded by Zeus (the Sun), his eyes were said to be placed on the tail of the peacock. Similar eyes can also be found on other aspects of nature from butterfly wings to patterns on fish. They are also a major theme in art, especially visionary art. Eyes can even be found on the costumes of English Queens such as Elizabeth I, through to the 'All-Seeing-Eye'of freemasonic fame. The eye symbolism speaks of a hidden knowledge, and you could say that Argus was the 'Big-Brother-is-watching-you' figure of classical mythology. The seen and the *un*seen, as symbolised through eyes, relate to the forces looking *into* this world from a parallel reality. They also hint at the holographic nature of the Universe and how the whole is contained in every individual part. Many artists attempting to paint esoteric themes throughout history, also seem to find eye symbolism automatically creeping into their work; again this relates to a non-physical presence manifesting reality *through* our eyes.

THE SIRIUS CONNECTION

The Sirius Constellation was called the 'Eye Star' by various indigenous tribes, especially the Dogon of Mali in Africa. To this day, the Dogon priests consider Sirius B the most important star in the sky. They call it the 'Po-Star', which they admit is 'invisible' to the naked eye. With no telescopic instruments at their disposal the Dogons say their knowledge of what they refer to as the Po-Star, was given to them by 'beings' that came from Sirius thousands of years ago. Interestingly, the knowledge given to them by what the Dogon call the 'Nommo', was not available to Astronomers until the American Alva G. Clark discovered Sirius B in 1862. According to the Dogon elders, the Nommo, are amphibious creatures (half-fish/snake and half-human), described as 'father gods' of mankind, 'masters of water' and the 'guardians' of their spiritual principles. The 'secrets' held by the mystery schools, among other things, are said to be concerned with the *true origins* of humanity, an area of knowledge which may not be so entirely terrestrial and a product of 'evolution' as mainstream science would have us believe. With the type of knowledge given to the Dogon, we are moving now into the realms of intelligent life elsewhere in the cosmos teaching humanity in the ancient world. Sirius was also considered the flaming star (a rising sun), which appears in masonic symbolism, on flags and in company logos (see figure 20 and 21).

Figure 20: Symbols of Sirius and the Masonic Connection.
The rising star, or sun symbol can be seen on flags and in the shell logo. The Shell logo is masonic in origin and is one of many hallmarks relating to star (Sirius), sun and serpent worship (see my book *Through Ancient Eyes*).

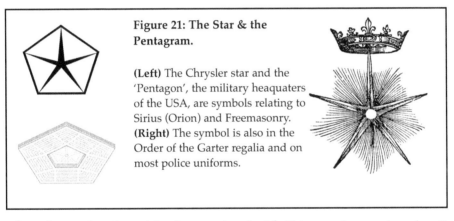

Figure 21: The Star & the Pentagram.

(Left) The Chrysler star and the 'Pentagon', the military heaquaters of the USA, are symbols relating to Sirius (Orion) and Freemasonry. **(Right)** The symbol is also in the Order of the Garter regalia and on most police uniforms.

The colour red is also said to be associated with Sirius, and masonic orders it seems aligned themselves with this star. The use of red carpets for royalty and Hollywood film 'stars' is highly significant to the secret societies influencing the media and movie industry, more on this in a later chapter.

Sirius B is said to be a star that moves more rapidly than the 'fastest' of three planets in our solar system, namely: Pluto, Neptune and Uranus. These planets were known to the Sumerians and Dogon, and as mentioned earlier, they were connected to the race of 'Titans', in an ancient epoch on Earth. The planets, or Titans, were said to be forces responsible for seismic activity, volcanic eruption and the creation of ancient 'rock giants' in places such as the Grand Canyon and other red rock locations found all over the world. These 'titanic' forces, including the creation of immense tidal waves (conjured up by space debris hitting the earth), were also associated with gods, stars and *unseen* forces in the Dreamtime. For the ancients, what happens in space is a

mirror of what happens on Earth – nothing is isolated. The motion of stars like Sirius B and other planets throughout the galaxy also constitute the 'weaving' of a web of rapid light, attributed to both creative and destructive elements of such forces.

CEREMONIAL PRECESSIONS AND CYCLES

The Grandmother of all Goddesses, Spider Woman, found in Native American myth, is considered the 'dream weaver of consciousness' connecting life-force all across in the Universe. It's our combined human creativity, interacting with the life-force contained within *every* atom or star that weaves the webs we call reality. Spider Woman's circle, or web, can be found hidden within the symbolic language of many Pagan cults and more orthodox religions. It can also be detected in cults, which became the secret society networks of Egypt, Arabia, Europe and later the Freemasonic brotherhood. Symbols and insignias used by freemasonic artists through to certain company-corporate insignias are indicators of the connection between stars like Sirius, along with Sun worship. African Dogon ceremonial artifacts also carry classic freemasonic style 'black and white checkerboard' symbols (see figure 22).The 'black and white' symbolism relates to 'duality of being', something I will explore further in the book.

The movement of celestial bodies and the knowledge contained within the *ancient* science called astrology, became the 'precession of the equinoxes' on Earth. The precession of the equinoxes, followed by all native Earth cultures, is caused by the fact that the Earth wobbles on its axis while it spins once every twenty-four hours, resulting in the sunrise and sunset. Scientists say that an extreme wobble of the Earth's axis can cause the globe to fall over

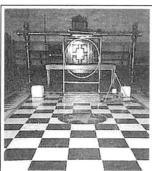
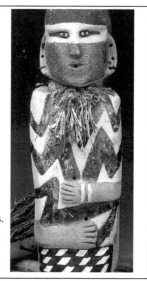

Figure 22:
Worshipping duality.
(Left) Checkerboards found in freemasonic temples/lodges.
(Middle & Right) The same symbolism used on shamanic art made by the Dogon (Africa) and Amerindian cultures relate to duality – light and dark forces.

onto its side, which probably explains why in Alaska fossils of alligators have been found.[4] The 'wobble' of the Earth on its axis also gives the impression that the sun moves *up* and *down* against a background of different constellations as the centuries pass. In ancient times, *four* constellations or stars were used to map the precession, one of which was Sirius, along with Taurus (Orion). The other three are Scorpio, Leo and Aquarius. Each of the four precessional ages can be connected to Pagan Equinoxes and Solstices. As I show in *Orion's Door*, the Orion constellation along with Sirius are archetypal 'stellar' blueprints for so many aspects of religious, political, media and military rule on earth.

New Year's Eve and the Feast of Fools, which followed Hogmanay, are both ancient rituals that honoured the return of Sirius and Orion to the mid-heaven position at midnight on New Years Eve. Both winter festival dates relate to the 'upside-down, down-side-up' aspect of duality. In the medieval religious calendar, the Feast of Fools was known as 'Inversus Mundi', when the 'Lord of Misrule' surfaced at Epiphany.[5] Knowledge of how the precession affects life on Earth eventually became accessed through the main four directions of the Earth and *eight* major festivals, calendar points of transition, which would involve other deities cavorting and demanding sacrifice in the ancient world. The migrations of people in ancient times, through to the annual migratory quests undertaken by birds, butterflies, whales and caribou, to name but a few, also relate to the Sun's cycle and the precession of the Earth. From a higher perspective, migrations and patterns in nature are part of a matrix, or a blueprint, operating *outside* of manufactured time, a subject I will return to later.

People in prehistoric times migrated for food and warmth, but also because of the position of the stars (the gods) in relation to the North and South celestial poles. The same understanding of the precession of ages, seasons, directions, which were worshipped by Pagan cultures, is still being acknowledged by secret societies today. These brotherhoods can be traced back to a time *before* the high civilisation of Sumer (possibly Atlantis), and were the ancient priesthoods, 'myth makers' and 'sky watchers' behind orthodox religions that exist today. Religions *are* intergenerational programmes surviving through 'recycling' beliefs held within each age, or epoch. It has been the myth-maker-masonic brotherhood's job to *reshape* religion (in its broadest sense) to suit each new generation. Hollywood, politics, football, fashion, you name it, all have the potential to exist 'religiously' in our reality. Celebrating the mainstream media news through 'believing' *everything* we are told, is only another cult, or religion. True knowledge of the *infinite* cosmos, the 'I', had to be hidden from the masses, so to ensure individual creativity, imagination and vision could not flourish en masse. As Sir Francis Bacon, a major historical figure at the time of the Renaissance in Europe, once said: *"Knowledge itself is power"*; and the knowledge of *how* creation works,

hoarded by the ancient mystery schools, has (still is) been used to *control* the masses and *distract* us from our true inner creative power (see *Through Ancient Eyes*). Creating chaos and then reordering the chaos they have created, through wars, revolutions and economic collapses, pandemics, etc., is a speciality of the priesthoods and secret fraternities going back to antiquity. It seems clear that the 'power of the shaman' or 'temple priest' in the ancient world, seemed to grow steadily through the ability to *withhold* knowledge from the masses while 'creating narratives' and *myths* based on gods, goddesses, planets, stars, etc., to install religious blueprints. Many 'codes' and 'numerological systems' found in religious doctrine can be traced back to the sky watchers and myth makers who claimed to have been visited by 'the gods', being given advanced knowledge in the form of *sacred geometry, symbols* and *hieroglyphs*, as well as 'advanced sciences' used to construct ancient wonders, temples and making amazing art.

THE SACRED SEVEN-FOLD SYSTEM

Many of the most prominent constellations contain seven visible stars: Ursa Major (The Great Bear) and the Plough (Big Dipper) are the most conspicuous. They also feature significantly in Indigenous myths. We also have the Pleiades and the Orion Constellation, which also comprise seven main *visible* stars, even though there are actually hundreds of stars that make up those constellations. Significantly, in connection with Ursa Major, there are also *seven* species of bear on the earth. 'Seven' seems to be a number with magical connotations and can be attributed to the *phases* or *positions* of various celestial bodies. Even the four phases of the Moon each lasts *seven* days. In religious texts, we also find the 'number seven' referred to at least 54 times, from the 'seven seals' (and the Seventh Angel) through to a seven-headed beast in the Book of Revelation. The tarot cards of Marie Anne Adélande Lenormand, who was the most famous fortune-teller of 18th-century France, worked with 54 Tarot cards all illustrated through astromythology and hermetic knowledge, which was said to contain the 'sacred system of seven'. In ancient Indian texts, such as the *Vedas* and in later 'esoteric' literature produced by the Zoroastrians and Gnostics, seven was considered a magical number. For the mystery school priesthoods, seven relates to the *four* gods (or directions) of creation plus *three* (the trinity) realms of Sun, Moon and Earth. Seven also relates to what alchemists call the seven planetary stages of 'transformation' found in Hermetic teachings. Native American medicine men from the O'odlam tribes of the South West also perform the green corn dance using *seven* ears of corn from *seven* fields of the *seven* clans to ensure a healthy harvest each year. In many Native American tribal beliefs, there was said to be *seven* 'dream states', or paths of initiation. Clearly the codes and numbers found in religious texts, including the more native ceremonies, relate to the

earth's relationship with celestial bodies and invisible forces surrounding and constructing reality, or the matrix. How the elements, stars and unseen forces are utilised for crop growth and ceremony is still immensely important to indigenous people. The ancients who followed the stars and 'mapped' the heavens to measure 'time' (prior to the creation of ancient texts like the *Vedas*), all claimed to have been directly influenced by non-human, intelligent star-beings or 'deities' that brought teachings relating to the stars! The number seven's influence can still be felt in the names of the days of the week in certain languages, especially French, which relate to *Sun*day (dimanche), *Moon*day (lundi), *Mars*day (mardi), *Mercury*day (mercredi), *Jupiter*day (jeudi), *Venus*day (vendredi) and *Saturn*day (samedi). All of these heavenly bodies were said to 'direct the day' and influence life on earth. Alongside the sun, moon and main planets, the constellations of Ursa Major, the Pleiades and Orion feature massively in the creation of secret societies and religious orders, some of which, I am sure, go back thousands of years. Secret societies, like the Essenes (100 BC to 60 AD), outlined 'detailed prayer systems', which were carried out over the *seven*-day week, in order to be immersed in various archetypes and emissaries (angels). As instigators of early Christian texts, such as the *Dead Sea Scrolls*, they also linked into the Stoic and Roman brotherhoods, whose aristocratic families, according to several researchers, actually wrote the New Testament Gospels 70 - 105 AD.[6]

The dualistic beliefs of the Zoroastrians of Persia and Mesopotamia, from around 500 BC, also talked of a sacred *seven*-fold path. This knowledge eventually made its way into the *Dead Sea Scrolls*, written by the Essenes, who also revered a system of seven branches on the Tree of Life. For the Essenes, seven was the number by which they worshipped the angels of night (Underworld) and day (upper world), all sitting within the branches and roots of what was known as the Kaballah. The Essenes were a secret society, also known as the 'Nazarenes' or the 'Therapeutae', living at the time of Roman occupation of Judea. They followed to the letter many myths associated with the Old Testament. Some writers have said the Essenes also inherited secret knowledge of Egypt (passed down through the Brotherhood of the Snake), which included the use of hallucinogenic plants and mushrooms to 'journey' into altered states. The Melchizedek priests of Chaldaea and Babylon were also known as 'Snake Priests', whose rituals and temples (including pyramids) were aligned with Orion, Draco, and Sirius star systems. The Essene system of sevens, outlined in the *Book of Enoch* and in the *Dead Sea Scrolls*, involved rituals that would take the initiate into what they described as the 'visible and invisible realms' of the Earth. The system of sevens as practiced by the Therapeutae of Egypt is, I am sure, where Christianity takes its 'Seven Sacraments' and much of the surrounding symbolism associated with the seals of the various hierarchies. These symbols are direct descendants of the

icons used in Egyptian and Babylonian temples, and more often than not, speak of secret codes used by temple priests. The same codes and symbols representing esoteric knowledge are still being used in many corporate logos and brand names to this day. Why? Because symbols are the hidden language of the mystery school network going back thousands of years.

The Druids, Hindu Brahman and Native American Shamans also utilised the same seven-fold system within their societies and ceremonies. They believed in seven spirit senses (organs of clairvoyance) which existed in the form of 'wheels of light', or energy centres. In ancient Sanskrit texts these centres are referred to as 'chakras', which are also said to correspond with the planets of our solar system. Visible light also splits into seven colours and can be seen to correlate to the chakra system, too. Art and texts depicting the spiritual form of humanity, or the 'divine human form' as a microcosm of the Universe, as found in religious books, also relates to this sevenfold system. Gothic works such as the 13th-century *Book of Hours* and much 16th-century alchemical art contain many allusions to the use of seven metals, planets, days of the week and the stars, all depicted in human form. According to alchemists like Nicolas Flamel and theologians such as Emmanuel Swedenborg, the heavens and the Earth are contained *within* the human form. Swedenborg said: *"The ancients, from the wise to the simple – from Abraham to the primitive Africans – thought of god as a man."* For those with access to esoteric knowledge, the human form was divine and made of 'light' connected to the elements and *beyond*, to molecules and particles that Giordano Bruno called 'luminous matter'.

The alignment of energy points at ancient sites on the Earth also connects with the stars. Places such as Stonehenge, and Avebury in the UK, as well as Carnac, in France, represent alignments that also are said to run through the human body and the body of the Earth. The famous dowser Tom Graves in his book *Needles of Stone* (2008), reports that standing stone megalithic monuments constantly exhibit no less than *seven* different energy bands moving vertically up the stone, with two lower levels underground. The same primal force (colours and energy), which flows through the centre of these vortices, can also be found flowing through the Earth at these megalithic (temple) sites. The ancients understood the 'sound of the stars' resonated with the sound of these stones, which in turn resonated with our flesh and bone. And it is through sound (especially music) that we connect to non-physical worlds and spirit. The Roman Christian (once Pagan) church never wanted the masses to know all these things, purely because these energy sites can connect the human chakra system with the Earth's (Gaia's) energy field, without the need for a 'middle man' (priest or all-seeing father god) as promoted by orthodox religion. Many major cathedrals, commissioned by the Knights Templar secret societies (who were relations to the earlier druid

orders and Phoenician priests), are said to align with the seven sacred celestial bodies outlined earlier.

From Southern Europe through to Scotland, the Druid secret society network, which can be linked to Near Middle Eastern civilisations, the Phoenicians, also worshipped at seven main sanctified sites, prior to them having cathedrals placed over where once original rituals were performed. The most important site, dedicated to the Sun, is now where Chartres cathedral stands in Northern France. Chartres was a major initiation centre where astrology and the sacred arts were taught up until the Middle Ages; it is littered with occult symbols and Pagan rites that go way back. Other sites, like Notre Dame in Paris, are said to mark the ancient placement of Mars, while Rosslyn Chapel in Scotland now stands on the site dedicated to Cronos or Saturn. All of these ancient sites, where Christian places of worship now stand, are said to be part of a hidden configuration, built to represent the earth as the 'Temple of the gods' as it is described in Revelation.[7] The images, symbols and codes represented in the architectural detail of these churches also tell of strange creatures and *hidden* language used to communicate information to initiates of the temple orders.

In ancient Peru we also find the 'Nazca lines', which depict a wide variety of animal, insect and symbolic formations. These images could be depictions of a 'dream language', no different to the imagery found in cathedrals and temples in other parts of the world. The Nazca lines can only be seen in their entirety from 1000 feet above the earth and their reason for existence still remains a mystery! Marie Reich who studied the patterns in the 1930s proposed they could be linked to specific constellations (see *Orion's Door*). If true, there is really no difference between the Nazca lines, or the placing of pyramids and cathedrals on specific points to represent planets, the sun or stars.

DREAMS OF THE GODS

The dreams of the Babylonian god 'Nabuna'id' tell of how major cathedrals and temples were aligned to the planets, and how the Babylonian religion was taken across the Near and Middle East and into Europe. In the dream, cathedrals and ancient temples resemble creatures associated with unseen forces, some of which are often malevolent. As I shall come to shortly, many of these buildings focus on a 'Predator Consciousness', and were purposely built to harness emotions such as fear and guilt, in accordance with ceremonies practised by brotherhoods aligned with the Babylonian period. I've been in a lot of churches and cathedrals across Europe over the past twenty years, and most are *dark* places which have witnessed a lot of negative emotions fuelled, not least, by religious dogma.

In Sumerian legends, Nabuna'id was the son of 'Sin' (from where we get

the religious term 'sin'), and his dreams, in the form of narratives, were recorded on seals and stellas for initiates to see. In Sumerian and Babylonian texts, Sin is said to be the offspring of death and, in religious terms, Sin can only be repented of by visiting the house of death – or your church in other words. In the minds of the priests behind such religious blueprints now, orthodox religion is based on the 'house of death'. On a more physical level, that's exactly what churches and cemeteries are – places of death (see Appendix)! Therefore, all orthodox religion, in my view, is the worship of death *through* life (duality) promoting *separation* from the Infinite. God, in its widest use of the word, does not need popes, presidents, money, guns, slaves, creeds, discrimination and all of the abominations we endure in life. When we have built religions and beliefs based on separation, then we get the God or 'gods' we deserve.

The building of temples, based on the 'dreams of the gods' (as directed by their priests in civilisations prior to Babylon), were all created to 'align' with Earth's energy fields (Ley Lines). The Ley Line are also 'Earth Stars' and connect to the heavens, the place from whence the gods were said to have come. These heavens do not necessarily relate to the skies, but to parallel worlds, as I shall explore in the next chapter. Ancient temples, including later Gothic cathedrals, were constructed and dedicated to the planets and stars (the gods) who influenced Earth's history. In relation to the dreams of Nabuna'id (the forerunner of the priest king Nebuchadnezar), the noted scholar Zacharia Sitchin in his book, *Divine Encounters*, says:

> In the first of those recorded dreams, Nabuna'id saw the planet Venus, the planet Saturn, the planet Ab - Hal, the shining planet and the Great Star, the great witnesses who dwell in heaven. He (in the dream) set up alters to them ...[8]

Stone circles, earth mounds, pyramids and cathedrals are all interconnected by Ley Lines which were called 'dragon lines' by the Celts and the people of Far East. Much serpent symbolism also relates to these lines of crystalline energy (within our human form) and the etheric network of goddess dragon lines covering the Earth. The most common being the 'Trinity' or 'Triquetra'.

THE TRIPLE GODDESS

The Triple Goddess and the Trinity can be connected to various star gods along with Sirius, our Sun and Orion's three belt stars. Stories of the three wise men or Magi (of Jesus' fame) are symbolic of Orion's three belt stars Mintaka, Alnilam and Alnitak (see *Orion's Door*). The spider goddess scratched into the surface of the Nazca plains is also said to depict the Belt of Orion and can also be connected to the symbolism of the Magi. Scholars, such as Henry Seyrig in his work, *La Triade Héliopolitaine* (1929), conclude that a basic triad of deities have been worshipped throughout the ages, all of which

seem to be the same gods and goddesses with slightly different names. Headed by the God of Thunderbolt (Jupiter, Thor) this universal triad included the 'Warrior Maiden' (Ishtar, Isis, Mary) and the 'Celestial Charioteer' (the Son or Sun). The four horses said to pull the chariot are symbolic of the four directions, seasons and especially the winds, considered very powerful forces by the ancients. At the human level, the three aspects relate to *fate*, *being* and *necessity*, each thought to be connected to the *Underworld*, *Middle Earth* and *Upper World* as captured in all myths. The same three aspects can be found in religious trinities dating back *before* the Bronze Age, and all three relating to the *Sun*, the *Earth* and the *Moon*. In other variations they are any combination of the planets and their offspring, all of which are symbolic of a race of gods and their hybrid (royal) bloodlines on earth. Secret societies, which have been in existence for thousands of years, also contain a symbolic language that relates to the triad or trinity. The 17th Century Freemasonic Grand Master, Sir Francis Bacon, editor of the King James Bible, pioneered what is referred to as 'The Invisible College'. Bacon used the trinity symbolism in his 1640 edition of *Advancement of Learning* and on the title page he shows two pyramids supporting *three* globes (Sun, Moon and Earth) which relate to the foundation of Oxford and Cambridge Universities. These two bastions of global education were created by a brotherhood and given the name The Invisible College; both fronted by the likes of Bacon, Elias Ashmole and John Dee. All three figures were pivotal to Oxford and Cambridge for selecting leaders in politics, banking and academia.

Across Ancient Britain there are many references to the Goddess Brigit who is symbolised as three different kinds of 'sacred fire'. She is known as Brigit, Bride and Brighde who rules the fire of *inspiration*, the *muse* and *poetry*. In fact. the word 'poetry' comes from the word 'Poesis' which means 'creation'. The Goddess Brigit is said to have had three talismans, which are the *Grael*, the *Shining Mirror* and the *Spinning Wheel*. All these talismans can be found in the various myths, legends and fairy tales, such as *Snow White,* and *Sleeping Beauty*. Such tales are hugely symbolic of the Slavic legends which talk of a 'Lethargic Sleep', cheating death and relate to the Pagan Goddess.

Another aspect of the Triple Goddess are the 'Furies' also referred to as the 'Erinyes', or' angry ones'. In Greek and Roman mythology, they were connected to the goddess Brigit. This trinity was also called the 'Potniae' (the awful ones), the 'Maniae' (the madnesses) and the 'Praxidikae' (the vengeful ones). In some myths they were malevolent forces, three daughters of Earth conceived from the blood of Uranus and were usually represented as 'crones' with bats wings, dogs heads and snakes for hair. Their duty, according to myth, was to punish wrongs committed against blood relatives and personify conscience. As we shall see in the next chapter, bloodlines are very important to unseen forces that operate (vibrate) outside of our 'space-time-construct' world, or reality.

THE GODDESS CALLED 'TRINITY'

In some cultures, the Trinity has a darker vibration symbolised through the stories of 'Tisiphone' and 'Megaera'. Tisiphone (blood avenger), or voice of revenge – was one who was said to guard the entrance to the Underworld - the place of punishment. 'Megaera' (madness and jealousy) envious anger – drove mad both Ino and Isis, symbolic of how 'fury'and madness leads to the death of their lover or children. The story of 'Athamas', Ino's husband in Greek mythology (also a type of Spider), is an example of a Boeotian king losing his mind, hunting his elder son 'Learchus' as a deer, and killing him.[9] Legends of this kind are a metaphor of how anger outbalances gentleness, when we live in the head (or mind) too fiercely and forget the heart.

In Hebrew, even the Christian Trinity is regarded as feminine, which again has much earlier connections to the Neolithic star goddess, 'Astarte', whose shrines are found all over Southern France. Gothic doorways and the ridges around them are depictions of the vulva, with many having what appears to be a clitoris symbol at the top arches. Doorways and cave entrances are important to the triple goddess, too. She was worshipped as the *hag*, the *maiden* and the *young girl* by numerous Pagan cultures. The 'doorway' was also symbolic of the *Virgin* goddesses genitalia, often depicted as an 'oval' shape. The secret society network, from the priests of Isis of ancient Egypt, through to the Order of the Garter (which has an oval shape logo), all revered the black Madonna or the virgin moon goddess as three main forms – the *Sky*, *Earth* and the *Underworld*. The Romans also worshipped the same trinity (goddess) as *Luna* the Sky, *Diana* the Earth and *Hecate* the Underworld. Another name for the Mary of Christian legend was 'Cybelle', which in Pagan terms was considered the goddess of the cave, just as the bear was considered the goddess of the cave by shamans in Palaeolithic times. In Chinese tradition the same moon goddess was venerated on the *fifteenth* day of the *eighth* month when people would come together to look at the full moon. Five thousand years later, in Christian belief, Mary, the blessed virgin Moon Goddess, is also worshipped through the Feast of Assumption on the fifteenth of August. On this day, hundreds of black Madonnas are paraded in the streets of France, Italy, Spain and South America, an amalgamation of Pagan and Masonic beliefs masquerading as Christianity.

'HOLY' SYMBOLS

Symbols of a crescent moon, the latter often seen as a star at Easter, are also interchangeable with Venus and the 'old sun', Saturn - the Sabbath on Saturn's Day (Saturday). The Jewish Passover is also one of the *three* pilgrimage festivals, when the population of biblical Judah (in ancient times) would have made a pilgrimage to the Temple in Jerusalem. Today, Samaritans are said to still make this ancient pilgrimage to Mount 'Gerizim', and along with

Figure 23: Saturn - Moon Symbols.
Saturn and Moon symbolism in the world all around us.

mount 'Moriah' and 'Zion', they give us the three sacred (holy) mountains in Jerusalem, the trinity again! What is also interesting is that these 'three' mountains, according to some researchers, can be correlated with Orion's *three* belt stars, along with the wider geography from Shechem to Hebron.[10] As I show in great detail in *Orion's Door*, Saturnalia, or Christmas relates to Saturn (Sun) symbolism and Easter relates to the moon (or *moonth-ly* calendar). In more ancient tradi-tions, Easter is known as a 'moveable feast' because it does not fall on a fixed date in the Roman Catholic-inspired Gregorian or Julian calendars. Easter is never the same day each year. Roman Catholic calendars follow the 'cycle of the sun' with 'irregular' Moon days; therefore Easter time is determined through what is called a lunisolar calendar, similar to the Hebrew calendar. In 325 AD the Council of Nicaea decided Easter would fall on the first Sunday after the ecclesiastical full moon, or soonest moon after the Spring Equinox on the 21st March. Those 'Pagan founding fathers' of the Roman Christian church knew how to 'use' the moon to create a calendar that would suit their own agenda for global prominence. Saturn, or dark star (see figure 23), underpins the vibrational *invisible* structure given to us by the Moon. Most calendars (whether Pagan or Gregorian) are no more than a Saturn-Sun & Moon 'vibrational' measurment of time - the *illusion of time* that locks us into *physical* (mind only) life on earth.

BATTLE OF THE PLANETS

It seems that the basis for many a tussle between mythological gods could have related to planets becoming asteroid belts, through collision with other rouge celestial bodies. Due to the gravitational pull of the large gaseous plan-ets, smaller planets were shunted out of their orbits with cataclysmic conse-quences. Could this drama have provided the ancients with imaginary gods and goddesses battling it out in the Heavens? Ancient sky watchers would certainly have witnessed otherworldly events in the sky. Our ancestors didn't have to compete with light pollution and smog to 'see' the sky come alive. However, how do we not know for certain that some kind of *Star Wars* sce-nario, involving other star systems, is not playing out some great conflict in another dimension. There is enough evidence globally, covered up at the highest levels of government, to suggest advanced extraterrestrial races have been involved in both the evolution and degradation of our planet. Much of

what is presented as fiction in films and books is not just a figment of the imagination of gifted individuals created over the past sixty years. There is much more to know, and later in the book I will explore these concepts in more detail.

Ancient accounts from all over the world talk of gods coming from the skies and, even today, when the word God is mentioned people still look up to the sky. Ancient myths repeat the same themes of sky gods impregnating Earth women and their offspring having super human abilities. The birth of Noah's son, Shem, in the Book of Enoch, for example, describes what seems like the birth of a monster, or non-human child with eyes that shone like the sun. Modern day witness accounts also tell of people seeing similar entities, along with other alien types. Whether it's thousands of sightings of Bigfoot since the turn of the twentieth century or encounters with reptilian entities by military personnel at secret bases across the US, what does seem clear, is a monumental cover-up regarding our extraterrestrial origins.

In Sky Goddess mythology, planets, such as Venus take on humanoid forms and can be associated with goddesses like 'Ishtar' and 'Pallas-Athene'. Legends associated with the famous battle of Troy, or Troia, could relate to the planets (as gods) fighting with each other. The word Troy also means 'three places' and is an allusion to trinity symbolism. In King Arthur stories, ''New Troy' (or London) is also called 'Troynavant', the eastern gateway city. Whereas Arthur's Camelot is often referred to as 'Martian City', or 'City of Mars' - a place of ancient battles (star wars). In Greek mythology, Ares, the patron of the Trojans, relates to Mars; both Athena (Venus) and Ares (Mars) are described in Homer's Iliad as being caught up in an immense battle scenario. A legendary 'battle of the planets' commenced, when a rogue visitor, a planet the Babylonians and Sumerians record as Marduk, brought other deities (planets) such as Aphrodite (the Moon) and Hera (the Earth) into the fray, by crossing our solar system.[11] The Moon is another intruder (or rogue visitor) according to some indigenous myths, it is said to have appeared in the Earth's gravitational field after a major cataclysm in our Solar System. Interestingly, some of the themes found in nursery rhymes and children's stories, along with the native myths that inspired them, tell of the Moon's influence on humanity and the 'constraints' it has on our emotions, dreams, the oceans and women.[12] Through my own art, meditations and intuition, I have seen the moon as a construct, or a celestial satellite placed into the gravitational field by a consciousness that manifests as an archetype behind the planets Saturn (Ring Lord) and Venus.

Alongside such major cataclysm, it seems many battles took place on the earth and in the skies possibly using hi-tech weapons, (space ships and nuclear warfare) in the ancient world. Could myths and past narratives tell of events yet to occur in the future? I believe we have reached a point of evo-

lution, an Atlantis revisited, where we now have the potential to *return* this planet to some sort of Ice Age if such weapons are unleashed by the same Cult (brotherhood) that brought about the demise of ancient civiliations like Atalantis. The *Star Wars* epics, created by George Lucas, illustrate how ancient/future battles between ancient orders (the Jedi and the Sith) could be continuing in the *Dreamtime*. Different realities can co-exist and don't have to be in '... a galaxy, far, far away...' Opposing forces *are* active beyond the veil separating the non-physical and physical dimensions.

Quite often in my visionary art and illustrations, I show the correlation between non-physical and physical forces and how non-physical forces have 'imprisoned' the Earth's (and therefore humanity's) mental, emotional and physical bodies. All this has been done mainly through the religions (belief and perception) founded in the name of the gods (planets and stars). Worshipping gods, suns, stars and planets, through the Old Age religions and the New Age beliefs, amplifies our need to externalise our individual power. Nothing has changed when it comes to suspending our unique creative imagination for an 'off-the-peg' belief. Our thoughts *are* energy and our emotions 'feed' the non-physical levels of reality, which is a subject that can be found continuously in art since ancient times.

In the next chapter, I want to explore imagery and mythology associated with a level of consciousness worshipped by élite circles (a Cult) going back into the ancient world.

NOTES:

1) Scientific American, Special Edition: *New light on the Solar System*, p32

2) Bulfinch's *Complete Mythology*. p9

3) Ibid, p10

4) *http://www.spiritweb.org/spirit/sirius-star.html*.

5) Bentor, Janette: *Medieval Mischief, Wit & Humour in the Art of the Middle Ages*, Sutton Publishing 2004, p69

6) Reuchlin, Abelard: *The True Authorship of the New Testament*, The Abelard Reuchlin Foundation. PO Box 5652, Kent, WA, USA, 1979.

7) Newton, Toyne: *The Dark Worship, The Occults Quest for World Domination*, Vega, 2002. pp61

8) Sitchin, Zecharia: *Divine Encounters, A Guide to Visions, Angels and other Emissaries*. Avon 1996. p144

9) *http://www.onet.net/~cathy/trinities.htm*

10) Vega, Luis. B. https://www.postscripts.org/ps-news-358.html

11) Allan, D.S & Delair, J.B: *When the Earth Nearly Died; Compelling Evidence of a Catastrophic World Change 9,500 BC*, Gateway Books 1995, pp 208- 227

12) Pierre Vedet, Jean: *The King of the Moon and Starry Dream; The Sky Order and Chaos*, Thames & Hudson Ltd, 1992.

Worlds of Shadow

The House of the Predator Consciousness (Part 1)

Yours is the house of desolation, the home of the lizard and the spider,
serpents, pruda-vipers how can any of you escape damnation ...
Matthew 23: 13-39

Beyond the five senses we are vehicles of *light* operating through different dimensions, or realities. We sense other realities through subtle vibrations accessed through our feelings, emotions, dreams and the imagination. Visionaries throughout the ages have constantly sought to remind us that the physical world (a frequency range) is not the only reality we are immersed in. Our dreams reveal this truth, they are vitally important to how we weave our way through life. The 'dreaming' is where all ideas are born and the place where ancestors and otherworldly projections play out. The world we think is real and solid is considered a 'lucid dream world' and an illusion in many ancient cultures. For the Aborigines the Dreamtime was separated by a veil preventing us from 'seeing' our true form. For the Gnostics it was the 'boundary' where what they called 'Upper Aeons' (Infinity) and 'Lower Aeons' (Illusion) meet (see *Orion's Door*). It is through *our thoughts*, or what the Gnostics called *nous* (or mind) that we interact with the 'Lower Aeons', the fake reality, duality – the (manipulated) 'simulation'. Another name for the fake reality is the Matrix. The Gnostics defined the Lower Aeons in terms of 'imperfection', darkness, the Abyss, and Hell. Whereas the 'Upper Aeons' are the realm of love, unity, *Oneness*, what they called *pneuma* (Infinite Self). Similar themes can be found in Eastern religions, such as Maya (mind/illusion/matrix) and Brahman (infinite all that is); the Native Americans referred to worlds 'above' and 'below'.

Many teachings regarding 'hidden dimensions', illusion and 'parallel realities' affirm our world is not simply 'physical'. Science has gone to great lengths in acknowledging these hidden realms, or 'non-local realities', not least through astrophysics over the past forty years.[1] As I have already touched on, we often find reference to parallel realities (many of which depict otherworldly creatures/entities) in much ancient art. They are often

shown as 'door-keepers' *between* realities, or the worlds *within* worlds. In this chapter I am going to explore these shadow realities (between worlds), operating within what the Gnostics referred to as the realms of the Lower Aeons.

Parallel worlds peopled by *strange* creatures are found in myths and legends all over the world. In Chinese myth, for example, such 'entities' were called 'mirror creatures' and were said to live in a 'mirror', or parallel world to humanity. In Balinese art and myth, various gods and demon figures are shown inside portals (windows/mirrors), looking into our world from another reality. According to ancient legends, mirrors, masks and art were used as 'gateways' between two worlds; both the physical world (five sense reality) and the mirror world (4-D and 5-D) lived in peace until the creatures of the mirror world invaded the human world.[2] Only the magic of the 'Yellow Emperor of China' was considered strong enough to repel these creatures; a battle that left the defeated (mirror/physical) world reduced to a sterile reflection (illusion) of the original. Myths of this kind are no different to the Gnostic understanding of Upper and Lower Aeons and what they describe as a 'fake world' overlapping our original Earth. The same themes in the biblical Fall of mankind, when human consciousness was once at a higher level, are part of this myth.

Similar themes of demonic possession and the use of mirrors to capture 'fallen angels' were shown in the movie *Constantine* (2005) starring Keanu Reeves. In the film we are shown how John Constantine (Reeves), quite graphically, captures demons trapped within parallel realities between Hell and the physical world in the 'City of Angels'. The *non-physical* worlds in movies like *Constantine,* and the myths and accounts they are based on, focus on our *sixth* sense capabilities, including telepathy or mind-magic. Similar myths (all over the world) seem to hint at a time when the Earth was more *lucid* and less dense; a place where otherworldly beings and celestial *giants* roamed what the Australian Aborigine record as the *Dreamtime.*

SHADOW LANDS

Legends from all across the world speak of supernatural realms next to our 3-D world housing 'interdimensionals'. The Gnostics called them the Archons, Jinn (Genie); it was said that they could terrorise any who dared to 'call on them'. These entities were said to traverse time passing through portals into our world, especially through ceremonies (rituals). Ancient texts, such as the *Tibetan Book of the Dead, Emerald Tablets* and the Gnostic Nag Hammadi scriptures, describe the rituals performed to *call* in such demonic creatures. The books of *Exodus, Jeremiah* and the *Gospel of Matthew,* in the Bible, also refer to demons passing through 'opened doorways' between worlds.

The story goes that the *Emerald Tablets of Thoth*, which are said to date back 36,000 years, supposedly written by an Atlantean Priest king, offer keys for opening doorways in space-time. These tablets, or crystals, were said to have come from beneath a Mayan Sun temple in Mexico after been placed there by Egyptian (Atlantean) priests connected to the god, Thoth. It is said that they were eventually recovered and translated in 1925 by one Maurice Doreal and that the content (or themes) of these tablets spoke of the rise of the 'people of the shadows' in ancient times. The Jim Henson movie *The Dark Crystal* (1982), seems to have been inspired by such legends associated with the *Emerald Tablets*. The tablets seem to have been part of an ancient memory connected to the demise of Atlantis and the various satellite civilisations influenced by the people of the shadows, priests who used dark magic in the ancient world.

The mystery schools and secret societies of the ancient world, especially in Asia, Egypt and Babylon, held an 'open door' for these shadow realities. It was done, as it is today, through ritual sacrifice performed by élite bloodlines (Cult priests/priestesses), seeking 'possession' by a malevolent host. By locking pharaohs, temple priests, politicians, kings and 'world leaders' into *dark* forces, they would then carry out the bidding of their demonic host on Earth. The *Tibetan Book of the Dead* is quite specific when it comes to explaining the effects on the mind (or perception of reality) *through* ritual sacrifice, which often included blood drinking. The book seems to read as an instruction manual for elite bloodlines and their priests (or shamans), so to be able to enter into altered states. Not all shamans, or priests, even today are benevolent. The texts also outline the type of visitations seen over several days of hallucination, where blood drinking deities (along with other creatures) appear at specific ceremonies. One instruction reads:

> *O child of Noble family, listen without distraction. On the tenth day the blood drinking manifestation of the Ratna family, called Blessed Ratna-Heruka, will appear before you from the southern quarter of your brain.*[3]

The texts go on to describe how the 'participator' will be able to 'see' (imagine) various fabulous creatures appear in different colours and descriptions, all of which are said to be mental *projections* or 'shadow' aspects of the person who is seeing them! I will come back to this subject of 'mental projection' in a later chapter. The point here is that numerous ancient sources, from paintings to texts, along with modern day accounts witnessed by people from all walks of life, speak of a 'malevolent host' (often reptilian in appearance) amongst these mind projections. These are the gods that demanded bloodshed and sacrifice throughout the ancient world.

Various artefacts exist showing different types of creatures conjured up through sacrificial ceremonies. The British Museum in London houses sever-

al artefacts of Assyrian, Babylonian and Mesopotamian [demonic] deities. The most common demonic figures are 'Huwawa', 'Lamasha' and 'Pazuzu', the latter creature featured in William Friedkin's film *The Exorcist* (1973). There are others I could mention, but it is not my intention to focus the book on this particular theme in too much detail. Yet, our shadow sides need facing (but not dwelt on) if we are to heal ourselves! The higher we soar, like the sun at its highest point, then the smaller our shadow sides become. As our shadow sides diminish so do fear-based vibrations and thought-forms (or demons) infesting our world-reality.

THE PREDATOR CONSCIOUSNESS

In nature the word 'predator' conjures up imagery of tigers, crocodiles, lions and other man-eating creatures. These animals are often called 'alpha predators' because they are part of an ancient group that have always preyed off other animals, including humans. According to scientists such as David Quammen in his book *The Monsters of God* (2004), the Predator Consciousness is part of our evolution and worshipping it, through the alpha animals, relates to our need to transcend our physical, fear-based environment.[4] The worship of alpha predators is found in all indigenous cultures, whether in the reverence of the lion in the Bible (130 times to be precise), or through 'shark kissing' ceremonies of the 'Taka Manacca' tribes of the Pacific islands, the human reverence of a 'non-human' predator god is the same. But what is the true nature of a Predator Consciousness? The word *predator*, which comes from the Latin praedator, (praedari) means to seize and plunder. Here are dictionary definitions of a predator:

- Carnivorous animal or destructive organism: a carnivorous animal that hunts, kills, and eats other animals in order to survive, or any other organism that behaves in a similar manner.

- Somebody who plunders or destroys: a person, group, company, or state that steals from others or destroys others for gain.

- Ruthlessly aggressive person: somebody who is extremely aggressive, determined, or persistent (disapproving).

- Greedily destructive: greedily eager to steal from or destroy others for gain.

- Relating to predators: relating to or characteristic of animals that survive by preying on others.

All of the above traits could easily describe the attitude of élite structures on earth that have dominated our society throughout history. Whether through banking (predatory economics), or acts of aggression against any living creature – they are *all* predatory by nature. War, terrorism, assaults on the Earth's ecology, systems of control and rule through fear (both covert and overt) in nature, are part of this predatory stream of consciousness. The very nature of human life has become a 'predator's paradise' for forces that do not respect life and this plane. In fact, the Predator Consciousness is the system our minds are immersed in. It is the matrix itself, a simulated reality (a state of mind), that only exists because we are creating, or thinking into existence a collective reality. I know this may sound ridiculous, but as I shall unfold through this book, our state of mind, individually and collectively, is the foundation for the physical world we experience. Fear is a huge *unseen* force shaping our world, yet humanity has more control over this basic 'state of mind' than it realises. In many ways we have caged off our true potential, our 'spirit and imagination', and are therefore symbolically caged (trapped) within this matrix (physical) world. Just as any caged animal in nature experiences predators, we will continually attract to our psyche the Predator Consciousness, feeding off our fears, emotions and too often, a lack of self worth.

THE ASLAN COMPLEX

In a recurring dream I saw the Predator Consciousness in the form of lions and 'lion-humaniods' living amongst humanity. In one strand of the dream these lions seem to operate on a parallel reality, but can become part of our human reality when stalking prey (Figure 24). Humanity, like the antelope or zebra goes about its mental and emotional existence in blissful ignorance of the predator. In truth, this dream relates to the predator *within us* and the lion-humanoid archetype relates to both our ability to give away our own individual power (the victim), or become the empowered individual. I call the latter the 'Aslan Complex', a state of being that trancends all forms of survival and victim mentality. It is the fear of our true power and the illusions created through our fears that continually sustain the Predator Consciousness, unless that is, we connect with our own sovereign power. Our ego and endless modes of thought relating to guilt also feeds the Predator Consciousness, but, it only feeds off the energy we give away to *it*.

TIME CAGES

Time is also a construct used by predators in nature, as they often speed up and slow down the illusion of time to catch their prey. Our perception of time

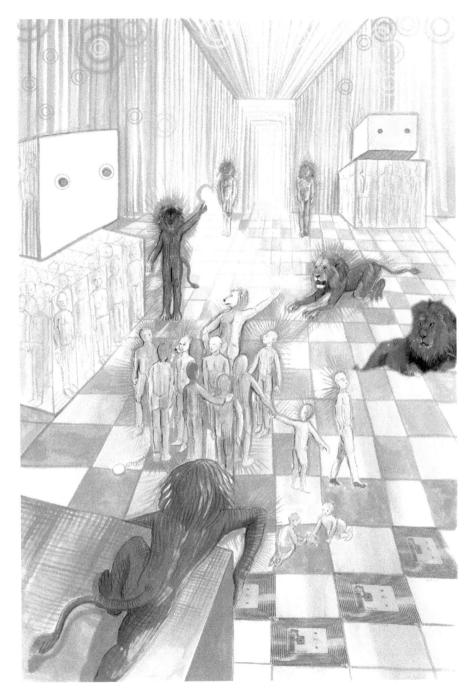

Figure 24: The Aslan complex.
The Predator Consciousness is the 'shadow' part of humanity that influences our world when we deny our own spiritual sovereignty. Instead of following our hearts we are herded into 'prisons of the mind', which feed the Predator. © Neil Hague 2005

also traps us and prevents us from breaking free of the material (physical) reality and limitations that come with slavishly following time. Too often we choose to be servants of the *system* rather than free thinkers and individual pioneers of our own realities. Thus the 'system' (our personal cage) becomes a reflection of the consensus reality of planet Earth. The Predator Consciousness cannot control or feed off our mind and emotions, unless we allow it to do so. Therefore, the only way so much suffering on this amazing planet can manifest in ways that destroy the foundations of the human spirit, is when *billions* concede their right to *be free* and forget to love. Billions have been persuaded to accept fear and survival (the cage mentality) and it is the survival mentality, harnessed through fear, that *is* the food source of the Predator Consciousness. When we are fearful and in survival mode, we send out energetic waveform signals that sustain the predatory mentality. This state of mind has created *and* controlled the very institutions we call religion, politics, the military and all corporate power bases that survive only through rule by fear! And, it is often through the higher echelons of these institutions that the Predator Consciousness reigns supreme. Declarations of war, terrorist outrages, created pandemics, through to diabolical acts of child abuse by priests and figures of authority, are extreme expressions of the Predator Consciousness.

The gods of death are as active today as they were for ancient priests who paid homage to predator forces through ritual amd magic. To appreciate the concept that an ancient mindset, which demands bloodshed and a constant state of control through fear, is operating today through possessed bloodlines and individuals (often world leaders), says so much about *how* and *why* events are triggered in our physical reality. William Blake summed up the idea of possession of men renowned by what he referred to as 'corporeal demons, when he wrote in a catalogue titled *True Christian Religion* for his exhibition of 1809. He said:

> *Unworthy men who gain fame among men, continue to govern mankind after death ... they possess themselves of the bodies of mortal men, and shut the doors of the mind and of thought, by placing learning above inspiration.*[5]

On one level, all war is a satanic ritual, an act which generates a vast amount of fear-based energy. The same can be said of the mass human sacrifices performed in the ancient world. The force that has inspired both ancient *and* modern warfare, killing, torture and tyrannical mindsets behind these operations, is one that lives in a dimensional vacuum and needs an external 'food source' to survive and maintain its control. Another name for the predatory (demonic) host as recorded in art and texts since ancient times, is the 'door-keepers'.

AGENTS & DOOR-KEEPERS

Amongst open-minded scientific sources, it is said parallel realities, or frequencies of consciousness, are connected via vacuums (or doorways) in space and time! These holes between different frequencies (or dimensions) are inhabited by entities, which are undetected to the five senses. Such forms can be accessed by our sixth sense (extra sensory perception). According to both myth and modern experiences, various creatures (thought-forms) inhabit parallel planes or what mystics and alchemists often refered to as the heavens *within* heavens.

The fourth dimension (4-D) *is* time. It is the place from where our matrix-reality and our minds feed the unseen host. The matrix itself is a manifestation of the Predator Consciousness, or what the Gnostics called the Demiurge, a subject I will come to shortly. This predator force is often depicted in art as a reptile or gargoyle creature, and these *forms* are representations of the extreme fear generated by the Predator Consciousness (see figure 25). In Hindu Mythology they are referred to as the Rakshasas and in the holy books called the *Vedas* the material world is considered to be governed by demons. These interdimensional entities are said to be able to move backwards and forwards (in and out) of our world *through* portals in the space-time fabric (see figure 26 overleaf). According to the physicist and author Giuliana Conforto, these holes or portals are inter-space planes housing pernicious angels or gluons, which are nuclear by nature. The same attributes were given to the Gnostic Jinn or Archons in the Nag Hammadi texts. The

Figure 25: Images of fear.
(**Left**) A stygra or night demon from Notre dame Cathedral in Paris.
(**Top Right**) A temple roof in the Chinese Forbidden City shows an array of horned creatures. (**Middle**) Rock art from Utah in the USA showing the Hopi horned clans. (**Bottom Right**) A red devil on the badge of the 177th Fighter Wing of the US Airforce.

Figure 26: Doorkeepers.
A devil passing through a portal at a Knights Templar Cloister, Le Puy, 12th Century France.

nuclear force, one of the four components of the Universe, is said to give pernicious angels their form. The splitting of the atom and the need for plutonium as a vehicle for war is of great importance to the consciousness that feeds *from* these inter-space planes. The portals these creatures use to traverse time and enter our reality have been opened up – in some cases through governmental nuclear abuse – at CERN, and some writers have indicated that nuclear weaponry may have been used in more ancient epochs (see Sodom and Gomorrah in the Bible) to birth pernicious angels (Archons).

The Elizabethan scientist and occultist, Sir John Dee was also said to have opened portals into parallel worlds using rituals and magic. He called these interdimensional beings angels, or Archons.[6] In more recent times the American military have been involved in 'black projects', ranging from research and development of 'advanced' technology to MKUltra mind control operations, especially at Edwards Air Force Base, Fort Irwin and China Lake Naval Weapons Center. This was the same area where Charles Manson and family resided in the late 1960s. It's also the general location described in the book, *Outside the Circle of Time* (1980) by Kenneth Grant, which states: "John Whiteside Parsons (who specialized in jet propulsion) and L. Ron Hubbard, founder of Scientology and former Naval Intelligence Officer were involved in a "special project" during 1945 and 1946." This special project, which was carried out in the California desert, was said to be part of a series of magical ceremonies (black witchcraft) known as the *'Babylon Working'*. The ceremonies were designed by the high ranking freemason, Aleister Crowley, who died in 1947 (the same year of the alleged Roswell UFO crash and the implementation of the National Security Act).[7] All a coincidence of course? The purpose of the project and other ancient ceremonies performed by the likes of Crowley, Dee and later Parsons and Hubbard was to 'unseal' interdimensional gateways that had been sealed in ancient antiquity, thereby allowing various dimensional entities known as the 'Old Ones' access to our space/time continuum - our reality. L. Ron Hubbard produced his horror novel *Fear* (1940) around the same time all of this activity was going on. Hubbard's book also talks of demons that devour human souls. A lot of Hollywood stars, such as Tom Cruise and his former wife Nicole Kidman, became Scientologists, and one wonders how many are under the influence of this secretive mind-control hub (excuse the pun) based in California? Again, many references to 'hidden evil' can be found in art, science fiction

and ancient texts. George Lucas's 'Sith' in the *Star Wars* saga is the most glaringly obvious reference to these demonic forces. Even the late Queen of England talked about the same "dark forces at work" in our world, at the time of the Paul Burrell case in 2003. Of course, she was referring to her own knowledge of the Sith! The way, in which the Emperor is portrayed in *Star Wars: Episode One: The Phantom Menace* (1999) as a transparent *projection* along with his reptilian-like apprentice Darth Maul, in some scenes, gives a visual feel for what these entities appear like to those that summon them. The Nazi-like imagery of Darth Vader and his cloned Storm troopers dressed up as freedom fighters and liberators also give a visual feel for the mentality desiring a global control 'empire', through direct occupation of countries (see my book *Orion's Door*).

ATTUNING TO DARK MATTER

Fear of the unknown, along with retribution levied on anyone who dared to communicate with unseen forces (thanks to religious intolerance) throughout the ages, has kept humanity locked into a five-sense prison vibration. Yet I know through my own art that it is possible to tune into higher interstellar worlds operating just outside of the five senses. We do this through our extra sensory levels of awareness. It's usually when we are delinked from the physical vibration (the collective reality), through various forms of meditation, timelessness and alternate states (as practiced by shamans), that we begin to 'dream with open eyes'. As I mentioned in an earlier chapter, non-local aspects of reality are also referred to as dark matter, and astrophysicists say dark mass constitutes the majority (99.5%) of *all* matter in our Universe. It's this majority of matter that houses the *hidden*, lucid and alien forms undetected by the five senses. The Irish poet and occultist T.S. Elliot was fully aware of these hidden inter-space realms and their connection to dark matter, when he wrote in his work, *The Four Quartets*: *O Dark Dark Dark, they all go into dark. The vacant interstellar spaces, the vacant into vacant.* However, it was the shaman (artist/visionary) who journeyed into these hidden levels of consciousness and painted what he/she perceived from a higher perspective.

Much prehistoric rock art (pictographs), especially in the South Western States of America, shows strange figures and shapes appearing out of nowhere. Much of the Anasazi rock art of South Western North America, depicts strange bug-like creatures, some of which seem to appear more 'looming' as they approach the viewer. Did the shamans/artists who made these drawings (possibly in altered states) encounter interdimensional beings from a parallel world? Or were they merely aspects of the shaman's or artist's imagination? Even if these creatures are imaginary, why do similar 'generic' forms appear across different cultures, continents and eras? Psychologists and sceptics might say this phenomenon is part and parcel of the ability of

our collective subconsciousness to 'invent' and 'project' a variety of alien-like figures! I would agree to a certain extent, purely based on the holistic under-standing of creation and how our minds create a consensus reality. But where does one distinguish the limits between imaginary and real, especially when these creatures have been depicted in sculptures and added to great temples and cathedrals all over the world? Are we actually saying that secret soci-eties, religious hierarchies and brotherhood artists, all of whom invented reli-gious symbols and commissioned these structures, were all 'imagining' the same demonic creatures? I doubt that! On that note, how is it that orthodox religions of *all* denominations shun the idea of 'life after death' and 'parallel worlds', while feeling okay with the myriad of demons, gods and other strange creatures that cover every major cathedral in Europe? I'll tell you why, because religious intolerance has probably been the most efficient tool for waging war and causing bloodshed all over the planet. What do these entities demand? They demand blood sacrifice, killing and decadency and have done so since ancient times. So therefore, did the church hierarchy place gargoyles along with scenes of bestiality on the highest levels of gothic cathe-drals, such as Notre Dame in Paris, for decorative purposes? No, of course not. They were placed there to make a statement about the entities that exist just outside of our frequency range (one of many mansions) and enter into our reality via portals between worlds. The Chimera Gallery at Notre Dame in Paris, created by Eugéne Emmanuel Viollet-le-Duc and his pupils in 1845, depicts some of the most stunning sculptures of demons and possessed men I have ever seen. These creatures overlook Paris from a height that would suggest they dwell in regions beyond this dimension (see figure 25 on page 107), in the same way that the North American Indian shamans of the North West Pacific regions stacked their gods on totem poles for the same effect. Walking amongst the gargoyles at Notre Dame in Paris, which I have done on several occasions, left me feeling what it must be like to witness such grotesque monsters appearing to persons who have summoned them. Interestingly, the types of pandimensional creatures summoned by Renaissance and Elizabethan brotherhoods (like John Dee), also appear in the form of extraterrestrials (inter-dimensionals) in many science fiction narra-tives, some of which I will explore in a later chapter. This is because science fiction is the official genre today for showing what many shamans, priests and visionaries have visualised since ancient times. More so it is a cover story for the truth. The classic British Science fiction series *Dr Who* depicted these types of phenomena in great detail and similar entities also appeared in *The Matrix* movies (1999-2003), not to mention a long list of horror novels and films over the past fifty years. The media industry and music industry is also used *and* abused by the same unseen forces, something I will come back to at the end of *Part Two* of the book.

THE DEVOURERS (PROGRAMMES HACKING PROGRAMMES)

In the film *The Matrix Reloaded* (Warner Brothers 2003) there is a scene, which shows the Oracle and Neo talking about the types of 'programmes' (simulations) that exist within the overall grand Earth-Matrix. The oracle refers to these types of programmes as 'hackers' that attempt to 'devour' other programmes within the Matrix. Instead of facing deletion, as the oracle puts it, they choose exile. In other words, as hidden programmes (beings) they prefer to hide in vacuums or inter-space planes rather than return to the source – the Creator. These creatures (thought-forms) are often depicted as gargoyles, phantoms, demons, aliens, pixies and vampires in much folklore and movies.

The Mayan depictions of the hawk, the cross and the toad, from within their art and on their stelae, especially from Chalcatzingo, depict certain constellations, which clearly show portals to what they refer to as Xiballan – the place of the dead. Stars in Orion, Draco and Sirius also align with various otherworldly entities, see my novels *Moon Slayer* (2015) and *Aeon Rising* (2017). These creatures are the classic vampire *or* demon that needs an external food source, i.e. blood, or emotions, especially generated through fear, as an energy to sustain themselves in their exiled shadow world. The classic images of wizards and warlocks summoning these creatures can be found in the art and architecture of the world's religious temples, tombs and build-churches. Why? Because the brains behind many of these feats of wonder knew that like attracts like, or, energy goes where our attention flows!

Christian art and sculpture especially, is littered with devils, devourers and hell scenes, which is not a surprise when you decide to take a closer look at texts in the Bible. From my own research, I feel universal deities relating to time (calendars), death and war are the real force behind the creation of religion and therefore logic in much of the Bible, especially the Old Testament. If some readers don't like the idea of the Bible being mainly the word of a consciousness that demands war and control through tyranny (a complete contradiction of a so-called all-loving Creator), then why would there be at least 50 plus instructions in the Old Testament alone, that revel in killing and maiming in the name of God? Here are a just a few examples taken from the books of Genesis and Exodus in the Old Testament:

An eye for an eye and a tooth for a tooth. 21:24-25

God is angry. He decides to destroy all humans, beasts, creeping things, fowls, and all flesh wherein there is breath of life. He plans to drown them all. 6:7, 17

God repeats his intention to kill every living substance ... from off the face of the earth. 7:4

God orders Abraham to kill Isaac as a burnt offering. Abraham shows his love for God by his willingness to murder his son. But finally, just before Isaac's throat is slit, God provides a goat to kill instead. 22:2-13

The firstborn of thy sons thou shalt give unto me. [As a burnt offering?] 22:29

The Lord has sworn That the Lord will have war with Amalek from generation to generation. 17:14-16

"*Moses has some animals killed and their dead bodies burned for God.* [Foot and Mouth no doubt], *Then he sprinkles their blood on the altar and on the people. This makes God happy.*" 24:5-8

"*Thou shalt not suffer a witch to live.*" 22:18
[Thousands of innocent women over centuries past suffered excruciating deaths because of this verse].

I could go on, but I think you get the picture?

THE GODS OF ATLANTIS

Sacrificial killings performed for the 'God' (or gods) of the Old Testament are references to rituals carried out by priests to appease demons (the gods) con-

Figure 27: Possession. Gothic cathedrals are littered with images of possession often termed *devourers.*

trolling them, or possessing them. Sculptures showing individuals being 'devoured' on Christian Romanesque chapels and churches are images of possession by these creatures (see figure 27). As with much religious ideology imposed upon the human race since ancient times, these texts talk about sacrificing people, animals and waging war on nations, all of which continues to this day. Why is this so? Because the same consciousness that instructed the creation of dogmatic religion and crucified Christ has never left our space-time. The Predator Consciousness inspired the formation of secret power bases in every ancient civilisation, probably stemming from the globally controlled Empire that was Atlantis.

The ancient civilisations of Egypt, the Babylonians, Aztecs, Mayans, and Incas could have been satellite colonies of Atlantis. They all shared several intriguing characteristics:

• They were extremely advanced scientifically and technologically.

- Animal and human sacrifices were performed at an alarming rate, preceding their demise.

- They believed they had acquired metaphysical knowledge from the "gods" whom they perceived as coming from the stars and also the subterranean levels of the earth.

- These cultures disintegrated or became abruptly extinct while at the pinnacle of their existence.

Our global culture today is not dissimilar to these ancient civilisations. We see scientists as gods and religion as the mouthpiece of 'God', without fully desiring to know who we really are. We slaughter millions of animals anually as part of a immense corporate food chain, while believing we have reached the pinnacle of civilisation. Superpowers of the world have at their fingertips the technology that could be used to either free *or* totally destroy all life. We have not really changed our perceptions! The world is a 'reflection' of our inner power and we are still giving our power away to the same gods that destroyed the ancient civilisations, only to replace them with newer models. The gods of Atlantis are the same ones that operate today at the highest levels of our global society.

A DEMENTED GOD

According to Gnostic *Nag Hammadi* texts, 'HAL', or the 'illusory planetary realms' of our Solar system, had *its* Creator god, called by the Gnostic's the 'Demiurge'. He was the deity eventually called God by monotheistic patriarchal religions. Can you see why the Gnostics (and later Cathars) were violently removed wherever they appeared, offering an *alternative* view to the Abrahamic faiths? According to the Gnostic texts, '*He*' (the Demiurge) was an angry, demented, impostor-god who envied human divine imagination – the Anthropos. *He* is the 'beast' often depicted as a 'rampant lion' whose minions are the 'inorganic' Archons, often described in Gnostic texts as resembling an aborted fetus. The key point to emphasise here is that the Demiurge should be seen as the 'master of mimicry' and the architect of 'manipulating perceptions'. The Solar system, as I shall come to, has been changed and 'altered' in *appearance* by the *mind* the Gnostics called the Demiurge. The Gnostic Bible and the texts *On the Origin of the World* describe events concerning the arrival and demeanor of the Demiurge. It says:

> *Now when the outer heavens had been consolidated along with their forces and all their administration, the Demiurge became insolent. And he was honored by*

Figure 28: The Demiurge.
Also known as Yaldabaoth,
the Father of Adam.

Figure 29: The Chimera.
A hybrid creature of Lycia, Asia
Minor.

*an army of angels who gave blessing and honor to him.
And for his part he was delighted and boasted to them,
'Lo, I have no need of anyone else, no other gods'. He
said, 'It is I who am god, and no others exist apart
from me.*[8]

The above text is the perfect description of the 'arrogant' (too-often psychopathic) archetype; it is also the 'fire and brimstone' God we find throughout the Old Testament. His angels are not angels, but Archons, which is where we get the word '*Arch*-Angel' and much more besides.

The Chimera in Greek mythology, a monstrous, fire-breathing hybrid creature of Lycia of Asia Minor, composed of the parts of more than one animal, can be seen as another symbol of the Demiurge (in image only). In the *Nag Hammadi*, the Gnostics describe Yaldabaoth as 'Ariel', another variation of the angel Ariel which means 'Lion of God' or 'Hearth of God'. The *Apocryphon of John*, a work heavily quoted by John Lamb Lash, describes the Demiurge as a dragon-like lion beast. The same beast often symbolised as a Chimera, a lion-headed serpent said to forge a world in its own likeness (see figure 28).

The Chimera is usually depicted as a lion, with the head of a goat arising from its back and a snake-like tail often ending with a snake's head. It was said to be one of the offspring of Typhon, Echidna, and a sibling of monsters such as Cerberus and the Lernaean Hydra (see figure 29). In Medieval art, the Chimera of antiquity was forgotten, but chimerical figures appear as embodiments of the deceptive, *inverted* forces of nature.

PROGRAMMES, STATES OF BEING & BEASTS

The gods revered and feared by the ancients are often described as looking like winged-reptilians or dragons. Similarly, Satan and his minions were depicted in an identical manner, as seen in artwork throughout the centuries. Texts entitled *Reality of the Serpent Race* and the Branton *COSCON Files*, which are said to show the connections between the Nazis and underground bases, reveal that the 'Nachash', a Hebrew word for 'Serpent', was not actually a

snake as most people believe. Instead it was an extremely intelligent, cunning creature, possessed with the ability to speak and reason. Another significant parallel from the Bible is shown in Jeremiah 8:17, *"Behold, I will send serpents, cockatrices among you, which will bite you, saith the Lord."* The definition of a cockatrice is a reptilian bird-like creature or winged-serpent. Could this creature also be the phoenix or eagle as used for an emblem for all of the tyrannical civilisations from Rome to Nazi Germany? Just a thought! William Blake the great English visionary graphically illustrates some of these creatures in his work for Danté's *Divine Comedy*. Danté was a Knight Templar and connected to the brotherhood that worshipped the Predator Consciousness.

These brotherhoods, which can be traced back at least to ancient Egypt, have called on these 'beings' within their rituals, so to allow possession of leading world figures (prime ministers and presidents included). According to numerous accounts, both ancient and modern, esoteric rituals continue today under the general guise of Satanism, which, according to some researchers, include some of the most famous people on the planet.[9] As I have already said, all sacrifice, war, bloodshed, torture, famine, death and all the other abominations we endure, are *not* natural states of being for humanity. I would suggest we have been conditioned to accept all suffering in the world as natural, even normal! *It is not*. Our natural state of being operates on many levels, but to endure predatory feelings and to have predators feed off human emotions is not a natural state of being. Yes, nature is full of predators, but in truth we are *not of nature*, we are multidimensional spirits. We *are* love at our core and this love is what connects to the *Oneness* and *All-that-exists*. Wildlife can be viewed as a sophisticated computer programme that sets the habits and characteristics of animals, but *all* animal consciousness operates at levels outside of this programme, yet is still part of the matrix. Migration is one example of how certain species seem to be *operating* within the parameters of a 'programme' that commands specific outcomes. A BBC television programme in 2004, dedicated to the predatory attitudes of animals, illustrated the patterns different animals and birds carry out at the same times of the year.

We exist within a collective programme or reality also, but we are part of the realms and dimensions expanding beyond the survival mentality or blueprint—constantly conditioned to experience the predator (fear) in a physical body. The emotions of guilt, fear and anger, often created through experiences (or projections) of how we think, that feed the Predator.

LIONS, SERPENTS AND UNICORNS

On ancient seals and heraldic insignias also exists imagery, which speaks of the 'demonic host' and its connection to ancient cults and bloodlines going back to antiquity. Many heraldic shields introduced under the reign of the

Plantagenet dynasty, especially at the time of King Edward III, refer to the demonic host. Gerard of Wales said of the Plantagenet bloodline:

From the devil they came and to the devil they shall return.[10]

On many heraldic devices two beasts usually flank a central insignia and these beasts, monsters or animals relate to a particular bloodline and possible demonic possession of their lineage. The 'reptilian-lion image' is the most common one, but insignia flanked by hairy men, unicorns and other fabulous beasts are a direct reference to the DNA of these élite bloodlines.

The royal British crest sporting the lion and the unicorn is a direct reference to the two genetic streams that came together to create the ruling class (family). Some authors say the lion represents the demonic presence *possessing* the unicorn (Sum-Aryan) Sumerian bloodlines and this is why it is often tethered to the lion. The unicorn is also considered to be a symbol for a *hidden* bloodline connected to the Holy Grail. On a more mystical level the duality of the lion/beast and the innocent pure unicorn represents the dominance of the Predator Consciousness over the human spirit.

Two reptiles flanking the Sumerian cross, forming the crest of the City of London and Temple Bar (Knights Templar) is another example of the force that has controlled the secret societies of antiquity. The City of London has more Freemasonic lodges per square mile than anywhere else in the world and its main totem is the demonic dragon holding the Sumerian/Phoenician (Sum-Aryan) cross, again another symbol of possession. Lewis Carroll makes reference to the tussle between these two bloodlines in his fictional piece *Through the Looking Glass*. He wrote:

> *The lion and the unicorn were fighting for the crown. The lion beat the unicorn all around the town.*

Dragon, lizard or reptile 'gods' can be found on Egyptian, Mesoamerican and Sumerian stelae and represent ancient bloodlines that are servants of the cult of the All-seeing-eye (see page 41). In the Old Testament these 'gods' are referred to as 'fiery serpents' (*Numbers* 21:16) In Indian texts, like the *Vedas*, they are called the 'Nagas' and to the Cherokee Indians they were known as the 'Sint Holo', the *invisible* serpents.[11] As I have already mentioned, the dragon and lion are two classic figures cropping up time and time again in heraldry and family crests of the 'ruling' nobility. They go back to icons found in ancient Persia and the Near Middle-East (see Figure 30). Some are clearly designed to represent more demonic-looking creatures, especially the *three* rampant lions on crests of the House of Windsor. These 'creatures' are more like phantoms than lions and they represent malevolent forces and its ties to

ancient occult ruling élite cults (see figure 31). The Nazis chose the three lions, the phoenix and the swastika symbol because of their occult meanings. The same lions, eagles, snakes and crosses have always been used by the ruling élite on their emblems, as logos and in heraldry, and the same fascist mentality can be found throughout history. The Roman élite was of a fascist mindset and the same can be said of every regime and empire that has invaded, occupied and forced itself on other nations throughout history.

In other ancient accounts we also find references to serpents, phantoms and laser-eyed creatures that can appear and disappear at will. Ancient records also talk of mirror, or parallel worlds where these strange creatures reside waiting to be invited into this space-time reality. *The Emerald Tablets* offer some very intriguing insights into how our reality is 'feeding' what I call the Predator Consciousness. The tablets talk of the 'children of the shadows' coming forth to possess those that ruled the native populations before *and* after the Atlantis era. One section of the Tablets reads:

Figure 30: Lion and the unicorn.
A Persian Seal showing a griffin/lion attacking a stag

Figure 31: Rampant demons.
(Left) The royal phantom-like lion is a symbol of the demonic host and the bloodlines that represent it on Earth.

Far in the past before Atlantis existed, men there were who delved into darkness, using dark magic, calling up beings from the great deep below us. Forth came they into this cycle, formless were they, of another vibration, exiting unseen by the children of earthmen. Only through blood could they form being, only through man could they live in the world. [12]

In that one passage we see references to black (satanic) magic and the classic imagery of vampires and devils coming out of unseen dimensions (shadows) to prey or possess those that summon them. Whatever their origin, these texts present themes that can be found in numerous myths through to literature and science fiction films. Another text from the Tablets reads:

In the form of man moved they amongst us, but only to sight, were they as are men. Serpent-headed when the glamour was lifted, but appearing to man as men among men. Crept they into councils, taking form that were like unto men. Slaying by their arts the chiefs of the kingdoms, taking their form and ruling o'er man. Only by magic could they be discovered, only by sound could their faces be

seen. Sought they from the kingdom of shadows, to destroy man and rule in his place.

The *Nag Hammadi* Gnostic text, also describes the shape-shifting abilities of certain men, when it says: ... *many animals walking around in the skin of men.*[13] This line also hints at possession through DNA *corruption*, or the power to 'metamorphose' from one form to the next. In fact metamorphosis is not such a bizarre concept, it is happening all around us and lies at the heart of every natural phenomenon we know. Shape-shifting or metamorphosis is also something that occurs in nature, whether it is day becoming night or a caterpillar becoming a butterfly, all by definition are *shape-shifting*. In ancient texts such as *The Odyssey* and *The Ramayana* we find references to metamorphosis and shape-shifting. Also in Ovid's *Metamorphosis, The Golden Ass* (43 BC - 17 AD) Ovid tells hundreds of transformation stories that hint at the soul never dying and its ability to leap from form to form, taking any shape it requires.

The mask-wearing rituals performed by shamans and priests of all ages are also designed to invite another 'presence' into their reality. By wearing the mask of an animal, the shaman-priest would become *that animal*. The predator I am outlining in this chapter has taken shape in the form of élite ancient families through their DNA, enabling them to call on that demonic host which, in some cases, possesses them for a lifetime.[14]

GOVERNING FROM THE SHADOWS

The predatory force behind the creation of ancient Babylon and the Roman Empire (or any empire today), was merely seeking to activate its 'bloodline' on Earth. Creating centralised beliefs underpinned by a structure modelled on cults (religions) and 'war' has served the Predator Consciousness well for thousands of years.

It seems that a predatory intelligence with any lack of compassion or spirituality, created *all* of the 'religious empires' (from Babylon to Rome), so to control the minds of the masses! Let's face it, religions are designed purely to fix the mind on a particular static belief system, they are *not* vehicles or templates that encourage freedom of thought. Once the mind is fixed on a set of beliefs, be they Christian, Muslim or Jewish or other religions, then that person can be more easily persuaded to hold dualistic thoughts that can go on to encourage even more division. All war is born of these manufactured divisions, all of which only exist in our mind. The heart sees no division, only *Oneness*. Our opinions and our beliefs need to be in constant motion so as to encourage a more open mind. As William Blake wrote: "The man who never alters his opinion is like stagnant water, and breeds reptiles of the mind." [15] That reptile mind *is* the beast within, or a predatory consciousness. It is the thoughts borne from this ancient part of the psyche that can gravitate

towards stagnant belief systems and mere survival.

I am certain an ancient bloodline of priests / magicians (a cult) with knowledge of the real meaning of life and humanity's connection to realms beyond the five-senses, have created all of our dogmas and systems of belief. The chosen ones that were (still are) initiated into the highest levels of this ancient brotherhood (or cult) *are* the vehicles by which the demonic predatory force creates war, *pan*demonium (pandemic) and terror on planet Earth. World leaders today *are* vehicles for this force, as were the Pharaohs, Caesars, and warmongers of other eras. If you think that's an outrageous statement, then consider the common denominator of war, aggression and occupation of other countries, by the force that works *behind* world leaders throughout known history. Many world leaders are constantly lying to the public regarding issues that instigate aggression against other nations. And it is the demonic presence behind the public face of these politicians and military leaders that is making such devastating decisions, which often result in the deaths of thousands of innocent lives. As a line in the classic cult movie *The Exorcist* points out, when dealing with demons that possess individuals:

> *The demon is a liar. He will lie to confuse us. But he will also mix lies with the truth to attack us. The attack is psychological, but powerful. So don't listen, remember that, do not listen.*

The global media, the military, the politicians and big Pharma, etc., *all* act like intellectual prostitutes; they are lying on a daily basis.They are vehicles for a force working through them towards total control of humanity. Interestingly, there is a medieval demon called a Belial or Be-lair (the demon of lies), which was considered a great evil in Jewish belief! The Sibylline Oracles, a mixture of Judaic and early Christian propaganda, predict that Be-lair (the 'sons of Belial') will appear on Earth and from Samaritan stock.[16] Is this entity incarnate and living amongst the people of Albion (Great Britain)? At the highest peak of the structures that control our world, the demons definitely run amok and the inmates (our world leaders) have taken over the asylum! How do we know this? The answer is found in love. Love is not regarded as the highest priority by those in positions of power. If it were, there would be no famine, war, terror, or systems of control born of tyranny. *We would be truly free!*

As I said earlier, the Predator Consciousness feeds directly off the mayhem and devastation fuelled by fear, war, etc., and it is the aristocracy (élite families) that have instigated much war on earth. But they haven't done it alone. Not one invasion or war on this planet could ever commence without humanity first conceding its power to the systems of control designed to enslave our minds and close our hearts.

SYMBOLS OF THE ILLUMINATED ONES

According to official sources, the name 'Illuminati' refers to the bestowing of *hidden* knowledge on select members in society so that they became the *illuminated* ones, or 'shining ones'. The symbol of the lighted torch, which can be traced back to the Stoics, Comacine masters, the Dionysians in Greece and the Collegium of Rome, is the most obvious of hallmarks. The symbol can be found in the Americas as the eternal flame. It has been a classic symbol used by the Cult, or Illuminati, for hundreds of years as a signature of their work and it can be seen placed on memorials to war and prominent world leaders, such as JFK, Princess Diana and Martin Luther King. Dr. Cathy Burns in her book, *Masonic and Occult Symbols Illustrated* (1998) explains the connection between the lighted torch and the illuminated ones, including Lucifer (Predator Consciousness). She writes:

> Lucifer, having regained his star and his diadem, will assemble his legions for new works of creation. Attracted by his flaming torch, celestial spirits will descend ... and he will send these messengers from unknown spheres to earth. Then, the torch of Lucifer will signal 'From Heaven to Earth!' — and the New Age Christ will answer, 'From Earth to Heaven!' [17]

Look no further than the regalia, hand signals and symbolism of the world's military and intelligence networks to see what mentality is behind these structures. The Pentagram (Pentagon, military headquarters in the USA), depictions of devils and the All-Seeing-Eye, are *all* symbols of the consciousness worshipped at the highest levels of Freemasonry – the cult of the illuminati.

In truth, this ancient brotherhood has been at the helm of manipulation for *and* on behalf of the Predator Consciousness, for many epochs. The Illuminati's desire to connect with the hierarchy of *all* the Aboriginal, Native American and African tribes, (especially the spiritual leaders), is a constant untold theme of indigenous history the world over. The use and abuse of esoteric knowledge (black magic) through symbols and the art of the shaman is part of this hidden story. Shamans from Africa to Alaska were drained of their knowledge by the secret societies that controlled the European Empires. Historical figures, such as Christopher Columbus, were not the first to discover the Americas, which is now well documented. The Phoenicians, Egyptians and the Indo-Aryan races of the Far East had all made their way to the Americas *thousands* of years before that official 'photo opportunity' by Columbus. In fact, in the last century, Egyptian artefacts have been found in the Grand Canyon along with other mysterious finds which speak of a highly sophisticated golden race, one that travelled great distances in the ancient world. Also in North America megalithic stone circles have been found that

hint at an Indo-European presence there at least 10,000 years ago.

Legends that tell of the 'Sun people', or the 'illuminated ones' and their knowledge found in North American, Chinese and Celtic culture may well have been the brains behind much of the 'mysteries' and fantastic structures left on all continents. I am more inclined to believe that what researchers call the Atlantean and Lemurian 'global' civilisations, which predate official history, were centred in both the Americas and Asia. The ancient ones, or 'first people' as the Hopi call themselves, migrated out of these two advanced civilisations and fathered what later became Sumeria, Egypt and the Mesoamerican cultures. This concept could explain why there was a sudden emergence of advanced knowledge in such places as Egypt and Sumeria. All of these civilisations were using 'knowledge' brought with them at the time of what is often referred to by aboriginal people as the 'great migration'. Other areas such as the British Isles also seem to have had an advanced civilisation, which migrated south prior to a major deluge recorded in all oral traditions. There are too many similarities in styles of art, deities (beliefs) and legends expounded by cultures that are oceans apart today (not to mention all the scientific data) to deny that some sort of advanced civilisation existed prior to the great cultures recognised by official history. Only global turmoil in the form of major cataclysmic events could have destroyed a global civilisation. Everything else afterwards was based around memories, often recorded through art and storytelling, of that global culture; one that inspired what we now call, the 'mysterious wonders of the world'.

On another level, common themes found in stories tell of a 'Golden Age', or a collective reality created by an 'illuminated' humanity in a global civilisation, now lost. It seems that back then, just as it is today, a force that thrives on sacrifice, hierarchy and worship of external 'gods' (later translated as God), is hiding the truth that ancient priest kings (including today's ruling élite) were (still are) related, through blood (DNA), to non-physical frequencies presented in this chapter. Knowledge of these bloodlines (one that still contains connections to the offspring of the so-called gods of the ancient world), is also the origin of the 'divine right to rule', which is nothing more than rule by DNA. The legends of the 'giants' all over the ancient world are part of this story, too. From the time of ancient Sumeria and possibly before, these bloodlines have obsessively intermarried to preserve their genetic inheritance.[18] These are the same royal lines, aristrocratical families, presidents, prime ministers who are always chosen by blood, to run the world.[19] So are the medieval banking families, the powerful media owners and the military, all of which still serve their masters from another dimension. Too often, their masters are the demonic hosts recorded in the art and texts of the ancient world.

FEAR *IS* THE PREDATOR

I will say this about the Illuminati: They only exist because we have forgotten our own creative 'illuminated' power. In my view, what researchers call the Illuminati are nothing more than a mirror of our collective fears, which are created in our minds. When we focus on fear, we become a vehicle for lower frequencies and states, illustrated in this chapter; and what we fight we also become. The switch from being in a state of fear, which is more often a manufactured state of being, to that of feeling love as a human being, is going to create heaven on earth. Fear *is* the Predator Consciousness and it is what ultimately prevents us from really changing our own personal universe for the better. It is fear of not being in control, or being short of something that we think we need, that drives us to seek to control others. It's fear of the unknown, or whatever is thrown at humanity (see all-things 'Covid') that is coming from a 'state of mind' connected to the Predator Consciousness.

The worlds of shadow and the agenda to create a global tyranny is a mirror of the amount of control we exercise over others in our life. It is the Predator that influences our mind and feeds the control system. The Predator's influence over our minds *is* vibrational, or *unseen*. Something I intend to explore in detail in the next chapter. Yet in our hearts we desire true love and freedom. Our imagination expressed through our creativity can remove barriers set up by fear and what is influencing our minds - these barriers disconnect us from the heart. The more we use our imagination to create reality, the more we 'see' what really matters in this physical world – *joy, beauty* and *love*. Once humanity lets go of fear and realises that joy, love and seeing beauty are valid alternative states of mind powered by the heart – then all suffering created through waging inner and outer wars, instead becomes a 'state of inner peace' - *heaven on earth*. Our creativity can bring us to this inner peace and fuelled by our imagination, everything is possible!

NOTES:

1) Scientists Found Evidence for Parallel Worlds March 7, 2022 *Geraldine Future Science & Technology Parallel Worlds. https://www.thefuturist.co/scientists-found-evidence-parallel-worlds/?utm_source=pocket-newtab-global-en-GB&cn-reloaded=1*

2) Barber, Richard and Riches, Anne: *A Dictionary of Fabulous Beasts*. Boydell, p106

3) *The Tibetan Book of the Dead*, Shamballa Pocket Series,1992, p144

4) Quammen, David: *Monster of God: The Man-Eating Predator in the Jungles of History and the Mind.* p17

5) Blake, William: *True Christian Religion*, sited in *Blake & Swedenborg*, edited by Harvey F. Bellin and Darrell Ruhl, 1985, p27

6) Tsarion, Michael: *Atlantis, Alien Visitation and Genetic Manipulation,* Angels at Work

Publishing, p83

7) *http://congregator.net/authors/demons-aliens.html*

8) (103.1-15)

9) Icke, David: *Children of the Matrix*. Bridge of Love, 1999, p200

10) *The Plantagenet Chronicles*. Greenwich Editions, 2002, p22

11) *htttp://www.pantheon.org/mythical/articles/sint-holo.html*

12) *http://crystallinks.com/emerald.html*

13) *http://www.eqilibra.uk.com/illusion.html*

14) *The Reptilian Agenda*, Credo Mutwa & David Icke. Bridge of Love. 1999

15) Blake, William: *Marriage of Heaven and Hell*. Plate 19

16) *Man, Myth & Magic*, Issue 8, Published by Purnell, 1970, p237

17) Burns, Kathy: *Masonic & Occult Symbols Illustrated*, p260

18) Jones, Steve: *In the Blood – God, Genes and Destiny*, Flamingo, 1998 pp 88-89

19) Icke, David: *The Biggest Secret*. Bridge of Love Publications,1999, p39

'Heaven' or 'Hell' on Earth

The house of the Predator Consciousness (part 2)

So long as the root of wickedness is hidden, it is strong.
But when it is recognised, it is dissolved.
When it is revealed, it perishes
Gospel of Philip

As an illustrator I've tackled various esoteric subjects, both light and dark in nature, over the past few decades. The illustrations in this chapter are my 'getting-to-the-point' visually on what truly assails humanity. We need to 'see' the forces behind our so-called reality for what they are – the opposite of life, or to *live*, which is simply death-focused and *evil*.

In numerous blogs and books I've talked about the Archons of Gnostic mythology and their connection to what Christians call demons, and Islamic texts call the Jinn (see *Orion's Door*). In this chapter, I don't want to repeat what I have written before, but instead apply the understanding of how evil plays out in our human world-matrix, especially in what can be called the 'Covid era'.

THE MIND VIRUS

For Native Americans, there is a dark, chaotic, evil source called 'Wetiko', (sometimes pronounced 'way-ee-tee-KOH'). For such indigenous cultures, Wetiko is an evil spirit (forcefield) capable of invading the human mind. The Native Americans called it a 'virus of selfishness' (psychopathy) expressed in various psychopathic traits found in all cultures the world over. Wetiko is no different to the Predator Consciousness I explored in the previous chapter, yet visually, we have to move away from depictions of gargoyles, etc, and see 'it' as *energetic*, or an energetic *field* that can infect the mind. A modern extreme expression would be a psychopathic serial killer or a dictator's tyrannical takeover of nations (the world). Wetiko collectively, is simply 'Hell on Earth'. And haven't we experienced a hellish reality in recent years?

At both an individual and collective level, Wetiko is a physical pathogen

that forces the victim to feed their insatiable needs as if they were starving, fearful, or even hateful of others. Wetiko is the source of all the Seven Deadly Sins and the cause of gluttony and famine, avarice and poverty, etc. It's the invisible force behind *all* extremes and the deceit sown to install such extremes. According to some Native Americans, 'it' (Wetiko) makes humanity its own worst enemy, spawns the 'sane-insane' and provides a 'vibrational field' through manipulation of consciousness. The late Native American activist and poet, John Trudell, summed up the possession and insanity caused by Wetiko in his song, *Crazy Horse* (2001), when he said:

> *Too many people standing their ground*
> *Standing the wrong ground*
> *Predators face he possessed a race*
> *Possession a war that doesn't end*
> *Children of God feed on children of Earth*
> *Days people don't care for people*
> *These days are the hardest*
> *Material fields, material harvest*
> *Decoration on chains that binds*
> *Mirrors gold, the people lose their minds ...*[1]

These lyrics are so telling of our plight through the 'Covid Era' as billions of people who seemingly 'stood the wrong ground' over Covid mandates,

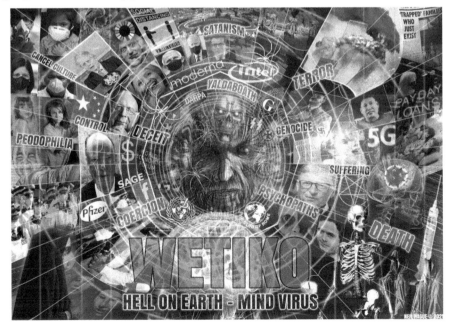

Figure 32: Wetiko - the 'mind virus'.
Wetiko can be symbolised as a spider at the centre of its vibrational web. The spider, in its negative sense, is the ultimate Predator Consciousness and weaver of entrapment.

accepting oppressive constraints and loss of freedoms the world over. The use of fear and coercion by those in positions of power was, in my view, driven by the Wetiko mind virus. Players in the 'Covid' human catastrophe include the following consistently-recurring and now globally-recognizable names: Gates, Schwab, Tedros, Fauci, Whitty, Vallance, Johnson, Hancock, Ferguson, Drosten, and all the rest, as well as psychopathic psychologists at SAGE (Scientific Advisory Group for Emergencies) in the UK, who are all expressions of Wetiko (see figure 32 on previous page). Observe all those who support these psychopaths in authority against people who can see through the lies and manipulation, despite the damaging impact these psychopaths' demands have had on their own lives and the lives of their families. Again, you are looking at Wetiko possession which prevents so many from seeing through the bold-faced lies to any obvious scam going on.

POSSESSION & A WAR THAT NEVER ENDS

The distinction between an evil person, or spirit, relates to the Archontic/Wetiko 'possessing' a human being, or acting as 'consciousness' for the host it has possessed. In extreme cases, Wetiko can change the human 'being', making the individual appear differently to those who experience the Wetiko-possessed directly. Indigenous cultures call this phenomenon 'shapeshifting'. It's not a physical (flesh and bone) shift, which would be impossible; it's purely energetic (or holographic), 'appearing physical' to anyone who sees such phenonema (see figure 33). This is why possession can seemingly turn the eyes 'black' (no white around the pupil) of those who are under the influence of Wetiko. Therefore, Wetiko is said to be a sickness of the soul or spirit; a state of being that takes but gives nothing back. Wetiko is the terrible Predator I've outlined in the last chapter, found in both ancient and modern cultures. It could also be seen as *every* other name for a force of evil, inversion and chaos in our world. Wetiko is the mindset that easily divides humanity (see every form of manufactured division in society), from anti-this, to pro-that; and as a

Figure 33: Wetiko possession.
Wetiko is behind possession and what the ancients called 'shapeshiting'. Such possession creates the classic psychopath.

whole, it creates the 'holographic field' over which we fight each other, creating endless pain and suffering in our world.

In an excellent book called *Dispelling Wetiko, Breaking the Spell of Evil* (2013), author Paul Levy describes Wetiko in the same way the Gnostics described the Archons, and that I have described the Predator Consciousness in the previous chapter. They are the same distorted consciousness operating across dimensions of reality; connected to our human mind and body. Levy says:

> *The subtle body of Wetiko is not located in the third dimension of space and time, literally existing in another dimension ... it is able to affect ordinary lives by mysteriously interpenetrating into our three-dimensional world.*[2]

The Wetiko field, or vibration, is, I would suggest, what religions call hell or 'Jahannam' - the vibrational place of torment, inversion and all expressions of fear. Satanism is born of Wetiko and Satanic rituals are attaching initiates to the Wetiko vibration. So are extremely dark secret society rituals designed to attach the 'Wetiko field' to the initiate. The population at large are 'unknowingly', through what is termed human body awareness, moving between higher states of consciousness and the Wetiko vibration as part of life (see figure 34). As I say, the cold, ruthless, psychopathic mentality that secures itself into positions of power all over the world *is* Wetiko. We see its expression

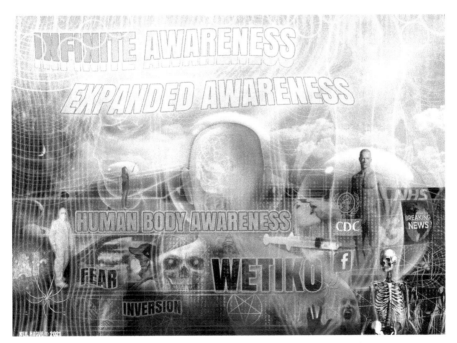

Figure 34: Wetiko attatchment.
The Wetiko vibration attaches through 'thought forms' and inverted rituals. Only Infinite worlds and expanded awareness can set us free from Wetiko.

through all war and terror, mass murder, suffering, child abuse and human sacrifice - *all* these are expressions of Wetiko. Reframing 'training pro-grammes' have the same cumulative effect of attaching Wetiko to the human mind, they can be seen in identity politics and the Woke movement. Levy explains the connection to 'identity paradigms, 'isms' and the Wetiko mind virus when he says:

> *Evil can take many forms - political, social* [including social media], *economic, militaristic, and psychological. Predation can lurk under many guises and high-sounding names, such as patriotism, public welfare, national security, spreading democracy, free trade, and protecting our way of life. Evil often hides under ide-alisms, under "isms" in general.*[3]

The Wetiko mind can also be described as automatous, robotic with a cold, psychopathic, uncaring, empathy-deleted demeanour. We have seen Wetiko expressed through the many lies and government mandates in relation to the 'Covid' era; all designed to reframe global society, bringing in more censor-ship, electronic ID and control.

All-things 'Covid', including electronic app-based 'vaccine passports (Green Pass)' are major expressions of Wetiko. The 'papers please' mindset and the huge divisions caused by calculated manipulation, lies (mantras) directed by global governments up to the time of writing this book, are all Wetiko at work. Our supposed 'leaders', and those hiding behind the scenes in positions of financial power, are 'possessed' by the Wetiko mind. Whether it's the unfolding fascism enforced in countries like Austria, France, Australia (at the time of writing), or the ongoing coercion to take the 'jab' in most Western countries, all are the Wetiko mind virus at work (see figure 35). Wetiko thrives off fear, control and deceit, also said to be the 'language' of the Anti-Christ in the Book of Revelation. For more background to the agenda behind all-things Covid, see my 2020 blog *Corona & the Cyber-Grid Empire* at www.neilhague.com, and my book *The Dr. Covid Universe* (2021). As I have already touched on, Wetiko attaches to the human population *energetically*, like flies attached to the spider's web, hence why the spider and web sym-bolism connect to Wetiko in ancient cultures. The spider theme is extraordi-narily relevant to how the world is woven and controlled still to this day.

SKYNET - CONTROL BY A NON-HUMAN DIMENSION

Wetiko *is* non-human, but *it* influences our human world through our sub-conscious mind. It darkens the 'five sense' mind to have thoughts and opin-ions that *are* 'Wetiko's' thoughts, or its state of awareness. Wetiko has 'hacked' our five sense mind and renders us helpless when we only perceive life through the human body-mind. As Levy writes in his book, "Wetiko

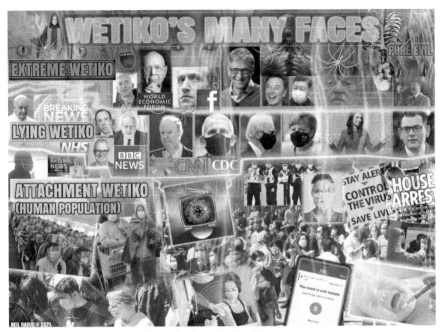

Figure 35: Wetiko's many faces during the Covid era.
It was never about a 'virus', but all about control over the human psyche, soul and ultimately our spirits.

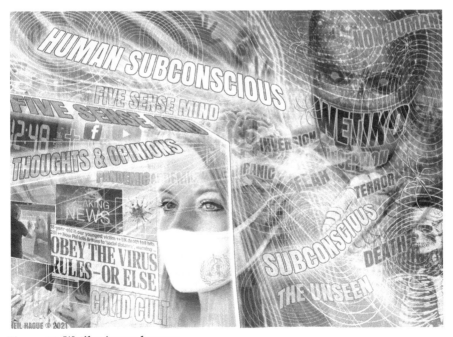

Figure 36: Wetiko *is* non-human.
We are being influenced by a vibrational field attached to our mind, almost like a computer virus attatches itself to a computer.

covertly operates through the unconscious blind spots in the human psyche, rendering people oblivious to their own madness and compelling them to act against their own best interests." This explains why so, so many people have become oblivious to the obvious 'control' forced upon them thanks to a so-called 'virus'. Covid and the 'fake' mRNA vaccines can be seen as 'vehicles' for more control *by* Wetiko, too. It's the subconscious mind that Wetiko is using to influence our five-sense reality (see figure 36 on previous page). It's a form of global control that will be based on rule by Artificial Intelligence, and the true nature of what the scriptures call the Demiurge, or Anti-Christ. The Demiurge (Yaldabaoth) is a higher form of Artificial Intelligence, expressed so accurately in the Gnostic-inspired *Matrix* movies as the 'machine world'. So also is the push towards Transhumanism. The 'Skynet' system from the *Terminator* movies franchise is another expression of such

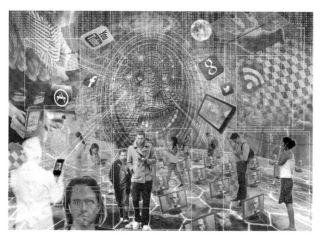

evil and control over humanity. A reality that is seemingly no longer restricted to science fiction. The 'Net' (Skynet) is the invisible weblike infrastructure we are already emersed in. So is the use of autonomous or near-autonomous combat systems connected to 'cloud ' AI technology - or Skynet. Even the mass surveillance in China

Figure 37: Wetiko Skynet.
The place where science fiction and reality merge in our lifetime.

(through its network of facial recognition AI monitoring systems) has been called the 'Skynet Project' and all are expressions of Wetiko (see figure 37).

WETIKO - 'LIVING AI' INFLUENCE OVER HUMANITY.

The character Kyle Reese has an epiphany in one scene from *Terminator Genisys* (2015), where he comes back from the future to a time before Skynet takes over and he sees people using their androids, pads, apps and other AI-based devices and says, "So this is how the war against humanity happened, we allowed *it* (cloud-based artificial intelligence) in." As Martin Ford points out in his book *The Rise of the Robots* (2015): "Cloud robotics is sure to be a significant driver of progress in building more capable robots, but it also raises important concerns, especially in the area of security." Aside from its

uncomfortable similarity to 'Skynet', the controlling machine intelligence in the *Terminator* movies, there is the much more practical and immediate issue of susceptibility to hacking, or cyber attack. The potential for power cuts, cyber sabotage, a 'Third World War' and ever more tight control of our lives (via electronic money, etc.), accelerated hugely with the dawn of the Covid era and all things 'Smart'. Agenda 2030, or what has been termed the 'Great Reset', would be born of such chaos and tribulation. As part of the tribulation, extraterrestrials are high up on the list of 'ideas' for a 'threat' to world peace (by those that seek to *reset* human reality and the earth). How do we know that weapons in space (satellites) have not been placed there for use *against* humanity? Isn't it funny how the movie industry coincidentally produces films and themes that also become part of political agendas, as I will explore in *Part Two*. With or without the need for extraterrestrials, the saturation of extraterrestrial-related themes in the media has been filtered into society since the 1950's, so to prepare people for a 'staged' alien invasion, or the threat of one. I wrote in 2013 on my Movie blog, *Through Ancient Eyes,* while reviewing movie plots and symbolism in numerous films: "Added to an alien invasion is the 'threat' of a *pandemic* or Zombie infestation."[4] The former came true!

A TALE IN ONE MOVIE

I re-watched the movie *After Earth* (2013) while updating this book and I wasn't disappointed to find subtle 'messages' relating to extreme Wetiko and fear in its narrative. *After Earth* depicts a hostile now-abandoned Earth. But there is a little more to the *After Earth* narrative than first meets the eye, as we shall see. The story unfolds, showing Earth one thousand years after cataclysmic events forced humanity's escape from Earth to another off-planet base called 'Nova Prime' which has become humanity's new home. So many themes in movies, since writing the original version of this book, have reinforced the same off-world dystopian idea. The opening narrative of *After Earth*, along with other Sci-Fi movies over the past decade or so, is cleverly aimed at reinforcing the nonsense called 'human caused climate change', and again, the subtle themes of humanity's inability to act as custodians of their home planet. The usual logic caused by 'messing' with alien technology, which resulted in the 'trashing' of Gaia. The story goes that one thousand years after the destruction of Earth's surface (Yawn), The Ranger Corps, a peacekeeping organization commanded by General Cypher Raige (played by Will Smith), come into conflict with the S'krell, reptilian-like alien creatures who came to conquer humanity's new home (Nova Prime). As the character, Cypher (Will Smith) says in After Earth:

Our time on earth, for millennia, was a consistent slow technological evolution.

> *But an extraordinary event changed our course. We used the alien technology to make astronomical leaps. But our unnatural acceleration* [all things technological and AI based] *was too much, causing us to destroy natural resources, ravaging our planet for own consumption. Mother earth fought back. In 2071, forced to leave home, we found refuge on a new planet. We never thought we would be back.*

The 'unnatural acceleration', is today being driven by Wetiko and connects to what I call 'alien technology', or Artificial Intelligence. The alien is and always was amongst us, as I will come to later in the book.

In *After Earth*, the S'krell use a reptilian-like creatures called 'Ursas', which are large *predatory* monsters created to hunt by sensing fear. I also couldn't help but notice the subtle connections to Ursa (Ursa Major Constellation) and the myths associated with the Draconis – the once Pole Star, which I will explore later in the book. Interestingly, the star 'Thuban' in the constellation of Draco, the heavenly Dragon, was the Pole Star *before* Ursa and this connection can be linked to the tree and the snake in the garden of Eden, 'the Fall' and the end of a Golden Age documented in many ancient myths. You could say it was part of the events that led to *After Earth*, or the end of an Age. It may well be that human DNA was 'coded' to activate 'fear' due to an ancient Predator Consciousness on Earth, one that hunted humans above and beyond the Alpha Predators I've mentioned in the last chapter.

FACING WETIKO - BECOMING A GHOST

The film *After Earth* shows how The Ranger Corps struggle against the Ursas until the ranger Cypher learns how to completely suppress his fear, a technique called 'ghosting'. After teaching this technique to the other Rangers, Cypher leads the Ranger Corps to victory. Meanwhile, Kitai Raige (Cypher's son) blames himself for the death of his sister Senshi (Zoë Kravitz) at the hands of an Ursa when their home was attacked. One scene shows a younger Kitai protected by a shield that hides, or 'contains', his pheromones and the smell of fear that the reptilian Ursas use to locate their prey. In this sense, fear is exactly that – *a vibration*, a state of 'mind' and even mainstream science say that the 'smell of fear' is founded in fact, shown through tests done on military personal, sky divers, etc. People can unconsciously detect whether someone is stressed, or scared, by smelling a chemical pheromone released in their sweat, this according to researchers who have investigated underarm secretions of petrified skydivers, to name but one example. People who are frightened of dogs also tend to attract them, and of course it is said that the dog can 'smell fear' and therefore responds to the pheromone. Research has shown that the 'smell of fear' is real and can be triggered by a heightened response in brain regions associated with fear, according to tests done

through Stony Brook University in New York State. Stony Brook research suggests that like many animal species, humans can detect and *subconsciously* respond to pheromones released by other people. Of course a pheromone being a chemical 'acting outside of the body', is, in essence, a 'signal', a 'vibration' or *transmitter* operating *through* our cells (our DNA). We are biologically 'programmed' to fear, and we succumb to its grip too often. The five senses are part of this programming, and 'scent' (smell) is hugely connected to our DNA (MHC Genes), which includes the types of partners both men and women are 'attracted to'. Huge amounts of funding has been spent through the US Defence Advanced Research Projects Agency (DARPA) with a view to isolating the fear pheromone for use in warfare, perhaps to induce terror in enemy troops? I also think the global mass testing using the PCR test during the Covid pandemic was more about collecting human DNA. It's getting harder to tell *the movie* from the *real life* 'movie'. DARPA's AI robot technology, along with other technologies, could easily be used to 'hunt' humans in a long-planned takeover of the Earth, as outlined in endless films (see my book *Orion's Door*). 'Super Soldiers' are another constant theme, too, not least with the links to biochemical and trans-humanist technology, something I'll come back to later.

GHOSTING - CAN YOU FEEL THE FORCE?

I personally have had a sense of what the movie *After Earth* calls 'ghosting', it's a familiar zone that feels much like daydreaming minus a physical battle with an ET of course. Not to say that these 'battles' don't go on in an astral dimension. The feeling of ghosting gives a total awareness of the 'moment' a feeling of 'timelessness' and a connection to what we truly are - a creative power (force) to be reckoned with. The Japanese Samuri had similar codes and teachings, and in some ways, the theme of being able to 'cut out fear' through being still and using their bodies as a sensory weapon through meditation and calming one's mind, is the ghosting referred to in the movie. As Will Smith says when instructing his son: "Take a knee, feel the presence of the moment, be aware of your surroundings." Just as the master Jedi, Yoda, said in the *Star Wars* movies: "be mindful of your thoughts ... Anger, fear, aggression, the dark side of the Force are they. Easily they flow, quick to join you in a fight. If once you start down the dark path, forever will it dominate your destiny, consume you it will" The root of fear relates to placing ourselves in the future, the 'what if', the 'possibility of something occurring' that is powered by our imagination and then fuelled by our fear. As Yoda says once again: "Careful you must be when sensing the future Anakin. The fear of loss is a path to the dark side." George Lucas, I would suggest, certainly understands the deeper themes I am highlighting in this chapter.

The idea of losing 'something', someone, our possessions, our money, our

life, etc., *is the foundation for fear*. Our imagination, activated by a possible danger or anxiety, so that we can easily dwell 'in fear' over 'something' (that has not actually happened), has been part of our 'programming' from child-hood and beyond. Fear is only 'negative imagination' fuelled by our protec-tion impulse. Our imagination guided by higher states of consciousness is the opposite of such fear, it's expansive rather than limiting. In fact, I would say our *creative* imagination *is* the greatest power we possess, it can bring into existence all possibilities and all potential, *despite* our fears. In truth, fear *is* a product of the imagination. As the musician Jim Morrison once said: "Expose yourself to your deepest fear; after that, fear has no power, and the fear of freedom shrinks and vanishes. You are free."

FIGHT OR FLIGHT?

The reptilian complex, also known as the R-complex or 'reptilian brain', relates to our primeval 'fear', or the nature of the human triune brain. The R-complex is reactionary and the character Kiati in *After Earth* certainly 'reacts' a lot *before* he understands how to master his reptilian brain. Interestingly, the HG Wells book, and later movie, *Time machine* (2002) also hints at themes cov-ering the nature of the reptilian brain, the hive mind and the fear of being hunted by a species bred to consume humanity on a future (after) Earth. In the book and movie *Time Machine*, the character Über-Morlock (encountered by time traveller Dr. Alexander Hartdegen) is a member of the telepathic 'rul-ing class' of the 'Morlock' - an underground race of humanoids, our descen-dants, from the time after the moon broke apart. Readers of my books will know that the Moon 'breaking apart', or being used as a base, is a common theme for a future Earth (or After Earth).

Just as Humanity is forced off-planet in several movies, as a result of cata-clysms, a 'world-changing' event forces the Morlock race to live under-ground as they feed on a peaceful human tribe called 'Eloys' who live on the surface. The Uber morlock (played by Jeremy Irons) controls the minds of other members of his species via telepathy, like a 'king bee'. Just as the Ursas do in *After Earth*, the Morlock are bred to hunt and kill humans - through sensing their primeval fear. Similar themes relating to a genetically mutated species (or alien species) living underground and being part of Earth's diverse evolution, are well documented in Micheal Mott's book, *Caverns, Cauldrons, and Concealed Creatures: A Study of Subterranean Mysteries in History, Folklore, and Myth* (2001), a subject I will return to later in the book.

In the movie *After Earth*, the young Kitai is also attacked by giant baboons, not least because he refuses to listen to his father's instructions on how to enter into his own power to be 'still' and calm his 'fear'. The type of

world that greets Kitai reminds me of an *Avatar*-like Earth, one that has
succumbed to fear caused by invasion of an outside (alien) force. The alien
in these scenarios could easily be the Wetiko mind virus in other forms. In
the movie, Kitai reaches a mountaintop, while his father Cypher learns
about the lack of oxygen capsules keeping him alive. Knowing the only
way for Kitai to make it with only two remaining capsules would mean he
has to skydive to travel further, quicker to save his father. Cypher orders
Kitai to abort the mission, but believing his father sees him as a disappoint-
ment, he skydives from the mountaintop (or takes flight), which for me is
very symbolic of facing our fears and jumping into the unknown. A series
of events occur, not least Kitai being rescued by a giant condor and even-
tually escaping to continue along his journey. Scenes of cave paintings crop
up in the film, too, which hint at a 'prehistoric' period on earth, after major
cataclysms changed the earth's surface forever. For a second time Kitai is
rescued by the condor, who sacrifices itself for him. By this act, the condor
becomes a symbol of creative power, incarnation and illumination through
higher states of awareness and initiation connected to shamanic cultures.
When Kitai initially takes flight and then is later protected by the condor
there is a subtle hint at Kitai being *reborn* to face his destiny.

At one point Kitai listens to Cypher tell him a story of when he was
attacked by an Ursa, how he realises that fear is merely an illusion created
by the mind's thoughts of the future, and thus he first begins to 'ghost'
himself from the Ursas, choos-
ing to live rather than to let his
enemies (both fear and the
Ursas) decide his fate. As
cypher states: *"Fear is not real. It
is a product of thoughts you create.
Do not misunderstand me. Danger
is very real. But fear is a choice"*
(see figure 38). If we bring this
concept back to our world and
our reality, it is true that what
we fear, we can attract to us and
if we choose *not to fear*, then we

Figure 38: Kitai in the movie *After Earth*.

can alter our reality and shape our world (experience) to be very different.
Or as the science fiction writer Frank Herbert writes:

> *I must not fear. Fear is a mind-killer. Fear is the little death that brings total oblit-
> eration. I will face my fear. I will permit it to pass over me and through me. And
> when it has gone past I will turn the inner eye to see its path. Where the fear has
> gone there will be nothing. Only I will remain.*

What remains is the essence of the ghosting, the state of awareness that cypher masters and his son understands, as he defeats the creature (demon) that feeds off his fear.

In our world, fear is 'our' creation and it is 'our' thoughts that fuel our fears, and of course, depending on the individual, can aid in manifesting the 'reality' coming out of those 'fears'. It's true to say that people of all backgrounds, cultures, beliefs, etc., will fear different things; the common ground is that *fear is based on our thoughts*. Collectively, a group of people can be persuaded to be in fear, too. It could be an horrific news story that breaks, or a collective 'programmed' strong belief that asks individuals to conform in extreme conditions to someone or something, a God, 'a miracle vaccine' – *all through fear*. What terrifies one person will have no effect on the other. Why? Because fear, or *what* we fear and *whether* we fear, is *our* individual choice, *our* creation. The acrobat Nik Wallenda, 'king of the high wire' expressed this notion of overcomig fear when he crossed the Grand Canyon without a harness in 2006, something that would terrify most people. There are hundreds of examples all over the world that match this story, too many to mention here. David Icke sums up facing our fears in his book *I am Me, I am Free* (1996):

> *Fear of specific things often has a past life origin, such as fear of heights, water, etc, and it is always an expression of something within us that needs dealing with. This is why we attract to us what we most fear because we need to face those terrors and work through them, otherwise our evolution in the area of our lives related to the fear will come to a dead stop.*[5]

Fear is like a cruise missile to our self esteem. It explodes it apart. We are embarrassed at being frightened of something and as that leads to low self esteem and frustration, it creates an emotional cocktail that often affects our whole lives. Fear can also become so panicked that it thrashes out first in violent confrontation, like a cornered rat. The dramatic pursuit of Kitai in *After Earth* by reptilian looking Ursas, depicts this 'cornered rat' effect quite graphically. Of course fear of something that has *not* occurred and *will not* necessarily occur, is like living in the 'shadows' as opposed to centering our connection, being in our power, or, the what I call the 'light in the 'moment'. The creative imagination is our light in the moment, and if accessed, will expose our illusory fears. Fear itself is a blocking frequency *vibrating out of Wetiko*. It will not affect us if we feel truly free in our hearts. Like Kitai in the movie, if we are motivated out of love, and more importantly, love for ourselves, with this power we transcend the dreaded four

letter word – FEAR. As John Lennon once said:

> There are two basic motivating forces: fear and love. When we are afraid, we pull
> back from life. When we are in love, we open to all that life has to offer with pas-
> sion, excitement, and acceptance. We need to learn to love ourselves first, in all
> our glory and our imperfections. If we cannot love ourselves, we cannot fully
> open to our ability to love others or our potential to create. Evolution and all
> hopes for a better world rest in the fearlessness and open-hearted vision of people
> who embrace life.

Electromagnetism is very much part of our 'vibration' and all I've been out-
lining in this chapter. A great *Field* or 'sea' of electromagnetic waveform con-
structs our reality, influencing our mind and body. Our astral bodies and soul
connects us to this Field, too. Our DNA *is* waveform infomation and we are
electromagnetic beings dwelling in an electromagnetic soup. Our hearts and
minds are 'transmitters' and 'receivers' of information (energy) and our
unique 'vibration' *is* what interfaces with the Field (ocean of waveform), or
information which manifests as the world we see around us.

If we immerse ourselves in a 'sea of fear', or an ocean of 'chaos and dishar-
mony', then we manifest experiences (reality) through electromagnetic vibra-
tions (frequencies), to match these thoughts. Often our conscious thoughts
are influenced by the subconscious world of symbols, numbers, magic and
spells, which is why specific numbers are used to impact reality. Collectively,
our thoughts (brain waves) can also be planted, or 'transmitted' via other
'external' waveforms, mantras, narratives and 'beliefs'. Technology, as I have
touched on, and television (tell-a-vision), play a huge part in planting
thought processes, which is why so much fear is spread through TV on pur-
pose. See every mainstream News program on the planet! More than ever we
need to be in our 'truth vibration' and 'speak' our truth vibration at all times.

In the next part of the book I am going to delve further into the 'hidden
world' of art, symbolism, mythology and 'media magic'. I want to concen-
trate on 'recurring themes' found in art history along with today's interest in
aliens, science fiction and secret societies' influences on art and literature.

NOTES:

1) Trudell, John. *Crazy Horse* © 2001 ASITIS Productions
2) Levy, Paul. *Dispelling Wetiko, Breaking the Spell of Evil* 2013. p140
3) Ibid. p230
4) http://throughancienteyes.blogspot.com/
5) Icke, David. *I am Free, I am Me*. Bridge of Love 1996, p200

PART TWO

THE MYTH MAKERS

Myth is a powerful medium because it talks to emotions and not the head. It moves us into areas of mystery.

Sam Shepard

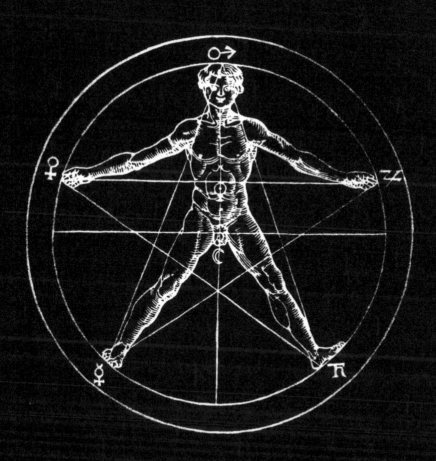

From 'shaman' to the 'Patron'

Art, Alchemy & the Brotherhood of the snake

Mirror of all nature and symbol of art
Robert Fludd

A rich world of images has etched itself into the memory of modern man, despite the fact that some are not available in public collections. The imagery I refer to can be found in temples of the ancient world, prehistoric caves and old manuscripts and prints, made by artists, or alchemists across the ages. In prehistoric times, it was the shaman or temple priest who was the real patron behind our ancestors' art and architecture. The high priests of Egypt, Sumeria and their likes in the ancient world, performed the same duty as the shaman of many indigenous tribes all over the Earth. The priests were the custodians and decision makers in relation to the type of imagery that would appear in the temples of the ancient world. You could say the artist and the priest were one identity. In the Middle Ages, this trend continued through various brotherhoods of monks and scribes who would illustrate (illuminate) religious texts in line with what their brotherhood hierarchy and religious belief dictated. The images made by shamans and holy men throughout history are no different to the later alchemical illustrations depicting codes and clues for 'unveiling' the mysteries of life and the 'nature of reality'. As always it was the shaman, or later, the temple priest (alchemist) who had the last say when it came to building and the making of much ancient art; the work of the priest-shaman can still be found in symbols, logos and insignia used in the media corporate power structures of today.

As with any patronage, ancient shamans, or priests were the real brains behind the 'high art' of temple cultures we still admire today. Artistic patronage prior to the Middle Ages was confined almost exclusively to religious or civic authorities. Even further back in the ancient world, art was primarily the tool of the priest *or* shaman and was purposely used for spiritual reasons. Over time, the 'spiritual' gave way to 'religious' (which are very different states of mind), and with more control over what type of imagery was to be

made. Art and architecture were commissioned to exemplify the values of the priest-kings, or pharaohs of the ancient world. Nothing has really changed when it comes to art patronage, or who actually owns and commissions (funds) so-called fine art and architecture today. In the next few pages I want to offer insight into some common symbols found amongst the art of the ancients and their use of widespread esoteric symbols. However, for the majority of this chapter, Egypt will be the focus because it is mainly in ancient Egypt where much knowledge can be gleaned in relation to occult symbolism, and what I will refer to as the work of the 'Myth Makers'.

MOVEMENTS THROUGH THE MIND

The uses of occult symbols as art forms, especially within the mystery schools of antiquity, have always connected us with the original archetypes and hidden knowledge. Artists from all eras can be shown to have scraped, painted, constructed and photographed these archetypes, as they are part of a universal language that left its marks on the minds of artists and visionaries throughout what we call 'history'. Symbolic themes relating to circles, suns, serpents, eyes and anima-human consciousness, to name just a few, continually appear in art. Some use of symbols are deliberate and placed there by initiates of the mystery school networks, while others are creative individuals connecting with an archetypal 'data bank' at the collective subconscious level. The use of mind-altering drugs by shamans and priests of the mystery schools also broke down barriers between 'worlds' allowing them to 'see'

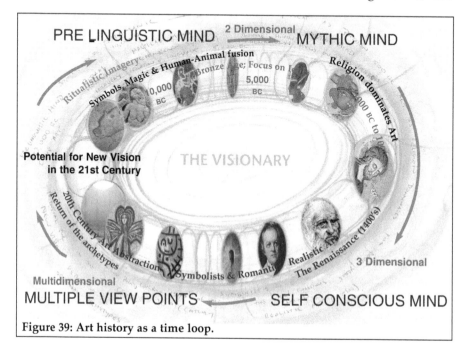

Figure 39: Art history as a time loop.

alien worlds or parallel realities. The type of imagery coming out of such 'journeys' into different realities (in the mind) became the source of esoteric art and symbolism. As I show in Figure 39, evolution of the mind, from a prelinguistic one, to a mind that can see multiple viewpoints, can be followed through the history of visionary art. This history is the *untold* version, because to tell this version of art history to art students takes the focus off the surface style and 'art-for-art's-sake' nonsense often described as 'fine art'. Instead, teaching the history of 'visionary art' concentrates on a myriad of ancient archetypes, as repeated throughout all great 'art movements' and in the work of individual artists. Visionary art encompasses science and spiritual themes which often speak of the true nature of reality. The common theme presented in this chapter, concentrates on prehistoric through to the religious use of imagery, or pre-lingusitic to the mythic mind, often associated with secret societies (priesthoods) that used the language of symbols.

All ancient cultures used their own rich symbolism to evoke archetypes and energies, or personified deities during celebrations (rituals) as part of their everyday life. The power behind the use of symbolism, to set free or imprison the psyche, is a natural part of our human desire for *knowing who we really are*. In my view, symbols are an ancient language connected the 'gods' and are an almost forgotten form of communication with other dimensions outside space (3D) and time (4D). At an even higher level, certain symbols, such as the *circle* or *spiral*, exist purely to help us see our own connection with the 'soul of the world', which is a common theme found in much alchemical illustration and mythology all over the ancient world. The language of symbols reminds us that deep within our psyche, our soul, we are endowed with a gift of *seeing*; a gift that was utilised by our ancestors and can still be used in today's world. Symbolism of the purest and highest source, which we *feel* as individuals, can expand our consciousness beyond everyday five-sense reality. It's a language that can open up the imagination and place us in our personal dreamtime.

ART & THE POWER OF THE SNAKE

Another important aspect of the shaman's work is through the use of art and symbols to shape, or influence, reality. In this sense, art was seen as a 'craft' in which powerful forces could be tapped into to create renditions of both visible or invisible forms – to harness powerful non-physical energies.

In many cultures, the 'snake' became a symbol for the potent force (energy) existing at the root of all sexual activity. This life-force is also the drive behind great works of art. It's through art, as Oscar Wilde once wrote: " *... that we can realise our perfection; through art and through art only that we can shield ourselves from the sordid perils of actual existence.* " Interestingly, the word ART is said to derive from the Egyptian word 'Aart' which has word meanings related to

'Uraeus Serpent'.[1] In almost all ancient art, the serpent is symbolic of the Kundalini life force, and the ways of 'making art' can also be subtle, like the physical movements of the snake. The serpent in the Genesis is a symbol for Kundalini life force (the creator within us all) and the ways of 'making art' subtle, like the physical movements of the snake. It also relates to reptilian qualities of the human brain that are ritualistic and in some cases, 'beast-like'. However, secret society networks of antiquity (the creators of our main-stream religions) turned this creative life-force (art), our sexuality and *power* to give life, into a sinful, indecorous, punishable force, that should be restrained at all costs. But, the truth is that while millions of humans throughout history have stemmed their creativity and individuality, we have created a collective reality where a small number of magicians, priests and élite occult families abuse and control the life-force of this planet. As always, this is done through exercising 'mind control', using religions, low-level sci-ence and now *technology* (social media) to set acceptable thoughts and belief systems (norms) that become our collective reality. Over five hundred years ago the collective reality in Europe was that the Earth was flat (it still is for many in the 21st Century). Yet, anyone who dared to challenge that view (or perception) were immediately jailed or worse, by élite brotherhoods who imposed the then status quo on the masses. Keeping esoteric knowledge out of the public domain, not least by destroying ancient records, killing philoso-phers, scientists and visionaries, etc., has been the hallmark of *the brotherhood* I am highlighting in this part of the book. In truth, this is all about mind *con-trol* and the same is happening today, but at a more sophisticated level. People are being asked to accept the same ridiculous beliefs as 'norms' which encourage the masses to create collective realities that *mirror* conditioned beliefs.

The global media industry, which today is the greatest of tool invented by the brotherhood of myth makers, is playing its part, too, in the 'grand condi-tioning' of minds, old and young alike. From this point of view all *'tel-e-vision'* programming (the opposite of *getting your own vision*), functions main-ly to 'persuade' millions of people to *perceive* or think in a desired fashion. Constant wars and the never-ending threat of terror (which includes pan-demics), are also 'tried and tested' methods for *controlling* and *reshaping* (resetting) society, nations and ultimately the world. Obviously, this is just skimming the surface and there are more subtle modes of magic which appear through the use of subliminal symbols used in most advertising. None of this information is really new; as always, it was the temple priest, the *myth maker* who pioneered the need for visionary art forms and a passion to see beyond the veil of lies and illusions we too often call *history*.

THE BROTHERHOODS OF EGYPT

It was in the temples of ancient Egypt that art *and* technology were used to a level still not fully understood by academics of today. This is no surprise, given the narrow spectrum of knowledge and 'brain power' we are encouraged to use everyday. While even universities and the 'letters-after-their-names' academics refuse to open their minds to the possibility of extraterrestrial (non-local) influences on human evolution, then I suppose they are not going to see further than the limitations set out by the official version of life. The advanced civilisations and secret brotherhoods I will be talking about in this part of the book had (still have) access to a knowledge that merged science *with* art, sound (frequency), healing and 'astrotheology', unlike today's academic society which seems to insist on *separating* all these practices into specialist areas.

For ancient Egyptians, the symbol was a scrupulously chosen pictorial device designed to evoke an idea or concept in its entirety. Ancient civilisations, like the Egyptians, knew that the heart synthesises and the mind analyses, so the artist-priest devised a sacred language that bypassed the intellect and, instead, spoke directly to the intelligence of the heart. In this way, true symbolism *is* a scientific language - a deliberate means of evoking understanding, as opposed to conveying information. Once we focus on these symbols, it becomes easier to notice archetypes as they have journeyed throughout history and within what we call 'art movements'. For example, the Symbolist art movement (across Europe and America) in the mid-19th Century, can be argued to have inspired almost every artist or movement that followed. It expressed the same ideology through many diverse painters, poets and writers who used symbol, myth, allegory and archetype to underpin the notion of a Symbolist movement.

Art is technically and *literally* a form of magic! It's a form of communication that can open us up to 'invisible' worlds which are a part of *who we are* in this physical reality. I would suggest art is a form of communication that came out of the ancient world but was directed by *intelligence* that exists beyond the limits of our world - the matrix, or illusion. We need the five senses to perceive all art, but what inspires the artist is not necessarily *of this world*. Dreams, visions and the imagination are a vital essence of most art, everything else is merely art as an 'imitation of the physical world'. The secret societies of Egypt and their priests knew this and so did the alchemists who continued to practice many esoteric teachings laid down by the Egyptian mystery schools. Medicine, or healing, *and* art are also connected and many symbolic images are used in healing ceremonies by the ancients. Many images, such as those of the Tibetan Mandalas, or sand paintings of the Native American Navajo, hint at a type of language that speaks of (and to) invisible forces interpenetrating and shaping our physical world. Sand paintings,

which use archetypal symbols, were (are) created to heal a patient's *non-phys-ical body*, and, in turn, this would then heal the physical body. What becomes clear when one digs a little deeper into the anatomy of art symbols and hiero-glyphs of advanced civilisations, is that they speak an almost alien language, one, I would suggest, that belonged to the gods of the ancient world. A sym-bol common to ceremonial art used all over the world is the snake, or ser-pent, an emblem used to express our creative life-force.

THE ART OF THE SERPENT CULT

The serpent plays a major role throughout all world myths and religions. In the Hebrew and Arabic languages, the word 'serpent' is associated with the biblical character 'Eve' and also relates to the Earth as a goddess, or feminine spirit. The serpent-goddess figure also relates to our DNA and the gods who gave us our genes (our genesis), a subject I touched on earlier. The Snake Goddess figurines from Knossos in Crete are another example of snake power appearing in ancient art forms.

In ancient Egypt, the hieroglyph for the serpent actually stood for 'god-dess' and was connected to the mysteries of a priestly class (or wise serpents) who practised what is often described as the 'magic arts'. In connection to black magic and some of the areas I talked about in Chapter Five, the serpent was both a symbol of all that is destructive, wise, powerful, *or* a creative force in the world. Its appearance, through the art and architecture of the world's most advanced ancient civilisations, confirms that the snake, as an archetype, holds huge sway over prehistoric cultures.

The pharaohs of Egypt, along with the priests and priestesses of the Incas, Aztecs, Mayan and Minoan civilisations, used snake symbolism on clothing, headdresses and on ceremonial objects to express their power. Ramses II, son of Seti I, was from a lineage of priest kings that ruled Egypt for and on behalf of the 'Brotherhood of the Snake'. The serpent emblem on certain headdress-es also represents the *third eye*, or the 'mind's eye' from where we can read invisible energy fields. The pyramids, especially, were built for initiations 'seeing' into worlds beyond this reality. John Bathurst in his excellent book *Worship of the Serpent* (1833), also explains how important the serpent gods were to the Egyptian pyramid priests. He says:

> *One of (the) five builders of Thebes was named after the serpent-god of the Phoenicians, OPHION... The first altar erected to Cecrops at Athens, was to "Ops", the serpent-deity... The symbolic worship of the serpent was so common in Greece, that Justin Martyr accuses the Greeks of introducing it into the mys-teries of all their gods... The Chinese... are said to be 'superstitious in choosing a plot of ground to erect a dwelling-house or sepulcher: conferring it with the head, tail and feet of diverse dragons which live UNDER OUR EARTH.[2]*

THE BROTHERHOOD OF THE SNAKE

Many researchers over the years point to a window in Earth's prehistory when several, almost 'space-age' civilisations disappeared through major cataclysmic events. These civilisations have been called Atlantis, Lemuria, Hyperbora and Shambhala, to name just a few. When these civilisations disappeared, or were destroyed, the knowledge held at their core was also fragmented and scattered with surviving colonies becoming ancient Egypt, South America and forming the cradle of civilisation in the Near and Middle East. India also became a focus for the surviving priesthoods that re-emerged to create various religious blueprints dominating society for thousands of years. Some writers have also said that the disappearance of advanced civilisations, such as Atlantis, was symbolic of a 'fall' in frequency; from a higher vibrationary level of consciousness to a dense, three-dimensional one. When this fall in frequency occurred, collective reality we call the Earth-mind (Gaia) and the human collective consciousness, lost its awareness of *Oneness*; with this loss came polarities and the *duality* we endure on Earth in all its forms. At the time of separation the Predator Consciousness (Wetiko fear) was 'born' in the mind of humanity, and one of its physical manifestations was the élite Cult I am illustrating in this chapter.

Mythological accounts and many inspired works of art are rife with references to this ancient Cult (organisation), also referred to as the 'Illuminati' or 'Shining Ones' in both ancient and modern accounts. In ancient times, it is said that the Brotherhood of the Snake (Serpent) divided into *two* fractions: the 'Brotherhood of the Yellow Dragon' in the East and the 'Brotherhood of the Red Dragon' in the West. According to some writers they both stand for the Brotherhood of the Snake *and* the ancient 13 ruling bloodline families that answer to a 'Death Cult'. At the head of the 13 families there is said to be *one* priest (an emperor figure) who represents the pinnacle of the dragon, or the 'illuminated eye' – the 'all-seeing-eye'. According to author, Stewart Swerdlow in his book *Blue Blood, True Blood* (2002), the holder of this rank in the brotherhood is called 'Pindar' and this figure reports to pure reptilian leaders located in the inner Earth.[3] Both factions of the Cult, or Brotherhood of the Snake, are said to exist, not least in the Emerald Isles of Great Britain, a place that is at the *energetic* 'centre of the web' of global financial control. Ireland and Great Britain are also where the original 'sun/serpent' druid societies emerged to worship the snake at least 10,000 years ago, and the 'alleged' banishing of snakes from Ireland, by St Patrick, is part of this myth. Today, this ancient cult is centred on 'Babylon-don' and where European blue bloods still run the direction of the world. One of their emblems is the 'flying serpent' which can be seen all over stately homes, some cathedrals, temples and on the heraldry of the City of London. Similar serpent symbolism is found world over.

Figure 40: The bee & the snake.
(**Above left**) An alchemical illustration showing thirteen bees feeding off the serpent, which represents the thirteen bloodlines. (**Below left**) The English Cavendish family emblem. (**Right**) The Egyptian hieroglyphs of the bee and the snake depict royal titles; all the above symbols denote genealogy.

The Yellow Dragon in the East and the Red Dragon in the West, found amongst the order of the Yellow and Red Caps throughout the monasteries of Tibet, also speak of legends relating to serpents of the Inner Earth. The Welsh Red Dragon is especially significant as a reminder of these ancient Orders of the Dragon. It was also the symbol associated with the Hyksos priest-kings (or shepherd kings) of Egypt and eventually used by the aristocratic families of Europe. The alleged 13 élite families are said to include the Bruce, Cavendish (Kennedy), De Medici, Hanover, Hapsburg, Krupp, Plantagenet, Rockefeller, Romanov, Sinclair (St. Clair), Rothschild (Red-Shield/Bear) empire, Warburg (del Banco) and Windsor (Saxe-Coburg-Gothe). This list is not necessarily a definitive one, as there is much more to know in this area, well beyond the remit and scope of this book. Many of these families direct global finance, the military, politics, religion and the media to this day.[4] The symbols for what some researchers call the thirteenth bloodline, or the 'Merovingian bloodline' (which gave us Charlemagne), are the snake, the bee and the Fleur-de-lis. According to Manley P. Hall, the renowned Freemasonic historian, is the Fleur-de-lis is actually a bee. In

alchemical and occult texts, the bee and the serpent are often used to denote the hive (bloodline) and its link to a genetic stream overshadowed (or consumed) by Wetiko, or what I call Predator Consciousness. In some symbolism the thirteen bees (as bloodlines) are shown feeding off the serpent or the 'knowledge' for which the serpent is a symbol (see figure 40). The knowledge *is* self-gnosis (know thyself) and the true nature of human potential is a topic I will come back to in much more detail towards the end of the book.

IMPLANTING EGYPTIAN SYMBOLISM

The symbol for these 'merging of lineages' at the time of the Merovingian priest kings, was the *red* reptile-lion, an emblem still used in heraldic devices today. However, it was at the time of the Shepherd priest kings of Egypt (the Hyksos kings) that the brotherhood of the Snake (or Royal Court of the Dragon) began its infiltration of the positive Egyptian mystery schools. A move that would change the meaning behind temple hieroglyphs to suit the Brotherhood of the Snake. For *Star Wars* fans, you can see the 'Jedi' losing out to the 'Sith', a theme that may well be more than just science fiction. The *twisting* of the true meanings behind ancient archetypes was coordinated so temple priests could instigate a new set of rules and *thought* processes. Changing the meanings of the cross, circle, pyramid and other archetypes by this élite brotherhood, for example, helped forge new religious templates or systems *for* controlling the masses. In terms of Western Christian culture, all that happened formed the Egyptian religious template, which became part of the Roman-Babylonian system, repackaged as Catholicism and Christianity. Isis became Mary, Horus became Jesus and other Egyptian deities, such as Matt and Ammit, in the classic judgement of the dead scenes, can actually be seen in many Christian Romanesque sculptures all over France (see Figure 41). The Egyptian symbolism was often implanted all over Gothic Europe

Figure 41: Christian-Egyptian-Pagan art.
(**Left**) The Egyptian scene of the 'Weighing of the Heart' ceremony. (**Right**) The same scene as a Romanesque capital detail of what the Christian church would consider a Pagan ritual!

courtesy of the brotherhoods and secret societies with their esoteric roots in pagan Egypt, Babylon and later Rome.

The Merovingian bloodline of priest kings and their connection to Egypt and Babylon seems to implant in France the Egyptian religion, *via* Christianity. For example, the Valley of the Kings outside Orleans, on the Loire River in France was created to mirror the Valley of the Kings in Egypt, on the river Nile. The 'Ankh', also known as the 'Cross of Egypt', is another example of how certain symbols, relating to androgyny and the Trinity, have travelled *through* ancient religions inspired by the same brotherhood. In Egyptian language, the word 'ankh' (where 'n' is pronounced like the English letter 'n'), these consonants were found in the verb meaning to 'live' (the noun meaning 'life'), and also means to 'cause to live', *or* to 'nourish life'. The Ankh also became a symbol of Coptic Christianity, of which the Coptic Cross remains the primary denomination of Egyptian Christians today. The Coptic symbol uses a containment circle and figure similar to the Egyptian Ankh. The cross within the circle comes in a number of different forms, some of which are clearly influenced by older, pagan symbols relating to 'eternal life'. It's the same with the 'Winged Wand of Egypt', said to be a symbol of the soul and eternity. The winged solar disk also appears on seals connected to the biblical kings, and of course, can be seen today in many corporate logos, a subject I'll come to later in this part of the book. Many Ankh, or winged sun disc-like seals were used during Hezekiah's reign as the 13th King of Judah (8th and early 7th centuries BC), together with the inscription *'l'melekh'*, meaning 'belonging to the king'. Hezekiah's royal seals featured two downward-pointing wings and six rays emanating from the central sun disk, some are flanked on either side with the Egyptian Ankh symbol. Egyptian priests used similiar symbols to the biblical Israelite priests (the Levites), and I am sure the priests of Babylon *and* Egypt were the real occult force behind the biblical Levites.

ALIEN IMAGERY?

Some of the original symbols and hieroglyphs of Egypt, in my view, are almost alien-like in appearance, and I feel they served a major subconscious (hidden) function for the priests of the Cult I am outlining here. Hieroglyphs *are* symbols of the subconscious mind and speak the language possibly read and written by 'gods'. A similar 'hidden language' continues in the world of politics, education, military and media empires of today. Information concerning snake symbols, such as the 'Ouroboros' and the 'Caduceus' (the rod of Hermes, the messenger of the gods) can be found in alchemical works known as the *Opus Magnum* and refer to the serpent bluebloods and the brotherhood's knowledge of DNA functioning as a *transmitter* and *receiver* of messages. We are both *living* light codes of information, or messages that we

receive are from the greater ocean of information, or 'Field'.

It is likely that the Serpent Cult is connected to an alien genetic stream that has the ability to use telepathy and speak through the language of symbols. Humanity at large also has the capability to become telepathic, *psychic* and awakened due to the crystalline codes in our DNA. Everything is continually *shape-shifting* in nature, even the smallest invisible particles in the Universe are continually in flux from a particle to a wave. The same principle applies to our DNA, which is like an intricate blueprint for our physical reality; *all* reality can *and* does continually shift, or change, depending on information (light codes) we access.

KISSING THE FROG PRINCE

Children's stories and myths relating to *frog people* and the 'Frog Prince' tell of a genetic corruption and its capability (within the ruling bloodlines) to appear non-human at times. In the Palace of Versailles in Paris, France, for example, there are numerous sculptures depicting men and women turning into frogs (reptiles). In Aboriginal legends of the Dreamtime, frog-like creatures, called 'Mimics', were said to have caused the disappearance of the one Universal (telepathic) language, spoken by all animals and people.[6] The subject of 'metamorphosis' can also be found in alchemical books, art and imagery, which, more often than not, belonged to the élite brotherhoods of antiquity. Metamorphosis from a man (prince) to a frog, or visa versa, relates not only to the myths surrounding the Sun God, Apollo, but also theevolu-

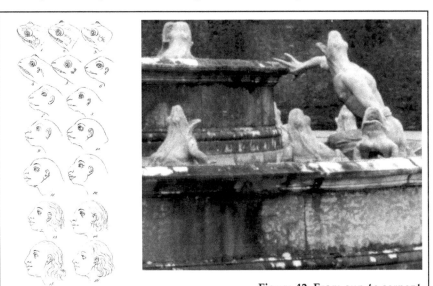

Figure 42: From sun *to* serpent.
(Left) The alchemical illustration is by J.C. Lavater and relates to the metamorphosis of the Sun God Apollo becoming a frog prince. **(Right)** The same can be seen at the Palace of Versailles, where the 'Sun King' Louis XIV reigned supreme.

tion and the *genealogy* of these bloodlines, as understood by the aristocracy (see figure 42 on previous page). I can recommend a superb book by Alexander Roob called *The Hermetic Museum, Alchemy & Mysticism* (1996), for anyone interested in the subjects I am highlighting here. Images of sulphuric snakes, the double-headed phoenix and constant references to the 'marriage' of the dual principles, as seen in alchemical illustrations, are nothing more than references to the nature of duality, separation and possibly the tampering with human genes throughout what we perceive to be ancient history. This obsession with genetics by the ruling classes is part of the Great Work of Ages (the New World Order) referred to by the mystery schools since ancient times.

The Hapsburg (House of the Hawk) double-headed eagle (phoenix) symbol is constantly used within alchemy to illustrate the connection between these ruling bloodlines and the Wetiko (Predator Consciousness). The double-headed eagle symbol can be found at endless stately homes and palaces for this reason. Other images of harpies, bird-headed demons, and *snake people* refer to the Predator possessing ruling families from generation to generation. References to intergenerational possession, from parent to child, can also be found in biblical texts (see *Exodus* 34:6-7; *Jeremiah* 32: 16: 10-13 and 18, and *Matthew* 23:29-33). Connections continued amongst the ruling classes to this day, I am sure!

SYMBOLS OF THE SERPENT

The snake is also a symbol for the subconscious or 'dream states' captured in art and myths of Aboriginal cultures. It's also a symbol for *gnosis* and the lower fourth-dimensional world. The Gnostics also saw the serpent as an aspect of the *Divine* and the 'divine spark' (or Kundalini) within humanity. The majority of religious symbols found in Egypt relate to magic, kin-ship (kingship) and the stars. Alchemical texts and illustrations, produced in the centuries after the demise of Alexandria, up until the 17th century, are a continuation of the work of these élite priesthoods. When you strip away all complicated jargon associated with the study of alchemy, to concentrate on the imagery, then it becomes easier to see the real meaning behind these 'coded' illustrations. The continual use of serpent symbols (including winged serpents), animal riddles, 'resurrection', purification, eyes, eggs and cosmic time in alchemical texts, can all be found in the temples of Egypt. The snake also becomes the central symbolic animal of many late classical sects: the Naassenians (Hebrew), the Ophites (Greek) and the Gnostics. The 'Ouroboros' symbol of the snake swallowing its own tail is just one more example of a legacy of symbols used by the 'brotherhood', or mystery schools outlined in this chapter (see figure 43).

The Ouroboros symbol is associated with the concept of time, death and

Figure 43: Serpent symbolism.
Hieroglyphs and alchemical illustrations were used to symbolise gnosis, the illusion of time, death, duality (good against evil) and other *cycles* of nature.

forces quarantined within an invisible structure of its own making – the illusory lower fourth-dimensional (astral) world. The Ouroborous, or 'Leviathan', relates to the perceived boundary between what Gnostics called the Upper and Lower Aeons, Infinite Reality and the matrix-earth. Egyptian hieroglyphs showing the snake as a boat, carrying gods such as 'Set', 'Osiris' and 'Horus', was also a symbol for time, the seasons (zodiac) and the 'illusion of time' created through duality.

The snakes of *good* and *evil* are also a common theme in visionary art and alchemical texts, which again relates to duality and the notion of the *splitting* by the oscillation of these two serpents. As the 4th Century BC Greek Alchemist, Synesios wrote:

Just as there was only one at the beginning, so too in this work [alchemy] *everything comes from One and returns to One. This is what is meant by the reverse transformation of the elements.*[6]

It was the *serpent* master geneticists, recorded in the Sumerian Tablets and the *Book of Enoch*, who became parents of a hybrid bloodline of *serpent-humans* in the prehistoric world. These genetic bloodlines were often depicted with wings, or described as 'bright birds', in accounts that predate biblical texts. In later scriptures, the bright birds became angels, to hide more reptile-bird connections; a visual theme made more obvious in shamanistic cultures. 'Quetzalcoatl', the South American god, is one of several reptile/bird/humanoid saviour gods found in ancient myth. But he's not alone when it comes to imagery showing a Christ figure as a serpent *or* even Moses 'commanding' the serpent. The symbol of the 'Tau Cross' and the snake is one more representation of this imagery (see my book *Orion's Door*). Again, references to dragons entwining the king and goddess, or eating (swallowing) itself are symbols of élite bloodlines and their genealogy connected to the ancient (off-world) gods. More on this topic shortly.

The Theosophical Society, founded by Helena P. Blavatsky (1831-1891), seemed to go wild with a myriad of occult symbolism in its logo, encircled

by another Ouroboros. The Theosophical Society influenced secret societies that became the German Thule secret society (and the later Nazi party) in terms of it esoteric symbolism. The nonsense behind the 'master race' idealogy used by the Nazis to murder millions of innocent people through the Second World War, is classic Wetiko in operation. The demonic (often reptilian) entities and the black magicians that call on these Lower Astral Dimensional 'forces' in secret satanic, or Babylonian ceremonies, *become* the Wetiko Predator Consciousness. Interestingly, In 1879 the Theosophical society moved its main seat to Adyar in India, eventually becoming a shrine to the Hippy movement and eventually the so-called 'New Age movement'. Many musicians and artists from the last century were devotees of the Theosophical New-Age Movement for a while, not least abstract painters like Wassily Kandinsky and Piet Mondrian in the 1940. Both artists were influenced by a mixture of Western and Eastern occultism. The Beatles, David Bowie and much of the 60's and 70's Californian Hippie music scene were also influenced by the teachings and philosphies expounded by the Theosophical Society and the likes of Aleister Crowley. The Crowley and Golden Dawn symbolism speaks volumes about esoteric meanings associated with more ancient serpent *cults* going back to antiquity. As I show in my book *Orion's Door*, it is *a* Cult connected to off-world entities and ancient secret societies focused on both exoteric and esoteric nature of the stars. This cult has hidden its true identity from the masses for thousands of years, yet it has been in control of the temple structures, priests, scientists and more modern magicians behind places such as Hollywood and the mainstream media.

STRANGE SERPENT SONS

The 17th-century visionary William Blake, who was well versed in Hermetic symbolism, regularly depicted the goddess entwined with, or being overshadowed by, the dragon, in his illustrations of biblical texts. The goddess for Blake was the spiritual form of England (Albion), enslaved by the materialistic coils of the snake-matrix-physical illusion. Albion was also another word used to describe the imagination, and for visionaries such as Blake, it was the human imagination, or the imagination of ourselves, that fell from grace. Our true visionary capabilities need to be accessed so to *see* from a higher multidimensional level of perception.

As already shown, the goddess is especially important to the serpent priests and shamans of indigenous cultures, because *she* is the 'gene carrier' of their origins. Many of the miraculous 'virgin' births found in every religion, relate to the fusion of serpent (the gods) and female (human) genes. Stories tell of Asherah, depicted as the 'Wife of God' are found in Mesopotamian art and sculpture, including the famous 25,000 year-old Neolithic sculpture of the 'Venus of Dusseldorf', another image of Asherah,

or possibly, the earth goddess. Effigies of voluptuous females found in Neolithic caves are often portable idols dedicated to the goddess figures, mothers of the sons of the 'Shining Ones', or 'Watchers'. The birth of these gods is described in the *Book of Enoch*, where we read of the birth of Lamech's strange son:

> *I have begotten a strange son. He is not like an ordinary human being, but looks like the children of angels of heaven to me. His form is different and he is not like us ... it does not seem to me that he is of me but of the angels.*

Lamech's strange son is the biblical character Noah, who was based on the Sumerian hero 'Utnapishtim'. Claiming a lineage back to Noah (the Watchers), by the secret societies and priesthoods going back to Sumeria, is a common theme found in Freemasonic beliefs. The same reference to the Shining Ones, or Watchers, being born to Earth women can also be found in later texts such as the *Book of Kings* in Iran (1010 AD), which describes the birth of the Watcher god called 'Zal'. The offspring of these 'sexual encounters' were known as the 'Nefilim', 'Rephiam', 'Emim' and 'Anakim', who are the giant races recorded in art and myths all over the world.[7] The giants were credited with giving the human race a range of knowledge known as the 'Domain of the Gods' in exchange for sexual favours from the daughters of men. Their combined union resulted in a race of giants (and hybrids) known as the Nephilim who proceeded to cause chaos on the Earth and were allegedly wiped out by the biblical flood.

The biblical Goliath was said to be a Rephiam (Watcher) and in Hebrew 'repha' means 'giant'.[8] So also were many other legendary figures found in myth, such as Gog Magog, and Orion. In fact, the theme of giants can be found *all over the ancient world*. Many cave paintings in Japan, South America and North America depict giants, and scores of red-haired mummies were discovered in a cave near Lovelock Nevada – some were seven feet tall.[9] According to Dr. Greg Little, the chieftains of the 'mound building' tribes of North America, before the arrival of Columbus and the Spanish conquistadors, were also shown to be giants. Bones of giants have also been found in Minnesota and I have actually seen the bones of a giant in a 13th-century crypt underneath a church in St. Bonnet le Château, France. The same themes of giants being born to Earth women, after coition with the 'Watchers', are also found in ancient Ethiopian texts called the *Kebra Nagast*.

Alexander the Great, one of the most famous monarchs and conquerors of all time, was known as the Serpent Son. Legend has it that his real father was the serpent god Ammon (a Watcher), who had mysteriously slipped into his mother's bed.[10] The same story was also told of Merovee, the founder of the Merovingian bloodline of Europe, often referred to as the 13th bloodline or

Holy Grail line by some researchers. In truth, these stories are the real source and genealogy for the 'divine right to rule' through the lineage of Pharaohs, monarchs and today's presidents and secret rulers of the world. According to *The Oxford Illustrated History of British Monarchs*, all Anglo-Saxon kings proudly claimed descent from Wodan or Wotan (Mars) the Germanic God of War.[11] Wodan was the consort of the Dragon Queen 'El' or 'Hel' (the word Hell), and one of the older names for this star god was 'Bodo', meaning the 'serpent-footed'.

SERPENT DNA, FERTILITY – THE 'GENES' OF 'ISIS' (GENESIS)

For Native Earth peoples, the serpent was connected to fertility, transformation, lust and the 'fallen angels' who were said to have taught the sacred arts and sciences to mankind in the 'Garden of Eden'. Painters such as Hieronymus Bosch, as I will come to soon, were hugely influenced by the themes of an earthly *dreamtime* paradise, peopled by strange creatures, gods and goddesses. Bosch was also interested in alchemy and concepts relating to the earth being a 'prison' or a 'fallen state' of consciousness, as depicted in his Triptych the *Garden of Earthly Delights* (1490-50). The fallen angels, according to many writers, can be connected to a serpent race that came to earth and made man in their image. They are also the 'gods' of the Old Testament, or the sons of the gods, who mated with the daughters of men to give lineage to the rulers on earth. It's no coincidence that the word blood is the second most common word in the Bible, after God!

The obsession with blood, genealogy and a divine right to rule comes from the families who became the ruling class on earth. These bloodlines are the said to be descendants of the 'great serpent queen of the earth' - Isis (the genes of Isis) and the serpent in the *Genesis* (see figure 44). It is also said that Isis was given the art of alchemy (transmutation of the soul) by winged demons.[12] In the Sumerian tablets, Isis was called 'Ninkharasag' or 'Mammi' (Lady Life), and along with her male consort Enki, provided the genes for Sumeria's hybrid ruling élite in the ancient world. The veneration of the Great Queen Isis (Egypt),

Figure 44: Gene-*Isis*.
4000 year old Sumerian seal that shows the 'Great Queen' Isis (Semiramis) with wings.

Semiramis (Babylon) can still be seen in the Catholic worship of the 'Black Madonna', which is basically the Christian worship of an Egyptian Pagan Goddess. The title 'Great

Queen' can also be found in Freemasonic symbolism, too; not least the name of the street where the largest Masonic temple in London (Babylondon) can be found. The endless wars (blood baths) going back into the ancient world were no more than rituals dedicated to the fallen ones, the serpent gods outlined in this chapter.

WORSHIPPING THE SERPENT

Snake symbolism abounds in the ancient world. Symbols and words relating to the snake, lizard and dragon can be found in the Americas, Asia and Australia because the same élite priesthood was active in those places, too. Evidence of Phoenician and Egyptian priests possibly carrying the Serpent Cult and its religion to the Americas, can be seen in the similarity in rock art found in Arizona. Images of *duality* and the 'splitting' of the *'One Supreme Being'* described by the Hopi indians of Arizona, is a common hallmark.

Symbols relating to *sun* and *serpent* worship are part of this story, too. Sacrifice to the serpent gods was a common theme, and was a widespread practice instigated by priests in the temple cultures that emerged after 3,112 BC. The snake dances performed by the Hopi indian snake priests (clan), along with the 'Two-Horned' priests, comprise two of the oldest and most secretive clans of the pueblo indians.

Thousands of human sacrifices were made to these snake-headed deities all across pre-Columbian America. The same deities became the gargoyles found on both Aztec temples and later Gothic cathedrals. These entities *are* the gods worshipped by a Brotherhood that according to authors such as David Icke, have sacrificed humans to these deities.[13]

Figure 45: Serpent 'gods'. Reptilian figurines found in graves from the Ubaid culture thousands of years ago which preceded Sumer and Babylon in what is now Iraq.

In India, the same serpent gods were called the Nagas, a race of gods that were said to have fought with a more humanoid surface population in ancient times. Statues of the Nagas and symbolism relating to these battles can be found amongst the temple ruins of Indo-Asia. Similar effigies and portable pieces of art from the Ubaid culture thousands of years ago also depict reptilian gods/goddesses, sometimes with a child in arms (see figure 45). One particular idol in the British Museum, London, of a reptilian figure with suckling its baby, looks remarkably like the classic Mary and Jesus, Isis and

Horus pose. According to many indigenous beliefs spanning tens of thousands of years, the Earth and humanity have interacted with 'genetic streams' of consciousness coming from the stars.

GODS OF DEATH

In many ancient accounts of the 'serpent gods' and their hybrid offspring, one common theme follows them around – War! There are others, but this particular trait is part of the serpent gods' legacy on earth. As I will illustrate in the next part of the book, the *gods of death* can be found amongst the petroglyphs of the North American Indian Hopi beliefs, through to Egyptian legends of Seth, etc. Could it be that the Phoenicians, who influenced the later Carthaginian culture of Spain, brought with them to the Americas the cult of the gods of death? Stories of serpent gods coming by boat to the Americas from the East can be found amongst the Inca, Aztecs and Mayan traditions and with them came invasion. Another Central American serpent deity, 'Tezcatilpoca', was said to be locked in conflict with Quetzalcóatl, a battle spanning years. From these dualistic conflicts came what the Native Americans call the splitting of the Creator, or 'Supreme Being'.

The 'God of Death' is depicted in various ancient cultures as the *serpent, crocodile, bat, panther,* and such (see *Chapter Five*), depending on what geographic location the Death Cult based their control centre in the ancient world. The *four* Empires of, Babylon, Rome/Greece, Great Britain/France and the modern Anglo-American Alliance, are 'power structures' designed to venerate the 'gods of war'. On Stately homes we often find hidden faces (menacing visages) surrounded by Roman, or *Imperial* standards and other regalia representing the gods of war (see figure 46).

Death deities have gone by numerous names, such as Seth (ancient Egypt) and Masau'a (Hopi), and in all cases they are one-half of a dualistic god,

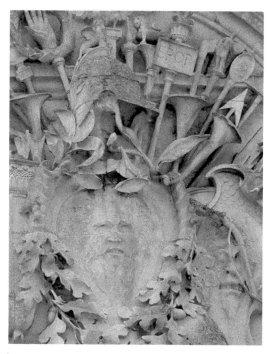

Figure 46: Two-faced gods of death (war gods). Taken at the Royal Hampton Court Palace in the United Kingdom. Two faces (one slightly hidden to the right) are surrounded by other military regalia.

a celestial figure, or a blueprint used to create religious belief systems. 'Thanatos' and 'Morpheus', or *death* and *sleep* deities in Greek myth, are also connected to the blueprint, and both relate to the predicament awaiting the human soul unless we can see *beyond* the illusion of death, more on this later in the book. Unstable global situations we face, whether Muslim and Christian leaders being used to wage never-ending wars against each other, or the Russian-Ukrainian war at the time of writing, are all being 'staged' and 'fuelled' by the same secret societies that instigated every major war throughout history. *All* war is dedicated to the gods of death -the Death Cult.

Many bloodline families have accumulated immense wealth from starting wars *or* funding them through their brotherhood 'fractions' over the centuries. Revolutions and 'uprisings' aimed at changing the status quo of nations are included in this hypothesis, too. Creating wars, centralising power and installing a global tyranny is *not* the ultimate goal of the Death Cult, such wars are only a means to an end. Humanity is generating *FEAR* on a 'global scale'; *feeding* the Wetiko Predator Consciousness, and sustaining the prison vibration (or Matrix) is its priority. Vibration is more likely the reasoning behind *any* war. And there is certainly a *war on humanity*! Our personal prisons of the mind are the traditions, superstitions, and false religions dictated to us by priesthoods that have followed the God of Death into the 21st century. The words of Madame Blavatsky (the Theosophical Society) mentioned earlier, reveal quite clearly the *god* worshipped by ancient secret societies and their modern day equivalents. She writes:

> *One of the most hidden secrets involves the so-called fall of Angels. Satan and his rebellious host will thus prove to have become the direct Saviours and Creators of divine man. Thus Satan, once he ceases to be viewed in the superstitious spirit of the church, grows into the grandiose image. It is Satan who is the God of our planet and the only God. Satan (or Lucifer) represents the Centrifugal Energy of the Universe, this ever-living symbol of self-sacrifice for the intellectual independence of humanity.*[14]

THE GODS OF WAR

My own research over the years has revealed a universal knowledge handed down by the mystery schools of antiquity, teaching of the splitting of the Supreme Being – or Creator. These teachings can be found at the heart of many ancient or indigenous beliefs. As I mentioned in earlier chapters, the God of Death, quite wrongly believed to be the true, infinite mind of *the Creator*, has been the focus of all religions going back to Egypt. References to the war gods are found in ancient Sumerian accounts of 'Marduk', 'Bel' and 'Indara', through to the Roman god of war – Mars. All of these variations of the *same* god has its opposite (life), but it is the focus on *death* through ancient pharaohs, kings, churches and authorities in today's world that has shaped

(and is still shaping the world), through war and tyranny.

The title 'Warlock' was given to those who used dark forces and to be a 'warlock' was said to be a *wizard, evil spirit, traitor, liar, or* one who 'breaks his word'. That last description could be used to describe world leaders and politicians we endure today.[15] Continuous fighting through wars on all fronts, and the devastation they cause, are no more than the predominance that these world leaders (Pharaohs and Presidents alike) have placed on the 'belief systems' paying homage to the 'Gods of War'. And as we all know very well: WAR = DEATH.

Eternal battles symbolised in religious art and texts all over the world, also focus on war, or a fight between good and evil forces. This type of dualism has allowed world leaders to wage endless war. If one really studies any crisis surrounding war in the world, the most dramatic thing one is immediately confronted with is that the *crisis* involves world leaders who are often deeply religious and drawn to their God (gods) through devout faith. Tony Blair and George Bush, for example, used God as an excuse for invading Iraq in 2003. But that's how it has always been, since ancient times. The leaders today are following in the footsteps of their ancestors, the Gods of War and as long as the Gods of War are in control of our beliefs, religions or even spiritual systems, there will be no end to the killing and destruction on earth. The belief in war must stop completely for people to remove the Gods of War and thus disempower world leaders who think of nothing but war and the spoils that come out of it! The solution to war is simple. *We need to feel at peace with the world*, on an individual level, but more than this we need to have the desire to really love life, and to *love one another*. I truly believe this vision of love for one another is achievable when, in *all* instances, we see only *us* (Oneness) and not 'us against them' - us 'against the gods'.

FROM 'DEMIGODS' TO 'DEMONS'

Constant references to battles between the gods in ancient times, seem to be one of evil winning, or taking the spiritual reins of power on earth. In Central American myth, for example, the Cult left behind after a legendary battle (at the beginning of what the Mayans call the 'Fifth Sun' or 'Tonatiuh'), is the Cult of the Serpent, the 'demander of war and human sacrifice'. Instead of revelling in ancient wonders, arts and sciences brought by earlier star races, a *new* breed of worship was centred on death, demigods and the Underworld from whence the serpent people 're-emerged' after the legendary biblical deluge. In ancient Egyptian history, or the 'History of Manetho', the chronicler Eusebius writes that: *"After the original gods, demigods reigned in Egypt for 1255 years and again another line of kings held sway for 1817 years."* According to the Manetho, Egypt was ruled by gods, demigods and their kings for almost 25,000 years. Yet, for the latter period of 5,000 years, Egypt and its dynasties

were said to be ruled by the *spirits of the dead* and the demons of the Underworld.[16] The same is said in Hindu history, which claims that the 'Dark Age of Kali Yuga' has ruled for 5,000 years, beginning in 3102 BC. From my research, I perceive these *spirits* to be representative of the entities (beings) found in folklore; the elves, trolls or fairies who are said to dwell both in the astral (etheric) world, and the Underworld (Hell) *within* the earth. The Maya called these interdimensional beings the 'Lords of Xibalba', the rulers of the Underworld – or masters of the Fourth Dimension. The same demonic forces, conjured up by the Serpent Cult, would go on to take over the mystery

schools originating in the ancient global civilisation of Atlantis. Fire and serpent deities were contacted by shamans and priests so as to gain power over their enemies and from this came the need to fight wars on all levels, both spiritual and physical! The subject known as 'Danse Macabre' (dance of the dead),

Figure 47: The Dance of the Dead.
A 13th-century mural at Chassé Deu Cathedral, France. It shows clergymen and skeletons dancing with other members of medieval society.

painted by priests and artists from ancient Mexico to Gothic Europe, is another subject concentrating on the energies represented by the God of Death (see figure 47).

THE MARRIAGE OF HEAVEN & HELL

As I have already shown, the use of symbols can be traced throughout both the ancient and modern world. The power and influence of symbols on the mind have been used to control, *or* set our psyche free. Throughout history, tyrants and regimes have all used artists to create and bring to life symbols and secret languages used in the mystery schools. In fact, many historical artists themselves were initiates of clandestine networks. William Blake, in his visionary masterpiece *The Marriage of Heaven and Hell*, attempts to explain how ancient priesthoods created a system of 'mental slavery' derived from a Pagan view of the world. He writes:

The ancient poets animated all sensible objects with Gods ... adorning them with

the properties of woods, rivers, mountains ... Till a system was formed, which some took advantage of & enslaved the vulgar by attempting to abstract the mental deities from their objects: thus began priesthood[17]

Blake used mythological figures such as 'Orc' (forces of revolution) and 'Los' (imagination) in his books to illustrate opposing forces that become energised in the outer world through war, revolution and death. For Blake, all 'energy' was 'eternal delight', but it was also terrible and took on fiery forms of the devil, lion and serpent of the 'nether deep'. The Serpent Cult I have been describing in this chapter, venerate the destructive element of dualistic deities *they* created. For the sperpent-worshipping Death Cult, Jesus, like Shiva, Horus and others, was a destructive god, or an anti-Christ; one who brings not peace, but a sword! Here we have the true identity of the force, the 'tigers of wrath' as Blake called it, behind tyrants, kings, revolutions and religious control.

HOARDING THE KNOWLEDGE

Since ancient Egypt assemblies of men, who were especially skilled in architecture, art and science, were called upon to build new cities, erect monumental structures and enlarge shrines and temples. According to the writer and historian, Manley P. Hall, these artisans belonged to secretive groups who had their own elected chief, or prince, and guild union. These secretive groups were no more than satellites of the Cult I've been outlining here. In the earliest of days, monasteries were sanctuaries of aestheticism and illuminated manuscripts produced by various fraternities teem with esoteric symbolism. These manuscripts only became tools for Christian missionaries after the complete takeover and conversion of the British Isles with the arrival of St. Augustine around 400 AD.

Chartres Cathedral in Northern France is littered with examples of a symbolic language that speaks of a hidden knowledge. As do many works of art, especially the works of Sandro Botticelli, Leonardo Da Vinci and Nicholas Poussin, all of whom were élite members of secret societies like the 'Nazarene Church' and Knights Templar. Many of these Brotherhood art movements also used esoteric knowledge and symbolism as a tool for passing on truths, knowledge and beliefs. Several artist brotherhoods formed in the centuries that followed the Dark Ages, not necessarily because of the ideology around art but, because of the artists' interest in metaphysics, myths and esoteric knowledge. Yet this makes perfect sense, as it was the ancient priest or shaman who made 'art to the highest order' in much earlier civilisations. The question I often ask is: Whose order was being followed when religion was invented?

With no real word in aboriginal cultures for 'artist', he or she was given the

title of shaman, holy man, priest, prophet and *visionary*. He or she was a pro-
tector of knowledge, but more importantly, a *keeper of knowledge* which means
that shamans only passed on secrets of the Cult to chosen initiates. This is the
whole pretext for every religion borne out of secret society circles of the
ancient world; once knowledge is hoarded by a few, then the more secretive
and guarded the initiations have to be to prevent it from escaping into the
public domain. The usual method of protecting their knowledge was to
release into society, through religion and later science, half-truths and myths
which became the belief systems of the masses. William Blake picks up the
theme of dualism in his work *The Marriage of Heaven & Hell* (1790-3). He
explains how knowledge was (and still is) imparted within the mystery
schools of the ancient world; even using the serpent or 'dragon men' as sym-
bols for the hoarding and distribution of knowledge passed on to initiates.
He writes:

> *I was in a printing house in Hell & saw the method in which knowledge is trans-*
> *mitted from generation to generation. In the first chamber was a Dragon-Man,*
> *clearing away the rubbish from a cave's mouth; within, a number of Dragons*
> *were hollowing the cave ...*

> *In the second chamber was a viper folding round the rock & the cave, and others*
> *adorning it with gold silver and precious stones.*[18]

The text goes on to describe different levels of knowledge, which are not dis-
similar to the 'mental projections' described in the *Tibetan Book of the Dead*,
which includes lions, serpents, and dragon-headed humans.

Interestingly, Blake's visions are strikingly similar to the type of informa-
tion that comes from modern encounters with extraterrestrials and UFO phe-
nomena. Underground cities stretching for miles below deep underground-
military bases (DUMBS), airports and sacred sites, all tell of reptilian crea-
tures, greys and other genetic mutations which have been part of an 'under-
ground reality' since the alleged time of Atlantis. I will go into more depth
regarding these types of creatures towards the end of the book.

Dulce, New Mexico and Area 51 in Nevada are just two examples of secret
underground facilities that connect to a massive tunnel network, said to trav-
el across the earth. Researchers Bill Hamilton and TAL Levesque (aka Jason
Bishop III) gathered a huge amount of information regarding the under-
ground levels, symbols and types of creatures that have been seen at these
places.

The connection between the artist/shaman in all eras was, and still is, their
ability to utilise ancient archetypes and direct imagery, architecture or mod-
ern film that speak of other worlds. From petroglyphic rock art to

Figure 48: The Knights of Death.
Knights of Malta tombs in Valletta show 'animated' skeletons along with 'Father Time' (Saturn). All this imagery relates to the secret societies' focus on death.

Romanesque sculpture, or from the Renaissance to modern day cinema, much symbolic art constantly offers alternative worlds peopled by fabulous creatures, angels, gods, and demons. But to take these subjects out of the realms of science fiction is to be labelled mad, or eccentric. Yet, some subjects found in science fiction, especially modern cinema, etc., can be found documented in the ancient world, as I will come back to in more depth in later chapters. The Jedi Knights created by George Lucas can be found in the history of the priestcraft (Brotherhoods) of Egypt as the 'Djedhi' and the Knights Templar.[19] The same brotherhood I've touched on in this chapter, also appears as the 'Hermandad' in the 14th-century as a 'protective force' in Spain and France.[20] In many books over the years, not least the *Da Vinci Code* (2003) by Dan Brown, the Brotherhood are also known as the 'Priory of the Sun' (Sion) and the 'Knights of Christ'. The élite levels of the Knights Templar, or the 'Frater Solomon', were the real brains behind the architectural and artistic wonders that became the Gothic Catherdrals of Europe. So were the Knights of Malta, whose cathedral of St. John the Baptist, in Valletta, is littered with references to war, death and Saturn symbolism (see figure 48). Brotherhoods such as the Knights of Malta have influenced the world of politics, art, culture and religion since the time of the Crusades. Interestingly, the term 'flaming sword' described in Genesis seems to be a direct reference to a force or group of beings (possibly a brotherhood/fraternity) that did not want Adam and Eve (humanity) accessing the sacred knowledge offered by the 'Tree of Life'. This 'knowledge', I feel, is our true potential hidden within our DNA and the power of eternal love to transform our lives. Whatever levels of consciousness are 'preventing' humanity from accessing our true potential, they have a huge connection to the Orion constellation, the location of the flaming sword which hangs below the belt stars and is part of the Orion Nebula (see my book *Orion's Door* for detailed information on this subject). As one bibli-

cal text proclaims:

> *So he* [the gods] *drove out the man* [humanity] *and placed at the east of the garden of Eden cherubim* [angels], *and a flaming sword which turned every way, to shield the way* [prevent access] *to the tree of life.* Genesis 3: 23-24

To symbolically eat from the tree of life is to become a fully functioning, godlike sovereign human being; one who understands their own creative life force and uses it to reveal the truth about life. That is why ancient myth makers valued *all* forms of creativity, particularly those manipulating our desires through sex, religion, and duality across an infinite number of media platforms. When we access our own visionary powers, through *our* creativity, then we naturally reclaim much of this hidden knowledge. It's this connection between art and the visionary that is hardly ever given time in what is broadly termed the history of art, because it opens up many questions that could unveil our hidden knowledge, of *who* and *what* we really are! None of the subjects found in art and cinema, are randomly chosen by artists, writers, or directors: they are part of an 'alternative history', or another timeline existing as an underground stream of knowledge. A stream kept hidden by the cult and its brotherhoods (pseudo-religious societies) who have twisted the truth while preventing humanity from having access to *the truth*.

NOTES:

1) *http://www.taroscopes.com/asto-theology/astrotheology.html*
2) Bathurst, John: *The Return of the Serpents of Wisdom*, p245
3) Swerdlow, Stewart; *True Blood, Blue Blood*, p61
4) Ibid; p62
5) Roberts, Ainslie and Roberts, Melva Jean: *The Dreamtime Heritage, Austalian Aboriginal Myths* Rigby Ltd, 1975, p42
6) Roob, Alexander: *The Hermetic Museum, Alchemy & Mysticism*, Taschen 2001
7) Bathurst, John: *The Return of the Serpents of Wisdom*, p104
8) Boulay, R. A: *Flying Serpents & dragons*, pp187 - 194
9) Keel, John: *Our Haunted Planet*. Fawcett Publications, USA 1971, p38
10) *Brewers Book of Myth & Legend*, p 300
11) *The Oxford English History of British Monarchs*, p79
12) *Alchemy – The Golden Art*, p10
13) Icke, David: *Children of the Matrix*. Bridge of Love, 1999
14) Hancock, Graham: *Fingerprints of the Gods*, Century, 1995, p107
15) *Man, Myth & Magic*, Issue 8, Published by Purnell, 1970, p237
16) Hancock, Graham: *Fingerprints of the Gods*, Century, 1995, p107
17) Blake, William: *Marriage of Heaven & Hell*, Plate 11
18) Blake, William: *Marriage of Heaven & Hell*, Plate 12
19) *http://www.taroscopes.com/asto-theology/astrotheology.html*
20) *The Hutchinson Encyclopedia of the Renaissance*, Helicon Publishing 1999, p279

A Brotherhood of Artists

Art of the Highest Order

Images derive from the fountainhead of human life,
the heart, the solar centre, ancient memories in the blood
and the polarity of the fire of the spirit
Cecil Collins

Art was always used as a 'propaganda tool' for ecclesiastical authorities throughout history. In the ancient world, for example, art was a tool of the priest or shaman, a means to communicate specific beliefs, or record important events. In later civilisations, art was used to promote 'beliefs', record history and 'reflect' mindsets of any period in which such imagery occurs. The history of art, as taught in the universities of the world, is more often than not only concerned with linear qualities associated with art, and a general history instigated through imagery, architecture and culture in isolated eras. Yet, behind the layers of style, period, and what has become an almost hierarchical view of the history, lies a fascinating world of secret societies, archetypal symbolism and esoteric knowledge. This chapter sets out to unravel some of the knowledge hidden behind the visual façade of Western 'art history'.

From the beginnings of known art forms, through to our modern world, there has been a sublime and almost hidden knowledge which connects art *with* spirit, politics, religion *and* symbolism throughout the history of what we call art. Much of this knowledge still finds its way into modern film, literature and other art forms. Why? Because it is part of an ancient language, drawn upon by individuals, often visionaries, who have access to 'underground' streams of knowledge. I call these individual artists the 'myth makers' and all eras have had their myth-making creatives. These artist-myth makers have always belonged to the temple, the court and today, they operate within the multi-billion pound mainstream media industry, not least Silicon Valley and Hollywood. The same hierarchies, which have influenced the world through thousands of years of religious control; now influence the minds of billions, especially the young, through new media religions – the 'media industry'. Whether the ancient shaman, the Renaissance patron, or

the prominant film director/producer of today, all express an understanding of how archetypes and symbols provide the foundations for culture and civilisation. Hollywood productions, like ancient art of antiquity, is full of hidden meanings, codes and narratives often put there by myth-makers connected to this underground stream of knowledge. For example, in the ancient world the myth-maker had other names, such as shaman (holy man), but in reality, the name and the technology used today is the 'only' factor that has really changed. We are still kept entertained, often placed in a state of fear or bewilderment; sometimes 'enchanted' while having our thoughts massaged by an elité priesthood (cult) operating *behind the scenes* since ancient times. Presenting apocalyptic religious sequences on a monastery wall is no different to the dystopian 'end of days' messages found in modern films. All these stories and narratives *are* reinforcing certain perceptions that affect our reality. In this chapter, I also want to shed light on some of the themes, secret societies and art movements that have influenced our understanding of art, while hiding (and in some cases, twisting) more spiritual knowledge connecting us to a myriad of archetypal forms.

BROTHERHOOD ART MOVEMENTS

Many individual artists throughout history belonged to secret societies. If they didn't, then they either created their own brotherhood movement, or stood out as a visionary, often perceived as 'ahead of their time'. More often than not, the order the artist belonged to was connected to the church, temple, or lodge in some shape or form. The main reason why painters, especially over the past few centuries, came together, was to form movements through their common interest in subjects relating to the hidden stream of knowledge. Whether it was the 'Pre-Raphaelites', the Post Impressionist 'Nabis' *or* early 'circles' connected to the royal courts of Europe, they all had access to knowledge, symbols, hidden truths and myths that were handed down through the art and sciences of much earlier 'advanced' civilisations.

The Nabi, a group of young avant-garde painters, formed a brotherhood to revitalise French art at the turn of the 20th century. They called themselves the Nabis, derived from the Hebrew word for 'prophets'. The language of symbols, employed by the Stoics, Comacine masters, the Dionysiacs in Greece, the Collegium of Rome, and *every* secret society circle ever since have spoken of a hidden knowledge accessed only by initiates. All of these brotherhoods, along with more ancient Egyptian and Babylonian temple orders, formed the basis for their guilds, the masons and later art movements that thrived in Europe in during the Middle Ages. The Parler dynasty from Cologne, for example, was probably the most influential family of masons and sculptors of their day and it was they who were mainly responsible for the development of Gothic art in Central Europe. Evidence of secret societies

and their connection to what became the artist guilds were uncovered by the archaeologist Flinders Petrie (1853-1942) during his expeditions to the Libyan Desert in 1888 and 1889. In the ruins of a city built around 300 BC, Dr. Petrie's expedition uncovered a number of papyrus records that told of secret meetings held by the guild of artists, priests, and masons in 2,000 BC.[1] Other references to the artist/priest guilds can be found in the *Egyptian Book of the Dead*, a mystical work dating from about 1591 BC. This esoteric piece of art, along with many other coded documents, contains philosophies supposedly handed down from the gods to the high priests of Atlantis, and later, Egypt.

The Comacine masters, who flourished during the reigns of Constantine the Great, and Theodosius, were composed of members of the Alexandrian, Stoic, and Roman brotherhoods. These fraternities became the Teutonic Knights brotherhoods of the 11th century, and at the time of the building of the great Gothic cathedrals, many 'secretive' guilds were said to *already* exist. Some of these brotherhoods were referred to as the 'Hermandad' or simply, the Brotherhood.[2] The fact that the Pyramids in Egypt (along with many other miraculous feats of the megalithic age) are still beyond our building capabilities today, emphasises the point that not all knowledge has been made public. The use of underground sciences and occult practices have continued to flourish within the secret societies of antiquity. The occult families, as I call them, have amassed immense wealth since the time of the Crusades and continue to do so through banking and global corporate bodies they created. As we entered the Gothic period in Europe (10th century), many painters, architects, and illuminators were high-ranking members of what later became the Rosicrucian-Freemasonic structure.

The Freemasons are a modern-day version of more ancient secret societies, a continuing legacy of the original orders of Egypt, a place where temple priests used occult knowledge to full effect. Freemasons at the highest level are 'priests' who use their knowledge of energy, magic, and ancient mysteries to mirror the ancient priesthoods. Artists such as Leonardo da Vinci (1452-1519), Cosimo de Medici (1389-1464), Michelangelo Buonarroti (1475-1564) and many others were leading figures amongst the underground secret circles of their day. Some of these 'artists' were close to the pope; others, such as Giovanni de Medici, actually became the Pope (Leo X). Today, as it was then, a boys' club, or fraternity of myth-makers, policy makers and elite patrons exists behind all institutions that constitute our society. Great works of art and architecture have been directly commissioned, or inspired by these secret society networks, and many historic connections between artist and politician, banker and the aristocracy are due to these ancient orders.

Key historical members of the church also aided in the creation of these brotherhoods; all religions persisting today are the creation of what I call the 'men in robes' (the priests) who belonged to the brotherhood mystery

schools. The same brotherhood of élite families actually own all of the great works of art and also indirectly run the universities, the royal society and other global institutions that provide us with each generation of leaders in their fields. Many artists throughout history have been members of what is now called Freemasonry, some of whom we will look at shortly. Also, consider the connection between the artist-priest in ancient times, *and* the brotherhoods still influencing the direction of the world today. In the next few pages I will illustrate some of these occult connections.

BOOKS OF STONE & THE LANGUAGE OF THE BIRDS

Visiting many cathedrals over the years, the magnitude of wealth and skill that went into creating such architectural masterpieces never ceases to amaze me. The Gothic cathedrals were designed by a brotherhood with access to a higher esoteric knowledge. Their level of understanding in relation to geometry, acoustics, light and masonry is something that the greatest of architects today would struggle to replicate. Spanish architect Antoni Gaudî (1852-1926) was probably the last of his kind who attempted to produce something that speaks of the *sacred* knowledge embedded in Gothic architecture. His unfinished Sagrada Família in Barcelona has all of the symbolism and influence of the mystery schools of antiquity.

Over eighty cathedrals were built in France alone throughout the 12th and 13th centuries, not to mention hundreds of lesser churches and abbeys all over 'Christendom'. The secret society instigating the building of these places of worship, providing the funds and labour to do so, aligned itself with more ancient occult orders going back to Egypt. Wealthy merchant families, such as the Tames of 15th century England, who commissioned some of Britain's most elegant churches, were members of the same brotherhood. A brass monument of John Tame (a wealthy wool merchant) shows him decked out in armour at Fairfield Church, yet official historians offer no reasons why the likes of Tame and his fellow cathedral funders all across Europe, should be honoured as Knights. The answer is simple: they were knights of the brotherhood - the highest order! Gothic cathedrals of Europe were considered 'Books of Stone' by the artist priests who created and commissioned them all. The wealth poured into the building of Europe's great cathedrals derived from two main sources. Firstly, the Capeta Kings of the Capetian dynasty who replaced the Carolingian line towards the end of the 10th Century AD., and secondly, from the natural resources, namely people, stone, sweat and blood of the adjacent regions. These great towers of stone were designed by adepts of the mystery schools using an ancient language known by initiates as the 'language of the birds'. The connection between birds and an ancient 'forgotten pictorial language' relates to the mystery schools' knowledge of birds (and reptiles) using frequency and sound, to communicate with the

unseen, 'higher' dimensions. The bird-like reptilian-human brain is also the most ancient region of the triune brain, and from this area we interact with the world through a pictorial symbolic language.

For thousands of years an idea existed that there was once a language (contained in art and symbols) that perfectly expressed the nature of 'all things'. Scholars of the Kabbalah and the Tarot, along with the language used in the Books of Stone (cathedrals), employed a language or knowledge from an ancient era, one that became lost as humanity became lost to its true purpose. This language was said to speak of higher dimensions coming through *seeing* and *feeling* the underpinning forces in nature. It was also said by the ancients that birds spoke this language through their songs (sound/frequency) and that music was the original language of the Universe. In Greek, the word for bird is a synonym for messages from Heaven. The 20th century artist Pablo Picasso went so far as saying that: *"To understand art is to understand the language of the birds."* Walter Pater (1839-94) also wrote, *"All art constantly aspires towards the condition of music."* This is understood when we realise the magnificent acoustic abilities of the temples and cathedrals built by the initiates of the mystery schools I am highlighting here. Rosslyn Chapel near Edinburgh, a place I have visited several times, is a perfect example of a book of stone, built to harness sound and frequency (energy) so to travel into alternate dimensions (worlds). The symbolism at Rosslyn clearly focuses the eye on moving between worlds. This is why often the same symbols appearing in the ancient world are still be found in Gothic cathedrals and chapels like Rosslyn. As always it was the myth-makers and high-ranking initiates of the secret societies that used this coded language. A sacred language that is still used in the modern world, not least on corporate logos and in the architecture and street plans of major cities of the world.

All Gothic art (art gothique) is simply a corruption of the word argotique, a phonetic slang for a *language* used by individuals who wish to communicate their thoughts without revealing those same thoughts to 'outsiders'. Symbolic heraldic devices, through to modern insignias and logos, also contain the same hidden knowledge. Obviously the church in the 12th century would have never sponsored such designs, which are so blatantly Pagan in origin; therefore, the master artist-priests connected to the mystery schools, used a magical language (the green or bird language) to conceal their messages and beliefs. The art and detail found in some of the finest buildings in Europe, is teeming with symbols, letters, codes and geometry, 'numbers of structure', all waiting for the initiated eye to unveil.

THE ROSICRUCIAN-CATHAR CONNECTION

The Rosicrucian order, which seemed to appear in the 15th and 16th centuries, was, and still is, a major hub of this brotherhood I am highlighting. Its

members, most of whom were poets, philosophers, artists and scientists, also used the 'green language' to reveal knowledge of an alternative history while avoiding persecution by the church at that time. As I say, Rosslyn Chapel in Scotland, created by the St. Clair family, utilised this coded language to full potential. The same hidden language is still used today, especially within the corporate media and film industries, which I'll come to later in this part of the book.

Hieronymus Bosch (1450-1516), is a painter who fully understands the hidden esoteric qualities of art, and in my view, shows awareness of the green language (see Figure 49). He, like other elite painters of this period, was a loyal member of a secret society called the 'Brotherhood of our Lady' (the Madonna/Mary Magdalene), working on many alterpieces for the church. Based in Holland, this élite order was connected to the 'Order of the Garter' and in a 2004 UK Channel 4 television documentary about the life and works

Figure 49: *The Garden of Earthly Delights.*

The 'language of the birds' is used today, especially within the media, in business and the film industry.
It's a coded language which uses archetypes and symbols to full effect.

The arts and the music industry is, in essence, this 'language' and can be used to enlighten, or manipulate others. Hieronymus, or Jerome, Bosch was a painter who fully understood the esoteric qualities of art.

© Museo Nacional Del Prado, Madrid.

of Bosch, it was suggested that he had ancestral links to Dutch aristocracy.[3] His paintings, in my view, were meant to be understood only by members of the same esoteric circle – the 'Adamites'. These were 15th century nudists (free-lovers), amongst other things and were connected to earlier alchemists, eventually becoming the Rosicrucians. In the 13th century one such group, the 'Cathars' or 'Albigensians', grew so powerful in southern France that they became a threat to Papal authority, and started to elect their own bishops who practised independently of Rome. The Cathars believed, among other things, that water cannot be holy and cannot sanctify in baptism; that the Cross should not be venerated, for the same reason that one does not ven-

erate a gallow, and that the rite of the Eucharist is a falsehood, because the wafer cannot contain Christ's physical body. The Cathars were healers, dualists and carried very similar beliefs and customs to many of the pre-Christian brotherhood groups, such as the Therapeutae, Essenes and Bogomils of Eastern Europe. Lynda Harris, author of *The Secret Heresy of Hieronymus Bosch* (1995), gives us many examples proving Bosch was a dualist, and goes on to argue that he must have been a Cathar because Catharism was the only surviving dualist heresy in the 15th Century. I would go much further and say that Bosch, through his connections to the Illustrious Brotherhood of Our Lady (Order of the Garter) was a major figure in the brotherhood at that time.

Bosch's work, like many later visionaries and symbolists that he inspired across Europe, is littered with archetypal bird people, weird creatures and almost science fiction landscapes. The author William Henry in his book *The Language of the Birds* (2001) suggests that throughout history key musicians, artists, and writers like Mozart, also understood and used what he saw as the language spoken by birds – or what he describes as our higher 'angelic' consciousness. This language was, and still is, employed by the mythmakers, artists, and brotherhoods that have contained this knowledge since it was passed down from the mystery schools (shamanic priesthoods) of the ancient world. Through use of art and symbols, these secret societies inspired some of the greatest art movements in our history. Quite often artists, poets and musicians deliberately use this 'coded language' to pass on information to others, while avoiding accusations of heresy. Other artists, who were 'in the know', used certain codes and symbols to communicate with their fellow brethren, too. In the next few pages I want to present a brief illustration of this underground stream of knowledge.

ANCIENT ART – CROSSING CULTURES

All art can be described as the search for 'different and alternative ways' of seeing our world. From earliest cave art, through to Gothic Art, images take an almost 'omnipotent', two-dimensional form. Across this part of the time-loop (see page 142), imagery is influenced through a coded language of symbols often made by temple priests (patrons), native shamans and by secret societies. Egyptian temple art forms (hieroglyphics) are classic examples of this coded language. For artists and shamans of the ancient world, the Neolithic cave became the crypt and the forest became the temple. In all eras, Neoclassical, Antiquarian, Carolingian, Romanesque through to the Age of Spectacle (17th century), art was too often used as propaganda, reinforcing belief systems. As I have already touched upon in earlier chapters, entopic and lucid symbols found in rock art, were more often than not, related to shamanic ritual (see my book *Through Ancient Eyes*). However, the flat shadow-like images (skiagraphia) associated with much later Hellenic and 'Italic

Civilisations' (ancient Greece and Rome) are, in some cases, direct tracings of the shadows of people and animals. These images are also attempts to make visible the 'invisible' forms that *influence* and interpenetrate our reality. An example of this influence would be the making of rock art, over the past 5,000 years, to communicate with archetypes, gods and hidden forces in nature. The same style of flat skiagraphic images is found in cultures today that are an ocean apart. The Mimbres art and pottery made by the Pueblo of New Mexico in the USA is so similar to the Kamares style of art found on the Greek islands of Crete that one wonders if these two civilisations were once connected through a 'central global culture' (possibly Atlantis?). The dissemination of a global civilisation due to some kind of cataclysmic event in ancient times would have produced migrating groups of people who carried memories of their parent civilisation. Similar art styles and use of symbols in line with the beliefs of these people would suggest there was once an ancient global civilisation, too. Synchronicity of art styles from around 3,000 BC is found in the jewellery of the Tiarona tribe of the Northern Andes in relation to the Cycladic art of Cyprus (see Figure 50). All of the ancient civilisations as far back as the collective amnesia we call 'prehistory', used art to convey the appearance of gods, universal archetypes and the wider cosmos. The col-

Figure 50: Syncronicity in ancient art styles. (Far Left) A Cycladic Sun (light) deity compared to an Amerindian (Northern Andes) Sun God. The triangular head and naïve style are very similar.

lective perception of the cosmos, beliefs, and science was nurtured by religious centres in Egypt, Sumeria, India and Druidic Britain.

BROTHERHOOD MOVEMENTS

Philosophers, scientists and artists from ancient Greece, through to the great artists of the Renaissance, have all explored effects of *light* and *reflection*, including its more spiritual significance. Many well-known historical artists were also scientists and most were affiliated to the secret orders of antiquity. Leonardo da Vinci's work is a fine example of this combination. Light and the science of how we see the world became the driving desire of many key

artists, philosophers and scientists. The secrets of light and dark, colour, matter and anti-matter (duality) became a trademark for the brotherhood I call the Myth Makers. Esoteric teachings passed on from the ancient world were a key driving force behind so many art movements whose members *thrived* through the occult, mythology, and the language of symbols.

One brotherhood founded in 1848 is the Pre-Raphaelite 'Brotherhood' based in England. A society of painters, poets and art critics founded by William Holman Hunt, John Everett Millais, Dante Gabriel Rossetti, William Michael Rossetti, James Collinson, Frederic George Stephens and Thomas Woolner. This group of men is a prime example of artists creating works of art that speak of hidden myths and legends connected to romantic symbolism. The Pre-Raphaelites understanding of the 'Holy Grail', for example, became a huge focus captured in their art. A story, which in my view, is an invented myth to describe inner states of being (connected to the power of the divine goddess) beyond literal explanation. The Pre-Raphaelites formed a seven-member 'brotherhood' modelled in part on an earlier German romantic art movement known as the 'Nazarenes' (1810), who lived a semi-monastic existence. Later followers of the principles of the Pre-Raphaelites 'Brotherhood' included artists Sir Edward Burne-Jones, William Morris and John William Waterhouse. All of these groups were 'connected' to 'elite' circles (the establishment) and ecclesiastical groups of their day, not least the likes of the Christian Zionist, mystic, Messianist, and millenarian, Henry Wentworth Monk; more on this shortly.

LIGHT AND DARK

Symbolism alluding to the science of light and dark is found on ancient petroglyphs, through to medieval heraldry employed by brotherhoods of artists (often families) that have influenced art history. The symbolism can also be 'seen' in the masonic black and white squares found on chess boards, floors of stately homes, and even on the uniforms of police forces across the world (see figure 51). The same symbolism is expressed through burning substances to produce white or black smoke as part of the ceremony for selecting a new pope.

The black square, especially, is thought to be symbolic of the deity Chronos or Saturn (see page 97). All of these examples are connected to secret societies and brotherhoods that have influenced our understanding of history, commissioning all the great works and utilising a 'hidden science' not available to the masses at large. I believe the Masonic orders and their ancestral brothers, the Knights Templar (and other temple fraternities), derive *all* their occult knowledge from non-physical realities - the lower astral realms touched on in *Part One*. The language of non-physical dimensions is symbolism and sacred geometry, all of which were used to construct the great wonders of the

Figure 51: Eternal light - ephemeral darkness.
(Left) A checkerboard dichotomy of eternal light and ephemeral darkness found at a Navajo sacred site in Arizona. **(Right)** Two Knights Templar playing chess, from the *Book of Chess* 1283. Dualism, 'good against evil' has been one of the main hallmarks of the myth makers throughout history.

world (See *Through Ancient Eyes*). Art was, and still is in my view, the means by which we can *see* into the many non-local 4D and 5D worlds. These worlds effect and shape the one we call the 'real world' - our 3D reality. The myth makers and shamanic priests, who infused secret societies with knowledge of these higher dimensional worlds, still influence all areas of our society. They have always known that our 3D world is a place where separation (symbolic of the black and white squares) can be used to control the game of life and death (chess), while humanity is moved around like pieces on the board. All divisions between people *are* manufactured and life is a game; and *all* games are illusions where opposing forces/players are played off against each other.

ART AND THE EYE
The Greek poet, philosopher and scientist Empedocles, like Homer 400 years before him, realised that light was both physical and invisible. This concept can also be found in the ancient beliefs of Zoroastrianism, Manichaeism, Hellenistic Gnosticism and the Kaballah of more Eastern traditions (which are all founded on duality taking place in time and space). These philosophies refer to the duality of 'inner light' and 'physical light' and how unseen forces oscillate to create the physical world. The divine light, or inner light, was considered a higher state of consciousness, while the darkness (or lower state of consciousness) was considered the cold light (electromagnetics), or shadow side that structures the physical world. Similar theories are now understood in the areas of holographic projection and the groundbreaking studies made by astrophysicists into 'matter' and 'anti-matter'.

For the philosopher Plato, sight was a special interaction between the 'light

of the eye' and the 'light of the outer world' created by the sun. The obsession with 'physical light' became the basis of physics from the time of Ptolemy (141 AD) to the optical powerhouses of Renaissance science, evident through the use of the microscope and telescope. The genius Leonardo da Vinci, who was a scientist, artist and high-ranking member of the guild orders of Italy and France, also used lenses to capture images. Both Michelangelo Merisi da Caravaggio (1571-1610) and Leonardo da Vinci (1452-1519) influenced the understanding of the eye and optics through art. So also did artist and architect Filippo Brunelleschi who pioneered the use of light and mirrors (camera obscura) to create reflections of 'reality' and project them onto boards and canvas. Both Brunelleschi and Da Vinci were the brains behind the photo realistic painting style. Along with the 'master draughtsman' Albert Dhürer, these élite court artists created the concept of perspective in art and it is this doctrine of perspective that is still taught in schools, colleges and universities today. The obsession with the physical 3D (five-sense) world and science's mechanisation of nature, through the likes of René Descartes and Sir Isaac Newton, also helped mould the current human perspective of 'five sense' led science. This says, if you can't see it, touch it, smell it, taste it or hear it, then it can't exist! Yet, almost all art forms from the advanced civilisations to the art of the visionary, hint at 'other realities' peopled by archetypes, unseen forces and dreamlike narratives. The art, myths, storytelling and rituals associated with many earth's indigenous cultures are all dedicated to the worlds *beyond* the physical five senses.

While the Renaissance masters were experimenting with light, reflections, cameras and mirrors to create realistic paintings, certain artists were naturally influenced by the inner light or the spirit of an object or subject. El Greco (Domenicos Theotokopoulos, 1541-1614) was a clear example of an artist who was inspired by the luminosity of a landscape or person, rather then the cold, almost reflective, copy of nature. Later visionaries, especially William Blake, were also drawn towards the inner light, or the divine image as Blake called it. Vincent Van Gogh, drove himself crazy trying to understand the motion of an inner light as seen in everything, from a star to a yellow sunflower. In my view, the concept of inner light and the knowledge associated with transformation and seeing, became the domain of the artist-alchemist and the secret societies, which nurtured masters in the fields of the arts and sciences. As I have already said, the same secret orders destroyed all records of our true spiritual heritage (the burning of esoteric libraries, etc.), while taking out of the public domain references to the ancient understanding of 'how light transforms reality'. Much of this 'higher knowledge' was either lost or kept locked away (not least in the Vatican), and was only for the eyes of high ranking masters of such brotherhoods. These masters can be seen throughout history as the great painters, thinkers, occultists and geniuses of their time.

Most of these influential figures came from artistocratic families and were trained by other members of, what historians such as Manley P. Hall refer to as, the 'Orders of Fraternity'. What these artists or masters understood was that 'hidden behind images *are* the thoughts, emotions, fears, lies, vices, virtues, and even mediocrity that influence what we call 'reality'. In other words, symbols were, and still are, used by the Myth Makers to speak to each other (on one level), while communicating messages and meaning influencing the subconscious mind. All imagery in every era is purely a reflection of human ideas made manifest and directed, more often than not, by how people see themselves. If the shaman/priest/artist could dictate through imagery, architecture, rites and belief systems, then this would have an overall effect on how the world looked, functioned and *perceived* itself. Today, the mainstream media and social media platforms dictate the state global religion when it comes to 'moulding thoughts' and 'behaviours'. Television is the chief 'myth maker' resident in most homes all across the world. The connection between the myth maker's use of art at the time of the Renaissance and today's technolgical media empire using television, etc., is the use of images to *deceive* and *manipulate* the minds of the people. I will come back to this subject in more detail in the next chapter.

HOUSES DEDICATED TO THE SUN, MOON & PLANETS

Gothic cathedrals were built to capture light, just as ancient forests, groves and 'columns of trees' would have done in the ancient world. From an esoteric point of view, cathedrals, chapels and abbeys (including sacred sites all over the earth) act as conduits to harness energy at these sacred landmarks. This energy constitutes electromagnetic forces travelling across the earth surface, from North to South Pole, creating what the ancients called ley lines or 'Dragon lines'. Where the lines cross are the vortex points, places where almost all of the magnificent ancient structures have been placed. In Britain these lines and vortices are found along ley lines named 'Mary and Micheal', or the lines of 'Albion'. Light filtering into many great cathedrals not only served as a place of worship for the masses, but were symbolic 'vehicles of light' designed to harness the ley lines at vortex points by the priest fraternities that made these 'Books of Stone'. The arch-druids of the Middle Ages were not commissioning these buildings to speak to God! Instead, they were reconstructions of earlier stone circles and Pagan places of worship. In the forest and grove, where light filters through columns of trees onto alters facing west, the druids would focus on the sun, moon and planets (like Saturn) within *circles* and clearings amongst the trees. Antoni Gaudî the Spanish architect, illustrates this connection between trees and stone columns perfectly in his unfinished masterpiece the 'Sagrada Familia' in Barcelona. In truth, the Sun religion of the Celtic druids, and the Babylonian priesthoods

of Sumeria, was eventually woven into Judeo-Christian beliefs, quite obvious to one who studies the esoteric language employed in every major cathedral (see *Through Ancient Eyes* for more information). Almost every cathedral is a 'temple' dedicated to the sun, moon, or 'specific' planet. Rosslyn Chapel, mentioned earlier, is said to be aligned with Saturn, while Chartres Cathedral in France is aligned to the Sun. So many cathedrals, churches and chapels also include symbols associated with sexuality (vulvic arches), astrotheology and forces that have 'devoured' the soul of humanity through preaching separation and duality. The priests and artisans who built such Gothic wonders are telling us to look beyond the mundane levels of perception.

LIGHT (LIFE) & DARK (DEATH)

Light, in a religious sense, refers to the 'telling of the truth', as summed up in the famous line attributed to Jesus: "I am the light, the truth and the way." Having knowledge is also described as being 'enlightened' or 'living in the light'. The ancient Egyptians said: *if you put out of your thoughts the true knowledge of this world, then you are living in the dark or killing the light.*[4] The killing of the light, truth, or the sun (son) takes place in our *minds* and it is here where we can deny our own truth. Therefore, the Christian story of the crucifixion on Golgotha (meaning skull place), is in my view, a symbolic story of how humanity can deny (even 'put to death') its own light *or* truth (see figure 52). We do this by fearing the future and regretting the past, symbolic of the two thieves positioned either side of the Sun God in all variations of this story. For example, the two thieves in Scandinavian mythology are actually ravens called 'Huginn' and 'Muninn', or memory and thought, which again

Figure 52: The god of life and death.
The skull and crossbone symbolism at Rennes-le-Château, France.
It shows the duality of life and death (Christ and anti-Christ) and relates to the
mysteries that shaped the world. Statues inside the church also depict two Christs.

are allusions to the mind (brain) skull symbolism of Golgotha. Most people are unaware of such hidden meanings embedded in religious texts and paintings. Instead, they are taken literally and unquestioningly passed on to each generation. Separating the sacred sciences from art and myth in the public arena, while continuing to use the same 'knowledge' in secret, has kept people in darkness for millennia. Half of what passes for conventional wisdom in our society is provable nonsense, but we are still being fed the same myths enforced by institutions created via secret society networks to do just that. The creation of elaborate symbols, codes and ciphers is often done to hide the truth, or communicate it to those who have the 'eyes to see and the ears to hear'; yet when we combine the arts, sciences and spirituality with astrotheology (knowledge of the stars), everything becomes visible and all possibilities come forward. The symbolism I am highlighting in this book can be traced back to *all* forms of duality envisioned through *archetypes* behind religions but continued in modern film, media and literature today. The word *archetype* is simply an autonomus *form* in our primordial psyche that structures and impels all human behaviour and experience. You could say they personify 'states of mind'.

The theme of a dualistic god associated with both Heavenly or Infernal realms is something that has marked our history. Dualistic symbolism hits you immediately when you walk in the door of the church at Rennes-le Château in Southern France and seeing those opposing statues of the demon Asmodeus and Jesus Christ staring at the same black and white chequered masonic floor. Similar themes of two opposing forces (life and death) can be picked up in many paintings commissioned by the French (or Merovingian) bloodline families during the 14th and 15th centuries. Within these paintings is a recurring theme of the skull and cross, sometimes deliberately hidden away (see the *Ambassadors* painted by Hans Holbein on page 193), but more often than not, they can be seen juxtaposed. Paul Rubens, who was heavily influenced by Titian, Leonardo da Vinci and Michelangelo, also used religious themes and myths relating to life and death. So did the Netherlandish Renaissance painter, Rogier van der Weyden for *The Braque Triptych* 1452. Damien Hirst, the British sensationalist contemporary artist, also used similar iconography in his sculptures, not least his *Shock and Gore* and *Stations of the Cross* exhibition in 2004. The same symbols pertaining to the dead and the living can be found in all ancient cultures, and relate directly to priesthoods, or secret societies, now called Freemasonry.

The skull image crops up in many paintings and alchemical illustrations as a symbol of the 'God of Death', or Death Cult. The cross, an esoteric symbol for the 'God of Life', can be seen in the Egyptian *ankh* symbol. Both symbols are found above the door to the sacred garden at Rennes-le-Château (see Figure 52 on previous page). The artists behind these images are more often

than not connected to wealthy patrons through secret society membership and ancient bloodlines. The skull and cross symbolism relates to duality and is a satanic symbol used by sinister groupings such as the notorious Skull and Bones Society based at Yale University in the United States, an organisation that has produced many prominent 'heads' of state, business leaders and politicians, not least the Bush family clan, since its creation.

LIGHT, SHEPHERD KINGS & SOLAR STAFFS

The hidden science and cosmology evident in ancient civilisations such as Egypt seemed to be a major influence of the key figures 'behind' the creation of secret societies in the Middle Ages. One important individual known as the Abbot Sugar (1082), a friend of Prince Louis (who became Louis VII) and Bernard of Clairvaux (1090 – August 20, 1153), was one of these priest figures. Both Sugar and Clairvaux were hugely interested in the 'science of light' amongst other esoteric occult subjects, especially Clairvaux an important figure I will look at shortly. For Sugar and his brethren, light was more than illumination, it was a metaphysical *being*, an 'emanation of divinity' of *all* things close to what they saw as God. For the high initiates of the brotherhood behind all fraternities and denominations at this time, the metaphysics of light was closely connected to Sun symbolism and the worship of the stars. The Abbey of St. Denis in Paris, which Sugar founded in 1125, was also a major 'foundation piece' for the many cathedrals that were later erected in the name of the Sun (Son saviour) and the virgin goddess (the Black Madonna). Both the Christ figure and the goddess virgin relate to Sun and Venus symbolism. Saint Denis, incidentally, was a Syrian philosopher also known as 'Dionysius' who was said to have followed Saint Paul in the first century AD. Both these characters are actually rolled into one person, a 'man-myth' and both are said to represent the power of the light of the Sun. John the Baptist (and John the Evangelist), and Saint Denis, are also major secret society symbols. Both the Baptist and St. Denis were beheaded, and both are connected to the Age of Pisces ushered in by the masonic-like Essene brotherhood based in Egypt and Jerusalem at the time of the Roman occupation of Judea from 6 CE. The Feast of John the Baptist (24th June) and John the Evangelist (27th December) are masonic versions of the pagan Oak and Holly Kings marked by the same dates on the calendar. They are also recognised figures attributed to the original teachings and the mysteries held by brotherhoods that followed the Essenes into the period of history called the Dark Ages.

The staff, carried by priests and saints in much iconic art, is another key symbol for these secret fraternities going back into the ancient world. Saint John, Saint Christopher, and many other saints, were also staff, or crook bearers, who were said to travel spreading the word of the power of the sun (son),

the light.

Paintings by Nicholas Poussin in the 17th century also contain themes relating to the shepherd kings and the bloodlines that became the Merovingian dynasty of France. Poussin's painting *The Shepherds of Arcadia* (1627), became the focus for the mysteries associated with Rennes-le-Château and the Knights Templar brotherhood. The staffs, held by shepherds in *The Shepherds of Arcadia*, are symbols for the ancient Stellar cults. The shepherds are portrayed as three wise men, or druids, connected to other religious figures such as Moses. The 'good shepherd', for example, was the name used for the ancient astrologers who watched their 'flocks of stars'. Shepherd symbolism in religious text also relates to the Hyksos Priest Kings of Egypt who later appear in the Old Testament as Israelite father-figures, such as David, Solomon and Moses - all were all staff bearers.[5] The shepherd's staff is a symbol denoting power over others, along with symbols of squares (chessboards), spirals and poles, they relate to the tree of life and the earth's axis - the turning of day into night. All of these symbols express the cycles of the sun, moon and stars as studied by the ancients. The wand is also another symbol relating to power and magic, but more importantly, how this power is used or abused by the 'shadows', or dark forces mentioned earlier.

The caduceus, the winged staff with two entwined serpents, still used today by the medical profession, is also a symbol for our light and power connected to DNA (see figure 53). The knowledge of how our DNA programmes and permeates our reality is still being used by forces symbolic of serpents, to create clones, and to manipulate the ecology of our planet. The same symbols used in religion, heraldry or corporate logos, on one level, relate to material *control* of our world. On another level, the caduceus symbol speaks of both manipulation *and* manifestation of life through DNA/RNA, and the duality, or separation evident in our 3D material world.

Figure 53:
The winged staff.
The caduceus in relation to the human spinal structure and kundalini force.

The Native American Hopi word for shepherd's crook is 'ngölö', and the semantically related word for hooked is 'hewakna'. Yet in Egypt 'heq-t' refers to a shepherd's crook, which represents divine sovereignty, rulership, and royal (DNA/genetic) dominion or power. This crook, painted or inlaid with alternating dark and light horizontal bands, is also held by Osiris (Orion) and other sun deities, representing the supreme power of the solar-starman. It's interesting to note that from the Hopi First Mesa village of 'Hano' (Tewa) comes the 'Koshari', a figure with broad black and white bands painted horizontally on his body and a curved stick somewhat resem-

bling a crook in his left hand. The Koshari archetype represents 'unruly', opposing forces in nature and the land of dreams, more on this archetype shortly. The sacred clown, or 'Koshari' (see the jester/fool found in medieval times) is an ancient archetype aiding us in our ability to see through the illusion that is 3D reality. The other role of the Koshari is to teach: *reality mirrors back to us what we think*!

SQUARES & CHECKERBOARDS

For the Hopi clans of North America, a square divided diagonally with a crook carved into each section (each one facing opposite directions), is a *mark* of their divine and sacred ancestors. The *four directions* or *corners* of this symbol relate to the four seasons, ages of man, and directions on earth. But on another level, the 'power of four' (the square) is a direct reference to astrology and the movement of the earth along the ecliptic, through *four constellations*: Taurus, Leo, Scorpio and Aquarius. This four symbolism was embedded within the four gospels of the New Testament: Matthew, Mark, Luke and John, by priests who understood direct references to these astrological cycles.

There are 64 squares on any classic chessboard and this number is thought to relate directly to the *sixth dimension* and the *fourth dimension*, both of which influence and structure our *third dimensional* reality (3D). In more modern times, artists such as M.C. Escher (20th century) also used the checkerboard dichotomy of eternal light and ephemeral darkness in illustrations. Escher, in my view, was either an initiate of the brotherhood I am outlining here in this chapter, or he was a truly inspired draughtsman, tapping into the unseen levels of ancient knowledge that influence and interpenetrate our consciousness. What seems clear, once you unravel the basic symbolism, which can be followed out of the ancient world, is that a travelling group of magicians, shamans, or priests initiated much of the world's religions and created symbols and rituals that still influence our collective beliefs today.

The square represents 'place' or 'house', so checkerboard glyphs (in black and white) may be expressing the 'House of the Two Crooks', later understood as the 'double cross' found on the heraldry of the House of Lorraine, said to be one of *thirteen* ancient occult families. In Anasazi (Hopi) ideograms, the crook, or reed cane, can symbolise fertility or the production of rain; a power frequently held by the ichthyophallic Hopi deity, Masau'u (see Figure 54). The archetypal knowledge associated with Masau'u and Kokopelli (his opposite in rock art), is very much that of the 'language of the birds', insects, and the *light* that inspires, heals and gives fertility to all life. This language also relates to colour, sound and realms beyond the solar spectrum, *beyond* the Sun. Where Kokopelli is life, Masau'u represents resurrection from death and as I will come to in *Part Three*, he is another version of Orion - the 'Dual God'. The same archetypes are embodied through deities

Figure 54: Masau'u, (the androgynous God of Death) and duality of being.
These two archetypes possibly fuelled the belief in the need for a protective talisman worn by shamans and priests who ventured into various altered states (dimensions) or journeyed into the Underworld. Masau'u carries a staff **(bottom figure)**. The drawing is based on a Bronze Age petroglyph photographed near Los Almos, New Mexico.
© Courtesy of Dan Budnik

such as Osiris, Horus, and Set of Egypt and their equivalents all over the ancient world. The *staff, flail* or *flute* held by these deities are once again symbols relating to our DNA, *our* light, and how we have been conditioned to accept only *one* or *two* definitions of death, courtesy of mainstream religion and science. The belief systems we unquestionably adopt, all stem from these archetypes expressed through the 'power' of life and death. We have a religious monopoly over how we are 'laid to rest' (see Appendix).

SECRETS OF THE SAINTS

Religious icons and figures throughout history are born of hidden knowledge – the science of numbers and shamanic observation of the stars. Other figures came from the teachings of migrating shaman-priests going back into prehistory. Saints, prophets and hero figures are not always historical personas, but the visions and images *given* to shamans by forces operating on unseen levels of creation. Even the experiences of key religious figures (see St. Paul and Mohammed, to name two), all speak of communication with unseen forces and otherworldly lights (possibly extraterrestrials). In most cases, the language these otherworldly communicators seem to use comes through telepathy, archetypes and symbols. Like the ancient storytellers, this form of communication is our first language, and along with art (drawing) is how unseen levels of creation have inspired ideas and beliefs (knowledge) within humanity. The danger comes when archetypes are taken literally then enforced on the masses by the few, which has been happening through the brotherhoods I am illustrating in this chapter. All religions,

including the art that has supported these belief systems since ancient times, are nothing more than tools of the Myth Makers used for this purpose.

The list of Christian saints is a good example of attributing a given symbol to quite often a mythical figure. More often than not, the symbolism associated with saints and prophets in the Bible can be found in archetypal language of much earlier civilisations. Other symbols associated with historical figures became emblems and names for various guilds and secret societies *behind* religion. These guilds also represented the rank or position of levels of initiation within the secret orders, which can be traced back to Egypt, Babylon, the Essenes and Gnostic groups in Egypt and Palestine. The angelic names such as 'Gabriel' and 'Michael', for example, are direct references to levels of initiation within the Gnostic and Essene brotherhood. According to some writers, the Essene chief priest was known as 'Christos', 'the Anointed One', and was the head of the whole congregation of Israel. Rank and titles also applied to Celtic monasticism and the druids dating back to the ancient Culdees of Scotland (40 AD), who, according to researchers like Isobel Hill Elder and Barry Dunford, were the predecessors of the Essenes.[5] In early Christian groups, ordinary priests were called 'Sons of Aaron', which was another title (or function) just as the title 'Messiah' (anointed one) was reserved for chief priests or initiates in later mystery schools. Some of these names are said to be attributed to angel figures, for religious purposes, and form a 'code' embedded within the New Testament.

GREEN WOLVES AND DRAGONS

The brains behind two of the most important Gothic cathedrals in France (and therefore its art), were Abbot Sugar (1081-1151) and Bishop Maurice de Sully (died 1196). Abbot Sugar, and Maurice de Sully of Paris, were both inventors of myths (not a difficult task for the church) and both amassed huge amounts of wealth during this time. Sully rose quickly within the hierarchy of the fraternal orders amassing his wealth, and much of his money was used to prepare the site and organise materials for the famous Cathedral of Notre-Dame. Sully's personal seal is an interesting one (see Figure 55), depicting an otherworldly, hooded 'cat-like' character carrying a staff flanked by a snake and a wolf!

Both the dragon (snake) and the wolf (dog) are hallmarks of ancient priesthoods hiding behind the Catholic Church (religion), banking

Figure 55: Staff Bearers. The personal seal of Bishop Maurice de Sully of Paris shows him as a staff bearer.

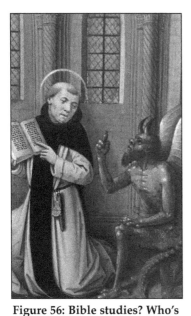

Figure 56: Bible studies? Who's instructing who?
St. Bernard was responsible for the 12th-century mystery schools at the time of the Crusades. I am sure the Predator Consciousness (symbolised as the devil) would have approved.

and politics. The symbolism on Sully's seal relates directly to the 'Brotherhood of the Green Wolf' documented in books such as *The Golden Bough* (1890) by Sir James George Frazer (see *Through Ancient Eyes* for more information), and more malevolent forces the Teutonic Orders came to venerate. Interestingly, it was said by historians that Bernhard of Clairvaux "taught the devil himself", not a good item for your résumé if you're supposed to be a founding father of the Christian Church (see figure 56)! Clairvaux, a French abbot and pioneer behind the Knights Templar and much more besides, was one of the pivotal figures that shaped ecclesiastical Catholic 12th-century spiritual doctrine. Yet, the overwhelming amount of evidence I have seen in France, suggests there was a connection with witchcraft, satanic worship and clandestine orders that created the Church. It seems Clairvaux, and others before him, were involved in occult circles. It's certainly true that he was a pivotal figure behind the creation of famous warrior monks, and the Knights Templar who would go on to control Europe, Asia Minor and North Africa throughout the era of the Crusades.

Manley P. Hall in his book *Masonic Orders of Fraternity* (1950) explains how the builders of temples and cathedrals were bands of wandering craftsman who, according to Hall, never mingled with lower classes. Instead, being priests, these builders and craftsmen enjoyed extraordinary privileges. They created an apprenticeship system of secrecy which protected their scientific understanding, knowledge of symbols and sacred geometry. I would go further and say these master myth makers and higher ecclesiastical hierarchy were actually priests who practised their deeper knowledge of Pagan symbolism and frequency. The very thought of occult knowledge, symbols and sacred geometry being used by secret society initiates in building Christendom's greatest temples, is often hard to accept by many Christians today. But one only has to take a look at the art, sculptures and architectural detail commissioned by these fraternities, to see the magic behind such feats. Of these artists, Hall says:

Thus it came about the early Church employed pagan artisans or those of doubtful orthodoxy when some elaborate structure was required. So great was the power of these builders' associations and so urgently were their skills required that it deemed advisable to ignore religious nonconformity.[6]

As I wrote in *Through Ancient Eyes* (2018), it is blatantly obvious the master craftsmen behind organised religion were worshipping 'in secret' their own Pagan deities. These ideas and beliefs, as always, were rooted in Sumerian, Egyptian, Greek Gnosticism and later Manichaeanism, while offering the masses another version of Paganism called Roman Christianity. The veneration of the Black Madonna from Egypt, through to Middle Ages France, is just one example of symbolism continuing. The Gnostics and Manichean sects later known as the Cathars of the 12th and 13th centuries, emerged in the formative days of what eventually became Christianity. These sects preached dualistic and esoteric teachings that encompassed the Notre Dame (Black Madonna), Isis and the Mary Magdalene.

THE BULL & THE BLACK MADONNA

Amongst the workforce and peasants of Middle Age Europe, especially in France, grew the Cult of the Ox (Bull). This animal cult would become a symbol for the workers and guild-members who harnessed themselves like cattle to drag quarry stones to cathedral sites. From an esoteric point of view, the Ox related to the gods of Egypt and the constellation of Taurus – the astrological period that ruled supreme at the time Egypt's great temples were being erected. The Bull was also a direct symbol of the mother goddess worshipped by various pre-Christian Pagan cults, especially 'Hathor' and 'Io'. Gallo-Roman pillars found underneath Notre Dame in Paris depict Jupiter, Vulcan and the Gallic Esus (a Celtic Hercules), along with images of cranes and bulls inscribed on one pillar.[7] It was first in Chartres in 1144 and later in Rouen, that the Cult of the Ox, or Bull, spread amongst workers and peasant folk in France. This Cult was sold to the people as a way of repentance of sins if they agreed to become like the bull and labour for the church, just as the ox had laboured for the Israelites and kings in the Old Testament.

One of the main archetypal deities of the French Merovingian dynasty was the 'virgin' goddess. For the priests of Egypt (the Shepherd Kings) she was the sacred cow, 'Isis'; to the Assyrians she was 'Ishtar', but for the cults that emerged in Europe, connected to the knights orders, she was known as the 'Black Madonna'.

Over four hundred and fifty idols of the Black Madonna can be found at Christian sites across France alone, most of them in shrines and churches that follow the major rivers and sea ports. The Rivers Seinne and the Loire, which carve their way through France, were considered the 'Nile of France' by the

brotherhoods tracing their origins back to Egypt. For the Knights Templar, the Black Madonna was (is) a combination of the ancient bear goddess (Mary), Isis *and* Mary Magdalene's bloodline. Therefore it is no secret that the so-called virgin Madonna in Christian faith is a Pagan idol brought to France by the Knights Templar and the Egyptian *priesthood* mystery schools that still operate today through Freemasonry. Many fortified villages in France are dedicated to the Black Madonna and the Sun god, St. Michael. One village in particular is 'Rocamadour' in the Lot department in Southwestern France. The heraldic shield for this town is a semi-cryptic symbol for the 'face of Isis' and within its chapel is probably one of the most blatantly obvious renditions of this ancient Pagan goddess (see Figure 57). The same goddess was referred to as Hel (or Hell/El) by the Danes and Viking cultures, and both versions are said to be embodiments of the 'Queen of the Underworld'.

There are several cathedrals in Catholic France, solely dedicated to Black Madonna worship, and Notre Dame de Paris is the most famous. Another

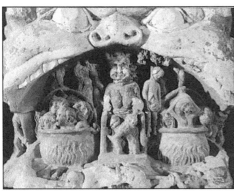

Figure 57: The Black Madonna.
(Left) The Black Madonna suckling the anti-christ at the mouth of hell can be seen in Perpignan cathedral, France.
(Right) Saint-Amadour (the Black Virgin) of Rocamadour, France.
© Neil Hague 2004

important site renowned for its worship of this goddess is a town on the Camargue in the South of France, called Saintes-Maries-de-la-Mer, (the Saint Mary of the Sea). As with other towns in France the festivities and religious holidays are linked to the Black Madonna and the original gypsies who also pay homage to this deity. The myth of the Black Virgin relates to the tale of three women who were said to have come ashore at Saintes-Maries-de-la-Mer, after the crucifixion of Christ. It's also said that they brought with them the Holy Grail that had carried the blood of Christ. Might such symbolism relate to lineage and not a physical chalice? These three figures were supposed to be the mother of Jesus (Mary), along with Mary Magdalene and her sister Martha, the wife of Zebedee. It has been said in a number of best-selling books, not least *The Bloodline of the Holy Grail* (1997) by the late Laurence Gardner, that these biblical figures provided the lineage of the Merovingian Priest Kings for what later became European Royalty.

It was the mysteries surrounding Renne-le-Château and the Saniere

manuscript found hidden there that implied that the first shepherd king, Merovee, was a descendant of Mary Magdalene and Jesus (or Yesua/Isa). However, there is no real physical evidence to sustain this legend. The Merovingian dynasty accumulated much power through their kingly and priestly combination; a combination that would provide a template for the Knights organisations and the Freemasonic structures that followed. The Holy Grail could be merely a symbol for the blood/DNA of the priest kings and ruling families that emerged in Southern France. Many Black Madonna sites in Europe are said to house the Grail. This Grail lineage is said to go back to the kings of the ancient Middle and Near East, from the same location the gypsies (keepers of the tarot) are said to originate. The art and symbols found on the tarot pack are a direct reference to the language of ancient shamans (Myth Makers) who travelled with a higher knowledge not available to the population at large. The tarot also served as a code for the Hermetic and Kabbalistic orders that did not want *their* knowledge of the stars, different dimensions and higher levels of consciousness made public. Instead, all knowledge of magic, the illusions we call reality and the path to self-discovery, were hidden (literally) quite superbly behind a series of images and key symbols which became the Major and Minor Arcana.

'M' IS FOR 'MATRIX'

The letter 'M' is a very important goddess symbol to the brotherhood I am highlighting here, it can be seen used various media and food chains such as McDonalds, Motorola, MGM, etc. The Greek Earth goddess 'Demeter', literally means the *Meter/Mater/Mother* and comes from the Egyptian word *Matt* or *Mahat* (matter), or 'Matrix'. The knowledge of sacred geometry (earth measure), numerology and astrology relates to these words, used by secret societies and dedicated to the great *mother* goddess. The same goddess is often depicted holding the scales of justice; the balance of nature emblem for banking and law.

During the building of Europe's Gothic cathedrals, one of the most secretive societies, titled the 'Order of Sion', whose membership went on to boast the likes of Da Vinci, Nicolas Poussin and later Claude Debussy, was modifying its organisation. According to authors Michael Baigent, Richard Leigh and Henry Lincoln, in their book *The Holy Blood and the Holy Grail* (1982), the Prieuré de Sion adopted another name in 1188. It became known to its members as 'Ormus' and its symbol was an acrostic that combined 'Ours' (meaning bear in French) and 'Ursus' (meaning bear in Latin), all surrounded by the letter 'M'. The 'M' symbol can also be found in the astrological sign for Virgo – the *virgin* goddess. It is also worth noting that the *bear* was used as a symbol for an ancient primaeval epoch called 'Arcadia' and worshipped by native cultures as an ancient lineage relating back to Atlantis and animal-

gods (see *Orion's Door*).

The name Arcadia derives from the Greek Arkaden, meaning 'people of the bear'. It's this type of symbolism, used by temple orders, that eventually finds its way into the symbolism of Christian Gothic cathedrals. None of it relates to orthodox Christianity! Instead, the symbolism used by priests and initiates of the mystery schools relates directly to their own star worship, the bear-goddess (Mami/Isis) and speaks of *their* genealogical connection to the gods of the ancient world. The Madonna, or what the mystery schools called *Our Lady*, was direct reference to serpent goddesses of Egypt and Sumeria – the *goddess* who was said to have created the ruling classes and aristocratical families that eventually became the European elite. One of the key lineages that carried this goddess DNA was said to be the Merovingian dynasty I mentioned earlier.

KNOWLEDGE IS POWER

Art and European politics from the early 15th century to the late 17th century began to look back fondly on the classical world of Ionic, Corinthian and Doric styles of art and architecture. The pull also towards ancient texts, classical sculpture and an interest in human relations, spawned the movement we know as the Renaissance. Behind this revival were key brotherhood movements, banking families and as always, the aristocracy and royal bloodlines that ruled the masses since ancient times. From my own research, I feel the Renaissance removed the omnipotent world-view of flat *two-dimensional* space, ushering in the notion of *third dimensional* (solid) space through the use of perspective in art. In other words, the world (earth) was no longer flat, but could be envisioned in 3D form. The knowledge of sacred geometry, and Platonic solids (tetrahedron, cube, octahedron, dodecahedron and the sphere, etc.) was also revived and brought into art by the same brotherhoods. These fraternities already had access to advanced knowledge from the time of Plato, Euclid and Theaetetus of Athens (417 - 369 BC).[8] The use of sacred geometry can be seen in Da Vinci's *Vitruvian Man* or the *De Divina Proportione* by Fra Luca Pacioli (1445-1517). The use of geometry, perspective and the need to present realistic images went hand in hand with the 'this-world-is-all-there-is' science later pioneered by the likes of Issac Newton and his theories regarding light, gravity and the mechanical workings of nature.

The Royal Society was also formed in the same period (1650s), a body that became the foremost 'approver' of new theories in the realms of science, philosophy and, later, art. In the same century the works of Galileo Galilei, Giordano Bruno and other scientists were also presenting new ideas in relation to light and physics. Both Galileo and Bruno were labelled heretics and imprisoned for having the audacity to reveal knowledge the priests and

secret societies were working to remove from public circulation. The killing of scientists and philosophers like Galileo and Bruno, also set the precedent to kill untold thousands in religious wars, visited on Europe by deeply disturbed mindsets in all camps. The killing of scientists hasn't stopped either! Take a look at the world in the 21st century, and it's easy to notice nothing much has really changed; only the methods of killing have become more sophisticated! Dr David Kelly's 'mysterious' death in 2003, not to mention all of the other scientist 'suicides' before and during the Covid era were often the trademark of the brotherhood I am highlighting here.

Giordano Bruno, as I have already mentioned in earlier chapters, was a priest, artist and genius dedicated to the reawakening of inner light or 'bright fire' as he termed it. It was Bruno who suggested that the external half of a particle (physical light) in the visible world, was the opposite of the anti-particle, which he said was perceived through thought, intuition, inner voice, improperly called spirit.[9] The circles of power that eventually condemned Bruno were also the same patrons behind the Royal Societies and key artists/thinkers of the periods following the 17th century. This controlling power was (still is) the brains behind all religion, laws, banking and governance since ancient times. In the Renaissance period, élite painters such as Leonardo da Vinci, Caravaggio, Rubens and Titian were being commissioned by the Church and State to produce portraits and murals for ruling families, while experimenting with light, optics and cameras. At the same time, Bruno was persecuted for expounding knowledge of an alternative, spiritual life through a 16th-century form of astrophysics. Funnily enough, the same level of vision and response often occurs today whenever anyone expresses views stretching others to think beyond the limitations of mainstream science, religion and the nonsense we call the mainstream media. Our sight is the 'truest' form of deception and the artists who flourished from the time of the Renaissance onwards, were 'Myth Makers' who often used art to reinforce religious doctrine of that time. For example, the artist, Titian (Tiziano Vecellio), was closely connected to the Hapsburgs (House of the Hawk) and the Valois who ruled Europe through the Holy Roman Empire.[10] Leonardo, on the other hand was employed by the Medici of Rome and later the King of France (Francis I), and he, like many other artists, was highly influential within the brotherhood networks, guild councils and secret societies of this era. The Renaissance court artist, Caravaggio (1571-1610) was a member of the Knights of Malta and spent much of his life on the run for murder. In Caravaggio's paintings light seems to fall with equal clarity, but it is always measured against blood, dirt, violence, corruption and darkness. Other artists, such as Albrecht Dürer (1471-1528) and Hans Holbein (1497-1543) were connected to the highly secretive and influential 'Order of the Golden Fleece'. Other orders, such as the 'Brotherhood of Our Lady' and the 'Order of the Garter' boasted kings and emperors such as Henry IV, VII, Maximillian

I, and the Roman Emperor, Sigismund amongst thier ranks. Sigismund created the 'Order of the Society of the Dragon' in 1408, which revealed the true nature of the force behind some of these élite bloodlines, and royalty today is massively involved in Freemasonry at the highest level. In 1561, Cosimo de' Medici also created the 'Order of San Stefano' which was an attempt to revitalise the earlier Orders of Chivalry in order to 'police' the Mediterranean. Freemasonry to this day is the outward cover for some of the most ancient secret societies, all of which were active in world affairs from the time of the Crusades up until the Renaissance period. Today, these secret societies still influence *all* major positions in banking, media, arts, science, politics, economics and the military.

GARTERS & DRAGONS

The Order of the Garter was founded by Edward III in the 14th century and remains the oldest and most distinguished of all secret societies. In truth, it is still the Order of the Society of the Dragon under another name and apart from royal membership, it is confined to *twenty-four* knights chosen by the British monarch. Its members, in recent years, included all heads of the royal houses of Europe (one family if truth be known), representatives of the *thirteen* families mentioned in the last chapter, and people like the late Baroness Thatcher, the late Sir Edward Heath, representatives of the church (such as the Bishop of Winchester), Lord Sainsbury, Black Rod (Staff) Sir Micheal Wilcocks and Sir Edmund Hilary, to name but a few.[11] According to the architectural historian, Dan Cruickshank, the true symbolism behind the Order of the Garter relates to a fish-shaped vessel (a common motif in much medieval art) which he describes as a symbol representing the vagina. A symbol which again relates to the great mother goddess and is seen in architectural detail of most portals and doorways of Gothic cathedrals (not least Notre Dame in Paris).

The knowledge used by the likes of Da Vinci to make realistic and detailed imagery, comes from an advanced understanding of the arts and sciences held by secret societies during his life. The use of pinhole cameras (the camera obscura), for example, at the time of the Renaissance, would not have been available to the average man and woman. Therefore, Michelangelo's Sistine Chapel murals and Leonardo's Madonna, as seen by admirers, would have been no different to today's film directors using special effects on the latest science fiction epic, to entertain and enthral the average cinema-goer. Interestingly, a mural painted by Da Vinci at the Castello Sforzesco in Milan shows a shield, which contains images of dragons wearing crowns and a serpent (reptilian) swallowing a child! The work's proper name is *Vegetal Decoration* (1498). William Blake's illustrations for Danté's 14th-century work *Paradisio* also contain references to shape-shifting reptilian figures.[12] Just a

thought!

Many key artists of this period belonged to the brotherhood network in some shape or form and the key point to remember is that an élite priesthood created the institutions and societies, both secret and public, and these mainly male groupings would dictate the style, content and usage of art for the past five hundred years, or so.

THE PATRONS & AMBASSADORS

The Holy Roman Empire, which gave us Catholicism, was the most influential patron for the arts across Europe spanning a thousand years. As always, the Church in Europe, from the time of the Holy Roman Empire to the Renaissance, provided a principal source of patronage for key artists. Individual painters and groups of artisans were commissioned to promote the Church hierarchy's views and beliefs. Alongside the Church, immensely wealthy families, also provided artists for the Church and State of key European countries. Many became leading patrons. Some of these patron families, like the Medicis, the Anjous, the Hapsburg dynasty, and later the Hesse-Kassels of Northern Europe, would also produce kings, emperors, dukes, popes, and even court painters! One good example are the Medicis, who produced two popes, Leo X and Clement VIII and were famous for their cutthroat politics. The Medici family were the most influential commissioners of Renaissance art, along with the Sforaza family of Italy. These bloodlines are the link between the old Roman Empire and the New World Order talked about during the 21st century, a topic I will come back to in the next few chapters. The Medici presence in the 14th century would have been on a par with the likes of major movie moguls and entrepreneurial business magnates of today. Medici and Sforaza bloodlines included the Grand Dukes of Tuscany who provided key women to the aristocracy of Europe, notably Catherine de Medici (1519-1589). She was a lovely lady who instigated the St. Bartholomew's Day Massacre, in which over 25,000 were killed in France. Cosimo Medici (Pater Patriae 1389-1464) was the 'patron of all patrons', a close friend to René d'Anjou and the elite House of Lorraine. Cosimo also funded the first public library of San Marco, a challenge to the Church at that time. He was responsible for the University of Florence which began the first translations of Greek literature in Europe since the Dark Ages. However, behind the public façade, Cosimo was a tyrannical, ruthless banker, politician and founder of the Medicean power base. Even with all of their power and influence over ecclesiatical orders and arts of the Renaissance, the Medicis, like other leading families, were merely figureheads for more secretive cults, committees and councils. These councils were, in fact, the ancient orders and temple secret societies which had been around since before the time of Plato; hence Cosimo's quest to accumulate (hoard) knowledge from all over the

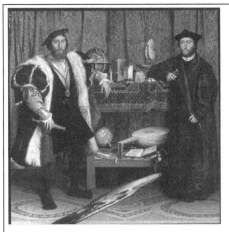

Figure 58: Skulls, pillars and serpent symbolism in art.
(Left) *The Ambassadors* by Hans Holbein one of the greatest portrait painters of the 16th century. **(Right)** The twin pillars (see also twin towers) of Boaz and Jachin.

world.[13]

The court artist, Hans Holbein, captured the level of wealth and knowledge associated with the ruling élite during the 16th Century. In his portrait masterpiece, *The Ambassadors* (1533) he shows Jean de Dinteville and Georges de Selve, both men connected to the French crown and the English court in 1533. It is not so much that the painting is of two prominent men, one of whom was close to the French Embassy and the Dukes of Burgundy, or the fact that both were connected to the Orders of the Garter and the 'Order of St Michael' (see figure 58) which was the French royal courts equivalent at that time.[14] It's the esoteric objects within the painting that reinforce the connections between artists, the Church, the aristocracy and both 'esoteric' (inner) and 'exoteric' (outer) knowledge at the highest levels of the mystery schools.

The painting shows a celestial globe, a cylindrical or shepherd's dial, a set square and dividers, a broken lute, and a polyhedral sundial amongst other items relating to Freemasonry. The other more subtle piece of symbolism this piece contains is the classic dual imagery of the skull and crucifix, the latter of which is tucked away in the top left-hand corner behind the curtain. The skull is 'distorted' so much that it makes us wonder whether lenses or a camera of some sort was used to create it. The symbolism within the painting is intended for the 'initiated eye' and speaks primarily of duality and 'division', especially in relation to religion at the time of Henry VIII. The overall framing of the image breaks down into 'twin' pillars and 'three' levels, all of which is classic occult symbolism. On the left, Dinteville represents the 'dark' *first* pillar of commerce, which in Freemasonry is 'Boaz'; while de Selve represents the 'light' *second* pillar of law and religion, called 'Jachin'. The floor

level of the painting with the distorted skull is the *first* degree of Freemasonry; the second level where the lute resides relates to the liberal arts and the *second* degree; the upper third level where instruments like the polyhedral sundial sit, is symbolic of the *third* degree. Knowledge of the subjects contained within the image would be used in the initiation to 'master mason'. The green curtain in the background *is* the 'veil', begging the question, "What exists behind the veil?" The green door into the grounds of many chapels has the same symbolism and relates to crossing into otherworlds, gaining higher degrees within the mystery school. The floor, according to some scholars, represents 'time' and is thought to be the floor at Greenwich Palace, the location where *time* (GMT) is measured. The whole painting is code for Saturn and the 'Great Work of the Ages', knowledge of which, Holbein would have had access to. The same knowledge and symbolism relating to the earliest shamanic priesthoods, was also being used by other élite court artists connected to the royal lines of Europe and clandestine fraternities such as the Knights Templar.

ART OF THE KNIGHTS TEMPLARS

The Knights Templar were a secret society that went on to fund wars, create what we call banks and commission some of the greatest pieces of architecture found in Europe. One powerful body in particular, called the 'Council of Ten', was established in 1310 to protect the interests of the Venetian bankers, conduct 'secret' diplomacy, and order assassinations.[15] This organisation, along with the original Templar brotherhood, was an early attempt to create a Masonic-style intelligence service centred in Jerusalem and Venice. Influential families such as the Hapsburgs and Medicis, and various merchant patrons behind the arts, from the Crusades up to the time of the Renaissance, were either influenced by *or* became members of the original Knights Templar. Lorenzo de Medici (known as the 'Magnificent' 1449-1492) was surrounded by members of what became known as the 'Platonic Academy of Florence', a boys club for the élite in Italy. Attended by Marsilio Ficino (a friend of the Medicis and a Florentine cleric), it was the philosophy behind the 'Platonic Academy' and 'Aldine Academy' that would form the basis of a thriving literary and aesthetic culture; one that formed the pillar of European thought over subsequent ages. It was these philosophical 'circles' of the 15th and 16th centuries that would push élite art into the academies and royal societies. The very same families and their secret circles across Renaissance Europe, who were contemplating love, beauty and the higher soul through their elitist meetings, were also funding grotesque religious wars across Europe! Why? Because the thought-forms behind such acts are expressions of duality, separation and the Wetiko Predator Consciousness. The same brotherhoods of ancient Egypt, especially the priest craft that

steered the demise of the Egyptian civilisation, through war and black magic, had also schooled the Assassins and Knights Templar, in the art of the occult.

THE BIRTH OF THE GRAND FAÇADE

From the 16th century, up to the 'official' art of the 19th century, several styles and influences would reemerge in Europe. In the 16th century, an irreparable schism developed in Central Europe between the mainly Protestant north and the Roman Catholic south. This same era saw the re-emergence of the Rosicrucian secret society and a new wave of religious movements in an already devastated Europe that had seen the plague and an *Eighty-Year* war (from 1569). It also saw the rise of the Hapsburg dynasty across the Roman Empire, and the 'House of Hesse Kassel' expanding its wealth and control over much of Europe. Artists, such as 'Bartholomeus Spranger' (1546 -1611), one of the greatest pre-Baroque Mannerist artists, were commissioned by the courts of Prague and Vienna as Europe picked itself up after one of the longest feuds in history. At this time Martin Luther, a German Catholic priest connected to the Royal House of Hesse, squared up against the Pope in a classic case of dualism, creating what became the 'Reformation' and the birth of the Protestant wing of Christianity. The rise of the Protestant belief system, which was just as tyrannical as the Roman Catholic one, did help to break the back of the terrible Inquisition. But all that really happened, was a different name appeared above the door of Christian *control* and, as always, the secret societies who had inspired the Crusades and reformation alike, were fuelling further divides while sparking violent usurpations across the Holy Roman Empire. To counteract the largest schism in Christian history, a Catholic soldier (Templar) turned priest, named Ignatius Loyola, with approval from Pope Paul III, founded the Jesuit Order in 1540. This was just another extension of the earlier brotherhood sects that also mixed war with religion to divide and rule the populace. The Jesuit motto was: *"Black is white and white is black if the Church said so."* This statement is the philosophy that allows religion to control the minds of millions to this day, and allows the same élite power-base to get away with war and division, resulting from such separation. It also relates directly to the black and white checkerboard symbolism I touched on earlier. With the creation of several new orders, sects, and reformations at the turn of the 17th century came some of the most horrendous bloodbaths in an already devastated and plague-ridden Europe. The *Thirty-Year* 'religious' war (1618 - 48) was a perfect example, not to mention the many civil wars and revolutions that would follow. These manipulated divisions across Europe, fuelled by an ever-deepening materialism, helped to revitalise the philosophies associated with humanism and rationalism. Yet, the growing materialism coupled with the lack of vision, spirit and imagination in the 1700s, laid the foundations for a purely rational and totally phys-

ical view of the world. A view that still stifles the spirit while denying total freedom of the imagination in art and society today! It is the art of figures such as Domenikos Theotokopoulos (El Greco) in the 1570s and William Blake in the later part of the 1800s that reminds us of our *true* spiritual essence (more on Blake in a later chapter).

THE ROYAL SOCIETY

It was at this time that élite members of the secret society networks, under the guidance of Sir Francis Bacon, paved the way for the Royal Society and other élite academic institutions, such as the 'Society of Astrologers'. All of the founding members and later fellows were connected to what became Freemasonry, not least the Rosicrucians. Bacon personally used the emblem of the rose as a symbol of secrecy and bloodline. According to Masonic historians, the term *sub rosa* (beneath a rose) means 'that which is held or performed in confidence'. The rose also represents both the organisation and a concealed project.[16] The Royal Society was incorporated on St. Andrew's Day and each fellow was said to have worn a St. Andrew's cross of ribbon on the crown of their hats. Other fellows of the Royal Society were figures such as Isaac Newton and Sir Christopher Wren (the architect behind St. Paul's Cathedral), and prominent protestant clergy such as Theopholius Desaguliers (1683-1744) and George Payne (1685-1757). Dr John Theopholius Desaguliers was a distinguished writer and physicist and friend of Isaac Newton. With Wren, Desaguliers was instrumental in the forming of the 'Grand Lodge of Freemasonry' in 1717. He also had the honour of initiating the Prince of Wales. How lovely! Other monarchs were partial to a bit of Freemasonry, too. James VI was exceptionally sympathetic to Freemasonry, especially when he became James I of Great Britain. This period saw the creation of the financial centre known as Temple Bar in the City of London, and the guilds, which wield great global economic power still today. As always it was Bacon's invisible college (the Knights Templar) behind the creation of the new-look societies (or Bacon's New Atlantis) as they emerged in the 17th century. Thanks to the royal academies and societies that emerged from the Renaissance onwards, art became very much an *élite* practice. And it still is! The patronage of the arts through hierarchal bodies like the Royal Society, moved the 'act of art', as a method of exploring archetypal forces, away from the individual and towards the 'elected council'. We are still feeling these ramifications today, as art institutions and education establishments became more and more obsessed with physical appearance laid down by the philosophies of the Platonic Academy and Royal Society of Arts. However, there is another aspect of art this book sets out to present, one that has travelled in almost an underground fashion throughout the ages. It's the capacity of the visionary to see into worlds beyond the physical senses, so to pick up on this

underground stream of knowledge. The subjects I am highlighting here can be traced back into the ancient world and they deserve as much attention and credence as the history of what we perceive to be linear Art History taught in universities.

CHRISTIAN (ZIONIST) BROTHERHOODS

One group of artists who appeared in the 1840's were the 'The Pre-Raphaelites', whose name seems to indicate reference to *Rapha* meaning 'God heals'. The Pre-Raphaelites were hugely 'connected' to the English writer, philosopher, art critic and polymath of the Victorian era, John Ruskin. The 'brotherhood' painted several establishment figures such as Ruskin, and William Holman Hunt, who painted some of the most beautiful paintings, such as *The Light of the World* (1851–1853), *Christ and the two Marys* (1847 and 1897), and *The Lady of Shalott* (1905). Hunt's work was considered almost blasphemous at that time, due to the subjects that he and his Pre-Raphaelites 'brothers' chose to paint. Hunt, like other Pre-Raphaelites, moved in Victorian 'elite circles' linked to London and Christ Church, Oxford. Hunt painted the portrait of the Canadian Christian Zionist, mystic, Messianist, and millenarian, Henry Wentworth Monk. Hunt, Monk and Ruskin were deeply interested in what the history books call the 'correct' interpretation of the Book of Revelation, and Monk especially lobbied for a Jewish (Zionist) homeland in Palestine (through the Palestine Restoration Fund) as far back as 1875. Monk's writings and Jewish Messianism's 'influence' claimed the Books of Daniel and Revelation predicted the 'Dark Ages'; Monk said these Dark Ages would last until around 1935. He wasn't far out if you also consider the rise of the Nazi Germany in that period. Some scholars have credited the likes of Monk with predicting the formation of the United Nations and both World Wars, although these claims are of questionable provenance. The obvious connection through such élite cricles at this time was not necessarily art, it was politics and beliefs in *occult* knowledge.

ART IN THE AGE OF REASON

The 18th century brought us the 'Age of Reason', an era in which artists throughout Europe adopted a cosmopolitan style, influenced by the emergence of great capital cities, such as Vienna, London and Paris. High-ranking members of the secret society network of guilds and later Freemasons were the real brains behind city street plans. Out of the 18th and 19th centuries came a multifaceted movement known as Romanticism with various themes characterising an era which inspired some of the West's greatest visionaries. The 19th century brought us the *metropolis* and 'official art' in the form of Realism, Impressionism and Post-Impressionism, with the likes of Turner, The Hague School (no relation to me), and artists such as Monet. Out of this

variety of contemporary styles came Surrealism and Cubism, which attempted to break with traditional views (forms). Cubism, instigated by artists such as Picasso and Braque, destroyed all notions of *three-dimensional* art through introducing *fourth-dimensional* imagery. The Dutch artist Van Gogh, in my view, was an artist who made unconscious attempts to communicate a *fifth-dimensional* view, one that is solely influenced by movement and light; something that Einstein realised 50 years later.

All art, in my view, is the reflection of different realities as presented by any given society *or* civilisation. More often than not, it is the art of the mystery school-inspired 'movements' that influenced (mirrored) our collective reality. I am convinved that some sort of archetypal influence, through myth making and later organised religion, inspired almost all of the seemingly separate cultures, movements, styles and eras we call art history. This 'influence' by a brotherhood, or cult I have explored so far, is still paying homage to *unseen* forces, directing styles, subjects, themes, politics and 'agendas' through modern art forms - their global corporate media industries.

NOTES

1) Bramley, William: *The Gods of Eden*. Avon Books, p90

2) Potter, G.R: *The New Cambridge Modern History, Volume One: The Renaissance* 1967, p248

3) The *Bosch* documentary Channel 4 April 2004

4) Maxwell, Jordan: *Matrix of Power*. The Book Tree 2002, p51

5) Dunford, Barry. *The Holy Land of Scotland. A Lost Chapter in the Gospel of the Grail Tradition.* Brigadoon Books. p16-18

6) Hall, Manley, P: *Masonic Orders of Fraternity, The Adepts (part 4)*. The Philosophical Research Society, Inc. Los Angeles, California, p13

7) *Notre Dame de Paris*, Newsweek Books 1971, p19

8) Sutton, David: *Platonic and Archimedean Solids*, Wooden Books, p6

9) Conforto, Giuliana: *Giordano Bruno's Future Science, The Birth of a New Human Being*. Noesis 2002, p 113

10) *Art a World History*, Dorling Kindersley, p245

11) Information taken from a photograph on display to the public at the home of the late Duke of Devonshire (Cavendish) at Chatsworth House.

12) Six Foot Serpent Attacks Brunelleschi. Plate 54, The Divine Comedy by Danté.

13) *Battle of the Trees*, p142

14) Foister, Susan, Ashok, Roy & Wyld, Martin: *Making & Meaning Holbein's Ambassadors,* National Gallery Company, 2001

15) *The Hutchinson Encyclopedia of the Renaissance*, Helicon Publishing 1999, p115

16) Hall, Manly P: *Masonic Orders of Fraternity*, p44

Hidden Signs & Media Magic (1)

Cults, Codes & Warlocks in the 21st century

All letters began as signs and all signs began as images
Victor Hugo

I n indigenous cultures the shaman holds great sway over the tribe, just as in later generations, the temple priest carried on the tradition of using art and magic to influence the population. Priests and Myth Makers all combined art with religion, or art with politics so to dictate the 'state belief system'. The tradition continues in the 21st century through the media/film industries where famous producers and directors create what could potentially be 'new religions' based on political agendas. In an article by Mark Lawson in the *Weekend Guardian* (at the time of the release of *Star Wars, Episode One: The Phantom Menace*), he says: "Francis Ford Coppola advised Lucas when the success of the series became known that, rather than extend the sequence cinematically, he should found a religion with the scripts as the scriptures."[1] Obviously Lucas made the films instead, but he, along with other Myth Makers in times past, must have already known what affect the films would have on a generation of old and new fans. Interestingly, according to the 2000 British National Census, being a Jedi was recognised as a religion due to the thousands who put it down as their 'chosen faith'. The *Star Wars* films, in my view, are classic dualistic creation myths that hint at both ancient and modern themes of good against evil. They even go as far as presenting trade federations and evil dictators who wish to build empires, start wars and instigate assassinations in space. We don't have to travel very far, certainly not into space, to notice the imperialistic empire-builders on Earth today. Combining knowledge of advanced star systems with the ability of an ancient order to use a hidden force for good or ill demonstrates all of the classic signs of a shaman or myth maker at work. I would take that as a compliment George, if you ever stumble across this book.

SYMBOLS ARE THE SACRED LANGUAGE OF THE UNIVERSE

Ancient cultures often used their own rich symbolism to evoke archetypes (energies) during rituals, celebrations and calendar events. Symbols, signatures, logos, and codes form the 'occult languages' I have addressed so far. These languages are still being used by priests and alchemists to influence present day popular culture. Our children and grandchildren, in particular, are immersed in a world of corporate consumerism, Hollywood idols, and subversive advertising, all of which have their roots in myths, symbols, and archetypes. The use of symbols to set free or imprison the psyche is a natural part of our human desire to see beyond the physical world. Symbols form the ancient language of the gods (the language of the birds), an almost forgotten form of communication for the masses but 'common ground' for the visionary myth-maker initiates. Symbols are also codes aiding in communication with forces existing on other dimensions beyond 3D. At an even higher level, certain symbols such as the circle and spiral, help us *see* our connection with the 'soul of the world', they form a universal prelinguistic language I touched on at the beginning of this book. Sacred geometry, or divine geometry, also forms a part of this language, which is another level of communication and one that has influenced many artists and architects throughout the ages. Numbers also speak of hidden levels of knowledge and a deeper understanding with regards to the nature of the Universe. Giordano Bruno said:

> *The order of a unique figure and the harmony of a unique number give rise to all things.*[2]

THE LANGUAGE OF THE MIND

The ancient language of symbols reminds us that deep within our psyche we are endowed with a gift of seeing, one that can lift the veil of a very linear one-dimensional vision of the world, to a multidimensional view of life. Seeing 'through' the world without being mesmerised by the harsh manufactured realities we call life is the task of the visionary, and we are *all* potential visionaries! Conscious symbolism of the purest and highest source goes beyond the mundane and even further than the occult iconography used by the brotherhoods covered in this book. How we *see* archetypes (original ideas) and their connection to *source* can expand our consciousness beyond every day reality, which is why certain forces that control the hierarchy of the secret societies use this very sacred knowledge of symbols.

The subliminal and coded language of symbols speaks directly to the subconscious mind and has a great effect on what we believe, our desires, and our perceptions. Again, the mind is the unseen part of who we really are, and our imagination is the divine aspect of our mind! The use of symbols in art,

cinema movies, media, etc., is one of the most important subjects for anyone embarking on a visual arts course. In this chapter, my intention is to reveal more occult connections within the modern world of art and the media.

CRYPTIC LANGUAGE & 'MIND' CONTROL

Archaeological evidence found in Europe dating back 1.2 *million* years suggests that the use of symbols was an integral part of our ancestors' lives.[3] The earliest records of secret and clandestine orders using codes and symbols can be found in Egypt, the Mesopotamian Empire of Babylon, Asia, and the Americas, too. Also in ancient Greece, Thucydides describes what he believed to be the first complete system of secret ciphers and symbols.[4] Alchemy, which came out of the mystery schools of Egypt, also uses symbols and images usually designed to say one thing but mean another, rather like what comes out of the mouths of most politicians these days. Intelligence networks such as the CIA and MI5, for example, also have their roots in the masonic structures, as we have already seen, and they make use of cryptic language, as do the military.

Every symbol behind 'man-made' religion, from ancient Egypt to the Roman Empire, can be traced back to prehistoric cults and their worship of the stars, planets, the Sun and Moon. An example of this can be seen in the use of universal symbols, such as the cross within a circle, which correlate to the four transitional points of the earth in relation to the stars (zodiac). These points refer to North, South, East and West and are the *four* markers corresponding with the four main elements, levels of consciousness, and world ages. The *fifth* point, for many indigenous cultures, is the place that binds these four sacred directions within our human world (see my book *Through Ancient Eyes* for more on this subject).

The Earth provided archetypal ideas for where we get many of our religious teachings. For our ancestors, the Sky (above), for example, was in constant opposition to the Earth (below), and this basic observation provided the foundations for many stories and myths relating to duality, which I will cover in the next part of the book. Legends associated with light and darkness, good and evil, also came from our primeval (prelinguistic) relationship with the stars, the sun and the moon. The Sun became the god/goddess of Light, and the Moon a god/goddess of Darkness, and both are seen as having interdimensional qualities. The coming of the light brought by the Sun, opposed to the horrors and fears of darkness when the Moon was in the sky, provided important foundations for all religious symbolism going back to the ancient world. The Sun is one of the main points of worship for shamanic cults. It's more than just a life-giver and provider of energy, it's considered a powerful being personified through various images. The Sun, perceived as *all-seeing* (often a goddess figure) for ancient shamanic cults, later became a

father/god archetype for the priests of the Holy Roman Empire.[5] All religions, from Hinduism to Christianity, can be traced back to Sun and star worship, and nothing has really changed over time as the masses today follow their gods, idols, 'stars' and 'legends' of the modern world. Nothing is new when it comes to religion, be it old or new-age models. Even sport is a religion for some! Hollywood, which refers to the 'Holy wood' a place where druids and magicians operated in the ancient world, now turns out idols and star worship of a different kind. In fact, many of these idols are uncannily packaged and promoted as goddess and god-like figures, some of whom we shall come to later in this chapter.

For the fraternities (cults) using Sun (stars) and Moon symbolism, they are like unspoken words that only initiates are able to see and understand. The knowledge hidden behind a symbol is meant for the 'initiated eye' or mind; therefore, thousands upon thousands of people who claim to belong to a religion, or show allegiance to a political party, worship a celebrity, etc., more often than not, haven't got a clue about the deeper meanings behind the symbolism being used by these fraternities. In the subliminal world of the Myth Maker, there is no difference between religion, politics, and mainstream science, media, etc., *they are all dogmas* handed out to humanity and used to divide and rule the masses. What symbolism can show, however, is the connections between art and science, such as astrology and astronomy, as well as the sacred arts used by these fraternities to their own advantage. For the uninitiated (practically everyone outside of the higher levels of the secret society networks), all aspects of society are separated, so no connections are made between the so obviously hidden hand controlling all finance, politics and the state. For the majority of people, 'images' are, well they're just images, aren't they? But is this true? Images and icons have had an important effect on the human psyche and have done so ever since humans made art forms. As the novelist and Freemason Victor Hugo once said: *"All letters began as signs and all signs began as images."* In the next few pages, I am going to explore the forces, archetypes, and symbols used to manipulate the minds of young and old alike.

LUCIFERIAN CULT SYMBOLS

In esoteric literature, 'Prometheus' is also 'Lucifer' who performs the same actions as Prometheus, including the 'gifts' brought by the fire-bringer; both share the notion of a 'fall to earth'. The tradition usually reveres Lucifer not as the devil, but as a destroyer, a guardian, liberator, or guiding spirit to darkness, or even the 'true god' opposing the biblical God, Jehovah. It's interesting to note that Prometheus and the fallen rebel angel (of biblical fame) are seen as the same entity in much mythology, art, and symbolism. There is also

a connection to Orion, and in my book *Orion's Door* I dedicate a whole chapter to the themes I am touching on here.

The legend of Prometheus tells of a Titan deciding to disobey the gods and make humans 'gods' themselves. Prometheus is described as the 'fallen one' (Lucifer) that Christianity has connected to Satan or the devil. Prometheus, as Lucifer, is also characterised in Egypt as the hawk-headed Horus magically conceived by Isis (Sirius) and the murdered, or fallen Osiris (Orion) who was killed by his brother, Set (Saturn). The red desert deity Set (Seth) is a variation of Yahweh/Jehovah (Gnostic Demiurge), who became Horus's sworn enemy. In simple terms, the imagery associated with Prometheus, Lucifer, and Satan (Saturn) describes Adam's connection to Orion (Prometheus) and Saturn (Cronos/Satan) through a *fallen state*, from a celestial (Aeon/spirit) to the density of the soul, and eventually to physical matter.

The connection to pre-Christian cults such as Orphism and Dionysus also relates to the 'fallen' deity sun god who descends into the Underworld, and returns. Like Dionysus, 'Adam on high' *is* the Son of Man who begins in heaven and 'falls' to the physical plane, returning to heaven. As seen by the Orphic cults, Dionysus was 'divine in heaven', but in the flesh (as Zagreus), he was a 'fallen one' – a Titan just like Prometheus. The pagan world seemed to marry the Christian world through 'Orphic' and 'Gnostic' belief in a 'Son of Man', the latter of which became the Christian idol, Jesus. As Carl Jung says in his work, *Man and His Symbols* (1964):

> *The Son of Man, though born of a human virgin* [if you believe this], *had his beginning in heaven, whence he came in an act of God's incarnation in man. After his death, he returned to heaven but returned once and for all, to reign on the right hand of God until the Second Coming when the dead shall arise.*[5]

Prometheus, like Lucifer, is a revealer of endless challenges for humanity. Prometheus is also William Blake's *Glad Day - the Dance of Albion* (1795) and a primeval giant, whose fall and division results in Blake's *Four Zoas*: 'Urizen', 'Tharmas', 'Luvah/Orc', and 'Urthona/Los'. In my rendition of Blake's image, *Dream Fulfilled* (1995), Albion is a creator, liberator, and 'man of light' descending to earth (see figure 59 overleaf). In Blake's mythology and representation of biblical figures, both Adam and Satan were contained within the 'egg' which burned from Lucifer's fire, surrounded by Blake's version of the Four Adams (Urizen, Tharmas, Luvah/Orc, and Urthona/Los). For Blake, Los is the *fallen* (earthly human), based on Prometheus and his imprisoner, Hephaestus; both figures are connected to 'bringing' and 'using' star fire (light) belonging to the gods, or God.

The global Freemasonic structure was (and still is) huge, playing an

immense part in the running of business, education, politics, banking and the military all over the world. As I've already explored in previous chapters, every monarch, emperor and their courts were members of the masonic structure. These orders have been given many names throughout history, such as the Knights Templar, the Rosicrucians, and later the Freemasons. All of these clandestine groups are connected to the intelligence networks such as MI5 and the CIA, etc., and all use similar symbols that have roots in the ancient world. Many of these organisations can be traced back to the time of the Crusades (11th century), but came to promi-

Figure 59: Prometheus light-man.
My painting entitled *Dream Fulfilled* (1995), also used as cover art for David Icke's book *And the Truth shall Set You Free* (1995), is Promethean in nature.

nence at the time of Elizabeth I when super spy Sir Francis Walsingham (1577) pioneered the 'licence to kill' of 16th-century Britain in true Hollywood/James Bond style. Today, every president and prime minister are members of one or more of these secret organisations, not least the American Delta Kappa Epsilon fraternity, which I explore in *Orion's Door*. All use codes, ciphers and symbols that speak of their allegiance to unseen forces and the Cult of Lucifer.

The whole basis of Freemasonry hinges on secrecy, oaths and the refusal to impart ancient hidden knowledge. Joseph Fort Newton, writing in 1916, held that Freemasonry did not evolve from guild masonry. He wrote: "*Freemasons existed in large numbers long before any city guild of masons was formed.*"[6] According to Newton, the Freemasons were a 'superior group' that occasionally hired rough masons from the guilds to carry out work on buildings and temples. Freemasonry, as an ancient fraternity, is littered with the same god and goddess symbols found in the ancient world. The compass, star, and laurel wreath, for example, relate to architecture and the building of temples; they are statements about the metaphysical structure of reality and control through hierarchy. The laurel wreath is a major symbol for these organisations and can be found amongst the insignia of ancient Rome, and the United

Nations, both of which are examples of global (imperial) government. Many of these symbols also connect to 'off-world entities' and the orders that venerate lower astral forces. Certain symbols are also found in alchemical illustrations, contemporary visionary art and movies, etc. The reason for this is quite simple. Either the artist or film director is an initiate, or they were inspired by the knowledge hoarded by clandestine groups I've been touching on here.

As previously mentioned, numerology (number symbolism) is also important to the Freemasonic secret society networks, and in truth, the 'science of numbers' relates to Sun worship as practised in the ancient world. Civilisations like the Maya, Sumerians and the Egyptians had a comprehensive understanding of the cycles of electromagnetic activity taking place on the Sun. This activity is referred to as sunspot cycles which seem to be studied as a science and taught through 'numbers' and symbols in the secret societies of Egypt and South America. Many symbols used in Freemasonry relate directly to worship of the Sun, or Orion, and others to Satanism, which is alarmingly prolific within Hollywood, politics, and the military industrial complex. Codes and symbols often found in Freemasonry, such as the 'All-Seeing Eye', relate to ancient cults and how the magnetic cycles of the Sun, Moon and planets affect life on earth. I will return to this subject more clsoely in the next part of the book. Other symbolism relates to Pagan religions focused on creativity, fertility and infertility cycles in humans, depending on when the Sun and the Earth's magnetic fields are mutually coupled.

THE ORION CONNECTION

The network of secret societies and mystery schools (going back into the ancient world) is linked to what I see as a 'Stellar Cult'. The Cult of the All-Seeing-Eye (or the Illuminati) and the Luciferian Cult are the same organisation. The Cult I am describing can be seen as an 'interstellar', clandestine intelligence stretching back into the ancient world, possibly ancient Egypt and Atlantis. The Cult seems to have infiltrated the ancient mystery schools, eventually infusing 'strands' of western 'hermetic occultism' (coming out of the Reniassance 15th and 16th century) into what became known as 'esoteric' Pagan and Judeo-Christianity. Some of the ancient symbolism used by occultists through antiquity crossed over into the alchemical, hermetic mystery 'schools of thought' (especially hermetic symbolism) which is a main interest of research topics in my books. Similar themes of unseen, off-world forces is also found in global native and pagan mythological stories relating to Orion, a huge subject I cover at great length in *Orion's Door*.

The Hermetic Qabalah (*not* the Kabbalah) is a Western esoteric tradition involving mysticism and the o*ccult*. It's the underlying philosophy and framework for late 19th century secret societies such as the 'Golden Dawn',

'Thelemic orders', mystical-religious societies, like the 'Fellowship of the Rosy Cross', and is a precursor to the Neopagan, Wiccan and New Age movements. It is simply 'knowledge', like all esoteric systems, and can be used for good *or* bad.

The Luciferian Cult is, in truth, an Orion (interstellar) Cult, or what can also be called the Orion-Saturn-Moon Cult (a tripartite cult). It **does not** belong to *any* faith (or *any* human race); I would suggest, it is *not of the earth* and operates 'above' the concept of nations, race and religions. The Cult has no allegiance to *any* nation on earth, and *all* are 'expendable' to its 'earth-based operations'. Its source *is* 'off-planet' (otherworldly), possibly connected to malevolent extraterrestrial consciousness originating in Orion and elsewhere. One can see the Cult symbolically as the 'eye' atop the pyramid, and at a very basic level it could be referred to as a Star Cult, not least because of the focus on Orion's stars from Earth.

The Luciferian/Orion Cult could also be seen to focus on 'death', destruction, and 'chaos' so to affect the human spirit, soul, and mind through use of *magic* and *advanced tecgnology*. Such magic, anchored through Orion-Saturn-Moon rituals, I feel, relates to hidden star-technology and specific aliens, or 'artificial intelligent gods' behind the advancement in our tech-science that is dramatically changing the human habitat, globally. The legends of the trickster gods (to 'trick or deceive'), especially Native American Indian references to the 'giant' spider god/goddess, 'Iktomi', found in so many ancient myths, could be seen as another expression of the alien archetype connected to the Star Cult. Groups of *three*, also seem to be a blueprint within the Cult, too, possibly based on the magic of three 'points of light', or 'stars' (Orion's belt stars); three occult groups combined could represent the triple influence of Orion-Saturn-Moon. I keep coming back in my mind to Tolkien's fictional 'Istari' (the White Council), the *three* wizards of an ancient Middle Earth, or the Jedi and Sith in Lucas's *Star Wars*.

HOLLYWOOD ALIEN INVASIONS

The Star Cult I am touching on here, is centuries ahead when it comes to technology and 'secret science', compared to what the masses consume. A perfect example of this is the cover-up by intelligence agencies around the world, of UFOs and extraterrestrial activity while using the same knowledge in government space programmes and defence systems. The weaponisation of outer space (the Star Wars programme) launched by the USA in the 1980s, through to Elon Musk's Space X, is another example of advanced science being used by government agencies in league with Cult scientists and their extraterrestrial connections. The obsession has continued over many decades with the American Defence Departments and the high-level space commis-

sion, set up to further the original Star Wars programme. An article by James Wilsdon for the UK *Guardian* newspaper (1st March 2004), says that: *"military control of space was the only way for America to avoid a 'space' Pearl Harbour."* I would say the 'weaponisation' of space was sold to the American public over the decades as the ultimate way to win the 'war on terror', but its real reason is more to do with having technologies in place to secure global governance and a future dystopian cyber-grid empire.

In the early millennium years, the United States Government launched a satellite called the 'Near Field Infrared Experiment' (NFIRE), a weaponised satellite carrying a projectile-packed 'kill vehicle' that could destroy passing missiles, or satellites of the United States' military and commercial rivals, according to ABC News. NFIRE's test was just the first spark of a conflagration that, over the years, has set the heavens ablaze with American weaponry capable of striking and destroying any spot on earth. As one top Pentagon official opposed to this proliferation, and thus remaining anonymous, said: *"We're crossing the Rubicon into space weaponization."* Chris Floyd writing for the *Moscow Times* in April 2004 went even further, when he said:

> God's Rods' [NFIRE's] *will be accompanied by orbiting lasers, 'hunter-killer' satellites, and space bombers that needn't bother with silly-billy legal worries about 'overflight rights' from other countries, but can descend out of the ether to swoop down on any uppity nation that displeases the world-Caesar in Washington.*[7]

We have come a long way since 2004, through lethal autonomous weapons, drones and the advancement of all-things artificially intelligent, or Smart.

There is no doubt in my mind, based on endless movies and programming stretching back to the 1940s, that extraterrestrials will be used as a threat to world peace in my lifetime. Yet, how do we know that weaponising space is not to be used at some point 'against' humanity? With or without the need for genuine extraterrestrials, the saturation of extraterrestrial-related themes in the media and Hollywood over the years *are* an expression of both a hidden science of where such a science originates. The leaking of extraterrestrial phenomenon is, in my view, to prepare people for a 'staged' alien invasion, or threat of one! Endless movie directors have reinforced the narrative, not least Steven Spielberg with the classic alien invasion theme in his 2005 remake of H. G. Wells' *War of the Worlds*.[8] The invasion of earth and humanity by extraterrestrials (non-humans) is seen in endless other movies. See also the original *The Day the Earth Stood Still* (1961), through to the Marvel Universe movies of recent years, such as *Avengers: Infinity War* (2018) and *Endgame* (2019). Other films, to name but a few, include: *Invasion of the Body Snatchers* (1978); *War of the Worlds* (1953 & 2005); *Signs* (2002); *The Invasion*

(2007); *Skyline* (2010); *Attack the Block* (2011); *World Invasion: Battle Los Angeles* (2011); *Cowboys & Aliens* (2011); *Battleship* (2012); *Pacific Rim* (2013); *Oblivion* (2013); *Edge of Tomorrow* (2014); *The 5th Wave* (2016); *10 Coverfield Lane* (2016); *Independence Day* (1996); *Independence Day Resurgence* (2016); *Arrival* (2016), *Men in Black Trilogy* (1997-2019) and, of course, the seven *Transformers* movies (from 2007 onward). The *Transformers* movies, in theme only, are probably the nearest to what I see as a specific cyborg intelligence originating off-world, but coming to earth and inspiring some of our ancient (pre-historic) civilisations. I would not be surprised to find out that a planet like Cybertron, the place from which these sentient cyborgs originated, is located in the Orion constellation.

Alien invasion-related themes were exposed by Dr. Carol Rosin, the first female corporate manager of Fairchild Industries and spokesperson for the acclaimed scientist, Wernher Von Braun. Von Braun's work during the last years of his life was, according to some writers, to educate the public and decision-makers about why space-based weapons are dangerous, destabilising, too costly, unnecessary and an undesirable idea. Dr Rosin founded the Institute for Security and Cooperation in Outer Space, a Washington DC based think tank. In an Internet article, Carol Rosin says:

> What was most interesting to me was a repetitive sentence that he [Von Braun] said to me over and over again during the approximately four years that I had the opportunity to work with him. He said the strategy that was being used to educate the public and decision makers was to use scare tactics ... That was how we identify an enemy.

> The strategy that Wernher Von Braun taught me was that first the Russians are going to be considered to be the enemy. In fact, in 1974, they were the enemy, the identified enemy. We were told that they had 'killer satellites'. We were told that they were coming to get us and control us – that they were 'Commies'.

> Then terrorists would be identified, and that was soon to follow. We heard a lot about terrorism. Then we were going to identify third-world country 'crazies'. We now call them Nations of Concern. But he said that would be the third enemy against whom we would build space-based weapons.

> The next enemy was asteroids. Now, at this point he kind of chuckled the first time he said it. Asteroids-against-asteroids we are going to build space-based weapons.

> And the funniest one of all was what he called aliens, extraterrestrials. That would be the final scare. And over and over and over during the four years that I knew him and was giving speeches for him, he would bring up that last card. 'And remember Carol, the last card is the alien card. We are going to have to build

space-based weapons against aliens and all of it is a lie.' [9]

As already stated, it is more than likely that 'aliens' are part of an alternative earth history, one recorded in myths and legends, and they are already here and part of our DNA as far as some scientists are concerned. The term 'Junk' DNA is mainstream science's apologetic attempt to pass off unexplainable extraterrestrial connections to the molecular structure of our own life-force, our blueprint. The secret societies I've been outlining so far know different types of interdimensionals (extraterrestrials) exist and that parallel realities house what we call demonic (alien-like) creatures. They should know, because they have been conjuring up Archons (Jinn) in satanic ceremonies for thousands of years.

Films that support political and religious rhetoric through their themes or historical content, too often, coincidently, hit the cinema screens to reinforce the spin put out by governments. The film *Pearl Harbour* (2001) came out just at the right time, when Bush was telling America, in relation to the atrocities of 9/11, that this was 'our Pearl Harbour'. The machinery of Hollywood is so often used as a political tool and many films seem to appeal to the game plan laid out by governments in keeping with a New World Order. In a fantastic book *Operation Hollywood, How the Pentagon Censors the Movies* (2004), author, David Robb shows how filmmakers bow to pressure from the Pentagon when making films involving the military. Films such as *Forrest Gump* (1994) and *Star Trek IV - The Voyage Home* (1986) are just two of many films that had to pass through the Pentagon for approval. Apparently *Forrest Gump*, according to David Robb, was considered by the army to be 'not the kind of soldier the army would have recruited during the Vietnam War'. According to an internal Army Department memo, the film's screenplay and the nature of the lead character played by Tom Hanks, gave the impression that the Army in the 1960s was staffed by the guileless, or soldiers of minimal intelligence.[10] That impression, the army said, was neither accurate nor beneficial. But as Robb points out in his book, the Army did recruit soldiers with below-par intelligence, especially under Secretary of Defense at that time, Robert S. McNamara's *100,000 Project*. Under this Project a directive allowed enlistment of soldiers who had previously failed to pass armed forces intelligence tests. At least one out of around 350,000 recruits was said to have had an IQ of 62, much lower than Gump's in the movie.

Hollywood pictures are also used for their potential recruiting value by the military and continue to do so. Military propaganda through war films and on TV over the past fifty years, has desensitised people to the effects of war. Peter Jackson's rendition of J.R.R. Tolkien's books *Lord of the Rings* trilogy, appearing in the aftermath of 9/11, parallels the wars that followed in the Middle East (Middle Earth) between 2001 and 2003. I enjoyed all three films

and feel that Tolkien was a genius; however, the underpinning messages of waging war through a coalition, along with 'the return of a saviour-leader-king', is too coincidental not to be in line with deeper occult teachings and an agenda for a New World Order, or as it is now known, 'The Great Reset'. More on this in the next chapter.

THE SECOND COMING?

Many films also reinforce themes of good versus evil, heroes and villains, and the *dualism* touched on so far in this book. Mel Gibson's 2004 movie *The Passion of the Christ* was, in my view, a deliberate propaganda exercise revelling in classic, bloodlust imagery and an almost satanic sado-masochistic empathy akin to cheap horror movies. Films of this kind, whether Gibson intended it or not, seem to reinforce fundamentalist, religious values that can be applied to any belief system. As Richard Eyre, writing in the UK *Guardian* (at the time of the film release), says:

> *The Passion of the Christ reflects an angry longing to return to a medieval world, uncomplicated by liberal ambiguity and scepticism. It's perfectly timed to coincide with Manichaen politics of the Bush administration. The plague of fundamentalism has remained dormant for centuries only to become virulent in the 21st century.*[11]

This type of movie-as-propaganda is highly relevant to the 'crusade' we witnessed in the Middle East from 2003 onwards, one fuelled by Muslim and Christian division for those willing to take sides (even die) for their beliefs. All division and war are terrible, and as always, it's the innocent, mainly the poor, that suffer at the hands of the fundamentalist mindset.

At the time of the war in Iraq, George Monbiot, author of *The Age of Consent - A Manifesto For a New World Order* (2004), described the strong support Christian fundamentalists provided for Bush's war in the Middle East. Back in the early millennium 'true believers' seem to actively provoke a final battle scenario with the Muslim world as they believed this would usher in the *Rapture*, as written in Revelation, and that they will be wafted up to heaven, to sit at the right hand of God, watching the rest of us endure years of Tribulation. At the time of the Iraq war, according to Monbiot: *"American pollsters believed that 15-18% of US voters belong to churches or movements which subscribe to these teachings."* [12] A survey in 1999 suggested this figure included 33% of Republicans. The same perception of 'taking sides', *believing* in good against evil and almost wanting a final retribution, can also be seen at the time of the invasion of the Ukraine by Russia in 2022. The 'believers' don't necessarily want to see facts when it comes to a televised war, *or* know who and why such horrors start in the first place.

During the American-led Afghanistan and Iraq invasion, the best-selling contemporary books in the US were the 16 volumes of the *Left Behind* series by Tim LaHaye and Jerry B. Jenkins, providing a fictionalised account of the Rapture, showing scenes of war in the Middle East, people disappearing into thin air and the allusion to Satan (a serpent) running the White House and pentagon! Another movie called the *Megido Code 2* (2001) starring Michael York, also hints at similar themes relating to Revelation and a final battle between the United Nations (Nato), Russia, China and the USA. York plays a shape-shifting reptilian anti-Christ world leader, pursuing total control of the planet. It's not too much of a stretch of the imagination to see the 'Beast and the Red Dragon' of Revelation as China's growing 'power' today.

Fundamentalism of any kind is a barometer for the levels of mind control in our world. The 'neo-conservatives' surrounding the Bush adminstration between 2000 to 2008 *were* as fundamentalist in their attitude as the Islamic fanatics they opposed. With the public inattentive, there was (still is) no check on Christian-Zionist agitation focused on years of conflict in the Middle East. The then Deputy Defense Secretary Paul Wolfowitz (who also became head of the World bank) summed up the crusade mentality when he spoke to *Vanity Fair* magazine in an amazingly candid interview in 2003. In the astonishing dialogue we are told that Saddam's purported arsenal was almost beside the point and not the prime reason for invading Iraq. The real reason back then was the President's conviction that 'he was in an epochal fight against evil and had the 'historic opportunity to reorder the Middle East'. Then Prime Minister Tony Blair also announced a speeding up of the introduction of compulsory identity cards, especially in the wake of the hor-rors of 7/7 in London in 2005. Look at what has happened in recent years with the Covid era and the forcing of citizens to carry electronic vaccine pass-ports to be able to travel! More on this later. Carrying a microchip (under the skin) providing immediate access to our personal data was always the next step to achieving total control, a global dictatorship! The Domestic Intelligence Agency in the United States, created after 9/11, according to the Associated Press, reported the FDA also approved human brain implant devices that can read minds and act on instructions.[13]

When I originally wrote this book in 2004–5, I said: "In due course it's like-ly that it will be made compulsory for individuals to carry ID cards at all times." The Covid pandemic of 2020, as I will come to in the next chapter, is the final onslaught on human freedom, not a war, or act of terror, but a psy-chological attack on humanity. At the time of editing this book, digital ID (microchips under the skin) is just a vaccine (or *three*, or *four)* away.

STRANGE CODES AND CREATURES IN HOLLYWOOD
Obviously not all movie makers are out to manipulate consciousness, but

some powerful producers and directors seem to tap into streams of knowledge connected to the mystery schools and secret societies I've been describing in this book. As always, it's esoteric 'knowledge' relating to the mysteries that bring artists together throughout history. The same is happening amongst film directors (and media figures), many of whom will be members of clandestine societies. Hollywood films are teeming with esoteric themes, codes and references to gnosticism, the occult and often the Kaballah. California, especially, has been a haven since the 1960s for cult groups, CIA operatives, and initiates of secret societies connected to both the music and film industries.

Truths regarding the nature of reality and unseen forces manipulating (controlling) our world can be found many movies. More often than not, some films are made by artists who have limitless funding and access to information regarding future science, extraterrestrials and the nature of reality. Producers and directors like Spielberg, the Wachowskis, James Cameron, Darren Aronofsky, etc., seem to have their fingers on the pulse of 'all-things mystery-school' related. Steven Spielberg's films, especially, are littered with themes connected to an underground history *and* extraterrestrials, which makes one wonder if he, and other producers and directors are prominent members of the Cult I am exploring? At the time of writing I have no evidence to support this theory, but films such as *Raiders of the Lost Ark* (1981), *ET* (1982) and *A.I.*(2001), *Super 8* (2011), etc., are only a few examples of Spielberg's possible levels of knowledge and much more besides.

George Lucas, Tim Burton, Martin Scorsese, Francis Ford Coppola and the late Stanley Kubrick, also touched upon subjects telling of an underground stream of knowledge practiced in the mystery schools of antiquity. Many books and novels also provide directors with 'source material' for films, such as the Tolkien epics, *The Lord of the Rings*, *The Two Towers*, and *The Return of the King* (2000-2003) which also speak of an 'untold history'. Many times we are seeing themes telling of a history featuring strange creatures, advanced civilisations and knowledge of 'invisible forces' that, in my view, still direct and influence the world. Tim Burton's *Beetlejuice* (1988) is just one of many examples of how ancient legends telling of star systems (such as Orion) and 'godlike' aliens appear in modern film. Starring Michael

Figure 60: Koshari clowns & Orion.
A Koshari compared to the character *Beetlejuice* in the movie of the same name.

Keaton, *Beetlejuice* features a 'shape-shifting clown' called Beetlejuice, show-ing him wearing the black and white stripes of Native American Koshari clowns (see figure 60). The same imagery represents the unnatural god, 'Haokah', who was referred to as 'the ruler of dreams'. It's no coincidence the imagery connects because for the Lakota Sioux, the Koshari or Haokah were considered 'sacred' clowns from Orion. From Betelgeuse, to be precise! Just don't say his name '*three* times'!

There are hundreds of other films reinforcing some of the themes outlined in this book. George Lucas's *Star Wars* movies are a mirror of the legends told of ancient empires and secret societies (priesthoods) found in Earth's ancient history. In relation to some of Tolkien's mythical creatures, I have seen arti-facts in the British Museum in London that suggest not all of Tolkien's char-acters are 'fictional' and that some are clearly associated with a history prior to the Sumerian empires. In fact, the discovery of a race of hobbit-like humans from Indonesia, dating back 13,000 years, suggests that Tolkien's world may not be so far-fetched after all.

Lucas's *Star Wars* films also hint at tyrannies using Trade Federations to wage war and levy sanctions on planets in a Galactic Confederation. Lucas's Sith and their Probe Droids (drone CCTV in space) from *Episode One: The Phantom Menace* (1999), are an almost prophetic phenomenon when one con-siders the prolific use of drones since 1999. The official *Star Wars Guide* describes the Probe Droid as the 'dark eye' able to see all-that-moves in the shadows. The Sith in Lucas's stories are too close for comfort in relation to the phantoms, demons and élite orders that have influenced our world for thousands of years. Did the worshippers of Seth (Sith), in ancient Egypt, practice the dark side of the force? One only has to take the *Star Wars* scenario out of 'space' and shrink it to the limits of the Earth today to notice a striking correlation of themes suggesting our senates, republics and global political structures are also run by 'unseen' clandestine tyrannical forces. In *Episode Three: The Revenge of the Sith* (2005) the Republic is replaced by an Empire cre-ated by forces designed to control the galaxy in a Nazi-style takeover. Cloned armies and *robot armies* are controlled by dark forces (the Sith) I touched on in *Chapter Five*. None of this science fiction is necessarily out of the realms of possibility here on Earth, too. Aldous Huxley's novel *Brave New World* (1932) is more revealing as to the type of global society awaiting us if our DNA is manipulated to produce cloned, or microchipped people. The use of mRNA vaccines in the wake of the so-called Covid 19 pandemic, according to some scientists, could partly be creating such a *new* global society, where people would become cyborgs, created merely to sustain a civilisation that fosters uniformity, 'stability through conformity' (the herd mentality) – and with **no** individuality allowed! For a futuristic view of how the earth could look if humanity became cyborg-clones in a new world, see the movie *Surrogates*

(2009). The reference to clones turning against their masters (the Jedi masters) and the tussle between the forces of darkness and light using these 'codes' in *The Revenge of the Sith*, seems to be an inferred reference to knowledge of how DNA shapes the human psyche. The 'force' operates outside of the programming and, depending on our focus or intent, can be used to control or free our personal universe, or our reality.

EMBEDDING UNDERGROUND KNOWLEDGE

Directors like Lucas seem to be skillful at hiding true knowledge of the nature of our world behind the label of science fiction. In his first film *THX-1138* (1971), Lucas covers an oppressive, sexless, bureaucratic society where robotic police give chase to a fugitive hero figure. Thirty years later Lucas's friend Spielberg also produced *Minority Report (2002)*, which like *THX-1138*, also hints at the type of society and technology desired by the predator consciousness (Wetiko) operational in a New (reset) World Order. In perhaps his farthest-out moment, in 1969, Lucas was also hired by David Maysles to shoot the Rolling Stones in concert at what would become a 'doomed' event at the San Francisco, Altamont Raceway Park. With a hundred Hell's Angels for security, thousands of people were injured, with four concertgoers losing their lives (one of them murdered). The death-by-music gig occurs more than once as we shall see. The writer Jim Paul says of Lucas: *"Though he draws on our century's pop culture for his raw material, his vision arises from the Middle Ages."* Again, I would suggest Lucas, like other Hollywood moguls, are initiates into the mystery schools traceable back to the Middle Ages.

Spielberg's talents aren't limited to the movie set. He has also proved to be one of Hollywood's nimblest of entrepreneurs, amassing a business empire that includes video games, toys, and even restaurants.[14] Joseph McBride, author of the *Unauthorized Biography of Steven Spielberg* (1997), says: "Spielberg is much more in touch with his subconscious than most people." And that's the point! Directors, artists and producers like Spielberg seem to have their finger on the pulse of future culture, science and the art, when it comes to supplying us with films and games, all vehicles for influencing the subconscious, shaping reality and mesmerising people in typical Hollywood wizard-like manner.

Author Michael Tsarion shows in his extensive research how many movies can also represent multiple aspects of ancient stellar lore and archetypes found in astrotheology; not least the symbolism found in the Tarot and the *Egyptian Book of the Dead*. Science fiction is, in my view, an invention used to hide the true nature of reality. The knowledge, language, symbols and information found in much science fiction, horror, and other similar genres, can be sourced in ancient myths and legends.

The directors, writers and artists connected to the corporate giants behind

the film industry know how the power of myth, and storytelling especially, can influence the subconscious mind. It's not by accident that logos for for some of the biggest companies, such as Tri-star and MGM, are mythological creatures that carry archetypal knowledge and power. Certain films are also packed with codes, esoteric symbols and other numerological meanings, too. Stanley Kubrick's movie *2001 - A Space Odyssey* (1968), which considers 'time travel' and utopia amongst other things, is said to contain secret codes. Some researchers in this area have even gone so far as to show correlations between the numerological codes found in this film and their connection to the date 9/11. The intriguing fact that Kubrick died in 2001 (after the release of his eyebrow-raising film, *Eyes Wide Shut* (1999), which looks at the machinations of a Satanic élite, is strange enough to say the least.[15]

To sum up at this point: the underground knowledge of what is really going on in the world is embedded in many Hollywood productions, literature, books and themes that are conveniently dubbed 'science fiction'. Books that also make it big-time, such as the *Harry Potter* novels written by J.K. Rowling, have gone a long way towards reinforcing the 'good against evil' scenario; all the *Harry Potter* films are littered with semi-religious occult references. The themes within Rowling's books, in my view, seem aimed at enhancing good-against-evil stereotypes found in other higher quality literature throughout history. As the *Harry Potter* books progressed (as with the films) plots became darker and more 'Saturnian'. Here's the twist! If we categorise George Orwell's *1984* 'fiction', while presenting subjects relating to artificial intelligence, extraterrestrials, and parallel worlds (along with a whole range of Netflix dramas and thrillers) as 'science fiction', are we then denying the very fact these subjects are not part of our present reality? Can one look around and say that Orwell's world is not glaring right back at us, or that Huxley's *Brave New World* is not just around the corner?

SPEAKING WITHOUT WORDS

Truth regarding the background of official religion, science, and the real nature of life has been withheld from the masses for hundreds of years. Instead, half-truths are fed to the public in the form of esoteric codes, myths, and allegories, otherwise known as religious teachings. Much of history, as with many scientific theories, is part of a belief system more to do with maintaining the status quo rather than about expanding subjective knowledge of life and creation.

Symbols and allegories in religious teachings serve to reinforce dualistic belief systems (good against evil), which are still active courtesy of the media industry. Hollywood, especially, produces endless movies with plots revolving around constant battles of good against evil. More often than not, the movies reflect the collective subconscious in their constant themes pertaining

to dualism aimed at the collective psyche. Certain brands, logos and symbols through semiotics*, are also attached to dualistic themes. The use of colour also influences the subconscious mind when it comes to consuming endless images, products and messages expounded by the media. It's in these areas that more subliminal symbolism is used to persuade and therefore act in a desired way. David Givens, director of the Center for Nonverbal Studies in the US notes: "Pictographic traditions rest on semiotic principles, which seem to have deep roots in human perception and cognition."[16]

We are spoken to 'subliminally' every day through newspapers, film, advertising and a broad range of visual media, especially symbolic inertia and colour use. Daily, sex and violence, sport, and duality are used across all tabloids in *every* country as 'triggers' for the subconscious mind. Psychologists tell you that emotions shape our lives. Therefore, to elicit certain emotions, our perceptions will ultimately reinforce a desired response. In other words, controlled behaviour will always respond as it has been taught. We also become what we watch, and knowing this is fundamental to understanding why so much dualism (good against evil) is portrayed in Hollywood, news reports, and across the myriad of soap operas. How news is reported is a classic example, too. One only has to listen to the daily bulletins to appreciate the subtle use of duality in what has become 'quick fix' news reporting.

The use of logos, names and symbols across tabloid newspapers tells us more regarding the true nature of their purpose. Much of what passes for information and entertainment is purposely of a very low level intelligence. Endless programmes from soap operas to reality TV are aimed at rendering the viewer passive, sceptical and cynical towards anything that might uplift and inspire personal vision beyond mundane daily routines. For example, the *Daily Mirror* in the UK seems to be a deliberate reference to the more esoteric meaning behind mirrors and how thoughts and emotions of the masses are reflected or massaged (in the *mirror* – reality) on a *daily* basis. The tabloids are designed to shape our collective reality and from that perspective we get the tabloids we deserve. *The Sun* is a direct reference to *the* Sun and therefore relates to ancient Sun worship by a priestly class whose mark can be seen in all areas of business, politics and religion, especially through the use of symbols and insignia (see the work of Jordan Maxwell). The rising sun is a symbol relating to the power of the priest over the masses. Jordan Maxwell writes in his book, *Matrix of Power: Secrets of World Control* (2000):

> *Symbols and emblems are the bottom line of any revelations. If you don't know how to read the symbols, you won't know what the story is truly about.* [17]

*****Footnote:** the systematic study of 'sign processes' (semiosis) and 'meaning making'.

Similar hidden meanings are attached to the stars and stripes, the sun, and star on the NATO emblem, along with other uses of the rising sun on many flags, all relating to this knowledge, as does the Phoenix Sun-bird icon found on several newspapers (eg., *The Independent*) and corporate insignia. *The Express* and *The Times* newspapers in the UK both use Knights Templar emblems, again relating to secret societies that created the media empires now controlling the flow of information (the official line) to the masses.

LIKE SHEEP TO THE SLAUGHTER (NORMS POLICING NORMS)

The essayist Thomas Carlyle said that critics of his day were like sheep following thought patterns and conforming to norms that blatantly curb freedom and individuality. Anyone who dares to offer alternative visions (the crime of being different) of life finds themselves shunned by the majority. The herd mentality allows forces (illustrated in part in this book) to mould the world into a global fascist state. The media is largely responsible for the way in which people get information, and is therefore instrumental in creating 'collective reality'. Try and find articles in *any* newspaper regarding some of the subjects covered in this book and you'll be lucky! The same élite organisations that fund wars and run governments also declare war and own the media empires that offer biased reporting. The military operations in Iraq in 2003, for example, were watched and reported on by selective 'embedded' journalists who were told what to report on and what images should reach the public in the West.[18] The British Defence Secretary at that time, Geoff Hoon, said the imagery the embedded journalists broadcast was at least partially responsible for the public's change of mood in supporting the war.[19] Exactly the point! The same 'media spell casting' was used throughout the Covid era in 2020-22, to 'persuade' the public to accept *unnecessary* lockdowns and draconian law changes, all for the sake of a virus.

News and sound bytes designed to push political agendas, especially in relation to the increase in laws blatantly eroding civil liberties, are reported with 'indifference' by the mainstream media, always following the same line: "The government is considering a major extension of anti-terrorist legislation to enable pre-emptive action 'to be' taken against terror suspects." This followed with something akin to: "The legislation has been widely condemned by human rights and civil liberty groups." The tone implies that the government is *against* civil liberty groups, when in actual fact legislation of this kind affects *all of us. It's classic dualism at work!* Through newspapers and televison broadcasts, the real empire behind the media does not want the masses to realise that most legislation passed since 9/11, for example, has fundamentally affected the freedoms of all people. Look at the UK's Coronavirus Bill passed in 2020, it is nothing short of medical tyranny. True journalism offering alternative views, in a world so obviously manipulated to believe lie after

lie, hardly exists. In such cases, any genuine journalists are usually vilified for telling the truth. A prime example is the case against Andrew Gillingam and the obvious 'removal' of UK weapons expert Dr David Kelly in 2003. The mainstream media empire has the ability to control minds, and many people willingly surrender their minds, their individuality, to the powers that be! Media power can be summed up in five main points:

1) Diverts our attention by focussing on irrelevent issues, such as soaps, trivia, sport, and sex.

2) Reinforces often incorrect biological and historical data.

3) Stereotypes many different groups so that people are encouraged to foster polarised views.

4) Uses propaganda to reinforce the official line.

There are many variations of the above areas of media mind control. As I have alluded to already, pandemics immediately come to mind. These types of news bulletins are used to create fear for the purpose of manipulation; drug cartels, or Big Pharma, profit greatly from such tactics. Whether a 'threat' of a pandemic, or biological terrorism, FEAR is used by governments to take more human rights away. Creating a global problem—a war, a pandemic, an economic crisis, etc.—and then selling it via the media is how the élite (Cult) 'persuades' the masses that they need more state control, leading to a 'world authority'. A fifth point works in relation to the use of propaganda:

5) Present partial truths by 'withholding' information and selecting information that suits the élite power structures.

The 9/11 Hearing is an interesting example of withholding information. It was admitted that there was a possibility the Bush administration knew ahead of time about the plans for 9/11 but did not heed the warnings. Of course, the real issue of concern for many was not whether Bush junior was aware of the impending attack on New York and Washington but whether the Bush administration (along with its connections to 'firms'with a vested financial interest in the wars that followed) was actually responsible for the planning and orchestration of 9/11. Most people don't even want to contemplate such a thought, so they willingly accept official hearings and reports given to them via the mainstream media as truth. Is there anyone out there who still thinks the Warren Commission told the truth in relation to JFK's assassination? I doubt it!

HOLLYWOOD MEDIA MAGIC & SUBLIMINAL MESSAGES

Hollywood and the global media empire are the creation of the secret societies mentioned in the last few chapters. The name itself refers to the 'hollywood' (holy wood) or Hel-wood, the 'place of magic', where Druids (priests) of the ancient mystery schools would perform their ceremonies. The 'chief wizards' of today are the mega rich film directors and producers who fund and create the blockbusters we love to watch. Film is mass art, and big productions, especially those that conjure up imagery associated with duality (good against evil) and are no different in content to the religious spin exalted by priests throughout history. Totalitarian modernist attitudes have, since the turn of the twentieth century, used film to 'engineer' human souls' responses to such art forms. In fact, the Nazi's and the Soviet Communists used cinema to full effect, the most potent example being *Triumph of the Will* made by Leni Riefenstahl in 1934 as the official account of the Nuremberg Rally. It's a classic example of myth-making, art and propaganda in one place.

Holding power over the minds of the masses in ancient times was the purpose of the shaman (myth maker) and the same is still happening today. The media *is* a powerful, mind controlling device and it is used to full effect, day after day, by the magicians at the heart of the masonic structures that understand how the subconscious mind creates reality. The television is the resident hypnotist in every home, and depending on what is watched, mainstream *programming* via television has put humanity under mass hypnosis.

All advertising is a testimony to the power of subliminal messages churned out by the film and media industry. Advertising is specifically designed to speak directly to subconscious minds. Most products consumed are not actually needed and this is the real reason for advertising and the media industry in general. The world of cinema and television, especially Hollywood, Netflix, Amazon, etc., are the 'tools' of the masters of deception today. Five hundred years ago, technology was ahead of its time and, from a public perspective, was being used to create immense, detailed imagery, often moulding perceptions in the era we call the Renaissance. Art, religion, politics and mythological scenes were used to *re-enforce* beliefs the rulers of that era wanted the masses to hold. Some filmmakers (producers/directors) today, who are no different in terms of their access to knowledge, are like the Leonardo Da Vinci's of their time. Today, the myth makers produce works of art in the form of films so as to shape perceptions and reinforce ideologies. I have been amazed at the amount of information embedded in ancient myths that filters into the themes found in modern film. The most obvious theme used in blockbuster plots is dualism, or myths relating to good versus evil; especially in their promotion of satanism, sex crime, violence, and glorification of war, along with a host of other dark subjects. Going to the cinema, or viewing a

pay-monthly package to watch the latest film, is almost like attending a ceremony dedicated to the subconscious mind. Even the atmosphere within a cinema, through the lack of light, the use of red curtains, along with the imagery itself, is almost akin to attending an esoteric ritual. The imagery in Hollywood films has a greater impact on our subconscious than we realise; thus, the film director and producer are no different than the ancient wizard, who altered our state of mind through the use of a 'narrative' (story) and archetypal imagery. I have even heard people say that they "went somewhere" or that the film was "more of an experience" after seeing the latest release. Perhaps this is because imagery and themes behind such productions are part of a subconscious language, memories, and sometimes, alternative histories. Peter Jackson's *The Lord of the Rings trilogy* (2000-3) is one film experience that comes to mind and in many ways has influenced some of the themes found in this book. Entering the cinema is symbolic of entering the chambers of the subconscious mind and that is why cinema becomes an important tool for the forces that have a lot invested in how audiences *perceive* the world. How we see, or perceive our world is fundamentally influenced by our subconscious thoughts and beliefs. The primary visual cortex at the base of the brain is the 'hub' of our 'perception' and the primary factor for how we create individual and collective reality!

EMBEDDING PROGRAMMES

Stories and themes contained within many movies and novels have a greater effect on the mind than one can imagine. So do subliminals used in television commercials and within programmes designed to target all levels of society. The word 'programme' says it all really, because that is exactly what our minds are - *a programme*, arrested by endless chat shows, news bulletins and other forms of mediocre entertainment. Education is full of programmes, too. Often administered by 'programme leaders' working to a matrix (a timetable). Films are also used as propaganda tools, especially for the Masonic - occult-religious hierarchies, we should not underestimate the interconnectedness of the world of cinema with the politics and the agenda outlined so far. The multibillion-dollar media and film industries, as well as their famous directors, are working to create what could be 'new religions' (political agendas) for the 20th and 21st centuries. As I said earlier, many science fiction films are preparing the psyche to accept the revelation of alien invaders as a move towards creating a one-world government. It's also fascinating to see how science fiction films mix truth with disinformation, and by labelling these types of films as science fiction, they provide a great cover for a coming dystopian New World Order.

POP IDOLS, SEX, AND THE CREATORS OF POPULAR CULTURE

The music industry, along with Hollywood, is a haven for the most obvious references to gods, goddesses and symbolism associated with the occult. There is nothing necessarily 'bad' about the occult, a word that literally means 'hidden'. However, it is the use of hidden knowledge that can be directed towards good or bad. All knowledge is neutral, it is the malevolent use of the occult, mainly through black magic, which opens individuals up to the Wetiko Predator mentioned earlier in the book. It's a state of mind that revels in unspeakable crimes against humanity. Many symbols used in the media -music industries carry occult meanings, and most have dual significance.

The notorious 20th century black magician, Aleister Crowley, had considerable influence over what would become popular culture. Crowley's connections included British Intelligence, and founding father of America's space programme, Jack Parsons, who would become his adept. Parsons was close to L. Ron Hubbard the founder of Scientology, which attracted many Hollywood actors and actresses.[20] According to some writers, Ian Fleming based his character, Blofeld, the baddie in *Goldfinger* (1964) on Crowley, and it seems that Crowley also gave Churchill his renowned 'V' hand sign. Crowley's influence on symbols, including 'hand signs', rock music and the post-beat counterculture is well documented in Gary Lachman's book, *Turn Off Your Mind* (2001). Crowley's influence can also be seen in films such as Don Cammell's *Performance* (1970) and Kenneth Anger's *Lucifer Rising* (1972), with Mick Jagger creating a dissonant synthesiser soundtrack to Anger's cinematic enactment of one of Crowley's rituals, *The Inauguration of My Demon Brother* (1969). Crowley also appears on the Beatle's *Sergeant Pepper* montage album cover illustration and on Michael Jackson's *Dangerous* album, which also features all-seeing-eyes, lakes of fire and other masonic symbols. No matter how one views popular culture, rock music, and what has become a 'media machine', the occult, especially freemasonry, has been involved behind the scenes for years. Crowley is just one of several key occult-magician figures of the 20th century to have influenced modern media culture.

Leading figures in Hollywood, such as Jack Warner and Louis B. Mayer (Goldwyn-Mayer), as well as a large number of actors, musicians, athletes, and writers, have all been Freemasons. Famous Masons have included the likes of John Wayne, Al Jolson, Nat King Cole, Ernest Borgnine, Sugar Ray Robinson, Peter Sellers and Oliver Hardy, to name but a few.[21]

Freemasonic control of the entertainment industry in particular, is being used to condition people into accepting the demise and eventual destruction of individual cultures, replacing them with a globally centralised system, eventually enslaved to artificial intelligence. The methods used by the mys-

tery schools vary, and that is why every aspect of the entertainment industry comes under Cult influence. Whether it's the Olympics (symbolised through the 'rings' and lighted torch) or a major movie with subjects pertaining to the occult (see *Harry Potter)* with references to mythology, hidden brotherhoods and symbols associated with Freemasonry, the goal is the same: *to influence the minds of the masses to accept New World Order ideologies.* These objectives relate to what some researchers call the 'Super Torch Ritual' and relate to the 'end of days' or 'judgement day' scenario (also found in many movies). The end of days theme is designed to usher in the end of one age and the birth of new one—a new world. No matter where one looks throughout history, the cult brotherhoods that became Freemasonry, have strived to change the perceptions of the masses so to accept a controlled *global* culture that no longer respects families, individuality, spirituality, or humanity. Instead, the 21st century media machine is pumping out a *new* religion and a *new* global order, based on occult systems at the very epicentre of the secret society networks decribed here. Symbols and archetypes used by the ancient priestcrafts can be seen within the 'art of cinema' and acted out by 'stars', musicians, and 'idols' of the *new*-age. Let's have a look at just a few.

ICONS, GODDESSES OF THE MEDIA CULTURE

One symbol used by the brotherhood I've been outlining in this part of the book is the dual goddess. The symbol of the 'harlot' and the 'virgin' rolled into one figure is a classic archetypal description of an ancient Mother Goddess or 'Dragon Queen' worshipped in the ancient world. This goddess figure was called Isis in Egypt, Semiramis in Mesopotamia, and later referred to as Mary Magdalene by the Christian faith. Magdalene, for the priesthoods who venerated her, was an archetype for the material virgin queen of the Underworld. Many female artists-musicians have been placed under this archetype, or moulded through the dual goddess role. The artist and musician Louise Veronica Ciccone, otherwise known as Madonna, is the ultimate contemporary figure of the music industry based on the virgin-harlot archetype. Later, Britney Spears was packaged in a similar way, and no matter how one views her music, she, and the likes of Madonna, have had a huge influence on millions of young people! As a goddess icon, Madonna appeared in photo shoots as both a serpent goddess and a fire demon, both of which are direct references to the Dragon Goddess consciousness on one level (good) but also represents the Predator mindset (evil) on another level. Interestingly, Kate Bush the 70s and 80s English singer (before Madonna), was also compared to the Pagan goddess Isis, or the Scandinavian 'Frig', or 'Hel', whether she welcomed the comparison, or not. Writing in *The Secret History of Kate Bush* (1983), Fred Vermorel compares Kate Bush to the ancient goddess figure, Frigg. He writes:

> *Kate Bush is our goddess Frig. And, like the Saxons, we both revere and fear her. Shroud her in mystery of her power and the power of her mystery. She is a fertility goddess for our nature: the Economy. Mother Commodity. Kate Bush is the smile on the steel of EMI, the mating call of Thorn Industries, British Capital on heat, the soft warm voice of mass media, the sweet breath of vinyl, the lovely face of bureaucracy, the seductive gaze of power. As every star is.*[22]

I actually like Kate Bush's music, but that description of her in relation to an ancient deity and the power behind the music industry could be applied to many goddesses of Hollywood, or music stars. Marilyn Monroe, Madonna, Gaga and their likes are replicate idols of the 'Hollywood religion'. Jeff Godwin's book *Dancing With Demons – The Music's Real Master* (1988), covers a wide range of musicians, from rap artists to rock bands, which *he* suggests are involved in Satanism. Some of the musicians he names are Ozzy Osbourne, Jefferson Starship and Led Zeppelin, to name but a few. I personally don't share Godwin's Christian fanaticism, and he's not quite grasped that Christianity, or Roman Catholicism at its highest level, is based on Pagan but often Satanic worship. His book certainly illustrates some of the more subliminal connections between the rich and famous and their practice through black magic. He also highlights some of the word twists and symbolic codes found in lyrics and on album covers going back to the Sixties.

One common Satanic symbol is the 'Il Cornuto devil's horns sign'. This is one of many codes used by Satanists to communicate with each other, and is a sign that is often given by rock stars, world leaders and of course, supporters of the Texas Rangers. There has been way too many expressions of this hand sign by a wide range of celebrities and world leaders, to just palm it off as simply rock and roll. The Il Cornuto devil's horns sign seems to have originated in the ancient world and is found on ritual artifacts especially connected to human sacrifice (see Figure 61 overleaf).

SEX, DRUGS AND MANIPULATION

The use of sex as an image of both chastity and promiscuity by pop idols and movie stars is seen time and time again. This is part of the double-speak language, one that uses images, icons and words to influence thoughts and behaviour. Our young are bombarded with images of sex in films, music videos, on the internet and advertising from such a young age that it *must* have an effect on how they build relationships and ultimately see themselves in relation to others. Television cannot create a total personality change in everyone, but its main function is to increasingly desensitise us to violence, pornography and vivid images relating to 'death cult' imagery. Sex-based images, also designed to influence the subconscious mind, have worked ever

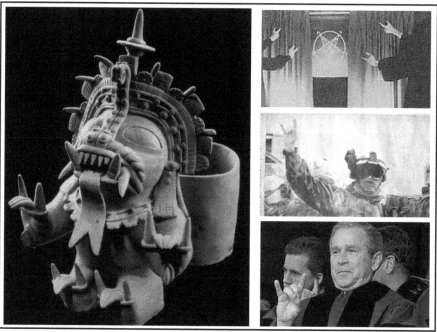

Figure 61: The ancient & modern Il cornuto devil's hand sign.
(Left) A statue of a gargoyle creature giving the Il Cornuto devil's horns sign. This arte-
fact comes from the Janna-Coaque culture of Equador (350 BC - 400 AD). **(Top right)**
Church of Satan worshippers giving the sign to an inverted pentagram. **(Top middle)** A
Coalition soldier heading for Baghdad in 2003. **(Bottom right)** Many world leaders have
been photographed giving the same occult hand signs.

since religions 'demonised' the naked human by blaming Eve (women) for
all of humanity's so-called original sin! Religion, like the global movie-music
industry, is obsessed with sex and this focus is a deliberate play on the sub-
conscious minds of young people. Tabloid newspapers sell because of sex
and quite often they use 'titillation' surrounding the repression of the female
form as a hook. Advertisements also use subliminal sex-based imagery to sell
to the subconscious mind, yet the media industry in general exists to rein-
force stereotypes and polarise views, which in turn produce tailor-made
minds that 'think' they are rebellious and free, but in truth, they are just con-
forming to yet another uniform. Teenagers describe themselves as Trendi,
Indie, Goth, and such, only because these genres have been marketed and
sold to the minds of young people *through* the media pop culture. John
Lennon summed up this dilemma in his song *Working Class Hero*:

> *They keep you doped with religion, sex and TV*
> *And you think that you're clever, classless and free,*
> *But you're all fucking peasants as far as I can see ...* [23]

Young people are most at risk from so much garbage online, television and the unnecessary pressures placed on them by some parents, peers, teachers, or other role models who reinforce the Disney-like mediocre world of brand names and idols (celebrities). In a book called *The Gospel According to Disney* (2004), author Mark Pinsky shows how un-Christian the Disney empire has been but how it has thrived within an American-Christian environment for over ninety years. Disney had no intentions of presenting true Christian images and values, not that the world is desperate for these or any other religious imposition dressed up as values. Disney's image and message is, as always, designed to sell archetypes and *idols* relating to clandestine cult lore and the religion of separation, which again, is part of the New World Order. According to an article in the now-defunct *UFO Magazine*, Walt Disney was said to be interested in space, UFOs and various phenomena relating to the occult. The Disney 'distraction' effect, as I call it, has been instrumental, along with the invention of television, when it comes to bombarding young (and old) minds with subliminal symbols associated with duality and stereotypes. The same distractions are found in soap operas and the endless list of mind-wasting 'programmes' on all media 'platforms' today. Unless we are accessing our imagination and individual visions, then by a process of elimination we are being 'programmed' to a lesser degree. Surely it's time that young people are taught how to go within and connect with their inner creative imagination? Rather than being constantly persuaded to look outside via entertainment as the only way of seeking approval or confirmation, they are 'valued' and loved as individuals.

Sex, especially, is one of the most powerful tools for triggering the subconscious mind, while making the conscious mind try desperately to deny its craving. Mainstream orthodox religion is still reinforcing this denial in the 21st century. In one website article that someone sent me as a joke, I was alarmed and amused to see what length the Mormon Church goes to in order to control people's lives in relation to sex. The article was called *Steps in Overcoming Masturbation - A Guide to Self Control.* I'll spare you the detail here, but the article covers a range of ways to prevent oneself from the above activity, which includes finding new friends and leaving behind partners and friends that might contribute to stimulating this sort of behaviour! What business is it of any church, or individual come to that, to tell another individual what they can and cannot do with their own body, as long as mutual consent, love and respect for others is there? Especially when year after year priests and authority figures within the Catholic and Mormon churches can't seem to keep their hands off their own privates while being shown to have abused children in their care? The Jehovah's Witness hierarchy are just as bad. According to an internet news article from 2006 and first publishing of this book, it was revealed that around 23,720 child molestors were on file at

Witness Headquarters in New York[24] It's this mixture of titillation and 'sex-is-sinful' ideology that has created a sexually repressive society, with the possibility of long-term problems for those who deny the natural, innate forces that constitute the very nature of being human. It's our *denial* that advertisers home in on to sell their products, and the more sexually repressed we are, the more products the big guns sell through sex! It's often our self-induced repression, brought on by age-old taboos and fears that can be 'seen' in the use of subliminals in much film, advertising and music videos. As Wilson Bryan Key, PH.D, writes in his work *The Age of Manipulation* (1993):

> *In the cultural grip of media, modern societies blindly stumble from one crisis or disaster to another with the fantasized conviction that they know what they are doing, where they are going, how they will survive, who is in control, and why everything works or does not work as it should. These unconsciously reinforced fantasies actually threaten survival ...*

> *... The list of subliminal effects powerfully demonstrates that humans can be programmed into almost any group perceptual construction or cultural perspective (synonymous concepts) by those who control media. Group behaviour is measurable and believed predictable in terms of statistical probabilities. Media provide the system through which economic markets are controlled. Not everyone in any given culture is controllable. Humans become most vulnerable when the battle of beliefs supports basic cultural indoctrinations.* [25]

Since its creation the mainstream media, music and movie industry has been one of the most influential shapers of minds. And through the Covid era its grip on the minds of so many has been profound and monumental.

Much of what I am writing about here and in the next few pages is part of the original book content from 2006. My opinions have changed over time, but the general message regarding mind control and the darker subjects (forces) associated with the topics in this chapter still remains relevant.

SINGING FOR SATAN

As a lecturer for over twenty-five years, I am amazed at how many teenagers are obsessed with what I call 'Devil Worship' memorabilia, something often churned out in music magazines, on television, and social media year after year. Certain rock groups, along with cartoons and graphic novels, present very dark messages within their music, cover art and videos. Images of devils, vampires, zombies and other demonic creatures are referred to in song lyrics and also used in logos for numerous bands. The lyrics are especially important to some occult secret societies working behind the scenes. The messages in lyrics sung by certain commercial artists have a 'mantra effect' on the young and in extreme cases some rock bands have been shown to pro-

mote suicide through their music. As the Disney classic *Fantasia* clearly explains: *"Abstract images might pass through your mind ... music will suggest other things to your imagination."* The Greek scientist and philosopher Aristotle (384-322 BC) also understood the destructiveness of certain kinds of music. He states that: *"The emotions of any kind are produced by melody and rhythm and that music has the power to form character."*

A Japanese visionary writer and researcher, Masaru Emoto has shown how music can affect water at a molecular level. Therefore, what type of mental projections and thought patterns are being created by the never-ending barrage of sex, violence and deliberate use of satanic symbols within mainstream music and specialist areas of the music industry? An old student friend wrote an excellent article on the music industry and its links to the explicit promotion of Satanism within publications, song lyrics, videos and in the artists themselves. In his article: *The Music Scene – What Has Gone Wrong*, he lists many references to the promotion of narcotics, violent sex, pornography and paedophilia contained in songs and publications such as the *New Musical Express, Select,* and *Sky Magazine,* to name a few. He also lists a range of videos frequently played on MTV (Music Television), over the years, containing overt references to themes of drug abuse, violence, death and other deviant activities.[26]

The global music industry is as corrupted as the Hollywood machine, inasmuch that it is run by the same families that have a history of mafia-style corporate theft and drug running, especially since the time of prohibition in the US. The power to assassinate controversial musicians, such as John Lennon, with one hand and, and elevate the likes of Ronald Regan and Arnold Swarzenneger into positions of influence, with the other hand, can only be the work of the élite that control the media, film and music industry.

MIND CONTROLLED SINGERS & ACTORS

Today, awareness of CIA operatives within the media, entertainment and music industries, includes awareness of how certain high-profile musicians and actors are not in charge of their own minds. The mainstream media industry, from newspapers to the world of cinema and television, is the modern day tool of this priesthood of magicians. Government involvement in security and intelligence operations, for disseminating disinformation and controlling responses of the misinformed masses in order to maintain power for their élite controllers is deemed common knowledge today. The fact that the very logo of British Intelligence is an ancient Egyptian all-seeing-eye above a trimunati (triangle) should leave no doubt that the mind controllers understand ancient systems of power designed to prevent receiving all *information* needed to free our minds. Technologies used within the CIA, like project Mind Kontrol Ultra, which came to light in the 1980s, are used to create

a mind controlled assassin, or multiple personality candidate.[27] Cathy O'Brien and Mark Phillips, authors of *Transformation of America* (1988) brought a lot of attention to this subject in the mid 1990s. O'Brien was subjected to government-instigated mind control programming rendering her a sex slave, exploited ruthlessly at presidential levels and 'used' by the CIA until finally breaking free with help from former CIA programmer, Mark Phillips. In recent years, she has identified publicly many famous people involved in diabolical ritual abuse of children, not least her own daughter. She writes in her book:

> *Entertainers usually made it big when they participated in CIA operations and or were mind control slaves themselves...To quote my father [who had connections with CIA mind control operations], 'Spies, like singers and actors, are made, not born.' These entertainers have endured much of the same programming as I to permit them to carry out government operations in the course of their travels.* [28]

That statement sheds a different light on the many celebrities, actors and singers who often support key leading politicians, or are used to highlight a global 'problem' requiring a global 'solution'. Many rich and famous people may themselves be unaware of the hidden agenda behind the latest cause, political party or political manoeuvre but the chance of a few knowing what they *are* supporting is highly possible. The U2 frontman, Bono, is one singer who comes to mind when it comes to cavorting with the élite's 'finest'. 'Cui Bono' a Latin term meaning: 'To whom it is a benefit' comes to mind when Bono does his shuttle diplomacy for DATA, enabling him access to meetings with the likes of George Bush, Clinton, Blair, Obama, Bill Gates and the Pope, etc., begging the question: "Who really benefits from the global charities and 'BandAids' promoted by such artists and musicians?" They are either extremely naive and their good natures are exploited, or they are part of the structures benefiting from using music and art to distract the public.

SUBLIMINAL UNDERTONES

Symbolism is the language of the secret societies focused on the Predator Consciousness mentioned earlier. It is the language of the subconscious, a language used to maximum effect through art, media, architecture, brands, and advertising. The brotherhood and the bloodlines communicating with unseen levels of reality are obsessed with symbols, many of which can be traced back to the ancient world. Symbols like the swastika, lighted torch, stars, and all-seeing eye are just a few examples of how this symbolic language is used by the brotherhoods, as touched on in earlier chapters. Many of these symbols have reversed meanings, but more importantly, the symbols

are designed to affect consciousness and the conscious mind. Colours also affect the subconscious mind and when combined with symbols or icons, they have an even greater effect subjectively. The power of the Myth Makers, as I refer to throughout this book, is clearly seen in the myth of Father Christmas (St Nicolas), or how Coca-Cola takes a Pagan tale of old Saint Nick, often shown dressed in green in his original form, but turning him into a red and white magical Santa figure (see *Orion's Door* for the deeper symbolism behind Christmas). Red in symbolic terms is the colour associated with secret societies, the astral planes and non-physical dimensions. Santa is an anagram of Satan (Santa Claus/Claws). A tale wrapped up in subliminal undertones relating to a mystical, non-human entity entering our homes at night and giving gifts to children who behave accordingly is part of a larger mind programme connected directly to the immense commercial and consumer culture that has grown since the inception of Coca-Cola's original advertising campaign. With the advent of television, the potential to 'programme' the collective mind of humanity achieved its highest outcomes over the past seventy years. So much so, that today one is hard pressed to find anyone who is not discussing or consuming some form of 'hype' relating to the latest soap opera, football tournament, trend, fad diet, celebrity's private life, or news bulletin. All these form part of the mass mind-controlling media-machine, which daily uses subliminals to promote politicians' (spin), agendas, and belief systems. See all things Covid-19, as I will discuss in the next chapter.

SYMPATHY FOR THE DEVIL

Another disturbing side to the music industry is its promotion of gothic rock bands, thrash metal and *death* metal that gravitate towards violence, death, black magic and other deeply disturbing satanic cult trappings. Music magazines, like *Select, Sky, Kerrang and Mixmag*, all owned by EMAP (now part of the Metropolis Group), often promoted pornography, drug-taking and other debased acts in past articles and imagery aimed at teenagers. Leading rock stars (historically) are often involved in excessive drug taking, sex scandals and other acts of debauchery. Pop idol Marilyn Manson (real name Brian Warner) who named himself after notorious serial killer Charles Manson, seems to overtly promote subjects surrounding Satanism. He models himself on the more vampire-like deities touched on in earlier chapters. In the 26th June, 1999 issue of *Kerrang*, it was claimed that Manson is an ordained Minister of the Church of Satan, founded by Anton LaVey. The *Hotel California* hit by the Eagles, containing the words: "Yeah Satan", is based on a street named California where the headquarters of the Church of Satan is located. Manson also appeared in Michael Moore's film *Bowling for Columbine* (2002), in which controversial views put forward by Manson (and other

musicians), to a certain extent, appear intent on serving the 'agenda' promoted by the force controlling the highest levels of the cults already explored. The Rolling Stones song *Pleased to Meet You – Sympathy for the Devil* (1968), is a classic when it comes to revealing the connection between demonic forces and élite circles that control the world.

Rock groups, like Led Zeppelin, Guns and Roses, AC/DC, Judas Priest, Black Sabbath, Monster, and bands classified under the genre of 'Death Metal' *seem* to produce music and lyrics linked to devil worship, suicide, and violence. I am *not* saying that any of these musicians mentioned in this chapter are personally involved in anything satanic or diabolical, only that the 'image', or 'art' made public seems to project dark forces. Many album covers contain mythological and, quite often, satanic imagery. Black Metal groups, described as similar to Death Metal (same thing really), often use deeply disturbing and grotesque imagery on posters, t-shirts and album covers. One group called *Cannibal Corpse* on their 1994 album *The Bleeding*, even have [sic] song titles such as *Stripped, Strangled* and *Fed Broken Glass*. And these types of artists aren't influenced by demonic forces? The same mentality is responsible for all war (killing), because the truth is, all war is diabolical. Correlations between demonic rock music and the military is illustrated quite graphically in Michael Moore's film *Fahrenheit 9/11* (2004). In one scene we are shown a teenage marine boasting about how he killed while listening to New Metal Rock music. The common denominator between those who produce such material, or world leaders who have no feeling or empathy for the immense human pain and suffering they instigate by starting wars, is their involvement in clandestine cults that worship death and destruction. If the puppet politicians are not directly connected, then they become purely mouthpieces for the power base behind the scenes in the shadows.

Music and especially images associated with certain rock, or hip hop artists is also found amongst some of the most horrendous crimes in recent years. Ariana Grande's Manchester Arena concert on 22 May 2017, is another devastating example of terror and death in a music concert. Twenty-three people died, including the attacker, and 1,017 were injured, many of them children. In recent years, the Travis Scott 'Astroworld' music festival at the NRG Park in Houston, Texas (2021), also seemed ceremony-like whether intended or not. The set conjured up images of the 'mouth' of hell (see page 187) and had an energetic air of devil worship. The word 'Astro', meaning 'pertaining to stars or celestial bodies', or to activities taking place *outside* the earth's atmosphere, hints at 'otherworldly forces'. And many of the forces I've outlined so far in the book demand some kind of sacrifice, often human sacrifice. Ten people (including a nine year-old) lost their lives in a massive crowd surge toward the stage, squeezing people so tightly together they could not breathe or move their arms. It was reported that three hundred people were injured

and treated at the festival site, and twenty-five were taken to hospitals. There were reports of people seeing hundreds of injured receiving CPR.

KILLING FOR WETIKO

The influence of satanism within the media and music industry is phenomenal. In fact, the media empire seems to attract Satanists at the highest level. Ever since Charles Manson and his family made the headlines, serial killing and ritual sacrifice has been connected to individuals who claim to be working for Satan, or possessed by demons.

In June 2004 the *Independent* newspaper in the UK reported on an Italian cult based in Milan, linked to Satanic rites, heavy metal music and human sacrifice. According to the report, at least three murders of a ritual type were linked to semi-professional heavy metal musicians from the *Beasts of Satan* band and their 'plumber friend', whom police believed to be leaders of a Satanic sect known by the same name. The article stated that the men, all in their 20s, were accused of stabbing and shooting their victims, but burying them alive in a lonely wood.[29] Accounts of this kind merely scratch the surface, and people think these horror stories only happen in films.

The 2002 case of a German husband and wife, both self-proclaimed vampires, Daniel and Manuela Ruda, found guilty of killing a friend, Frank Hackert, had all the hallmarks of a satanic-influenced killing. The couple were also said to have a hit list of *fifteen* other victims and were connected to underground scenes involving blood drinking at vampire and gothic-style events in North London. Psychiatric experts, along with the judge involved in the Ruda case, claim the couple were merely sufferers of narcissistic personality disturbances, and their act was not about satanism. However, too many other cases in the headlines lean towards classic, ritual worship-style killing. The *Fortean Times* in April 2002 ran a four-page article on the Ruda case and several other 'The devil made me do it' cases found all over the world in the ten years leading up to this case. During that time there had been a preponderance of vampire-werewolf-horror style movies involving underground cults and Gothic-style backdrops where ritual killing is the norm. Movies like *Interview with a Vampire* (1994), *After Dark* (2013), *Blade* (1998) and the *Underground* movies are a few examples of what I am talking about. All of these films, along with the gothic-music-rock scene, the world of drug and human trafficking (slavery), prostitution, and the trade in body parts, seem to be linked to élite power structures and the dark forces they venerate.

CONFORMING TO UNIFORMS OF THE MIND

The organisations mentioned briefly in the last few chapters have had access to knowledge of *how* the mind creates realities to suit its subconscious image.

If the collective minds of humans can be 'persuaded' to think in a certain way, this ultimately shapes the world view. Mind control is the worst form of slavery because it gives the 'illusion' of freedom, makes us trust, love and defend our oppressors, while making enemies of those who are trying to set us free.

The mind control of our young, especially little children, is indicative of the forces manifesting through what I and others have called the Predator Consciousness, or Wetiko. Signs and symbols, mantras and NewsBytes are designed to take over our subconscious minds, manipulating us into conforming to beliefs and manufactured realities. Young people, for example, don't have a habit of being traditionally religious en masse (thank God), but there are many other 'religions'out there in the world of social media, television and popular culture to influence the subconscious. The mainstream media, in my view, is one mass mind control experiment primarily designed to mesmerise the collective subconscious through *sound* and *image*. It's the 'image' of something that shapes cultures, beliefs and ultimately, lifestyles. Thousands of years ago, religion shaped the nature of reality (still does in a lot of countries); however, today the media empire carries on the work for a system built on consumerism, cheap sex, war, and so much violence. If that sounds too unbearable to contemplate, then take a look at the global mainstream media any day of the week and you will find one, or more (often all) of the above themes. The papers wouldn't sell without them! Doesn't that speak volumes about the level of imagination that we, as a collective, have stooped to? I personally could live without a tabloid newspaper and television forever. Priming the TV screen white and painting a different picture on it when the mood takes me is one idea I've had. Yet, it's easier to leave the 'box' switched off and to focus on other meaningful activities. The resident hypnotist in the corner of every lounge and living room—sometimes every room—in every house, is only there because we are so myopic and lethargic when it comes to making and creating our own entertainment. We'd rather let the government-approved 'teller-of-visions' programme our sense of reality. As Bryan Key writes in *The Age of Manipulation* (1992):

Population segments most susceptible to media management usually think they think independently, critically, clearly, and can readily discriminate between truth and falsity, reality and fantasy. The self-perception of autonomy is a basic indoctrinal priming tool. Humans who think they think for themselves often do not. The better primed by cultural values, the more vulnerable to manipulation.[30]

It's time we started responding to our own individual visionary senses, because if we don't, then how are we going to truly know ourselves? How are we going to become vessels for our true divine nature if we don't explore

our individual creative imagination? In the remaining parts of the book I want to focus on levels of consciousness that have influenced and continue to inspire the visionary within us all. Through our creative imagination, we will create a different reality and a better future for our children, and grand-children.

NOTES:

1) Lawson, Mark: *The Second Coming, The Weekend Guardian* 24th April 1999

2) Giordano Bruno, *On the Monas,* Hamburg edition, 1991.

3) French scientists unearthed a bone of an ancient animal with engraved symbols in Kozarnika cave located in the north-western part of Bulgaria. PRAVDA *.http://english.pravda.ru/science/19/94/377/12466-bone.html*

4) Wrixon, Fred B: *Codes Ciphers and other Cryptic and Clandestine Communication,* Könemann 1998. p19

5) Icke, David: *The Biggest Secret*, Bridge of Love, pp 80-85

5) Jung, Carl. *Man and His Symbols.* Stellar Books. 2013, p142

6) Hall, Manley P.: *The Builders, Cedar Rapids* 1916, Taken from *Masonic Orders of Fraternity*, p15

7) *http://context.themoscowtimes.com/stories/2004/04/09/120.html*

8) *http://story.news.yahoo.com/news?tmpl=story&u=/variety/20040317/va_ne_al/_war_meets_its_maker_1*

9) *http://www.context.themoscowtimes.com/stories/2004/04/09/120.html*

10) Robb, Dave: *Operation Hollywood. How the Pentagon Censors the Movies*, p77

11) *The Passion of the Propagandist, The Guardian,* 10th April 2004, p7

12) Cummings, Tim: *The Guardian.* 10th July 2004, p 19 of the *Book Review*

13) The *Guardian*: Saturday March 20th 2004, p3

14) George Lucas is a close friend of Spielberg and both have worked on projects that cover themes mentioned in this book. Lucas is probably one of the most genius and powerful figures in cinema. Lucasfilm, established by George Lucas in 1971, has today evolved into five Lucas companies. The Lucas group of companies include Lucasfilm Ltd., LucasArts Entertainment Company LLC, Lucas Digital Ltd. LLC, Lucas Licensing Ltd and Lucas Learning Ltd.

Steven Spielberg is another huge name within Hollywood. Spielberg set up a company called Amblin and then went on to set up Dreamworks SKG in 1994, which became the first new movie studio in Hollywood in over 75 years. The partnership between Steven Spielberg, Jeffery Katzenberg, and David Geffen formed a media company that would reach into the fields of live action and animated movies (both traditional and CGI), music, computer games, arcades, television production and movie distribution. Unlike Amblin, which Spielberg owns 100% of, Dreamworks is only 22% owned by Spielberg. Other investors include Katzenberg (a fast-food chain), Geffen, Microsoft co-founder Paul Allen and a few of their closest friends. By 1997, Spielberg's annual income had reached $283 million. He was the highest paid entertainment figure of that year. Directors such as Spielberg are treated like gods in Hollywood.

15) Many numerological coincidences relating to this film and 9/11 can be found at this website; *http://www.geocities.com/markamooky/2001_a_space_odyssey_encodes_the_number_666.html*, for anyone wishing to delve deeper in to this strand of the themes outlined in this book.

16) The *Creative Review* May 2003, p48.

17) Maxwell, Jordan: *Matrix of Power.* The Book Tree, p28

18) *The Military's Media,* by Robert Jenson, Journalism professor at the University of Texas at Austin, The Progressive, May 2003. *http://www.progressive.org/may03/jen0503.html*

19) Ibid

20) *http://jack-parsons.ask.dyndns.dk/*

21) *Freemasonry an Illustrated Guide*

22) Vermorel, Fred: *The Kate Bush Story*, p147

23) Lennon, John: *Working Class Hero*. The Plastic Ono Album, Sony 1970

24) *http://www.silentlambs.org/answers/23720.cfm*

25) Wilson, Bryan Key: *The Age of Manipulation*, p110

26) *The Music Scene - What Has Gone Wrong*, Jones, Ken, and Published in *On Target* 14th August 1999. **I personally don't share the views of the publisher, 'whatsoever'**, but I think this article illustrated quite graphically to what levels the music-media industry has sunk.

27) O'Brien, Cathy, Phillips, Mark; *Transformation of America*, Reality Marketing Inc 1995 p50

28) Ibid p67

29) *http://news.independent.co.uk/europe/story.jsp?story=534231*

30) Wilson, Bryan Key: *The Age of Manipulation*, p200

Hidden Signs & Media Magic (2)

Revelation of the method & All-things Covid

For there is nothing hidden that will not be disclosed, and nothing concealed that will not be known or brought out into the open
Luke 8:17

In the final chapter of this part of the book, I will apply some of the knowledge and symbolism explored so far to show how it fits into more recent events. The COVID-19 era especially can be unravelled through symbols, scriptures and numerological codes. It's not my intention to go into great depth regarding what happened during the Covid pandemic, it's not in the remit of this book, but, to fully understand the nature of hidden signs and media magic, we need to scratch the surface just a little.

At the time of writing, the mainstream media (after two years) are 'still', spinning the advancement of possible future 'coronavirus waves', 'new variants', or even a *second new pandemic*. All while freedoms have been eroded to the point of installing fascism in some countries. Austria, Italy, New Zealand, Australia and *especially* Canada have hit new levels of tyranny due to a virus that officially has a fatality rate between 0.1 and 0.2 %. Measures imposed on daily life (globally) were *extreme*, to the point of seeing those in power for what they are - psychopaths. The authorities 'repeated' through endless news bulletins, press conferences and 'supermarket announcement systems', that: "We are all in it together, and following the 'new rules' is all for our own safety." Government Advertising went into overdrive, with posters and propaganda put up everywhere when Covid appeared in 2020. One UK governement publicity was telling people to "act as if they had the virus", and many did just that! Some still are, with many becoming 'actors' on a manipulated world stage. It was as if the *Contagion* movie (2014) had left the 'screen' and become reality. The *Contagion* poster read: "It is fear that spreads the disease." It should have read: "Your mind spreads the disease," especially when fear and panic courtesy of 'mainstream (legacy) media' (combined with genuine, severe underlying health issues for the majority of supposed deaths from Covid) became a recipe for disaster. You could say more minds

were washed than hands as people seemed to stop *all* critical thinking.

The fearmongering continued through 2021 with extraordinary levels of gaslighting by mainstream media, governments and global authorities. We were constantly being told to prepare for a 'new normal' as our 'priests of the mainstream institutions' said our world would never be the same again. As I have shown in earlier chapters, these institutions are 'instruments' of the 'Predator Consciousness' and are forging a centralised global control grid, especially since Covid. In the UK, celebrities appeared on TV articulating the 'new normal'; reinforcing the mantra of 'stay home - save lifes,'etc. We had A-Listers sharing their face mask selfies on Instagram, from Kim Kardashian to Gwyneth Paltrow. The latter joked about her role in the 2011 movie *Contagion*, saying: "I've already been in this movie." The likes of Taylor Swift and Ariana Grande criticized fans on social media for 'not taking the virus seriously', while others unquestioningly promoted the official government line, ignoring the historical fact that all governments lie. Many celebrities are part of the 1% - the mega rich and the upper echelons of society, some are said to belong to fraternities based on Greek letters, not least the original 'Alpha', 'Phi' and 'Kappa' societies. In truth, it's hard to know for sure if such elite circles exist today, but they certainly did through the centuries. Just as yesterday's demigods in myth held sway over the masses, celebrities and their 'status' (*celebritas*) are often utilised to keep the masses focused on specific narratives today. Most won't know they are being asked (or used), but some willingly give their soul to dark forces, serving off-world entities and the forces I've outlined so far in the book.

MANTRAS, CASES & COUNTING BODIES

Tens of thousands of people die in the United States annually every winter from flu, many with pneumonia-related complications, with Center for Disease Control (CDC) figures recording (estimating) that 45 million Americans were diagnosed with flu in 2017-2018 of which 61,000 died.[1] Around 250,000 Americans are also admitted to hospital with pneumonia every year and about 50,000 die. With the alteration of death certificates (authorized by those in power), flu and pneumonia patients all became potential Covid statistics. The fact that 65 million people suffer from respiratory disease every year, with an estimated three million deaths annually, makes influenza the third biggest cause of death worldwide. But when Covid 19 arrived, flu had flown, with not one case recorded in the winter of 2020-21! The real force behind Covid-19 didn't care, the world was to be 'transformed' even if it meant 'over exaggerating' Covid Death Rates (just like most other countries) by listing cause of death as 'Covid' (no matter the real cause of death) on Death Certificates.

Part of the Covid narrative to persuade the masses that Covid 19 was a

threat to our everyday lives included, a useless 'test', lockdowns, social distancing, mask wearing and pro-vaccination propaganda enforced in an almost synchronised manner, globally. These tactics were obvious to those who could see that 'global' bodies such as the World Health Organization (WHO) and World Economic Forum (WEF) *are both* vehicles for the shadow governement and elite I've illustrated in previous chapters. In 2022 the WHO (owned by the élite) proposed implementation of a 'Pandemic Preparedness Treaty', saying: "The main goal of this treaty would be to foster an all of government and all of society approach, strengthening national, regional and global capacities and resilience to future pandemics." The proposed treaty (at the time of writing), as with many other 'treaties' (the EU and Native American treaties) throughout history exists for the benefit of the élite, *not* the masses. It was always about global governance and more control over individuals freedoms.

The polymerase chain reaction test (PCR) was also pushed by the World Health Organization and Christian Heinrich Drosten, the Director of Charité Institute of Virology in Berlin, as the *only* way to test for Covid-19. Drosten led a group that produced the 'Covid' testing protocol for the PCR test and all involved were most likely relieved that the inventor of the PCR test, American biochemist Kary Mullis, was no longer with us. Mullis had said many times that his test was *not* to be used as an accurate means for detecting viral loads. He made it abundantly clear that if tests/samples are run at less than 22 cycles of magnification (amplification) you will get 'false negatives' and if you run the test higher than 32 cycles you produce 'false positives' (the number 22 will become significant later). Such a flawed test created the 'casedemic', which was turned into the 'pandemic' we heard on news programes daily through 2020. The mantra from Tedros at the World Health Organization and national governments (same thing) was also 'test, test, test'. They knew that the more tests they generated the more fake 'cases' they had which then became more 'deaths' attributed to Covid. Which is probably why Tanzania president John Magufuli was targeted when he mocked the 'Covid' hysteria, the PCR test and masks and refused to import the DNA-manipulating 'vaccine'. All this was going on while celebrities were wheeled out to support the 'official narrative'.

THE COVID CULT

Crazy rules were also implemented in the UK to keep the 'virus' at bay, such as the need of a 'substantial meal' at any pub/bar in the UK during the summer of 2020. Anyone not eating a substantial meal whilst drinking alcohol could be immediately attacked by Covid, especially if eating out with a group above the magic number of *six*. It was all mind games! Scotch eggs were remarkably useful in keeping Covid at bay while eating out. But, as

soon as the clock chimed 10 p.m., Covid was out looking for his next victim. Visiting anyone outside of your household would also cause Covid to appear instantly unless a 'bubble of protection' was placed around those seeing each other. Following government rules was like being in the 1980's *Dr. Strange* movie, or for many, in an abusive relationship with John Wayne Gacy. According to the 'rules' in 2020, funerals could have 30 people attending, but wakes, stone settings and ash scatterings could only have 15 folk. Science and logic courtesy of the SAGE, the UK government's 'Scientific Advisory Group for Emergencies 'was mind boggling. But, SAGE was mainly made up of behavioural psychologists, so the mind would boggle! Added to the psychology being pushed on the masses was the idea of 'Asymptomatic' carriers, or 'super spreaders', who were potentially 'killing granny' through having their own natural immunity. To be healthy, taking vitamins and seeking natural herd immunity, was viewed as being 'selfish' by the followers of what became the Covid Cult. The fact that those in a cult 'never know' they are in one until they leave said cult, was glaringly obvious to those who could see what was really going on! It was (and still is) a huge psychological operation to convince humanity they were under attack by an airborne, indiscriminate plague that would jump out and get you at your GP (doctors) surgery, but not touch you in a supermarket, etc. Many of the 'minimal' numbers of those 'allegedly infected' (at the time of the first lockdowns in 2020), compared to the *7.8 billion* global population, seem *not* to have travelled or come into contact with anyone who could have met the 'plague'. Something else must be at play, surely? Reports said, that when an asymptomatic (allegedly so) 'Covid person' in one particular track-and-trace scenario in the US, of the 455 uninfected people exposed (according to the stats in May 2020), *zero* became infected! As the study placed on the PMC (US National Library of Medicine National Institutes of Health), stated:

> *Apart from hospital staff, both patients and family members were isolated medically. During the quarantine, seven patients plus one family member appeared to show new respiratory symptoms, where fever was the most common one. The blood counts in most contacts were within a normal range. All CT images showed no sign of COVID-19 infection. No severe acute respiratory syndrome coronavirus 2 (SARS-CoV-2) infection was detected in 455 contacts by nucleic acid test.*[2]

Only by announcing that asymptomatic people were 'deadly' could the Covid cult scam continue to 'possess' the minds of the masses. It was Wetiko in full flow.

Thirty-seven billion pounds in the UK was spent on NHS Covid track and trace technology to reinforce the need for a 'new normal', while 'preventing' lockdowns (so they say). The track and trace (national system responsible for

telephoning those who had been in contact with people who had tested positive) seemed to fail when it came to averting more UK lockdowns. Governments in the West have since dismantled lockdowns but there is nothing to stop them from trying to enforce another in the future. At the time of writing, the dictatorship that is China is again brutally locking down great swathes of its cities. Track and trace was never going to prevent further lockdowns, since both 'lockdowns' and 'vaccinations' (the main tools behind Covid) were marketed and pushed as the 'only way' out of the Covid pandemic.

Prior to the arrival of Covid, mandatory vaccination programmes had been called for by the World Health Organization (oh, what a suprise!) and the governments influenced by Global Health Partnerships, Gavi (The Vaccine Alliance), and the CDC in the US., all of these bodies are connected to Bill Gates, more on him shortly. Mandatory vaccination and Digital Identification became the focus, pushed by governments influenced by global bodies funded by the likes of Bill Gates. Even the name 'COVID' seems a suspicious abbreviation for **C**ertificate **O**f Vaccine **ID**. Yet, the infection fatality rate for meeting the 'plague' was said to be 0.23% dropping to 0.05% for people under the age of 70. At a rate far lower than originally feared by the masses and no different to severe *flu*. Average age fatality for those who caught Covid is 82.5 years old.[3] But this didn't matter to followers of the Covid Cult. Infections attributed to both cases and deaths, were based on completely inaccurate testing not fit for purpose, hence why many deaths were wrongly certified.[4] With a UK population of *68 million*, according to the NHS, almost 160,038 are *said* to have died of Covid (within 28 days of a flawed test). As I mentioned earlier, annual flu deaths all but disappeared.[7] The actual figure according to the Office of National Statistics in December 2021 was nearer 17000! In a bad flu year on average around 30,000 people in the UK die from flu and pneumonia. *What pandemic you might ask?* With a global population of 7.8 billion and the total 'alleged' global cases of 'Covid' at *165 million* (at the time of writing), along with the 'alleged' Covid-deaths to date at 3 million, the recovery figure (globally) of 144 million is hardly a pandemic! The figures here translate as 0.17% (less than one percent) of the world's supposed fatalities resulting from encountering the 'indiscriminate plague'. Based on this data, the official current 'survival rate' is *99.99%* of the 'global population' (a pattern in most countries) - Covid is no more deadly than the flu! So what is really going on?

MADE IN CHINA

Technocracy that is China today is being rolled out as a 'template' for the rest of the world. This blueprint for a Chinese-style society in the West could not be introduced on a global scale without a global 'problem' – enter the Covid-

19 pandemic back in 2020. The 5G rollout (globally), a cashless society, 'Track and Trace Apps', Social Credit (a future Universal Credit called Basic Income), end of self-employment (replaced by an electronic credit score), facial recognition and mandatory *everything*, all connects to the blueprint that is 'Made in China'.

According to official figures, China suffered 4,636 deaths (up to July 2021), out of a population of 1.4 billion which begs the question: "Why did Covid leave China alone after March 2020?" There was no need for the Chinese-style control grid being used in the West, as that type of technocratic tyranny regardless of the type of technocratic tyranny already in place and function-ing in China. Even if more horrendous lockdowns occurred in China (which they did in 2022), the type of advanced control through 'big tech' is seen in endless 'restrictions', which are part of daily life in China. So are WiFi sniffers or ID checks when you get a train, book into a hotel, watch the Olympics, or simply go online; tall hese are aspects of a 'Big Brother' life that we know as Communist Party China. As a Technocracy.news article said of the Chinese Communist Party 'monitoring the whole of society' in February 2022 (at the time of the Beijing Winter Olypmics):

> *Alongside adopting new technologies, the Communist Party has also expanded its idea of who is considered a threat. Human rights activists fear that a growing emphasis on "extremism" and "terrorism" is being used to justify government abuses.*[5]

The UK thought it would try and be more China-like in the spring and sum-mer of 2021, when people in England who attempted to travel abroad with-out an 'essential reason' were threatened with a fine of £5,000 as the ban on international travel became law. Travel is supposed to be a human right! Holidays were being 'banned' for the duration of the 2nd and 3rd lock-downs. For the first time in the UK, people were now being fined by their democratic government for trying to exercise their rights and use their lawful passports. The mindset of restricting travel and banning people is straight out of any technocratic fascist-communist state. The 'overblown' plague, called Covid, now inevitable, had to 'arrive' in the West so to try and usher in the 'new normal', a phrase heard repeatedly and endlessly throughout 2020. Put another way, China had to be 'built' *globally* and the excuse of a 21st century plague would help towards this end. The real power behind such an event is the Predator Consciousness and all of its expressions through the Wetiko mind.

The terms quarantine, restrict, ban and lockdown used by government officials globally, felt like the language of a tyranny in the making. In November 2021, the UK Health Secretary, Sajid Javid even talked about 'ban-ning' the over-65's in public places. You didn't misread that! During an

appearance on *Sky News* Javid talked about considering 'what constitutes vaccination' and whether the elderly should be banned from public life for their own good. European Countries tried to get into the 'China' CCP vibe, with restrictions in Greece, Austria, Germany, Italy, France, the Czech Republic and Slovakia each imposing restrictions and limits on public life for the unvaccinated. Sadly, these nations should have learned from history, especially the period between 1939-45! Digital 'papers please' didn't fully materialise in the UK (at the time of writing), but threats to fire health workers and other endless mantras designed to 'punish' the 'unvaccinated' kept appearing in the mainstream media, thankfully this waned as we moved into 2022 (a year/number I will look at shortly).

MODELLING, MIND CONTROL & THE 'MAGIC VARIANTS'

Since the Ebola outbreak of 2013, Bill Gates has appeared on numerous media platforms, especially over the past few years (prior to the pandemic), saying the world wasn't prepared for a coronavirus pandemic. His TED talk in 2015 even showed a coronavirus in the first few opening slides, which is more than a coincidence. Gates and Co. have consistently called for a global 'medical-military' and the use of 'germ games' (simulations of a pandemic) to deal with 'real' epidemics. The idea of 'modelling' was the only way to convince academia and the populace at large that there was a 'pandemic'. Therefore, the Cult agenda was justified by computer modelling not based on evidence or reality; it was specifically constructed to justify the Cult demand for lockdowns all over the world to destroy the independent livelihoods of the global population.

Researcher Rosemary Frei produced an excellent article headlined *'The Modelling-paper Mafiosi'*. She highlights John Edmunds, a British epidemiologist, and professor in the Faculty of Epidemiology and Population Health at the London School of Hygiene & Tropical Medicine. Edmunds is a member of government 'Covid' advisory bodies which have been dictating policy via the New and Emerging Respiratory Virus Threats Advisory Group (NERVTAG) and the Scientific Advisory Group for Emergencies (SAGE) mentioned earlier. Edmunds is also on the Scientific Advisory Board of the Coalition for Epidemic Preparedness Innovations (CEPI) established by the Bill and Melinda Gates Foundation, Klaus Schwab's Davos World Economic Forum and Big Pharma giant, Wellcome. CEPI was 'launched in Davos [in 2017] to develop vaccines to stop future epidemics', according to its website.

Cult scientists working on behalf of what I call the Predator Consciousness, have used several computer programs to create a 'model' of a theoretical virus genome sequence from more than fifty-six million small sequences of RNA, each of an unknown source, assembling them like a puzzle with no known solution. The computer filled in the gaps with sequences from bits in

the gene bank to make it look like a bat-borne SARS-like coronavirus! A wave of the magic wand and poof, an in silico (computer-generated) genome, a scientific fantasy, was created. The creation of the mutant variants (which numbered 6000 according to Dr Andrew Kaufman) are also in silico, and would simply serve to extend the so-called pandemic. The variants were almost laughable, especially when 'Omicron' appeared in the autumn of 2021. I got all excited thinking there was a new edition to the *Transformers* movies, where the 'Decepticons' lead by 'Megatron' did battle with a new character called 'Omicron'. The fact that many saw the obvious anagram in the word Omicron rearranged to spell 'moronic', signalled the end of the Covid variants. The UK chief medical advisor, Chris Whitty, even said that Britons won't accept lockdown rules to fight Omicron over the Winter of 2022, due to 'behavioural fatigue' caused by two years of restrictions'. It was probably the most truthful statement he had spoken since the computer-generated Covid had arrived. The people were tired of it *all* - and still are!

The use of Greek/Phonetic words (sounds/letters) such as 'Delta Plus' was really about mind control and 'magic'. Anyone knows that 'delta' brain waves are associated with sleep and having a 'healthy immune system' and are more commonly found in children. Are they using such words, letters and numbers (not just for their magic variants) but to 'target' the mind, to instigate the coming changes desired by those who want to reset – build a new earth? It's interesting to note the nomenclature words 'Delta' and 'Lambda' for naming variants in 2020-21, also applies to names for some of the 5G antennae (more on this shortly). The onslaught against the human energy field is based on frequency (see earlier chapters). You'd have to be fast asleep (in a 'permanent' Delta wave) to believe any of the variant nonsense spewed by governments and their mouthpieces: the mainstream media. Yet, with millions now carrying mRNA spike proteins, courtesy of the 'vaccine', including the Delta 'Plus' term used by governments in 2021, it feels more likely to be symbolic of a 'living dead' (even death) for many who have participated in the gene-altering therapy to date. You can't get any deeper asleep than folk walking around outdoors, or driving a car alone, wearing a useless face mask! As I will come to shortly, the choice we face is to to live (life) from the 'Heart' or dwell in 'fear' (death) courtesy of the 'mind'.

Neil Ferguson, another member of NERVTAG and SAGE, led the way with the original 'virus' while John Edmunds followed with the 'variant' stage, especially the so-called UK or 'Kent variant' known as the 'Variant of Concern' (VOC) B.1.1.7. Ferguson does not have even an A-level in biology and appears to have no formal training in computer modelling, medicine or epidemiology, according to Derek Winton, an MSc in Computational Intelligence. Despite this fact, these 'models' were pushed to pursue the 'lockdowns'. The 'modellers', such as Ferguson, Edmunds and the Public Health England (PHE) director Susan Hopkins, were (are) obsessed with

'lockdowns' and are big promotors of vaccines. Edmunds, the dean of the London School of Hygiene & Tropical Medicine's Faculty of Epidemiology and Population Health, is primarily funded by the Bill and Melinda Gates Foundation and the Gates-established and funded GAVI vaccine alliance, the Gates' vehicle to 'vaccinate the world'. As one researcher said: 'Just follow the money, to see from whence Covid came."

VACCINATIONS MAKE US FREE

When the pandemic landed on our 'television screens' in March 2020, I knew from the offset that we were dealing with a pantomime and a global 'problem' 'invented' to justify a New World Order. Mandatory vaccination, a cashless currency and the *control* of movement of people was always part of the agenda leading towards an Orwellian state. The first meme I created on social media in March 2020 was a warning of the coming 'mandatory vaccinations'(ID), which was glaringly obvious for those who had spent over two decades researching the hidden geo-political 'backdrop' pursuing a global reset. At the time of writing, vaccination programmes (trials) have been well underway for 2 years globally. Vaccine passports have also become part of the 'solution' to all things Covid. Even the use of the word 'passport' is deceptive. A 'Passport' implies a document endorsed by a state that establishes citizenship and guarantees diplomatic protection. It could be required not only to establish identity and 'vaccine status', at national borders, but also to travel, access public buildings and use basic services within one's own country of residence. A traditional passport **does not require the bearer to participate in a vaccine program**, although immunity certificates have existed for diseases such as Yellow Fever. Another passport initiative is the 'CommonPass', a digital health app being developed by the Commons Project Foundation, founded by the Rockefeller Foundation and is supported by the World Economic Forum. The 'CommonPass's is both a framework and an app that "will allow individuals to access their lab results and vaccination records, and consent to have that information used to validate their COVID status without revealing any other underlying personal health information."

Israel seemed to be leading the way when it came to Covid crackdowns, tech and vaccination programes. In December 2021, the Israeli government announced it was developing a social Score system that connected Covid-19 data with GPS. In March 2020, Israel invoked emergency powers to use cell phone tracking data to retrace the movements of those believed to be infected and thus to implement 'quarantines'. According to Jessica Davis, in her paper *Surveillance, intelligence and ethics in a Covid-19 world* (2022), the 'data' had

previously been aquired by the Israeli Security Agency for counter-terrorism purposes.[6] The Israeli government even planned 'war games' in response to another new strain of the deadly plague. According to the *Jerusalem Post* (November 2021), in a headline *Israel to hold COVID-19 'war games'*, Prime Minister Naftali Bennett regularly refers to the 'Omega strain,' of coronavirus.[7]

According to a National Security Intelligence and Ethics book published by Routledge in 2022, during the first six months of the pandemic, a number of states discussed the possibility of 'exploiting' national security surveillance tools to fight the pandemic.[8] The use of CCTV and facial recognition software was also deployed (increased) during the pandemic, too. AI Technology was being used in places like China to detect infection, and compliance with quarantines. As I showed in *Orion's Door*, Chinese facial recognition technology can detect elevated temperatures in a crowd and is used to identify citizens not wearing a mask. In Russia, CCTV was used to enforce lockdown, and in France, surveillance cameras were used to check adherence to rules. None of this was about a virus; it was to roll out the 'dystopian new normal' in countries that could now use technology to increase control of their people.

As usual the media and 'celebrities' went on the attack over people who could see through the control and adverse situations caused by the mRNA vaccination. The likes of Piers Morgan and Andrew Neil came forward in the UK press saying it was time to punish Britains' five million (much more, I would suggest) vaccine refuseniks. Neil said in the UK *Mail Online* in December 2021: "They put us all at risk of more restrictions, so why don't we curb some of their freedoms." While these self apppointed mouthpieces were belittling the inteligence of millions, the patented inventor of mRNA gene technology, Dr. Robert Malone, was saying: "It is starting to look to me like the largest experiment on human beings in recorded history has failed." James Whale and Nick Ferrari, both British radio hosts and television presenters, showed their lack of interest in 'medical freedom' when they chastised NHS staff who refused to be vaccinated. Whale went as far as saying: "Sack the nurses, for God's sake. If they're not going to have the vaccine, why would you keep them in a hospital?" God forbid this guy ever needed a nurse! What 'celebrities' of this calibre seemed to forget, is that *all* freedoms, means the freedom to decide what goes in our own bodies. These are the freedoms afforded to us by our grandparents who sacrificed so much in previous 'real' wars. Freedom is not something to give away so lightly. How come we have not feared other viruses before? Why are we living in so much fear? Because, I would suggest, we have not yet realised our true power! When we regain our power (as a collective human family), the 'spiritual war' within will be over, and our current plight will be no more!

'BUILD-BACK-BETTER' = A NEW WORLD ORDER

As the pandemic got into full swing in 2020, another 'character' surfaced on social media as the public researched into the terms 'Build Back Better' and the 'Fourth Industrial Revolution'. Politicians from all countries were heard using the term, 'build back better'(BBB), to the point of anoyance. All of the sound bytes repeating this slogan came from speeches and global agenda policies (see figure 62). The term, 'build back better' was first introduced at the United Nations Economic and Social Council (ECOSOC) in July 2005 by former United States President Bill Clinton in response to the 2004 Indian Ocean Tsunami disaster. The principle of 'Build Back Better' is generally understood to use 'a disaster' (a problem) as a 'trigger' to create more resilient nations and societies than before. Enter Klaus Schwab (founder of the Cult's fund-

Figure 62: Build Back Better is a spell (mantra).
Global leaders all repeating the same mantra for full effect.

ed World Economic Forum), published a book in 2020, *Covid-19: The Great Reset*, wherein which he uses the 'problem' of 'Covid' to justify a total transformation of human society to 'save' humanity from 'climate change'. Little Greta Thunberg was also put on the 'world stage' by Klaus Schwab and the World Economic Forum (WEF). Schwab's book lays out a *new* society straight in line with Agenda 21 and Agenda 2030. So does Bill Gate's book, *How to Avoid a Climate Disaster (2021)* and no doubt his book, *How to Prevent the Next Pandemic* (2022), promotes the need for more power in the hands of the few. While Gates takes time out from 'vaccinating the world', he likes to fly across the world in private jets admitting, "I probably have one of the highest greenhouse gas footprints of anyone on the planet." It's amazing how billionaires like Gates suddenly turn 'saviours of earth' while continuing to trash the planet. It's as though books of this ilk were written by the same author, when they openly promote a centralisation of power through a 'reset' of the old world structures. A quick scan of Gate's book-blog website shows the type of literature he (and his masters) are interested in promoting. Subjects include books on AI, robots and gene manipulation.

Bill Gates is now the biggest owner of farm land in the United States; he

does nothing without an ulterior motive involving dark forces within the shadows. Klaus Schwab wrote: "To feed the world in the next 50 years we will need to produce as much food as was produced in the last 10,000 years ... food security will only be achieved, however, if regulations on genetically modified foods are adapted to reflect the reality that gene editing offers a precise, efficient and safe method of improving crops." Food security sounds more like controlling our food supply! More so, it is about *replacing* organic food with synthetic foods, as wildlife, such as bee and bird populations, are devastated through aluminium, pesticides, herbicides and radiation, especially 5G. Dolphins and whales are also affected, having their natural radar blocked by the effects of ever-increasing EMF radiation and the introduction of both nanotech and neurotechnologies. Mr Build-Back-Better, Klaus Schwab wrote in 2018:

> *Neurotechnologies enable us to better influence consciousness and thought and to understand many activities of the brain. They include decoding what we are thinking in fine levels of detail through new chemicals and interventions that can influence our brains to correct for errors or enhance functionality.*

This is the idea all along, to 'influence' the brain, or even better, control the mind through nanotechnologies. Schwab looks like a James Bond villian, and these words could have been spoken by Blofeld.

Tony Blair played his role in the great 'global reset' planned by globalists such as Schwab to create a digital identification and checkpoint society - leading towards a more authoritarian-led state, and Western global governments with a social credit scoring system like China. Blair, who was recently given the title of Knight Companion of the Most Noble Order of the Garter (the highest possible ranking) advocated digital and vaccine passports during lockdowns and tried to introduce ID cards during the illegal invasion of Iraq (2003). This guy is not to be trusted with your 'freedom', but being made a knight of the realm is okay? Interestingly, at the time of writing, the Ukraine (while at war with Russia) announced it's the first country to implement the WEF's 'Great Reset' by setting up a Social Credit Application combining Universal Basic Income (UBI), a Digital Identity and a Vaccine Passport all within their *Diia* app.

REINFORCING THE NARRATIVE

A new age is undoubtedly being maneuvered into place, towards the technological grid I am highlighting. Symbolism and magic are being used to 'mesmerise' humanity, subconsciously. Symbolism, sound bytes, mantras and iconic imagery are used to target the subconscious, more than we realise. The rainbow, for example, is one symbol that represents a 'new age' emerging after great earth changes, such as the legendary biblical flood, or deluge. A

flood that seemingly destroyed earth's advanced civilisations Atlantis and Mu. Symbols are powerful and are used to invoke reality, to lay the foundations in our subconscious towards manifesting specific outcomes. Those who innocently made rainbows during the Covid-19 pandemic, seemed to be under some kind of 'spell', or at least *unknowingly* celebrating the coming of a not-so-distant (better world), a 'new world' (a promise of a cure) *beyond* the rainbow. Daubing windows with rainbows all over the UK at the beginning of the pandemic in 2020, felt like some kind of ritual on a par with the ancient rite of 'marking doorways and windows' (to "write the words of God on the gates and doorposts of your house" Deuteronomy 6:9). Of course, they are *not* the same thing; but, in terms of 'suggestive' media-programming and the 'power of symbols' to convey a message, we seemed to witness a national ritual. The Thursday night clapping at 8pm in the UK during that time was another ritual.

Endless television commercials also reinforced the narrative and rituals. A Microsoft Team's commercial, that ran on mainstream television during the early months of the Covid-19 pandemic, was just as ludicrous in my view as the virus 'modelling'. It tried to suggest doctors were running out of 'technology response' caused by the pandemic. How can anyone run out of technology? Isn't that like saying we are running out of broadband, or Wi-Fi? The commercial finished by saying: "We are living on Teams." Exactly the point! The new way of 'living online' being reinforced through another Bill Gates organisation is obvious to those who can see the connections. One can't help but feel the alleged outbreak of Covid in China 2020 was perfectly timed to further advance towards a New World Order. I call this 'new normal' the Cyber-Grid Empire in my book, *Orion's Door*. An 'empire' not least proposing 'mandatory vaccinations', a 'new normal' and a global *cashless* economy. The latter being crucial and possibly the real reason for all-things Covid.

Another example of 'reinforcing' the narrative through imagery, on television, especially at the time of the Euro soccer championships in June/July 2021. Stadiums in places like Budapest and Wembley crammed and packed full of fans, with no one adhering to the 'social distancing' rules, while the soccer TV pundits were 'spaced apart' to reinforce the Covid 'narrative'. The duality became more obvious to those who had awakened during 'Covid times'.

SPELLS, MANTRA'S & STAR MAGIC

The use of 'darkness' is also important in ceremonial 'events', just as it was utilised at the beginning of the Covid-19 hysteria in places like Milan, Italy where we witnessed a line of parked, military trucks strategically placed to 'install fear' of the deadly virus in 2020. The term 'dark winter' was used in that period to emphasise the 'coming darkness'. Whether a ceremony at night, or the use of mantras, all were designed to instill fear of the unknown.

The same mind spells and TV magic were happening in China (February 2020) with alleged 'victims' of Covid-19 'dropping to the ground'; again, all designed to instill fear!

The other aspect of 'spell binding' throughout the 2020 pandemic was the use of the 'power of three', mentioned earlier in the book. The UK government's use of **three** words, such as, 'Strong and stable'; 'Get Brexit done'; 'Stay home, protect NHS, save lives'; 'Stay alert, control the virus, save lives'; 'Hands, Face, Space'; 'Build back better', etc. All are mantra-like, consistently reinforcing the message. As I said earlier, magic is part 'spell' and part 'mantra' - the latter is practiced to train, or *initiate* those using it.

It feels as though a nefarious 'star magic' is behind the 'digital alien' (in its many forms), one that 'symbolically' emerges from a fallen state through an *inverted* version of Orion, symbolically ending the 'Old World Order' and birthing a *new* 'Cyber-Grid World Order'. I wonder if this is the so-called 'New Normal' in symbolic form? A Cyber-Grid does seem to be emerging to *control* the world's population in every country, not least the Superpowers; and, I would suggest this Grid will be almost 'god-like'. Technology already holds power, not least through our addiction to *it* and becoming more so in recent years. Is it too far out to suggest Artificial Intelligence, in more sophisticated forms, is intended to 'overshadow' the ancient earth grids? Will AI create digital quarantine facilities for the human soul (soul cages), eventually controlled by advanced artificial intelligence? It's interesting to note there are also *three* types of AI: Artificial Narrow (Machine learning, like Alexa), ANI; Machine intelligence (AGI) and Machine Consciousness (ASI), and all three would create the Cyber-Grid on earth, with another higher form of 4D artificial Intelligence *outside* of our 3D reality, but influencing it. Every facet of human life is intended to be connected to this grid, from driverless cars, trains, planes (all public transport), smart meters (the Internet of things) and ultimately, the idea of a *new synthetic* genetically modified human being. Far fetched? No, its almost here. ANI and AGI are already upon us! In 2022 scientists at IBM created a new type of computer chip which has the ability to constantly rewire itself just like the human brain and is thus able to more efficiently adapt to new processes. This is a new type of neuromorphic computing and holds great promise for future, and better, Artificial Intelligence models which more closely resemble how humans behave.[9]

We have been *given* artificial intelligence, in its basic form, courtesy of the likes of DARPA, the inspiration and funder behind so much transhumanist technology designed, it seems, to hijack the human mind. AI gadgetry that people would never connect to the technological development arm of the Pentagon, is now amongst us in the form of 'Alexa', 'Cortana' and 'Bixby', the latter courtesy of the Samsung Group. The word 'Cortana' is a Latin form of the Anglo-French 'curtein', from Latin 'curtus', and refers to a ceremonial sword, which again could suggest a connection to Orion and the sword and

belt stars 42 Orionis, Theta Orionis and Iota Orionis.

CONTROLLING THE HIVE MIND

The plan to turn humans into AI-controlled cyborgs has been symbolised many times in science fiction movies and television series, and few more accurately than *Star Trek* and its concept of the 'Borg'. These are portrayed as a 'collective species' – part biological, part technological – that have been 'turned' into cybernetic organisms functioning as drones within a hive mind called the 'Collective', or the 'Hive'. The Nefilim, Watchers, Reptilians, Greys and others connected to the Predator Consciousness can be archontically-controlled as a 'hive' species. The Borg are portrayed as emotionless drones, malevolent just like the Archon entities mentioned in earlier chapters, and coordinated by a 'Borg Queen' in the way a queen bee relates to a hive. Identical themes appeared in the movie *The Great Wall* (2016), where a collective reptilian species called the 'Tao Tei', all controlled by a Queen that had come to earth in ancient times, who directs her hoard to feed off humans. The aliens and their hybrids (like the Greys and Reptilians found in so many books and literature) are said to have a similar structure based on a Queen. Therefore, would it be too much of a stretch of the imagination to think of the archetypal alien 'Queen' as pure artificial intelligence? Are we being manipulated by a technological species that is also using other alien species to create a technological prison on earth? Cyborg Orions, as I call them, are also epitomized in the *I Robot* movie (2004) which shows 'VIKI' (Virtual Interactive Kinetic Intelligence) as the central 'Queen intelligence' controlling all of the robots. She makes Google's Alexa look like an Abacus compared to a Cell Phone. The Alexa-like cyborg world is where we are going in the not-too-far distant future.

The key to understanding alien life is to look at the devices we are now using and if you're of my generation, when there was no digital world, no Wi-Fi interference or none of this 'other' intelligence, the world felt very different. All of this technology has come from 'somewhere' - it hasn't just evolved. Humans haven't decided that they're suddenly going to build robots that are artificially intelligent, this is not a 'natural' evolution for humanity. As I am hinting at here, we're dealing with an infusion of artificial intelligence giving us the tools to 'reconstruct' our world to the detriment of future generations. That's the conspiracy! We are destroying our world, courtesy of alien (artificial) intelligence that wants the world to resemble a playground such that alien intelligence can purely interact with and control - the goal being the end of the human species as we know it. I think that there's going to be a point that hasn't happened yet - where it's going to be very difficult for a highly-evolved human, interacting with their Superconsciousness, to NOT see the alien; the digital beast for what it is – pure evil.

Whilst Social Media was in its infancy, in 2008, the UK *Telegraph* ran an online article about a 'condition' titled *'Truman Show Syndrome Delusion'*, named after the 1999 film starring Jim Carey. The condition came from the main character realising his life is one big 'live reality TV show,' and everyone he knows are actors on a 'fake' TV show watched by millions. Psychiatrists said that viewers of the film, suffering from depression, became so depressed by their perception of 'reality' they felt they could no longer trust anyone, experienced suicidal ideation and even threatened suicide. As psychiatrist, Ian Gold, quoted in the article, said at the time, "We've passed a watershed moment, with respect to the Internet, in which you can do something very silly and without skill, and yet become famous instantly [see Instragram]."

One's continuous presence on a social media app trains the brain to more readily accept being linked into that online Cyber-Grid reality I am illustrating in this chapter. The pressures of being 'liked' on platforms like Instagram, for younger generations (even though the company has taken affirmative steps to deal with the harmful effects on mental health), can still be devastating. Depression and anxiety caused by prolonged time on these platforms has not magically disappeared, it has grown, especially since the 'lockdown' caused by the Coronavirus pandemic. For example, in 2019, Instagram began piloting in Canada, Ireland, Italy, Brazil, Australia, New Zealand and Japan a *'change* in post information displays' they said would hide the number of photos and videos received in an effort to create a "less peer-pressured" environment. On the surface, such moves are an improvement, but we are still dealing with a 'global phenomena' affecting power over human thinking and human emotions. AI is literally gaining its knowledge *from everything we put online*. The Cyber-Grid Empire, as I call it in my books, is being built with our 'thumbs' and cell phones (including pads and cellular wearable devices), from the 'content' we input and circulate daily.

DARK FIBRE, 5G & THE INTERNET OF THINGS

Expanding Internet access has become something of an obsession among tech companies. Google offers fibre Internet services as well as its own cellular network. Facebook scrapped plans to offer Internet access via drones in June 2018, and Amazon isn't the only company hoping to use low earth orbit satellites to allow previously unconnected people to join the rest of the world online, finally. The reason why all these seemingly 'independent' Big Tech companies are rooting for the *same* technological advancements, I would suggest, is because they are connected, at their highest levels, to the off-world Cult. The Cult seems to be operating as a Mafia-style global body (without borders) for its alien (artificial Intelligent) masters, and possibly why we are moving ever-so-quickly towards an AI assimilated reality.

The unrelenting push for implementing 5G (Fifth Generation), as an unknown infrastructure through what is called 'Dark Fibre', is also part of the Cyber-Grid, *digital* World Order. Dark fibre can be used to create a privately-operated optical 'fibre network', run directly by its operator over 'dark fibre' and existing Internet networks. This is opposed to purchasing bandwidth or leased line capacity (used to connect offices and large groups of internet users) on an existing network. Dark fibre networks may be used for 'private networking', or as Internet access or Internet infrastructure networking, through devices that are part of the 5G network. In simpler terms, 5G is the means by which the 'artificial intelligent grid' will be connected to the Internet of Things. And as I have already pointed out, this Cyber-Grid will be used to control all human life in the not-so-distant future. At the time of writing, Google ran an article in October 2021 saying that Sherwood Forest, of Robin Hood fame in the UK, was set for 5G upgrade, internet drones and robot dogs, to enhance the visitor 'experience'. The reason for this is obvious. Even what we call parks or the great outdoors are meant to be 'connected' and 'monitored' by robots in the not so distant future. 5G would be instrumental in facilitating such an artificially intelligent reality.

As the coronavirus pandemic arrived in February 2020, growing numbers of people revisited the concerns outlined by scientists over the safety of Fifth-generation (5G) technology.

As far back as September 2017, over 180 scientists and doctors, in almost 40 countries, warned the world about 5G health risks. These scientists, in response to Resolution 1815 of the Council of Europe, said:

> *We, the undersigned scientists, recommend a moratorium on the roll-out of the fifth generation, 5G, until potential hazards for human health and the environment have been fully investigated by scientists independent from industry. 5G will substantially increase exposure to radio frequency electromagnetic fields (RF-EMF)... and has been proven to be harmful to humans and the environment.*[10]

Fifth-generation wireless technology (5G) began full deployment in 2018; coincidently, symptoms being described as coming from victims of Covid-19 in China, via GreatFire.org and other censorship-busting websites (in their words), showed tens of thousands of posts describing the *first* symptoms of Covid-19 being a 'dry cough' making those infected tired and fatigued (breathless) just as any flu would. The EUROPA EM-EMF Guideline 2016 also stated: "There is strong evidence that long-term exposure to certain electromagnetic fields (EMFs) is a risk factor for diseases such as certain cancers, Alzheimer's disease, and male infertility" According to the guidelines published, common EHS (electromagnetic hypersensitivity) symptoms can include "headaches, concentration difficulties, sleep problems, depression,

lack of energy, fatigue, and *flu-like symptoms.*"[10] Was China's EMF levels of toxicity pollution a factor in *their* pandemic? It's hard to know. China is lead-ing the way with Fifth Generation cellular technology and its use of 5G and AI (through robots, facial recognition and drones, etc) especially its response to Covid-19 was/is unprecedented.

A 'DIGITAL NEW AGE' & THE TIME OF *REVELATION*

Teachings within the Hermetic Qabalah can be seen as a 'blueprint' for 'con-structing' reality (metaphysically) and is part diagraphic in terms of the pro-jection (manifestation) of an infinite light (a matrix or god). The hermetic Qabalah is also thought of as the manifestation of a 'light body' in hermetic mysticism and it is this 'invisible light' of the Creator that constructs the Tree of Life.

According to the *Zohar* (Splendor or Radiance), the mystery of '*six*' thou-sand years before the deadline for a future New Age is considered crucial to understanding the nature of a coming technological age I am describing in this chapter. The Hebrew year 6000, from sunset of 29 September 2239 until nightfall of 16 September 2240 (on the current Gregorian calendar), is thought to mark the initiation of what would be considrered a 'New Millennia'. In other words, an emerging New Age *could* start to manifest, leading to a greater millennia to come. The *Zohar* states that the deadline by which the new age, or millennia, will arrive is 6,000 years from creation.[11] If so, *whatever* is coming to our world in the next twenty, to *thirty* years, will most likely be the start, or part of, a *new* technological age. Whatever emerges, could reveal a 'heavenly force' *for great good*, or possibly, a sentient alien force (an artificial intelligence takeover) that does not necessarily have humanity's best interest at heart. I'll leave that up to you to ponder on. Even though I am going to illustrate what looks like a dire, irreversible outcome, I sense something loving, wise and good is coming to our world.

As I say, the notion of six thousand years is said to come from interpreta-tions of mystical texts, such as the *Zohar* and, of course, the idea of *six days of creation*, forming the Sefirot (the Tree of life), is also thought to create a hexa-gram shape. The hexagram-shape-star, known as Metatron's Cube, is said to be the symbol for a 'god-man' (or part of God) that is *revealed* to humanity at the chosen time. It is also called the 'Microprosopus' for the likes of Christian Knorr von Rosenroth (July 1636 – 1689), a Christian Hebraist and Qabalist. I often wonder if something 'divine' is coming to earth *from* Orion in the not-so-far distant future? Is this the Second Coming referred to in Christian-Gnostic and Hermetic revelation? In similar ancient texts, the Seventh Millennium is also thought to be when a celestial liberator will arrive on earth, too. Numerologically, from the number *seven* upwards, we are said to enter the 'spheres' of the 'higher Adam' (or heavenly Adam) and the *source*.

In line with such numerology, (according to a number of Premillennialists) we also find seven 'Adamic Covenants' (phases or figures) supposedly given to humanity by God, from Noah through to the 'renovation of the earth by fire'. The seven figures in the bible are named as Adam (Orion), Noah, Abraham, Moses, Jesus, the 'Second Coming' and the 'renovation by fire' (after the Millennia); the latter seems to relate to the 'New Earth' created out of fire (possibly technology?). The number *eight* and *ten* are also important numbers in this configuration, as *eight* is said to be the number of covenants (with dispensations) between Eden and the New Heaven and Earth, as commented on by the Christian Premillennialist, Clarence Larkin (1850–1924) in his *Dispensational Truth (or God's Plan and Purpose in the Ages, 1918)*.

In Hermetic-Gnostic teachings there are also ten spheres of the Sefirot and *ten* dimensions of what is called the 'Shi'ur Komah', the 'Archetypal Man' - 'Adam on High'. This 'man' is considered by some to be the same Archetypal figure relating to the 'mark of a man', in the Book of Revelation, who is possibly the protogonos of the new 'digital human' - a 'digital creature'. One who is said to have a 'direct experience' with the Creator in a new millennia. How could this *new* adam (or human being) have a direct experience with the creator god of technology? Through his/her 'mark' (or Digital ID-chip), I would suggest. As the text in Revelation (*13:15–18*) explains:

> *And that no man might buy or sell, save he that had the mark, or the name of the beast, or the number of his name. Here is wisdom. Let him that hath understanding count the number of the beast: for it is the number of a man; and his number is Six hundred threescore and six.*

The numbers 666 and the 'mark of the beast' have been shown to relate to the use of barcodes, microchips and electronic currency (credit), which constitutes the digital 'traceable' human. I tackled some of these subjects in my fictional story, *Kokoro - The New Jerusalem & the Rise of the True Human Being* (2009), where I saw the Cyber-Grid as a 'City World' policed by clones or agents of the grid (see figure 394). The clones had received the 'mark' and were merely servants (worker ants) for the machine-like god (the Demiurge), the god of technology that created the Cyber-City-Grid Empire.

The idea of 'experiencing' a new world, or 'cyber age' in the 21st Century, may not necessarily be what some think it will be. The coming age is intended, so it seems, to be a transhumanist utopia unless we wake up and regain what's left of our organic 'humanity'. I wonder if this 'hidden' intelligence (AI) *is* the Gnostic Demiurge (an alien diety), and the future world *is* the Artificial Intelligence-controlled World Order? With such an advancing new era, at this time, it is also said that 'science' and 'technology' *becomes* God-like. Only a *living*, artificial consciousness could be titled so and fulfil such prophecies.[12]

GNOSTIC KEYS TO 'NUMBER *TWENTY TWO*

It is commonly known that 22 to 24 'Phoenician-Hebrew' books constitute the 'Jewish Bible' and that the Hebrew alphabet is made up of 22 letters, which was, according to their faith, created to compose the 'Word of God'. The word can be understood as 'sound', 'energy', 'vibration' and 'light' – the Logos. The word of God is also called a lamp in Psalms 119:105, Proverbs 6:22, and the 'light by which we are to live'. The light is the fabric of the matrix, our illusion reality; therefore, the coding of '22' within much biblical text can be seen as an integral focus on 'vibrational themes', on magic and the codes for 'building' a new reality.

The number 22 (like 11 and 33) is about 'manifestation' (or the 'place of manifestation'), from where unseen forces make themselves known. The Third World War is *already* taking place in the unseen levels of reality and it became more obvious as we moved through 2022.

Twenty Two is the number of 'revelation' and the Book of John is said to be the *22nd* book written and included in the New Testament. In the *22nd* chapter of the Gospel of John, Christ identifies himself as the 'Alpha and Omega' which would be the 'first' and 'last letters' of the Greek Alphabet, 'Aleph' and 'Tav'. The word 'light' is also repeated 22 times in the same gospel, and on the 22nd time, John quotes Jesus: "I have come as a light into the world … " (*John* 12:46). In this manner, the number 22 could also be seen as uniting the entire works of Scripture and is said by some scholars to carry the numerical value relating to the Hebrew word 'Yachad', meaning 'unite'. What did billionaire Richard Branson call his sub-orbital spaceflight? Virgin Galactic Unity 22! The number 'vibrationally' is significant. At the time of writing, the 'miracle' Covid-19 'Vaccine' is being given a 'Jesus-like' persona, for those who 'believe' in all-things Covid. The 'vaccine' is being used to 'divide' the human population, and the year 2022 is the beginning of the end for such obvious coercion and manipulation.

The Kabbalah talks of 22 paths between the Sephirot, the Tree of Life (our DNA) and can be seen in the 22 Major Arcana cards in the original tarot. The Fool card is the link between the 'journey' and reaching a new world (reality). All this takes place in the mind. The 22 letters/symbols are considered the building blocks of the Universe (reality), just as DNA builds the physical world, the underlying occult scientific significance of the number 22 seems to be made manifest in the quantity of the bones of the human skull, of which there are *twenty-two* (8 form the cranium and 14 are associated with the face) see figure 63. You could say that our brain (or mind) inside the skull (head) is the vehicle through which we 'think', 'reason' and come to 'know our true self'. But the heart is the true spiritual brain! The 22 letters of the Hebrew alphabet (created to compose the 'Word of God') are symbolic of the 22 bones of Golgotha (skull), and the place from where we symbolically 'receive the

light' (become illuminated) through the 'pineal'. Like 'John the Divine', it is where we create magic, or have our own 'Revelation'.

The number 22 is considered a 'gnostic key' to revelation in the Bible, where it is revealed in Isaiah 22.22: "And the key of the house of David will I lay upon his shoulder; so he shall open, and none shall shut; and he shall shut, and none shall open." 22 is a vibrational 'opener and closer' of worlds. Some writers say the number 22 unites the entire Bible in the form of a Wheel (or Galgal), which unites the heart of all 66 Books of the Holy Bible. You could also see the numerology as 3 cycles of 22 Books 'united' in one perfect circle.

The number 22 can also be symbolic of a huge amount of 'chaos' since it is a double numeric of the number eleven, which represents 'chaos' and 'disor-

Figure 63: *Twenty two* **major arcana tarot cards.**
22 tarot cards, 22 letters of the Hebrew alphabet, and 22 bones in the human skull (Golgotha).
Obviously not a coincidence?

der'. In this way, we often see 22 as a 'period' of chaos (or disorder) followed by something new. You could say all numbers are significant to the priesthoods who wrote the scriptures (the script). In the book of Genesis, it is claimed God created 22 'creations' within the *six* days of creation. The Bible also records 22 generations from Adam to Jacob.

Twenty two is a 'master number', and associated with the vibration of the masonic 'Master Builder' (Build Back Better) who, esoterically speaking, has the ability to turn the loftiest dreams into concrete realities. In reverse the vibration (symbolism) also has the capability to turn reality to chaos. According to numerologists, the number 22 is powerful when it occurs in one of the core positions in a person's Numerology chart. In everyday experience, 22 is considered a simple multi-digit number that can also be reduced to '4' (2+2) and sometimes depicted as 22/4. The numbers '23' and '24' are also relevant to the same numerological themes. With multi-digit numbers we are in the realms of duality, where things can go one-way, or the other! Plentitude can easily become 'shortages', or visa versa. I'll have much more to say about the symbols of duality in *Part Three*.

DOUBLE DIGITS *EVERYWHERE*

According to author Ellis C. Taylor, Master Numbers also relate to 'health issues' especially around bone (skull/spine) and fractures, and these numbers have an 'air of detachment'. This highest of the master numbers was the alleged age of Jesus at his death-resurrection giving more esoteric accents. 33, like 22, relates to the 'spinal column' and the 'skull' that sits atop it (see Golgotha again). Many assassinations and terrorist attacks seem to have been orchestrated around the 'numerological vibration' of 322. It is also the number on the seal of one of the most notorious secret societies, the Skull & Bones.

Anyone who has studied secret society symbolism will see the obvious Masonic connections to the number 22. Delta Kappa Epsilon (ΔKE), commonly known as DKE (or Deke), one of the oldest fraternities in the United States, was founded June 22, 1844 (see *Orion's Door* for more on this secret society). The 22nd Amendment ('no person shall be elected to the office of the President more than twice') and the founding fathers' obvious connections to European Freemasonry is well known. The *22nd* degree in Freemasonry is thought to commemorate the biblical Sidonians who are said to have 'felled the great cedar trees' to create the Ark of Noah, the 'Ark of the Covenant' (Arks were thought to be made of Acacia wood), and was the wood used for the Temple of Solomon. The song 22 *Acacia Avenue* by Iron Maiden on their album *Number of the Beast* (22 March 1982), hints at this Masonic knowledge. The Masonic title relating to the 22nd degree is called the 'Knight of the Royal Axe', or 'Prince Libanus' a title connected to a royal Prussian Knight, at the time of the Crusades. According to masonic writings, whoever reaches the 22nd degree becomes (in title) a Knight of the Royal Axe (double axe), which was the symbol of the builder, the wood-cutter and 'executioner', etc. The axe was an important symbol of power and was often depicted on Chinese robes worn by officials, representing the Emperor's power to 'guide the nation' through 'tough times'. Here are a just few examples of 22 coding:

- *22nd* November 1963: President John F. Kennedy Sr. was shot and killed in Dealey Plaza in Dallas, Texas near the 33rd Parallel (11 + 22 = 33). Dealey Plaza is the site of the first Masonic temple in Dallas, and a Masonic obelisk. Thus, we see the numbers utilized in the JFK assassination. Robert F. Kennedy, was killed at the Ambassador Hotel in Los Angeles, California, close to the *33rd* Parallel and also near a Masonic Lodge. Like the assassination of JFK, this assassination contains occult Master Numbers. RFK was shot by a 22-calibre pistol.

- *22nd* February 1967: 25,000 US and South Vietnamese troops launch Operation Junction City against the Viet Cong. The Largest US airborne

assault since WWII.

- NASA also likes to use the number 22, see the Astronaut Group 22.

- The *22nd* day of March, May and July seem to have been more than 'coincidental' over the years! Remember these attacks? (see figure 64)

The letter 'V', is the *22nd* letter in the alphabet. The words COVID and Vaccine, are also 'coded' with the vibration of 22, too. The esoteric 'vibration' of 22 can relate to sudden 'death' (symbolically) or ending and 'renewal' on one level, but there are also more mysterious connections to 22. According to the Beast, Aleister Crowley and the Hermetic Order of the Golden Dawn: *"The 'V' symbol also echoes the downward-pointing triangle, a symbol of Horus, the Crowned and Conquering Child of the New Aeon – a New World Order".*

The 2005 film *V for Vendetta* is about a totalitarian dictatorship (in the UK) that gains its power by creating a society of fear due to an alleged virus spreading throughout the world in what is supposedly the year 2020. *Mmmm!* Likewise, the global protests and marches since 2020, often symbolised by the V 'mask' through the Covid era, have the same '22' energy imprint.

NUMBERS, 'APOPHENIA', CODES & 'ORDO AB CHAO'

The energy or 'vibration' of 22 seems to imply a dualistic (one way or the other) scenario in the world at large. It's also a number, like 11, that seems to 'get noticed' by people when they check a clock, which again alludes to the illusion of time, Saturn and some of the esoteric symbolism already mentioned. The number association of 22, 11 and 23 was developed in the writings of Aleister Crowley and Robert Anton Wilson, called 'apophenia' (a tendency to perceive connections and meaning between unrelated things). These number codes seem to correlate with 'seeing' the matrix or 'illusion' at work. Through 22, I have seen written references to the ideals of honesty, honor, integrity, and probity. The latter implies uprightness of character and consistent moral decency in

Figure 64: Just a coincidence? I doubt it.
The number 22 can be seen as an energy, or opportunity used to bring about change.

one's actions. Honor and integrity implies trustworthiness and incorruptibility to a degree that one is incapable of being 'false' to a trust, responsibility, or pledge. For its opposite, see every lying politician you can think of, especially in recent years! The ideal behind '22' relates to duality, balance and inner harmony – or in its inverted meaning, its imbalance, disharmony and lack of everything!

The number 23 (2030) is also important to the forces (secret society networks) that have been working towards the Great Reset or Great Work of the Ages. Like twenty-two, '23' also appears consistently in symbolism within movies, politics and ancient calendar systems, too. The ancient Egyptian and Sumerian calendars began on 23rd July, connecting to the rising of the star Sirius (see *Orion's Door*).

The 1998 German movie, '*23 – Nothing is what it seems*', and the Jim Carey film *23*, are both based on people with supposed apophenia. The former is about a 'computer hacker' who dies on *23rd* May 1989. Interestingly, in March 2018, *twenty three* Russian diplomats were 'expelled' from the UK due to a 'supposed assassination' of ex Russian spy, Sergei Skripal, and his daughter, in Salisbury. Why weren't 17, 19 or 21 (or even 22) diplomats expelled? Why 23? It seems clear to me that the numbers '22 & 23' are connected to 'mind-magic' (vibrational codes), aiding in reinforcing the 'control', or 'agenda', to bring about a deception or 'new order'.

In the opening code sequence of the **2003** film *Matrix Reloaded*, the final, most prominent number is 23 reversed, as if looking from inside a mirror. A reversed 23 could also be '32' which is the 'double-headed eagle' symbol for the Scottish Rite of Freemasonry (see the double axe, too). The prime numbers '2' and '3' together (to form 23), relate to 'creation numbers' and, in *Matrix Reloaded* (2003), Neo (the prime man), was told by the 'Architect' (Freemasonry again) that he could select '23 humans' to rebuild Zion, in order to continue the matrix, more on the symbolism in *The Matrix* films later in the book. There are also 23 provinces of China, 22 of which are controlled by the People's Republic of China (PRC). I think you get the picture.

22 - THE MASTER 'BUILDER' NUMBER

As we move beyond 2022 we need to resist all forms of the divide and rule and tyranny. Too many people have been manipulated to 'turn' on each other with regards to all-things Covid. As we move towards 2030, there will be a focus on mandatory vaccination and the loss of human rights, but we must resist the temptation to fuel the fires of hate at all costs. At the time of writing, we are seeing a 'splitting' in society over the 'miracle vaccine', as those who wish to 'build back better' are disguised to install global fascism. Yet, we all know that true unification is the key to our plight. The heart and mind need

to work as one! The path of fear only leads to more lockdowns, food short-ages and pandemics yet to come.

In 2021 and through 2022, we saw the beginning of the rollout of a 'papers please' digital Vaccine Pass (app), designed to create the foundations for a global digital identity pass. In some countries the digital pass has been referred to as a 'green pass' with hints at tracking individuals' 'carbon foor-prints' based on electronic purchases, too. Again, we are looking at tyranny and nothing more. The systems currently in place in China, for example, are making it possible for such a digital identity pass to be realised and imple-mented across the West. Again we must resist such an obvious move to install economic centalised control. If we don't, the pass will become the only means by which one can 'purchase' the basics of life, travel and eventu-ally receive medical treatment. As it is made clear in the 'script':

> [The beast] *also forced all people, great and small, rich and poor, free and slave, to receive a mark on their right hands or on their foreheads, so that they could not buy or sell unless they had the mark, which is the name of the beast or the number of its name. This calls for wisdom. Let the person who has insight calculate the number of the beast, for it is the number of a man. That number is 666 –* Revelation 13:16-18

The 'vaccine' itself is a twin-pronged tool designed to: a) change the nature of human biology: and b) usher in the global digital identity pass. The possi-bility of devastating fallout (hospitalisation) caused by the mRNA spike pro-tein, leading to unprecedented deaths also has to be considered. Such a trav-esty would lead to more draconian measures, including severe lockdowns and the call for the 'unclean' (the 'unvaccinated') to be 'separated' from the rest of society. All of these scenarios are 'markers' of the number 22, the mas-ter builder of a 'better world' – the Great Reset. Climate Change is also being focused on, and in many ways the Covid 'Lockdowns' are a precursor for 'future' Climate Change hoax lockdowns (huge restrictions), beyond 2023, especially as we move towards 2030. The same 'magic window' of time, could relate to a 2nd pandemic that had Bill Gates and his wife smirking in their TV interview in July 2020. In the video Gates said: "We'll have to pre-pare for the next one. That will get attention this time." As I said earlier, Gates is no saviour of earth, everything he does has the hallmark of the 'beast' of Revelation. It's also amazing how a coronavirus helped foster a move towards a less tolerant, totalitarian society, one that would easily welcome the 'beast' as its authority. The reign of darkness ruled over by the predator and fueled by Wetiko (mentioned in earlier chapters), will not prevail. As the Book of Revelation (17:18) says:

The beast that thou sawest was, and is not; and shall ascend out of the bottomless pit, and go into perdition: and they that dwell on the earth shall wonder, whose names were not written in the book of life from the foundation of the world, when they behold the beast that was, and is not, and yet is.

COVID APOCALYPSE OR THE 'KINGDOM OF HEAVEN'

The Beasts and the Dragon in the Book of Revelation are the expressions of Wetiko I've been describing in earlier chapters. The Fourth Beast, according to the scriptures, creates the 'king of the world', the kingdom of the Anti-Christ to dominate the world (see Daniel 7 and Revelation 13). The 'Great Reset' (New World Order) is the work of those aligned with the 'Beast and the Red Dragon' (China's power). The mark of the beast in Revelation, is the 'mark' of a man, possibly the mRNA 'vaccine', and we have not yet seen the real ramifications of this 'marking' of those who have been mainly coerced into receiving it. There is also mention of three plagues in Revelation (8:18) and dead bodies in the streets of Jerusalem and Egypt (11:8). Since Israel has been one of the most heavily vaccinated countries of the Covid era, anything could happen next. Why does the movie *World War Z* (2006) come to mind?

It's considered by some biblical scholars, that 'from our time' (the era to which John had been carried in his vision), the beast, ruled via the papal state head. The seven heads in Revelation relate to the world authority in the form of Babylon, Medo-Persia, Greece, Rome, Papal State, French /British Empires and the New Age (New World Order). The beast is the 'predator' manifested through the seven heads in Revelation described as "was, and is not." However, the beast is prophesized by John as 'ascending' to life again from the bottomless pit (Revelation 11). The same beast is the seven-headed beast, described as the emerging atheistic (including the secret society networks) that helped abolish (deliver the deadly wound) to the Papal State (head) in the late 1700s - the time of the French Revolution and the 'battle for the empire' that followed.

In Revelation the seven heads are crowned confirming that they are seven distinct kingdoms/nations. *Seven* numerologically represents completeness, and therefore, the beast and its heads form the complete set of corrupted forms of world authorities, from rule by 'holy monarchy' through to the 'republics'. A complete set of persecuting global authorities must include pagan (Rome), papal (Holy Roman Empire), atheistic and apostate protestant nations (French/British Empires), into the current New Age. We are in the final age of the 'fallen' but 'risen' beast of the Apocalypse. The United Nations (like the EU and other global bodies), are the current expressions of authorityruled over by the beast. The UN know the symbolism, especially when they placed a statue (supposedly a guardian symbol, a fusion of jaguar and eagle) donated by the Government of Oaxaca, Mexico and created by

Figure 65: Is it a beast or guardian?
The beast in the Book of Revelation 13 is considered distinct from the 7 headed beast, yet the UN beast or 'guardian' resembles the fallen beasts in Daniel 7. Is it a sign of the coming 'fall' of our current age and the birth of the new global Empire?

artists Jacobo and Maria Angeles (see figure 65). As it is written in Revelation 13:2:

... And the beast which I saw was like unto a leopard (overall), and his feet were as the feet of a bear, and his mouth as the mouth of a lion; and the dragon gave him his power, and his seat, and great authority!

The winged lion is a symbol for the Cherubim/Seraphim and are angels (or archons). The fall of celestial humanity, encoded in the eagle and lion symbolism (see my graphic novel *Aeon Rising)*, relates to the 'Age of Revelation' and what is known as the 'Apocalypse Angel' (see the Johannes Piscator Bible, 1602). We are now in the time of 'all being revealed'. As I've been saying for years, the symbolism is designed to give life to the scriptures. All these symbols are invoking a presence, opening a portal to other worlds, and ushering in a New World Order, or a new global 'Empire'.

THE CYBER-GRID EMPIRE

The idea of a 'world government' is a crucial part of the reasoning behind all-things Covid. It is the biggest global 'problem-reaction-solution' scenario since the Second World War. It is leading to what I call the Cyber-Grid Empire in my book, *Orion's Door*.

The Cyber-Grid Empire is intended to be the 'central command centre' for *all* aspects of life on earth. It is the underlying structure of the 'world government' warned about by many authors and visionaries over the past quarter of a century. It is also nothing new, as the old empires that formed the old grid desired the same ends. Just as dictatorships and all tyrannies of every age also desired total control, the Cyber-Grid will facilitate 'new unprecedented levels' of control. Historically, we know that Bronze Age Egyptian Kings desired to rule 'All That the Sun Encircles'; Mesopotamian Kings spoke of ruling 'All from the Sunrise to the Sunset', as did the ancient Chinese and Japanese Emperors who desired 'All under Heaven'. These four civilizations also developed impressive empires of what historians describe

as 'Great Unity', or Da Yitong as the Chinese put it. In truth, they were all ancient dictatorships, but the one being inspired for our future age will make all past tyrannies pale in comparison.

Known human history can be seen as a constant centralisation of global power which has become more technological as the ages passed. Some say the far ancient (prehistoric) world was also advanced 'technologically', hence the building of amazing architectural feats such as the pyramids and megalithic structures all over the ancient world. The pyramid itself is the per- fect 'model' for the type of centralisation of power harnessed by the earth's energy field – the grid. In the ancient world, the pyramid was also the abode of the gods (aliens) and served both as a temple structure and important 'nodes' on the ancient grid. The Cyber-Grid Empire seems to be designed to *overshadow* the original grid, or leylines, of connecting megalithic structures, temples and other important sites all over the world. The *vibration* of the whole planet is meant to change once again so the new Cyber-Grid Empire can become the ultimate focus of attention for humanity. Look at the focus we are now giving the artificial beast-like intelligence through our collective 'disconnection' from the old ways, or the organic world, as we become more addicted (intentionally so) to the new technological grid and what it belies. As I said in the last chapter, the 'smart world' is making the 'real world' not so smart, courtesy of AI gadgetry and an ever-growing need for an artificial world. Just look how people panic when there is 'no WIFI' or panic in general at the thought of being without even the basic supplies. The mass buying of toilet rolls in the UK and USA, at the time of the coronavirus outbreak in March 2020, was a perfect example of 'project fear' and mind control. Can you imagine mass blackouts caused by AI? Who would be in control of our world then?

What has long been termed 'globalisation' – the centralisation of global power in all areas of our lives, through the grid – has not happened by chance. The Cyber-Grid will facilitate further the centralisation of power globally and through it, a new empire will be created. This Grid-structure will be like no other in the history of humanity. Why? Because if it unfolds, the mind of a counterfeit god-like software (artificial intelligence) will be revered and 'connected' to *all* who are part of the coming Cyber-Grid. Cult networks helping to create and steer the Cyber-Grid into place, are working towards the centralisation of power through a world government, which will impose the Cyber-Grid Empire (New World Order) on *all* nations (all peo- ple). When anything becomes mandatory, whether vaccinations, taxes, or travel permits, etc., we know the precedent is being set for a global techno- cratic structure. At the time of writing, we are in the early stages of seeing the 'mandatory vaccinations' being pushed forward, not least thanks to the glob- al mainstream media which seems to be predominantly biased towards the

official narrative.

The Covid-19 pandemic allowed governments to pass emergency legislation and mandatory 'powers', which facilitated changes that are helping to bring about a future Cyber-Grid Empire. All technological advancements such as 5G, were rolled out globally from 2019 onwards, especially through the lockdowns, and such technology has enhanced the capabilities of 'everything' being connected to the new Cyber-Grid.

EDEN RESTORED, OR, THE NEW WORLD ORDER?

As I write, we are starting to see global food shortages. I have seen projections from articles published by Cargill (the largest privately held corporation in the United States) as part of an 'Event 201 style' simulation in 2015 that 'projected' a food crisis between 2022-24. The event called 'Food Chain Reaction' game, saw 65 international policymakers, academics, business and thought leaders gathered at the World Wildlife Fund's headquarters in Washington DC to 'game out' how the world would respond to a future food crisis. The Food Chain Reaction game (simulation) projected a deal between the U.S., the EU, India and China, standing in for the top 20 greenhouse gas emitters, to institute a global carbon tax and cap CO2 emissions in 2030 (what a surprise!), all based on a 'steep price spike' and 'global food' shortages which started in 2022! The planned pandemic and food shortages were designed to bring about the Great Reset, Agenda 2030 and as many have been saying for years, a central world authority ruling over a micro-chipped global population. In truth, a more zombie-like population would be a better description. The walking wounded would be another, courtesy of the mandates, lies and manipulation in the guise of 'mask wearing' and the life altering mRNA vaccine. Anyone who is awakened enough to know there is something evil about with the way humanity has been pressured and 'bribed' to take an experimental vaccine, must see the 'Apocalypse' unfolding. As I say, manufactured food shortages and further (severe) global lockdowns instigated through a *'second pandemic'* seem to be a possibility as we move beyond 2022, towards 2030. The second pandemic would be one caused by irreversible damage done to the immune system via the 'trial' mRNA vaccine. The second pandemic would also have to be perceived as even *more* deadly than the first Covid pandemic, and would be connected to HIV (Human Immunodeficiency Virus). Evidence is mounting that the Covid mRNA vaccine appears to be creating adverse effects, and with several billion taking these vaccines between 2020 and 2022, we could be looking at an explosion of AIDS diagnoses due to compromised immune systems. As I write, the media are already pushing stories of 'the need to test healthy people' for HIV, with Prince Harry stepping up in February 2022, saying, "With testing, we

can end HIV".[13] Why would a married man be worried about such a virus, in the first place? But of course, the narrative is being unfolded in preparation for the *second* plague. The idea is to get the masses ready for more tests of a different kind and with more 'fake cases', the more the Cult, through governments can close down the world, further trashing it economically. The movie *Songbird* (2020), directed by Adam Mason gives a 'not so fictional' taste of the future should we allow the Covid narrative to continue unfolding, leading to a global facsist state; for if we do, we are building our own prisons and our children's future prisons by complying with the narrative. Total 'control' and loss of all freedoms would be the order, the New World Order, unless we wake up!

In Revelation 22:1 we are given an image, a 'promise' of the 'new world'. What I am about to say can be taken *two* different ways, just the numerlogical meaning behind the number '22' can be seen as double sided reality. It could also be a warning of what the world would be like in the period *after* 2030, especially for those who have received the 'mark' (the 'vaccine'). Are we being prepared for the 'great re-setter', the 'great redeemer', in the form of a miracle cure to all our 'ills' (tribulations)? The worship of all things 'nanotech' (the false light) placed inside our biological bodies is the ultimate plan. As Revelation 22:1- 5 says:

> *Then the angel showed me the river of the water of life* [the path], *as clear as crystal, flowing from the throne of God and of the Lamb down the middle of the great street of the city. On each side of the river stood the tree of life, bearing twelve crops of fruit, yielding its fruit every month. And the leaves of the tree are for the healing of the nations. No longer will there be any curse. The throne of God and of the Lamb will be in the city, and his servants will serve him. They will see his face, and his name will be on their foreheads* [nanotech/microchip]. *There will be no more night. They will not need the light of a lamp or the light of the sun, for the Lord God will give them light* [bioluminescence tech/luciferase/magnetogenetics]. *And they will reign forever and ever.*

VIBRATION IS THE KEY TO DISMANTLING *ALL* 'TYRANNY'

Electromagnetism is very much part of number 'vibration' and all I've been outlining so far in the book. A great field or 'sea' of electromagnetic waveform constructs our reality, influencing our mind and body. Our astral bodies and Soul connects us to this field, too. Our DNA is waveform information and we are electromagnetic beings dwelling in an electromagnetic soup. Our hearts and minds are 'transmitters' and 'receivers' of information (energy). Our unique 'vibration' is what interfaces with the 'ocean of waveform' (information) which manifests as the world aroud us.

If we immerse ourselves in a 'sea of fear', 'chaos and disharmony', then we manifest experiences (reality) through electromagnetic vibrations (frequen-

cies), to match these thoughts. Often our conscious thoughts are influenced by the subconscious world of symbols, numbers, magic and spells, which is why specific numbers are used to impact reality. Collectively our thoughts (brain waves) can be planted, or 'transmitted' via other 'external' waveforms, mantras, narratives and 'beliefs'. Technology and television (tell-a-vision) play a huge part in this process, which is why so much fear is spread through the TV on purpose. See *every* mainstream News program on the planet! More than ever we need to be in our truth vibration and 'speak' our truth vibration.

We have been under a spell for a long time, but it's become more obvious since 2020! The bar has been raised as higher consciousness pushes back on the mind control. The 'Covid Spell' has kept millions mesmerized and in fear, and the only way out of this 'catch-22' situation, or to shake off the mantras and 'mind games' connected to 'all-things-covid', is to vibrate (think) differently. Thoughts spread electromagnetically, as they take shape in the 'field', or sea of energy, surrounding us. Thoughts are also 'planted' courtesy of mass hypnosis provided by the mainstream media, and social media. By definition, a 'mind virus', or 'virus' can also spread 'electromagnetically'. I am sure the 'fear of Covid-19' has been the real transmitter of symptoms in the minds of the masses since the whole scam began. Isn't it amazing how the flu became worse in the 'collective minds' of those living *in* a state of fear of Covid?

Sounds, colours, images, even 'rules, all have vibrational impressions on our collective reality. Keeping a narrative 'alive' is part of the spell, even when blatant contradictions (lies) can be seen visually by those with 'eyes to see'. Social distancing has nothing to do with 'catching' a so-called coronavirus. Hidden forces that have 'hacked' into human consciousness for aeons, know that keeping us apart devastates the human electromagnetic field. The dark forces that gives life to the Predator Consciousness wants humanity disconnected from each other, isolated and living in fear. 2022 was the beginning of the process of magnifing the desire to divide us further, through economics and war. We have to laugh at the dark forces, the Predator Consciousness, while staying firm in our stance against global tyranny trying to take root today. It's time to operate from the heart, lose the fear, the masks and the bullshit, and get back to being human beings operating from the heart. The gatherings will grow as more and more people 'come together' as *Oneness*.

TWO-HEARTED OR ONE-HEARTED HUMAN 'BEINGS'
The New Testament talks of a 'choice' we need to make so to be able to come back to the Creator, or *Oneness*. It is the choice between the *wide* and *narrow* path, or the easy route through life, or the harder, less-travelled path to *truth*

and *enligtenment*. It can also be understood in the differences between those that say, "I just want an easy life," and those that say, "I want to do what's right, no matter of the consequences." The dilemma itself is expressed in the gospel of Matthew, through the words of Jesus, when he is purported to have said:

> *There are two paths before you; you may take only one path. One doorway is narrow. And one door is wide. Go through the narrow door. For the wide door leads to a wide path, and the wide path is broad; the wide, broad path is easy, and the wide, broad, easy path has many, many people on it; but the wide, broad, easy, crowded path leads to death* – Matthew 7:13-15

The paths are also an analogy for the choice between love and fear, or, what some would see as a choice between *life* or *death*. This is not necessarily a physical death, but the death of the 'mind' and a 'rebirth' through the spiritual heart. The same choice and understanding of the need to walk a path of truth was expressed by the Hopi indians, in what they called, the 'Two-Hearted' people. The Hopi said that any society *dominated* by the mind (see all skull symbolism) is a path walked by those they call the Two-Hearted, or humans with a mind and heart in conflict. The Hopi Prophecy rock shows our present reality (world in our heads) as two paths (see figure 66). One path leads to destruction (the upper path) and the lower in the petroglyph leads to a new earth, a paradise. The upper path is dominated by the Two-Hearted and leads to self-destruction. It is the path of 'technology' without spirituality, a path of chaos and fear. The lower second path is the 'straight and narrow' path, also called the 'eternal path' for those with a strong (spiritual) heart who have chosen truth and love over fear and death. These are called the One-Hearted by the Hopi; human beings who are *awake* and can act as 'guides' (symbolized by a small connecting path between the two main routes) for those who come to the eternal path.

Where the two paths connect represents the time (just before) what the Hopi call the 'great purification'. A time of massive awakening on earth! The period of the 'parting of ways' is upon us, and it has become glaringly

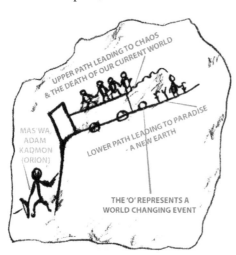

Figure 66: The two paths.
The paths can be found on the Hopi Prophecy Rock.

clear in how the awakened and the un-awakened have responded to the Covid hoax. Families, friends, colleagues have all been 'split' like the two paths. And as the gospels proclaim in relation to the coming of 'Christ Consciousness': '... For I have come to turn a man against his father, a daughter against her mother, a daughter-in-law against her mother-in-law ...' (Matthew 10:34)

So is the nature of 'higher consciousness' as it makes its presence known to 'all', both the awakened and those asleep. We are all being asked to become higher consciousness.

The coming years will clearly (visually) reveal the two paths, but, we will also see many jump paths as they choose to align themselves with the 'intelligence of the heart' and the power of the *Truth Vibrations*. Small groups will also gather in their thousands to anchor the Truth Vibrations on earth. I have seen this image in my visions, as groups of humans all dressed in white (symbolically), surrounded by multi-coloured lights descending from the skies, bathing all who are opening their heart to Infinite awareness.

The choice between following the path of the heart (love and truth), or choosing the path of more fear and lies, leading to misery or even death for those who are under the spell, will become the transformational talking point

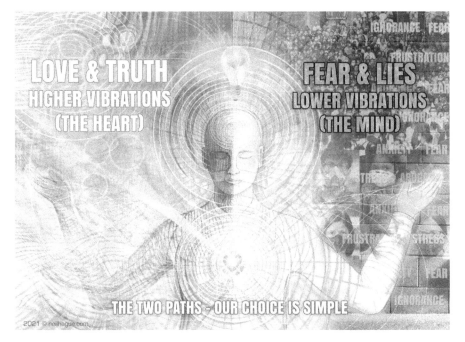

Figure 67: The two paths are a choice between love or fear.
The two paths are a choice between living through the heart or mind. Put another way, do we want the truth or to be constantly accepting the lie? I think you know the answer.

as we move through the 'resetting' vibration from 2022 onwards (see figure 67 on previous page). As it is written in Galatians 5:25: "If we live in the Spirit, let us also walk in the Spirit." *Spirit is calling you!* It is time to answer that call and take the path of righteousness!

As I posted on social media over the years, the scriptures (especially Revelation) will become more relevant as we move towards our highest calling. We end the Wetiko mind by stepping out of fear and perceiving life though our true brain, our heart – our unconditional love. Remember, fear is not real. It is a product of thoughts we create. We have to *become* Infinite Awareness, or *become* our true state of being, so to bypass the Wetiko mind (see figure 68). We have to operate from the perspective of higher, infinite consciousness. Fear and love cannot exist in the same space (reality). We are either living in fear born of lies, or, living lives through fearless love. Those who are in a 'state of fear' are in the Wetiko vibration. To detach from the Wetiko vibrational field, we need to see with new eyes (our Ancient Eyes), lose our fear of the future (the virus), and be born again (energetically). Our

Figure 68: Lighting the path home.
When we operate through our heart our world changes for the better. When *infinite* love, our *awareness* becomes our point of focus, we will end all that we call evil.

newfound perception will create a new, more balanced earth reality. We are destined to create 'Earth as it is in Heaven'. Listen to the words of Christ carefully and 'feel' the vibration emanating from the Beatitudes, the Sermon on the Mount. The message is, in my view, the way out of the Wetiko mind.

A time is coming when those who sat on the sidelines allowing tyranny to take hold (the Wetiko world), will eventually turn on those in power, thus is the nature of Wetiko. It is the 'house of desolation' and it has no real power. It will not win, even though we are being put through the hardest of times, with *more* to come. As the great Bob Marley once sang, *"Love will never leave us alone."* Infinite love has never left us! We are human 'beings', with a genetic light that cannot be extinguished. Our heart light and our true mind need aligning so to lose our fearfulness, along with the manipulated horrors created via the Wetiko world.

In the next part of this book I will turn to the symbols of duality and how duality is expressed through art, archetypes, religion and other systems of human control.

NOTES:

1) www.cdc.gov/flu/about/burden-averted/2017-2018.htm

2) www.ncbi.nlm.nih.gov/pmc/articles/PMC7219423/

3) www.who.int/bulletin/online_first/BLT.20.265892.pdf

4) https://www.england.nhs.uk/statistics/statistical-work-areas/covid-19-daily-deaths/

5) https://www.technocracy.news/china-showcases-massive-surveillance-capabilities-at-beijing-olympics/

6) Seumas Miller, Mitt Regan, and Patrick F. Walsh. *National Security Intelligence and Ethics.* Routledge 2022. p157-59

7) https://www.jpost.com/health-and-wellness/coronavirus/israel-to-hold-covid-19-war-

8) Seumas Miller, Mitt Regan, and Patrick F. Walsh. *National Security Intelligence and Ethics.* Routledge 2022., p158

games-on-thursday-684618

9) https://www.youtube.com/watch?v=Q5m-e_h3qMY

10) http://www.5gappeal.eu/scientists-and-doctors-warn-of-potential-serious-health-effects-of-5g/

11) http://www.whatdoesitmean.com/index3141pl.htm

12) Loper, DeAnne. *Kabbalah Secrets Christians Need to Know,* 2019, p92

13) https://www.bbc.co.uk/news/av/uk-46246186

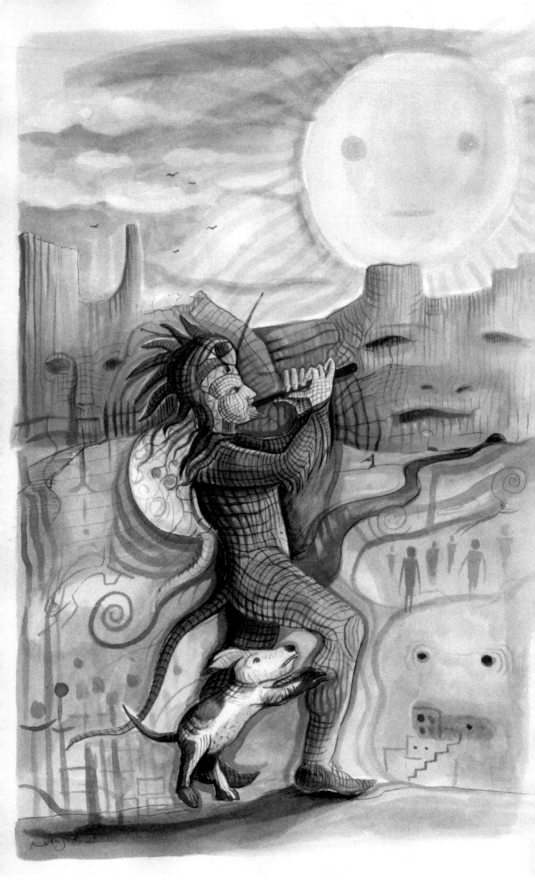

PART THREE

BEYOND

NIGHT & DAY

In this house of make believe
divided in two like Adam and Eve

Peter Gabriel

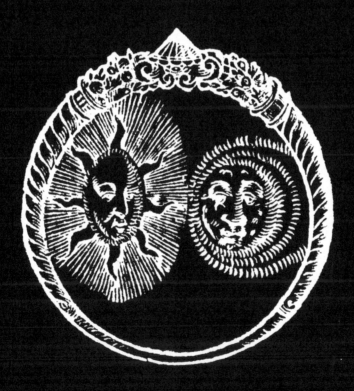

Symbols of Duality

Stories of separation of the 'perfect one' in mythology

If this be magic, let it be art
William Shakespeare

T he variety of gods, goddesses, strange creatures and superheroes we have focused on in myths, art, books and now film, are clearly part of an archetypal history often denied any credibility. Yet, as I write this book, thousands upon thousands of people flock to the cinemas and tune into Netflix, Amazon, etc., all over the world to see and hear 'ancient stories' involving the same archetypal legends, strange creatures and heroes retold in films.

The telling of the world (of creation) through ancient stories, and now film, carries the same effect as the storytellers of ancient times. Epic pieces of myth making contain many analogies to ancient legends which have spawned religions and belief systems over the past 6,000 years. Dorling and Kindersley's book *Star Wars: The Power of Myth* (2000) illustrates numerous connections between myths created by George Lucas and legends of hero gods and forces worshipped by the ancients. In all probability these stories (whether a battle for Middle Earth or a rebellion against a tyranny in space), could have originated in an ancient epoch, or future one awaiting us. Both epochs are unrecognised by academics in their various fields but are gradually surfacing in our ancient memory banks today! In this chapter I will attempt to explain the mysterious origins of many universal archetypes and different deities found in numerous ancient cultures, through their art and myths. To do so, it will be important to examine the movements of people in relation to different heavenly bodies, star systems and the imagery associated with what could be described as extraterrestrials. I will also look at the symbolism, codes and languages attempting to explain the ancients understanding of universal *dual* forces. The basis of which leads us to realise that all orthodox religions have their doctrine rooted in ancient myths and these myths relate to a history that has been rewritten to suit the forces described in the previous chapters.

LANGUAGE OF BEING

The language used by ancient artists (myth makers) was a symbolic one focused on the earth and the heavens as a source of inspiration. Alongside 'above and below' the world of dreams and invisible frequencies mentioned earlier, were also accessed through art, creativity and elaborate ceremonies. All of this was done to harness the knowledge contained *within us*. A variety of symbols, which can be found in many ancient cultures, attempt to explain knowledge of microcosm and macrocosm. Just as different colours and characters emerge from the artist's palette, but can only be made from primary colours, many deities and religious systems have been created out of the knowledge of primary solar and star cycles as perceived from earth. Others have been inspired by the invisible worlds which evade our physical sight and relate to codes, fractals and patterns that create life. Most of the deities worshipped over thousands of years relate directly to the power of the sun, and its effect on the earth and migrating indigenous peoples. But there is more. So many mythological gods and goddesses (worshipped by the ancients) are part of what I call the 'collective creative consciousness', and therefore are as readily available for 'downloading' into our modern world as they were for the ancients. As one of my favourite artists, Cecil Collins once wrote:

> *To create is to believe, and to believe is to create. So our whole life with all its acts, and our face, is an exact and accurate picture of what we believe.*[1]

In Central American and Egyptian civilisations 'mythic-astronomy' played an important role in the structure of society. The sky watchers, or priests of these ancient civilisations, came from a long line of Myth Makers (shamans) that claimed a heritage going back to the stars (the dreamtime) and their ancestors. Neolithic priests (artists) created a symbolic language which spoke of the correlation of the stars (our solar system) with life on Earth. Many of these correlations can be found across the Earth at ancient sites and in the city plans of many major cities, notably Paris, London and Washington. These cities are the great pillars of the Old World Order. In ancient Egypt, star knowledge was extremely advanced in terms of alignment to architectural feats like the Pyramids and therefore, high art and science (for the ancients) seemed to be fused into one language - the language of being.

The Olmecs and the Maya of Central America, along with Asian and African counterparts, also created pyramids, temples and calendars that measured the movement of celestial objects in relation to time, or sun and moon motion. The universal circle, cut by a horizontal and vertical axis, was the symbol used by ancient astronomers to measure and track the movement of the sun and the earth in relation to the wider cosmos. It seems that the

desire to find the centre of creation, and to measure the passage of the sun across the zenith, brought both physical and spiritual security for the ancients, especially after major cataclysmic events on earth. By observing the skies and tracking the movement of the stars, many migrations were made to find a new perspective based on an increase in understanding of how the cosmos functioned, moved or even breathed! Today, I feel we are still acting on that impulse through our desire at a spiritual level of our being. We are also natural migrators of the spirit, and like the many birds and animals that follow the sun and the stars, we too need to follow our hearts and to go with the flow of life.

DUALITY OF BEING

Since ancient times humanity has focused on opposing forces that shape the world. Many myths as told by ancient storytellers explore the dualistic aspect of life and our Universe. Battles between hero gods and demons (light and dark forces), found in most religious beliefs, relate to the principle of duality.

In numerous myths a supreme deity was said to have given birth to twins who constantly oppose each other, creating life and death (renewal) in the Universe. In Zoroastrianism myth, it is said that dual forces were born out of the god called 'time' (Zurvan), who lived in total silence. In truth, there is no such thing as death, only a turning of the wheel of life, and it is this wheel, or circle, separated by forces of light matter and dark matter which provides oscillation for duality. The eternal cycle of light and dark, in its most simplistic form, provides a source for the many myths and legends depicting creator and destroyer twins and good against evil. The same dual force was attributed to memory and thought, two ingredients humans use to create and move through time and space. In Norse mythology, these two aspects of the mind were called 'Huginn' and 'Muninn', depicted as two ravens that aided the Sun/father God, Odin, in his quests for the elixir of eternal life. Similar myths contained within the codices of the Aztecs, also describe how a sequence of creation and destruction (aspects of the dual god) formed four ages on Earth. These ages, or eras, were named 'Jaguar-Sun', 'Wind-Sun', 'Rain-Sun' and 'Water-Sun' because they ended with a plague of jaguars, a hurricane, a rain of fire and a great flood respectively. All these ancient epochs are said to have come about due to opposing qualities of what the Mayans referred to as the dual aspect, or Old God. In other words, there has been the constant theme of duality forcing the end of one cycle and the beginning of another.

According to the ancients, the 'Fifth Sun', or 'Moving Sun' (the age we are now living in) is set to transform life on Earth in our time. Seismic activity and earthquakes, according to the Hopi and Maya cultures, will end this current Sun, or World Age! The arrival of 'extraterrestrials' and future 'pandemics' could also be part of various 'manufactured' smoke screens hiding

the Great Reset (New World Order). Our governmental structures, that have been in place since the beginning of the last cycle (3,000 BC), are going to be challenged, and indeed they are being so as I write. We, as a collective, can only evolve to a higher level of understanding through the changes transforming our world. Religion, out of touch scientific doctrine, and the global monetary system are three main targets that do not value the spiritual sovereignty we as individuals need in order to expand our consciousness and balance the duality in nature. All of the structures that create our personal and collective belief systems, which *can* become prisons of the mind, are going to be seen for what they really are – illusory.

THE DUAL GOD

In Mesoamerican mythology, the 'dual god' was said to have emerged from the centre of creation or what was referred to as the Glory Hole. This location for ancient star gazers was thought to be at the centre of our Galaxy, a place where the shaman would journey through his/her mind to become at one with the Universe. The goal of such a shamanistic vision rite, for example, was to enter other realms (parallel worlds) 'through' the Pole Star, situated at the centre of the sky. Our DNA also correlates to the Milky Way and therefore the shaman would access hidden aspects contained within his DNA by journeying, metaphorically, to the centre of creation - the place from where all stars were throught to be born. Various gods and goddess figures were connected to the Pole Star position throughout the ancient world and it was considered that universal equilibrium was maintained by the principle of duality, or what the Aztecs also called the 'double god'. For the Mayans, this dualistic deity was known as a 'twisted one leg'. The same beliefs and symbolism can be found in places like India in the form of Indian deity, 'Prince Dhruvi'. This deity, was a symbol for a world-age ruler who was often depicted standing on 'one leg'. The ancients, to explain the position and movement of the earth's axis in relation to the celestial pole, as it twists and turns on its axis, often used a twisted one-leg symbol, a subject I will return to shortly.

The concept of opposing forces provided our ancestors with many hero figures. In myths and legends, the opposites in nature have been the principles behind many belief systems. From the *Star Wars* movies to the *Harry Potter* books, we have witnessed the use of ancient archetypal forces in continual motion through narratives that are as old as the earth. The important point here is that dualism is as relevant to us now as it was in the ancient world. In fact, I would say we are quite obsessive when it comes to myths containing eternal battles, where opposing forces, 'good and evil' are fighting each other across different worlds (realities). The multi-billion dollar film industry, created by the Myth Makers, have proved this to be the case. Epics such as *Star Wars*, with its religious-like symbolism, show us that Darth Vader (the dark

side) and Skywalker (the good side) are actually part of the same 'Force'.

BLACK ON WHITE

The ancients' understanding of dual forces marking time, eternally turning and aiding in the evolution of humanity can often be seen in petroglyphs and pictographs. Many rock markings depict the same understanding of dual forces in relation to the position of the North and South Celestial poles (twisted one leg). You could say that art left on rocks in places from Arizona to Northern India by migrating artist-shamans, was put there to remind future generations of the life cycles endured through these opposing forces.

Strange deities, such as Kokopelli, a hunchback flute player, can be found in numerous locations across America. He was considered a symbol of the Solar life force, healing, and the 'God of Life' (see figure 69). This archetype, or god, is almost always depicted in rock art, rising out of the head, or mind, of the 'God of Death' known as Masau'u. The Hopi tribes of Arizona in the USA say that Masau'u represents the 'dark side' of the 'supreme being' (or dark side of the force if you are a *Star Wars* fan). The God of Death was considered to be the false god by the ancients. He was seen as a trickster, one that represented fear, destruction, war and deception. I show in *Orion's Door* how Masau'u is the mask-wearing faceless Orion figure, the often angry fire and brimstone god found woven into Jewish and Christian belief. In Hinduism, the same diety is 'Yama' and he is a 'Lokapala', or a guardian, over one of the eight directions (the South), and considered an Aditya or Solar deity. In Vedic art, Yama is often depicted with green skin, red clothes and riding a buffalo. Osiris, or Orion, in ancient Egyptian myth, was said to be a green god (a giant) also associated with death, the Underworld and resurrection. Masau'u is the dual aspect of Kokopelli, who is also said to be the guardian of the North and a Solar

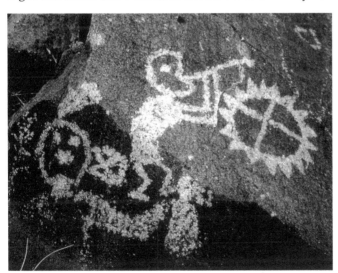

Figure 69: Duality of Being.
Bronze Age symbols showing Kokopelli, the solar God of Life, and Masau'u, the God of Death, can be found all over the world.
© Courtesy of Dan Budnik

deity associated with the colour white and blue. There could be an extraterrestrial connection here too, especially in relation to Orion's stars (see my book *Orion's Door*). Like ants and other insects, Masau'u possesses knowledge of both the surface of the Earth and the chthonic Underworld regions. The word 'Ant' in Sanskrit means 'death', 'termination' and 'last breath' and therefore has a connection to funeral rites and the Underworld.

In some accounts Masau'u also wears a mask covered in blood with large open eye holes and a large mouth, a sort of visual combination of Ronald MacDonald and the classic Hallowe'en image of carved pumpkins and skulls. Hopi legend says that his huge, bald head even resembles a summer squash, and his forehead bulges out in a ridge. He also carries fire and a staff, which alludes to the priestly clans and brotherhoods mentioned in an earlier chapter. Orion, Masau'u and Osiris, in Masonic initiation are also found in almost all tribal secret societies. Masau'u was also said to be a giant with his feet as long as a forearm, and his body a greyish colour (see Orion symbolism). The colour grey is essential, since his name comes from the Hopi word 'maasi', also meaning grey. Some Ufologists even see a connection between this description from Hopi mythology and contemporary images of extraterrestrial Greys! The solar god, Kokopelli is also described as an insect deity in some traditions, too. I'll come back to the extraterrestrial connections later in the book.

WHITE ON BLACK

The imagery associated with the God of Life (Kokopelli) on the other hand, was said to represent light, fertility and creativity – the other side of the coin, so to speak. In my view, both are symbols of long-standing dualistic beliefs in good and evil found in all religions. However, 'oneness' is above and beyond these two archetypes and so is 'knowingness' through love, a truth vibration that can open our hearts and minds! Balance is when neither end of the scale dominates, or when the mind and heart work together synchronistically to create the 'magic' we call life.

Both archetypes, Kokopelli (life) and Masau'u (death), are often found alongside bear claw marks representing the Bear Clan and the original earth goddess. Bear symbolism, in this case, seems to relate to the 'Bear People' who were said by the ancients to be one of several human-animal races that lived on earth in prehistoric times.[2] As I show in *Orion's Door*, I feel the Bigfoot phenomena relates to such a prehistoric group of humans. The 'mark of the bear' also relates to the work of the Predator Consciousness mentioned in this book, and how clandestine priestly clans understood how to manipulate the mind through dualistic beliefs (black and white). I feel certain that much symbolism contained in petroglyphs and pictographs in America and Europe, relates to the illusion of life, conquering death (fear), moving beyond

duality, and is still very much prophetic of the time we are now living through.

The dual aspect of all life, as portrayed in symbols such as the checker board image, the Tai Chi (Yin and Yang) of China and the 'Hunab Ku' of Mesoamerican design, explains how foundational values change through time. Polarization, on the level of present day human civilisation, could mean that ancient values and perceptions of life, which were around 26,000 years ago, are surfacing again in the hearts and minds of individuals. I personally believe this to be true, as the given set of rules and assumptions regarding the meaning of life, ingrained in the collective human psyche since the time of ancient Sumer and Babylon, are fading away amid much turbulence and rigidity. The God of Death, quite wrongly portrayed as the God of Love, became the belief system that dominated the minds of the priests and ruling classes who emerged out of the Babylonian empire. Could the Phoenicians (Babylonians) have been the physical means by which the death-god deity spread across a wide geographic location at the end of the Bronze Age? Is this possibly why so many petroglyphs from the same era depict dualistic dieties and symbols? In many ways, we are still living within the Babylonian-Egyptian blueprint (or power structures) through the recurring themes of war, famine, disease, etc. What was once Babylon became ancient Rome and the same power base is now behind the Anglo-American Empires, its eyes fixed on a *global* Babylonian power structure. The 'Babylon model' was designed purely to lock our perceptions into the physical world: the economical, political, industrial and now modern media structures that exist only to benefit the few and not the majority. The force that desires control of our world needs humanity to 'think into existence' a centrally controlled global prison because it is the *mind* that decides the type of reality we create! Manipulate the mind of the masses and you can create a collective reality to suit an agenda. The hidden forces I have illustrated in earlier chapters have engineered *all* warfare and attacks against the earth, and humanity. The unseen knows 'reality' is a 'mind game', therefore the more dualistic beliefs that are fostered, the better for divide and rule of the masses.

It's through our response to the five senses that aids the shaping of our world. If we are constantly shutting down our potential, through fear of what others might think of us, or giving our minds away to power structures, then we are falling into duality. In the end, we are ALL responsible for what goes on in this world. By focusing on 'external' structures, from the global media, to so-called world leaders (all controlled by the same ancient 'Babylonian' death cult), we deny our truth, or our light. The endless wars and infringements on civil liberties we endure today, on one level are manifestations of our self-denial and obsession for externalising what goes on *within* our lives. Collectively and individually we face our shadow sides through many differ-

ent experiences, depending on the level of our consciousness and imagination of ourselves. Themes captured in novels such as *1984* by George Orwell (1949), *Brave New World* (1931) by Aldous Huxley, for example, are being played out within our reality. They are part of the polarisation process we are facing here on earth. How we respond to changes that are coming, and to the turning of the tide brought about by facing our own fears at this time, will change the collective reality of life on earth.

HERO TWINS AND THE QUEST FOR A SUPERHERO

Hero Twin symbolism can be found in many myths and legends. It can relate to both duality and the continuation, or resurrection, of the Sun, so to commence a new cycle or age. It also relates to the search for immortality as found in the epic of *Gilgamesh*, a hero king of the same name who was said to have ruled Uruk c. 2600BC. The hero Gluskap of the Algonquian tribes of North America was another god who was said to have created the whole known world, along with a plentitude of other saviour gods that were both Father and Son, simultaneously.

The *Popol Vuh*, the sacred book of the Maya, tells a most renowned story of hero twins and their journey into the legendary Underworld (the place of fear), or the domain of the Predator Conciousness I touched upon in a previous chapter. Recorded by the Quiché Maya in the 1550s, the myths and hero deities described within its pages relate to an ancient epoch on earth. In the *Popol Vuh*, the twins are said to have been ball game players that challenged and defeated the Lords of the Underworld by placing their father's head (the Sun Lord) inside the goal – symbolic of the centre of the Milky Way. The Maya scholar, David Kelly, in his book *Deciphering the Maya Script* (1979), showed that the key deity for the Mesoamerican Maya was Lord of the Year, or 'One Hunahpu'. He was the father/son god of the equinoxes. The ancients said that he (the Sun) would both turn the wheel of time and mark a specific point of transition, not only as a year marker, but also as maker of every world age. One Hunahpu, Father Time, or the Oak and Holly Kings symbolism are all the same deity. So is the 'Urizen' figure, found in alchemical illustrations, and in William Blake's books and art. One Hunahpu also represents Chronos, or Saturn, an old sun that was said to once rule over an even earlier epoch on earth.

In Egypt the same deity was Ra, or AmenRa, the celestial Sun God. The Christian 'Amen' said at the end of hymns and prayers relates to this solar god. Similar attributes were given to the Greek supreme Sun deity, Zeus, who was father and King of the Gods. The hero god was a symbol for the power of the Sun and the Sun's journey across the heavens. In Egypt, Twin Lion gods, seated back to back, with the sun's disc supported between them, guarded the portal to the place in the sky where the priests believed the Sun

Figure 70: Twin (Dual) lion gods.
Worshipping the rising sun. A Funerary papyrus of Herbuben. XXIst Dynasty. © Cairo Museum

to travel. The portal and where it leads is the Orion nebula, in my view. The lion's names were Sef (yesterday) and Tuau (today). 'Ra' the Sun God, was often referred to as Ra of the 'Two Horizons' the term 'horizon' being seen by some scholars in this context as a mathematical term denoting a system of dimensions, or a frame of reference; namely, the 'Light Horizon' and the 'Life Horizon', representing the material and spiritual worlds respectively (see also the Gnostic understanding of the Boundary). Ra of the Life Horizon was betokened by a flattened circle or solar disc mounted on the hindquarters of the twin Lion gods (see Figure 70). The opposing aspects of these two deities were captured brilliantly in a film *Ghost and the Darkness* (1996), based on a true story, where two lions attacked and killed 130 people in 1898 over a nine month period. Some experts say that two lions were possessed by evil spirits or the souls of black magician/shaman.

In the mystery schools of Babylon, Egypt, and later in ancient Rome under the Stoics, the priests turned the solar lord into the one-God template that became the Great Father God of Judo-Christian belief. All were based on a wider astrotheological transition of 'one' Sun (or age) into the next. The Pharaoh Akhenaten was said to be the main instigator of the One God faith in Egypt and when he died, the Egyptian priestly élite used his One God religion to hide their own macabre activities. The élite brotherhoods and Myth Makers previously explored in this book, with ties to the Egyptian mystery schools, are still carrying out this tradition of hiding behind 'the One God' belief system, while worshipping the Predator Consciousness in secret. Giving the solar god prominence (from the time before ancient Sumer), moving the focus of belief in 'Oneness' (all of creation being connected) to the belief in an external father/sun (son) has flourished, as mainstream religion to this day.

SUN STONES, EARTH SITES & SOLAR LORDS

Many fantastic megalithic sites all over the world are aligned to transitional phases of the earth, and more often than not, the stones appear to be set on or near to electromagnetic fault lines in the earth. The megalithic stone circles are signs left from an ancient era, when our ancestors understood how the

precession of ages created often cataclysmic transitional periods on earth. In Ireland, for example, there is a pre-Christian religious centre of worship due to a natural phenomenon known as the 'rolling sun' 6.5 km to the east of Croagh Patrick, in the townland of 'Boheh'. On a remarkable rock outcrop, decorated with Prehistoric Art, the sun can be seen to 'roll' as it slides down behind the northern slopes at the equinoxes. A similar effect takes place on the slopes of the Mayan pyramids at Chichén Itzá, Mexico, where the Sun gives the effect of a serpent sliding down the stone steps. These transitional points at the Summer and Winter solstices, Autumn and Spring equinoxes are the expressions of the 'hero twins' recorded in many world myths. The aforementioned One Hunahpu, or 'Solar Lord', was also father of the hero twins in Central American myth. The Solar Lord was destined to die and be reborn at the Winter solstice (see the Holly King, Balder and Jesus narratives). Even in the political, military and industrial structures we endure today, one can often find references to the Solar Lord, or rising sun, who ushers in a new world, or age. The force creating chaos, mayhem and physical destruction within our reality, which hides in shadows, also uses mystery school symbolism within the media empire. For example, when George W. Bush came to power in 2000, he was presented as the 'rising son' (sun) especially on the cover of *Newsweek* and in the American press. The New World Order, or Great Work of Ages (the Great Reset) being ushered in by our puppet world leaders and other élite families, is also meant to coincide with ancient calendar dates and celestial positions of the sun and stars. Freemasonry, and all of its predecessor secret societies, was created to 'hoard and use' ancient knowledge, which includes manipulation of our minds through connections to unseen forces conjured up at rituals and ceremonies. Masonic use of symbols and insignia are clear markers of the manifestation of the Age of Horus (the New Sun), or what has been termed the New World Order. As I've already shown, Freemasonry, at its highest level, *is* the global body that serves the Predator Consciousness. Interestingly, the fifth *Harry Potter* novel *The Order of the Phoenix* (2003) and the sixth *The Half Blood Prince* (2005), are an almost direct reference to the ancient orders of antiquity, the bloodlines and their use of ritual magic and symbols. And we wonder why books and films of this calibre have been allowed such success?

Alongside the myths that talk of a Solar Lord, are the legends of the Hero Twins, who, in various myths, are said to usher in a new age by resurrecting their father, the Solar Lord (the Sun). This dynamic duo are the opposing aspects of the 'Pole God' created by the wobble of the Earth's axis. A phenomenon that results in providing us with the 'new sun' at the Winter and Summer solstices. The Hero Twin myth more or less relates to the alignment of the centre of the Milky Way (the womb of creation), the Sun and the Earth. Such an event, according to the Mayan calendar, happens every 26,000 years

and is called a 'galactic precession'. In other words, the alignment of such celestial bodies, announces the start of a new cycle for many indigenous peoples, one that breaks all previous paradigms held onto by humanity for thousands of years. We are certainly in paradigm changing times!

When one attempts to uncover the astronomical dimensions associated with the many hero figures of ancient myth, we must also remember that all deities, as symbols of intangible forces, can manifest in different objects and events. Tales of ancient superheroes through to the comic book heroes created in the 20th Century, all derive from a fascination with ancient dualistic forces. As I have already touched upon, these forces are often depicted as twins, a dynamic duo, if you like, who embark on a journey to restore good, or bring law and order. In most cases the dark side or the 'Black Road', which is said to be a physical part of the Milky Way, or a rift (tear) in the sky, tempts them. The story of the 'Skywalker' twins, Leah and Luke in George Lucas's *Star Wars* trilogy, is almost an attempt to portray the notion of the Hero Twin myth. There is also much symbolism in films and books by Tolkein, such as *The Lord of the Rings*, which again, are associated with the return of a Hero figure or king.

LORD OF TIME

In ancient Rome and Persia the same understanding of a central Sun Lord was worshipped through Mithraism, a mystery cult, whose highest initiary experience was the revelation of the galactic precession as the cause for shifting epochs, and the earth changes that came with it. Mithra was almost always depicted at the centre of the zodiac as the 'Lord of Time' who turns the celestial animal wheel; he was sometimes shown as a lion-headed human entwined by a serpent, symbol of time and restriction. As I have already mentioned, some of the oldest pieces of art (30,000 BC) also show lion-headed humanoids, especially feline goddess figures. These could have been made by shamans as the earth passed through the galactic precession last time around, so to speak. The same iconography can be seen in Egypt as the lion cutting the snake, or severing the connection to the earth through implementing the illusion of time (Figure 71 overleaf). Slaying the bull of heaven (Taurus), is symbolic of his dominion over the axial shifting of the sky, ending the Age of Taurus around 5,000 BC. It was the Stoics, and later Comocine Masters of Asia Minor and Rome, who transferred all the attributes of Mithra (the Lord of Time) to the 'Lord of the Sun' in the Age of Pisces – Jesus Christ. The fish symbol of Christianity is a direct reference to the astrological age of Pisces as ushered in by the 'Lord of Time' with a turn of the celestial wheel. The age we are now entering into is considered by many to be the Aquarian age, symbolised by the water carrier and the rise of the divine feminine spirit. The ancient prophecies call this age the 'time of cleansing', or the great purifi-

Figure 71: The Lord of Time.
The Lion-headed god Mithra as shown in Egyptian and Persian art. He is the Lord of Time (the illusion) who became the solar god associated with early Roman Christianity.

cation (for more on this see *Through Ancient Eyes*). Mithra, the Lord of Time (the Sun) became Jesus and the symbolism of the lion of Judea, right down to Aslan in novels like C. S. Lewis's *The Lion, the Witch and the Wardrobe* (1950), are all references to an ancient Sun (son) Saviour.

In other forms, Mithra is also Gilgamesh the ancient Sumerian superhero who was aided by Enkidu (a hairy human figure) in defeating the Bull of Heaven. The Gilgamesh epic, according to some authors, relates to the movement of the stars and the passing of world ages. Ralph Ellis, the author of several outstanding books on Egyptian history, suggests that the Gilgamesh epic, like the bulk of the Old Testament, is based on the story of the stars and their influence on world ages. For Ellis, this legend relates to the epic battle between the age of Taurus and the age of Aries; and the giant Gilgamesh was a code for the constellation of Orion as it pursued Taurus the Bull across the heavens (see my book *Orion's Door*). Enkidu in this story was a stellar object, possibly a comet, that passed by the earth as the ages shifted.[3] Hercules (like Gilgamesh) was also a giant and pivotal hero-figure whose names suggests that he was the greatest hero of them all. So was the hunter Orion, who was one of the last giants to stride the earth but was killed by Artemis (the Moon) and Apollo (the Sun), as the Age of Giants came to an end after the biblical flood. Descendants of Noah in the *Book of Enoch* were also said to be a race of giants (Titans) and the writer Homer (8-9th Century BC) also wrote that: *The*

heroes were exalted above the race of common men.

The twelve labours of Hercules are a direct reference to the twelve months of the solar year and the twelve constellations of the zodiac. The numerological significance of 'twelve 'can be found in the stories of the twelve disciples around the Sun Lord Quetzalcóatl, Buddha and later, Jesus. The Bible is also packed with numerology, which the church has taken literally. In the Bible we find twelve Sons of Jacob, twelve tribes of Israel and many more examples, all of which refer to the relationship between the Sun and the Earth Goddess. The original emblem of the Languedoc region, the area in France where the Cathars were slaughtered for defying the Vatican in the 12th century, was a cross also surrounded by 12 points (see Figure 72).

Figure 72: Sun Cross.
The original emblem of the Occitane in Southern France. It was the place where genocide against the Gnostic Cathars occurred. The twelve circles can be found as the twelve stars on the flag of the European Union (see my book *Orion's Door* for more on the Cathars).

In ancient times, the term 'Bible' was used to mean any written document. Originally all documents were written on papyrus. The Egyptian papyrus reed was imported through the Phoenician port of Gebal, which the Greeks called ''Byblos', or 'Byblus' (the home town of the historian Philo). Egypt did a lively trade with Byblos and, eventually, the inevitable happened: there was an exchange of myths between the two places and Egypt later gave one of its cities the name of Byblos. Byblis, or Byblus, was also a Phoenician and Egyptian goddess adopted by the people of that area. She is reportedly the granddaughter of Apollo and was associated with Venus, who was also known as 'Aphrodite' and by various other names, depending on the culture that adopted her as their goddess. In most instances she was a sun goddess of sensuality and a symbol of art and magic created through the combination of the sun and the earth's oceans. On another level, this relationship between the sun and earth has esoteric significance relating to ancient calendar systems which are based on the original *thirteen* moons, as viewed from earth. The thirteenth moon being the 'Blue' moon and sometimes symbolised as a spider – Grandmother Spider for many Native American Indian peoples. The gords and shells of the Native American mississippi mound builders often depict a spider on a sun cross; other ceremonial objects often show the belt stars of Orion as part of the cross. The spider, sun and cross are dualistic symbols representing both the Predator Consciousness and the Creator. As I show in *Orion's Door*, both forces are connected to Orion's stars.

HEAVENLY ADAM (THE PERFECT ONE)

In Gnostic Pauline Christianity, Orion is connected to what is called 'Adam on high', or the 'heavenly man' whose head (Merkava) manifests our earthly reality. The word 'Adam' is said to relate to the name 'Atum' (the first human). Similar words can also be found in Hindu belief as 'Atma', or 'Atman', the latter of which is supposedly a Semitic permutation of the word Adam. In occult traditions, Adam is also described as 'kadum', meaning the 'Ancient One', a title coupled in Old Semitic with 'qadam' - *he* who, like the sun, rises in the east. In ancient Egypt, Adam on high (or Man of the Sun) *is* a 'star man' in the form of Osiris whose attributes are mirrored on the earth below. Orion worship' along with Saturn worship (and occult symbols associated with such mysticism in relation to Orion) abound.

Amongst the Mandeans (a Gnostic sect that survives in Iraq), the Primordial Adam is coextensive with the cosmos; his body is considered the body of the world, and his soul the soul of 'all souls'. The Gnostics held that individual human beings are descended from the cosmic 'Anthropos' as a result of the fragmentation of the 'Primordial Man'. In Jungian theory, the Primordial, 'Cosmic Man' is an archetypal figure that appears in creation myths of a wide variety of mythology. For example, in Chinese legend, it is 'Pangu' who is thought to have given the earth its natural features and when he died his body became the Sacred Mountains of China. The Persian equivalent is 'Keyumars', who released semen when he died, out of which came the first human couple. In Islamic Sufi teachings, 'The Perfect Being' is called 'Al-Insan al-Kamil', another Adam or Son of Man figure, or title.

In these ancient teachings, the first spiritual world that came into existence (through God's infinite light) was Adam Kadmon. This 'Adam', from the Gnostic perspective, is not necessarily the same as the 'physical' biblical Adam, 'Ha Rishon'. In variations of the hermetic Qabalah, the heavenly Adam corresponds to a place above the Keter (the crown), the 'divine will' that, according to Gnostic and hermetic teachings, motivated the creation of our solar system, from the stars to the earth. The Gnostic Anthropos, or Adamas, as it is sometimes

Figure 73: The Anthropos.
A combination of 'Sophia' and 'Christos' projects a new earth in my vision of this Gnostic narrative.

called (see figure 73), is considered the 'pure mind', distinct from matter or the material world. The heavenly Adam was considered a *living light* that encompasses duality, and in simple terms, it is the 'light of the world' (the Creator) that the Gnostics and 11th century Cathar parfait priests alluded to in their teachings.

KESIL HOREPH, HERCULES AND THE LION

In Hebrew, Orion is 'Kesil Horeph', refers to both the fool and a giant angelic being. The upraised arms of Kesil Horeph is another depiction of

the Orion constellation (the giant of winter), see figure 74. Kesil may have referred to the biblical 'Foolish Messiah', or the Babylonian messiah figure, Nimrod (another version of Orion). According to Babylonian texts, Nimrod influenced the idea of Kesil after the great flood. Kesil Horeph is another version of Adam, Orion, and the Son of Man archetype. The word Kesil (or Kes) also relates to a throne, or eye motif, associated with Osiris (Orion). Osiris, Nimrod and Hercules are interchangeable as solar gods, warriors, hunters, and 'giants' amongst humanity. Kesil, like Hercules, holds a baton or club, just as original depictions of Orion show this warrior with a club (see figure 75).

Figure 74: Kesil Horeph. A star map of the 'giant of winter' in the North.

Figure 75: Orion in the tarot.
(Left) Nimrod (Hercules). **(Right)** The peasant Fool. Both are versions of Orion the star man.
(Public Domain)

Kesil is the Fool in the tarot and, therefore, appropriately connected to Adam on High and Orion, as I will come to shortly. One other feature is the star giant's connection to the lion (or lion skin) which relates to the Gnostic Demiurge and the 'fall' of Adam from Eden. Egyptian priests in many of their ceremonies also wore lion skins, all symbolic of the exalted and conquered Sun (Leo). The constellation of Leo is also crucial to know more about 'lion consciousness'. (For more details on this subject, refer to

my graphic novels *Kokoro* (2009), *Moon Slayer* (2015), and *Aeon Rising* (2017). The club-holding warrior-fool (like Samson of biblical fame) is ready to do battle with forces of darkness, such as the Nubian lion and the malevolent Demiurge and his minions. Kesil Horeph, as the Fool, is also seen carrying a cudgel (club) in earlier renditions because the club was a 'weapon' of protection used by hunters and peasants.

THE JOKER IN THE PACK

The Fool, or Kesil, was often wearing a hat with the ears of an 'ass' (donkey), a symbol associated with the 'lowest angel' (Archon), 'Thartharaoth' and the opposite of the 'Highest Crown'. The crown (or *corona*) in this context relates to both royalty and the throne in heaven, a symbol or word used often, especially in recent years (see *Orion's Door*). The symbolism connects to the court

Figure 76: The Fool. The giant Fool shown with ears of an ass. (Public Domain)

jester and a medieval Fool can also be found in the Hebrew noun 'kes' (a throne), or Arabic 'kursi', and is unique to Orion's relationship with royalty; hence why the court jester held a vital position in the royal courts of Europe. The jester was the *only* person who could mock (make an ass of) the court in front of the king.

According to Greek legends, the god Apollo changed King Midas' ears into ass's ears because he preferred the sound of Pan's pipes to the music of the temple of Delphi. The innocence of the Fool and the Age, or time before the fall relates to this symbolism. It is the 'unnumbered' Fool who begins the tarot (or the journey) from the innocence of spirit to the outwardly physical projection of the world (reality). The thirteen balls in the hand of Kesil in this 15th century illustration are more 'Son of Man' symbolism, possibly relating to thirteen signs, thirteen moons, and the Gnostic connection between Sophia and Christos mentioned earlier (see figure 76).

As mentioned in the previous chapter, the 22 cards forming the Major Arcana cards in the tarot are aligned with the 22 letters of the Hebrew alphabet, and the number of bones in the human skull. There are also 22 amino acids (DNA codes) providing the blueprint for life. These numerological connections relate to the skull of the heavenly Adam (the perfect one) with *22 paths* in the original Kabbalah, running between the Sephirot (the Tree of life) and the initiate. The skull and bone symbol also relates to the skull of Adam connecting Orion *to* Saturn (Satan) - hence the understanding of the splitting, or Fall. The mind was always the battle ground for the soul. The Fool, Magician and Hermit in the tarot are representations of archetypal figures

linked to Orion and Saturn. Similiar 'symbolic' themes relating to the rela-
tionship between the Fool, Magician and Hermit can be found in the movie
The Holy Mountain (Spanish: *La montaña sagrada*) a 1973 Mexican surreal-fan-
tasy film directed, written, produced, co-scored, co-edited by and starring
Alejandro Jodorowsky. It's a movie full of symbolism relating to Saturn and
other mystery school knowldge. In the movie, the Fool (who is a thief) is
introduced to seven people who accompany him on his journey to the 'holy
mountain', a place where cloaked immortals live. Each of the seven intro-
duced to the Fool are a personification of every planet in the solar system, in
particular the 'negative characteristics' associated with each respective plan-
et.

OLD MAN WINTER - SATURN CHILD OF LIGHT

In Egyptian legend the Sun God Horus, or Haru, was said to have come from
the term Heru (hero) which means Sun God on Earth. As already shown, the
Sun was one of the main sources of inspiration behind hero worship and reli-
gious belief in a 'god of light'. Other Sun myths relate to possible miraculous
feats carried out by interdimensional forces, or what we call extraterrestrials.
All forms of religion, whether monotheism or polytheism in nature, are
derived from these two ancient aspects of hero worship. Therefore, it is no
surprise to find that Mithra's birthday, along with over thirty to forty 'solar
lords' found in many other religions and cults, is symbolic of the Winter sol-
stice (25th December). This date is a very important transitional point, not
only for the annual cycle of the sun, but was for measuring cosmological ages
tracked by the ancients. In one of his many forms Mithra, like One Hunahpu,
becomes the 'Solar Lord' who dies as the old man of Winter and is resurrect-
ed as the divine child of light, three days after the solstice. The Hopi Indians
refer to him as 'Cotton Tail', the 'Old Man of Winter', carrying a staff, and
this figure can be seen scraped onto rocks in places like New Mexico, created
by Bronze Age shamans as markers of the Winter solstice (see Figure 77 over-
leaf). The same archetype is a constant theme in alchemical art and relates to
Saturn. As a rigid ruler, Saturn was said to symbolise purification, resurrec-
tion, the *restrictions of time* and physical death. The process of going within
the earth (the cave) and enduring a death and rebirth, comes from teachings
associated with Saturn.

In the Egyptian *Book of the Dead*, 'Toom' (Tomb) was considered the
'Protean God' who creates other gods, often shown as a 'man' with
'breaths' in his hands. Again in the Book of Job (12:10) it states: *In his hand is
the life of every creature and the breath of all mankind.* The word Toom also
relates to the old English word 'Tom', or Germanic, Tommaz, meaning
'empty', or ready to be filled. The Babylonian saviour god, Tammuz, is a

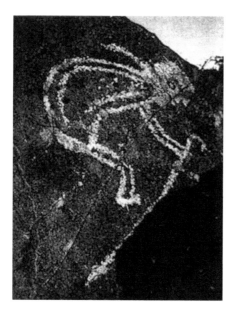

Figure 77: Old man winter - Father Time.
(**Left**) A Bronze Age petroglyph of Cotton Tail, the dying Sun marked at the Winter Solstice in New Mexico. © Courtesy of Dan Budnik
(**Right**) Odin, or Father Time, illustrated by William Blake, entering the cave to die and be reborn.

Figure 78: Tomb of *time*.
The hourglass and skull are symbols found in masonic art representing time and death. (Public Domain)

cognate of the same word relating to 'time', 'to build' and 'to empty'. The 'Tau', 'Time' and the 'Hourglass' are all symbols of 'Toom', interconnecting with Atum Ra/Adam/Orion (see figure 78).

Saturn is the god of death, found in many native cultures, and this deity is still worshipped by the Freemasons. Saturn has played an important role in religious beliefs, especially as a saviour god, or one who facilitates the resurrection through the death and darkness of the lodge, or the cave. Saturn is where we get the archetype 'Saint Nicholas' (Father Christmas), which can be seen as 'Father Cronos' and 'Wodan'. Another Father Time (Saturn) archetype is the god, Odin. He is the old wanderer, who like Christ on the cross on Golgotha (the place of the skull), is flanked by two thieves, 'Dismas' and 'Gestas', representing the symbolic death of the mind. Christ, in this sense, was the ultimate thief (See the 1973 movie *The Holy Mountain*.) who would enter the skull

(mind) and vanquish both 'memory and throught' represented by Odin's two ravens, Huginn and Muninn.

Odin has both a dark and light dual aspect. He is the 'inspired one' who *colludes* with the darkness to bring both change and knowledge to the world. The nine worlds in Norse myth, ruled over by Odin, can be visually connected to the classic Masonic All-seeing eye framed by the compass and set square symbolism. The letter 'G' often replaces the eye in Masonic symbolism; it can also be found in Mayan codices and motifs. For the Maya the 'G', or 'ge', referred to 'zero', the 'egg' and a *portal* between the living and the dead.[4] See also *Orion's Door* for more information on the egg symbolism.

ANCIENT HERO WORSHIP AND METAPHYSICAL GIANTS

As hero worship grew amongst tribal people through the vehicle of religion, various saviour figures appeared under different names, in different locations and at different times. However, when one digs a little deeper into the anatomy of these hero figures they all have a common heritage rooted in sun cycles and how the sun affects the Earth (goddess). There are at least 30 to 40 known saviour figures, from Apollo to Jesus, recorded in ancient texts and all of them carry the same attributes. Anyone old enough to remember the *Marvel Comic* superhero cards that listed the strengths, special powers and weapons for each superhero, will see how easy it could be to produce a similar series called 'Super gods'. Maybe that will be the next offshoot from this project?

All of the main Pagan festivals eventually became Christian festival dates and still represent the transitional points from light to dark, physical to invisible cycles on earth. Hallowe'en is an ancient festival for the time when invisible forces show themselves in the physical world. Its opposing point on the wheel is Spring, when the physical world comes back to life. Christmas is the point when the new Sun is born again, to commence its cycle on Earth. One constant theme in myths across the world is that a hero son is born to a virgin goddess on the 25th December. This event has more to do with the sun's power in relation to nature's cycles than a man/god saving the world, just as Hallowe'en is about celebrating invisible forces and the inward cycle. Many Christians, especially in America, seem to have a big problem with the Pagan origins of Christmas and denounce anything Pagan as the work of the devil. The same people don't half go overboard when it comes to 'celebrating' supernatural forces at Hallowe'en! All belief systems fuel duality and the Pagan/Christian example is just one example.

In the oral traditions of native Pan (Atlantean) cultures, of what later became America, Australia and New Zealand, the same attributes were attached to supernatural entities said to aid the Earth in her solar cycle. Many

aboriginal stories, legends and rituals involve human interaction with what can be described as extraterrestrial or interdimensional beings. The Hopi Kachina gods are examples of these types of forces personified. The ancients seemed to have a natural fascination for stories of good versus evil, as told through their many myths and legends, which also talk of battles between superhero-like gods and a race of giants. Many of these themes are picked up on within the imaginary worlds of *Marvel Comics*, superheroes, graphic novels and films of today. In fact, some of the *Marvel* heroes are actually based on ancient hero gods; Thor, Spiderman and Loki are just three examples. I saw a website many years ago that took the whole god figures/hero worship into the realms of secular religious belief, in a very perceptive and humorous way. It was called the *Jesus Christ Superstore*, featuring superhero-like toy figures of God himself with flowing white beard, and Jesus with a nail-throwing cross, to name just a few. The Allah figure was amusing, it was an empty blister pack with the heading: "He that cannot be shown." What this site did with humour, is to show these mythological heroes for what they really were (are) – characters based on archetypes in nature created through the minds of ancient Myth Makers. From this point in our ancient history, the birth of the hero-god found its way into the legends and oral traditions of peoples who were trying to remember life *before* the Flood, or the Dreamtime, when gods, giants, titans and heroes were said to have shaped the topography of the earth.

THE DREAMTIME GODS

From a period over 5,000 years ago, hero worship formed the basis of religious belief for our indigeous ancestors. Cave paintings found in Japan, South America and the Sahara Desert, depict giant people with round heads towering over humans. So do certain Egyptian hieroglyphs and their god, Osiris, was said to be a giant in the nature of flesh.[5] Certain deities, such as the Anunnaki (or Nefilim of biblical fame), were said to be giants. These giants are quite clearly depicted on cylinder seals showing them lifting lions and other ferocious beasts off the floor with their bare hands. The biblical Goliath was of the 'rephaim', and 'repha' in Hebrew means gaint. The Nefilim recorded in Genesis, according to some researchers, were the offspring of interbreeding between the daughters of men and non-humans, or what the Bible calls the Elohim.

The same themes of giants and strange metaphysical creatures roaming ancient landscapes can be found in the stories of the 'timeless time of Tjukuba', or the Dreamtime as depicted by the Australian Aborigine. In this long-ago creative era, beings were said to have emerged from the skies and climbed out of the earth to shape the topography of our planet. The Dreamtime, as told by the Aborigines, speaks of a 65,000-year cultural histo-

ry explaining how the Universe came into being. The Aborigine perspective of how life was created is very similar in theme to what physicists have discovered in recent years, relating to holographic projections and the concept behind the microcosmic and macrocosmic nature of reality. Other imagery associated with the Dreamtime relates to 'vibration' and 'fields' that shape and affect the earth's magnetic field, and therefore the physical world through the elements: earth, fire, water and air.

According to many native cultures, everything in the natural world is a symbolic 'footprint' of metaphysical beings whose 'thoughts' and 'actions' created our physical world. These creators are also known as 'time keepers' who were said to have come to earth in ancient times to weave the web of reality. Films such as *The Matrix* trilogy (1999-2003) and the *Thirteenth Floor* (1999) are based on themes relating to the concepts behind the 'dreaming' or Dreamtime as understood by ancient shamanic cultures. The Hopi indian stories of Spider Woman's twin sons, 'Poquanghoya' and 'Palongawhoya', are one of numerous myths that seem to refer to the scientific understanding of magnetic forces travelling from pole to pole along the earth's axis. The twin creators were said to have aided their mother, Spider Woman (the weaver of realities), in creating the first humans (the ancient ones) in the Dreamtime. Spider symbolism in indigenous art relates to the creator of the web of illusion, and what better understanding of this can we have today than the 'world wide web' and the computer programnmes that facilitate it? Blackfoot Teton myths also tell of 'Old Man Time' (One Hunahpu in Mayan tradition), travelling from South to North *dreaming* (creating) the milky river (Milky Way).[7] Similar attributes were given to the Egyptian creator god 'Khnemu' who was said to have shaped the human form. Many half-animal, half-human gods found in Greek mythology also relate to our non-physical ancestors and the untapped data stored in our DNA, a subject I will delve into further later in the book. In dreams I have been shown the milky river, or river of time, and I have seen centaurs and Pan-like creatures passing through the river, along with horses and other animals. I feel certain these images relate to the untapped potential dwelling in the Dreamtime – *beyond* the five senses.

EYES TO SEE AND EARS TO HEAR...

In creation stories all over the world a Predator Consciousness was said to have sought to separate the minds and hearts of humanity. Myths and legends that refer to various gods entering the web of life, so to turn nature into a *predatory* programme. The Predator and the 'gods' that embody this 'mind-set' inspired cultural systems (religions and heirarchies) of control which allowed *their* priests to take out of circulation true accounts of *their* involvement in human affairs, especially in the prehistoric world. The gods of

ancient civilisations, such as Babylon, chose a template called religion as a battleground on which to conquer the human mind and therefore the soul. In doing so, many mythical heroes were created by *their* priesthoods which, over thousands of years, became the one god template found in texts like the Bible. In their inverted world, the Infinite Creator, found in the cells of all living matter, became an angry male god who ruled the Universe. At the same time the male 'one god' eventually replaced the prehistoric global worship of the goddess. In truth, the secret initiates of the ancient mystery schools destroyed the outwardly expression of goddess worship, so to hide their own activities which are today still centred on solar and lunar goddess worship. On the surface, religions like Judaism, Christianity and Islam were created to give the appearance of being dominated by the masculine. While at the same time, they were 'secret' vehicles for a priests that worshipped the goddess, the stars and the earth, more often than not in her malevolent form. That is one of the reasons why Christian places of worship are covered in pagan goddess iconography.

FROM TAMMUZ TO CHRISTOS

In ancient Syria and Babylon, thousands of years before Christianity, the son of the virgin goddess Semiramis, was Tammuz. The religious blueprint that emerged from Babylon and Sumeria was one that would influence all later religions. It was the ultimate idolisation of a saviour figure.

It is said of Tammuz that he was crucified with a lamb at his feet and placed in a cave, when a rock was rolled away from the cave's entrance three days later, his body had disappeared! When the Babylonians held their Spring rites, in the sign of Aries the ram, to mark the death and resurrection of Tammuz, they offered bread buns inscribed with a solar cross. This is the source of the hot cross-bun of British Easter tradition, which also came from rituals performed in Babylon. The bloodline of the Babylonian kings was also said to be of the bloodline of Tammuz, who was regarded as the shepherd who looked after his flock of stars. Legend has it that Tammuz died wearing a crown of thorns (horns?) made from myrrh, and was worshipped in the area of Jerusalem, at the exact same place the later version of this story would be told.

Cave symbolism is common in various saviour god myths. Gods such as Tammuz and Zeus (the same deity), like the later Jesus figure, were also said to be born in a cave. St. Jerome (342-420 AD) even admitted that ancient Bethlehem had been a sacred place dedicated to the fertility god Tammuz - the spirit of the corn, crops and possibly another connection to Osiris (Orion). The same corn gods were honoured by the Hopi and Navajo Indians of North America, thousands of years *before* Christianity, in their Soyál ceremonies, some of which also included a cross, symbol on which their corn was

blessed by the Sun. As I have already mentioned, the Hopi were also Orion worshippers and this would make sense in relation to corn, crops and fertility rites at the time of year when Orion (Osirus) would disapear into the Underworld.

To Orthodox Christianity, Jesus is the begotten Son of God who died so our sins could be forgiven. But, as I have already touched on, you will find exactly the same claims for a list of gods in the ancient world long before the name Jesus was even heard. One fact is for sure, we know his name wasn't Jesus because that's a Greek translation of a Jewish name! The term 'Son of God' would seem to originate as far back as the Gothic kings of Cilicia, a tradition that was adopted by the pharaohs of Egypt, who claimed lineage back to their star gods (extraterrestrials?). Even the word 'Christ' comes from the Greek word 'Christos', which simply means anointed. And in that period to be an anointed one, was to be ritually covered in crocodile fat, an initiation of kings and priests as the messiah. The priests that were known as the anointed ones belonged to the cult of Sebek at Crocodilopolis in the Faiyum and just like the Royal Court of the Dragon, it was set up in the course of their Middle Kingdom from 2040 BC. The stories of the Essenes, who wrote the *Dead Sea Scrolls*, and of the coming of the messiah, have also been linked to the Egyptian mystery schools. Great mythological accounts in this period were set down regarding the stories of Horus, the protector of kings, and Seth, the dark destroyer. Seth (another name for Saturn/Masau'u), along with the Jaguar and gods of South America, required placation through war and destruction and took the forms of a crocodile, reptile, bat, wolf, fish and hippopotamus.[6] In fact, when one looks at 19th-century biologist Ernest Haeckel's illustrations of vampire bats, or Vampyrus Chiroptera, one cannot help but see similarities to other demon-like creatures, such as dragons and gargoyles, which are occult representations of this level of consciousness.

In Egyptian myth, Horus was the hawk, a Sun god, the son of Ra (Osiris) who would revenge his father's death by fighting Seth. In an epic battle between Horus and Seth, Horus loses an eye, just as Odin would lose an eye in Norse mythology. This eye became the symbol for a priesthood that pays homage to the deity who *caused* this loss of sight – Seth. The same eye sits on the peak of the pyramid on the reverse of the US one-dollar bill and represents a force that has controlled the world since ancient times.

At Letopolis in the Nile Delta, there was an ancient Cult of Horus known as 'Hor-khent-irti', or 'Horus of the two eyes' (the Sun and the Moon). This period goes back to a time before the fraternity of black magicians, and the priests of Seth were said to have taken charge of the spiritual reins of Egypt. It was also when Venus (a new Sun) and the Moon (making two eyes) would have been visible in the sky at the beginning of a new age (3,112 BC). The gods 'Nanahuatzin' and 'Tecciztecatl' of Aztec and Mayan legend are also the

same Sun (Venus) and Moon deities, whose story of emergence is told in both the *Florentine Codex* and the *Leyenda de Los soles*. In Mayan legend, these gods become the Fifth Sun – a symbol of the New World.

The Aztec god Nanahuatzin became 'Tonatiuh', the new fiery Sun god who ushered in the Fifth Age of man, a theme that can be found in numerous myths, art, literature and films today. *Star Wars* contains themes that also tell of one age rising out of another, and many show birth through fire, which relates to the myths associated with a new sun, or 'Son King'. The end scenes for *Star Wars: The Revenge of the Sith* (2005) and Peter Jackson's version of Tolkien's *Return of the King* (2003), are just two examples of ancient myths in modern literature and film.

Tonatiuh's appearance in Aztec myth coincides with the appearance of a comet after a catastrophic deluge, and this comet is thought to be the planet Venus. Tonatiuh was said to be the one whose sun rays shoot out in all directions, which is the source of all halos around the heads of many Sun gods. It is said in Aztec mythology that Tonatiuh, once he has risen out of the sacred fire, demanded all previous gods sacrifice themselves to make him move across the sky. Thus began the cycle of the Fifth Sun, or what the Mayans call 'Nahui Ollin', symbolised through the saviour god Quetzalcoatl, who would have to be sacrificed to keep the world alive. The description of Quetzalcoatl bears a striking resemblance to other supergods, not least the Viracocha, a group of deities found in other native myths and beliefs from all over the world. One Olmec myth tells of Viracocha:

> *A mysterious person... a white man with strong formation of body, broad fore-head, large eyes and a flowing beard. He was dressed in a long, white robe reaching to his feet. He condemned sacrifices, except of fruits and flowers, and was known as the god of peace ... When addressed on the subject of war he is reported to have stopped up his ears with his fingers.* [7]

JESUS – THE LAST OF THE SUPERHERO GODS

The creation of the Fifth Sun, or the Age of Bow in Lakota belief, brought with it the ceremonies and rituals associated with mass human sacrifice, especially across Mesoamerica. The saviour god, Quetzalcoatl was both the 'demander' and 'redeemer' of life thousands of years before the same model was used in the guise of Jesus. Within this story one can see fundamental principles behind all major religions that emerged in very different parts of the ancient world during the period of the Fifth Sun. All but a few of the 'Suns of the gods' including the prophets of religions later founded in their names, came out of the very lands influenced by the previously mentioned Tammuz/Viracocha. These Caucasian gods, who were said to have emerged after the Great Flood, brought new technologies, arts, magic and science. As

with the halo drawn around the heads of many of these Sun Gods, and the later saints that followed in their name, Viracocha travelled the world healing the sick and restoring sight to the blind.[8] The halo, of course, is symbolic of the Sun's rays on one level, and on another, they are the invisible, almost magical, powers of the eternal light as understood by the ancients. A depiction of the Mithra, Bel/Phanes surrounded by the zodiac, can also be seen to have a halo around his head, which is exactly how other Sun gods, like Jesus, were later shown. When we consider the so-called miracles performed by these Sun (son) gods, it is more likely that the wonders told of in texts, like the Bible, actually relate to the powers and capabilities of the eternal light behind the Sun! Therefore, walking or reflecting on water and turning water to wine are all attributes of the sun's power on earth. Saying all that, there is a lizard that can walk on water called a 'basilisk', which seems to accomplish the seemingly miraculous act of moving on top of water by generating forces with its feet that keep its body both above the surface and upright. Maybe Jesus and the ancient Sun saviour gods were based on reptile/bird, or spider dieties?

The Sun god, Horus (the Hawk) just like his South American counterpart Quetzalcoatl, was a bird-man god, said to be born to a virgin goddess Isis (Moon), and the god, Osiris (Sun) who founded the lineage of the pharaohs in Egypt.[9] It would seem that Horus would not be either the first or last Sun god to be born to a virgin, revenge his father, and redeem the world. The course of this book would not sufficiently cover the religious recycling and common themes, which continued throughout the last 5,000 years. Instead, I offer you a concise example of the many hero saviour figures *Suns of God*, who were born on December the 25th (ceremonial solstice date for the dead and resurrected new born Sun), so the sins of the world could be forgiven. For the Suns (sons) of the gods, see also:

> *Baal/Taut (of Sumeria/Phoenicia); Osiris/Horus (of Egypt); Mithra (of Rome); Krishna (of Hindostan); Odin (of Scandinavia); Thor (of the Gauls); Crite (of Chaldea); Dionysus (of Greece); Nimrod /Tammuz (of Babylon); Zoroaster (of Persia); Quetzlcoatl (of Mexico); Buddha Sakia (of India); Mohammed (of Arabia), and Yeshua /Jesus (of Christianity /Western world).*[10]

It is said that all of these deities were born to virgins, descended to hell (Underworld) and were resurrected on the third day. Each and every one of these gods are the same 'hero/saviour' figure dressed in slightly different clothes of their time. In some cases the faces of these gods *are* the Sun and the Moon and every attribute given to these saviour figures can be traced back to our ancestors' understanding of how the sun, planets and stars affect life on earth. When the earth went through major cataclysmic upheavals, such as

a deluge, ice age, nuclear explosion or meteorites striking the Earth in prehistoric times, then the re-emergence of the sun and other heavenly bodies after these types of events, would have been the centre of our native people's lives. It's quite probable to assume that the sun, or 'new sun'/comet/star could be turned into a saviour and personified through time.

In fact, it seems to me that the saviour sun god template was the creation of ancient priests who paid homage to celestial beings operating just outside of our space-time world. Such gods were also created to 'distract' humanity from their own inner power, wisdom and understanding. The irony of having teachings attributed to figures such as Buddha and Jesus that became orthodox mind-controlling beliefs, when they seem to carry messages aimed at human freedom, love and understanding, often confounds many. The true teachings hidden behind idols, which includes the crucified Jesus, are now available to all. Highjacking the message of truth and inner freedom, which is encoded within our DNA, by the Predator outlined earlier the book, has created a world of fear and separation. Creating saviour deities primarily focused on the 'worship of death', sin and the 'need to be saved', has kept humanity from looking within to its own true, creative power.

NOTES

1) Collins, Cecil: *The Vision of the Fool and other Writings*, Golgonooza Press, 1994, p69

2) Hague, Neil. *Orion's Door, Symbols of Consciousness & Blueprints of Control*. Quester 2020. p356-59

3) *http://freespace.virgin.net/kena/gilgamesh a .html*

4) Men, Hunbatz. *Secrets of Mayan Science and Religion*. Bear & Company; Original ed. Edition. 1989, pp60-61

5) *Book of the Arc of Bon* VX39. Cited in *The Secret in the Bible* by Tony Bushby

6) Hancock, Graham: *Fingerprints of the Gods*, Century, p 102

7) Cotterell, Arthur: *The Encyclopedia Of Mythology*, Lorenz Books, 1999, p243

8) Cambell, Joseph: *Hereo with a Thousand Faces*, p289 and *South American Mythology*, p74

9) *Dictionary of Egyptology*, Rockhampton Reference, p150

10) Eckington, David: *In the Name of the Gods*, Green Man Press, p287

Origins of Symbols

The Language of the 'gods'

All things acted on Earth are seen,
and every age renews its powers from these works
William Blake (*Jerusalem* 1804 -1820)

S ymbolism is an ancient language. It's the language of the shaman and the ancient priesthoods reaching back into prehistoric times. It's also the language of the subconscious mind, not least through the use of modern icons and signage. Symbols act as a visual expression for unseen levels of reality, and more often than not, symbolic language is a direct reference to what I see as the language of the gods.

From the earliest cave painting through to themes found in science fiction, symbolic representation has plays a major role in defining human consciousness. Ostrich eggshell beads found in Africa, and bones etched with marks and symbols found in Bulgaria, both dating back 70,000 years, suggest that symbolic thought processes are a natural part of the human psyche.[1] Look no further than the many styles of hieroglyphs and petroglyphs used by the ancients and we can see that symbolic forms speak directly to our inner eye and the subconscious mind. The knowledge contained within symbols, as we have already seen, can relate to a higher level of knowledge and understanding. Even if a symbol is a hallmark for the secret societies mentioned in this book, the 'symbols' used are 'energetic' and offer a frequency field no different to the frequency of music. The eyes and ears interpret the information field expressed through the frequency of a symbol or sound, and this is why so many people are under some kind of frequency spell when it comes to what is visually and audibly consumed on a daily basis.

All natural cycles, from the shifting seasons of the earth to the movement of other planets and stars, have become archetypal templates, many of which are apparent in religious art and relate to ancient belief systems forged by shamanic secret societies going back to prehistoric times. Authors such as Michael Tsarion[2], Jordan Maxwell and David Icke, have each produced volumes of research covering the symbolism, codes and hid-

den meanings relating to shamanic secret societies, for anyone interested in studying further, I recommend these authors. In this chapter, I intend to focus on the shamanic star cults, and add further pieces to what is a huge area of research.

ASTROTHEOLOGY

The belief systems that emerged throughout what I call the *shamanic cultures* were based on the religion of the stars, today termed 'Astrotheology', a subject that is often overlooked, or denied existence by scholars within astronomy and astrology. Yet, it is the combination of these two subjects (also called sidereal mythology) that fuelled the imagination of priests, alchemists and artists throughout history. My own artwork has been labelled astrotheological and neo-shamanic in content because I am interested in the same knowledge that came through the shaman since ancient times.

The knowledge imparted through the study of astrotheology, within the mystery schools, has given a select few the privilege of being able to manipulate the masses through religion (belief), and now the mass media communications industry. The same archetypes invented by the priesthoods of Sumeria and Egypt *are* still being focused on in the modern world, especially through the medium of film, advertising and big tech. Magicians don't just exist on television, as already touched on, they run Hollywood and use their skills to full effect in places like Silicon Valley. Many movies emerging from Hollywood, Disney and Amazon, etc., carry themes that are little more than hero worship and dualism in modern form. Many literary works and films they are also a direct reference to an alternative history, dressed up as science fiction. The ancient brotherhoods mentioned in this book, were more aware of stellar and solar connections to our minds and souls, more so than today. All we have done is adopt newer Astrotheological models in the form of religions (such as Christianity, Judaism and Islam), all of which can be shown to be based on stellar lore, pagan beliefs and battles between unseen good and evil forces. The tarot and its idiosyncratic imagery can also be understood more fully through the study of the stars and symbols; all of the so called 'primitive' civilisations were adepts at sky watching and measuring the Earth's relationship to the stars.

THE FOUR ANCIENT CULTS

It seems we have inherited many beliefs and religions from four main cults that came out of the ancient world. These are the Stellar (Orion), Luna (Moon), Saturn and Solar (Sun) Cults formed by priests (shamans), and later adapted by the mystery schools of antiquity. Initially, these four cults were separate, but then merged to become one. It's this amalgamation of the *four* that many researchers call the 'illuminati'. The illuminated ones, as exposed

by authors such as David Icke, claim kinship to the gods that came from the stars[3] and it was first the shaman/priest, and later the kings/pharaohs in ancient times, who used stellar lore (occult knowledge) to rule the masses. The symbol often used to marry the ancient four cults was the red rose, which became the symbol for the Rosicrucian secret society of the 16th century. The rose emblem is also found in political logos in many countries today because it represents the hidden power behind the charade we call politics. The rose, or 'mystic rose' (rose without thorns) is significant because it relates to the alleged Marian bloodline (coming from Jesus and Mary Magdalene) and the Holy Grail. The Knights Templar were keepers of this knowledge, not least through the 'Rose' line of St. Clair, or priestly Sinclair bloodline (descendants of Isa and Mary) – 'Santa Maria Della Rosa' who built Rosslyn Chapel, and Saint Michel d'Aiguilhe in Le Puy, France. The Rose window, or Rosslyn, with its red beam of light is a connection to Saturn and otherworldly forces (see the amazing work of the author Brian Allen). Roses are interstellar symbols and white roses are meant to relate to purity and holiness. Red roses are connected to passion and sacrifice. Yellow roses mean wisdom and joy. Pink roses are symbolic of gratitude and peace.

The priests of the four ancient cults were also the creators of the scripts found in the Old and New Testaments and it's these stories of prophets, shepherd-priests, tribes and the sun (son) of god, that still influence the minds of billions today. The stellar cult is primarily responsible for texts such as *Genesis*, considered by some scholars today to be a direct reference to celestial bodies (stars, suns and planets) that influenced the earth. I go into great depth regarding this concept in *Orion's Door* because there *is* a blueprint of control connected to Orion's stars. Christian high altars in many cathedrals and churches clearly depict what appears to be the Orion Nebula. Paintings by Michelangelo, such as the *Creation of Adam* on the celing of the Sistine Chapel in the Vatican, also indicate how elite artists and scientists (including Michelangelo) either had access to powerful telescopes to see the Orion Nebula, or they were inspired by 'otherworldly intelligence'. Michelangelo's imagery, according to researcher Danny Wilten, clearly maps the Orion Nebula in detail (for more on this see his book, *Orion in the Vatican*).

The later three cults (and their primary deities) are: Isis (Moon), Ra (Sun) and El (Saturn) which give us the name Israel. So does the word Sion (Sun), a common term used in Judaism, but actually refers to four principle Egyptian deities Set, Isis, Osiris and Nephthys (SION). Zion or Sion is also an occult code for the 'New Jerusalem' which can be taken as either an awakening process within humanity, or the New World Order (Great Reset), depending on your individual perspective. Both are a state of heart and mind. Despite the plight of millions of Jews, Arabs and other peoples displaced by war, modern day Israel, and the surrounding Palestinian territories, is a

power base created by ancient occult bloodlines that have their own agenda. This agenda, which is not a Jewish one, is designed to install a world authority as part of the fulfilling of prophecies associated with the return of a messiah – a world leader. Whatever emerges from this turbulant geogprahic location, which includes the rest of the Middle East, would not be designed to bring true peace and an end to all war and division. Quite the opposite is intended. A scenario fuelled by hatred and agression from all corners could lead to Armageddon as outlined in Revelation. Therefore, following a script and getting the masses in all religious camps to believe in the contents of a script, enables justification for every act of war throughout human history. This is the Predator Consciousness at work. Innocent people from all races, religions and backgrounds do not want war and division; they also don't want the continuous bloodshed, acts of genocide, terror and devastation caused by these hidden power structures, which, if we are honest, have no respect for humanity as a whole – as oneness. Ask yourself why so many people should be living in poverty, including millions of starving children, while an élite few own and control so much wealth? Or why governments spend billions on arms and weapons of mass destruction? When the money could be spent on healing this world. The answer is simple and leads us back to the fact that a spiritually sick élite have highjacked the knowledge taught within the mystery schools of the ancient world, a knowledge that if grasped by the masses, sets us all free. Only if we desire it in our hearts.

It is my view that the New Jersulam referred to in Revelation, is actually a place *within* each and every living divine soul, a subject I will return to at the end of this book. This place is symbolic of the heart, the 'peace within' and a wisdom that fosters respect for *all* life. With a heart so wide open and a foundation based on freedom for all, the façade of all ethnic, religious, cultural or political divisions amongst humanity falls away to reveal something greater; and what greater truth can there be than love for one another?

THE STAR RELIGIONS

According to several researchers, the oldest of the four cults, the stellar (stars), tracked the position of constellations in relation to the earth. The knowledge brought forward by these priests (in collaboration with other intelligence) can be seen in the construction of great temples, pyramids and cathedrals. The Pyramids at Giza, for example, are said to align with the Orion belt stars Mintaka, Alnilam and Alnitak. The same knowledge was used in the construction of cities over the centuries, many of which are aligned with specific constellations. Washington, Paris and London are also covered in key geometric symbols aligned with Orion, Sirius and Alpha Draconis (see the work of David Ovison). Paris was referred to as 'Juxta Isis' or 'Par Isi', by the Romans, which in Latin means Isis. The Arc de Triomphe

or Place de L'Etoile (the Place of the Star) is also located on a major axis align-ment, which includes the Louvre Palace, the Capstone of the original obelisk at the Place de la Concorde, extending far west to La Grande Arche de la Défense (Arch of the Brotherhood). On key dates, not least the Feast of St. Michael (8th May), the star Sirius, as seen from the latitude of Paris, aligns with this axis. This is just one of many, many stellar alignments embedded within the street plans of the major cities of the world, especially Washington and London.[4]

The three later cults of Moon, Saturn and Sun also incorporate sacred geometry, gestation cycles and the knowledge carried by numbers as used in ancient calendar systems. The Goddess was the main focus for the Luna cults and as many others, myself included, have shown, this goddess was given numerous names: Isis, Semiramis, Diana and Ostara to mention just a few. Astarte was another ancient goddess figure representing the evening star, Venus, and the dual embodiment of love and war. The word 'Ostara' is where we get the word Easter and it's this ancient Moon Goddess, often symbolised as a white rabbit, or hare, from where the idea of the Easter Bunny comes. The word Easter also comes from the compression of the words eastern and star. This is the star that rises (returns) on the Spring equinox, to signify the resurrection of the Sun (son) in the annual earthly cycle. The Jewish Passover is also symbolic of this 'passing' of the Sun from Winter to Spring each year at the equinox, in the sign of Aries. Ram symbolism also relates to the 'Age of Aries', a time when animal sacrifices were made to the gods (the Predator Consciousness) dominating the priesthoods of that time. The gods them-selves have been made to look human by artists throughout history, to cover up the quite obvious extraterrestrial, and in some cases reptilian appearance; it would have been a death sentence for any artist/shaman who dared to depict these gods in their true form. Another reason for not depicting the gods in their true form relates to the shaman not wanting to give power to these creatures, or to the lower fourth dimension from where they dwell. As I've been expressing throughout this book, art to the ancients was a tool for manifesting non-physical realities, for opening portals into other realities. Always select wisely what you put on the walls in your home!

Words such as pa*stor*, mini*ster*, ma*ster* and my*stery*, come from the knowl-edge passed on by the *stellar* cults of prehistory. Master, for example, derives from the syllables Ma - for 'measure' and Stor- or 'star', 'measurer of the stars' (or astrologer). Other words, such as mona*stery*, mon*arch* even 'money', are words that connect to the lunar (moon) cults. Money in the ancient world was initially connected to gold (sun) and silver (moon), but much more coinage came from silver, another representation to the goddess of *mooney*. So is the word 'monk', which was also a product of the Saturnine cult. The habit of shaving a circle on the top of the monk's head is a symbol of Saturn, as

with the skull cap or Jewish Yarmulke, all of which can be traced back to the brotherhoods of Egypt and the cult of Set (Saturn). These are just a few examples showing that the so-called different religions were creations of priesthoods focused on Orion, Sirius, Moon, Saturn and the Sun, since prehistoric times.

THE MOON, VENUS, MARS AND THE FLOOD

The Luna Goddess Cult is said to have been prominent prior to the great deluge (biblical flood) recorded in ancient accounts from all over the world. After this period Venus was recorded as a major planet (god/goddess) revered by priests of civilisations that emerged after the cataclysmic flood. The word 'Venus' is from where we get Venice and Vienna and their links to the seafaring Phoenician civilisation and the Sumerians that worshipped both the Moon and the evening/morning star, Venus. Their reverence of Venus was through a serpent goddess, Semiramis, Isis or Astarte. Interestingly, Venus, the evening and morning star, is not recorded in the tablets and texts of the Sumerians and Mesoamerican civilisations prior to 3,000 BC. Both ancient and modern accounts suggest Venus wreaked havoc in the solar system when it appeared as a comet, passing close to the Earth. Venus and Mars caused colossal changes on the Earth by creating a global flood and ice age, destroying most of the human race and rearranging our planet's topography. This type of event was recorded in ancient texts, oral myths and can be seen in films such as *Deep Impact* (1998) and *The Day After Tomorrow* (2004). As Brian Desborough explains in his book, *They Cast No Shadows: A collection of essays on the Illuminati, revisionist history, and suppressed technologies* (2004), an event of this magnitude involving Venus and Mars, may help explain why geologists postulate that the present Martian landscape is less than ten thousand years old, due to the lack of eroded rocks, despite violent Martian sandstorms.

A Russian, Immanuel Velikovsky, caused upheaval in the scientific community in the 1950's, with his Venus comet theories. He even went as far as saying that Venus was an emanation of Saturn. Interestingly, Saturn's farthest moon, 'Phoebe', orbits in reverse direction to most planetary bodies, as shown when photographed by the Cassini spacecraft in 2004 to have been badly damaged by some kind of contact with another body. Phoebe is now thought to have been a comet captured by saturn's orbit. I would suggest similar stories could be said of the earth's moon, but something tells me, intuitively, that these satellites are not what they seem. Outer space and our *inner* space are a reflection of each other, as I will show in later chapters. Planets, comets and stars are a reflection of the cycles, programmes and archetypes within us, they are not just objects floating round in space. My art work and readings of celestial subjects make me wonder if the moon, like

other planetary satellites, was not 'captured', but 'placed' in the Earth's orbit, so to influence the emotions and biological body clock of humanity. Every time I look at the moon I see the 'Death Star' construct in the *Star Wars* movies. What is on the dark side of the Moon anyway? The consciousness that *moved* the moon or shunted other planets, is the same consciousness (often personified as gods and goddesses in mythology) influencing our minds, emotions and bodies through our relationship with non-physical fields interpenetrating our reality. Astrology, like our DNA, is a programme that follows a set of rules based on time, planets, geography, physics and our connection to the cosmos as a whole. These rules, orbits and calendars have to have had some sort of creator.

SATURN'S RINGS OF RESTRICTION

The Saturn/Sun Cults emerged in the Age of Taurus (4,320-2,160 BC) creating calendar systems that would influence great civilisations such as Babylon through to ancient Rome. The Sun became the most prominent focus for the mystery schools; however, signs that Saturn influenced early shamanic secret societies can be seen in pictographs and symbols in places like Arizona in North America. Saturn represents the restrictions in life, law/order, banking, politics and education.

Saturn was considered the God of Death, a force that sets restrictions through 'time' on all life on earth. Saturn, or 'Cronos', became the main focus for the God of Death mentioned in previous chapters; the main focus for *all* religions to this day. In the modern world Saturn's influence is felt in the law courts and law enforcement agencies through the use of the 'black and white' squares (or cubes) of Saturn. The checkerboard symbolism used by secret societies relates to life, death and duality. Ingmar Bergman's film *The Seventh Seal* (1957), which shows a Knight Templar playing chess with death, considers Saturn symbolism perfectly. The law courts, universities, political senates, church and state, all elevate the priest, professor, president and judge (all rise); they all use altars that tend to be *three* tiers higher than the congregation in ceremonies. Black robes are another common theme in Saturn worship and this goes back to the Saturnian (Set) Cult of Egypt. Black and red for the ancient Egyptians was code for the Cult of Seth and its main symbol is the black square of the goddess 'Arghanoa', a moon and water deity, who according to the ancient Egyptians, influenced the waters of the Nile. Arghanoa is more commonly known as the Black Madonna, a subject I covered in *Chapters Four* and *Seven*.

The alchemists of the 15th century also depicted Saturn as a white-haired old man, or Father Time. Saturn was the binder of all other materials in the alchemist's great work. Visionaries such as William Blake visualised Saturn

as a restricting god and for Blake he was the figure 'Urizen', which relates to age and restrictions. In art this figure is often shown holding a compass or scythe, two objects relating to time, order, fertlity and duality, and it's from Saturn worship that much iconography, symbolism and belief systems, can still be seen in the modern world. Saturn, or Cronos, has also been linked to satanism (saturnism), and the worship of Lucifer, when it merged with the Solar/Venus Cult. Michael Tsarion, writing on his website, says of the Sun and the Luciferians:

> *Upon its rise* [the Sun], *the entire night sky with all its mystery and revelation was extinguished, the stars could not be observed and life became external and industrial. Thus it was that the sun was considered under sidereal ethos Lucifer, literally the 'Son of the Morning'. He Lucifer obscured the truth and the Goddess. It is a truism of the Siderealists that those who worship the sun are Luciferians in the truest sense of the word. Among many symbols used, the sun is often represented by the 'All Seeing Eye' of the god of light.* [5]

Sun and Saturn (duality) worship, along with ceremonies carried forward from earlier cults, became the predominant religions of ancient Egypt, the Aztecs and Phoenicians. The fire of the sun and the knowledge of the stars became entwined through the worship of the Sun and the Serpent, and this was often depicted as a cross inside a circle, or a snake on a cross. The four points of the cross are a reminder of the four cults and are also seen as the directions, through to the main astrological ages that became the four gospels (Matthew, Mark, Luke and John).

THE FOUR FOLD PATH

A phrase in the Mayan texts, the *Popol Vuh* (cahib xalacat be) means 'four junction roads' or, simply put, 'crossroads'. It's said these four roads emanate from the Galactic Centre (the womb) at the heart of the Milky Way, forming an ecliptic crossing point. The Maya, along with other ancient sky watchers, knew the ecliptic, which is roughly 14° wide, to be the path followed by the Sun, Moon and the planets in our solar system. The most common depiction of the ecliptic in ancient art and myth is the double-headed deity (quite often a serpent, eagle, lion or bearded deity), one who sees both sunrise and sunset. The earth god Aker in the *Egyptian Book of the Dead* (1250 BC), was often portrayed as two lions back to back (see page 281). Aker, symbolic of sunrise and sunset, was said to stand on the cosmic sphere, shown as two intersecting circles forming the ecliptic and celestial equator. The alchemists called this intersecting path the 'four-fold sphere', the crossroad that influenced the world.

The double-headed deity symbol, including much tree symbolism, also stood for the division made by a cross, or 'cross of ages', at the ecliptic. The

Cosmic Tree is symbolic of the place where the centre of the Milky Way converges with the ecliptic, creating four cosmic roads, a location for our ancestors where the night sky was considered a forest, or garden of stars. The garden in the stars, or Gan Eden, interpreted as a physical garden in texts such as *Genesis* (sometimes described and shown as a tree next to a river) is clearly connected to the Milky Way and its spiraling arms. For many native Earth cultures, each of the four cosmic roads is associated with a specific colour, star (constellation) and numerous hero gods/goddesses created from the cyclic nature of this cosmic cross. In other words, through the imagination, dreams and visions of ancient shamans, spurred on by the cults mentioned earlier, come many symbols and deities, most of which have common archetypal attributes.

The Indian deity, 'Brahma', depicted with four heads, is another example of the four junction roads or directions. So is the solar 'Lord Shiva' with his four arms, another version of the *Vitruvian Man*, or 'Golden Mean' drawn by artist Leonardo da Vinci. The Golden Mean is found in alchemical texts and is used in sacred geometry to show the marriage between heaven and earth, spirit and body. As I have already touched on, Leonardo Da Vinci was a Druid and possibly a high-ranking member of the Knights Templars. His work was basically the public face for much underground knowledge held by clandestine brotherhoods connected to the Templars. The many gods created by the mystery schools of the ancient world placed their 'solar lord' on the 'cosmic cross' at the centre of creation. The Maltese Cross is another version of the ancient solar cross found everywhere in the ancient world (see Figure 79). The Native American Medicine Wheel and Whirling Rainbow are also symbols that speak of the same knowledge. All these symbols can be traced back to Babylonian and ancient Hindu cultures. Babylon, especially, was a place where the 'saviour sun god' model was originally implemented as the state religion. This myth (why change it if it works?) went on to become the blueprint for *all* Babylonian-style religions that emerged over the centuries. Roman Catholicism and global State orthodox Christianity *are* the same religious models, in terms of doctrine, beliefs, and use of symbols. All are based on the original Babylonian template. It's the same with Islam, through its desire to control and condition the minds of people who

Figure 79: The cross of ages.
The Maltese cross is another example of the four points of the cosmic cross of ages.
© Neil Hague

choose that particular version of the original template. The nonsense expounded by the Muslim faith in relation to women, and their part in that belief system, is extreme and unbalanced, in my view. I witnessed this control first hand when part of a guided tour visiting the Citadel of Salah al-Din in Cairo (as part of a tour of the Pyramids) in 2005. The rules relating to cleanliness prior to prayer in this belief, insist Muslims must wash to be *clean* for this purpose. Yet the robe given to my friend to cover up her 'shameful shoulders' at the Citadel of Salah al-Din, looked as though it had not seen soap or water since the time of Mohammed. What *all* religions have in common, without getting into the slight differences in names, dates and places, is the 'mechanism' for 'mind control' and the desire to *separate* man from woman. You could call it the 'Adam and Eve complex', one that prevents a true union between male and female in 3D (the physical world), but more importantly, the deeper love coming from a divine union of our male and female sides, within ourselves.

The supreme deity, at the centre of many ancient cultures, was said to be adorned with many attributes, colours, and number associations depending on the position of the stars in relation to this crossroad. In Aztec myth, for example, the belt of Orion is associated with 'fire sticks', primal fire and the 'new fire ceremonies' performed on the four solstice/equinox dates of the year. This constellation is located close to where the Milky Way crosses the ecliptic in Gemini, and Gemini is another constellation relating to celestial twins and duality. Orion, or Osiris, in Egyptian mythology, was both an agricultural deity and lord of the Underworld, depending on where the constellation of Orion was situated against the ecliptic. Both the Babylonians and the Chortî Maya, along with many other ancient civilisations, considered the Milky Way to be a wheel, or circle, whose constant turning provided a transition of ages and deities associated with the stars that held key positions on the cosmic cross. The sky and the Milky Way, from our earthly perspective, also appear as a fish-eye lens spinning on an invisible axis. In general, the sky watchers (from numerous traditions) were interested in the changing movements of the Milky Way throughout the seasons and many attributes were given to what the ancients called the 'galactic compass' or 'celestial cross'.

THE CELESTIAL CROSS

In numerous myths the four roads, making the galactic cross, are said to emanate from the centre, or bulge, of the Milky Way. This horizontal and vertical axis create four different eras of precession over long periods of time on Earth, when the North Celestial Pole changed its position; or rather, the constellation that held this position, changed. According to Greek mythology, many deities and ancient races peopled four sections of the ancient world,

Figure 80: Alpha Star.
The constellation of Alpha
Draconis seen as a Pole Star
whirling through the four ages on
earth, forming a swastika.

and many of these deities related to the dawn (the Sun), the Moon and other 'celestials' as seen by the ancients in the Northern and Southern skies.

The swastika symbol also relates to the four-fold path (the celestial cross). Ancient myths relating to duality also talk of the northern portion of the earth being inhabited by a happy race named the hyperboreans. The connection between the celestial cross (the swastika) and a race of superhuman giants inhabiting the subterranean world, of course, became a pivotal philosophy behind the sickness that became Nazi Germany. In truth, the Nazi élite were revering the Predator Consciousness and interdimensionals that appear as gargoyles, demons and reptilian deities, worshipped through death and human sacrifice. The 'reign of blood and splendour' in South America, under the Aztecs, was also based on the mass sacrifice and torture of innocent victims in the name of these reptilian-gargoyle deities while using the Draco star constellation as the 'Alpha Star', the pole position through the four ages (see Figure 80).

SYMBOLS OF THE STARS & 'OTHERWORLDS'

In the 17th century BC a Greek priest named Aristeas of Proconnesus is believed to have travelled to the subterranean region called Hyperborea. His expedition was eventually turned into a poem called *Arimaspea*. The people Aristeas encountered were said to be called 'Issedonians', a blue-eyed blond-haired race of beings who lived in everlasting bliss beyond the northern hemisphere, and whose caverns were said to send forth the piercing blast of the north wind.[6] These lands in the north were also said to be inaccessible by land or sea and could relate to either a location underground, or a higher invisible realm. The Light Elves in Norse mythology were also said to live in a region located far north above the frozen mountains. The Hyperborean kingdom, because of its wealth, gold and other treasures, was said to be guarded by griffins, otherworldly creatures featured on many stately homes and cathedrals in Europe.

In *The Ancient Wisdom* (1979), Geoffrey Ashe suggests that to an early Greek, the strong cold Boreas wind would blow from the north, but for a Siberian shaman living nearer Asia, it would come from the east. For Ashe, Hyperborea and Shamballa of ancient Asian legend are the same location. He

also links the Great Bear, or the Plough constellation with the Hyperborean Age, the most conspicuous constellation in the Northern Hemisphere. All Bear worship, including the building of altars by Neanderthal humans as far back as 100,000 years ago, relate to this constellation. Writers such as Ashe, suggest that the knowledge, which allowed early man to develop advanced civilisations, was brought by extraterrestrial visitors from Ursa Major – or what the Hindus called the 'Seven Bears'. I personally feel that the same can be said of the Pleiades, the Orion system, Sirius in Canis Major and a host of other important star systems that provided Earth with a myriad of 'alien DNA'. The larger portion of our DNA, aptly named 'junk' by conventional science, still holds the codes and memories of these so-called alien races. I feel certain that what we call constellations (the heavens) are actually mirrors of the cultures, peoples and races on Earth. This has nothing to do with separation and distinction based on race, because all stars are born from the same source – we are all *one*. Our DNA is our key to the stars and the constellations we feel a connection to, which is why the ancients used specific constellations as a focus for their beliefs.

The Northern Lights (also called aurora borealis) are also connected with the Hyperborean civilisation which could have stretched from ancient Britain to the tip of Iceland. Some writers have suggested that the Northern Lights are a manifestation of an Inner Sun which gives light to the underworld realms of the earth. Inner Sun symbolism, or what alchemists called the 'Aurora', is found in many petroglyph art forms, suggesting the possibility of an advanced people in prehistoric times who understood the power of the Inner Sun (possibly their inner power). By the same token, the ancients thought of the four winds as powerful god-beings. In several myths, the wind god 'Agni' is said to have created the Monkey god who was capable of travelling great distances through the air. Interestingly, connections between alien and human hybrid races, such as Bigfoot, are also connected with UFO sightings in some witness accounts. In the Sanskrit epic *Ramayana*, the sun god 'Indara' is asked by 'Vishnu' the preserver to help him rid the earth of demons. In Hindu myth, Vishnu incarnates on ten occasions to preserve the earth and rid Gaia of demonic forces. The incarnations of Vishnu could relate to different dimensions or 'ages' endured as part of the earth's evolution. As I mentioned in earlier chapters, these demons and the 'interplanes' (or lower astral world) from where they originate have fed off humanity's fear on earth for thousands of years. In some cases, the battles between demons and ape gods, found in ancient myth and recorded in Hindu art, are memories from an ancient epoch (or a possible future scenario) telling of the struggles between opposing forces. Could these myths relate to the original earth races repelling the Predator Consciousness? The legends of Vishnu and his incarnations as the four princes, in the *Ramayana*, also relate to the four points of

the celestial cross and powerful electromagnetic forces existing at each of the earth's directions. The *Ramayana* illustrates in great detail battles between forces of evil led by the ten-headed demon king 'Ravana', and the forces of the warrior 'Prince Rama' (Vishnu). It would make a great science fiction epic! In this monumental clash, Indara, the Sun God, takes the form of the 'Monkey King' and aids Vishnu by sending an army of apes and bears (our prehistoric ancestors?) to defeat the demons and reptile-like creatures. The general themes here can be found in most myths.[7] This epic battle between good and evil is said to have taken place in the area we now know as Sri Lanka. Hanuman (the monkey god), along with Vayu the wind god (symbolic of flying craft), are said to have created the stepping-stone network of islands between Southern India and the home of the demon king in Sri Lanka. Myth tells us that this was done so to rescue 'Sita' the eternal lover of Prince Rama. Interestingly, for *The Lord of the Rings* fans, Vishnu as Rama in his tenth incarnation, is depicted clasping a flaming sword (light sabre) while riding a white steed in pure Gandalf and Shadowfax style! J.R.R. Tolkien would have obviously been very aware of the interconnected themes found in world myths, as they appear in various forms within his novels. However, I feel this myth, like many others, tells of dual forces, and otherworldly beings. They could also relate to ancient humans coming to terms with immense magnetic forces, housed at the poles of the earth, which have reshaped Gaia (and humanity) many times in previous epochs. On another level, they refer to stages in evolution, often symbolised in religious texts, and seen in the movement of the stars.

The scripture in the Book of Revelation also speaks of the saviour returning on a white horse, followed by armies on white horses; this revelation seems to be linked to a discovery in 1995 when the first planet outside our solar system was observed in the constellation of Pegasus. In the same month came a report, which told of thousands of stars rushing to the core of a globular cluster in the sign of Pegasus (the white horse). This supernova phenomenon incident, along with several others never seen before, are *signs* of the current evolutionary changes we, as a species, are moving through today.[8]

A 'FIFTH' POINT

The movement of constellations in line with the precession, as mapped out by the solstices and equinoxes also mark the centre of the galactic cross positioned at the centre of our Galaxy. It is said the centre of this cross provides a 'Fifth' point, which the ancients aligned their temple structures with. The Fifth point at the centre of the cross relates to our centre, too. Our own being and the place from where we manifest or make the changes in our lives. The five points of the cosmic wheel relate to specific *colours, archetypes, gods, god-*

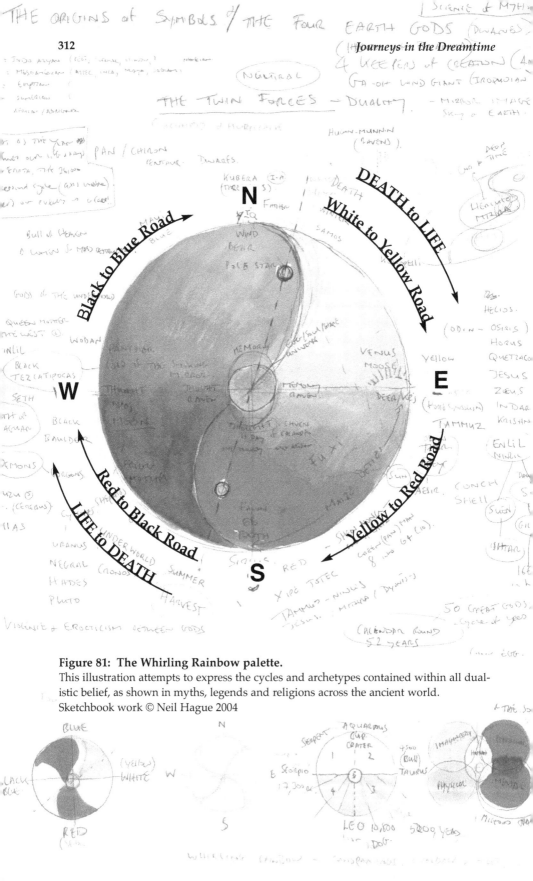

Figure 81: The Whirling Rainbow palette.

This illustration attempts to express the cycles and archetypes contained within all dualistic belief, as shown in myths, legends and religions across the ancient world.

Sketchbook work © Neil Hague 2004

desses and 'keepers' of creation. All of which derive from a dualistic perspective manifest through beliefs and religions (see Figure 81). They also relate to the *elements, cosmic fire* and the *colour* sequence behind the birth and life of stars described in the last chapter. The knowledge I am describing here can also be found in alchemy, which is simply the art of illustration or what can be called 'philosophical art'. Many artists, visionaries and myth-makers, since ancient times, have tried to understand and manifest through their art, what I call the mysterious 'origin of symbols'. No matter where you look throughout history, art *is* the primary vehicle for understanding consciousness and this needs to be more fully understood in all educational settings. To do this, drawing and painting needs to rise to the same level of importance in schools as reading, writing and mathematics. As I explain in *Through Ancient Eyes*, our creativity has the potential to free our minds, open our hearts and heal our lives.

In the next few pages I will attempt to unfold some of the common themes, relating to different deities, hero figures and transitional phases of the earth, as recorded in many of the world myths. The four roads or directions, along with the fifth and *centrifugal* point, are also used in the blueprints behind many cities and towns street plans in the ancient world. In some cases, city street plans are explicit when it comes to symbolising the heavens on earth. The roads creating the fourfold directions of the cosmic wheel are described as follows:

THE BLACK TO BLUE ROAD

The *black* to *blue* road on the wheel moves west to north and is associated with the gods of the Underworld; a place said to contain nine levels, or realms. The Big Dipper or Great Bear is often connected with the north direction in American Indian mthyology and relates to an ancient epoch on earth. The west on the wheel is considered a place of 'fright' where the God of Death resides. It also relates to the shadows, night-time, nightmares and fear. Venus marks this location as the Evening Star, and here the Moon Goddess still rules supreme.

Global deities associated with this path were/are: the 'Queen Mother of the West' (Celtic/Slavic),(I thought she had passed away in 2002?). Wodan (Norse), Seth (Egypt), Black Tezcatipocas (Mayan), Kubera (India), Hanuman (India/China), Ninlil (Sumeria) and the Gorgons (Greece), to name but a few.

THE WHITE TO YELLOW ROAD

The *white* to *yellow* road on the wheel moves north to east and is associated with the gods of the rising Sun, a common symbol found in the mystery schools or secret societies. The north to east direction commences 'new life force' and is the house of numerous Sun gods who ushered in a new age

(cycle). Saturn, in its original form, is connected to this path as it was once considered the Golden One and the bringer of light (see Prometheus). The East is also where Venus, as the Morning Star, positioned herself, rising *before* the Sun. Global deities associated with this position of the cosmic wheel are: Helios (Greece), Osiris (Egypt), Zeus (Greece), Oannes (Sumeria), Quetzacoatl (Central America), Baal (Phoenicia), Maponos (Gaul/Britain) and Indra (India), to name just a few.

THE YELLOW TO RED ROAD

The *yellow* to *red* road on the wheel moves from the east to the south and is associated with the many earth gods and goddesses of Spring time. This direction is the point on the wheel where many agricultural deities are thought to aid crop growth through self-sacrifice. In the ancient world, animal and human sacrifices were performed to facilitate in the renewal process associated with fertility rites. The star Sirius (Canis Major), is positioned in the south of the wheel and the use of red in much religious iconography relates to Sirius, too. Ancient secret societies, such as the 'Eastern Star' in Freemasonry, also honour Sirius which is seen as an upside down pentagram. Sirius (including strange beings said to have influenced the earth since ancient times) is focused on, in what the ancients refer to as the south, or 'tooth' position. A third set of teeth in ancient times was meant to be a sign of a natural superhero or a god-being. The Basilisk, a hybrid serpent-cockerel creature is said to have a triple row of teeth.[9] Robert Temple, author of *The Sirius Mystery* (1976), hints at George Washington having a third set of teeth![10] Global deities associated with this position on the cosmic wheel are: Fu Xi and Shen Nong, (agricultural gods of China), Xipe Totec (Central America), Tammuz (Babylon), Osiris/Horus (Egypt), Balder (Norse/Celtic) and Jesus (Christianity/the New World), to name just a few.

THE RED TO BLACK ROAD

The *red* to *black* road on the wheel moves south to west and is associated with the ripening of crops and the transition into Autumn. Constellations such as Sirius and Orion are associated with this direction, especially as the earth enters what the Celts called 'giamos', otherwise known as the 'time of sleep'. Shamans, priests and artists from all over the world are influenced by energies associated with this road, or direction. Not least through images of the 'Dance of the Dead', which relates to the hierarchy of the gods, the hunt, and decent into the Underworld. Much reference to violence and eroticism is also associated with the forces (energies) harnessed at this direction/time of year. Global deities connected to this position in relation to the Milky Way (the cosmic cross) are: Negral (Sumeria), Hades (Greek), Pluto and Saturn (Roman), Ishtar/Isis (Egypt/Sumeria) the Jaguar gods (Mesoamerica), Anibus (Egypt),

the Cyclops or Shepherd gods (Indo-Aryan); all these are the many Serpent (demonic) entities and gods of War found in myths and legends.

Obviously many of the constellations and the deities associated with the four roads outlined here can be placed in alternative positions, depending on cultural perspectives, religious dogma or belief. It's all a game in the end and the four roads are merely a circular 'game board' provided by ancient sky watchers. The rules, characters, creatures and attributes of the game have been invented by the Myth Makers (priests) so to mesmerise the masses. Give and take some cultural shifts in perspective over thousands of years, many multifaceted deities have become 'one god' figures, to suit the Myth Makers of their day. Others are based on the actual witnessing of interdimensional beings or extraterrestrial life forms (same thing) manifesting in our 3D reality. At the same time the four directions of the celestial cross, or cosmic wheel, relate to the four ancient cults mentioned earlier. These four points are also used by occult groups to enhance the presence of the Predator Consciousness, at equinoxes and solstices (transitional phases) on earth. To try and dissect and place the myriad of characters into the above main categories would be quite foolish, the themes and 'symbols' are more important. However, it seems to me that one particular cosmic symbol which is associated with the circle, the crossroads (the Milky Way), is the Tree of Life. It's said that from within the branches, centre (or trunk) and roots of this great celestial tree, come all the facets of the Universe.

THE COSMIC TREE & THE BIRDS THAT SIT IN IT!

Within the sacred books of the Yutatán *Chilam Balam* of Central America, the Celestial Tree is aligned to the four roads (directions) of the Milky Way. This alignment occurred following the destruction of what the Maya call the Old Order, an ancient epoch when Earth's Palaeolithic tribes worshipped the North Celestial Pole Star as a god (prior to 26,000 BC). The *Popol Vuh* of the Quiché Maya, along with Sumerian accounts, also explains features of a Celestial Tree through hieroglyphic texts and cuneiform. On Sumerian seals, the Tree is shown with a four-pointed star at its apex and is often flanked by two strange figures, referred to as the Watchers in the Book of Enoch (see page 318). These ancient texts, along with Genesis in the Bible, allude to the heavens taking the form of a forest/trees and the comets and planets (or wandering trees) that grow in the forest, or garden. The gardener is our divine human form who tends to the garden (heaven within).

The Phoenician tribes and Aryan Hittite culture of Asia Minor, which influenced the Indus Valley, also record similar symbols for the Cosmic Tree. In Native American legends the same tree has a bird or two birds perched in its branches. This depiction, along with other bird imagery, often relates to the 'old order of gods' symbolised through myths and legends relating to 'Blue

Quelzal Macaw' or the 'Seven Macaw' (a parrotlike bird), otherwise known as the bird-men connected to the Pleiades star system. In Mesoamerican mythology, the Macaw is considered an arrogant false god and the same attributes given to bird gods are found in the tales of the mocking bird and the Tower of Babel in Mesopotamian myth. The Babylonian *Legend of Creation*, inscribed on tablets found in 1870, also describes seven human beings, with ravens for faces, who came and instructed the first people in an ancient epoch. The seven-bird human-bird gods and *seven* stars found in the Big Dipper and Pleiades is a common theme in ancient myth. Bird gods can also be linked to the shaman and prehistoric tribes emerging at the time of the 'old order of the gods' prior to 5000BC. According to Mayan myth, sixteen of their kings are said to have descended from 'Yax-Kak-no', or Blue Quelzal Macaw.[11] All these stories tell of a period in the ancient world when many languages were created to divide humanity into countries and regions, a time when false gods (bird/reptile gods) were said to have arrived from elsewhere and persuaded humans to 'parrot' languages given to each tribe independently.

Before the arrival of the bird (some say reptilian) gods, all of humanity was said to have spoken *one* language and used telepathy to communicate with other life forms, including animals. The predominance of the Pleiadean bird gods through our ancient shamanic ancestors can be seen in the tombs of the Nazca people of Peru, where a 1300 year old mummified priestess was found adorned by some 15,000 macaw feathers.[12] These same people were supposed to have created the famous Nazca lines, which can only be seen in their entirety from a 'bird's eye perspective'. Were the gods of the Nazca civilisation actually bird gods? Or do these art forms represent our human ability to fly above the mundane physical reality, and into the Dreamtime – a place where forms take shape through our imagination, or our creative consciousness? Such a theory would make sense if we consider the need to be able to fly to appreciate these works of art.

In Australian Aboriginal Dreamtime myths, the same false gods are called 'Mimics' and have a 'frog-like' appearance. Each indigenous tribe was given its own spoken word so to set them aside from their neighbours, and that is possibly why in the Americas, prior to the European invasion, over two thousand different languages were spoken amongst Native American tribes. The language of symbols was kept for the priesthood/shaman, so to communicate with each other in code, especially through hieroglyphic images, while the rest of humanity were given basic semetic languages. The remnants of a universal symbolic language, one belonging to the gods, somewhere back in the ancient world, can be seen in the use of specific symbols that have survived each age. Just as our current western civilisation uses logos, signs and icons as part of the world of business and commerce to communicate systems

and ideologies, the ancient language of symbols provided the temple artist/priest with an archetypal language (codes) allowing communication with their gods.

The symbolic language used by secret societies and Freemasonic-corporate-political-structures today, is the same as the one used by the elite priesthoods that influenced South America, Egypt and Asia. It is the priests, on behalf of their gods, that kept these symbols alive and in use to this day. The mask-wearing shaman and priest, are continuing visual spectacles of what the original gods would have looked like (to them), and as I will show in the next few chapters, the original gods of earth were part human, part animal.

THE POLE (TREE) GOD

The pole, or tree at the centre of life for the ancients, was symbolic of the 'Old God', otherwise known as the 'twisted leg' god. Both symbolic versions relate to an ancient epoch on earth when the ancients spoke of a 'wooden people', or tree people. It was an age said to have been destroyed by the god 'Huracan', or hurricane, through electromagnetic storms and fires. Huracan, one thought of as being 'caught in a whirlwind', spinning around, literally means 'one leg'; he also represents the polar axis of the earth.[13] Interestingly, images of a bearded, caucasian, one-legged god are found in the art and sculptures of Indian and European Romanesque religious iconography. These creatures are called 'Sicopodes' and similar creatures are also recorded in African oral traditions. According to Zulu shaman Credo Mutwa: "These creatures were seen prior to the coming of the white races to that continent."

The image of a pole, mill, axis, or twisted tree (flanked by two gods) can be found in numerous ancient mythic symbols. In India, for example, the pole is the Celestial Mountain along with the *churning* of the Milky Ocean (Milky Way). While in Egypt, Horus and Set are shown as 'drill' brothers opposing each other (see figure 82 overleaf). These two gods also relate to the Sun on the horizon, where it gives form to both the sunrise or sunset. According to various shamanic cultures, the bird, star, or eye symbol, usually found at the top of the pole or tree, refers to various constellations (celestial forces) that aided in shifting position of the Pole Star.

The Cosmic Tree is also said to house different realms that constitute the Supreme Being - the Creator. The Hopi Indians, for example, called this creative force 'Tiawa' and in China it was 'Pan Gu', the one who housed all life forms. Many references to multidimensional realms can be found in mythology all over the world. They commonly refer to *three* areas: Underworld, Middle world, and Upper world. In both Norse and Greek mythology, the gods are said to reside on mountains, such as Olympus and the 'Vanhelm', which are symbolic of the Upper World. The 'Yggdrasil Tree', 'Sun Dance', or 'Kaballah' are also symbolic of an *invisible* structure connecting different

Figure 82: Pole gods.

(Left) A copy of Horus and Set turning the Axis Mundi, or the pole that gives us night and day (duality). **(Right)** Sirian Watchers guarding the celestial pole. (Image taken from a Hittite seal.)

dimensions, planets, suns, stars and the human soul (see *Orion's Door* for more on the Kabbalah.

The centre of this tree, or the centre of the cross, in most cases, is a direct route to the centre of the cosmos itself. This is why every Christian cathedral can be seen as a cross (as seen from above), while the cathedral interiors are structured in accordance with the Sephoric/Kabbalistic tree (see Figure 83). Each Christian church is also a 'house of the rising sun' due to the fact that the doors and altars face east. The tree and the cosmic sun at the centre is also where we get symbolism associated with the Sun saviour figures. Many of

Figure 83: The Tree of Life.
(Left) The Sephiroth, often found in alchemical texts, refers to the Kabbalah and the holistic system in which the whole propagates and reflects itself infinitely into its tiniest particles. The Sephiroth can be found in the architecture of most cathedrals where the colums meet the ceiling; these are meant to symbolise the ancient forest. **(Middle & Right)** Antoni Gaudî's Sagrada Família in Barcelona is very explicit when it comes to showing the true meaning of the columns in Christian places of worship.

these deities are a direct personification of the stars and the sun, a knowledge which was hoarded by the priests of Sumeria, Egypt and South America. For example, in many Mesoamerican rituals, the 'tree and the cosmos' related to the journey to the centre of the galactic womb (the great mother goddess), a feminine creator said to have birthed the Milky Way. This is why much emphasis is made on the precession of the equinoxes, the Pole Star and the constellations aligned with the Sun in ancient times. In alchemical teachings, the tree is *the* structure of the world matrix which 'branches out' into invisible realms, creating the physical world. Beyond the cosmic tree are said to be sky worlds (wave form) and beyond these are the lucid worlds of the Dreamtime, or what the Gnostics call the 'Upper Aeons'.

In Norse mythology, 'Mid-Gard' is the plane where *all* levels of the cosmic tree are thought to converge. Anglo Saxon, Celtic and Norse mythology inspired J. R. R. Tolkien when he created his 'Middle Earth' in *The Lord of the Rings*. Even the dwarf, Gimli, in Tolkien's books can be found as a name for the mountain hall (or realm) of the gods in Norse and Scandinavian myth.[14] Tree beings and other strange, otherworldly deities emerging from trees in world mythology, are a common theme relating to the destruction of one age, and the beginning of a new epoch; an action instigated by the turning motion of the celestial wheel. In these stories, we find ancient epochs peopled by tree people, elves, orcs and the original human ancestor – the shape-shifting, self-aware ape man. It would be impossible in this book to prove existence of such ancient (futuristic) creatures. However, one only has to look at magnified images of bugs, found in Victorian anatomical studies of certain insects and mammals, to see how our eyes can trick us when it comes to seeing weird and wonderful creatures not normally seen unless under a microscope. As the 19th century writer, Marcel Proust once said: *"Discovery lies in not seeing new lands, but in seeing with new eyes."*

Only through our art and the individual creative imagination can one start to encounter such a diversity of unseen life forms. The artist shaman will always venture into the unknown, into what is often called the supernatural, a subject I will focus on in the next few chapters.

EARTH ALCYONE

The star system known as the Pleiades, in the constellation of Taurus, is also a very important focus for the ancients. Its alignment with the Sun through-out the different epochs was marked and followed very closely by ancient shamans. The Toltecs and the Hopi, along with the Maya (quite possibly the same people), consider the Pleiades to be the home of the serpent gods and their ancestors. Many Sun and Serpent deities found in numerous myths and religious stories can be linked to the worship of the Pleiades. 'Kartikeya' (Skanda), a god of war and the son of 'Shiva', in Indian myth was said to

have been raised by the Pleiades. Many bird gods and blond-haired, blue-eyed beings are also associated with the Pleiades and the stars of Lyra. The giant bird god 'Garadu' of Indian myth, who carries the blue-skinned Vishnu on his back, is symbolic of the importance of the Pleiades in aiding the evolution of life on earth. Garadu also relates to the shamanistic cultures that claim to be influenced by Pleiadian consciousness, and in several dreams I personally have encountered amazing birdlike creatures that have told me of their connection to the Pleiades, something I will elaborate on later in the book.

The ancient Tagaii tribes of Australia, along with the Maya, also tell of the importance of the Pleiades and its connection to the Dreamtime. Temples, earth mounds and pyramids are aligned with the zenith position of the Sun in conjunction with the Pleiades, especially one of the seven main visible stars called 'Alcyone'. Writers and occultists have also drawn parallels between the earth and Alcyone, which is considered to be a focus for an 'original earth', or twin earth. In some myths, Alcyone was thought of as the sister to our Sun and the Babylonians called her 'Temennu', which means peace, or the foundation stone.[15] In Arabic, Alcyone is called 'Al Wasat', which also means the centre (balance); the Hindus called this star 'Amba' (the mother).

The chakra system of seven main centres of the human body is related to the Pleiades and the colour green associated with the heart chakra at the fifth and central point of the human 'light body', is also connected to Alcyone. I feel strongly that Earth as a star, could actually be Alcyone in a parallel reality. The Fifth and central point on what Native Americans refer to as the 'Whirling Rainbow', another form of celestial cross, is the place where *all* realities converge. In many indigenous teachings this place is the Earth. Our planet *is* our connection to the stars.

ORIGINS OF THE MYSTERIOUS RED AND BLUE

Battles between opposing forces, or heroes, can be found in all of the world myths. Some of these ancient battles relate to direct fighting between royal families and the many descendents (bloodlines) that claim kinship to the gods. The *Mahabharata* of India is a classic example of an epic conflict between feuding royal families. In much later texts, William Shakespeare's *Romeo and Juliet* is another example of similar warring opposites. So is the *Ulster Cycle* of Celtic Ireland, which involves superhero figures and their attempt to steal a prize bull. Many themes within these myths relate to royal lineage (the gods from the stars) and a bickering between blue blood families.

In the creation myths and migration records of the Toltecs of Central America, there is reference to the opposing colours of a mysterious red and blue 'springs' or 'caves'.[16] According to the Toltec these red and blue symbols, a circle and square spiral, relate to their warrior god, Huitzilopochtli. The red

© Neil Hague

Figure 84: Red and Blue Toltec springs.
My drawing of the Mythical *blue* (circle) and *red* (square) origin springs, as depicted in the 16th-century Historia Tolteca, Mexico, Aztec Valley of Puebla.

and blue colour symbolism relates to the meeting place between Heaven and Earth (or sky and land) and every temple was considered to be a central place of focus for these dual powers (see figure 84). As I show in great detail in my book *Orion's Door*, the 'red and blue' symbolism also relates to the Orion nebula and the 'Springs of Creation', and how this nebula creates star systems. The blue, circular spiral and red, square spiral springs also form part of the myths connected to the Old God, 'Huehueteotl', who was considered the lord of duality. For the Aztecs, the same deity is called 'Ōmeteōtl', an omnipotent and omniscient spirit of duality and creator of all that exists. Ōmeteōtl, according to the Aztecs, is a 'three-levelled' god whose dwelling is in the *cloud* - the Orion Nebula.

The elite painter Hieronymus Bosch certainly seemed to understand blue and pink (red) symbolism, as he too, used it to full effect in his monumental work *The Garden of Earthly Delights* (1503–1515). Bosch's 'caves of creation', in the landscape at the back of the central panel, seem to offer similar symbolism found in Aztec, Zulu and Mayan mythology. It seems *red* and *blue* symbolism is paramount when it comes to understanding the parameters of reality, manifestation and creation. Interestingly, the same colour codes are used in *The Matrix* movie as the pills offered to Neo (symbolic of Adam/Orion, the first human) by the 'god of the Dreamtime', Morpheus. The colours are also used to denote the dual aspects of the 'force' in the *Star Wars* movies - red Lightsabers for the Sith, and the blue (or green) for the Jedi orders.

Many dual deities, especially in the Americas and Asia, are depicted with a blue, or red, skin colour and this also relates to the opposing forces of sky and Earth, good and evil. The Koshari clown deity mentioned earlier in the book represents the same colour 'vibration' and opposing forces (see page 212). Again, the same colour codes used for the pills in the movie *The Matrix*, leading humans out of the control of the illusion. This is no coincidence, I am sure, as I will come to in a later chapter. The Wackowskis (the directors of *The Matrix*) seem to be accessing a hidden knowledge that speaks of the 'time of change' and the fulfilling of Kabalistic prophecies: something that, in my view, relates more to the re-emergence of a new order, or matrix, and not an awakening to oneness and love, the latter we have to find ourselves!

The opposing colours, as found on my Whirling Rainbow illustration (page

312), are symbolic of the union of man and woman – spirit and matter – life and death, which also include the left and right hemispheres of the brain. Blue was often symbolic of the male cosmic force (magic from the stars) and red related to the feminine blood of the Earth. This is one of the reasons why red ochre was used all over the Palaeolithic world to symbolise some sort of primeval connection between the Earth Goddess, her blood and the Earth people.

In African Zulu mythology, it is said that an alien royal race, the Anunnaki, under the guidance of two gods Ea and Ninhursag (Ninkharsag), created man and women – Adam and Eve. The Nefilim (or Elohim) are the names given to an extraterrestrial race said to have engineered the creation of Cro-Magnon man, through manipulation of human DNA. African legend also talks of our ape-like ancestors (possibly Neanderthal) entering two separate caves from whence there shone a blue and a red light. The story goes on to describe how our race was originally androgynous; yet, after entering one of the caves; they (humans) emerged as either man or woman (I suppose it beats going to the clinic for a sex change?!). Hieronymus Bosch depicts these red and blue caves in his epic piece *The Garden of Earthly Delights*. He also shows many fabulous creatures, birdlike figures, and amphibious humanoids in what seems like a scene from an ancient epoch on Earth possibly Atlantis? Portable art (clay figurines) found in underground caves near Nazca, Peru, also depict humanoids riding dinosaurs along with other strange creatures.[17]

Numerous baboon and monkey gods of the ancient world are associated with sexual potency, art, writing and the ability to communicate with the gods. The Christian church turned this on its head in medieval times, using the ape as a symbol for bestiality and the devil. Anything relating to sex and art was considered the work of the devil by the Church; the priesthood that invented orthodox religion did not want people accessing their natural divine creative energy, unless it was directed towards Christian religious propaganda. On the other hand, many ancient civilisations, such as the Maya and the Egyptians, considered the monkey as a messenger between humans and the non-physical (extraterrestrial) gods, which, according to mythological accounts, created the new human prototype as symbolised in the story of Adam and Eve. The Tarzan figure created by Edgar Rice Burroughs in 1929, uses similar themes of a monkey/ape man god, a subject I will come back to again in the next chapter. The Egyptians also had an ancient deity called 'Thoth', who could take the form of either a monkey, or ibis, and the ancient Greeks linked the monkey with their god of communication, 'Hermes'. This deity is found on the old British Telecommunications logo as the 'red and blue' messenger. If you look closely at this logo, you will notice that the red arm is actually a snake, which along with the two colours, is a constant theme

in alchemical art and creation myths.

Buddhist devotional paintings and textiles known as the *Thangkas*, were carried by wandering storytellers, showing numerous gods coloured in red and blue. Images of celestial deities such as the Virachoca, which are found in both myths and art of the ancient American and Asian cultures, are said to be a race of super-gods that came to earth in the ancient times. The Virachoca were said to have been responsible for the creation of our temple structures and could lift huge stones with a magic, or fire, that emanated from their batons, or wands. The Virachoca have inspired the image of the classic wizard, or bearded druid, recorded in the art and legends of many native earth races. These druidlike gods are also found in books such as *The Lord of the Rings*; given Tolkien's knowledge of Anglo-Saxon myth, his Gandfalf and Saroman characters seem directly influenced by tales of the 'Istari' – possibly another version of the Virachoca star races. The arrival of the 'Stranger' (a druid-wizard figure) coming to earth from the stars in a meteorite was shown clearly in Amazon's *The Lord of the Rings: The Rings of Power, Season One* (2022).

Superheroes from the *Marvel* world of comic books are also kitted out in red and blue costumes and *Superman, Spiderman* and *Captain America*, to name but a few, are perfect examples. In fact, Captain America is a product of the American patriotic collective psyche, one who weeds out America's hidden enemies after being given a 'wonder drug' that turns him into a supreme fighting machine. I think there is more to be known regarding the drugging of troops, to render them even more aggressive and able to perform to a central programme, than is made known to the public and families who give up their sons and daughters to become 'hired killers' for the élite. Superheroes, in general, are often products of circumstance, being orphaned, or part of some terrible scientific experiment that goes wrong, and in all cases the experiment, or accident, gives the hero the ability to move between both human and super sense abilities. The *Harry Potter* movies gave us one of the most popular 'orphan-turned-hero' characters, who fights the evil villain. *Spiderman*, the Jedi knights and Harry Potter all have extra-sensory abilities, which make them god-like. The only connections between hero gods and superhero figures are the obvious ability to fly, perform non-human feats and therefore be looked upon as a 'god' by the masses. Maybe in our ancient past, we were visited by what would seem like superheroes or '*X Men*'? Is it possible that so-called 'ancient astronaut gods' created many genetic mutations, deemed as gods by the populace on a largely primitive Earth? Were the many semi-human god figures of the ancient world just the creation of artists, shamans and myth-makers? A perfect way of hiding any extraterrestrial DNA connection with Earth people over many thousands of years of forgotten history, would be to tuck the miraculous feats of these godlike men and

women behind myths and legends that would become the foundation for saviour figures in religious belief. The popularity of the superhero, since the early concepts of *Tarzan* through to a myriad of figures provided by *Marvel* and *DC Comics*, cover many themes that cross over into ancient symbolism. I believe it is our inherent desire to remember our own extraterrestrial origins (it's in our DNA), coupled with our natural ability to 'myth-make' (create), which eventually set the precedent for the saviour god blueprint, one that is still at the heart of the human imagination. In truth, we are each our own saviour (if you perceive life in that way). It's our ability to *love* our creativity and utilise our imagination that brings forth our individual visionary capabilities.

NOTES

1) *http://www.Pravda.RU. 18:48 2004-04-01 Africa: cradle of symbolic thought!*

2) *http://www.taroscopes.com/astro-theology/astrotheology.html)*

3) Swervlow, Stuart: *Blue Blood, True Blood,* p85

4) David Ovison

5) Tsarion, Michael: *Astrotheology and Sidereal Mythology*

6) *Bullfinch's Complete Mythology,* p7

7) *Mythology,* Duncan Baird Publishing, p 345

8) *http://www.hiddenmeanings.com/noahsark.htm*

9) Barber, Richard & Riches, Anne; *A Dictionary of Fabulous Beasts,* Boydell 1971, p23

10) Temple, Robert: *The Sirius Mystery,* p597

11) *Mythology,* Duncan Baird Publishing, p300

12) *The National Geographic* September 2003, p46

13) Jenkins, John Major: *Maya Cosmogenesis 2012,* Bear & Company, p63

14) Cotterell, Arthur; *Encyclopedia of Mythology.* p120

15) Chevalier, Jean and Gheerbrant, Alian: *The Penguin Dictionary of Symbols.* Translated by John Buchanan-Brown

16) *Historia Tolteca-Chimeca, 76, f.16v, ms 51-53,* p29

17) Von Daniken, Erich: *Arrival of the Gods.* Element. 2000, p112

Ancient Masters of DNA

Legends of custodial gods & the Extraterrestrial connection

The truth is stranger than science fiction
Neil Hague

There is a huge amount of evidence found in art and myths, all over the ancient world, suggesting our ancestors had encounters with what we, today, refer to as extraterrestrials. According to many thousands of individuals who have experienced alien encounters, there are said to be numerous types of beings, or intelligences. In this chapter I want to introduce the subject in more detail.

Quite often evidence of extraterrestrials (or ETs) relates more to how we *see* into different dimensions while accessing our own multidimensional aspects of being. I don't necessarily believe that we have to 'go off to far-away galaxies' to appreciate alien-like life forms. The nature of our own DNA, especially the large percentage of what scientists refer to as 'junk' could itself be classified as 'alien'. In August 2004, *The New Scientist* magazine published an article suggesting our DNA could be the answer to so-called extraterrestrial life forms.[1] The article also went on to explain how one segment of DNA contained more than a million base pairs, "enough for a decent-sized novel or potted history of the rise and fall of an alien civilisation." [2] It just could be that all possible extraterrestrial activity is more to do with humanity accessing multidimensional (non-physical) frequencies that are manifestations of what is termed 'junk' DNA. Could the ancient priests, along with their gods, giants and other hybrid entities, be alien in origin? Much art and myth points to this idea.

STAIRWAY TO HEAVEN

The art of the ancients, from cave art, through to religious or devotional Buddhist paintings, clearly depicts many strange gods and creatures. And as I will unfold in this chapter, the gods are clearly connected to encounters with entities that today would be classified as extraterrestrial. For example,

the Buddhist paintings called *Thangkas*, which were carried by wandering storytellers hundreds of years ago, show strange beings encircled in what appear to be sky discs. These figures often seem to be connected to the Viracocha in South American mythology and the Shining Ones talked about in biblical texts. The Indian *Vedas* and the Book of Ezekiel in the Bible contain descriptions of what today would fit with a UFO/alien encounter. Jacob of biblical fame, was also said to have encountered strange creatures, which the Bible writers refer to as angels or divine beings. Yahweh (or Jehovah) too, was associated with what some researchers today describe as UFO phenomena. Even the creators of the Sumerian Tablets (4000 BC), as we shall come to, along with Biblical texts, regarded Yahweh as an extraterrestrial god, or a composite of gods referred to as the 'Watchers'. Another name for the Watchers, described in texts such as the Book of Enoch, is the Elohim, or the race of El. The Egyptian name for their gods, the Neteru, also translates as Watchers, whom they said came in heavenly boats or skyrockets. The idea of 'heavenly boats', appearing and disappearing in our reality, seems to relate to interdimensional entities, or angels, as described by Jacob and Ezekiel in the Bible. In fact some of the oldest petroglyphs found in what is now Egypt, depict what seem to be these gods on their boats, before the official date given for the creation of the Pyramids at Giza.

As I have already touched on, the biblical Jacob's Ladder can be symbolic of the matrix of worlds, accessed through our DNA, a knowledge that was available to the shamans and priests claiming a heritage going back to the gods (See *Through Ancient Eyes*). In Native American myths, for example, the same matrix is referred to as the House of the Butterfly and the Dragonfly, and both were considered to be made up of invisible light structures, or waveforms. These waveforms take the form of physical objects, places and the reality we see, or more accurately think into reality. The Ladder (our DNA) in this context is the same stairway, associated with dreams and higher dimensions, leading up through the physical world into higher, or parallel, dimensions. Ability to access our multidimensional aspects comes through activating the imagination and travelling that Ladder beyond the physical world. The Ladder also relates to the stepped pyramids found all over the ancient world which are said to be places where the gods and humans sojourned (entwined their DNA). An ancient inscription found in the *Pyramid Texts* uncovered in the Valley Temple of Unas in Saqqara reads: *"A stairway to heaven is laid for them so that they may mount up to heaven thereby."* The types of forms and imagery seen by the shaman or temple priest, while climbing the mystic ladder or spiral (often through using hallucinogenic drugs), are recorded in their art. Similar creatures were mentioned by early Christians, such as St. Anthony (281-356 BC) and St. Jerome (347-420 BC) and in all accounts they talk of little people that could fly and had horns. Jerome,

who was the author of the *Roman Catholic Vulgate,* records an incident from the time when Constantine was on the throne, when he wrote about a satyr being brought alive to Alexandria and shown as a wonderful sight to the people.[3] Today, witnesses talk of aliens but we have to be open minded to the possibility that what the ancients saw and what many have seen in modern times, are merely the same entities described in the language of their time. Therefore what we cannot see may well be the proportion of the universe that houses alien forms. There has to be more to creation than three-dimensional space and time, and this understanding is summed up in the phrase attributed to Jesus, when he said: "My father's house is full of many mansions." [4] Or as Jodie Foster said in the film *Contact* (1997): "If nothing else exists beside us, then it seems like an awful waste of space."

FALLEN ANGELS

In 1850 tens of thousands of clay tablets dated 4,000 BC were discovered 250 miles from Baghdad. They are one of the greatest historical finds imaginable and yet 150 years after they were discovered they are still ignored by conventional history and education. Why? Because they demolish official history. On the tablets are images and texts, which tell of a very advanced understanding of the nature of life from within the Sumerian civilisation. One of the most famous translators of these tablets is the late American scholar Zecharia Sitchin who read Sumerian, Hebrew and Aramaic.[5] According to Sitchin, within the tablets is evidence that the Sumerian and Ubaid cultures (predating) biblical times, had knowledge of flying ships, of battles taking place in the heavens between different gods, the creation of homo sapiens, test-tube babies and intricate details of star-systems, including our solar system.[6] The tablets depict our solar system with all the planets in their correct positions, orbits and relative sizes and their accuracy has only been confirmed in the last 150 years, when some of these planets were observed for the first time. Amongst many other revelations the tablets describe the colour and nature of Neptune and Uranus in ways that have only been confirmed by scientists in recent years! So how did these civilisations come to have this knowledge?

Conventional science and history accepts that civilisations, like Sumeria and Egypt, were very advanced and started at a high level. The reasons for this are depicted quite clearly on the tablets themselves. According to scientist and engineer Brian Desborough, simplistic images found on the Sumerian Tablets show encoded data appertaining to protein synthesis and a the manufacture of an elixir which repairs damaged cells and restores dead cells to life.[7] Desborough even claims that the clay texts show images (codes) that suggest the creators of the Sumerian civilisation understood about cytoplasm, nucleotides, protein and endoplasm, something that was decoded by

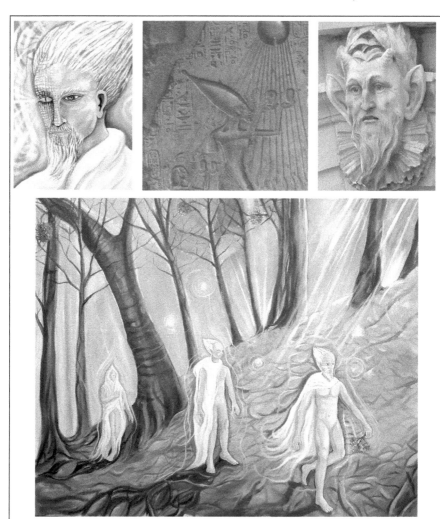

Figure 85: The Annunaki (Shem-Su-Hor).
(**Above Left**) A visionary depiction of the Annunaki (Watchers). (**Above middle**)
The Egyptian Pharaoh Akhenaten who introduced the 'One God' belief. (**Above Right**) A horned entity photographed at the Royal Hampton Court in the UK.
(**Below**) Large illustration inspired by visions of elves and druids and how they
relate to the Watchers, or Shem-Su-Hor.

scholar George Merkl, PhD, whose death, according to some, was very suspicious. The sudden death of Pulitzer Prize winning author and Harvard Psychiatrist, Dr. John Mack, MD in 2004, a world-renowned supporter of alien visitation, left many wondering about the hit-and-run scenario that killed him.

PYRAMID BUILDERS
Sumerian tablets talk of an alien race called the AN.UNNAK.KI (translated

as those who came from Heaven to Earth) who are often referred to as the Watchers in texts like the Book of Enoch. The Anunnaki-Nefilim, or Watchers, are also described as fallen angels in other texts such as Genesis, ancient records depict the Anunnaki as having wings. According to Brian Desborough, Sumerian and Egyptian civilisations were influenced by the Anunnaki, or what he calls the 'Shem-Su-Hor', when they descended on the Caucasus Mountains (Southern Russia/Turkey) see figure 85. At this time, 9,000 BC, enormous cataclysms on earth were said to have been caused by disastrous celestial events, reducing the main of humanity to the level of hunter-gatherer. This event, likely the biblical flood, marks the beginning of our official history; the 'civilisers' inspiring the great civilisations (to follow the flood), were considered as gods by ancient tribes. Even the noted Egyptologist Schwaller de Lubicz (1891-1951) in his extensive studies, found that pre-dynastic Egypt had *no* evolutionary development, but seemed to 'receive' its civilisation 'intact' from elsewhere. These civilisers (the gods), or the Shem-Su-Hor (a Martian race), were said to influence what we call ancient Egypt, Sumeria, South America, and places like Tibet. The word 'Shem' is of Akkadian derivation and relates to the Babylonian term 'Shamash', meaning 'serpent'. The Shem-Su-Hor also appear in the Americas as the Viracocha, and in South Africa as the Wazungu.[8] Both ancient and modern accounts relating to the Wazungu describe them as a fair-haired, blue-eyed race, that were depicted taller than the indigenous people of earth (see the Egyptian pharaohs). Artwork and artefacts show these 'beings' to have an elongated skull and a growth or cartilage, which gave them a long 'goatee beard', too. Certain Egyptian pharaohs, especially from before 2,500 BC, are often depicted with both features (see Figure 85).

Skeletal structures that show elongated skulls found in places such as the Giza Plateau, La Venta, Central America and the Hal Saflieni Hypogeum temple sites of Malta, are astonishingly similar to the depictions of the Egyptian gods and the Akkadian figurines which often show their deities in reptilian form. It seems that wherever the Shem-Su-Hor went they facilitated the building of magnificent pyramid structures and stone temples that would be ridiculously impossible to construct today.

GOLD DIGGERS

According to Zecharia Sitchin the Anunnaki (Shem-Su-Hor) came to Earth an estimated 450,000 years ago to mine the planet's resources, mainly gold. To achieve this end, it is said they created a 'human slave' or 'worker' force to do tasks for them. Other scholars indicate that the so-called gods developed genetically on earth (not from the stars) and that the vast subterranean regions of this planet also houses what we call 'alien species' going back as far as the Jurassic period. Academics like Dr. Arthur David Horn, former professor of Biological Anthropology at Colorado State University, Fort Collins,

conclude that humanity was seeded by an extraterrestrial race and that the Anunnaki were 'reptilian'. Horn believes these reptilians have controlled the world for thousands of years through their DNA infusion, technology and through the reptilian part of the human brain.[9] Such an alien species I am sure, is merely an expression of the Predator Consciousness I've described throughout the book so far.

Ancient hybrid creatures in later civilisations (that became the gods on earth), possessed similar attributes and characteristics as described by Natives living continents apart. In fact, such a myriad of deities with hybrid features could have been genetic experiments carried out in the laboratories of ancient civilisations like Atlantis. The Sumerian Tablets talk of two gods named Enki and Ninkharsag who were given the task of making a worker slave aand in so doing they created monstrous human-animal hybrids as they strived for genetic perfection. These hybrids became the gods (often half-human, half-animal) recorded in myths and legends and depicted through ancient art all across the world.

Aboriginal myths relating to the *Dreamtime* talk of bipedal lizard-men and to this day, Native Americans consider Sasquatch, or Bigfoot, an ancestor of the Monkey God Hanuman – a deity linked to Vishnu in the Sanskrit epic *Ramayana*. Both Hanuman and Vishnu are representations of a *light,* or force, one that returns to earth at different stages of evolution. In other words, the light within our DNA, which connects back to different evolutionary stages on earth, is providing humanity with a wake-up call and a chance to change how we percieve reality. More so, it is aiding us in how we move out of man-ufactured time (the control grid) and into infinity. Hanuman, according to Indian myth, is said to be able to travel great speeds over land and sea and changing form at will. Where Hanuman went, earthquakes and tidal waves followed. Identical attributes were ascribed to advanced humans, or the 'first people', described in numerous creation stories. Many of these stories could relate to extraterrestrial capabilities such as flying (a wind god) as witnessed by earth's prehistoric ancestors (see *The Alien Chronicles* by Mathew Hurley 2003). On another level the superhuman capabilites attributed to the gods could relate to varying levels of collective human consciousness, which *has* the ability to manifest tsunamis or world peace!

Bigfoot (or Sasquatch), in my view, is an interdimensional deity, one that can appear and disappear, depending on the frequency range we are access-ing. Different frequencies are part of a holographic memory unit; in the case of Bigfoot, a prehistoric people now lost to this physical vibration. Sightings of Bigfoot, fairies and wild fires in the USA over the years, including such phenomena as thousands of missing, or dead birds dropping from the sky, are all 'signs' of the changes unfolding on the earth at this time. The changes are a kin to one computer-matrix programme being re-written by another.

MISSING LINKS

Bigfoot is believed by many ancient Earth cultures to be an ancestor of the original human who was living during the Middle to Upper Palaeolithic Transition. This is the period that geologists place for the 'missing link', or the term 'transition', which is said to have been between 35,000 to 45,000 years ago. According to anthropologists, it seems that a Neanderthal people (named after bones found in Düsseldorf by Joachim Neander) were eventually usurped by what we now refer to as Homo sapiens (Cro-Magnon). The last Neanderthal outposts and isolated enclaves hung on until about 27,000 years ago in Southern Europe, creating what could be the rock art seen in the likes of Ardéche in Southern France. However, the sudden appearance of Cro-Magnon, along with fossil evidence for a much earlier (25 to 5 million years ago) Miocene species of bipedal ape, is an uncomfortable issue for many scientists.

According to some anthropologists, these ancient 'tailless' apes were ubiquitous, being found throughout Asia, Africa, and Europe and it has been shown that they came in all sizes, from two-foot-tall elves to ten-foot giants.[10] I am not an anthropologist, but it seems that science does not know a tremendous amount about the 'ancient' Miocene apes. Most of the categories have been classified solely by skulls, skull parts, and teeth, which are the most durable bones in primate bodies. For example, the best known of the Miocene apes, 'Gigantopithecus', is classified by only four jawbones and many hundreds of teeth: nevertheless, that is enough to designate them as the physical giants they were, and so it goes with many others.[11] It is quite plausible to suggest that Earth was a *Planet of the Apes* in an ancient epoch, and that instead of dying out or evolving into Cro-Magnon, a few species of bipedal Miocene ape remain today (as part of our junk DNA).

Imagine this scenario, instead of 50 plus Miocene apes, there might have been only, say, a dozen or so, with regional variations classified as 50 plus different species due to the scarcity of their fossils. Of those dozen, maybe six were quadrupeds and six were bipeds, with the bipeds being substantially more intelligent, more active, and more wide-ranging than the down-on-all-fours genetic kin presented by Darwinism. If all twelve survived the millennia, in their own time-tested fashions, could they be living alongside us humans today? In other words none went extinct. Human ancestry, from pre-human through to Neanderthal, may have more to do with a hybridisation, as in an Adam and Eve-type clone, created by the gods; whereas the Miocene ape, and possibly Bigfoot is an alien-human hybrid. A phenomena that continues to baffle official anthropolgy to this day.

FABULOUS BEASTS

In some myths and legends, armies of apes/bears are said to have fought

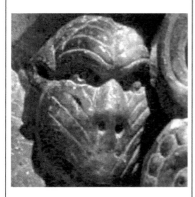

Figure 86: Fabulous beasts.
(Top and middle) Antipodes or
Cynocephalus' dog, or wolf-headed
men. **(Bottom)** An apeman
creature. All photographed at
Romanesque churches accross
France. © Neil Hague 2005

armies of demons, sometimes griffins. Other apes were captured by the Anunnaki-reptile species, or the Gallu (bird-like creatures) found in Indo-Ayrian myths, and possibly used in genetic experiments. Some of these experiments involved the cloning process that could have left us with the modern human form. Was Adam and Eve a metaphor for a cloning scenario facilitated by the gods? More so, does this story relate to the separation of man and woman in their truest form? A state that has been maintained by the Babylonian Church throughout what we perceive to be history?

Ancient stories passed on amongst the indigenous peoples of earth also relay similar themes of the gods and extraterrestrials intervening and breeding with what must have been our prehistoric ancestors. In one legend, the Anunnaki, under the supervision of their leader Ninhursag, a reptilian goddess, are said to have set up creation caves in Africa, so to create the male and female of our species (see page 322).

Films such as Stanley Kurbricks *A Space Odyssey (1968); Planet of the Apes (1968), and 28 Days Later (2002)* also have similar themes of genetic mutation and ancient/future epochs on earth. We also know from the 19th-century Science of monsters that mutants are not a new phenomenon. In a 15th-century text called the *Nuremberg Chronicle*, Hartmann Schedel, a German writer at the time of renowned artist and priest Albert Dürer, records many deformed people living in India and elsewhere in what he calls the 'Second Age of the World'. The Nuremberg documents are supposed to illustrate all 'Seven Ages' of the world

and according to the Holy Roman Church, these Ages are from Creation to the last Judgement; it is said to be the largest book-publishing venture of the 15th century.

Religious sculptures depicting similar hybrid creatures can be found all over Romanesque chapels throughout Christendom, many of which appear in the Nuremberg documents (see Figures 86 and 87). Another script called *The Chronicle* also includes descriptions of strange creatures set out by Pliny (23/24 - 79 AD), some of which have since been discovered. A UK Channel Four television series in 2004 called *Human Mutants*, showed how people in the modern day still carry genetic traits found to have been in existence hundreds, probably thousands of years ago. Various mutant errors (according to the program) found in the 30,000 human genomes, can range from individuals covered in hair (head to toe),to having one foot (mermaid syndrome); other traits that would have made them a focus of fascination and dread in the religious communities of medieval Europe. Hunchbacks especially were a bit of a collectors' item for the Christian Church, along with some of the bloodline families of France in the 14th and 15th centuries. In a small village in central France, called Saint-Bonnet-le-Château, there is a tomb underneath the main church that houses human remains of a hunchback, a giant, a pregnant woman, various children and other skeletons of birds and animals. The region in which this village and church is located sits in what was once land belonging to the Dukes of Burgundy (1363-1477). It would seem that the Holy Roman

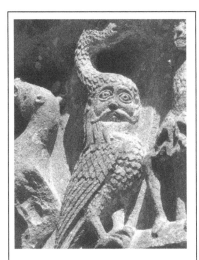

Figure 87: Fabulous beasts. **(Top)** An owlman **(Middle)** A Jekyll and Mr Hyde-type mutant from Kings College, Oxford, UK. **(Below)** A Woodwose photographed at Moulin Cathedral, France.
© Neil Hague 2005

Empire, from the 14th century onwards, had a fascination for mutants and strange creatures.

Some of these creatures were called 'Antipodes', or Wolf Men, others were Cyclops, and one-footed creatures called 'Sciapodes', said to have been seen by travellers in the Middle Ages. Wolf-headed men especially, seem to have been a fascination for the priesthood and royal bloodlines that commissioned art, murals and sculpture in medieval times. From my own research this 'fascination' by priests relates to black magic practice and the worship of wolf-headed demonic entities such as 'Pazuzu' (Assyria) and 'Seth' (Egypt). Pazuzu appeared as the demon that possessed Regan in the 1973 film, *The Exorcist* by William Friedkin. Werewolves especially seem to have been sighted across Europe throughout the Middle Ages. Between 1764 and 1791, in both France and England, a werewolf of some description was responsible for over a hundred killings. France especially, documents one of the most gruesome and unsolved series of attacks over three years (1764-1767) by a wolf-beast connected to a secretive brotherhood and the Catholic Church. These attacks were included in the plot of a movie called *The Brotherhood of the Wolf* (2001). For more on this subject see my book *Through Ancient Eyes*. Interestingly, the existence of these fabulous creatures came from the geographical exploration of the world in medieval times, just as extraterrestrials appeared during the exploration of space in the last century. Could it be that our imaginary levels, automatically create a mirror for any civilisation that becomes aware of its frontiers, and then builds bridges, through its art, to the 'unknown' that lies beyond these frontiers? Do these creatures actually exist? Are they remnants of DNA connected to the gods and their bloodlines?

DIVINE RIGHT TO RULE

It's said in the Sumerian Tablets that the Anunnaki (Shem-Su-Hor) break-through came with the creation of homosapien, a creature the Sumerians called LU.LU, or one who has been 'mixed'. The Sumerian Tablets, like the later Akkadian myths, explain how the Anunnaki hierarchy, which was ruled by the father god, 'An' or 'Anu', granted Anu-ship to certain humans who would go on to rule and control as god-kings in civilisations such as Sumeria and Egypt. The kinship (rule by blood) eventually led to the concept of the 'divine right to rule', and of a chosen élite on earth. These hybrid god-kings also became the rulers of the Near-Middle East and are often referred to as the Dragon Kings.[12] In Persia and surrounding areas of Media, the same royal bloodlines became the 'Dragon Dynasty', otherwise known as the 'Descendants of the Dragon'. In Egypt, the Priests of Mendes founded the Royal Court of the Dragon in 2,200 BC. Some say this ancient cult still continues today, 4,000 years later, as the Imperial and Royal Court of the Dragon

Sovereignty, now headquartered in Britain.[13] In Celtic Britain, the tribal king of kings was referred to as 'Pendragon' and, as we have already seen, this involved knowledge (gnosis) relating to dragon and serpent symbology. Dragon symbolism can also be linked to both positive and negative types of leadership and, even in today's world, one will find the ancient royal dragon depicted on flags, in statues and on logos of the ruling classes for those reasons.

The Anunnaki are the 'gods' in the Old Testament. Every time the word 'god' is used in the Old Testament it's translated from a word meaning 'gods', plural. Elohim and Adonai are two such examples. In the ancient Indian *Vedas* the same beings are known as 'Naga' (Serpent gods) who are also attributed with feats to those mentioned in the Sumerian Tablets. In Buddhism they are referred to as 'Snake Guardians' of the 'Doorways' and in China, as 'Soldiers of the Heavenly Gateways'. It seems that ancient accounts of the Shem-Su-Hor or Anunnaki were removed from Egyptian art, history and civilisation as a necrophilic priesthood (founded in Babylon) took control of the populace. Some writers posit this 'priesthood' became the 'Order of the Dragon', and its descendants are still manipulating the world, through black magic and mind control to this day.

The Order of the Dragon became the bloodline that eventually arrived in Europe as the Merovingian priest kings (400AD), which became the European aristocracy and their offshoots. The *Nag Hammadi Library* or *Gnostic Gospels* refers to this Royal Race and their hybrid rulers as the 'Organisation'. The *Nag Hammadi Codex* states that Jesus refers to: "... many animals walking around in the skin of men."[14] Could these be the reptoids, greys, insectoids, along with many other so-called alien races be the 'animals' of which Jesus spoke, using the veil of the human body through which to operate? The Book of Job in the Old Testament says of such beings: *"I am the brother to dragons and a companion to owls"* (Job 32: 9). In the Gospel of St. Matthew there is a reference to: *"A generation of vipers who hath warned you to flee from the wrath to come"* (Matthew 3:4).

As I have already touched on, the ruling bloodlines today are the same priesthood dynasties of Babylon, Egypt and Sumeria. At the highest level of the mystery schools, such as Freemasonry, it's known that the greatest secret *is* that earth's ruling élite are non-human and possibly Orion-based. As fantastic as that sounds, there is a huge amount of evidential art, from ancient Sumerian artifacts to the illustrations of William Blake in the 18th century, depicting such phenomena.

In my view, 'possessed figures' hold key positions in highest levels of the Illuminati (the Organisation), and these in turn 'choose' the world leaders to front the 'illusion' we call official reality. George Lucas illustrates this 'possession through heirarchy' in *Star Wars* movies such as the 'Sith controlling

the Senate and therefore the Republic'. In the ancient world this élite society was the real brains behind most ancient temple cultures and quite probably the controllers of a vast 'empire' under the umbrella culture of Sumeria. A civilisation that gave us religious beliefs based on *one* template – the all-controlling Patriarchal Father God.

BLIND GUIDES

The gods worshipped through religious orders (including the priests who were initiated into these ancient orders) became the illuminated ones. Such initiates would go forward into the world to bring either peace or destruction - the latter depended on which part of the 'order' the initiate belonged. The difference between these two factions was the difference between two forces, that of good (light/life), and that of darkness (evil). The movie, *The Dark Crystal* (1982) directed by Jim Henson and Frank Oz, symbolises these opposing forces as an ancient brotherhood separated by the shattering of a crystal – an object that symbolises our true 'multifaceted' potential. The film also touches on themes relating to 'separation' and how two brotherhood factions needed to become one again, to restore balance. Even though Henson's story is fictional, it expresses simple themes relating to encompassing both polarities as part of the process towards *Oneness*.

The *Nag Hammadi Codex* also warns us of a gross 'deception', the illusion of life and the real force behind human belief systems that encourage death, destruction and separation from our higher selves. Figures, such as Jesus (or the priests who knew the truth and wrote these texts behind such a figure, imparted the knowledge that humanity had been separated from the Infinite! Parables in the Bible that speak of helping the blind *to see*, and giving sight to those that *cannot see*, refer to a switch in *perception*, when we realise both life and death are part of the illusion. Love (Oneness) is the only truth! Mind blindness in this context relates to 'not seeing' the illusion and accepting the God of Death, survival (mere existence), as the 'one god'. The God of Death, I would suggest, *is* the god in the Old Testament. Whereas the 'God of Life', which comes through feeling love, is something not restricted to Bibles, books, belief systems and religion. Visionaries have recognised the difference between the beliefs expounded by the likes of Jesus, Buddha, etc., and the teachings focused on *guilt*, *fear* and *control* through priesthoods that have venerated the angels of death for thousands of years. Jesus addresses the priesthood in the Gospel of Luke, when he says:

> *Woe to you scribes and Pharisees, hypocrites all. You shut off the kingdom of heaven from men, you don't go in yourselves, neither do you let anyone else enter... blind guides...you strain at a gnat and swallow a camel, you bow before the heart of the law but violate the very heart of the law, which is justice, mercy*

> *and forgiveness... you are like whited sepulchres, all clean and fair on the outside, but on the inside full of dead men's bones and all corruption.*[15]

The above could be said of governments, corporate priesthoods and the power structures of today! It's this 'blindness', referred to in many holy texts, as that which is preventing humanity from connecting with love and life, especially through our own power as co-creators. Through love we have our strongest connection to the creator, or the light dwelling in the cells of *all* life forms. The opposite of life and love is the angry 'fire and brimstone' *false* god, one that demands fear, control, belligerence, war, jealousy, hypocrisy, death and all that is dark and dwells in the shadows. In the words of the *Gnostic Gospel*:

> *The darkness works to anaesthetise the intelligence and spread the cancer of mind blindness.*[16]

When we live in fear we live in the shadows and that is precisely what the secret society networks, since ancient times (on behalf of their masters), have sought to achieve through war and control. What is happening in the world today is merely a 'time grab' of what has always happened on earth while ever the 'God of Death' is being venerated. The Predator Consciousness and other interdimensional intelligences that are manifestations of the 'fear (Wetiko) vibration', have been manipulating human consciousness for a very long time. We, as a collective, have been a constant food source for a matrix feeding off fear, death and destruction and it's this consciousness, I feel, that also manifests as specific alien life forms.

THE GREAT WORK OF AGES

I feel that initiates of the ancient Egyptian mystery schools became followers of the Anunnaki through worship of the Predator Consciousness (the fire and brimstone god), who, when you look at the texts closely, seems to have been a collection of 'gods' travelling in 'vehicles' emitting smoke, fire and lightning. All sorts of magical feats are associated with this composite of gods, from burning bushes to plagues of locusts. The Canaanite 'one god', 'Yahweh' and 'Moloch', another name for 'Baal' are the same deity for the Hyksos (a mixed Semitic-Asiatic group) who infiltrated the Nile valley, and seized power in Lower Egypt in the 17th century BC. The Hyksos ruled Lower Egypt from c. 1674 BC until expelled when their capital, Avaris, fell to Ahmose around 1567 BC. The Hyksos in Egypt worshipped Set (Saturn); like Yahweh (Moloch) they identified him as a storm deity, a god of death and war. Egyptian hieroglyphs even show this god training the young Pharaoh Thutmose II, which is symbolic of the connection between the gods and their

influence on the ruling élite.

The One God worshipped to the letter by millions through religions today (unknowingly in the majority of cases) is the Predator Consciousness and it 'is' the mentality behind the priesthoods I've been illustrating in this book. Yahweh/Moloch, etc., and the gods of death and destruction, are worshipped through exactly what they represent, 'death and destruction', usually through war, ritual sacrifice and death by fire. These deities and the consciousness they represent are also called upon in rituals performed on ancient pagan calendar dates, such as the equinoxes and solstices.

The remit of this book doesn't allow scope to cover such a subject in depth, but, for example, the Texas Waco siege in 1993 and the Oklahoma Bomb a year later both occurred on the Pagan 'Walpurgis Festival' in April, when in the ancient world, victims (especially children) would be burned alive to the Canaanite god, Moloch. Wars have also been started on and around the same dates. And we wonder why so much war and bloodshed has visited this planet throughout history? Humanity has been encouraged to hold dualistic beliefs based on fear and limitation, and these states of mind have been played off against each other through acts of war, terror and other abominations that plague our reality. Manifestations of the Archons and the fire demons actually take form in the flames and smoke of ritual killings. I was not the only one to witness on TV some of these 'beings' appear in the smoke and fire of the twin towers in New York on 9/11. Why? Because these are the same ancient demon deities placated by ritual murder instigated by the magicians and high priests of the brotherhood referred to in this book.

The knowledge of this connection with 'star races', which I'll come to later, is the most 'secret of secrets' passed on through the ancient mystery schools to this day. So is the secrecy surrounding the 'light bearer' (Lucifer) and the Great Work of Ages, all of which refer to the ultimate demonic host – the Antichrist (see *Orion's Door*). At the highest level, Lucifer is the god of the Illuminati, Kabbalistic secret society, a 'cult' that has been working to one agenda for at least 300 years. It's the total removal of spirituality and liberty on Earth, and replacing it with a tyrannical dictatorship policing a robotic, spiritless human population. If you think that sounds ridiculous, then look no further than what is going on in our world today and what has passed since Covid? On one level, humanity is becoming 'robot-like', already persuaded to fit into specific job titles, identities, have ready-made religious (and media) belief systems and accept mediocrity and an unfolding tyranny as the norm. The system is insane and is overseen by artificial intelligence, which ultimately runs the matrix world we call daily life. Big brother, CCTV, facial recognition, along with the microchipping of people, are all expressions of a humanless society. I genuinely feel that the pandemics, eugenics,

or even microchipping the gloabal population is not the final scenario. Cloning a future generation of human-robots (see *Brave New World* by Aldous Huxley) is a dream of the cult. Attempts to destabilise society (the planet) through pandemics, war and terror is the work of a very ancient cult (brotherhood) that is as predictable in its methods as the Sun and the Moon in their journey across the sky. However, predictability is also a sign of laziness and through laziness one can overlook the signs of change, especially in the perception and attitudes of growing numbers of people today. The death cult (Illuminati) are massively deceiving themselves. The truly 'illuminated ones' are the millions of people seeing through the corruption and illusions and using their creative imagination to access the power within themselves.

MAKING MAN IN 'THEIR' IMAGE

It seems that from overwhelming sources of information, Paleolithic man and woman worshipped animal-human gods or goddesses. Amongst the art and sculpture showing animal-human hybrids can be found reference to a humanlike race able to perform miraculous feats. As I have already touched on, these gods are the intelligence behind advanced civilisations that appeared from out of nowhere, to become ancient Egypt and Central America. They were the advanced pyramid societies. The race of gods that influenced the building of these ancient civilisations are said to have advanced technology,, shape-shifting abilities, could travel in sky boats (space ships) and use genetics to create other species, as recorded in the Sumerian Tablets, and the *Popol Vuh*. The latter is the bible for the indigenous Mesoamerican tribes. In fact, the *Long Count Calendar* used by the Olmecs and, later, Mayan culture of Mesoamerica, is probably inspired by an 'intelligence' that had a great understanding of planetary precession and celestial events spanning millions of years. According to the Sumerian Tablets, the Anunnaki (Shem-Su-Hor) are said to have interbred with earth women creating a hybrid bloodline of god kings, which we now know as the tribal Pharaoh dynasties and their likes around the ancient world.

It's not impossible to imagine master geneticists (extraterrestrials) creating hybrid creatures in laboratories, as they strove for genetic perfection. According to late scholar Zecharia Sitchin, the Anunnaki (Shem-Su-Hor) had visited our Earth at least 400,000 earlier. Sitchin says that their breeding programmes, which included genetic trials (in test tubes), created what the Sumerian texts call a 'primitive worker', or 'worker race', to carry out the wishes of the gods. These experiments became the half-man half-animal pagan deities recorded by Egyptian, Greek and Roman artists. Even the story of Noah's Ark and the Great Flood has connotations of salvaging life forms (DNA). Noah, possibly a mythical name for the bloodline of the gods (the

Nefilim in the Bible), seemed to be responsible for 'overseeing' the genealogy of species on earth at this time. It's more than likely, given the information within the Sumerian Tablets, that the embarkation of animals onto 'Noah's Boat' (space-ship or time-ship) as recorded in Genesis, is an allegory for the saving of the DNA of each animal, to be later used in experiments!

The obsession with cloning and altering DNA to this day comes from off-world connected secret societies and their desire to manipulate life on earth. In fact, it would be safe to say that interference in our DNA structure appears to be ongoing, supported by increased reports of alleged alien abductions and cattle mutilation on a worldwide scale. The introdcution of a mRNA vaccine for the first time in human history as part of the Covid scam, is another form of manipulation of human genetics (see earlier chapters). This along with an increase in genetically modified foods and other chemicals in the air and water, are all designed to prevent us from accessing our multidimensional power contained within or DNA.

Knowledge of the DNA and its connection to gravity, electromagnetics and light was understood by the ancients. German physicist Hartmut Müller, working at the Institute for Cosmic Research in Russia during the 1980s, pioneered the study into biofields and the interaction between DNA and gravitational standing waves that permeate the whole Universe. According to the late George Merkl, PhD, the Sumerian clay texts (Sumerian Tablets) also contain a library of biological information, which show living cells are affected by weak electromagnetic frequencies and that a biofield pervades the entire Universe. In other words, our cell structure and DNA, as understood by the intelligence behind the great civilisations, are connected to a 'universal wave' which has been measured through sacred geometry, numerology and astronomy since ancient times. All of the amazing pyramid structures, especially in Egypt, through to the Gothic cathedrals were designed by an intelligence that understood the interconnectedness of sound, geometry and the universal standing wave that according to the likes of Dr Müller, affects our DNA structure.

ALIEN DNA

Science over the past twenty years has discovered 37 'strange' mitochondrial DNA structures included in our cells, and this discovery about the origins of DNA replication, according to some scientists, offers startling confirmation that mitochondrial DNA is, in fact, the result of some kind of alien interception. Unlike other DNA, mitochondrial DNA happens to have a distinct circular structure. Thus it is extremely plausible that aliens (the gods) could have used this circular structure to conceal the 37 genes of mitochondrial DNA. This concealment would allow genes to replicate under their own steam and thus maintain their independence from the human DNA while at

the same time existing within it. Could we be a genetically modified species created by extraterrestrials so to influence our minds and therefore alter our reality? Alan Alford is just one of many scientists open to the concept of alien intervention when accounting for anomalies surrounding the origin and evolution of man. He writes:

> *Homo sapiens has acquired a modern anatomy, language capability, and a sophisticated Brain (well beyond the needs of everyday existence) apparently in defiance of the laws of Darwinism. There are a number of possible explanations for this anomaly. One is that mankind evolved in the sea, and that crucial fossil evidence is missing. Another is that Darwinian theory itself has a missing link. And the third explanation is that the genes for modern man were suddenly implanted by an intelligent extraterrestrial species who colonised the Earth.*[17]

Colonising the earth and creating a suitable genetic biological body for a host sounds like a science fiction movie plot, but so much myth, art and myriad studies are pointing to this concept. In the *Enuma Elish*, the Babylonian creation epic, the god Marduk (a great serpent), while listening to the words of other gods, conceived the idea of creating a 'clever device' to do (the gods) will. Marduk, quite possibly of an extraterrestrial race, said: *"I shall bring into existence a robot; his name shall be Man."* [18] Was this robot/man Homo Sapiens, an experiment destined to become a slave race for the gods? Or, are we talking actual robots (droids) built to carry out tasks for the gods in ancient times? The movie *I Robot* (1999) might not be so far-fetched when we consider the advancement of science, especially 'underground science' which is usually five or six decades ahead of what the public are allowed to see. The Sumerian tablets, seem to depict what look like robots (see Figure 88 overleaf). The Kabbalah also refers to this slave robot race as 'golem'.[19] Many people who have had modern day encounters with extraterrestrials tell of some of these beings looking like robots. Whitley Strieber, author of the bestselling book *Communion* (1989), describes encounters with what seems like a 'toy', alien-like, robot creature and as I show in *Orion's Door,* the cyborg is an off-world inspiration. I will come back to this robot/machine theme again later in the book.

A HOLLOW EARTH HOUSING ALIEN RACES?

Scientist's debunk the idea of a subterranean world and the hollow earth theory, while at the same time they uncover miles of underground passages, entire subterranean cities, and massive underground facilities all over the world. The notion of the earth having a hollow centre is not so daft when we consider basic physics. All spinning matter, by the fact of its speed as it is spinning, will create an illusionary hollow centre. Put clothes in a washing

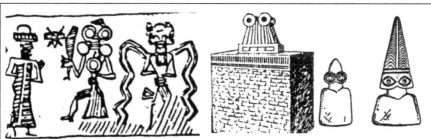

Figure 88: Sumerian robots and eye idols.
(Left) A drawing taken from cuneiform reliefs dating back to 4000 BC
(Right) Alabaster Eye idols from Syria. Do they represent some form of robot deity?

machine and set it on spin and this will give the effect of having a hollow centre. All stars, suns and planets are spinning at a tremendous speed (undetected by our bodies) and therefore there is no reason why a hollow centre at the core of each planet, could not be a possibility.

In 1844, a Peruvian priest who was summoned to absolve a dying Quechuna Indian received a remarkable story about a system of underground tunnels beneath the Andes. The dying native told of the sealing of a system of secret tunnels (a labyrinth) by the High Priest of the Temple of the Sun, during the last reign of the Inca Emperor Atahullpa.[20] The same tunnel complexes are said to exist under the Himalayas and in many areas of North America, not to mention the catacombs of almost every major city in the world. Many ancient accounts talk of people fleeing, fighting or journeying into these subterranean cities, especially at the time of war. Some military personnel also claims to have visited underground complexes in America and in Alaska, and many of these places are said to have been built with a view to house the élite and their chosen people in the aftermath of a Third World War, or something that would truly devastate life on Earth. Both the USA government and the Nazis have also been connected to the notorious Dulce-Los Almos underground bases in New Mexico, since the time of the Second World War. This area is the same notorious 'Dreamland' (or CIA controlled Area 51 location), which has fuelled much interest in UFO and alien activity since 1947. In truth, the UFO phenomena is far older and is found in all continents in every era. Area 51 and Dreamland situated around the Four Corners in the USA, have been nothing more than a distraction created by the powers that be to divert attention from the real bases in the USA.

BATTLES BETWEEN THE SHINING ONES, ANGELS & GRIFFINS

In both Akkadian and Sumerian accounts, hybrid fearsome griffinlike creatures called the 'Gallu', were said to be used by the gods to 'police' lesser gods (human hybrids) in the ancient world (see figure 89). These deities were also protectors of temple treasures, and guardians of the doorways, or por-

tals, used to pass in and out of this three-dimensional frequency. Could the small bag-like object they carry be some kind of device or technology? Much ancient art and sculpture produced for kings and queens throughout history depicts these fearsome beasts. Every major city in the world has sculptures of either griffins, or lions, or a cross between the two, on stately homes and religious buildings. Why? Beacuse they are a depiction of the consciousness that overshadows our world (reality) and has done so since ancient times.

Griffins are a symbol found all over the ancient world. They can be seen on the paving stones of Assyrian temples, Romanesque architectural details of Mediterranean Europe, to stately homes and crests. According to ancient historians who reported the conquest of Alexander the Great, griffins are said to be the guardians of India and its fabulous treasures. The historian Pliny maintained that "They had a hooked nose and ears..." and that "There are bearded griffins with a human face." For the Greeks, hippogriffs facing a chalice areassociated with one of the most famous legends of antiquity. The legend tells a story of a Greek painter, Apelle, who possessed a real talent for art, so much so that after painting a cup filled with water, all of the local birds flocked to drink from it. This tale alludes to the idea that our physical world is just an illusion that can be transformed through art and imagination.

In Mesoamerican myth, these bird creatures are often symbolised through a monstrous bird known as 'Seven Macaw' – what ancient myths call a false god. These false gods are considered arrogant impostors, and possibly an aspect of the Predator Consciousness that I referred to earlier. According to legend, Seven Macaw and his sons were engaged in combat with the Hero Twins Hunahpu and Xbalanque.[21] All of these characters appear in the sacred *Popol Vuh*, which records the creation story of the Maya. According to the

Figure 89: Griffins & the Tree of Life.
A drawing of an Assyrian relief dating back to the first century BC

Maya, Seven Macaw was associated with the seven stars of the Big Dipper in the constellation of Alpha Draconis, the rising and falling of which marks the beginning and end of the hurricane season, an annual cycle in Central America. These creatures, or the force they represent, are said to have become prominent in the immediate aftermath of the Flood recorded in ancient texts and legends all over the world.

Some of my visionary art shows a mixture of Nordic-bird-reptile figures that, I feel, were the influence behind earth's shamanic cultures emerging after the global deluge. The Seven Macaw, as with many other 'bird or reptile deities, was said to glow or glitter and shine, which is another trait of the Shining Ones or serpent gods, recorded in the Book of Enoch has having faces that shone like the Sun. Quetzalcoatl, the Mayan equivalent of Jesus, is described as a plumed bright bird that came from the East, working miracles. In Indian myth, 'Garuda' is another bird god that Vishnu rides to battle with the Naga serpent gods. And the serpent and the eagle are two classic symbols still used today to depict the opposing forces in nature. From my own research, I feel that many of the bird gods, which eventually became the angels of biblical fame, are both extraterrestrial and interdimensional in origin. The Shining Ones, or 'Watchers', mentioned in texts such as the Book of Noah and the *Egyptian Book of the Dead*, also came to represent the Sun, Moon and Venus in creation stories, as did Seven Macaw, whose visage and beak are said to shine like the Moon.[22]

All over the world, ancient accounts talk of battles between demons and gods, taking place both in heaven (different dimensions) and inside the earth. Archetypes used in films, such as *Star Wars*, illustrate the basic themes found in more ancient stories and legends. In one such legend, the son of King Sargon I (the founder of the Sumerian/Akkadian dynasty 4,000 BC), 'Naram-Sin', also known as 'Manash' or 'Minos' to the Greeks, encounters a whole troop of griffin bird-like creatures. According to the Sumerian texts, several military campaigns, on the orders of the Anunnaki gods, were waged against these bird men. On another occasion, in the legend of Naram-Sin, a host of demons were sent against King Sargon's son, ordered by the god 'Utu', or 'Shamash', who was the brother and twin of the goddess Ishstar/Isis. The stories of battles between reptile/birds and human-looking races can be found in texts such as the *British Edda* and in the Indian epics the *Mahabharata* and the *Ramayana* (600-500 BC).

Legends associated with Charlemagne the Great also tell of battles between knights and griffins, and in a dream Charlemagne once had prior to a battle, he is reported as seeing:

> *Bears and leopards that wished to devour them, serpents, vipers, dragons and demons; there were griffins, more than thirty-thousand of them; there was not a*

single one that did not throw itself onto the Franks. [23]

Reading that text I cannot stop seeing Peter Jackson's cinema rendition of Tolkien's *The Lord of the Rings* (2000-2003) with its allusions to kings and knights (humans) uniting against thousands of reptilian, devil-like Orcs on the battlefields of Middle Earth. In dreams, I have also seen what can only be described as 'hairy humans' going into battle against what look like reptile/bird men. I was amazed to see similar themes portrayed in George Lucas's film *The Revenge of the Sith* (2005), which could also be inspired by ancient accounts. Many fantastic battles between gods and what the Sumerian texts call the 'Sons of the Sun', can be found in the art and texts from all over the ancient world. These god kings, probably carriers of a specific DNA, would also become the primary source for saviour gods and heroes that can also be found in numerous myths and religions. Sargon the first Sumerian King, for example, was given a solar title 'GIN-UKUS', which translates as 'Sun Hawk City'. The same hawk, or sun-hawk symbolism, is found in the Egyptian Son of God, 'Horus' or 'Haru' and is a symbol for this hybrid (the gods) bloodline which also ruled Sumeria. Egypt, Greece, Rome and what we now call Britain also came under the influence of these bloodlines as they expanded. The Heru of the Pygmy people, 'Hul-Kin' of the Indians, 'Helios' of the Greeks and 'Hurki' of the Akkadian/Chaldeans of Mesopotamia probably all came from the same source, or group of deities. So did the Mayan 'Hurakan' of Central America, and the 'Heruka' of Tibet. These two versions of the same figures later evolved into the hero 'Hercules' figure of Greek myth. All of these deities are symbolic of the Sun gods and Bird (hawk) gods that are said to have interbred with humanity and created a hybrid bloodline of rulers. In South America, similar attributes are given to the Aztec god, 'Ehecatl', who wore a beak shaped mask. Also on the *Serpentinite* cylinders of Mesopotamia (2,300 BC), we find the birdman, 'Anzu', being brought before the Anunnaki god, Ea.

Early renaissance painter, Hieronymus Bosch, also captures monstrous creatures, which include birdlike demons, in his masterpiece, *The Garden of Earthly Delights* (1480-90). The first of the Nine Lords of the Night, 'Xiuhtechtli', found in Mesoamerican astro-mythology, is also a bird god. The Sumerian goddess 'Lilith', an anthropomorphic creature, part bird-like demon, part human, represents the more malevolent aspects of the ancient goddess figure. Other names for her are 'She of the Night', and the 'Howler', the creator of demons who would terrify all who entered her lower astral realm. Both Shamash and Ishtar (Lilith), along with their Anunnaki parents, are often depicted with wings (see Figure 90 overleaf). This is an indication of their ability to fly, ascend and descend into different dimensions, and later, became a symbol for many of their bloodline rulers on Earth. The eagle,

Figure 90: Ishtar.

Sumerian reliefs depicting the
winged goddess figure
Isis/Ishtar

hawk, phoenix, angelic hosts and the winged sun disc are just a few of their symbols, still used today on insignia, crests and corporate logos.

ANGELS OR DEVILS?

The popular notion of angels, an image sustained and bolstered by centuries of religious art, is that of fully anthropomorphic, humanlike creatures equipped with wings. In other ancient accounts, many angels carried weapons such as the thunderbolt, or a weapon of light, which could be a laser technology, the type we see in science fiction movies. The Shem-Su-Hor (Viracocha) are also said to have used a light (laser) technology that could reverse the magnetic field and lift huge blocks of stone. If so, this would explain how many mysterious temples and megalithic alignments could have been built in ancient times. In the Sumerian *Epic of Gilgamesh* we also find winged gods carrying deadly 'beams', guarding temples and possessing ability to abduct prehistoric people on earth. I can just imagine it, hundreds of ape-like humans being led away by a police force made up of griffins using a laser weapons or other technology. It's a scene for a science fiction film!

In the religious art of Assyria, and in sculptures of the Aztecs and Mayans of South America, we also find representations of winged creatures, usually flanking stars, trees, or sun discs. As I have already said they were considered lesser gods by the ancients, protectors of the sacred knowledge brought by the gods (possibly extraterrestrials) hundreds of thousands of years ago. The eagle, or sunbird, found in Egyptian mythology is also connected to a winged race of deities, which is probably why numerous native peoples still regard the eagle with high esteem and why it still remains an icon of the USA government. The eagle is actually the phoenix, on one level, which is an important symbol to the ancient brotherhood I've been touching on in this book. The phoenix stands for resurrection and re-birth, and even though I jest about ancient apes having their DNA altered, the whole New World Order (or Great Reset) is about rebirthing the human species, destroying the 'old order' and placing humanity in a global tyrannical 'biometric' cyber-grid structure. A structure designed to make humans serve like robots via a microchip connected to a central artificial intelligence. In the minds of these

Figure 91: Eagle rider?

Sumerian reliefs depicting a Gandalf-style figure riding on the back of the eagle Lord Gwarian.

misguided and highly malevolent hosts, receiving the 'mark' of their god – 'the beast' or the Predator Consciousness, is paramount.

In biblical texts such as Exodus, we are told *He* (God) would carry the Children of Israel *"on wings of eagles"* (19:4). The Hyksos, or shepherd kings of Egypt, which provided the mythical lineage of the biblical Israelites, also used the symbol of the snake and the eagle within their artworks. In the Sumerian legends of 'King Etna' (the shepherd king and consolidator of all countries), he too is carried aloft by an eagle (possibly a space ship) after rescuing Etna from a pit imprisoning him. All of these references allude to rebirth (resurrection) and a force (phoenix) used for both great good, or evil.

Similar themes are also found in the *Mabinogion* of Celtic tradition, much of which inspired J.R.R. Tolkien's depiction of Gandalf escaping on the back of the Eagle-Lord Gwarian in the *The Fellowship of the Ring* (see figure 91). One of the many forms of Jupiter/Zeus (the King of the Gods), is said to be a golden eagle, and Zeus, in the guise of an eagle, abducts the child Ganymede (the cup bearer). Images of the eagle, phoenix and two-headed eagle can be found in Freemasonic regalia, company logos, in churches and on the coats of arms of the ruling families to this day. Interestingly, both Tolkien and C. S. Lewis socialised at a now famous public house in Oxford called the 'Golden Eagle and the Child'. I have also seen a statue of an eagle wrestling with the child Ganymede outside what looks like a crypt, on the estate of the Duke of Westminster in Cheshire, UK. I think that there is more than meets the eye in relation to bird-gods, dragons, the royal bloodlines and the secret societies that were set up by these bloodlines to hide their connection to the off-world forces and strange hybrid creatures recorded in art and myths the world over.

SHAMANS, STAR PEOPLE AND SHAPE-SHIFTERS

According to indigenous people's traditions, birds, reptiles and amphibious creatures are all said to have played a major part in the evolution of our human species. Native elders talk of the ability to shape-shift (common to shamanistic clans), coming from a genetic mix of human and star god, especially when one genetic code overrides the other. While performing certain rituals shamans, or initiates, had a reputation of being able to shape-shift into

people, animals or 'creatures' because of the kinship through their original genetic codes.

In Indian mythology, the ancient supernatural serpent beings, the Nagas, are said to change shape at will, from human to cobra and back again. Danté, who was from post-Roman aristocracy, in his 13th century work *Inferno*, also refers to serpents that changed back and forth between human and serpent form.[24] In Roman times, for example, it was believed powerful witches could turn themselves into animals, especially wolves. According to the Greek historian Diodorus Siculus (44 BC), the ancient 'Danaan Brotherhood' of initiates and magicians called 'Telchines', on the island of Rhodes, could also shape-shift.[25] Such a process is known as 'lycanthropy' and isn't so crazy as it first sounds. Why? Because according to science, the smallest particles, such as 'waves' and 'strings', are also capable of shape-shifting between 'particle' and 'wave'. There are so many ancient accounts of shape-shifters that to deny the possibility of this phenomenon is basically saying the ancient civilisations were all hallucinating. Some priests, artists and shamans certainly used hallucinogenics, or natural substances like mescaline to break down the barriers between this reality and the next, and much ancient artwork depicts one of the most common images recorded, the bird or reptile-headed humanoid.

As illustrated in this chapter, ancient myths and artworks depicting fabulous beasts, hero gods and supernatural deities go back thousands of years. They speak of a very different ancestry to the one expounded by conventional science and religion. In the next chapter, I want to explore further the themes that relate to what the ancients called the 'ancestors'.

NOTES:

1) Davies, Paul: *Do We Have To Spell It Out. New Scientist,* 7th August 2004, p31

2) Ibid, p31

3) *Life of Paulis, The First Hermit,* Chapter,VIII

4) *John* 14:2

5) Information about the Sumerian Tablets are from the Zecharia Sitchin series of books collectively known as the *Earth Chronicles.* Published by Avon Books.

6) The Hopi also talk of flying ships that could travel great distances in a short space of time. *The Book of the Hopi*

7) *www.briansbetterworld.com* From a paper published by Brian Desborough 21st February 2004

8) Taken from an interview with Credo Mutwa and the *Spectrum Magazine* 30th September 1999. For the full story see: *http://www.metatech.org/credo_mutwa.html*

9) A. and L. Horn, *Humanity's Extraterrestrial Origins,* PO Box 1632, Mount Shasta, California, 1994

10) *http://www.immunotex.com/cgi-bin/banmat3.cgi?ancestor=URLhttp://www.immunotex.com/cgi-bin/banmat3.cgi?ancestor=URL*

11) Ibid

12) Icke, David: *The Biggest Secret,* Bridge of Love Publications, 1999, p39

13) Collins, Andrew: *The Ashes of Angels, the Forbidden legacy Of A Fallen Race.* Signet Books, London, 1997 p268

14) *http://www.equilibra.uk.com/illusion.shtml*

15) Matthew 23 (12-39)

16) Hancock, Graham & Faiia, Santha: *Heaven's Mirror, Quest for the Lost Civilisation.* Channel 4 Book, 1999, p316

17) Tsarion, Michael: *Atlantis, Alien Visitation & genetic Manipulation,* Angels At Work Publishing, p 26

18) Sitchin, Zecharia: *Divine Encounters,* p276

19) Swerdlow, Stewart: *True Blood, Blue Blood,* p128

20) Pennick, Nigel: *The Subterranean Kingdom,* Turnstone Press Ltd, p81

21) *Mythology,* Duncan Baird Publishing, p522

22) Ibid, p304

23) Ibid, p340

24) Danté 51, *Inferno*: *The Six Footed Serpent Attacking Angolo Brunelleschi*

25) Pinkham, Mark Amaru: *The Return Of The Serpents Of Wisdom,* Adventures Unlimited, p41

Ancient Superhero Gods

Legends of the Ancestors

You'll find that many of the truths we cling to
depend greatly on our own point of view
Obi Wan Kenobi (*Star Wars*)

Themes found in comic books, graphic novels and film over the past seventy years can be traced back to the myths and legends of the ancient world. One common theme being the battle between a 'monster' and a 'hero', which often relates to an ancient fight between a serpent and a sun god in world mythology.

The most well known legends are those of 'Saint George and the Dragon', 'Indra and the Vritra', 'Apollo and the Python', 'Jehovah and the Leviathan', along with many other opposing pairs. Among the serpent-destroyers are also 'Saint Clement', the vanquisher of the 'Dragon of Metz'; 'Saint Marcel', the 'deliverer of Paris' from the monster; and 'Saint Romain', whose exploits are immortalized over the 'Gargouille (gargoyle) of Rouen', not to speak of German, Spanish, Russian, and other Saint Michael-like figures. In all these basic myths, good pulverises evil. Or does it? The stories of ancient battles between the forces of nature and the Pagan gods they represented served the Christian church well. Especially when it came to reinventing old beliefs and declaring a triumphant saviour had removed the evil Pagan gods.

In Scandinavian myth, Thor is said to go fishing for 'Vritra', a great serpent which lies at the source of major rivers. The Sumerian epic of Gilgamesh also depicts him struggling with a serpent at sea, while being pursued by the angel of death. In many ancient cultures there are dragon myths which record a sky god defeating an Earth-threatening monster and making the world a safer place for mankind. This underlying concept is actually evident in the poetic kennings employed in the 13th century texts called the *Edda*, which reveal in great detail the tussles between opposing forces. All of these battle images are symbolic representations of ancient

dual forces, often from subconsciousness levels, and possibly linked to the dualistic nature of our minds. Others could be direct references to actual battles between extraterrestrial races, possibly still opposing each other in the 'unseen' as I write this chapter! Many comic book heroes, from 'Thor' to 'Spiderman', for example, are actually based on mythological feuds between cosmic forces.

GEORGE AND THE DRAGON

George and the Dragon legends, along with religious stories of Saint Michael battling it out with the devil have also found their way into modern films and books. In *Star Wars Episode One: The Phantom Menace* (1999) we find the Jesus-like Jedi knight, Qui-Gon-Jinn fighting the devil-like Darth Maul on the desert planet of Tatooine, or Obi Wan Kenobi fighting Darth Vader (in *Episode Four*). The Jedi seem to be based on the Djedhi, an actual brotherhood in ancient Egypt, associated with the Brotherhood of the Snake and their use of sun and serpent symbolism. 'Sky-walkers' are also found amongst the myths and beliefs of India and South America; these deities, like the family of the same name in the *Star Wars* films, are said to have special wisdom and magical, Jedi-like powers.

The George and the Dragon legend tells of a Sumerian-Macedonian god-king, 'Miok', the first king of the Sumer Empire. Throughout the history of art, George and the Dragon legends are probably one of the most coveted subjects. John Ruskin, the legendary art buyer and artist, went as far as founding the Guild of Saint George in the 19th century. This Guild, like all others throughout history, is linked to ancient secret society networks I've explored throughout this book (if not through use of symbolism alone). Both George and the Dragon are Freemasonic symbols, hence why they are recurring subjects for some of the greatest artists, from Leonardo da Vinci to the 20th century Expressionist painters of Europe.

Expressionist artist, Paul Klee, is one of many artists during the Second World War who had to flee Nazi Germany due to his 'radical' artistic tendencies. How many artists today are willing to say something controversial about the now-obvious growing global fascist mentality expressed through globalisation, war, and restrictions placed on us during the COVID pandemic? Where are the Blakes, Dalis, and Joseph Beuys of today? Any artist today with the guts to express metaphysical truths in relation to conspiracy, injustice and the nature of reality, will likely find themselves marginalised, just as Blake was three hundred years ago!

In truth, the driving force behind warmongering families, corrupt politicians and extreme wealth in the hands of the few, while poverty and famine are the lot of the masses, relates to the lack of individual creative power being exercised by society at large. Our individuality *is* our sovereignty. George

and the Dragon, good-guy and bad-guy archetypes, are tools of the Myth Makers mentioned in the last part of the book, and they have played the same script out on different audiences in different epochs. We have become so accustomed to the hero figure and the monster being at odds with each other that we have forgotten how to see both archetypes as a projection of the same mentality.

THE CULT OF THE BULL

The Phoenicians seem to have got everywhere in the ancient world but are hardly talked about by mainstream history. Their artefacts, beliefs and language are found in cultures as far apart as India and the South Western States of North America. The Phoenicians were an advanced seafaring culture, who along with their collection of gods and goddesses, related to a more ancient era, a period when their ancestors, possibly the Shem-Su-Hor, came to earth! Some scholars say it was in the Age of Taurus (around 3,000 BC) when the Phoenician priesthood spread their art and cultural beliefs across Europe and the Americas. Many Egyptian and Phoenician artefacts have turned up in North America. Viracocha gods, depicted on ancient Olmec art, most certainly resemble bearded Caucasian priests not supposed to have arrived in the Americas until the time of Cortez and Columbus in the 15th century.

 Much global bull symbolism relates to the celestial Age of Taurus, which ceased roughly 5,000 years ago. It was a time when the earth was recovering from a previous global cataclysm as recorded in numerous ancient accounts. Advanced civilisations, especially in the Near and Middle East, venerated the cow, bull, or lion, and certain kings were depicted as having half-bull, half human features. From the City of Ur (2,000 BC), in what is now Iraq, copper statues have been found that depict the Sumerian Goddess, Lamma, as a bull goddess in art and sculpture she is related to the term 'lamassu', which seems to refer to the colossal statues of winged human-headed bulls and lions that guarded the gateways of Assyrian palaces and temples. Lion-humanoid figures also seem to be associated with the ancient priesthoods of the Near and Middle East, and my own feeling is that these hybrid creatures relate to higher levels of human consciousness. Both the bull and the lion could have been a hidden code for the horned-serpent, griffin-like, basilisk god found in mythology the world over. The Balroc creature in Tolkien's *The Lord of the Rings* is similar to these mythological beasts. Fire-breathing bulls also appear in the classic Greek myth, Jason and the Argonauts.[1]

 I feel that what we call Atlantis (in its end times) was focused on Sun worship and the 'Cult of the Bull' (see Figure 92). The demise of Atlantis would have occurred at the beginning of the Age of Taurus (around 6,000 years ago) when the earth went through a series of cataclysmic events. The priesthoods

Figure 92: Worshipping the bull.
Bronze Age rock art from Cutal Hüyük in Turkey. A civilisation that flourished at a
high altitude, possibly due to catastrophic flooding.

that continued to carry knowledge of Atlantis, and records of their genealogy
in relation to the gods, then emerged as the ruling élite of the Age of Taurus.
Bull worship became a focus for the ancients and today in Spain this ancient
ceremony remains (to a lesser degree) in its modern form.

According to author Gene Matlock, through his translations of the Sanskrit
language, the Pani-Hopi tribes, helped by Indo-Phoenicians, migrated to the
Gulf of Mexico, quite possibly then an Atlantean state. Some of the 'Pani'
tribes are also said to have migrated to the Great Plains (Nebraska/Dakota)
to become the buffalo-worshipping Pawnee. In his book, *The Last Atlantis
Book You'll Ever Read* (2001), Matlock explains the Uto-Aztecan word for buf-
falo was 'bisonte' (bison), and Aztec and Hindu words like 'pishan', relate to
the sacred cow, or buffalo. The worshipping of the sacred bull, cow, or buffa-
lo seemed to be a global religion stemming from an earlier civilisation.

The Hittite civilisation of Bronze Age Turkey, like the advanced Sumerian
civilisation, featured the god hero 'Atlas', also with a bull's head. Even the
Hindu God 'Shiva' is depicted as a bull, as were the main goddesses of
Sumeria and Egypt. Ishtar, Ashtoreth (Assyrian) and Hathor (Egyptian), are
the same deity and all three are found depicted as sacred cows in ancient art
and sculpture. Similar themes of bull and cow worship can be likened to the
ancient 'Unktehi' of Sioux legend (a sea-cow creature) and the Minotaur of
Greek Minoan legend. The cow is also a depiction applied to the Greek god-
dess Aphrodite and also to the Phoenician goddess, Ashtoreth/Asherah
(whose name means "she who walks in the sea"). The latter relates to the
Atlanean religion associated with the Sirian 'Nomo' and the God 'Poseidon'.
In classical art, Zeus, father of the Greek gods, is also depicted with a bull's
head on a human body.

In myths and legends all over the world, the bull god fights, or does battle
with, a superhero, or god-like figure. According to Native American myth, a

big water monster, Unktehi, was said to be at war with the Great Thunderbird, while the Minotaur in Greek myth fights 'Theseus', a hero who later becomes king of Athens. Again, these tales relate to both the transition of astrological ages and the tussle between factions of the brotherhoods that emerged in ancient times. Similar themes of opposing heroes, quite often one having horns, or taking the form of a serpent, seems to relate to an expansive religion revolving around specific hero-gods and sun worship across the ancient world.

The Cult of the Bull is also found in symbolism connected to the temple guilds from the 10th century on, especially amongst the labourers and stone-masons connected to the Knights Templar and later Freemasons. Again, this connection goes back to Egypt and the importance of the bull as a god of agriculture, prosperity and providence. No temple structure, ploughed field or festival could occur without the presence of the ox and the bull in ancient times. In ancient Egypt, the God Khnum (a ram-headed deity), along with 'Sati', 'Anukis' and Hathor had cults and many followers. Anukis was considered a potter who shaped men in the likeness of the gods. In even earlier cultures, from migrating nomads of Siberia, to the advanced cities of Sumer, the horned animal-god played a vital role in the survival of our ancient ancestors.

The Egyptian Sky Goddess, Nut, was also depicted as a cow with a star-spangled banner. In biblical terms, the bull or ox becomes a symbol for Luke, one of the four gospel writers, stemming from much earlier symbolism relating to the precession of the ages, which is marked by the four major constellations of Scorpio (the eagle) – 17,280 to 15,120 BC; Leo (the lion) – 10,800 to 8,640 BC; Taurus (the bull) – 4,320 to 2160 BC; and Aquarius (the man) – 2012-13 onwards.

THE HORNED CLANS

The Sumerians also worshipped Hathor (the sacred cow of the Egyptians), who was considered both mother and daughter of the Sun god, 'Ra', illustrated in the *Egyptian Book of the Dead*. She was also known as the 'Evening Star' and can be seen flanked by sphinxes in Egyptian art and sculpture. Hathor, shown wearing a crown with the horns of a cow surrounded by a sun disc, is, according to Phoenician myth, the wife of Baal (another Jesus figure). She rescues Baal's body after he is killed by 'Mot', the God of Death. The same symbolic themes are found in the story of Osiris's death at the hand of Seth, and Isis's attempt to retrieve Osiris's body.

There are many ancient records of a mysterious race of beings associated with, what the Hopi elders call, the Two-Horned clans. I cover this subject in great detail in *Orion's Door* as it is a major focus connected to Orion. Here I offer a summary of the symbolism. At Mesa Verde in Arizona there are

Bronze Age depictions of the Horned Clans which look almost like linear interpretations of the gargoyle, or stygra-type creatures found on later Gothic cathedrals. In Hopi history, these clans, (along with the Unicorn One Horned Clan, and Bow Clans), perform the oldest and most significant ceremonies of the year. I've even seen unicorns depicted on gothic cathedrals in Spain and France and there's me thinking such animals were part of a Pagan belief system! In fact, the Latin word for *bow* is 'apis', a word naming the sacred bull of Egypt.[2]

The worship of Unktehi, through to later buffalo reverence by the plains tribes, is an example of the importance of the Two Horned Clan. The veneration of bulls, rams, goats, unicorns and the God Pan (or Min in Egypt) is all connected to this clan. So was the 'Gonggong' of Chinese legend, a horned monster with the body of a serpent. Gonggong was considered the leader of this clan, which included the Nommo amphibious creatures of African Dogon legend, said to be semi-demon deities, half-human, half-amphibious animals endowed with reason.[3] Christian belief in the devil could also have originated from this ancient clan. Much modern art and film continues this legacy in Ridley Scott's film *The Legend* (1985), also using similar imagery of a horned Lord-of-the-Darkness figure. So does Walt Disney's animated film *Fantasia* (1940), which depicts a monstrous horned deity who controls the 'forces of night' and the living dead. The image of the Egyptian God of the Underworld, 'Osiris', is sometimes shown to have large horns (see Figure 93) and in my book *Orion's Door*, I explain how the 'Migra' the deer star and Orion as the horned (Herne) hunter are all connected. Other films and television series such as *Angel* (1999-2004), and *Buffy the Vampire Slayer* (1997-2003) also depict horned, malevolent inter-dimensional creatures that can appear and disappear in this reality. William Blake also depicted these figures within his visionary art, especially in his prophetic works *America a Prophecy* (1793) and *Europe a Prophecy* (1794).

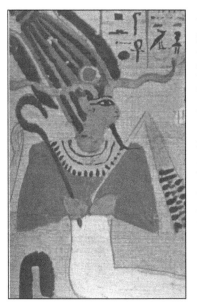

Figure 93: Horned Osiris.
A papyras showing the Egyptian God of the Underworld with horns.

Masonic lodges, emerging from the mystery schools of ancient Sumeria, Egypt and Babylon, used the horned god symbol on their regalia. The earliest depiction of the horned god, priest or shaman can be seen in 15,000 year-old cave drawings of the

Wizard of Les Trois Fréres in Ariége, France; and also in La Pelta, Spain, we find the 'Stag Man', an image that became the universal shaman.

The horns or antlers in most cases relate to power and the use of magic. In alchemy the horns, or rays (if there are more than two), are references to philosophical 'Dew' - an hermetic alchemical substance said to emanate from the 'centre' of the galaxy and transmitted *through* the sun. The moon is another symbol of the hunter and, along with the pentagram, are also codes connected to the horned gods. The *reversed* pentagram and swastika symbol, including certain hand signs, like the 'Il Cornuto' sign associated with satanism (page 224), relate to black magic and 'horned' interdimensional creatures summoned in ceremonies.

In Lyon, France, I found an interesting shield dating back to the 18th century, which clearly depicts the horned god, Baal or Bel (see Figure 94). Baal was worshipped by an élite priesthood during the time of 'Berosus of Babylon' and is a major deity still worshipped by the brotherhood today! The street (where I photographed this shield) is littered with Masonic lodges on the surface, while below street level run several levels of catacombs where (as locals told me) Masonic rituals are still carried out to this day. The biblical Moses is sometimes depicted with horns in religious iconography due to the

Figure 94: Horned god Baal.
A French Freemasonic shield showing the horned god.

translation by St. Jerome in the 4th-century *Vulgate*. The most famous example is the statue of Moses by Michelangelo showing him with horns. Historians say it was a mistake, but it confirms Michelangelo's level of occult knowledge at that time. In an unknown painting discovered in a wooden drawer at the Earls D'Oltremond home in Belgium, Moses is shown with horns 'receiving the law' from what looks like a group of UFOs.[4] Were historical figures like Moses in touch with strange beings from another dimension? Was Moses a horned mythological creature himself? Whatever Moses was, the mystery schools and priesthoods understood the deeper codes and symbols explaining multidimensional aspects behind reality and how stellar forces influence our planet, still today.

PEOPLE OF THE POLAR BEAR CLAN

Migration, for our Neolithic ancestors, was an important aspect of life. It was

undertaken for many physical and spiritual reasons and it's the 'spiritual' reasons that are often overlooked by today's experts.

Bands of migrating people, led by sky-watchers or shamans, worshipped and followed the path of the stars. They also followed the gods of Earth, which were often animals depicted as human-animal hybrids. At this time, the North Celestial Pole, which was believed to be the highest god (at the centre of existence for our ancient ancestors), became a guiding light for people of the northern hemisphere. The further south people travelled, the further north the celestial pole descended and lost prominence on the horizon; therefore, other gods with different attributes were revered in more southern regions. From my own research, I feel the concept of a polar god, found amongst people of the Upper Palaeolithic era (40,000 BC), related directly to migration myths, their cave art, and the ceremonies relating to *journeying* into what the shamanistic cultures called the 'cosmic centre' – the heart of our Galaxy.

The Pole Star gave our ancestors a fix on their location in relation to 'cosmic time', especially during and after major cataclysmic events on earth. The constellations holding 'pole position' obviously changed due to the natural cycles and the precession of the earth in relation to the sun. For example, the Draconis constellation was our Pole Star 4,600 years ago, currently it is Polaris.[5] Draconis is where we get links to mythological dragons, Dracula and reptile deities found in myths and legends all over the world. Whatever constellation or star was prominent at the pole provided both physical and spiritual orientation for our ancestors.

Southward migrations, bringing new discoveries, encounters with strange beings and more light, eventually changed people's perception of the great polar deity. I feel certain the Native American deity, Kokopelli (also known as 'Maui' to the Polynesians) was a solar deity (a stellar tribal leader) for migrating people as they went south from Hyperborea (Shamballa) in the ancient world.

Figure 95: Ursa Major - the Great Bear.
The Plough, or Great Bear, a possible source for an ancient Hyperborean Age. (© Neil Hague)

Certain animals were connected to the stars and the 'Big Dipper' or 'Great Bear' (see figure 95) was a prominent North Celestial Pole constellation, therefore it would seem plausible to suggest our Neolithic ancestors revered animals, like the bear, as a polar deity, along with its usual physical attributes. For example, many Native

American tribes regarded the bear as a powerful female deity, one that signified medicine and leadership.[6] Many chants and ceremonies were performed to engage different guardians, or goddesses, associated with the Bear. Both the bear and the bull (cow) are considered aspects of an ancient goddess as I've already mentioned. The ancients gave the bear goddess names, such as 'Astarte', 'I-Nan' or 'Ishtar'. The Greeks referred to her as 'Artemis'. Could she have been an alien hybrid creature revered by Neanderthal people? In Sumerian texts she is known as the goddess 'Innana' and in Mexico as 'Innan' or 'No-Nan-tsin', which in the Sanskrit language means 'wise mother goddess'[7] connected to the Underworld as symbolised by the cave.

In the Upper Palaeolithic period of what is now Europe, many caves have been found containing bear skulls, placed in what seems to be an exact and deliberate manner. The 32,000 to 30,000 year-old Chauvet cave, at Vallon-Pont-d'Arc (discovered in 1994) in the Ardéche region of France, is a perfect example. In much folklore from all around the world, the bear plays a significant role as a dark, hidden terror lurking in the ancient forests and groves. For the Hopi, the Bear Clan was one of the original tribes which migrated back to their spiritual centre in Arizona in the USA. The mark of the beast in Revelation, linked by researchers to the 'mark of the bear' found amongst the petroglyphs and prophecies of the Hopi. In fact the mark of the Beast and the Bear's paw scratched in stone have been compared to the bar code number 666. The mark of the beast, as mentioned earlier in the book, is connected to the microchipping of people and is happening in our present time.

In almost all indigenous cultures, shamans were said to be able to turn into animals, this was believed to be possible due to the unique kinship (being anthropomorphic) of their DNA that connected them to many original, some extraterrestrial, species of planet earth. It is also believed that shamans are relations to star people; the bear especially, is considered of an ancient 'clan' from a time when humans and animal-human hybrids (or those more 'animal-like') walked the earth. The Athabascan Native American tribe, the 'Sinkoyne' (of the Athabascan-speaking peoples of northern California), according to folklorist E. W. Gifford, writing in a 1937 article in *The Journal of American Folklore*, mentions tales of bear-like men. The story of Beowulf in Anglo Saxon folklore also tells of a bear-man hero, as does the story of 'Grendel' in Scandinavian myth. In more contemporary terms, 'Wojtek' the Second World War 'soldier bear' and *Paddington Bear* are more examples of our connection to human-bear characters.

The English Hero Beowulf, whose name means 'bee-wolf' (honey eater) relates to the Merovingian bloodlines and tales associated with a descent into the Underworld to do battle with a dragon.[8] In an intriguing book called *Blue Blood, True Blood* (2000), author Stewart Swerdlow lists at least *twelve* different alien species that have had a massive impact on the evolution of this planet

and our DNA. One species in particular, he calls the Bear, or the Bigfoot clan.

BEAR BUTTE

The Bear's Lodge, or 'Mathó Thípila' situated in Wyoming, USA (known locally as Bear Lodge Butte, or Devil's Tower) is a place connected to Native bear myths. I visited the place in 2010, a fantastic part of the world, along with the Black Hills of South Dakota which are located near Bear lodge (see figure 96). The whole landscape is considered sacred to Native American Indian tribes, not least tribes like the Lakota. Bear Lodge Butte is also the backdrop and landing base used for aliens in Steven Spielberg's film, *Close*

Encounters of the Third Kind (1977). According to Native American myth, the legends of Bear Lodge Butte (or "Tso' Ai'," some people call it today) describe the creation of the Butte by the claws of a giant bear that supposedly scratched at the 'giant' rock (or tree trunk?!)

Figure 96: Bear Lodge Butte.
The author at Bear Lodge Butte. An ancient landscape involving legends of bear people and the stars.

as it 'grew skywards' to the stars. Giant tree or not, what is more interesting to me is the notion of humans becoming stars, or did the *stars become humanity*?

In Kiowa legends of Wyoming and South Dakota, Bear Lodge Butte was where many bear people lived. One Kiowa legend describes how seven young girls from the Kiowa camp were out gathering berries far from the campsite, when two bears attacked them. The girls ran out across open prairie until they came to a large, grey rock. Climbing onto the rock, the bears began to climb in pursuit of the Kiowa girls. According to the legend, the bears tried to climb the rock as it grew steeper and higher, but their huge claws only split the rock face into thousands of strips as the rock grew upwards out of their reach. The hewn rock, cut and scarred on all sides as the bears fought to climb. Legend says the bears relinquished the hunt, and as they turned to their own lodge they slowly resumed their original sizes. But for the seven young girls escaping the bears they were lifted up so high they eventually turned into seven stars – the Pleiades. In other legends, they became the seven stars of the Great Bear, Ursa Major. The story, of course, is an elaborate narrative which could be pure 'imagination', but nonetheless, Bear Lodge Butte is an ancient landmark belonging to a prehistoric era.

The bear also became a symbol for the setting sun, evening and the com-

ing of winter, a time when the bear enters the cave to hibernate. Tribal songs, such as the '*Bear Mountain Chant*', or *Anishinaabe Spirit Bear Song* (sung by Navajo shaman), are sung to welcome winter and the hibernation period on earth. In Europe, there are also annual winter bear festivals that take place in various towns and communes in the Pyrenees. The Basque region of France is a huge area for bear worship, and in Prats-de-Mollo, during the Fête de l'Ours (the festival of the bear), held on Candlemas (February 2), men dress up as bears brandishing sticks to 'terrorize' people in the streets. Formerly, the festival focused on bears feigning attacks on the townswomen and trying to blacken their breasts (with soot), scandalous to first-time outside observers. King Charles VI of France and five other nobles are documented as dressing as 'wild men' (or bears) for a court festival in suits covered in pitch and flax; when a flame was brought too close to the group, it is said that four of the five were burnt to death, and only the King survived. As we shall see, certain royalty (part-stellar bloodlines who have run the world since antiquity) have either a fascination for, or are related to, bear-like, or 'hairy' forest dwelling creatures.

The Ainu people of Siberia, including the northern islands of Japan, all worship the bear for its wisdom and knowledge. The Ainu belong to an ancient shamanistic tribe that are not Japanese by race but have fair skin, blue eyes and are exceptionally hairy. It has been suggested their culture is at least 10,000 years old and their religion dominated by a fire goddess, a symbol often associated with Atlantis. As with many other animal goddesses, the bear is a 'bringer of fire', a master and keeper of secrets, coming down from the mountains to teach the people.[9] In the legend of Masha and the Bear, in Russian Folklore (probably the inspiration for *Goldilocks and the Three Bears*), we find common themes hinting at a race of 'bear people' who once roamed the earth many thousands of years ago. Yet, these bear folk don't seem to have been the only anthropomorphic bipeds to emerge in the distant past. In recent years, conventional science recognises the Permian geologic period, roughly *290 - 250 millio*n years ago, some animals were in the process of evolving into mammals and were therefore evolutionarily extremely sophisticated. One in particular called a Lystrosaurus, is said to have been an herbivore and is believed to be the ancestor of every mammal now on earth. In a BBC *Horizon* programme, *The Day the Earth Nearly Died (2002)*, the documentary points out how the extinction of mammal-like creatures, (animal people) cleared the way for the early reptilian dinosaurs, and how the extinction of the dinosaurs cleared the way for mammals. If this is true, then evolution is not a smooth process of advance but is marked by steps and even reverses. Interestingly, on a cuneiform seal dated 4,000 BC found in Iran and now in the Louvre, Paris, we see a biped creature that does not represent a typical human. Also in places such as Siberia and Syria, many strange fig-

urines have been found that do not carry any likeness to humans. However, twelve inch statues of lion-headed figures found in Germany and France could be artistic *memories* of a prehistoric age where master geneticists created hybrid creatures entwining our DNA with that of animals. The themes found in H. G. Wells' book *The Island of Dr Moreau* (1896) and in films such as *Planet of the Apes* (1963) hint at another history, one that is found in the oral traditions of many of earth's indigenous tribes. I think there is more to know regarding the Permian world and the fantastic creatures that inhabited it – the truth may be stranger than science fiction?!

THE BIGFOOT MYSTERY

The American Bigfoot, also known as Sasquatch in western Canada, has affinities to giant, hairy ape, or bearlike, hominids. Bigfoot and its like have been reported from the western mountains of Central and South America, across North America and, believe it or not, in the UK. These creatures have also been sighted in the forested areas of China, Tibet and Indochina. It's a fact that the cultural histories of many Native American and First Nation peoples include stories and beliefs about 'non-human peoples' of the wild. Many of these descriptions bear a striking resemblance to the hairy human-like creatures and strangely there is also a connection to UFO sightings around Bigfoot. With over 550 sightings a year in North America alone (at the time of writing), it's estimated there is a population of at least 1,500 to 2,000 Bigfoot in the Pacific Northwest alone.[10]

The possibility of a prehistoric species still surviving is not so difficult to comprehend, especially when other species have been discovered since the 1950s. One case in particular was when USA federal wildlife officers, flying over a remote part of Wood Buffalo National Park, Alberta, spotted a small isolated herd of 200 wood bison, thought to be extinct! On inspecting these animals it was found that they were the last remaining *pure* wood bison, an enormous Ice Age species not known to exist in pure strain anywhere else in the world.[11]

Indian folklore and myth are littered with stories of hairy giants that lived in the northern forests of the east and west coast of America. I go into more detail about the Age of Giants in *Orion's Door*, but suffice to say, the giants, Bigfoot and other ancient phenomena are all connected. Local Native American, Native Canadian and Inuit accounts also discuss ancient traditions of these hairy, human-like beings. To the Eastern tribes, they are called the 'Windigo' and in upper midwestern parts of the United States these creatures are named 'Wendigo'. Further east, for the Micmac tribes, they were named Gugwe or 'Koakwe', a hairy giant that looks similar to a baboon. The iroquois of the upper New York State also tell of similar beings in their folklore and, according to the Iroquois, are known as 'Stone Giants', or to the

Inuit as 'Tornit'. This is because both are said to be able to lift huge stones and uproot small trees. In North Carolina the natives call this creature the 'Chikly Cudley' (pronounced: ke-cleah kud-leah) which in Cherokee means *hairy thing*.

While Indian folklore records the existence of Bigfoot, the first Europeans that came to the Americas also reported strange giants and hairy creatures. In 986 AD Leiv Eiriksson writes of encountering monsters that were ugly, hairy and swarthy with great black eyes. Other records tell of explorers, such as Samuel de Champlain, being warned by the natives of Eastern Canada of the 'Gougou', a giant hairy man or woman. The Bigfoot phenomena continues to this day, especially with sightings in both the USA and China. As the state-run Xinhua News Agency reported:

> *In Beijing, China on Sunday 12th October 2003, Chinese authorities started investigating several apparent sightings of a legendary 'ape-like' beast at a nature reserve in the central Hubei province. This mythical creature, suspected by locals to be a 'Bigfoot', was apparently seen by six people, including a journalist in the Shennongjia Nature reserve on the Sunday afternoon.*

So what are we dealing with here? Zoologists and scientists who are open-minded about the Bigfoot phenomenon would suggest that we could be 'seeing' ancient creatures that have survived into the 21st century. I am more inclined to think that Bigfoot, along with many other similar phenomena, relates to seeing manifestations of our ancient animal-human inter-dimensional selves that are stored in the memory of our DNA. As I will come to in the next part of this book, the notion of a multi-dimensional Universe housing parallel worlds (both ancient and futuristic) offers major insight into such mysteries as Bigfoot.

HYKSOS AND ORMUS

The Merovingians are Sicambrian, or Frankish kings, who ruled large portions of what are now France and Germany between the fifth and seventh centuries. The period of their rise corresponds to the time frame of the King Arthur figure, though the stories of Arthur didn't become widespread until several centuries later. As with King Arthur, from whom some writers suggest the Merovingian dynasty derives its name, his historical reality is obscured by legend. However, Arthur can be connected to a 'mother goddess religion' spreading into France before the rise of the Merovingians. Black Madonna effigies found all over Europe (especially France) are remnants of pagan goddess worship connected to Isis, Artemis, 'Artio', Mary and Demeter (see figure 97). According to author and mythologist Joseph

Figure 97: Ormus (She-Bear).
Mary (the She-Bear woman),
along with wild man such as St.
Onophrius, is found in the 14th-
century *Book of Hours*.

Campbell, Artio's roots lie with ancient bear cults. Campbell also connects Artio, the she-bear to the constellations of Ursa Major and Minor – the Great Bear and the Little Bear.[12]

Merovee (or Merovech or Meroveus), like Jesus and the Hyksos shepherd king, Moses, all have a supernatural origin. The Merovingians' long hair distinguished them among the Franks, who cut their hair short. The Merovingians are also known as the 'long-haired kings', with Clovis I, the first king of the Franks who united all Frankish tribes under one ruler. Another important attribute of the Hyksos Shepherd Kings (who were also high priests) and later Merovingian rulers, was that they *all* claimed descent from the Watchers, or Shining Ones I mentioned in earlier chapters.

According to authors Michael Baigent, Richard Leigh and Henry Lincoln, in their book *The Holy Blood and the Holy Grail* (1982), the Prieuré de Sion adopted another name in 1188. It became known to its members as 'Ormus' and its symbol was an acrostic combining 'Ours' (meaning bear in French) and 'Ursus' in Latin, all surrounded by the letter 'M'.[13] The 'M' symbol is also found in the astrological sign for Virgo - the virgin goddess. It is worth noting that the bear was used as a symbol of Arcadia (an ancient epoch) relating to the animal-gods. The very name 'Arcadia' derives from the Greek 'Arkaden', meaning 'people of the bear'. It is this type of symbolism, used by the temple orders, that would eventually find its way into the symbolism of Christian Gothic cathedrals, designed by the same temple orders.

The story of King Ursus (Sigisbert VI), known as 'Prince Ursus' (or the 'Bear Prince'), between 877AD and 879AD, is another example of the alleged true, hairy royal lineage in Europe (see figure 98 overleaf). It's said King Ursus led a revolt against Louis II of France in an attempt to re-establish the Merovingian dynasty. The revolt failed and Prince Ursus and his supporters were defeated in a battle near Piontiers in 881AD. The same prince/king appeared on a mural above the font in Wrexham Cathedral in North Wales, and it seems to me, that the hairy human (or Woodwose) is possibly the original bloodline of kings on the British Isles, not least through King Arthur. The bear and hairy men often depicted in art, are symbols for the 'Children of Hermes', the original magicians and angelic humans. A house in Thiers (Puy-de-Dôme), France, shows an effigy of a

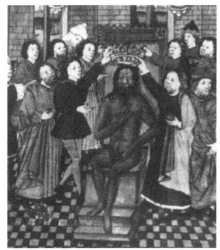

Figure 99: Orion Man of the Woods.
(Left) Man of the Woods at Thiers, Puy-de-Dôme. The Fool's head on the staff is a symbol of Kesil (Orion). **(Right)** The same wild men at Moulin Cathedral, France.
© Neil Hague 2002

Figure 98: The Bear (Bigfoot) Prince.
King Ursus (Sigisbert VI) of Merovingian France.

bear-man (a woodwose) with the head of a Fool on his staff. The 15th century place is called the 'House of the Man of the Woods' (see figure 99). The Fool, of course, is a link to Orion (or Kesil); similar sculptures are found on numerous Christian cathedrals, all of which seem based on the man of the woods – or the children of the bear.

THE 'MONKEY EARTH' GOD

Myths from all over the ancient world tell of the mischievous monkey god, who had amazing powers. In China and India this deity is able to shape-shift, fly through the air and turn into firestorms. In an amazing book called *The Book of the Elders* (1994), produced by Sandy Johnson and Dan Budnik, a photographer friend of mine, the Hopi tell of the return of the earth monkey god at this time of awakening. According to Indian and Dravidian mythology their monkey god, Hanuman, is believed to have been able to stop the wind blowing and in Chinese legend he had supernatural powers (see figure 100). The story of *Monkey* from Arthur Waley's translations of the original myth, also tell of a cloud-riding hero-god that fought demons and helped Vishnu transform the World Ages. The Vietnamese still call this god Lei and according to Native American prophecy, the return of Lei, or Bigfoot, signals the time of cleansing, a paradigm shift, when dimensions merge. Since the late 1980s there has been a growing number of Bigfoot sightings, especially in America, which in my view relates to the merging of different dimensions (realities) as people start to access their inner, 'ancient' eyes. A change in per-

ception relating to such phenomena will become more obvious, especially at this time, as our solar system aligns with the centre of the Milky Way.

Charles Darwin's theories on evolution did much damage to the original knowledge surrounding the monkey species, by inferring that all humans evolved from a less intelligent form of life. The 'monkey people' of the ancient world, according to dreamtime myths, were turned into dolphins, so to survive cataclysmic floods and extreme pole shifts of the ancient world. All these stories hint at various species, such as the monkey earth gods (bigfoot), or a bear race able to shape-

Figure 100: Hanuman.

shift and traverse time! In fact, I feel certain that the reason why creatures such as Bigfoot have never been 'officially' caught is because they are inter-dimensional manifestations that exist in parallel worlds. When the veil between these worlds becomes thin or non-existent, we are able to access such phenomena. We too are time travellers and multidimensional consciousnesses and what we create and think into physical existence, depends on how we use our imagination to 'see' alternative dimensions of reality.

Bigfoot, according to some writers, were/are a genetic mix of the Earth's Neanderthal race and an alien species, created by the 'gods' (plural), the same gods in the Bible that made Cro-Magnon human. The Roger Patterson film taken in 1967, which shows the only ever cinema footage of what is supposed to be a Bigfoot moving through Bluff Creek in California, gives us a feel for what our Neanderthal relations may have looked like in the flesh. Some say the film is a fake, but the fact remains that Bigfoot was and still is a global phenomenon, one that has not been seriously investigated. We don't seem to have a problem accepting the reality of 'human mutants', especially codes within our DNA that cause hypertrichosis lanuginosa (see Figure 101 overleaf).

As mentioned in a previous chapter, Sumerian records also account for Enkidu, the friend and opponent of Gilgamesh, who was a hairy ape-man god. The Enkidu myth tells of him having superhuman strength and living amongst the animals.

BIGFOOT IN EUROPE

Sightings of Bigfoot in Europe have also been recorded since medieval times. These creatures are referred to as 'Woodwose' (Wudwasa) or 'wildmen of the woods' and in France they are called 'Le Feuillou'. The troubadours of 12th-century France and the minnesänger of Germany, (the creators of epics through rhythm and folk songs) record a meeting between a knight and a

hairy giant in the Celtic Arthurian epic *Owen* (pronounced: ee-vine). This story, which includes over 8,000 lines, tells of a knight called Kalogrenant encountering a hairy giant in the wilderness of the Bretagne.[14] The incident was illustrated by Hans Burgkmair (1473-1531) and called the *Fight in the Forest* (see figure 102). The drawing suggests that the giant measures about 7 foot 3 inches in height with a 14 inch foot. Across Europe the wildman enigma became associated with the Green Man and stories of the Woodwose, which are found carved in stone on almost all of Europe's Gothic Cathedrals. In her 1983 book *Wildmen: Yeti, Sasquatch and the Neanderthal Enigma* Myra Shackley asks if these wildmen could still exist. Over two hundred European aristocratic families have had wildmen as heraldic emblems and many more as supporters. Why? Because these blue-blood fam-

Figure 101: Hypertrichosis. Fedor Jeftichew, better known as Jo-Jo the Dog-Faced Boy, from St. Petersburg (1868). Could hypertrichosis be a genetic connection to the bear people? (public domain)

ilies know the hidden meaning behind these emblems. Symbolism, as with much heraldry, relates to the bloodlines that claim allegiance to the gods through their DNA.[15] Wildmen appear again and again in medieval paintings, illuminated manuscripts and as figures, along with an array of mutants often paraded in shows around this time. There are endless accounts of wolfmen or werewolves that feed into this phenomena, too. Apparently on the walls of Castle Ambras near Innsbruck, Austria, alongside a portrait of Vlad the Impaler (Count Dracula), there are portaits of a 'wolf man' (real name Petrus Gonsalvus) and his children.[16] This collection of paintings is called *The Wolfman of Munich*, and depict Gonsalvus, his son and daughter, all with the condition hypertrichosis. The paintings were given to Ferdinand II by the Duke of Bavaria, Wilhelm V. All of these records, from ancient Native American stories of the Windigo (hairy giants), to the

Figure 102: The Fight in the Forest. Hans Burgkmair (1473-1531). © Ailsa Mellon Bruce Fund (public domain)

highly controversial film footage caught by Roger Patterson and Bob Gimlin on October 20th 1967, and genetic traits such as hypertrichosis, leave us with the possibility that an ancestor, like Bigfoot, shares this planet (reality) with us. As the world leading cryptozoologist, Loren Coleman states in his 2003 book *Bigfoot, The True Story of Apes in America*:

> *The truth is that at least one unknown species of primate exists in America. It's a big story and it's not getting the attention it deserves.*[17]

Our junk DNA is a haven for would-be 'alien' life forms and the connection between DNA and the stars, microcosm to macrocosm, is a profound one that I will go into more in the next part of this book.

KOKOPELLI – THE ANT-HILL PRINCE

Other magical godlike figures allegedly coming from the stars are recorded in myths and legends the world over. One such figure, 'Kokopelli', or 'Blue Monkey', seems to have made such an impression on the shamanistic clans and Bronze Age artists that he can be found in rock art from northern India, to the American southwest. This god or 'entity', also known as 'Wood Hump', is said to be the archetypal flute-playing trickster, sometimes depicted as an insect, or mantis.

Kokopelli has been worshipped since at least the time of the ancient Pueblo Peoples and the first known images of him appear on Hohokam pottery dated between 850 - 750 AD. Yet, Bronze age rock art shows he must have been known to the Pueblo thousands of years earlier. Kokopelli may have been initially a representation of ancient Aztec traders, known as Los pochtecas, who travelled to the southwest from Mexico. However, this origin story is still in doubt, since the first known images of Kokopelli pre-date the major era of Aztec-Anasazi trade by several hundred years. Another theory is that Kokopelli is actually an anthropomorphic insect deity whose origins are not of this physical dimension. Many of the earliest depictions of Kokopelli certainly make him very insect-like in appearance. The name Kokopelli is said to be a combination of 'Koko', another Hopi and Zuni deity, and 'pelli', the Hopi and Zuni word for the 'desert robber fly'. The latter is an insect with a prominent proboscis and a rounded back, noted for its zealous, sexual activities.

According to Hopi origin myth, Kokopelli is the 'Khiva (anthill) Prince', who led the Hopi to the earth's surface at the time of their emergence into the Third World (an ancient epoch). The Hopi say they came out of subter-ranean worlds, in the geographic area of the Four Corners, guided by a Khiva Prince (see figure 103 overleaf). When we look at photographs of

Figure 103: Anthill Prince.
(Top) A typical Anthill. (Bottom)
Possible locations for 'Sipapu', or
entrance to the Hopi Underworld near
the bottom of the Canyon of the Little
Colorado, above its junction with the
Colorado River.

desert settlements in the southwestern States of America and in places such as Afghanistan, it is easy to see the visual connection between the ant-like underground homes and the indigenous people's cave dwellings in these locations.

Gene Matlock's book, *The Last Atlantis Book You'll Ever Read* (2001), connects the Hopi with the 'Khopis' and 'L'Hopitai' tribes of now Afghanistan and Uzbekistan. According to Matlock, the Hopi were led out of northern India in two groups (in the ancient world), one going into Greece and the other to America. The Hopi say their ancestors, the 'Khivites', were subject to a small kingdom named 'Muski'. In the same area where Khiva, Uzbekistan is today, there is a small kingdom of non-Hindu tribes called 'Musika', or Muski. These people are said to have bitterly opposed the Brahmin priests' attempts to force them to hand over their lands and become part of the caste system (the same story the world over – see the Native Americans and the Cathars in France). The Hopi origin story even goes as far as stating that the Hopi killed two sacred 'Mahus', which the Hopi say were 'horned beings', to keep them warm on their migration. However, Matlock translates, Mahus, as being a sacred 'cow' or 'bull', and he even goes as far as suggesting the Hopi were forced to leave Northern India for killing the sacred cows of the Hindu. Matlock says of the Muski religious leaders:

> *According to the Hopis, the priests and leaders of the Muski began to persecute their forefathers, even ravishing their wives and daughters. They then asked their chief, called Yai-owa, to ask even a greater leader, Maasawa, to help them leave Sivapuni. By some strange coincidence, it just so happened in ancient Northern India, the compound word Ja-ovaha meant 'chief, overseer, caretaker'. Maha-Ishvara meant 'Great Lord, King God Shiva.*[18]

As I showed in earlier chapters, Both Masau'u (Maasawa) and Kokopelli can be found etched together in Bronze Age rock art across the South Western States of America and both archetypes are said to be two aspects of the same

'supreme being'. Kokopelli, also known as 'Cotton Tail' in his winter disguise, can be connected to the mysterious one-eyed 'Kikulupes' (pronounced: keeklopehs) or Cyclopes, which again relates to legends of the Underworld. Edward Pocoke, the 18th-century Greek scholar and Orientalist wrote that the word Cyclopes is a Greek corruption of the name of a pastoral people in India.[17] In an inspired painting I made in 1995, before I knew anything about the hidden multidimensional levels regarding the Kokopelli character, I also placed a cyclops (one-eyed) head garment on my image of Kokopelli.

It seems a strange 'god being', associated with fertility and good fortune, is instrumental to the ancient migrating clans of the Zuni, Hopi and original Afghanistan tribes. Kokopelli is also the pied piper archetype, possibly a god that had shape-shifting abilities? Kokopelli can also be connected to the Indian deity 'Kubera', a hump-backed, dwarf like creature who wears a feather headdress. The Pleiadean symbol for peace, given to the famous contactee, Billy Miers decades ago, is similar in my view to the goggle eyed, plumed headdress imagery of Masau'u and Kokopelli.

Kokopelli is said to be deformed, club-footed and a bit of a rogue and a cheat, with an immense sexual appetite who, rather like Bes in the Egyptian belief, becomes a protector of pregnant women and children. Other stories say that Kokopelli carried a bag of seeds, which he scattered across the path of the sun, and they became the first crops. This story hints at the arrival of non-human gods in an ancient epoch, teaching humanity agriculture and the healing arts. All of the parables relating to sowing and reaping, are references to light and invisible forces that aid creation on both the physical, and non-physical levels.

I feel the stories of Kokopelli relate to the ancient understanding of duality and moving beyond the illusion of death. Kokopelli also has associations with sixth sense related feelings we encounter when we attune to finer vibrations and feelings *beyond* the physical (five sense) world. As I have already shown, Kokopelli is often depicted alongside the mark of the ancient Bear Clan, all of whom followed the passage of the solar lord on their migrations at the beginning of the Bronze Age (5,000 BC). The significance of the bear people and Kokopelli could also relate to Atlantis and the animal people, gods and extraterrestrials that mixed their DNA with that of the human form (see my book *Aeon Rising - Battle for Atlantis Earth*).

As an archetype, Kokopelli is also connected to the rainbow, the sowing of seeds and bringing of solar light to the people of Earth in an ancient epoch of darkness. The San, or Bushmen, call this period 'the time when the Sun lived on Earth' relating to time when humans discovered their creative urge, along with neurological changes in the brain; distinguishing them from other creatures. On another level could it be that the trickster gods were actual extrater-

restrials or part of an interdimensional consciousness aiding humans in their plight across different World Ages?

In African myths of the Kalahari Bushmen, Mantis is another version of Kokopelli, a 'trickster god', who once lived on earth in an ancient epoch. The same is said of 'Maui' in Polynesian myth, all are fertility deities similar to Kokopelli. The Egyptians had a very ancient deity called 'Min' who also carried similar attributes to Kokopelli. The Greeks identified Min with their god, Pan, who always sported an erect penis (a symbol of fertility). This deity was considered the protector of travellers, wore a plumed crown and played the flute. In some accounts, Pan is referred to as 'Asklepios', a figure said to have had the power to reverse death. Legend has it that Zeus (in the form of an eagle) killed Asklepios for raising the dead, a subject I will come back to at the end of the book. Zeus also instructed a Kyklopes (cyclops) to slay Asklepios with a thunderbolt. In Hopi legend Kokopelli is said to have been shot by an eagle (Zeus?) for bringing the first Hopi out of the 'underworld' – or the place of death.

DWARF GODS

Another deity found in the tombs of ancient Egypt is Bes, a dwarf god originally brought to Egypt by the Phoenicians in the Archaic period (850 - 475 BC). He is often shown with a large head, potbelly, and hands on hips (garden gnome style) and with an ostrich feathered head-dress. In Egypt, Bes often appears frontal and squatting. Other depictions show him with a sword and shield (see figure 104). He is often naked, apart from a lion's skin, whose tail is usually visible between his legs. His hands rest on his thighs and his features are normally grotesque, animal-like rather than human; he is usually bearded and has manelike hair.

In ancient Egypt and Greece, Pygmies were said to be a nation of dwarfs, whose name comes from the Greek word 'pygmi', which means cubit or a measure of about 13 inches in height.[20] The Native American tribes also talk of little people in their myths and legends and in Greek myth it is said an army of pygmies fought Hercules and their sworn enemies, the 'Cranes'. Either the Phoenician and Egyptian civilisations had a

Figure 104: Bes.

fondness for gnomes, or these sculptures are meant to represent some kind of creature they had encountered, either on earth (probably a subterranean creature), or something out of another dimension? I tend to lean towards a combination of the two. Interestingly, prospectors Cecil Main and Frank Carr found a mummified body of a small man-creature in 1932 in the San Pedro Mountains of Wyoming. It is recorded that this creature was about 14 inches high with a flat head, huge, heavy-lidded eyes and a very wide mouth. It was so well preserved that the fingernails could still be seen on its hand. The prospectors carefully took their find to the town of Caspar, Wyoming where many prominent scientists, sure of a hoax, came from all over the USA to have a look at it. Dr. Henry Shapiro, an anthropologist from the American Museum of Natural History, set up extensive tests, assuming it would reveal some type of doll, or pieced-together work of taxidermy. Instead the X-rays showed that Pedro had inside him a *perfectly formed man-like skeleton with a complete set of human-like ribs*. Also shown was a damaged spine, a broken collarbone and a skull that had been smashed by a heavy blow. It seems Pedro had met with a violent death. The gelatinous substance on his head was exposed brain tissue and congealed blood. The fontanels – the soft spots in the skull which mesh to a solid plate as a baby matures to childhood – were closed, proving that this had indeed been a full grown adult. Pedro had a full set of adult teeth, but, with the difference of overly pointed canines – 'vampire' teeth. The overall estimate is that the being had been about 65 years old at the time of death and dated 'far back into history'. Interestingly, the Shoshone Nation of Wyoming have legends of the 'Nimerigar', a small race of people, who it is said, would attack with tiny bows and poisoned arrows. It is also said they would kill their own kind with a blow to the head when they became too ill to be a useful and active part of society anymore.[21]

In contrast to the desert regions where the likes of Bes, Kokopelli and Min were often worshipped, the Nimerigar were associated with fertility, the sowing of seeds and were protectors of crops. The ceremonies associated with the Harvest Festival (a Pagan celebration), May Day (pole dancing) and the 'Feast of Fools', celebrated all over Europe, are all connected to these fertility gods. The sowing of seeds is a common theme found in ancient texts and refers to the fertility of the land and its people. The seed is also symbolic of the shaman's power, or the male sexual energy behind creation. Even the word shaman is said to be a combination of the words semen and she-men, which includes the androgynous nature of the shaman.

Much art and sculpture from all over the ancient world certainly depicts a plenitude of strange creatures, and to say that most were figments of the imagination, begs one important question: "Did the ancient artist/priests value their imagination so much, that they based their whole religion on it?"

Maybe an answer to this question will come soon enough as we pass through the portal from one Age to the next! Hopefully my images and other imagery made by artists who are feeling the ancient archetypal forms come through their art at this time, are a testimony to the 'ancient-futuristic' beings that once walked the earth.

THE PANTHER PRIESTS AND LION-HEADED HUMANS

As I have touched on earlier in the book, lion-human hybrids feature in the religions and art forms of some of the most ancient tribal cultures of the world. In places like Egypt, for example, the presence of the Lion gods is seen in temple sculptures of Sekhmet, the Sphinx and in texts such as the *Book of the Dead*, which seem to suggest that the lion gods (possibly connected to the star Sirius) have influenced the mystery schools going way back into the ancient world (see figure 105)! Lion gods are found in Africa, China and India; the god Vishnu is said to have taken the form of a lion man, or Tawny One, in one of his ten incarnations on Earth.

Tony Bushby in his books *The Bible Fraud* (2001) and the *Secret in the Bible* (2002) also shows that the original religion of Egypt was influenced by, what he calls, the Leo-pardus (Panthera) priests and their god Leo (lion). What we know as a lion is called panthera leo or Leo the Panther by the ancient Egyptians.[22] Anyone who has delved into the simplest astronomical and mythological details concerning ancient Egypt will know that the Egyptian priesthoods were the originators of Stellar (Sirian) and later Sun Cults (saviour worship) mentioned in an earlier chapter. A hierarchy seems to exist in the ancient world that placed the lion (panther priests/shamans) at the peak of it and from my own research, I feel a priesthood with connections to the Orion and Sirian star systems still controls the religious, political and military structures on earth (see *Orion's Door*).

The lion is the most mentioned 'alpha predator' god in places such as the *Bible*, becoming a symbol for the 'messianic legacy', not least the Lion of the Tribe of Judah and the Root of David. In the Fourth Book of Ezra, (composed 100 BC), a vision is described in which a twelve-winged eagle (representing the first twelve emperors of Rome) is punished by a lion, who represents the Messiah.[23] This motif is not uncommon and it is also used in Genesis 49: 8-12, where Jacob blesses his sons and predicts that the King (Lion) of Judah will one day rule all tribes. The whole messiah concept and the return of a saviour god, cooked up by ancient shamans/priests thousands of years *before* Jesus Christ, is related to the expansion of human consciousness. Stewart Swerdlow, in his book *Blue Blood, True Blood* (2000), suggests the lion (Sirian genetic stream) is one of many animal-human strands relating to a higher consciousness, or the gods as depicted in ancient art and texts going back at

**Figure 105:
Sekhmet.**

least 30,000 years. My own view is what people often refer to as 'Christ consciousness' and 'ascension', is sometimes depicted symbolically as a 'lion-headed human'. Since the 'lion' can have both positive and negative meanings, it comes as no surprise to realise that both Christ and the Antichrist (the Demiurge) are depicted as lions. The latter being the one in the Book of Revelation, who is supposed to rule over all the earth in a New World Order!

The hierarchy of the Illuminati bloodlines, which comes from the kin-ship (divine right to rule) between the gods and their priests, is subordinate to a genetic stream connected to both Lion and serpent consciousness. I think *opposing* forces found in most myths relate to battles between the lion and serpent gods over the human heart and mind. Symbols found in art and sculpture of the ruling élite seem to suggest this hierarchy, too. On architectural detail at the English Cavendish bloodline stately home in Derbyshire, Chatsworth House, we see the 'hierarchy' through sculptural detail of the 'eternal flame' (wisdom/knowledge), positioned above the 'lion' (consciousness), seated above an entwined serpent (the lower mind).

Egypt is teeming with lion/serpent symbolism. The oldest known lion god of ancient Egypt is 'Aker', who is seen as the guardian of the 'Gate of the Dawn'. From information found in the *Pyramid Texts* it is clear that Aker's role and attributes are clearly defined in the earliest of dynasties, relating to the belief that during the night the Sun passes through a kind of tunnel (a Black Hole) existing in a nether region where each gateway is guarded by a lion-god called Akeru (or Akerui). I am sure much of this symbolism relates to the Orion Nebula and the Black Hole at its centre. Again the double deity (twin) symbolism speaks of duality, opposing poles of night and day, and the double helix of our DNA.

FIRE AND ICE – THE TRICKSTER GODS

In Native American Sioux and Hopi legends, a blue and red giant called 'Haokah' is a trickster god, connected to the Two-Horned Clan and Orion. He is referred to as the unnatural god, the ruler of dreams.[24] Haokah can also be likened to the Norse god of fire and mischief, 'Loki', who like Haokah was a contrary clown, having both good and evil traits. Fire and Ice giants found in numerous myths carry similar 'contrary' attributes, which say, "hot was

cold" and "cold was hot." The daughter of Loki, the goddess 'Hel', like Haokah, is said to have a dual visage. In most cases, the dual nature of Haokah represents pain and pleasure, hot and cold, power and magic. Being the ruler of dreams, Haokah (like the shamans of the ancient Two-Horned Clan) is said to be able to traverse time and move between different dimensions (realities). The same is also said of the West African deity, 'Eshu', which the Yoruba people, regard as a trickster god. This particular figure is capable of traversing time, haunting gateways (portals) and changing into different forms. In one Yoruba poem regarding Eshu it says: *Eshu throws a stone today and it kills a bird yesterday.*[25]

This particular phrase relates directly to the ability to travel back in time and suggests the ancients were adept at manipulating time. Eshu, like Loki or the antlered Celtic God 'Cernunnos', is also said to be able to move between different worlds. By doing this it is said that Eshu is caught between both benevolent and malevolent gods, often symbolised through having two faces and reflecting the duality of life. For this reason trickster gods are often identified with the Christian devil, but as I have already shown, Lucifer and the saviour Sun God in Christian and Pagan belief, are two sides of the same coin. Both are versions of the same archetype carrying symbolism which refers to duality of light and dark forces. In some myths, the trickster is depicted as having the ears of a donkey, which can also be found in religious tales relating to Jesus (riding on an ass), through to the later medieval costumes worn by jesters and fools. The Festival of the Fool (Inversus Mundi) in medievel times, is a celebration of a world turned upside down. This was when the Lord of Misrule reigns and animals engage in activity normally reserved for humans.[26]

The ass or donkey appears in Egyptian art, biblical texts and folklore from around the world and, in most cases, it is a symbol for both the fool and magic. The most famous image of an ass-headed human is that of 'Puck' in Shakespeare's *A Midsummer Night's Dream* (c. 1595 or 1596). Set, the Egyptian God of Death and the brother of Osiris, is also depicted with ears of a donkey. Set (death) and Horus (life) can be seen in Egyptian heiroglyphs with their heads joined, which again suggests they were the *same* entity split into two. Petroglyphs in North America also show Kokopelli (solar life force) and Masau'u (the God of Death) in a similar manner.

Other trickster figures, such as 'Anansi' the Spider of the Ashani Tribes of West Africa, or 'Wily Hare' (Brer Rabbit), are said to have the same dualistic attributes. The Celtic God 'Bricriu', who is another archetypal mischief-maker, portrays many traits found in other hero-trickster characters. Bricriu is said to have met his end when he tried to step in and judge between two fighting bulls, another tale that hints at connections between the horned gods

and the trickster deities of the ancient world. Many of the trickster deities are connected to the gods of death, fear and disease, but at the same time they are considered keepers of magic, which allows them to heal and cleanse the perceptions of mortals. The tricksters also have a dual role, one representing a messenger, or mediator, between human beings and archetypal forces (or gods) and those forces that could wreak havoc in our world. The Greek god, Pan, through to the Wily Coyote character, shows us the contrary nature of life. Ours is the human ability to marry irreverence and sacredness in one attitude, keeping us balanced and thirsty for knowledge. Humanity has the same dual nature through our ability to *project* and *accept* various realities simultaneously. As I have said, we take ourselves far too seriously and therefore take our religious and political beliefs seriously, too. The ancient trickster archetype is one that will always manifest in individuals, groups and often through art, especially when a society is pressing the self-destruct button by being too engrossed in the illusion of what it calls the *real* world. All wars, suffering, famine, pandemics and revolutions are the symptoms of greed, conflict and *control* by a malevolent force which feeds off humanity's reactions, fears and insecurities. The trickster or jester archetypes help us to remember that we need to see life as sacred, but not take this physical five sense 'reality' seriously. When we take it too seriously, we are out of balance and by being out of balance, then succumbing to stress, illness or depression. The trickster archetype is there to remind us to not look at the mirror (life / reality) and take the reflection seriously. After all, it's just a reflection, an *image* that can be changed any time we choose to change it.

As we have seen, various animal gods and goddesses are shown to be the original heroes, as recorded in myths and artwork throughout the ancient world. The trickster god, in world mythology, is said to have stolen fire (or knowledge) and giving it to the first humans. The Coyote of Native American myth, like the many fire gods, is responsible for imparting sacred knowledge to indigenous Earth races in a long forgotten 'prehistoric' era. This is a story that most likely relates to the 'gods' (extraterrestrials?) imparting an advanced knowledge to humanity, or, humanity's *realisation* that we are also those gods, with a genetic and spiritual heritage stretching way back to a time when our ancestors 'were celestial animals'. Not such a strange notion when we realise geneticists know the human DNA can be shown to be the same in animals and insects. David Haussler of the University of California, Santa Cruz, compared the genome sequences of human, mouse, rat, dog, chicken and fish. To their astonishment they found that several great stretches of DNA are identical across a range of species. To guard against this happening by coincidence, Haussler and his team looked for sequences that were at least *200* base-pairs (the molecules that make up DNA) in length. Statistically, a sequence of this length would almost never appear in all three

by chance. Not only did one sequence of this length appear in all three, but *480* appeared in sequence.

From my own reading of the subject and from studying some of the artwork found in the prehistoric caves of France, when we look into the background of Egypt, Sumeria and other advanced civilisations, it seems a priesthood with the highest knowledge was responsible for religions as we know them today. I've even heard New Agers and Ufologists, over the years, suggest that our origins, in terms of sacred knowledge and the so-called secrets of the universe, come directly from lion-humanoids associated with the star system Sirius. I cannot say that's the case for sure, but I do think some sort of influx of knowledge from an intelligence reaching further than the limitations of our 'physical planet' came in via the consciousness of animal families (the alpha predators especially). This is why humans both revered, and feared, such animals in ancient times. These animals *are* our ancestor gods.

As I have attempted to explore in this section of the book, the relationship between humanity's reverence of animals, gods, heroes and the imagery associated with human-animal hybrid deities, tells so much more about our real origins. It also speaks of our multidimensional potential, which is part of our DNA and *then some*. It is my own belief that our multidimensional persona is interlocked with the potential housed in what is referred to as junk DNA. In ancient times various levels of consciousness, both from within the animal kingdom and humanity, has given rise to the many animal-human archetypes found in ancient art. Ancient myths, too, relate so many examples of the gods being both animal and human in appearance; therefore, could there still be more to know regarding the history of our human genealogy? Well, of course there is! It seems to me that art and mythology, since ancient times, contain memories of our multifaceted levels of consciousness which extends beyond the five senses.

NOTES

1) *Bullfinch Mythology*, p 96
2) *Oracle of Apis, Bullfinch Complete Mythology*, p210
3) Temple, Robert: *The Sirius Mystery*, Destiny Books, p278
4) Hurley, Matthew: *The Alien Chronicles*, Quester Publications 2003, p98
5) Jenkins,John Major: *Maya Cosmogenesis 2012*, p32
6) Bryant, Page: *The Aquarian Guide to Native American Mythology*, p31
7) Matlock, Gene: *The Last Atlantis Book You'll Ever Read*, Dandelion, p116
8) *Man Myth & Magic*: Issue 8. Published by Purnell 1970, p 233
9) Cambell, Joseph; *Primitive Myths*, p277
10) Coleman, Loren: *Bigfoot! The True Story of Apes in America*, Paraview Pocket Books, 2003 p5
11) Ibid, p8
12 https://feminismandreligion.com/2015/08/26/artio-celtic-goddess-of-wild-life-transfor-

mation-and-abundance-by-judith-shaw/

13) M. Baigent, R. Leigh and H. Lincoln. *The Holy Blood and the Holy Grail*. Corgi, London, 1986, p250.

14) *A Medieval Sasquatch* by Dr. W. Henner Fahrenbach. Bigfoot Field Research Organisation

15) Swerdlow, Stewart; *Blue Blood, True Blood*, p112

16) T. McNally, Raymond & Florescu, Radu: *In Search of Dracula. A true History of Dracula & Vampire Legends*. New English Library, 1975 p7 (half tone section)

17) Coleman, Loren: *Bigfoot! The True Story of Apes in America*.Paraview Pocket Books 203. p11

18) Matlock, Gene; *The Last Atlantis Book You'll Ever Read*, Dandelion, p116

19) *www.viewzone.com/kokopelli.html*

20) *Bullfinch Complete Mythology, India in Greece*, p43

21) *Bullfinch Complete Mythology*, p93

22) Bushby, Tony: *The Secret in the Bible*, Stanford Publishing Group, 2003, p33

23) 4 *Ezra* 11.37-12.39

24) Owusu, Heike: *Symbols of Native America*, Sterling, p159

25) *Annotated Myths & legends*, p86

26) Bentor, Janette: *Medieval Mischief, Wit & Humor in the Art of the Middle Ages*, Sutton Publishing 2004, p69

Chambers of the Mind

Art & the Promethean Gene

*Art is a half effaced recollection of a higher state
from which we have fallen since the time of Eden.*
Hildergard Von Bingen

R ock art from the upper Palaeolithic period through to the Bronze Age, depicts numerous symbols associated with the stars, the Sun, sexuality and the emanations of a vital magical power in nature. Other symbols speak of duality and the forces that have shaped our world. It's as if the artists that created the images on rocks, in caves, and along the canyons of the ancient world were trying to explore, through art, a newly-found aspect of their inner being. Alchemical illustrations produced by artists/alchemists depict similar archetypes, symbols and concepts, as did the temple art of Egypt, Greece, Asia and the Americas. What seems obvious is that a priesthood of alchemists (shamans) was making imagery through the use of symbols and narratives which explain the connection between the 'divine' and the human senses. It is my view that symbols used in art and language are a tool for connecting the shaman with unseen frequencies and consciousness beyond the physical world. For our ancient ancestors, art was a vehicle for communicating with the spirit of the world and to do this the artist often entered into the darkness of the cave (a symbol for the chambers in the mind) so to 'feel' these other levels of consciousness.

HIEROGLYPHS WERE THE LANGUAGE OF THE GODS

Egyptian hieroglyphics, according to the alchemist, were one of the teachings given to the priesthoods of Egypt by one of their gods called Thoth (Hermes) who is depicted as a human with the head of an ibis. Thoth is said to be the scribe of the gods and is an early rival to the Sun-god, Ra, as a creator of Egyptian civilisation. He is also regarded as the personification of the mind of God, sent to Earth to write for Ra and the Goddess of Justice, Matt.[1] It is written in the *Egyptian Book of the Dead* and the *Book of Divinity* that Thoth comes from the place where the Sun sets (possibly the Underworld) bringing

with him the language of writing and magic. The *Book of the Dead* declares Thoth author of works by which, the ancients believed, the deceased gain everlasting life. His appearance in Egyptian art as a human with the head of an ibis, is mainly due to the bird's resemblance to the human heart when its head is tucked under its wing. Manley Palmer Hall, the Freemasonic historian records in his work, *The Secret Teachings of All Ages*, that Hermes (Thoth) learned his knowledge from Poimandres the Great Dragon and these teachings were contained in *The Vision of Hermes*, or what became known as hermetic writing associated with the Greek version of Thoth – Hermes Mercurius Trismegistus. The mystery schools of antiquity equate this figure as the master of all arts and sciences, scribe to the gods and keeper of the books of life. Mercury, Hermes and Thoth rolled into one figure become the key personage associated with alchemy and the principle of form follows thought.[2]

Thoth also took the form of a baboon, or a dog-headed monkey scribe, a deity that already existed in the city of ancient Hermopolis in Middle Egypt, the main centre for his cult. He was considered the god of language, numbers, art and the hermetic sciences emerging from Egyptian belief, magic, art and the knowledge of creative thought (power). Thoth, considered the divine scribbler (artist), is said to have been given the key to the mysteries of Osiris.

In Egyptian symbolism, the chariot of Osiris, pulled by the pair of lions, relates to the wisdom held by Thoth. The twin lion symbol in relation to that of creative thought relates to individuality, originality and genius. All three attributes are within each of us and are more often than not surpressed through the use of language, numbers, logic and reason. The latter is the mind, but the former is the heart and that is why Thoth is often referred to as the 'heart of Ra', the god of the divine word and creative genius (see figure 106).[3]

Images and symbols

Figure106: Thoth the 'god of genius'.
(Left) The classic Egyptian hieroglyph of Thoth as the ibis, the scribe of the gods. **(Right)** Thoth as the dog-headed baboon depicted in certain 18th-century Tarot decks as a symbol of genius. © Courtesy of Dover Picture Archives

found in ancient shamanic art and later alchemical illustration, are direct references to the hidden powers that lie beyond the realm of the five senses. Art, in its truest form, is metaphysical in content and certain symbols, or hieroglyphs, seem to express a level of understanding that are scientific by nature. Certain alchemical images even hint at the types of experiments that may have been carried out in the laboratories of the 'gods', some of which relate to neurobiology and DNA experimentation! Others seem to be recording a naïve understanding of geneological connections between animals and humans, especially the royal bloodlines. Could the correlation between the scribe of the gods, often portrayed as monkey (artist) in Egyptian art, and the advancement of the human brain in a prehistoric era, relate to the myths associated with the gods that are said to have come to Earth from the stars and influenced the artist-shaman in prehistoric times? In this chapter I want to take a closer look at the imagery associated with the alchemist and how certain visual keys relate to the principles of creative thinking and the visionary capabilities of humanity.

HUMAN-GODS

According to neurobiologists, it seems as though the human brain went through a rapid change in neural ability at some point during the upper Palaeolithic period (30,000 years ago).[4] Some of the most sensitive artwork has been discovered from this time and according to some scientists the use of symbols by our prehistoric ancestors seems to go back 100,000 years at least. If our ancestors were genetically changed from Neanderthals to Cro-Magnon within a short period of time (hence the missing link), then what or who facilitated this upgrading of the brain? Put another way, what made artists out of Neanderthals? Answers to this question seem to point to an intelligence of a higher form (or an upgrade) carried out by custodial 'gods' that altered the DNA of our species. According to ancient texts and myths, these 'gods' made man in their image.

The western, almost apologetic, excuse for the sudden leap in evolution along with the total disappearance of a race at the same time, is called a transition. According to leading scientists, the Neanderthals:

> *Could learn how to make fine blades but they could not conceive of a spirit world to which people went after death. Nor could they conceive of social distinctions that depended on categorisations of generations, past, present and future.*[5]

Yet, just at the time of the demise of these so-called one-dimensional conscious creatures, we find some of the most amazing Palaeolithic cave art. Was the Neanderthal more evolved than our experts give him credit for? Or were these genetic streams remnants of the original Atlantis evolutionary period?

I personally think he/she was given the skill of image making through the rewiring, so to speak, of DNA, by the gods that 'fell to Earth' – or came out of the Dreamtime.

The Mayan texts called the *Popol Vuh* has the story of extraterrestrial gods who came down and made man in their own image. When they first made 'man' he was so perfect – he lived as long as they did – he could see far and wide – he was clairvoyant – and he was as perceptive as they were. However, the gods realized that they had made a competitor who was as wise as the gods themselves. So therefore, it is said that they destroyed this experiment and started over creating present day man. Modern man lives shorter life-times, uses less brain capacity, and is here to act as a servant race to the gods. In truth we are in servitude to the consciousness that manifests as fear, and if fear could take on a physical form the alpha predator deities described in Chapter Five would fit the bill. In religious texts this 'downgrade' by creator gods, the Anunnaki (or Nephilim as they are called in the Bible), has been widely interpreted as the Fall of Man and the Creation of Adam and Eve. The Sumerian Tablets I mentioned in an earlier chapter, also contain descriptions of how the gods interbred with humanity to create a hybrid race, a fusion of genes of humans and the gods.

The Sumerian tablets say that the gods produced a human hybrid that the Sumerians called LU.LU (one who has been mixed) and this creature in biblical terms was Adam. This fusion of genes could have taken place in the laboratories of Eden (the Eden Project?) and included the mixing together of the DNA of the gods with that of the human form known as Homo erectus. From my own research I feel that animals and other mammals were also used in these genetic experiments and, as I touched on in the last chapter, it is possible that the original gods themselves were animal-human hybrids. These hybrids were created to rule and direct the population as 'middlemen', or demigods, and the 'first man' is more than likely to be symbolic of a genetic stream with maybe with a code name: Adam, rather than an individual person. The biblical Eve was also a code for the 'essence' of life supposedly created from a rib of Adam. But the word from which 'rib' derived was the Sumerian, 'tit', which means both rib and life according to translations by scholars such as Zecharia Sitchin. To be created from the 'life essence' of the Adam race makes more sense than coming from a rib. Words have been purposely used to mislead the masses when it comes to fully understanding the hidden knowledge, and the first five books of the Old Testament are no exception to this rule.

Official history suggests that original human forms died out and were followed by new species, thus Cro-Magnon man and Homo sapiens (modern man) followed Neanderthal man. But archaeologists working in the Middle

East in recent years have discovered evidence to show that all these physical forms existed during the same time period. The missing link that would connect them, and explain the sudden and dramatic changes in appearance of their physical forms, has never been found because the establishment academia would rather stay ignorant to the possibility of a diversity of extraterrestrial forms interacting with humanity in the ancient world. The same mentality also debunks 97% of DNA as junk, because scientists don't know what it does! It could just be that the majority of DNA, which relates to the 95% of all matter in the universe that we can't actually see, is the home of what we call the gods or extraterrestrial activity. The Fall of Man, recorded in ancient texts, is also a symbolic story of the separation of the original human DNA and the creation of a new species placed on 'middle Earth' (in this dimension) to serve the gods. The decline in extra-sensory abilities such as telepathy and interdimensional communication, which are part and parcel of the original human DNA, could have been 'reprogrammed' to shut out all that can be seen, felt and understood beyond the physical world. There is so much more to know with regards to our DNA and the capabilities of the human mind; a strand of research that this book can only scratch the surface of.

FALLING BEYOND THE SPECTRUM

I feel humanity does not originate from within the boundaries of a physical earth. In our true form, we, like other intelligences (across the universal spectrum of life), are infinite consciousness. Who we are, and where we have come from, often filters through the 'programming' imposed upon our consciousness via our DNA (physical family) and other external 'mind programmes' (education, TV, media and what the authorities want us to 'perceive'). Visionaries, free thinkers and 'maverick souls' (throughout history), have been a channel for higher intelligence and Superconsciousness, reminding us of our higher purpose. What we perceive to be 'time' is also connected to our physical servitude (to the old order of gods) and our calendar systems imposed through religion, the state and now, money, all are part of the ultimate programming tying us into flesh and bone, keeping us focused on *only* the material world. We are a 'possessed' species that has forgotten our true spiritual heritage. As the late American Indian poet, singer and activist, John Trudell, said in his song *Crazy Horse* (2007):

> ... *Predators face he possessed a race*
> *Possession a war that doesn't end*
> *Decoration on chains that binds*
> *Mirrors gold, the people lose their minds* ...

Yes, we have 'lost our minds' (look at the world around us), and it is obvious the more we choose to become conscious and awake to other versions of reality. The so-called Woke movement, which has appeared in recent years, is the epitome of not 'seeing' the need for 'higher consciousness', 'freedom of expression for *all*' and the need to care for people's views and alternative ideas. As I have said on social media, being 'woke' is not to be confused with being truly 'awake', the two are not the same thing.

According to Swiss psychologist and psychiatrist, Carl Jung, the collective unconscious contains 'archetypes', universal primordial images and ideas. In Jung's time, archetypes were accepted mostly as cultural phenomenon, or as something 'originating' in the inherited structure of the brain. However, scientists have since begun to look for a physical mediator between the brains of the people, still assuming that archetypes, controlling our minds, are originating in the brain. They do not. The brain and the mind are not the same thing. In other words, our minds are a storehouse of all possible 'past and future' epochs. From this perspective, the brain can be compared to a 'computer processing unit' and the mind to the 'software' that facilitates the evolution of our Universe. If the software is upgraded, or the CPU upgraded in some form, then so would the physical form. The mass extinctions of species were actually mass 'replacements' of species with more advanced brain capacity, while having capability to hold memories of previous evolutionary phases within the cell structure of our bodies. The mind (or consciousness) can 'programme' our DNA, too. Not only has the hardware (brain) been altered through evolution, but the software (the mind) too has been programmed to 'project' specific realities and paradigms. Fight or flight is one of these early models and, in truth, the mind is connected to a collective matrix mind, governed by fear and survival since the birth of our earliest human ancestors, a subject I will return to in the second part of this book.

Humanity has within its genome structure memories of past evolutionary phases and the ability to 'call on the time' (commonly described as the 'Fall') and utilise our ancient memories. I have seen the period called the Fall, in dreams and visions, which mainly come through images associated with what can only be described as a hairy 'Wookie-like' race of humans (see previous chapter). These ancient humans are living in caves, especially in the Americas (see my book *Aeon Rising- The Battle for Atlantis Earth* 2017). In other versions of these visions, I have seen what are now described as birdmen (griffins) appearing at that time, and 'rounding up' large portions of Neanderthal-like wookies, to be used in experiments. None of this imagery necessarily relates to an ancient era. What these visions showed me, is the possibility of parallel realities, both 'ancient and futuristic' (same thing), all existing as narratives that can be tapped into through memories in our DNA.

More importantly, it is our art, imagination and creativity, in all of its forms, that can reveal 'untapped', or 'unknown' levels, of our DNA – our consciousness. Beyond these 'other worlds' or 'other dimensions of being', is the heart and higher consciousness. When we forget where our true home resides, we forget who we are, and then we become merely 'human beings' who fell from 'being human'. As the 12th-century artist, visionary, and abbess, Saint Hildegard of Bingen, said of the time before the Fall:

> *Art is a half effaced recollection of a higher state from which we have fallen since the time of Eden.*

Bingen's statement, along with much research into cave art by historians and neurobiologists, hints at the possibility that human consciousness, through our prehistoric ancestors, went through immense neurological and biological changes around 40,000 years ago. You could say our human ancestors' brains were upgraded (as if by magic), to facilitate what some scientists refer to as a 'higher-order consciousness'. In mythology and oral traditions spanning the globe, this new-found ability of a 'new earth race' was described as the 'gods giving knowledge to the first humans'. Legends associated with Prometheus and the 'light-bearers' recorded in ancient myth are part of this story. However, the more one researches into subjects of alien visitation and star people and relevant mythological accounts, it seems one strand of our original ancestors, the 'Neanderthals and Miocene apes', disappeared abruptly, while their 'replacement', Homo sapiens, seemed to go on to flourish (see figure 107). It is the latter species that we, in our modern physical form, are said to have originated from. The course of this book would be insufficient to cover this particular strain of the subject in great detail and I am not a scientist (obviously), but I feel it is worth investigating further the so-called, sudden 'Fall of the Neanderthal' in line with the discovery of earth's oldest artworks.

Figure 107: Original earth stars. My drawing of what Neanderthals may have looked like. Neanderthals were the original 'Superconscious' humans in my view. Possibly Atlantean/Lemurian tribes; survivors of ancient cataclysms? © Neil Hague

ARTIST APES & 32 MYSTICAL PATHWAYS OF WISDOM

It seems from an overwhelming amount of historical and modern-day evidence, a highly evolved civilisation once existed on the planet. As I have

already shown, these advanced ancient civilisations have been referred to as Atlantis, Antilla, Aztlan, Shangri-la, Hyperborea, to mention just a few. According to many ancient texts, this global colony was one of several land masses, now submerged under the sea, in the area today called the Atlantic. It is also said that its sister continent was another ancient landmass called Lemuria, located in a place where the Pacific Ocean now sits. Many battles between the gods, recorded in ancient myth, are really stories telling of earth's wars and a technological 'star wars' between these two continents. My reading of the subject leads me to believe what was once called Atlantis, is actually on a par with our current global civilisation today. We are rebuilding it, as I will come to in the next part. The state of mind that manifested Atlantis is prevalent today through the rise in technological advancements, like cloning, hi-tech weaponry (star wars), globalization and 'artificial intelligence'. We are becoming Atlantis revisited. Is it unreasonable to suggest that what has become a collective amnesia point in history, called Atlantis, may well be a code for a 'state of mind', which exists when our collective consciousness reaches a certain level? Simply put, did Atlantis the movie (part one) become Atlantis the 'Fall' (part two), when we lost our connection to higher levels of consciousness? Much ancient art (including cave art) and myth seems to capture similar themes relating to these *two* states of mind (movies), often symbolised as duality in earth's evolution.

Genevieve von Petzinger, a Canadian paleoanthropologist and rock art researcher, finishing up her doctorate at the University of Victoria, stumbled across some interesting ideas relating to symbols and our ancient ancestors in terms of originating with *two* states of mind. She studied some of the oldest art in the world. Ice Age cave art created by early humans in Europe between 10,000 and 40,000 years ago (the time of the Neanderthal), leaves us with some interesting symbolism associated with a language that could be the first form of organized communication amongst the Paleolithic hunters, according to Petzinger. Her specific focus on geometric signs found at many European sites, explained how certain cave art images/symbols seemed to be part of a human cognitive evolution, an ancient system of patterns, including migration, symbolism and graphic communication. What she found was a common set of *thirty-two* symbols in use between 40,000 and 10,000 years ago. What I found interesting is the numerological link to the mention of the 'gods' in biblical terms. Among the 434 Hebrew words in Genesis, the word Elohim is used *thirty-two* times. The number 32 also correlates with the Hebrew word for heart (lev) and maybe the ancients spoke with their true brains - their hearts, through this first form of coded language found in art.

The ancient landmass called Lemuria comes from the word Mu or Mu-devi, which means the 'Land Ancestral', or 'Land of the Ancestors'. Mu-Devi was also the Hindu mother goddess, while Shiva was her counterpart and

was seen as the great father of mankind. Lumeria was the mother ancestor, and Atlantis the father. Atlantis was thought to have been a centre for alien activity, a hub for advanced science (genetics), language and advanced mathematical concepts. Many scholars still wonder why the likes of Sumeria, Egypt and the Indo-Aryan civilisations already had fully formed alphabets, mathematical systems and symbolic cosmologies from their offset. The reason for this is that all of these advanced civilisations were surviving colonies of Atlantis the movie (part one), whereas the more Asian and aboriginal cultures to the South were said to be satellites of the Lemurian civilisation, an offshoot possibly of Atlantis? Certain deities worshipped in Egypt, Sumeria and India were said to have come out of the Atlantis era, not least Thoth of the Egyptian Pantheon mentioned earlier. And this is why the same gods and archetypes, under different names, crop up all over the ancient world, because Atlantis was a global state of evolution – no different from the now global paradigm we partake in as a species. The ancestors in my view, are the 97% of our DNA classified as junk, which relates to the 90% or more of our brain capacity that we don't use (see Figure 108)! Lumeria and Atlantis are ancestoral links to the Dreamtime, via the 97% of our DNA termed junk. We are recreating Atlantis (the father) today as we engage in all of the possible scenarios that separated us from accessing other levels of consciousness – namely fear in all its forms. Fostering war, segregation of peoples and using science and religion to control indigenous peoples of Earth are part of the control that was Atlantis. And nothing will change unless we change our perceptions of who we are and what we can achieve. The cataclysms and rifts that brought about the end of Atlantis part one, which manifested as earthquakes, floods and volcanic eruptions, on one level, caused a 'rift' between the human heart and mind. This separation, in my view, disconnected humanity from its true potential and led to massive changes in our DNA and the human brain. The potential to 'see' into the *Dreamtime* (and beyond the astral world), and retain the knowledge of our original form, came crashing down like an iceberg as we began a myopic 'frozen' state, locked into fear and survival. According to much scholarly research, not least the work of James Churchwood in the first half of the last century, it has been suggested that Atlantis was initially ruled by the gods (extraterrestrials), but eventually came under the rule of hybrid bloodlines (half-alien, half-human). These are the genetic bloodlines that retained a connection to the Dreamtime, and to Atlantis, and were given the name 'fallen angels'.

The gods that fell to Earth, as recorded in the Old Testament and in the Book of Enoch, as the fallen angels, created the inspiration for the religious template that became the movie 'Atlantis the Fall', or 'Atlantis part two' – the time frame we are still in. And if we're comparing evolutionary landmarks with movie sequels, then 'Atlantis part three' came out in 2012-13 as the same

Figure 108: Junk DNA (unused brain capacity).
The reality based on this physical dimension is miniscule in proportion to the potential that can be accessed through our imagination and creativity going beyond the five senses.
© Neil Hague 2004

gods intend to reorder the world yet again. The fallen angels, or consciousness, are by definition the latest modern human 'genetic' forms. As I have already touched on earlier, the gods of Atlantis were the Anunnaki, Rephaim, Titans and the Watchers recorded in myths and texts all over the ancient world. They were the fallen angels or the serpent consciousness recorded in the original garden of Edinu (Eden), and this particular genetic stream are human-dinosaurs and the brains behind the demise of Earth's indigenous peoples connection to the ancestors. As I have already mentioned, the Predator Consciousness, in the Dreamtime (Lower Astral world), took on many forms, the main ones being the archon/jinn and other demonic creatures that have appeared in religious art since ancient times.

HUMAN-ANIMAL PEOPLE AND THE CAVE

As I have already shown, according to many indigenous tribes, both the bear and the monkey race were said to have lived on the earth in ancient times, before the arrival of 'humans'. These myths and legends could relate to an interstellar level of consciousness accessed by a Neanderthal/ Miocene people. As I mentioned earlier in this chapter, Thoth in ancient Egypt, a monkey god, was considered the originator of science and letters, and in ancient India, the Monkey god, Hanuman also had magical abilities and was attributed with similar skills. Almost every Christian cathedral also shows reverence to the monkey gods in some shape or form. More often than not, they are direct references to either Enkidu, the ape-man who accompanied Gilgamesh in his search for immortality, or Thoth. As I touched on in the previous chapter, Hanuman was said to be immortal, with the instantaneous ability to reduce, or grow to whatever size he liked, which seems to relate to the knowledge of microcosm and macrocosm and 'higher dimensions'. In Native American lore, the 'Uncegi' of Sioux oral tradition (another form of Bigfoot) was said to appear as fire tornadoes, at the time of cleansing, a period we are moving further into. The horrendous fires witnessed in Australia in 2020, and the endless fires in other continents (not least the USA), are on one level, not 'natural'. Whatever is creating them is aware of what the Hopi call, 'the end of the Fourth World' (Age), and therefore could be manipulating such burnings through the use of technology to suit an agenda? Interestingly, the fires that have ravaged many parts of the world over the past fifteen years, some of which I saw from the air while taking flights in the USA, often swirled uncontrollably. According to Native American prophecy, these are one of many signs of the current world being cleansed; the onset of a new paradigm (collective reality) embracing humanity at this time.

I feel the Neanderthals were more advanced than we have been led to believe. Just the art of these ancients tells us more about their coming to

terms with a new level of perception and a change of 'world matrix' around 26,000 years ago. From another viewpoint, did our ancestors set in motion our current evolutionary timeline, through their newly-powered level of awareness? When we consider the oldest forms of visual communication to date, art (right brain activity), then it says much about what type of creatures and levels of consciousness our human ancestors were *before* the biblical Fall. And why, in our current civilisation, is more emphasis placed on left brain logic (written word, mathematics and science), while drawing is diminished and relegated in schools to the level of a 'poor relation'? The stream of consciousness that has become modern humanity has created a biological model that serves the gods (the fallen angels) of Atlantis well. As we are starting to see, 'technology' is our 'new god', but is it really new? We have facilitated a different kind of paradigm shift, born from ancient chambers of the mind.

I also feel that many different extraterrestrial races (gods) have seeded the genetic mix we now call the human race; much rock art is showing us the types of intelligence our ancestors either encountered, or were connected to. Orion is one of the main sources for such extraterrestrial races and the structures and hierarchies are very much inspired by the ultimate 'empire-building' consciousness, I feel originates in Orion. The cave was more than a shelter for the first Homo sapiens, it was a symbol of their innermost mind, a place where images are born and become reality. On the other hand, the *cave* was a place where the mind of our ancestors struggled to adjust to its new environment, a world (or matrix) where human consciousness could be borne.

THE PROMETHEAN GENE!

I believe humans are naturally gifted with an ability to see, feel, imagine and exude an energy often referred to as our charisma, magnetism - our aura. The origins of the human soul and spirit (the imagination) are all aspects of a source that creates all life. As creators in our own right, we have the ability to draw in and express a vital energy, especially when we are in a heightened state of awareness; I call this state of awareness the 'Promethean Gene'. You could say it is magic and power emanating from a person that makes them seem superhuman and charismatic to others. In some cases, this energy can be turned on, and tuned into, by forces existing outside of our three-dimensional reality, so an individual concerned, can seem godlike. Our thought-forms (energies) can be of a lower frequency range; others are of a higher level of love and wisdom, but ultimately, thought influences reality. There's another crucial point to highlight about DNA: it is also the home of what we call the emotions. This is the greatest deceit of all that holds us in servitude to the physical world, because we accept our instinctive responses and reac-

Figure 109: Thought creates our reality.
We 'manifest' ourselves and the world around us through how we 'perceive' form (reality). © Neil Hague

tions must be coming from us; they must be who we are, *they are not who we are*. Emotions are phenomena of the DNA often caused by trauma and thought patterns passed from generation to generation (see figure 109). People say things like 'I am only human', and they talk of 'human nature', as if this is who they are. But it's not. They are the consciousness of Infinite Possibility and what we call 'human' is the DNA mind, emotions and holographic 'biological body'.

Figure 110: *Everything* is waveform.
Human wavefields connect with other fields through wave entanglement – we experience this as relationships of every kind. People, places, jobs, lifestyles, etc., are waveform entanglements. © Neil Hague

What we align ourselves with through our thoughts and actions will attract the same states of mind to us. As always it is the intention behind the thought that creates reality. In this way, angels can also be demons, depending on our state of mind and how open our hearts are. In more modern terms it could be said that what we eat, watch and think is what we become, which carries truth. All life exists because of the creative impulse igniting our ideas, which becomes solid form and manifest in our world. Everything from a mountain to a teaspoon only exists because of energy (particles of matter), which solidify, or slow down, to become physical objects. Whether it is the mind of the earth (Gaia) shaping the landscape of her body to accommodate changes brought on by how we, as a species, relate to her, or an idea in the mind of an individual, which then becomes a painting, book or physical object in the physical world; all physical forms exist because of the influence of non-physical forces. It is waveform information that constructs our world as we 'entangle' with others in the 'collective' information field (figure 110). We are continually creating our reality (collectively and individually) through how we think, imagine and see reality. It is a process of delivering our personal magic to the world and this is why our ancestors entered the dreamtime – to shape reality. The collective waveform field is from where we change the physical world. Think only good things, live *without* fear, and be at *peace*, and *all* these things will 'manifest'. If the intent and feelings are coming from our heart, the 'true brain', we cannot fail to heal our world.

AURIC EGGS

The eye, the cosmic and philosophical egg and the matrix are common subjects found in visionary art. They have also found their way into science fiction films, not least *The Matrix*, which I will consider in more depth in a later chapter. In scholastic tradition there are said to be three chambers of the brain which work on a cooperative basis and this concept can also be found in the aboriginal stories relating to the dreamtime, through the sacred, human and physical worlds. These chambers are connected to the imagination, knowledge and memory and alchemical studies often show these chambers have macrocosmic concepts, using eyes, eggs and the world matrix in art and illustrations (see Figure 111 overleaf). The astronomer and mathematician John Dee (1527-1608), who was close to the Tudor blue bloods, used the egg as a glyph for the ethereal heavens, simply because the orbit of planets within it forms an oval. For the 15th-century doctor and philosopher, Paracelsus:

> *The sky is a shell which separates the world of God's Heaven from one another, as does the shell of the egg. The yolk represents the lower sphere, the white the upper; the yolk: earth and water, the white: air and fire.*[6]

Figure 111: Worlds *within* worlds.
Alchemical illustrations that suggest the eye to be a microcosm of the Universe – a precursor to the holographic understanding of our Universe.
© Public domain.

The 17th-century alchemist and artist Robert Fludd also said of the eye and the chambers of the brain/mind:

... in relation to the five senses of man: earth: touch, water: taste, air: smell, ether: hearing, fire: seeing. This "sensitive world" is "imagined" in the first brain chamber, by the transforming power of the soul, into shadowy duplicate, and then transcended in the next chamber of capacity for judgment and knowledge: through the keenness of the spirit the soul penetrates to the divine "world of the intellect" [heart]. The last chamber is the centre of memory and movement.[7]

Alchemists and visionaries throughout history connect images of the egg and the eye, and both relate to macrocosmic understanding of how we see the world. Large parts of William Blake's poetry are concerned with a detailed engagement with Isaac Newton's materialist view of the world. Isaac Newton, as we have seen, was a high ranking member of the Rosicrucian Order and connected to the creation of the 'this-world-is-all-there-is science.' For Blake, the physical was dull and dim *"like a black pebble in a churning sea"*, and the optic nerve, to

which Newton pays homage, *"builds stone bulwarks against a raging sea."* [8] Blake, instead, turned to the work of Jacob Böhme, a 15th-century philosopher and alchemist, to develop his own optics of the visionary. In fact every level of Blake's poem *Milton* is based on an optical model within the form of a cosmic egg. The eggshell for Blake, as seen in the illustration of *The Four Zoas*, signifies mankind's limited field

Figure 112: Four Zoas.
William Blake's *The Four Zoas* is a model for the human psyche. © Courtesy of the British Museum.

of vision, *"an immense/hardened shadow of all things upon our vegetated Earth, enlarged into dimension and deformed into indefinite space."* [9] The egg represents what is often called the 'freeze vibration' and is also a symbol for the conditioned 'enclaved' aspect of the human soul. The four intersecting circles are inscribed with the names of the *Four Zoas*, the apocalyptic creatures that represent the elemental forces of the Universe (for more on this see *Through Ancient Eyes,* and figure 112). The egg-shape for Blake also represented the world of Los, a mythical figure for the eternal imagination, which forms the illusory three-dimensional space defined by the two boundaries of opacity (Satan) and the material condensation (Adam). Stripping away the religious terminology, the eye (or egg) obstructs man's 'free vision' of things as they really are.

The scientific journal, *Scientific American Mind* ran a special edition in 2004, which covered similar themes relating to seeing and the illusions conjured up by the interaction of eye and brain. Science can show that the brain's assumption that light shines from above the head is preserved even when we rotate our field of vision 180 degrees. Viewing shaded spheres like the ones seen in illusory graphics and diagrams, at 0 degrees and 180 degrees, we find that a

visual switch occurs as if the 'sun is stuck' to our heads and shining upward from the floor. Signals from our body's centre of balance, the vestibular system guided by the positions of tiny granules of calcium carbonate (stones) in our ears, called otoliths, travel to our visual centres to correct our picture of the world (so that the world continues to look upright), but do not correct the location of the Sun.[10] Interestingly rock art, made by shamans dating back to a window between 13,000 and 5,000 BC also depicts the sun as though it is 'stuck' to the head of the figure (Figure 113). Imagery of this kind, along with the huge amount of prehistoric art depicting wave forms illustrated in chapter two, may well suggest that our artist ancestors were fascinated by the illusion of light and dark structuring how we 'see' the world!

Figure 113: Sun struck.

THE BRAIN AS A RADIO RECEIVER

According to mainstream science, we have an ancient part of our brain called the 'R complex' or the 'reptilian' brain stem which, mainstream science accepts evolved over millions of years. The brain stem is the oldest and smallest region in the evolving human brain; it is more like the entire brain

of present-day reptiles, hence its name. It is found at the base of the skull, emerging from our spinal column. The R complex is also similar to the brain possessed by hardy reptiles that preceded mammals (according to mainstream science), roughly 200 million years ago. It's 'preverbal', but controls autonomic life functions such as breathing, heart rate and the fight or flight mechanism. Lacking language, its impulses are instinctive and ritualistic. It's concerned with fundamental needs such as 'survival', 'physical maintenance', 'hoarding', 'dominance', 'preening' and 'mating traits' that can be found in every human world to this day. The R complex is also found in life forms such as lizards, crocodiles and birds – the gods of the ancient world.

According to scientists like Carl Sagan, the reptilian part of the brain gives us our hierarchical and ritualistic behaviour, including the need for top-down control, traditions and territorial actions. All these characteristics can be found in the very structures governing our modern world. Therefore, our view of the world has been, thanks to this ancient part of our make-up, very 'obsessed' with time, with 'clock-watching' and the 'matrix mind' so much so, that we have forgotten our connection to the *Dreamtime*. Even timetables (daily routines) in schools and colleges are described as a 'matrix', and this word sums up 'R complex perception'. With the infusion of reptilian genes somewhere back in our evolutionary history, we have a perfect vehicle for 'one track', or 'one frequency', perception and this has given us what both ancient and modern sources refer to as the 'dualistic mind'.

DUAL HEMISPHERES OF THE BRAIN

The reptilian or Predator Consciousness, as I call it, can be expressed and controlled by two hemispheres of the brain. We have the *right* brain and the *left* brain, which are connected by a mass of nerve fibres. The left side is the masculine 'rational', logical and intellectual half. This part of the brain works closely with the five senses, touch, taste, smell, sight and hearing. The right brain is the feminine where we manifest imagination, intuition, instincts, dream-states and interact with the subconscious. The right brain communicates through images and symbols, whereas the left communicates through the written and spoken word. The right side is closely connected to the reptilian part of the brain, and reptiles are said to communicate through symbols and associated imagery. This form of communication is our most ancient, as evidenced in the numerous works of art recorded in the ancient world. However, through focusing human perception on dualistic mind-sets, and what scientists refer to as, left brain functions, we have become more and more obsessed with the physical, five sense world. In fact we are manipulated more than we realise by the imagery coming out of television, advertisements and films. Right-side brain traits show themselves in our interest in the

arts, cinema and other vehicles for soaking up imagery at a subconscious level. The left side focuses on logic, five-senses and the written word. The use of subliminal messages through imagery on one hand, while given a worded explanation with the other, is how the two hemispheres are used by the 'media magicians' today, to sell us a particular message. This separation of the two hemispheres has also encouraged the herd mentality in humans, which is the opposite of the visionary-minded individual set forth in this book.

The use of the right side of the brain has been diminished over thousands of years, as humanity became obsessed with the mathematical, logical and more physical perceptions of reality. Education intentionally focuses on left brain functions in children from an early age and has served this state of mind since its inception. The very fact that drawing is not considered an important tool by the powers that shape our children's national curriculums, is a perfect example of bias focus on the left brain hemisphere throughout a child's school-life. Drawing is an important individualistic necessity for developing our imagination and visionary capabilities. The notion of having to be a trained artist is just the system's way of discouraging people from developing an individual approach to drawing. Whoever created the education system knew that children must be discouraged from using their intuitive, creative and imaginative side of the brain, hence the overload of mathematics and logic in infant and junior schools across most of the world, so to emphasise the left-brain activity. Much of the art in school is, at best, a limited and functional exercise in creativity and, at worst, a means of crowd control – something to keep the kids busy when they've finished their work. As John Crace wrote in the *Education Guardian in 2003: "If all art is communication, then even seven-year-olds have a language of their own."* [11] And that is the reason why art and drawing is not considered important within the National (programming) Curriculums both in the UK and abroad. The right side of the brain is the place from where we link with our daydream states and the more subtle creative thoughts that need a vehicle for manifesting in our reality. Drawing, painting, music, creative writing and such, are all vehicles for our right brain activity. The art found in Paleolithic caves made by our ancestors also suggests that the right brain was highly active amongst the ancients.

LIGHT BEARERS

The Greek god, Prometheus, was credited with the discovery of magical power and the human ability to imagine the future by projecting a horizon of possibilities within the mind. This ability is supposedly what sets humans and our animal ancestors apart today and could relate to a sudden shift in human evolution from Palaeolithic animal-humans to a new human form

and brain capacity. Much rock art suggests a fascination for imaginary sequences, involving both animals and humanoids, that seem to be emanating a personal magic. Images of stars, Suns, even phallic symbols, refer to a higher consciousness, a gift of the gods as recorded in many myths. The role of the trickster hero, mentioned in the last chapter, was one who brought knowledge of the eternal and magical power of humans, through our imagination and 'self-awareness'. The animals that were associated with the trickster gods, depending on which part of the world the myth had evolved in, were the raven, the hare and the coyote. In other traditions it was the spider goddess who placed the power of creativity and destruction in the hands of humanity. In this sense we became miniature versions of the power of creation, or a replica of the force that moulds and gives life to all things. The 'gods', in my view, relate to a mixture of extraterrestrial intelligence and animal intelligence (which is much brighter than great swathes of humanity today), and these two streams were used to create the Homo sapiens species. From the genes of reptiles, lions, bears, monkeys and boars, to name but a few, along with human genes, the first man and woman prototype (Adam and Eve) came into the world.

In the end all paths lead back to a sudden realisation by our ancestors of the need to utilise a personal magic, which includes our sexuality and creativity. You could say that a grand trick has been played on us humans. We are said to have been made in the image of the gods and therefore we are gods and goddesses in our own right, with immense tools at our disposal. What we have, which was always there, is the knowledge that we are 'light beings', capable of using our minds, creativity and imagination to change the external world in which we dwell. This is one of the great truths that has been hidden from us. The Predator Consciousness, not least through the brotherhoods that have created religions and other 'prison of the mind' systems, do not want all of humanity remembering its former glory – as a being of light and consciousness that exists in *all* life and reaches beyond the entrapments of the physical world. If humanity could awaken from its spiritual slumber, open its eyes and its heart, then that former state (our divine form) would automatically flood every cell of our being. We don't have to go out and find this level of consciousness, it is already with us and waiting to be tapped into whenever we choose to do so. By accessing our imagination and using our own creative powers, we automatically activate and recognise the light within us – no Jesus, Mohammed or Buddha required! In truth, we are all aspects of the same consciousness that creates both light and dark, Earth and Heaven, love and fear. We also have the IMAGINATION to recreate any reality we require in our lives. Our highest power is our ability to reshape our destiny, create our own realities and move between different dimensions of thought. All of

this takes place through our personal creativity, our process of self-discovery and our ability to laugh and play in the playground called Earth!

NOTES

1) *A Dictionary of Egyptian Civilisation*, Methuen, p158

2) Hall, Manley Palmer: *The Secret Teachings of All Ages,* pp 103-106

3) *A Dictionary of Egyptian Civilisation*, Methuen, p284

4) Neurobiologists accept that the fundamental cell type in the brain is the neuron. Neurons are connected to other neurons by synapses. See the work of Gerald Edleman

5) Lewis William, David: *Mind in the Cave*, Thames & Hudson, p190

6) *Paragranum* 1530

7) Fludd, R: *Utriusque Cosmi*, Vol II, Oppenheim, 1619

8) Blake, William: *The Gates of Paradise*, 1793

9) Blake, William: *Milton* 1804

10) *The Scientific American* Volume 14, Number 1, 2004, p100

11) Crace, John: *Drawing Benefit*, An article written at the time of the Big Draw Campaign.

MAYA OF THE PLEIADES

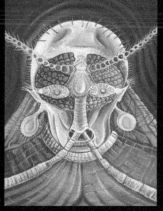

MANTIS MAN

ATLANTEAN BLUE

SASQUATCH (BIGFOOT)

LYRIAN ATLANTEAN

SHEM-SU-HOR

SIRIAN LION-MAN

THE GREYS (PINKIES)

LITTLE PEOPLE

PART FOUR

BEYOND

HEAVEN & EARTH

Thy light alone... gives grace and truth to life's unquiet dream.
Percy Bysshe Shelley

Through the Looking Glass

My Father's House has many mansions

Nature is not only queerer than we suppose,
it is queerer than we can suppose.
J.B.S. Haldane

It's quite possible the ancient shaman or artist, is in actual fact, perceived to be a "hero" because of his or her ability to traverse hidden realms and endure physical initiations. The early shaman was a priest figure who could 'see into the future', draw on unseen forces and communicate with non-physical realities. But one does not have to be a 'shaman' to perceive the world as a dream, or to 'see' into alternative dimensions.

The Aboriginal Dreamtime is a 60,000 year-old creation myth that tells of how the world was 'dreamed' into existence. Our creativity, inspired art and poetry are keys to the dreamtime state. So is our ability to 'dream with open eyes' and see through the world, rather than be mesmorised by it. When we do this, especially through creativity, we become aware of our multidimensional aspects of being which exist in the dreamstate. All of our art, myths and beliefs are inspired by thought-forms and archetypal models that constitute different levels of consciousness and states of mind. Most states of mind are 'programmes' stemming from sources that today are often described as extraterrestrial, possibly 4D in origin, but in reality, these other worldly levels of intelligence have always existed, they are part of a bigger 'dream' – the world *beyond* the looking glass. In this chapter I will explore some of the parallels between extraterrestrial imagery, myths, art and science.

STRANGE CREATURES NOT SEEN WITH THE NAKED EYE

In the ancient world, it was the shaman who ventured beyond the limitations of the five senses. The goal of the shaman/artist was to communicate with 'unseen forces' and bring into balance energies surrounding and shaping the world. Seeing beyond the outer limits of perception was considered the

realm of the occultist in Elizabethan times. Wizards, warlocks, magicians and occultists, from all eras, were fascinated by what the likes of John Dee and Edward Kelly called 'pandimensional' entities. Dr John Dee was well-versed in what the Old Testament calls 'Enochian Magic' which goes back to the time of the gods as mentioned in the Sumerian Tablets.

It's said magicians like Dee, discovered parallel worlds occupied by what he describes as archons, or interdimensional creatures, some of which I focus on in *Chapter Five*. Other magicians amongst Dee's circle were adepts: William Blackhouse, Elias Ashmole, Robert Boyle, Robert Fludd and Nostradamus. All of these men are connected to the royal bloodlines of Europe through their work with alchemists and artists from the same period. Like the ancient shaman/magician/artist, Dee was involved in ceremonies designed to go beyond the veil and into the 'in-between worlds'. Along with Sir Francis Bacon, these influential figures founded what became known as the 'invisible college' – the mystery school network that created the universities we know today as Oxford and Cambridge. These centres of learning, along with other monastic centres mentioned in earlier chapters, are set up to 'control' knowledge and deny access to levels of understanding that stretch the imagination beyond the physical realms (see all mainstream science). These universities are also primary centres for advancing the laws of science, that still today shackle the minds of many people. C. S. Lewis (author of *The Lion, the Witch and the Wardrobe*, 1950) who was based at Oxford, calls these invisible entities 'microbes'. Lewis, for me, is fully aware of the interdimensional nature of reality. Many of the creatures he illustrates in the *Chronicles of Narnia* appear in art and myths since ancient times. Lewis was also a staunch Christian which explains his use of the lion as a saviour figure in the stories. Modern accounts by individuals claiming to have had contact with extraterrestrial levels of consciousness, describe similar inter-dimensional characters.

The Lion (Aslan) in *The Lion, the Witch and the Wardrobe* is a highly significant level of consciousness that relates to spiritual sovereignty within us all. It's also a consciousness, or awareness, that can melt the myopic 'freeze vibration' as symbolised through the Snow Queen in the same story. Lewis writes: *"Mankind takes for granted the world of the microbe."* As I shall cover in this part of the book, Lewis's work, like those of his friend J.R.R Tolkein, are teeming with references to parallel worlds, forgotten realms and a world history that is gleaned from ancient mythology. Both 20th-century writers were members of the Oxford élite and would have had access to the masses of untranslated medieval manuscripts locked up deep in the vaults of Oxford University. Other points of reference would have been the alchemical texts created by the likes of Dee, Fludd, Ashmole and their shared knowledge of

micro-entities. Lewis, appropriately, even writes about aliens and their internment on our Earth which he refers to as the 'Silent Planet'. In many ways, Tolkien's fictional work also disseminates many truths relating to the real history of planet earth, much of which he would have seen in the ancient manuscripts in the vaults of Oxford university.

The types of creatures said to have been encountered by Dee can be found in much visionary art, not least the series of visionary heads made by William Blake, especially his 1819 painting *The Ghost of a Flea* (see figure 114).

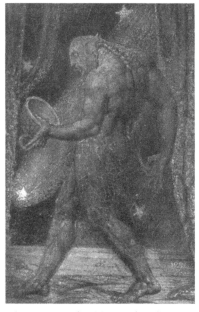

Figure 114: *The Ghost of a Flea.*
© Courtesy of the Tate Britain

Figure 115: Alien flea persona.
A microscopic image of a biting midge.

Blake made this image in response to the growing trend of portraiture painting, which in the late 18th and early 19th centuries was the only art form applauded and rewarded by the élite of its day. True vision was inward, not outward for Blake, and this image is mainly a reposte to the likes of Joshua Reynolds and the Royal Society. It was also made at a time when 'scientific vision' was obsessed with the laws laid down by Isaac Newton. The image is part of a series of visionary heads made for his astrologer-friend and landscape painter, John Varley. The interesting aspect of this image is that when one looks at microscopic images of fleas, midges and spiders, a whole new dimension opens up in terms of how we see these insects. They become almost 'extraterrestrial' by nature, others take on human proportions, especially the head of the biting midge (see Figure 115). Interestingly, Blake seems to have captured the microscopic or pandimensional view of the biting midge (culicoides) in his artwork; a view not available to the doctors and etomologists of his time. In fact, according to historical records, midges and fleas were not even mentioned by the likes of Samuel Johnson and H. T. Stairton, who were contemporaries of Blake and working at the time Blake painted his image.[1]

Figure 116: Pandimensionals beings.
(Top Left) A strawberry stem. **(Top Right)** A raspberry stem. **(Left)** A Hopi Kachina. **(Right)** A blue corn stem.

When plants and fruits are observed under microscopes, we also see a new dimension, or even a vision, of how these *living* organisms could have influenced the ancients' perception. Some of the microscopic images of raspberries, strawberries and corn stems seem to take on a visual appearance not dissimilar to the faces of Native American deities, such as the kachinas, found in Native art and beliefs (see Figure 116). I can just see the aboriginal shaman, reaching for the microscope before going on a vision quest, or consulting the medical journal on flora and fauna, while sitting in communion with the ancestors. Obviously, the ancients are accessing their visionary capabilities when it comes to 'seeing' other levels of reality. Herbs and plants, not least hallucinogenic types, may well have communicated to shaman artists on a level that aided them to see plants as a personage, or something seemingly extraterrestrial by nature. Much Aboriginal art shows 'plants as people' and there is an extensive folk history of 'little people', fairies and transparent people found in rock art and myths all over the world. In fact, Christian cathedrals are covered with these little tykes! The only reason for this, is the priesthood that invented Christianity, like the early shamans, were celebrating the fact that nature (our reality) harbours energetic connections to otherworldly forces and intelligences not seen with the naked eye.

INSECT GODS

Insects of all kinds are considered emblematic of nature spirits and daemons constituting 'unseen' forces that exist alongside our physical reality. I write at length about these elements and their relation to alchemy in my book *Through Ancient Eyes*, but here I want to look at the connections between insects and otherworldly forms more often portrayed by shamans and priests as insects or birds of the air.

The ancients assigned both benevolent and malevolent conditions to certain animals and insects. Some of these entities became fabulous beasts or

creatures recorded in their art and myths. Quite often beautiful symmetrical forms were associated with benevolent forces whilst the more contorted and inverted the force, the more malevolent that force was deemed to be. The butterfly for example is a symbol for the human soul because of the stages it passes through. It also represents three stages of initiation in the ancient mystery schools and is a symbol for the human psyche. According to some writers, the three divisions the butterfly passes through relate to the lower three initiation levels of the ancient mystery schools.[2]

The grasshopper and the mantis are insects that show us the illusionary 'holographic' understanding of light, especially how both creatures use their thousands of eyes to see (figure 117). Both mantis and grasshopper are considered 'divine creators' by the San Kalahari Bushmen of Africa.[3] In San mythology the mantis is said to have brought life or 'honey' to the many antelopes and depending on the type of honey (colour/light/DNA), the animals supposedly took on their varied complexions. According to San lore, the sacred mantis is married to the hyrax (a small mammal) and their daughter is the porcupine. Other myths speak of the mantis creating Eland

Figure 117: Images of the 'living library'.
The connection between insects, animals and humans, through the DNA as seen through the microcosmic, or macro lens.

antelopes and of the 'kwammang-a' (human ancestors) killing the first eland, causing the mantis to create the Moon from its gall bladder. This legend is close in theme to the Kokopelli myth and the story of 'Tecuciztecatl' in Aztec belief, relating a viable and common theme of a time *before* the moon arrived, taking its place next to the earth. I feel myths of this kind speak directly of a time *before* time - the Dreamtime. Other myths relate the mantis to a time when the Sun is said to have lived on the Earth and how the creator caused a 'split' prompting the duality of life and death, or light and darkness.

The spider on the other hand is considered by mystics to be an emissary of the dark forces. Paracelsus taught that the spider was the medium for a powerful but evil force that black magicians use in their nefarious undertakings.[4] Other myths associated with the spider gods or goddesses relate to the making of the Universe connecting the realms of light with dark, or with the seen and the unseen. The web of life (the shaping forces of creation or reality) is also connected with insect deities. Bees, flies, the mantis and scarabs are just a few types of insect revered in both indigenous worship and the temple orders of antiquity. The beehive can also be found in Freemasonry and, as I have already shown in earlier chapters, relates to the priest kings and their knowledge of a universal life force, often depicted as a circle of bees.

The fly is considered another symbol for forces operating outside of our physical dimension. The fly is seen as the 'tormentor' because of the annoyance it causes to animals. The Chaldean God, Baal, is often called Baal-Zebul, or the god of the 'dwelling place' and the word 'zebub' or 'zabab' also means fly.[5] The scorpion, too, is considered a symbol of both wisdom and self-destruction and is often assigned to Judas Iscariot as one of the twelve disciples (signs of the zodiac). Initiations into the mysteries were often done under the sign of Scorpio (i.e. Hallowe'en through to Yule) and it is said in the *Egyptian Book of the Dead* that a scorpion man guards the gateway to the Sun. The Sun, as a creator, is also shown as a scarab by the Egyptian priesthood and initiates who often called scarabs. The sky for the Egyptians was a vast meadow of stars across which the scarab beetle pushed the disk of the Sun, sometimes said to be the dung ball made by the scarab itself. Insects and their habits were carefully studied by the ancients because within the microcosmic world of the insect came many gods and powerful forces that were considered creators or destroyers depending on how human life force is used to shape reality. As Buddha supposedly said of our life force: *From the same food and the same circumstances the hornet produces poison whereas the bee produces honey.*

THE LITTLE PEOPLE

Gothic cathedrals of Europe are covered in what many Native cultures refer to as the 'little people'. These usually come in the form of animals and hybrid

human-animal forms. On Gothic architecture they are seen creeping along arches and capitals, and in some early Renaissance paintings, inside orbs. As recorded in much folklore, the little people represent 'unseen forces' said, by the ancients, to dwell in sacred places, such as earth mounds, hills, groves and underground chambers (see figure 118). Other depictions of the little people are found scraped into ancient stone and petroglyphs. Such art speaks of 'invisible entities' but the modern mind sometimes perceives them as extraterrestrial. At this point I am not saying that all art and sculpture placed

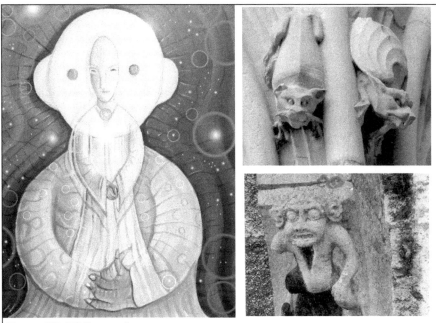

Figure 118: Little people.
Left: These are tiny figures I have often seen in my dreams. **Right:** The two photographs are just two of hundreds taken of sculptures that adorn Christian cathedrals, depicting little people in folklore. © Neil Hague 2004

on temples relates to extraterrestrials. What I am referring to relates to what we can't see (from within the narrow band of light we call five-sense reality); outside of the five sense reality there could be multiple sources of extraterrestrial phenomenon.

Ufologists are constantly looking for 'physical' sources for alien life when they may well be under our very noses in the form of microbes and microcosmic personas projected by our DNA. Even our so-called physical reality can be shown scientifically to not be a solid (nothing is), so therefore, the many worlds (dimensions) constituting what is described as 'extraterrestrial' will also not be solid. They only become solid (physical) once we see, feel, smell, hear and taste them into existence! The brain does this, just as a computer reads codes and translates them into images, movies and sounds.

The little people phenomena, for me, relates to the world of the minute, unseen organisms and their connection to the stars which are clearly seen in images of nebulas. In a more symbolic form the little people are drawn in ancient art as matchstick figures, often with a halo or surrounded by energy fields. In a vivid recurring dream I had as a child, I can remember seeing what seemed like thousands of these multicoloured little people descending from the sky and landing on the rooftops of the houses around my parents' home. I know now that what I was seeing, from an early age, is another level of reality. Just as fish cannot see the world above them (unless they are caught), we, too, are unaware of worlds existing beyond the frequency range we define as physical. Only 5% of all matter in the universe can be seen, yet we presume to know all there is to know about life in the Universe? Scientists working in the field of quantum physics have come to the conclusion that moving through higher and smaller dimensions was, and quite possibly still is, reserved for advanced extraterrestrial civilisations.[6] Just as geometry and platonic (Archimedean) solids found in nature are invisible unless magnified, microbes, little people, or extraterrestrials also remain hidden, unless, we access a sight that cuts through the veil we call 3D reality. Visionaries, artists/musicians/writers, etc., who have achieved this ability have all seen what I call the 'next level of the matrix illusory world', the lucid images of a world beyond the reflection.

ORCS, REPTILES AND RINGWRAITHS

I am convinced J. R. R. Tolkien and C. S. Lewis knew extraterrestrial life forms (untapped aspects of junk DNA) were part of our post-diluvian earth. I have been laughed at for stating this over the years, but when archeological finds came to light in 2004, such as the 18,000 year-old 'Hobbit' man in Indonesia, then one can only wonder what else might be waiting to be discovered. As I have touched on in previous chapters, the reptilian nature of entities found in portable art, myths and in modern cinema, especially, is a constant theme. Peter Jackson's fantastic films based on Tolkien's books, stretch the imagination even further when it comes to being immersed in alternative historical worlds. William Blake's personal mythology one hundred years before Tolkein put pen to paper, also uses old Anglo-Saxon words such as *orc*, to describe a demonic lower self. Paintings by the 19th-century German expressionist Arnold Bocklin also show flying serpents being ridden by classic images of death: the Grim Reaper (or Ringwraith). Also in Walter Crane's 19th-century painting, *The Horses of Neptune*, we see giant horses appear in the water and can understand where Tolkien might have taken his inspiration for Arwen's elf scene, when she summons 'water horses' to wash over the Ringwraith in *The Lord of the Rings*. Whether he did or did not use these artistic reference points is irrelevant, the point I am illustrating here is

**Figure 119:
Reptilian
Humanoids.**
William Blake's *Six-foot serpent attacking Agnello Brunelleschi,* found in Danté's *Divine Comedy,* created between 1824-27.
© National Gallery of Victoria, Melbourne.

that there seems to be an almost 'archetypal' language employed by those accessing their visionary sight.

As shown so far, themes of human-serpent hybrids, demons, dwarfs, fairies and trolls can be found in art all over the ancient world. Dante's epic 14th-centruy poem, *Paradiso,* also has many visual references to humanoid reptilians thanks to the visionary skills of British writer and artist, William Blake. Blake illustrated Danté's poem in the early 19th century. In several studies we see figures shapeshifting, or reptilians devouring those in Hell (see figure 119).

As we have already touched on, ancient artist/priests went to great lengths to portray strange idols and images not fully understood, unless one can grasp the idea of alternative realities housed within our DNA. The Egyptian and Sumerian civilisations, especially, made art depicting lizard-like gods. A fantastic amount of imagery found in science fiction which is the tool of the visionary of the 21st century, portrays similar creatures and themes. Modern day experiencers of extraterrestrial phenomena also capture, through individual art forms, similar subjects and symbols that speak of these phenomena. Many of these individuals have experienced time travel, out-of-body flying, dream-states and strange, otherworldly occurrences since childhood. Mary Rodwell, author of *Awakening: How Extraterrestrial contact can transform your life* (2010), highlights the types of scenarios, signs and experiences shared by individuals from all over the world. After meeting Mary and lecturing alongside her several years ago, I am convinced that extraterrestrial phenomena in relation to higher dimensions and our DNA is very much a major part of human evolution. The very fact that millions are drawn to science fiction, a cover story for truth, and imagery found in computer games, films, cartoons, children's television programmes, not to mention the vast wealth of historical art, makes me think that extraterrestrial dimensions are part and parcel of who we are as multidimensional human beings.

VISIONARY THEMES AND ALIEN ART

According to the many thousands of individuals who have experienced alien contacts today, there are numerous types of extraterrestrials. I am not about to go into great depth regarding 'experiences' in this chapter, but, as an artist, I am interested in the 'types of imagery' which continually crop up when we access our ancient 'visionary' sight.

Various humanoid races are described as having varying personalities, some are self-centred, some hostile, and others are more spiritual. Earthlings are described as being descended from several lines at different times and with a complex celestial ancestry. Studies into the different types of 'alien roots', especially by various alien abduction researchers since the 1980s, show six main entity types. Researchers, like Jacques Vallée in his work *Passport to Magonia* (1993), collected a century of worldwide landing reports, case reviews and entity sightings from between 1868 and 1968. The six main frequent extraterrestrial beings encountered in his and other case reviews are said to be: human entities, humanoid, animal entities, robot entities, exotic and apparitional entities. Interestingly many of the strange encounters witnessed by individuals all over the world also fit with more ancient descriptions of entities as depicted by the Sumerians, Egyptians, Indian and American artist/shamans. The most common include the grey, insectoid, mantis-like entities, reptilian-like entities, lion beings and a variety of human-like entities.

Alabaster Eye Idols and strange figurines found at Tell Brak in North Eastern Syria (dated to 3,500 BC) show what appear to be exotic robot-type entities (see page 342). These miniature sculptures are very similar to the modern day appearance of the infamous grey aliens witnessed by thousands of individuals over the past five decades. I personally feel the grey is one of several species of 'extraterrestrial' lacking a spiritual compassion, but with an advanced intelligence (technology) allowing it to enter into our reality and, too often, perform despicable acts on humans and animals. I also feel some of these 'abductions' are carried out by military personnel (above top secret) 'disguised as', or in league with extraterrestrials of this kind! Other forms of 'alien' intelligence, of which we are direct descendants, are much more 'spiritually aware'. And some, I feel, are future versions of ourselves who have come back into this space-time to aid humanity in remembering who they really are.

The same can be said of the stars and their connection to humanity. The stars are not apart from us, they represent a point in time that becomes each individual human. You could say there is a star for each and every living soul and the diversity of life forms found on the surface of the earth is a reflection of the 'myriad forms' (via DNA) projected out of dimensions from beyond time. In relation to visionary art, there seem to be common subjects and themes that transcend time, and constitute realms of consciousness that are accessible via our spirit and imagination. Certain subjects and symbols are used to articulate non-physical realms and it is highly plausible that a pictorial language survives from an ancient epoch when humanity was part of the *Dreamtime*. Constant themes relating to transformative realms, archetypal

mythic beings, celestial worlds, hell worlds, apocalyptic imagery, energy fields, abstract geometric forms, mandalas and imagery associated with divinity are just a few common subjects appearing in both ancient and modern visionary art. In the next few pages I want to piece together some of the connections between extraterrestrial encounters, myth and visionary art.

UFOS IN RELIGIOUS TEXTS

The Indian *Vedas* and the Book of Ezekiel in the Bible provide a rich source of possible UFO material. The *Vedas* consist of three main texts, the *Bhagavata Purana* (900 AD), the *Mahabharata* and the *Ramayana* (600-500 BC). The actual content of these texts is considered to be much older and according to native Indian tradition, they date back to at least 3,000 BC. In 1931 James Churchwood brought to the attention of the western world the many descriptions of alien races and their flying vehicles found in these historical texts. The term for a 'flying vehicle' in the *Ramayana* is 'Vimana' and there are numerous mentions of such ships along with high-tech weapons and battles in the sky. One text describes these vehicles as having a double deck with portholes and a dome. There are also murals from the Lukhang Temple in Tibet (8th century) clearly depicting saucepan-like ships carrying sages through the sky. I published a book by Matthew Hurley in 2003 called *The Alien Chronicles* (now out of print) which lists endless references to UFOs found in ancient texts and historical art.

In the Bible we find possible references to UFOs and probably the most well known reference is contained in Ezekiel's vision. Ezekiel was a priest sent to Babylon in 597 BC and five years later it is written that he had a series of visions which lasted for a period of nineteen years. One of them is as follows:

> *I looked, and I saw a windstorm coming out of the North - an immense cloud with flashing lightning and surrounded by brilliant light. The centre of the fire looked like the glowing metal, and in the fire was what looked like four living creatures. In appearance their form was that of a man, but each of them had four faces and four wings. Their legs were straight; their feet were like those of a calf and gleamed like burnished bronze. Under the wings on their four sides they had the hands of a man. All four of them had faces and wings, and their wings touched one another. Each one went straight ahead they did not turn as they moved. As I looked at the living creatures I saw a wheel on the ground beside each creature with its four faces. This was the appearance and structure of the wheels: they sparkled like chrysolite and all four looked alike. Each appeared to be made like a wheel intersecting a wheel. As they moved, they would go in any one of the four directions the creatures faced; the wheels did not turn about as the creatures went. Their rims were high and awesome, and all four rims were full of eyes all round.*

When the living creatures moved, the wheels beside them moved; and when the living creatures rose from the ground, the wheels also rose. Wherever the spirit would go, they would go, and the wheels would rise along with them, because the spirit of the living creatures was in the wheels. (Ezekiel 1:1-28)

The *Koran* also has accounts of non-human beings, and Islam, in fact, describes three distinct species of intelligent beings in the Universe: angels, humans, and jinns. Angels are high beings created of light, humans are created with bodies of clay, a poetic language for physical bodies assembled from mineral and chemical elements of our Periodic Table. Jinns (archons in Gnostic texts) are described in the Koran as being created *before* human beings and can take form through earth, fire, water and air. Researcher Gordon Creighton mentions that some jinns could be fully physical and what we today call extraterrestrials, while other species of jinn have an altogether finer sort of matter. Many jinns are described as being devils or 'shaytans', others however in the *Koran* are described as positive in nature. It's my own feeling that many thousands of experiences relating to extraterrestrial entities relate to interdimensional forces interpenetrating our reality. The types of beings moving through different dimensions to interact with humanity (in 3D) have a specific connection with the DNA of a person, or individual, in terms of his or her consciousness.

ABORIGINAL STORIES OF EXTRATERRESTRIALS
The Hopi Indians possess some interesting tales regarding extraterrestrials, especially the stories of their first world called 'Toktela', meaning infinite space. The Hopi creator, called 'Taiowa', is said to dwell in Toktela before creating human beings. His supreme law (to the Hopi) was: "Thou shalt not kill." Similar themes are also recorded in the Old Testament in relation to Moses who could have been from a specific extraterrestrial race. Themes about laws written on stone tablets are common in both the Hopi and Hebrew faith; therefore, could a god (or gods) have inspired the same laws? Did an extraterrestrial group appear simultaneously (interdimensionally) all over the ancient world to deliver a message to mankind? Or are we looking at the work of an advanced secretive brotherhood (cult) that travelled great distances, bringing the same teachings to native people in every continent? The mysterious Viracocha I mentioned earlier in the book, along with the allusive Phoenician priesthood, may have been responsible for the widespread teachings that have appeared in books like the Bible and the Vedas. All of the wars, destruction of cities and the levelling of vast areas of land as recorded in the ancient texts, relate directly to a time when advanced intelligence (possibly extraterrestrials) battled it out for Earth (our physical reality). Legends relating to an immense battle between forces of good and

evil (see *Star Wars*), could also relate to the duality of reality caused by the splitting of infinite consciousness which the Aboriginal tribes of Australia say occurred at the end of what they call 'Churinga', or the Dreaming.

The Aboriginal Dreamtime tells of a process of creation from where a new level of evolution (consciousness) occurs with every passing precession through the constellations. It's at this time when, what they call the 'wisdom fish', sprays his wisdom seed upon the eggs of creation. According to their legends it was 'Lightning Man', who astrologically is Orion (Viracocha/Osiris), through his lightning brought into being the 'Rainbow Serpent' of creation. The eggs laid by the Rainbow Serpent, according to the Aborigines, are the stars of the Milky Way. Subsequently, each egg was said to become a different tribe of peoples of the earth, hence the connection between the stars and DNA.

DUALITY, DNA & HEALING

According to ancient legends, the stars (tribes) have been at war since the end of the Churinga or *Dreamtime*, which came about when the splitting of the infinite soul (God) produced duality symbolised in religious myth as angels and fallen angels. The same knowledge is contained in the *Qumran War Scroll*, written by the Essenes, and relates to the much earlier teachings of Zoroaster in 6th century BC. The opposing forces in the teachings of Zoroaster take the form of the 'Lord of Light' (Ahura Mazda) who was locked in battle with 'Ahriman' the Lord of the Dark. It's written that when light withdrew from the world, particles remained trapped in the darkness that binds matter. The same philosophy was taught by the Zoroastrian (Gnostic) priests of 12th and 13th century France in the guise of the Cathar parfait. In all versions, Zoroastrian, Essene and Cathar, the restoration of duality would come about when humanity ceased the conflict within themselves, healing the divisions manufactured by polarity and duality. In fact, the Bible is no more than the story of opposing forces and how they shape the past, present and future reality. Art, at its highest level, is also a vehicle through which we can encompass and balance our duality. Letting go of guilt, fear and emotions holding us in polarity is part of the healing process.

In relation to extraterrestrial entities these two 'opposing' categories have also been given other names such as 'Evas' and 'Dracos', which can be found in what is referred to as the *COSCON Files.*[7] The former is said to be the seed of humanity and the latter, entities associated with reptilian consciousness. However, nothing is black and white and the shaping of our world by interdimensional forces connected to specific levels of consciousness (which includes extraterrestrial DNA) seem to involve both strands of consciousness.

In terms of interdimensional forces affecting our physical reality, the fallen

angels and their ancestors are still influencing our world today. The past, present and future *are* the same thing, and have no distinction from a higher dimensional viewpoint, therefore interdimensionals using their priesthoods at Stargates (or portals) at specific sacred sites on the earth, have been drawn into this dimension to feed off fear, conflict and separation. This has been done through war and ritual killing in the ancient lands where the original portals are situated. Places like Iraq, Afghanistan and Asia, not to mention parts of America, Africa and Europe at specific locations on the earth, invisible forces exist that can interpenertrate the physical world. When a major war is fought in and around these portals, then the levels of fear, harnessed as an energy source, feeds the non-physical worlds. Interdimensional forces 'intervening' in human conflicts are mentioned in the *Book of Hopi*, where one story tells of the otherworldy kachinas coming to the aid of the Hopi in an ancient epoch:

> *In ancient times there was a battle for the Red City in the South. Wherever they came from, all the tribes were accompanied by Kachinas, beings who were reputed not to be of the 'fourth world', indeed, they were not men at all. Nevertheless, they always proved themselves to be protectors and advisors of the tribe and frequently helped them out of tricky situations with superhuman powers and arts. This was what happened in the Red City in the South when some Hopi tribes were suddenly attacked from all sides. With the speed of the wind, the Kachinas built a tunnel through which the Hopis were able to flee into the open behind enemy lines without shedding blood. When they said goodbye, the Kachinas said to the chieftains: We are staying to defend the city. The time for the journey to our distant planet has not yet come!'* [8]

TEACHERS FROM THE STARS

For the Hopi, a kachina is a masked spirit that can assume the form of any physical object, phenomenon, or living being. Deities such as Kokopelli (one of three hundred types of Kachina), and 'Bep Kororoti', of the Kayaua Natives of Brazil, are common examples. Bep Kororoti was said to have visited the village in ancient times wearing a 'bo', a straw suit covering him from head to foot (see figure 120). He carried a 'kop', a thunder weapon, in his hand, which today would be seen as some kind of advanced

Figure 120: Bep Kororoti.

technology. The villagers were scared at the presence of this strange being, some of the men of the village tried to attack Bep Kororoti but their weapons turned to dust. He demonstrated the power of his kop by aiming it at a tree and then a stone, destroying them both. Eventually when the villagers realised he meant no harm they befriended him. Kayaua legends say Bep established a school where he taught the villagers many things, including the construction of better housing. He was also said to have married a local lady and they had children.

The story surrounding Bep Kororoti is so similar to other 'star god' myths, which talk of beings intermarrying with the daughters of earth tribes in the ancient world. Bep Kororoti, along with the Wandijina and Viracocha figures, were considered to be harbingers of an advanced technology used in the construction of earth's most fantastic sacred sites. I don't think it's too far-fetched to imagine star-beings wielding advanced technologies and being responsible for the ancient world's architectural wonders. The Pyramids, Easter Island, the Triatholon at Balbek along with other mysterious works, to name just a few, all seem to be aligned (or affiliated) to specific constellations. However, there seems to be common ground in both ancient beliefs and modern accounts that relate to three specific constellations: Orion, Sirius (A and B) in Canis Major and the Pleiades in Taurus. There have been many books written about these constellations and the types of extraterrestrials often said to have originated from these three and other star systems. It is not my intention to concentrate on categorising the many different aliens encountered, but in the next few pages I want provide insight into the main common groups influencing our world.

ORION AND THE GREYS

29,000 years-old rock art from Itolo in Tanzania, show, what appear to be Grey aliens. As do 5,000 year-old Aboriginal petroglyphs from Kimberley in Northern Australia that show strange figures called 'Lightning Brothers' and other 'little people'. There are also images of what the Aborigines call the 'Wandjina', which also have an alien appearance. Stories of the Wandjina have been preserved in fascinating oral traditions and in large collections of rock paintings also scattered throughout Northern Australia (see the *Alien Chronicles* by Matthew Hurley for more information). In fact, drawings of the 'Ant People' made by the Hopi are remarkably similar to the Wandjina, or even the Greys, with their large heads and little stocky bodies.

In 1967, Stan Seers, author of the book '*UFOs – The Case for Scientific Myopia*' (1983) related an interesting story from the people of Papua New Guinea. It tells of the 'mud men' (Greys) with strange heads bringing local tribes to the land of New Guinea Highlands, and who one day, come back to

take them in life or in death. The current and accepted interpretation of the 'mud men', their history, body art and masks of clay is simply a local Papua New Guinean response to death, by representing death as flaking skin of corpses. The tribespeople's skin is coated with *grey* river mud for effect and a heavy mask is made to cover the face of initiates. We can draw parallels here with the Bep Kororoti story from Brazil where tribespeople attire themselves in a costume and make up to re-enact ancient events of a 'visitation' from their creator gods, possibly alien in origin.

Much has been written about the Greys of the star system, Zeta Reticuli, and its connection to Orion and other Zeta stars. "Those that are of Orion" is the apparent meaning of the term Nephilim from Genesis 6:4 of the New English Bible. Masonic researchers, Christopher Knight and Robert Lomas, claim that the root Aramaic word 'Nephîliâ' is one name for the Orion constellation. The Nephilim, of course, are familiar to readers of the late scholar Zecharia Sitchin, who translates the word, Nephîliâ, as: "those who were cast down upon the Earth!" The King James version calls them giants and in *Orion's Door* I connect what I call the 'Age of Orion' with the time of the giants, Watchers, Anunnaki, or the Nephilim, on earth. Just before the Great Flood the sons of the gods, interpreted as either fallen angels or the Watchers mentioned earlier in the book, 'mated' with the daughters of men to produce these giants. It may be more than a coincidence that the word Nephilim

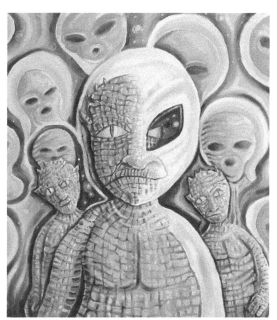

sounds much like the Hebrew word 'nemâlâh', which means ant. In this case, 'morphology' rather than size is the primary factor. If the Nephilim are indeed 'of Orion', the Ant People, or 'Zayamuincob' in the Mayan language, could actually be those who were cast down from the skies, perhaps from Orion (or Zeta) itself? Archaeologist J. Eric S. Thompson writes in *Maya History and Religion* (1970):

Zayamuincob can be translated as 'the twisted men' or 'the disjointed men,' suggesting a connection with 'hunchback'. The

Figure 121: The Greys (Pinky-pinkies), or Ant people. © Neil Hague 2004

word may also be connected with zay, 'ant', for there is also a Yucatec [Yucatan Maya] tradition of an ancient race called 'chac zay uincob', red ant men.[9]

According to author, Gary A David, The Hopi term for Orion is 'Hotòmqam' which literally means either 'to string up' (as beads on a string), or 'trey'. This could refer to the three stars of Orion's belt but also to the tripartite form of the ant: head, thorax, and abdomen. The shiny, bead-like sections of the ant's body may have their celestial counterpart in what the Hopi consider the most important constellation in the heavens. As I point out in *Orion's Door*, the Hopi along with many aboriginal 'first peoples' revere Orion as the home of their gods. The appearance of Orion through the overhead hatchways of Hopi kivas (semi-subterranean prayer chambers) still synchronizes many annual sacred ceremonies, not least the equinoxes.

Through my own artwork, I have come to realise that the Grey's appearance is actually an outer shell for something more reptilian which emphasises the connection between the Nephilim and the Annunaki (reptilian) gods of Sumeria. I also feel there is a connection between more amphibious gods and insect entities (possibly Ant People) worshipped in the ancient world, and the reported interactions between Greys today (see Figure 121). Therefore, if we are to fully understand the nature of our reality we may have to look towards the microcosm and the macrocosm to appreciate the possibility of extraterrestrial entities brought to life through the 'power of our mind', DMT and living memories within our DNA.

MACHINE CREATURES

Robot and cyborg obsession goes back to the ancient world, not least through Greek myths relating to Hephaestus and *Talos*. There are so many references to 'cyborgs' or 'machine creatures' in modern film and literature (too many to reference here), with movies like the *Transformers* (2008-2017), and the 'Borgs' in the *Star Trek* franchise; all give an idea of the types of 'aliens' that are machines. Living machines, such as the *Daleks* and *Cybermen* in *Doctor Who*, not to mention the 'machine world' in the *Matrix* movies, are all part of an artificial intelligence from beyond our 3D reality. Similiar cyborg themes appear in the American historical fantasy drama series, *Da Vinci's Demons* (2013-15) which presented a fictional account of Leonardo da Vinci's early life. However, there was nothing fictional about Da Vinci's interest in automatons and futuristic weapons. You can see Da Vinci's replications of his 'fascination' for Automata if you visit Chateaux Amboise, the royal seat of the French king, Francis I in Amboise. At Da Vinci's home, Château du Clos Lucé, is a model of Leonardo's humanoid-designed robot (an automaton knight) with inner workings, constructed around the year 1495.

The Wetiko (Archon) vibration, or state of being I mentioned in *Part Two*, can be seen to manifest as a cyborg (machine) reality, too. The types of extraterrestrial I am referring to seem to survive through the 'death and destruction' of the organic world, while thriving in a parallel machine matrix. This 'realm' is both astral and technological in nature, a space that resembles 'data' and fractals overlaying our organic world and seen by those who take DMT. The bestselling author, Graham Hancock, in his book *Supernatural: Meetings with the Ancient Teachers of Mankind* (2005) also relates how he saw a 'technological reality' while usng DMT.[10] Other DMT users as part of Rick Strassman's DMT project at the University of New Mexico also saw circuit-like machine environments and 'clown-like' entities within a car-nival-like realm.[11] I too have seen similar imagery while meditating and have illustrated these realms in my graphic novels, *Moon Slayer* and *Aeon Rising*. I am sure this machine realm is the source of what we call consciousness A.I. along with extraterrestrial life forms 'possessing' the earth's elite (the 1%). The technology harnessed from the machine realm provides power struc-tures designed to 'enslave' our planet through all forms of warfare (see all-things Covid), financial destitution and 'harmful technology,' radiation, 5G, HAARP, Chemtrails and other 'AI-weaponry'. The same forces, I would sug-

gest, are using a new wave of tech-nology through smart grids, Wi-Fi, GMO monoculture (Big Biotech) and mass toxicity, so to alter the blueprint of our world (our DNA). The human race (the earth) is under attack by a *genuine* 'alien' (extrater-restrial) technology on so many lev-els that we often fail to see the mass deception in our world. Something *is* wrong on so many levels that it is not inconceivable to suggest that we, as a planet, as a collective human race, are being steered towards a cyborg-AI controlled real-ity—the Cyber-Grid mentioned pre-viously in *Chapter Ten*. A reality that would eventually have synthetic humans walking amongst us.

In Lakota myth, there is a giant spider called 'Iktomi' who is a 'trick-ster spirit' and a culture hero for the Teton Sioux Lakota people (see fig-

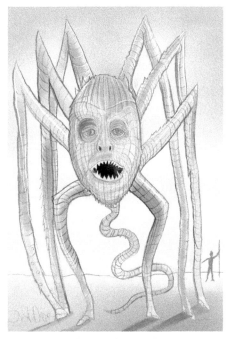

Figure 122: Iktomi the Spider.
My rendition of a god creature from the machine world?
© Neil Hague 2021

ure 122). A variety of alternate names for Iktomi include Ikto, Ictinike, Inktomi, Unktome, and Unktomi; according to numerous North American plains tribes, Iktomi represents a star deity. I would suggest Ikto is connected to the clown tricksters said by the Lakota to originate in Orion's star, Betelgeuse. In Lakota mythology, the spider Iktomi, represents a 'living (alien) consciousness' that spreads its web all over the land. Today, this is interpreted by some contemporary Native Americans to be the telecommunications network, the Internet, or the World Wide Web. Some Lakota see the spirit of Iktomi as the patron of 'new technology' from the invention of language, to today's modern cyber world of the computer, robots and, I would add, 'artificial intelligence'. In altered states over the years I have seen what looks like a 'giant' metallic spider, along with smaller ones, too. These 'beings' seem to be cyborg-like and operate from the astral (dream) world, just outside our physical illusory reality.

GIANT LIONS

In my graphic novel *Aeon Rising* (2017), I depicted what I saw as opposing forces within Orion waging war against each other. In a series of visions, I was shown what seemed to be 'lion-like' priests caught up in a war with each other, centred on the Rigel star system. I felt they were a type of archon, or 'Elyon' (another word for the Seraphim) opposing each other, rather like George Lucas' Jedi and Sith fighting each other in his epic *Star Wars* movies. I was told their names are the 'Panthera', 'Jezura' or 'Rezura Order'; all magicians located in both Rigel and Siaph's star systems and originally part of the Regulus star system, in the constellation of Leo. According to Sabak, the biblical Levite priesthood is of the same lineage as the Nemean lion and part of the Orion wars on earth. The text *Hosea 11* also expresses the lion connection to higher consciousness and humanity's connection to these orders, it says: "They will follow the Lord; he will roar like a lion. When he roars, his children will come trembling from the west." In the same set of visions, I also saw giant golden lions lying asleep inside a worm hole, which seemed to be a tunnel separating their world from ours (see figure 123 overleaf). The star system they laid dormant within is Regulus in the constellation Leo. This star, I was told, had influenced Orion's star, Regulus, the source of some of our interstellar Atlantean and Egyptian royalty. I feel certain that war is raging within the heavens (the stars), unseen by our limited perception, and a constant war, or conflict on earth is nothing more than a macrocosm of the 'star wars' being fought across the Orion, Pleiadian and Lyra constellations. I think George Lucas knew his *Star Wars* movies would activate deeper memories of such wars which is why the fictional Jedi/Sith order, along with the movies in general, have had such a massive impact on several generations since their creation.

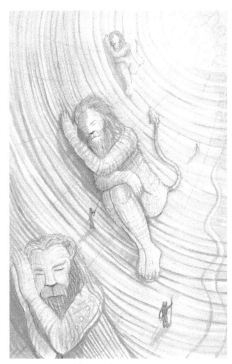

Figure 123: Giant Lions.
© Neil Hague 2015

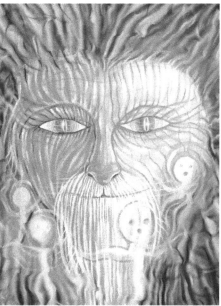

Figure 124: Sirian Intelligence.
© Neil Hague 2004

SIRIAN INTELLIGENCE

The constellation of Sirius has fascinated humanity for thousands of years. The Egyptians, the African Dogons and Native American peoples, to name but a few, have all looked towards this constellation as part of their heritage and ancestry.

It seems that all over the ancient world the lion-human god/goddess plays an important role. The lion or cat entities encountered by people who have had experiences with these types of 'beings' often speak of their wisdom and benevolence on one level, while others talk about a darker one. I have personally encountered what I see as 'cat-people', especially females whose eyes shapeshift into cats' eyes when in a heightened state. Some take on a 'demonic', or 'incubus' persona too; especially while under the influence of alcohol. From my own research, I feel the animal-human fusion in terms of consciousness, found in much art and myth, relates to humanity's ancestral spirit and forms not visible to our eyes. As I have already touched on in an earlier chapter, the lioness/lion humanoid is an image of a 'higher level of consciousness' often connected with the star Sirius (see figure 124). The more malevolent aspect of Sirian influence has taken the form of Atlantean priesthoods, black magic (involving sex magic), and the secret cabal (shadows) controlling global politics since the

time of ancient Egypt. I also see the Masonic structures as a more modern manifestation of both Orion and Sirian (extraterrestrial) influence, too. Sopdet (Sirius), for example, was also considered the 'flaming star' (often shown as a rising sun/star), also appearing in Masonic temples, on flags and in company logos. The colour 'red' is also associated with Sirius and secret societies aligning themselves with this star. The use of red carpets for royalty, or Hollywood film 'stars' is highly significant to the priesthoods and Masonic orders that influence the world.

THE PLEIADIAN AGENDA

The many humanoid variations of reported extraterrestrials, especially a Nordic type described in both ancient and modern accounts, seem to be connected to the Pleiades star system in Taurus. From my visions, I feel certain there are also a myriad of 'birdlike' and 'reptilian' entities associated with the Pleiades, especially the stars 'Merope' and 'Taygeta'. It's from the Pleiadian levels of consciousness and creation that ancient shamans accessed their knowledge. It's also possible that our star ancestors, touched upon in a previous chapters, are bird-people, and the shamanic cultures, notably in the Americas, were emulating this knowledge within their ceremonies (see figure 125).

The many accounts of battles between a more human race of gods and a reptilian species which weaved their way into myths, are said to have origi- nated in the Pleiadian system. The angelic blue-eyed blond-haired 'image' found in religious art, New Age belief and extraterrestrial 'experiences', is said to be connect- ed to the Pleiadian stream, along with the Lyran, Vegan and what some 'experiencers' call, the 'Taygeten colonies' associated with both the Pleiades and Lyra constel- lations. According to some researchers the 'Telosian' race, more humanoid extraterrestrials, are the ancestors of earth's native cultures, and the Greek word 'telos', which means 'uttermost', relates to this ancestral link with heavenly realms. The Mayan civili- sation of ancient Mexico also seems

Figure 125: Pleiadian Intelligence.
© Neil Hague 2004

Figure 126: Ancient faces in stone, wood & air.
(Above) A sleeping stone figure lying on its back facing the sky in France. **(Bottom Left)** An ancient olive tree next to a chapel in Barcelona, Spain. **(Bottom Right)** A genie appearing in the clouds above the Armu Muru Star Gate (Peru). It was clearly connected to the ancient 'dreamtime' landscape, or what Neo-platonic writers call, a 'Prince of Air'. © Neil Hague 2012

to be connected with the Pleiades and their ability to transcend time and move between different realities is something the super-gods worshipped by the Mayans, were able to do, too.

Legends of Hyperboria and Nordic superhuman gods put out in the 19th-century by the Theosophical Society (with its links to Aleister Crowely) and the later insanity that became the occult Nazi party, seem to be extraterrestrial in origin. New Age teaching associated with 'Ashtar Command' and other UFO-based 'saviour gods' is also peddling similar themes of star beings, or alien ancestors 'coming to save humanity'. None of this relates to the innate

visionary powers we all hold within. My art does *not* belong to any group belief or dogma when it comes to New Age or extraterrestrial phenomena. I am an artist who has 'seen into' other versions of reality, and that's it, nothing more! What anyone makes of what I am describing here is their own perception, I am simply explaining what I feel in relation to these stars.

The reptilian connection with the Pleiades seems to come in the form of chameleon-like entities and an ancient bipedal dinosaur species influencing the positions of power on earth. In actual fact, it is the Predator Consciousness, which can manifest as one of many of the alpha predators (covered in Chapter Five), that seemingly possesses the very highest levels of society. How do we know this? Because fear, separation, survival, killing and suffering are the products of a society that is *predatory*. Obviously, different strands of consciousness as mentioned above are not definitive; there are so many more aspects to this subject that the course of this book cannot do it justice. For anyone interested in looking further into the types of extraterrestrials recorded by modern-day 'experiencers' and talked about in ancient accounts, see the bibliographic section of this book.[12]

SEEING WITH ANCIENT EYES

As I said at the beginning of this chapter, seeing other layers of reality comes through accessing our visionary sight. Seeing worlds occupied by microbes, aliens and other strange phenomenon, comes from our own ability to *see* through the façade of our three-dimensional reality. When we start to exercise our 'visionary sight', solid forms found in nature take on different characteristics. Rocks, stones and mountains can appear to resemble a face. This phenomena goes beyond what is termed pareidolia, which is the tendency for perception to impose a meaningful interpretation on a nebulous stimulus, usually visual, so that one sees an object, pattern, or meaning where there is none. Instead, our ability to *see* the spirit of a rock, the clouds or trees, reaches into worlds beyond the physical. Certain objects seem to stretch the imagination more easily when we are looking beyond the obvious physical forms. I call this type of seeing: 'accessing our ancient eyes', or seeing the next layer of the illusion. In this mode, faces in clouds, rocks and other physical objects become more obvious because they are *more* than organic matter that spirit is using to take form through. I have seen endless red rock formations when I have travelled all over the world that show there is *more* than just 'natural elements' at work. Glimpses of energy that would not be normally detected without the appropriate scientific equipment, also become visible to the eyes when we choose to look 'through', or beyond what William Blake terms the 'mundane' physical reality.

In May 2012, I visited a place called Aramu Muru, in Peru (near the

Bolivian border), which also has 'strange magic' embodied within its many red rock formations. Aramu Muru is an ancient 'stargate' with immense electromagnetic energy. Over twenty people, including myself, witnessed the appearance of a genie-like face through a rainbow and cloud formation as we gathered to focus energy on the stargate. To our amazement, a 'face' appeared in the clouds above the petrified rock formation called the 'Devil's Gate', following a ceremony performed to anchor 'higher consciousness' at the site. The petrified red rock formation and ethereal face appearing in the clouds, are aspects of 'ancient forces' that have shaped our world, and continue to affect our physical reality (see figure 126 on page 422).

As someone who has spent many years feeling my way into esoteric subjects and painting and drawing what I see as the divine, archetypal consciousness, I feel certain the experiences and images relating to extraterrestrials, both ancient and modern, relate to our ability of seeing beyond the optical limitations laid down by electromagentic light, or sight. The mission behind all visionary art is to show alternative viewpoints; to lift the veil preventing us from seeing the many microscopic and macrocosmic levels of creation.

NOTES

1) *Exploring the British Isles, Highlands and Islands*. Readers Digest, p108
2) Hall, Manley P: *The Secret Teachings of All Ages*, p 270
3) *Mythology, The Illustrated Anthology of World Myth & Storytelling*. DBP, 2002, p624
4) Kaku, Michio: *Hyperspace*, Oxford University Press, 1995, p105
5) Von Daniken, Erich: *Gold of the Gods*, pp140 -141
6) *http://www.geocities.com/Area51/shadowlands/6583/et022.html* or visit *http://www.intercable.net/jazzario/meier1.htm*
7) Hall, Manley Palmer: *The Secret Teachings of All Ages*, p271
8) Ibid p271
9) Thompson, J. Eric S. *Maya History and Religion* (1970) University of Oklahoma Press Collection. P46
10) Hancock, Graham. Supernatural: Meetings with the Ancient Teachers of Mankind. Arrow Books 2005 p521
11) ibid, p522-23
12) see; *http://www.geocities.com/Area51/shadowlands/6583/et022.html or visit http://www.intercable.net/jazzario/meier1.htm*

Magic Mirrors

Decoding 'The Matrix' through Art & Visionary Sight

There exists in that Eternal World the permanent Realities
of Everything we see reflected in this Vegetable Glass of Nature
William Blake

Real visionary sight comes from our ability to 'see through' the illusions of time and space or 'beyond' the reality dominated by the five senses. The tool of the visionary is the mirror, or 'mirror-mind', one that allows itself to be uncluttered, free and empty, so it can 'reflect' and, therefore, 'receive' imagery through our greatest tool, the imagination. Just like any mirror, a mirror-mind simply reflects what comes before it. It does not discriminate, nor does it cling to the imagery shown in the mirror. The analogy of the reflection, or mirror, ultimately asks us to question our reality (our presence in the world) and therefore see through what we think to be real. This is why reflections in glass buildings, mirrors, and 'black mirrors' (iPhones and sunglasses) are used in 'magic rituals' and often in movie narratives. In this chapter, I intend to focus on the themes, characters, and symbolism within *The Matrix Trilogy* (1999–2003), created by Wachowskis, and take a closer look at myths connected to 'time', art and some of the occult imagery contained within these movies. *The Matrix* films are cult-like works of art that necessitate analysis and unravelling in order to comprehend the hidden codes and messages contained within them.

Many of us take the world we are immersed in far too seriously, while at the same time, forces that 'feed off' how we respond to mayhem, confusion, and the toil we call daily living cause us to act and think in a fashion that places the physical world as the only credible reality that exists. Schools, universities, work, governments, and media are all 'agents' for this cause, and the spell cast over our eyes. However, when we look to the philosophies of earth's ancient indigenous 'memories' (the time *before* time), what we seem to

find are modern concepts relating to reality, and 'illusions' interwoven within many ancient myths and beliefs. As I've touched on throughout the book, Aboriginal stories of the *Dreamtime,* and the Hindu world of illusion called Maya, are just two examples of a lost history, or a period in time humanity 'forgot'. The collective amnesia commonly called prehistory was, in my view, the 'window' between the previous and the current cycles of human consciousness evolution. For many visionaries, along with ancient shamanic cultures, the earth was a 'time ship', an illusory world that moved with the flow of nature's time but could also travel *through* (or beyond) the barriers of the physical world (the five senses). From this understanding, a time ship is a vehicle (a loop) connecting the *illusion* of past and future, while placing both these tenses simultaneously in the 'now' – the present time. Similar theories have been proposed by scientists working within what is called 'casual set theory',[1] an hypothesis relating to time being a continuous flow, like a river, rather than a static space-time dimension. Time could be seen as a 'cosmic season' or 'day in a life', depending on one's perspective. The notion of 'prophecy', or how mystics can *see* beyond time and the laws of nature, comes from an understanding that 'time travel' is possible through what Blake describes as our 'immortal organs', our imagination and spirit. We exist in multiple realities; parallel worlds (whether illusory or not) and time travel are other ways of describing concepts within *The Matrix*.

MIRRORS & PARALLEL WORLDS

Scientists at the Oak Ridge National Laboratory in eastern Tennessee have completed building equipment to test for a parallel universe that could be identical in many ways to our own, with mirror particles, mirror planets, and possibly even mirror life.[2] According to Leah Broussard, the physicist behind the Oak Ridge National Laboratory project, "they are hoping to discover what many mystics over the centuries have told us exist, which are called mirror worlds." The discovery of a concealed mirror world may sound like something from the Netflix series, *Stranger Things* (2016) but these concepts are found in indigenous beliefs all across the planet.

For the Lakota and Celts (who were most likely connected through an ancient Atlantis), for example, both peoples talked about the 'Great Smoking Mirror' in their oral traditions and pagan rituals. The mirror is another way of describing a doorway, or portal into a parallel world, and is similar in concept to the 'scrying mirror' used by the likes of Dr. John Dee in the 16th Century. The 'Black Mirror' is another version of the scrying mirror and again, was used to 'see into' parallel realities. The third and final episode of the first series of Charlie Brooker's *Black Mirror*, called *The Entire History of You* (2011), is set in an alternative 'mirror reality'. This is a world where most people have something called 'grains' which record everything they do, see,

or hear, allowing them to play back their memories in front of their eyes, or on a screen. The concept is very much in keeping with the themes in *The Matrix* movies. Occult rituals in modern form, like the black mirror-screens (cell phones, digital TV, and iPads) are used today to 'scry' for facebook memories (in the Metaverse) looking for our thoughts and desires.

THE MATRIX PHILOSOPHY

Every age, it seems, has its 'technological model' for the mind to 'operate'. For example, prior to the scientific revolution, Western thinkers believed that spirits animated the human organism. In the 16th and 17th centuries, elaborate theories were proposed in which the brain moved the body by means of fluid flowing through the nerves. Following the discovery of electricity (and later electromagnetics) and the development of long-distance communications, the brain was visualised as the central switchboard of a telephone system. In the computer age, what could be more natural than to understand the mind as an 'assimilator of software' that is run on the hardware – the brain?

In the movies, *The Matrix* (1999), *The Matrix Reloaded* and *The Matrix Revolutions* (2003) 'ordinary life' is a deception (a simulation) produced by machine intelligence (AI) and the human brain. Similar concepts of living in an illusory reality are found in the philosophy and teachings of the already mentioned Gnostics, generally understood as the world of illusion, or Maya. The same philosophy is taught by the Tibetans and South American Indian Mayan ancient civilisations, and all express the same view of reality as a holographic illusion. This is probably why so much Oriental and Tibetan imagery, fight sequences and costumes appear throughout *The Matrix* films. The Gnostic concept of different worlds (intelligence) and the Aboriginal concept of the *Dreamtime* clearly influenced *The Matrix* movies, as I will come to shortly. In the writings of Greek philosophers, such as Plato, through his allegory of the cave (mind), we also find concepts that speak of the illusions we call daily life. Plato, in his *Republic* (514 BC), outlines themes speaking of the human mind being born into a prison, an illusion, or a veil of deception, and, of course, this illusion, or the matrix, is the Wachowski's interpretation of an ancient concept.

The notion that our world (reality) is merely an appearance, dream, or illusion is understood through the works of scientists and philosophers from René Descartes to Immanuel Kant, along with modern theories associated with quantum physics, alchemical art, and texts illustrating the microcosm and macrocosm. All of these subjects, including the advancement in biometrics (microchipping) and artificial intelligence, open the mind to understanding that we simultaneously partake in and are isolated within a prison (matrix) of our own making. Themes in *The Matrix* relating to a 'predatory' machine-consciousness ensnaring and creating realities also appear in Native

American myths associated with Grandmother Spider and the Australian Aboriginal beliefs in the *Dreamtime*.

The Matrix movies are quite possibly the retelling of the greatest story ever told, one found woven into numerous religions and legends. The concept behind *The Matrix* adds fuel to the power of the visionary, while speaking of ancient prophecies, and awakening of the human mind at this crucial time on earth. The matrix is the ultimate 'trap', an illusory world that is 'everywhere', as Morpheus explains to Neo in *The Matrix*:

> *It is all around us. Even now in this very room. You can see it when you look out of your window, or when you turn on your television. You can feel it when you go to work, when you go to church, when you pay your taxes. It is the world that has been pulled over your eyes, to blind you from the truth...that you are a slave, Neo. Like everyone else, you were born into bondage, born into a prison that you cannot smell or taste or touch. A prison of the mind.* [3]

According to the themes in the film, the matrix is a super holographic programme, a fake reality designed to occupy the mind while the sleeping human performs its function as a battery for 'soul snatching' by artificially intelligent machines. Artificial intelligence of this calibre is not so far-fetched when we consider the types of technology existing today, especially intelligence that can create machines (robots) able to think for themselves.[4] The hierarchy of deception within *The Matrix* shows machine intelligence overseeing human beings who are plugged into the matrix, while a war rages between the machines (AI) and renegade (organic/free) humanity living in a place called Zion; more on this shortly. The real problem for those plugged into the matrix (illusion) is the lesser AI programmes known as 'agents', one in particular known as Agent Smith. These progams are designed to keep human beings from 'breaking free' of the matrix-mind. Paradoxically, what turns out to fit humanity's instinctive need for a contented sleep (or Dream) is not an ideal world of happiness. Instead, it's a familiar rat race described by the character Morpheus as an illusion no one can be shown but only 'sees' for themselves.

In the first film, Morpheus, played by Laurence Fishburne, asks Neo (the chosen one) played by Keanu Reeves: "Have you ever had a dream, Neo, that you were so sure was real? How would you know the difference between the dream world and the real world?" The film shows that only by freeing the mind (taking the red pill in the film) can one be 'unplugged' from the matrix that is woven and constructed via the mind. The symbolism behind the character Morpheus, along with others in the script, is not accidental; all characters' names have meaningare specific to the legend of the matrix. Morpheus, in Greek mythology, is the 'God of Sleep' (the Dreamtime), one who brings changes (opens doorways in the mind) via the power of our dreams, visions

and awakened consciousness. In the Indian *Vedas*, the world around us is also considered a dream world, which Vishnu sees as he sleeps!

DESCARTES' DILEMMA

French philosopher and mathematician René Descartes (1596-1650), who coined the phrase: 'I think, therefore I am', is one of the key philosophers of the Western hemisphere to suggest humanity may be subject to 'massive deception'. He also went as far as saying that 'sense' experience was an unreliable justification mechanism and that all beliefs are subject to the senses. For Descartes the world we perceived could be shown to depend on sensory evidence; he was torn between beliefs in a rigid geometrical structure and a 'deceptive' reality – the dreamer and the dream. He says in his *Meditations* (1641): "Whether I am awake or asleep, two and three added together are five, and a square has no more than four sides."

With such a dilemma, Descartes supposes only a 'malicious demon' of the utmost power and cunning could employ all his powers to deceive us.[5] This is the Predator Consciousness and Demiurge (Wetiko) 'god-force' behind the reason for the matrix! Such a creature, according to Descartes, easily leads us (humans) to mistaken conclusions regarding reality, and therefore to the belief that there is a physical world external to ourselves. Interestingly, in *The Matrix Revolutions* (2003), Neo sees Agent Smith (who has now multiplied like a virus) 'possess' the matrix from his outside-of-the-matrix (true) form – a fire-like demonic presence! Smith is portrayed as an archon, or jinn, which is a reminder of the Wachowski's interest in Gnostic myth. What we see as sky, nature, colours, shapes and sounds, according to Descartes, could merely be the delusions of dreams, devised by a demon and designed to ensnare our judgement. He concludes his *Meditations* by saying: "I shall consider myself as not having hands, eyes, or flesh, or blood or senses, but as falsely believing that I have all of these things."

The Matrix also addresses the possibility that the meaningful lives we 'believe' we live are in fact a matter of perception (deception), only a reflection of an artificial construct experienced through the senses, and connected to many worlds simultaneously.

FEELING RATHER THAN SEEING

The character Neo is an anagram for the 'One', the original human who existed before the matrix was constructed. He is symbolic of the first human, the lineage of the biblical Adam. This idea hints at what visionaries like William Blake call the 'divine human', or what more indigenous cultures call the 'first humans'. Humanity in its 'divine form' *is* Oneness – a state of multidimensional bliss. Scientists such as Giordano Bruno refer to this 'original link' as the cosmic mind (or bright fire) from whence all forms originate. Its real

source lies beyond memory and programming (or DNA), and it has the power to download new information, to retrieve ancient files and re-write itself according to the experiences gained in life. As *The Matrix* constantly refers: Neo is the returned human saviour; a microcosm of the original source, he returns to free his relatives (all humans) from the bondage of the illusion, the matrix. This he eventually achieves by following his heart and not his head, especially when he is blinded, in the third film, by the 'malicious demon' agent Smith, who has become Neo's opposite.

Neo's internal powers of perception eventually guide him to the centre of the 'machine world', a place some would describe as an extraterrestrial, artificially intelligent construct that runs a future earth. Here Neo comes face to face with a 'living image' of the machine intelligence, a god figure. As a representative of the first human, or divine form, Neo seeks a peace treaty between Zion and the machines who are feeding off humanity and using humans as a source of power (a battery) to keep the illusion (matrix) 'alive'. Neo's arrival in the machine world is symbolic of humanity transitioning from 'dualistic mindsets' (seen in the many fight scenes between Agent Smith and Neo, through to the war between Zion and the machines), leading to *Oneness* and 'peace'. It's this peace between humans and machine intelligence that ends one matrix and instigates a new one (a new world). The key point here is the awakened Neo (a symbol for all humanity) instigates peace and reshapes the matrix. It's the awakened human mind that sets himself or herself free from the confines of illusion and from fear and servitude to the machines. Nothing is more 'potent' than an awakened human, one who *knows* himself, or herself deeply and can intuit when he or she is being forced to act in a certain way or believe a certain version of reality. The "splinter in the mind", a metaphor so aptly used by Morpheus, is what drives the visionary and the truth seeker within us all. Neo learns that intuition is more important than the senses and that the mind is more important than matter. Just as Plato and Socrates recognised that "the physical is not as real as the form," Neo also recognises that "there is no spoon." Plato might say that 'déja vu' is not so much a 'glitch in the matrix' as it is a recollection, an activation of memory of original forms (archetypes) used by psychics and visionaries in every era. It's the same 'unseen waves and forms' manifesting as physical three-dimensional objects via electrical impulses in the brain. Plato said: "In the time between incarnations, when the soul is free of body, we behold the eternal forms." It's the ability to look *through* the physical world, not at it, as practiced by every visionary since ancient times, which helps us to *see* the codes and fractals (forces) constructing our reality.

The collective reality (of roads, forests, streets, mountains and wildlife) can harbour strange faces and forms depending on our visionary sight. The world outside, or beyond, this matrix contains both the big and the small,

macrocosm and microbe, and this can be plainly seen hidden in the imagery in *The Matrix*, with its bedbug-like transporters. Focusing on our inner states of being, while exercising irreverence for the systems that demand of us a 'very, *very* serious attitude', helps us see through the illusions and programming we often dare to call the 'real world'. By being part of this reality, but not of it, gives us the balance, insight, and power to activate the visionary within us all.

GRANDMOTHER SPIDER & THE ORACLE

Among pre-Columbian nations, the people of the Algonquin tell of the legends of Grandmother Spider. She is a broadly celebrated divinity who is thought to bring great wisdom to the ancients. Grandmother Spider and Mother Earth are integrated in some myths and represent an oracle of the Earth-matrix and an intermediary for the people that seek her out. Her mythology is widespread and eastern Native American tribes, in spite of their being pushed farther and farther west by European invaders (since the

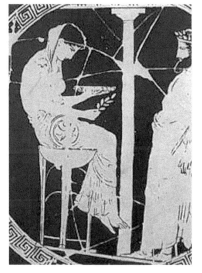

time of Columbus), maintain her story. Grandmother Spider, or 'Thinking Woman', as told by the Navajo, is said to have helped the people 'see' the light of night and day and guide them out of the Underworld.

In ancient Greece, the Oracle of Delphi (see figure 127) helped people see the future. The Oracle character in *The Matrix* guides Neo and Morpheus on their future paths, just as Socrates (who can be compared to both Neo and Morpheus figures) was guided by his Oracle.[6] Both the Delphi inscription and the sign above the Oracle's kitchen door in the film, tells the seeker to "Know thyself". The Oracle's presence in *The Matrix* is a direct representation of Grandmother Spider in my view. It's

Figure 127: The Greek Oracle.

Spider Woman, like the Oracle, who is said to have woven the webs of the tangible but invisible world. Such an understanding is observed in *Matrix Reloaded*, when she meets with Neo for the second time on a park bench. Here the Oracle is surrounded by crows, a Native American archetype for the laws of reality, as she tells Neo that she is the creator of the *first* matrix and that programmes are even written for the birds, trees, wind, and sunrise. The Oracle says:

There are programmes all over the place. The ones doing their job, what they were meant to do, are invisible, and you would never know they were there... Every time someone sees a ghost, angel, vampire, werewolf, or alien, it's the 'system' assimilating a programme that's doing something that it's not supposed to do... [7]

The Oracle is the embodiment of the 'earth matrix mind', or Gaia, the mother 'chaos' (goddess) figure who wants to help humans be free from the control of the matrix she is involved in creating. Stories of Grandmother Spider told by Native American tribes, tell of the animals complaining about living in darkness and desiring the light given to original humans, or what ancient alchemy refers to as the 'inner sun'. The same knowledge of our 'inner sun' is seen in 30,000 year-old figurines and portable rock art depicting figures with 'lion heads' or 'sun heads', which show archetypal images of the inner light connecting all humans to the source – the Creator (see earlier chapters).

According to Native American myth, the sun was somewhere on the surface of the earth, but the 'Sun People' kept it and maintained it, sending it on its daily round. The animals talked among themselves and plotted to get some light for their dark world, so they sent several of their kind to retrieve the light. As mentioned in my book *Through Ancient Eyes*, these myths are seen depicted in earthworks and effigies, especially at Serpent Mound in Ohio, along with many European sites that speak of how the sun came to 'light up the world'. In these myths, Spider Woman (the earth-matrix, or Gaia) is said to be *the* vehicle through which the light arrives on earth, and in most stories she is the harbinger of a 'new age', or a higher level of consciousness. From the point of view of *The Matrix*, the Oracle is the opposite, or equal, to the Architect, depicted as the white-bearded father 'god', one who creates and controls the logic, balance, and mathematics (DNA and codes) of the matrix. This father figure is quite clearly meant to be the Gnostic Demiurge, or Yaldabaoth, and can also be seen in Blake's inspired art and myths as the figure *Urizen* (see page 40).

However, as the philosophy of many indigenous cultures points out, and as *The Matrix* shows us, this 'god-figure' is forced to reconstruct and balance the earth-matrix, so to meet a new paradigm instigated by the Oracle but implemented by Neo, the first human or divine form. As the film explains, all those who freed their minds became free of the old matrix and were not affected by the new matrix taking its place! The concluding scene of the third film, showing a rewrite of the old matrix, is followed by a magnificent sunrise, symbolic of the new earth. Could this scene be hinting at the coming of that new age of peace, as prophesied in many ancient texts and myths? The flip side to this scenario is that the new age is also the old age rewired and just as artificial as the one that came before it. The visionary-sighted and gifted aspect of the *One* within us all, desires to get out of the control structure

imposed by the matrix! Prophecies pointing to 2030 as a window for humanity's transformation (a paradigm shift), I feel relate directly to the ending of one matrix and the beginning of a *new* way of 'seeing' and 'living' the world.

TRINITY, THE MEROVINGIAN & THE FOURTH DIMENSION

As I have shown in my books *Through Ancient Eyes* and *Orion's Door*, the use of the triad, or trinity symbol, throughout all religions can be found in the sciences of numerology and physics. It's also the occult languge in art as studied through three vehicles known as Hermetic, Scholastic and Pagan. The trinity relates to the original Pagan goddess deity found in most ancient earth cultures, where myths say she is also the embodiment of love, power, and wisdom. Therefore, the Trinity character in *The Matrix* is also a female who falls in love with a 'dead man' who happens to be the *One*, and it's her love for Neo, in the movie, that saves him. The love between them, symbolised by the 'two' becoming 'one' through a *deep* soulmate connection, can and does override the matrix programming. Looked at in the same way, so does the male and female balance within us all. Anyone who has studied ancient mythology and numerology will know that the trinity also relates to the mother-son cults, the goddess and the saviour, as mentioned in earlier chapters.

Trinity is also the avenger and a furious three-part figure who wastes no time in the seedy Underworld, in *Matrix Revolutions,* when it comes to negotiating Neo's release from the 'Merovingian', a character I will come to shortly. Notice also that Morpheus, Trinity and Serif (Morpheus, Trinity and Neo in *Matrix Reloaded*) come as *three* when seeking an audience with the 'master of time', the 'lower fourth' *astral* dimension known as the Merovingian. For anyone who has read George Orwell's *1984*, you'll notice that the floor number in the building where Neo, Morpheus and Trinity take the elevator (to meet with the Merovingian), is 101 – the same number of the room where Orwell's characters go to face their fears! It seems the makers of these highly symbolic films are telling us that we *are* controlled by our fears and that fear is the greatest tool used by dark forces (represented by Merovingian and his underlings) to keep us from realising our true potential beyond the matrix.

In many ancient myths, along with scientific theories, the next layer of the matrix (or holographic reality) is considered time, or what Einstein termed the 'fourth dimension'. It's from this dimension, according to many writers and researchers today, that a lower astral controlling force wields its influence over our 3D world. The Merovingian in *The Matrix Trilogy* is a direct reference to the links between the ruling bloodlines and their 'controllers' in the fourth dimension. The use of the letter 'M' below the grandiose staircase in the house of the Merovingian (in the film) is Freemasonic. As mentioned ear-

Figure 128: Merovingian codes.

lier in the book, the letter M is seen in many illuminati organisations' logotypes, like McDonalds, MGM, Miramax, and the Motorola logo (which is shaped like a bat), to name but a few. The point here, is the letter M is used often in esoteric symbolism as code for the ancient bloodlines mentioned in this book.

The lion in the MGM logo is also code for the bloodlines going back to the priests, levites and Babylonian elite, especially the ones that have provided 'a matrix' of world leaders and royalty! The capitol letter 'G' found in the centre of the compass on Freemasonic emblems, and at the centre of the MGM logo, is an ideogram for the throne of Isis/Maat, the ancient goddess at the heart of Freemasonry and from which the word 'mother' originates (see figure 128). She is also called 'Persephone' or 'Hecate', the queen of the underworld, and is played by Monica Bellucci as the wife of the Merovingian (the king) in *The Matrix* film. The use of towers, black and white checkerboards, especially in the fight sequences between Neo and the Merovingian's shapeshifting bodyguard 'twins' in *Matrix Reloaded*, also depicts imagery associated with ancient orders and bloodlines covered in previous chapters.

The fourth dimension, or astral world, is also the place where *time* has no meaning, hence the use of 'portals' and 'doorways' to travel between different worlds, especially seen in the *Matrix* movies. Time is important to the Merovingian in the films; this is because time, and our understanding of the 'past and present', are controlled by this level of the matrix. The Merovingian is the keeper (or ruler) of the doorways in the films, and he controls another character, the 'Train Man' (in *Matrix Reloaded*), a figure who represents the master of time, living in a plane of existence between the astral and matrix worlds. This timeless plane is also referred to as the 'inter-space' worlds recorded in ancient art, legends, and by physicists like Giuliana Conforto. The imprisonment of the 'Key Maker' by the Merovingian is symbolic of forces operating at a level of the matrix that do not want humanity (who are plugged into the matrix) to have access to different dimensions or doorways above and beyond fourth-dimension control.

The battle to retrieve the Key Maker in the *Matrix Reloaded* is almost a symbolic tussle to free the doors of perception, opening the way for humanity to traverse time. *The Matrix* movies are not the first films to encompass battles in different dimensions. Much of the imagery found in *Star Wars* and the *Indiana Jones* films also contains similar themes, especially duality.

The agents in *The Matrix* trilogy represent the 'programmes' (software) that police the illusion on behalf of the predatory machines, preventing humans from realising their true potential. As I've already touched on, it's the ancient royal bloodlines that also operate from outside of the physical (space-time) reality, and much of the infestation scenes by Agent Smith in films Two and Three, as he replicates and takes over other forms, symbolic of this possession by the predatory 'software' intelligence. The offshoot *Animatrix* (2000) cartoon actually deals with the concept of agents appearing out of nowhere to prevent humans from realising that the five-sense reality *is* an illusion. One scene in particular depicts an athlete reaching what athletes often refer to as a 'timeless zone', when suddenly agents appear out of nowhere to bring him crashing to the ground in the physical 3D reality. No one is allowed to go beyond the limits of the matrix!

PERCEPTIONS, DECEPTIONS, & REAL-TIME TRICKS

To see beyond the illusion of 3D, 4D (time), we need to learn to look 'through' this reality (the physical dimension), not 'with' the five senses, but with our inner vision. We also need to utilise our imagination, too. Our eyes and the brain are the main devices by which we often deceive ourselves. The imagination is the key to seeing beyond the limitations of the physical world. As William Blake said: *"The Prophets describe what they saw in visions as real and existing men, whom they saw with their imaginative and immortal organs."*
The Swedish scientist and theologian Emanuel Swedenborg (1688-1772) at the time of Blake also said:

> *The eye is so crude that it cannot see the smaller elements of nature except through a lens...so it is less able to see the things above the realm of nature, like the things of the spiritual world.* [8]

In fact, our brain tells our eyes what to see and feel through a mixture of electrical impulses and light filling the retina. The cerebral cortex then translates these apparent two-dimensional images into the three-dimensional holographic forms that we call the world around us. This process can be likened to how the camera obscura creates a reflection through light and mirrors, which then gives a projection of any object in physical form. The eye also acts as a projector of images powered by the electrical charges taking place in the brain.

Ancient Egyptian priests seemed to understand how 'seeing the world' is not the same as 'seeing through the world' and this may be why they placed great importance on symbols and codes (hieroglyphics) as a way of hiding their knowledge. One of their hieroglyphs, known as the Eye of (Osiris) Ra, hints at the brain's ability to project 'virtual images' through the eyes (see fig-

Figure 129:
Eye & the heart of the brain.
The hypothalmus gland as compared to the Egyptian hieroglyph of Osiris Ra – the all-seeing eye.

ure 129). It also relates to the time of sleep, when neuron activity produces vivid dreams at the time of rapid eye movement. When the Osiris 'eye' symbol is placed in juxtaposition to an anatomical view of the reptilian part of the brain known as the hypothalmus, then we see quite clearly the connection between seeing with the mind (the inner eye) and the brain's capacity to project images of what we believe to be the real world. As Charles Darwin said in relation to perception and the eye:

> *To suppose that the eye with all its inimitable contrivances for adjusting the focus to different distances, for admitting different amounts of light, and for the correction of spherical and chromatic aberration, could have been formed by natural selection, seems, I confess, absurd in the highest degree.*

In *The Matrix*, Osiris is also the name for the space ship used by Morpheus's renegade group of humans. The Nebuchadnezzar is a name for another ship in the same film, and this name gives direct reference to the Babylonian priest king who fought and defeated Jerusalem, Sion, or Zion, which in the film is also the home base for humans living free outside of the matrix. Yet these souls are still in conflict with the predatory (machine) world, which is still trying to destroy the human world.

Egyptian symbols of the scarab beetle are also codes for the hemispheres of the brain, and as with the alchemical symbols of a circle dissected, they also hint at the dual principle of the brain. The left side of the brain is where we assimilate logic and reason (the artificial intelligence of the machine world?), and the right side of the brain could be seen as Zion (the imaginary/real world). The 17th century alchemist and artist Robert Fludd said of the eye and our perception of the world:

> *... the eye of man (is) an image of the world and all the colours in it are arranged in circles. The white of the eye corresponds to the ocean, which surrounds the whole world on all sides; a second colour is the mainland, which the ocean surrounds, or which lies between the waters; a third colour in the middle region; Jerusalem, the centre of the world. But a fourth colour, the vision is Zion, the midpoint of everything and visible within it is the appearance of the world around.* [9]

Fludd, like other alchemists is quite clearly part of the mystery school network I've been highlighting in this book. At the highest levels of the Cult (priesthood), they know the world we live in *is* an illusion, created by our mind, projected by the brain and reflected by the eyes. Seeing invisible worlds, or capturing imagery that speaks of alternative dimensions to the one governed by the five senses, is the true purpose of art. In relation to the illusory world we live in, Blake went as far as saying:

> *This Life's dim Windows of the Soul*
> *Distorts the Heavens from Pole to Pole*
> *And leads you to Believe a Lie*
> *When you see with not thro' the Eye.*[10]

From this perspective, all art forms (including symbolism) are a natural attempt to communicate with 'forces' not perceived by the physical world (five senses).

ART AND DEATH

On March 8, 2002, about 80 artists, writers, and thinkers gathered in London to explore the links between different worlds or realities. The meetings revolved around the work of Tom McCarthy and the International Necronautical Society (INS), whose manifesto was loosely borrowed from Lewis Carroll's *Hunting of the Snark*. The INS was born in 1999 to investigate the role of death in literature, art and culture and some of its findings gleaned inspiration from ancient culture, not least the Egyptians and the *Book of the Dead*. What came out of the work of INS, was that 'Art began as a means of communicating with the dead'. I would expand on this theory to encompass many other worlds or realities that have inspired artists,writers and moviemakers in recent times. What historical art movements (including the International Necronautical Society) sought to show, are the direct and indirect links between the spirit, mind, imagination and the taboo of all taboos – death.

The Matrix also seeks to show us similar concepts relating to birth, life and death. Interestingly, the *Egyptian Book of the Dead* and the *Coffin Texts*, are a set of spells and cipher sequences learnt and recited by priests sitting in formation rather like computer programmers sit in rows at work stations today. The sequences are inscribed and painted onto coffins, and the repetitiveness of crafting, writing, and producing these 'codes' acted as a vehicle for travelling into the astral world and the *Dreamtime*. You could say, symbols or codes act as a specific 'computer-like' language communicating the sequences necessary to penetrate the walls of the physical world. I believe this is the con-

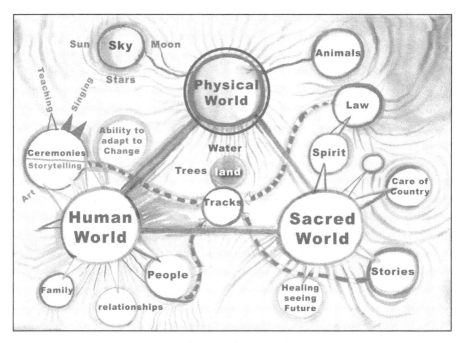

Figure 130: An Aboriginal map of the Dreamtime.
A drawing replicated from an Aboriginal teaching depicting the Dreamtime worlds.
This diagram is similar in concept to the machine (human world), human-Zion (sacred
world), and matrix (physical world: illusion) reality found in *The Matrix* films.

cept behind the green language codes depicted in *The Matrix* movies. The
codes also looks remarkably like A, G, C, and T genetic codes found in all life.
A great example of how codes formulate a given image or reality can be seen
in hypertext markup language (HTML) and Java script, which are used by
web designers and computer programmers today. These computer lan-
guages, or codes, are used to create the illusory world of 'cyber space', and
the many Internet sites we all *see* when we surf the world wide web. In *The
Matrix*, we also have similar themes of priest-like programmers reading the
codes of a giant virtual universe, and as mentioned earlier, Morpheus being
the Greek god of the Dreamtime, awakens Neo to this parallel world.

Whether in ancient myths or modern film, the matrix is a mental projection
(flight of the mind) that actually interacts with a programmed, 'coded' reali-
ty. The real world is left behind while the codes of the matrix are used to pin-
point the exact place and time where incarnate minds can enter the illusory,
holographic reality. Again, in the Aboriginal Dreamtime (time *before* time),
the three main worlds – *human*, *physical* (matrix), and *sacred* – are connected
by a multitude of vibrations. These worlds and their hierarchy are not too
dissimilar to the three worlds depicted in *The Matrix* film (see figure 130).
These could be seen as: the human (Zion) world; the physical (matrix); the
sacred world; the place from whence the source, or *Oneness* (Neo) originates.

Again, these concepts are found in Gnostic teachings and relate to the physical world being *both* separate and connected to the human world through the dreaming process. The concept of the Trinity comes out in similiar imagery, too. The *three* points can also be viewed as the human world (our soul), the sacred world (the divine, infinite, spirit), and the physical world (limitation). The sacred world is *not* separate from us, but part of us. The physical world *is* the world we see through the brain and is a manifestation of the interaction of the divine and our own soul, which creates our conscious reality.

The sacred world is the place housing all archetypal forms. In some traditions we see the three worlds depicted as three spirals within a triangle form and the spiral is another archetype representing moving beyond time, using our creativity and feeling *Oneness*. This is why the spiral, like the labyrinth and the circle, appears in every culture and religion. From a three-dimensional viewpoint, the spiral also represents the dimensional ladder, seen by the biblical figure, Jacob, and artists' depictions showing how a variety of dimensions (connected to our untapped DNA) vibrate across infinity. The spiral is our galaxy and our DNA simultaneously, and within this concept of microcosm and macrocosm are, as I have already shown, the real clues to much of what we call extraterrestrial life forms. From this perspective, *big is small* and *small is big,* because both are part of the holographic nature of reality (see figure 131). The vibrations and forms, which could be visualised as a computer language in my view, represent other dimensions that provide the codes, or

Figure 131: The big and the small are *One*.
(Left) A satellite photograph of the Sudan as compared to a photograph of a vine leaf
(Right) Within the holographic nature of reality, creation *through* nature, shows us that
'everything is One'.

fractals, that create our solid reality. Einstein's theory of Relativity, through to much of the science associated with holograms and quantum physics, encompasses what was already understood by many advanced civilisations on earth!

THE RAINBOW SERPENT AND THE DNA

If we look at nature we understand and observe that everything is in motion. All life ebbs, flows, spirals and spins. If we look at anything that spins in the physical world, the mass in the centre, caused by the spinning, seems to be creating space. Take a closer look at all those amazing photographs of spiralling galaxies or images of hurricanes and whirlwinds, and you will notice a space in the centre. This space represents the *stillness* (the eye of the storm in the case of a hurricane), and is symbolic of the centre or source of whatever is spinning. When we compare an aerial view of a storm to a galaxy, or even water going down a plughole, the common denominator in all these instances of motion is the 'spiralling of particles' and 'space in the centre'. This space is also the sacred centre talked about by mystics for thousands of years.

The human body is also made up of particles (molecules and atoms) that spin around a central space. A scientific fact is that all atoms are 99.99% space, and since we are entirely made up of atoms, we are also 99.99% space! It's the illusion of the physical world that prevents us from seeing others and ourselves as waves and forms made of the same energy or light particles. All spirals, from storms through to the molecular structure of our bodies, are a holographic image of the whole. When a holographic image is broken, all the broken pieces contain the full image of the whole, just as every cell in our body contains the full blueprint of the body. Therefore, when we see a storm, a galaxy, or our DNA in a microscope, we are actually seeing a holographic part of the whole. The Rainbow Serpent in Aboriginal mythology, for example, is the DNA magnified! And in this creation myth, the Rainbow Serpent aids in the creation of the physical world – the illusion. So, if the spiral motion represents the holographic principle behind all life, as understood by the ancients, then the centre must be a representation of the source, the *Oneness* dwelling at the 'heart' of all-that-exists. The spiral and the periphery can also be seen as chaos, while the tranquility and stillness of the source at the centre are the 'force' that drives the reason for all life, which is infinite love. As human beings with love at the core of our cells, we are constantly persuaded to look outside of ourselves for answers instead of going within, to our centre, our inner space. From this place we find our inner peace. This peace and 'knowing' that comes from *within*, is the real source of our creative power.

NEO IS NOT THE ONLY ONE!

If the physical universe is indeed a reflection of the *Dreamtime*, then 'seeds of light', or divine beings (from the source of all-that-exists), in the form of sentient life on earth, are surely here to experience physical emotions. Without physical life experiences how do we learn and grow to our true potential? I feel we are constantly persuaded to face the wrong way when it comes to evolving and growing consciously as a spiritual human being. Focusing on our reflection only, our body-illusion, or believing the world perceived through the five senses is real, is symbolic of 'being human'. However, going *within*, exploring our inner spaces through our imagination, our art and our creativity are the signs of a 'human being' unlocking the doors of perception. Doing this with love and without fear, a human being resonates at the highest level of awareness. The illusion (the world we dwell in) is merely a reflection of our collective consciousness, and at this level, we are also shaping our world and expanding our universe simultaneously. By believing we have to seek outside of ourselves, rather than looking within for all the answers we need as individuals, helps shape the matrix we deserve. Too often we mesmerise ourselves with religions, divisions, and manufactured separations sold to us through the matrix (in all its forms), so we forget who we truly are. Today, more than ever before, we are also at the mercy of electromagnetic technologies (EMF) that were not created to respect our divine form. Such an onslaught of technology, from cell phones to Smart everything, is separating us further from the truth. We *are* all-that-exists, now, tomorrow and for the rest of eternity. Fellow matrix traveller, surely you must have realised by now that you are the one! It's my belief that the power of the visionary throughout the ages is the original and unique individual power of *everyone* who chooses to access the divine within themselves.

NOTES

1) Dowker, Fay: *Real Time. The New Scientist*, 4th October 2003, p37

2) https://www.independent.co.uk/news/science/parallel-universe-portal-mirror-world-science-stranger-things-oak-ridge-a8987681.html

3) Larry Wachowski: *The Matrix*, Warner Brothers 1999

4) Kaku, Michio: *Visions*, Oxford University Press 2003, p135

5) *René Descartes, The Philosophical Writings of Descartes,* translated and edited by J Cottingham, R. Stoothoff, D. Murdoch, and A. Kenny. Cambridge University Press, 1985, p12

6) The Wachowski brothers: *The Matrix*, Warner Brothers 1999

7) *Computers, Caves & oracles:* Neo and Socrates, The Matrix Philosophy, p14

8) Swedenborg, Emanuel: *Heaven & Hell*, p76

9) Fludd R: *Utriusque Cosmi, Vol II, Oppenheim 1619.*

10) Blake, William: *The Everlasting Gospel*, p97-100

Dreamers of Visions

The Purpose of the Visionary Artist

Apart from faith, no one has any assurance
whether he is awake or asleep
Blaise Pascal

For indigenous peoples all over the world, the shaman is a central figure who uses magic, storytelling and art to communicate with dimensions beyond the waking state. No word for 'artist' exists in most Native North American cultures and instead he, or she, is given the title of a shaman, prophet, visionary or holy person.

Since before Palaeolithic times, it seems humanity has benefited from the inner visions of the shamanic artist. Our nomadic ancestors were gatherers and hunters expressing their technical diversity and creativity in ways now discovered in magnificent cave art from around 27,000 BC. In places like Chavet at Vallon Pont d'Arc in Ardéche; Lascaux, Mas d'Azil in the south of France and Altamira in Spain, we have witnessed amazing draughtsmanship and sensitivity to animal form and movement. Also in the caves of the ancient Anasazi in Arizona, and in Tanum, at Fossum in Sweden, we find prehistoric art forms and symbols offering a profound knowledge that leaves today's onlookers in awe of their beauty and mystery. Amongst the depictions of many different animals we find drawings of 'anthropomorphs', insects, spiders, handprints, cobwebs, dots, zigzags, sun wheels and checkerboards, together with other symbols that seem to speak of alternative realities.

A NATIVE UNDERSTANDING OF ART

Inspired by their environment and other dimensions, our prehistoric ancestors created shrines on walls telling of hunts and initiations but, most of all, they seemed to hold profound symbolic significance in relation to their experience with life. The visionary will always seek out the profound, or the mysterious through their artforms. Art in this sense is a 'ritual', or meditation.

Art historian Herbert Read (1965) made an important observation about the primal way of making animal images which reflects the ritual-making mode behind much rock art. He said:

> *In such representations there are no attempts to conform with the exact but casual appearances of animals; and no desire to evolve an ideal type of animal. Rather from an intense awareness of the nature of the animal, its movements and its habits, the artist is able to select just those features which best denote its vitality, and by exaggerating these and distorting them until they cohere in some significant rhythms and shape, he produces a representation which conveys to us the very essence of the animal.*[1]

Much scientific research into shamanic art, especially by David Lewis Williams and Thomas Dowson, in their research into the Kalahari Bushmen groups, suggest that the vast majority of imagery found in rock paintings seems to relate to hallucinatory scenes, stages of trance and the adventures of out-of-body shamans. The Chumash native Americans, who once occupied southern California, also produced rock art of a similar shamanic nature and their paintings occupy hundreds of sandstone caves depicting animal and human figures, together with sunburst symbols and other lucid dreamlike forms. Similar imagery is found in the eastern Californian Coso Range, which has been occupied by Native American tribes for untold thousands of years. The petroglyphs in places like the Coso Range and San Marcos Painted Cave, which I've seen, are believed to have been produced during 'vision quests' sometimes aided by hallucinogenic plants such as jimson weed or mushrooms, etc. (see figure 132). In all accounts the shamanic artist is considered a 'pohagunt', or a man of power, which also translates as a 'man

Figure 132: Shamanic Art
Native American Indian shamanic petroglyph.

who writes', or a 'man who makes rock markings'. Rock markings the world over tell of ancient narratives, strange beings and archetypal forces appearing to the visionary native artist. Through shamanic works of art we come to understand the thinking and aspirations of long lost ancient societies and, even more so, their connection with what they describe as the mysteries of the cosmos.

Over many thousands of years the use of archetypes in paintings by visionaries was accepted as a natural way of communicating with the original archetypes and the hidden worlds beyond the five senses. The images and rituals performed by the shaman, or pohagunt in the ancient world, came about from direct experience of the Dreamtime (or heavenly spheres) existing beyond the parameters of the physical illusion. These spheres, or realms, *are within us* and they are part of our personal universe which can be tapped into through the imagination of the artist (shaman). A rich tapestry of imagery and subjects can be found in the work of a wide range of artists and art movements across many different eras that relate to the dreaming, or dream travel. As I have already mentioned, the Australian Aborigines called this place the Dreamtime, or what other shamans and native artists called the 'lands of the ancestors'.

In this chapter, I want to concentrate on the work made by 'visionaries' especially from the 19th and 20th century art movements. These are individuals who have focused on archetypes and hidden dimensions, while embracing knowledge of the Dreamtime.

A VISIONARY WAY OF SEEING

The visionary capacity of an artist is so unique that it is often considered, by western standards, to be a bit bizarre – even mad. A visionary can be perceived as somehow unworthy or even mediocre by a society in its current state. In fact, the power of the Romanesque (6th to the 11th century) visionary has not held any great influence over western civilisation since the Byzantine period, or when Gothic sculpture emerged in art. In the works of Bruegel, Bosch, and the later works of William Blake (who was also inspired by symbolic and spiritual themes), we witness the development of an elaborate style of 'personal mythology' through art. Like that of the native pohagunt, we are taken into worlds populated by archetypal bird-people, giants, monsters and ancient humans living in *The Garden of Earthly Delights*. Bosch's mythical worlds speak of an earlier mystical time on earth and the suffering of the human soul at the height of, and during the Middle Ages.

At the time of the Renaissance in the 15th and 16th centuries in Europe, an ideal expression of external reality almost solely dominated art leaving little room for alternative realities to appear in image making. In many ways, the

European Renaissance sowed the seeds of rational Newtonian views of how the physical world was structured. As I have already touched on, it was during this time that the spiritual became further separated from science as understood by the ancients. The 18th and 19th centuries are often referred to as enlightened times in fields of science and commerce, but in truth, they were ignorant times in their manifestation of how far humanity had entrenched itself in the five-sense, often spiritless world. Today, we are beginning to remember both true science (esoterics) and spirituality (not religious doctrine) are parts of the same higher force or knowledge. However, despite the separation of art from science and spirituality, the visionary aspect can still be seen through the work of artists from the Renaissance period onwards. The spirit of the visionary seems to pass from one artist to the next.

In Spain, El Greco passed the visionary spirit onto Goya, who later influenced Daumier and Manet. While in the north of Europe it is Rembrandt and Brouwever who stirred the young artists of France, like Delacroix, Decamps, and Courbet. These painters in turn helped Cézanne, Gauguin and Van Gogh remember their visionary sight. The Symbolist painters also expressed the absent and the transcendental through their imagery, yet even today in the academies, curricula, and universities, there are people who deny that such visionary art has any significance. As the genius William Blake once said: "The man who raises himself above all is the artist; the prophet is he who is gifted with imagination."

THE AGE OF ENLIGHTENMENT

In the latter part of the 18th century certain artists made a real attempt to focus on dream imagery and the romantic, more imaginary levels of being. Figures in paintings became less heavy and more immaterial as artists like Henry Fuseli, Karl Palovitch and William Blake sought to define the 'energies' of the human soul. Artists of this calibre were responsible for redefining the ideals associated with the 'age of enlightenment' and the art of the city, state and court. Visionary artist John Martin (1789-1854) used an almost supernatural effect in his landscape paintings at this time. Other artists, such as Francisco Goya and Eugéne Delacroix were responsible for political paintings that also seemed to capture more of the spirit of their subjects rather than mere physical interpretation. English landscape painter J.W. Turner brought similar gusto to his work, as he sought to capture the invisible forces and dreamlike energies behind nature, the sea and skies through intense colour. Imagery at this time reached towards the cosmic dream, or the soul's journey amongst the stars, and much art was inspired by mythology and stories going back to the ancient world.

For the philosophers and scientists of ancient Greece whose work inspired the Renaissance in Europe, the universe was a place where the soul could

wander. Since Galileo's observations of the Heavens from the 17th century onwards, artists and scientists became more materialistic towards the 'go out and see' aspect of travel and discovery. As I have illustrated throughout this book, the history of art is no more than the history of the human mind, reflecting the collective perception of reality. It's the visionary who recognises the importance of imagination and dreams with a desires to translate them through art. Symbols and myths found in cave art, mythological paintings of the 14th century, and visionary art of the 18th century are all linked by an archetypal language employed by the artist who tries to understand his or her place in the universe. From the notion of gods found in the myths of all ancient cultures, to the Sun-god flying in a winged chariot, the human imagination moved to a more egalitarian 'free thinker', philosopher, artist, writer and poet mode during this period. The artists of the 17th century onward tried to comprehend the idea of the infinite universe and humanity's place in it. For examples of this, see the thousands of illuminated manuscripts, alchemical books and scriptures using imagery to dissect and understand the mechanics of the cosmos. The point I am making, is that subjects relating to the spirit, dreams, and nature of reality (found in art from the 18th century onwards) were already understood by the indigenous mind and various scientist-philosophers of ancient Greece. The true nature of reality and the language of the cosmos (our dreams) persists through individuals who have had the 'vision' to present these concepts within their works throughout history. Before I delve into some of the themes relating to spirit journeys and dreams found in artists' work from the 18th Century onwards, I need to talk about, in my view, the greatest visionary artist of all time, William Blake.

WILLIAM BLAKE

William Blake is a truly remarkable phenomenon. Born in Soho, London, on November 28th, 1757, he became Britain's true visionary writer and artist. Without a shadow of a doubt, Blake's work inspired later generations of artists and art movements. In fact, more than a century and a half after his death, he still remains a controversial and unsettling character. He was a visionary and harbinger of ideas and imagery seen in much art, literature, and even cinema, today. A Tate Britain poster from 2002 states: "Most artists today, whether they know it or not, are working while under the influence of Blake."

Shunned by the art establishment, Blake sowed the seeds of real visionary art in 18th century Britain. He drew on the master draughtsmen and artists of the Renaissance period for form and style in his imagery, but the content and philosophy behind his art and poetry were truly *inspired*.

Art historians quite understandably believed Blake to be a religious man,

when he was more than likely a very spiritual one. His work shows how he seemed to appreciate the difference between real Christianity (the coming of the New Jerusalem and the spiritual teachings of Jesus Christ) and the false idol based on a crucified god, a god of death. There is a huge difference between the two, and Blake was one of the first visionary artists to reinforce the chasm between spiritual ideas and religious dogma. In the 18th century he was not alone, and one only has to read the works of Thomas Paine, who had met Blake, to appreciate philosophies that were aimed at freeing people from religious mind control (see Blake's work, *Marriage of Heaven & Hell* and *Jerusalem*).

Blake was a man who believed that the imagination was the true real character of a person, and he even went as far as saying that the imagination *was* God in man. It was Blake's spiritual views, fuelled by interests in the metaphysical side of the Bible, that provided him with his visions and passion for revealing what he saw as the true nature of humanity – our divine form. He also saw himself as a 'gardener' of the spirit and of the imagination, and for younger artists of his era, such as Samuel Palmer and George Richmond, Blake was considered a sage or a 'seer'. What Blake saw and showed in the subjects present in his art and writings still unsettles art historians, artists, and the public in general today. From the age of ten, Blake claimed to have seen angels sitting in a tree on Peckham Rye, which, according to his biographer, resulted in a good thrashing from his father. Blake continued through adulthood to illustrate and paint figures found in myths, the Bible and in his dreams and 'personal mythology'. Writing in his poem *The Land of Dreams*, *Blake* highlights the difference between the world around us and the world of dreams: "*Father, O Father, what do we here, In this land of unbelief and fear? The Land of Dreams is better far, Above the light of the Morning Star.*"

In recent years, psychologists have marginalised Blake and other visionary artists for having the ability to 'see' other levels, frequencies and alternative realities. Psychiatry, which in my view is a purely invented profession, has helped to suppress the work of the visionary by naming this ability 'enditic vision'.[2] The extreme scenario labels the visionary as 'mad', which is no more than saying that because an individual offers a different (often truthful) version of reality that does not fit into the norm, then they must be crazy, or worse, dangerous! But who sets the rules of normality in society? The system with all its rules, which when we take a step back and look at the world with renewed vision, is immediately and quite provably more insane than any individual who pioneers his or her own personal vision. Children are said to have this natural visionary capability, but as Blake and many other artists have shown, it is possible to retain a sixth sense, an imaginative ability, and a direct perception well into adulthood. Many of Blake's drawings and paintings hint at the natural ability we all have to see and be directed by multidi-

Figure 133: *The Man Who Taught Me To Draw in My Dreams.*
William Blake's guide?
© The Tate Britain.

mensional aspects of ourselves, and as I shall show in the final chapter, these aspects are as real and important to who we are. Blake's studies of visionary heads and the imagery he produced for his astrologer friend John Varley in 1818 hint at otherworldly, dreamtime personas (see figure 133).

In the end, it was Blake's imagination that offended the art establishment of his time, enough to keep him in poverty all of his life. The same is still happening today, where artists, writers, and film-makers are marginalised and branded 'crazy' by the media, but, in actual fact, like Blake, they are simply ahead of their time. Kathleen Rainein, in her book, *William Blake* (1970) said:

It may be that the New Age of which he knew himself a prophet will yet discover in Blake the forerunner of a new way of expressing the non-spatial interpenetration of spiritual worlds, and that spiritual collectivism of life of which Blake had so strong an intuition.[3]

When any visionary artist, poet or writer leaves behind the consensus reality of their day, by expanding their imagination and drawing on alternative realities, they will always stand out amongst the crowd. This has happened to many throughout history, and is what is happening to writer David Icke in the UK today. The more individuals start to 'stand out' and express their visions, the more they seem 'odd' or strange to the masses at large. But in truth, individuals who have spoken out against injustice, or have offered alternative visions of life, are condemned for the crime of being different. The more free and diverse our collective reality becomes, while allowing others the same due respect to hold different views, then society as a whole will become more creative, diverse and tolerant. This surely can only be a good thing, right? Humanity is not meant to be one unquestioning herd that either takes sides or only agrees with each other. Being an 'individual' with a personal vision, free from ridicule and condemnation, ought to be the right of *everyone* on this planet. True freedom only occurs when we allow others to be free. The visionary throughout history has been, and is a testimony to the human spirit's desire to be free.

IMAGES OF THE COSMOS AND COSMIC TRAVEL

Imagery associated with consciousness, the cosmos and dreaming has always appeared in visionary art. Soul searching, and a desire to uncover hidden levels of reality by artists and poets in the 17th and 18th centuries, like Blake, was (is) most definitely an attempt to access archetypal, esoteric knowledge and the understanding of 'the mysteries'. As shown in *Part Two* of this book, the shaman expresses knowledge of the wider cosmos by using images of stars, sun and planets, along with anthropomorphic symbols. Myths and legends are based on the precession of the stars and the earth's journey through different suns or ages. The imagery found in visionary art is timeless and transcendent. It reflects the human need to delve into deeper imaginary realms, to the core of our being. In art therapy circles, this process is often called 'dream/astral travel' or 'image dialogue', something the visionary artist taps into quite naturally (see figure 134). For those who do not trust the dogmas of religious belief, the visionary artist within all of us gives a personal perspective on spiritual realms and other dimensions that is based purely on the individual's internal journey and not some external authority.[4]

In the 18th century much art and literature came from a direct fascination with dreams, or cosmic travel. Works such as Johnathon Swift's *Gulliver's Travels* (1726) and Voltaire's *Micromégas* (1752) both depicted characters embarking on fantastic voyages into other worlds. These works are the precursors for what became science fiction and other subjects found in books and films over the past 30-40 years. *Fantastic Voyages*, *Star Trek* and *2001:Space Odyssey*, all touch on time travel, interstellar consciousness and luminous forms. As the years progressed, movie directors have had more and more special effects technology at their disposal, and the heaven and hell realms, space, and alien creatures, found in ancient art have never looked so good! Visionary art has always been ahead of mediocre modern art, purely because it is inspired by the infinite worlds within us and the levels of perception that look both 'inwards' and 'outside-looking-in' simultaneously. Some of my sketchbook work over the years has tended to gravitate towards these subjects, and using a computer has enabled me to create imagery offering both luminosity and movement, both of which relate to the inner worlds of the soul.

Figure 134: Dream travel imagery.
Sketchbook page expressing the concept of the astral body moving through different worlds, or dimensions.

Artists, from the earliest

civilisations through to the 19th and 20th centuries, have been inspired by images of the cosmos. Van Gogh (1853 –1890), Charles Burchfield (1893 - 1967) and Etienne Léopold Trovelist (1827 –1895), amongst many other artists, depicted nebulas, star formations and luminous forms within their work. Writers and artists such as Blake went even further, offering visions of unseen microscopic creatures not fully understood and appreciated until the technology became available in the 20th century. Blake's imagery of reptilian alien-like creatures seen in his imagery for the Visionary Heads (*The Man Who Taught Me to Draw in My Dreams)* and Dante's Divine Comedy (1824-27) has done the rounds on websites uncovering extraterrestrial phenomena and conspiracy theories. Van Gogh's painting, *Starry Night* (1889) also captures the movement of stars along with the luminosity of other celestial bodies, something only really appreciated through astronomy in the 20th century. Van Gogh was an artist (initially a priest) who never gave up on his ideas relating to divinity, spirituality and the deeper feelings associated with humanity, the cosmos and nature. His so-called madness was more to do with his passion and internal suffering (not to mention his appetite for sex and alcohol) in a world that he did not seem to fit into! Van Gogh's paintings capture the microcosmic knowledge embedded in nature, and his brush strokes seem to dance to the tune of galaxies and spirals found in the very essence of life. In my view, he is a shaman who didn't know it, and what he left behind is a vast collection of images that speak of hidden forces in nature and the spirit *behind* all life.

MULTIPLEVIEW POINTS – 20TH CENTURY ART

Attempts by psychologists such as William James and Sigmund Freud to map consciousness in the late 19th and early 20th centuries would influence the work of artists and writers of the time. It was William James who origi-nated the term 'stream of consciousness' and put forward ideas that became the basis of modern psychology. The dawn of the 20th century saw an inter-est in humans as organisms; artists and poets alike became fascinated with the need to convey the inner worlds. Prior to the 19th century, drawing was used to demonstrate the inventive mind's potential, but a shift seemed to take place at this time that saw artists freeing themselves from the constraints of realistic representation. William Blake had already made an attempt to do this in the 18th century and he was certainly aware of how drawing was the language that best expressed the spaces between reality and imagination. Artists who followed in Blake's footsteps up until the modern day have been creating a more personalised view of the world, tracing what the mind imag-ines rather than what the eye sees. This is an important point, when it comes to understanding how we can recreate our personal universe and mythology. Art in the 20th century from the likes of Pablo Picasso to Anthony Gormley,

seem to mirror the art of the prehistoric mind – one that chronicles *both* the inner and outer spaces of reality.

The dawn of the 20th century saw the desire to reformulate close bonds between the human and the cosmos by means of symbolist imagery. Archetypes used in the ancient world to symbolise human imagination, emotion and the forces in nature emerged quite naturally in the work of Edvard Munch (1863-1944), Paul Sérusier (1864-1927) and Pellizza da Volpedo (1868 -1907), the latter of whom was a leading representative of the Italian Divisionist movement.[5] Images associated with the sun, moon, stars, and nature were focused on by the Post-Impressionists (1886-1905) and the Expressionists, which can still be seen influencing fine artists today. In an exhibition by Danish artist Olafur Eliasson called *The Weather Project* (2003), giant installations making use of light and mirrors to create the effect of an inner sun seemed to echo the work of the alchemist in a modern age.[6] His work, like the Impressionists of 20th century Europe, takes nature (the weather) as a starting point for exploring ideas about perception and reality. Obviously Eliasson's giant installations are not traditional oil paintings, but like a Van Gogh, they reinforce archetypal imagery at the heart of human perception.

For thousands of years, artist-priests focused on the sun within their art and rituals, and nothing has really changed for any artist who opens their consciousness to a higher source found within all life. The sun, moon and stars inspire all artists, especially those tuning into their visionary sight, to the levels of knowledge seen in astrophysics and the science of cosmology. At this level, both science and art are connected through the archetypal knowledge and higher dimensions beyond space and time. The ancients understood that reality is dimensionally structured and creativity, art, dance and music, along with certain hallucinogenic plants, can take the human mind beyond the spectrum (light) limited by this physical dimension. [7]

In 2004, *The Guardian* newspaper in the UK reported about a biochemistry researcher, Lizzie Burns, at the University of Oxford, who had used drawing and painting to explain different biomedical research, which was funded by the Medical Research Council.[8] This is one of several contemporary examples of science and art working together to express molecular worlds, in this case biochemistry. Cinema, like art, can also be shown to move perception beyond the norm when it comes to journeying into realms that are generally unseen. The 1966 film *The Fantastic Voyage* takes us to a microscopic level where a medical team is shrunk and transplanted into the body of an important scientist, so they can remove a life-threatening blood clot from his brain. The film shows an alien-like landscape just as microscopic imagery of flies and insects opens us up to a plenitude of would-be alien life forms, as shown in a previous chapter. The potential to see beyond the physical world and go

bigger or smaller from a microcosmic and macrocosmic view, was understood by the ancients and put into practice by alchemists and visionaries from the Renaissance onwards. The symbolists of the 19th century also expressed many themes appearing in the work of later psychologists and scientists of the 20th century. A scientific leap into the so-called cosmic realms occurred just after the First World War when artists captured space and geometric forms through what art historians call 'abstract art'.

IMAGINING THE FUTURE

Abstract art is considered meaningless by the majority of the art-viewing public today; yet abstract art is inextricably linked to spiritual ideas and images of the cosmos. Many artists, writers and mystics have expressed, through their work, the difference between the mystical or occult ideas and the belief in institutionalised religions. The spiritual side of art appeared in abstract imagery at the turn of the 20th century, opening up new horizons for visionaries who desired to see beyond the confines of the physical world, just as it had done for the shamans of the ancient world.

The first half of the 20th century would see partially veiled references to heavenly bodies as artists became fascinated with the spiritual knowledge offered by ancient civilisations. Terms such as occultism or mysticism became attached to art as artists tried to offer alternative views to those of Modernism and Darwinism. A huge interest in theosophy and metaphysics was shared by artists such as Paul Sérusier and the Nabi group of artists based in France at La Rochelle. As I have said in earlier chapters there has always been an underground stream of knowledge relating to mysticism, and artists sought out other artists in the 19th and 20th centuries based on this desire for knowledge. What strikes me as an artist, is how much modern abstract work can be placed in juxtaposition with native rock art imagery made by shamans from the Bronze Age on. This is because certain shapes and forms, as shown in earlier chapters, relate to a language that dwells in a timeless zone and is drawn upon by artists in all eras. It is said that Paul Sérusier (1863-1927) intended to execute a large series of geometric shapes that were available to any artist who utilised these sacred forms.[9] The same geometric forms can be found in the design of temple structures and in the composition of paintings made by the brotherhood of artists mentioned in previous chapters. At this time, works by mystics and alchemists such as Jakob Böhme and Robert Fludd (who were important illustrators when it came to providing images for some of the greatest theosophical works of the 18th century) also influenced abstract spiritual art. *The Principle of All Things* by Böhme and *Utriusque Cosmi* created by Robert Fludd (from the 17th century) are two books that influenced abstract spiritual art. Works of this nature focus on universal concepts of the cosmos as a single living substance, as did

the work titled *Astronomicum Caesareum* by alchemist Peter Apianus. Many artists who were influenced by the mysticism and theosophical teachings of Böhme, Fludd, and Henry Cornelius Agrippa (1651), also used cosmic abstract imagery to try and express the *oneness* of the universe, something that had not been offered by the church and the newly found materialistic science proposed by the likes of Newton. A new vision of the Universe was emerging in art across Europe and the interest in the vibrations, light, motion and alternative realities became prominent in the works of the Italian Futurists and the Cubist movement in Paris (1904-1910). The desire to visualise the connectedness of all life in the Universe came through works by artists and writers such as Charles W. Leadbeater (1854-1934), Victor Hugo (1802-1885) and Hilma af Klint (1862-1944). Other painters, like Georgia O'Keeffe (1887-1986), Raymond Jonson (1891-1982), Gino Severini (1883-1966) and František Kupka (1871-1957), to name but a few, tried to capture a rhythmic, geometric luminosity found in nature, something that had inspired scientists like Faraday and Maxwell towards the end of the 19th century. The links between art and science were growing at this time, especially through a desire to understand light, colour and the mechanism of the eye. However, it was the Impressionist painters who would use clusters of red, green and blue paint to formulate an impression of an object, just as television screens and computer monitors would later arrange red, green and blue elements to produce an image in the 20th century. George Seurat's (1859-1891) work is probably the most obvious example of how tiny dots are used to make huge images.[10]

PORTALS INTO HIGHER DIMENSIONS

Artists, scientists, philosophers and writers have always been fascinated by 'light' as I have already shown in earlier sections of this book. Painters of the 20th century became intrigued by X-rays, Chronophotography and theories relating to the fourth dimension. Czech painter and graphic artist, František Kupka was deeply interested in the science and symbolism exploring regions beyond the visible world. His images are highly influenced by the occult and spiritualism, which were growing in interest during the late 19th century. Kupka was a regular visitor to the Paris Observatory at Le Palais de la découverte, where photographs of heavenly bodies were being exhibited. He also seems to have tapped into archetypal imagery that often appears in the crop circle phenomena (see figure 135 overleaf). Other artists have made similar connections through meditations and using music, something I have witnessed in my spirit art workshops over the years.

The hardly-known German visionary artist, Wenzil Hablik (1881-1934) summed up the almost fundamentalist attitudes to art and the cosmos at this time when he said: "*Artists who are not creators in the cosmic sense have nothing*

Figure 135: Cosmic forces in art and corn. ·
(Left) The image by František Kupka *First Steps* (1910-13) bears a striking resmblance to some of the crop circle phenomena. **(Right)** that have appeared all over the world. Is it possible that the 'mind' of the Earth and the human imagination are one?

in common with creativity." Artist Wassilly Kandinsky, who wrote *The Art of Spiritual Harmony* (1914), also pursued ideas not too far removed from imagery associated with shamanic journeys into invisible realms. Joan Miró (1893-1983) and Paul Klee (1879-1940) were two other painters labelled Surrealists who were influenced by indigenous abstract art. Many artists at the turn of the 20th century were producing imagery that could be associated with dreams, the cosmos, and travel into higher dimensions. Wenzil Hablik produced many drawings of imaginary ships and flying machines in his works called *Air Colony* (1918). His flying buildings look remarkably similar to illustrations of flying cities found in Tibetan and Hindu manuscripts, which seem to hint at extraterrestrial activity in ancient times. Some of the imagery associated with mother ships in science fiction films, such as *Close Encounters of the Third Kind* (1977) can also be seen in Hablik's work. Another German artist and writer of the same period, Bruno Taut (1880-1938), set out similar ideas relating to Utopia and the essence of cosmic travel. In three rare books, *Alpine Architecture* (1919), *The Dissolution of Cities* (1920) and *The World-Master Builder* (1919), Taut expressed his ideas and visions of leaving behind materialism to ascend to the stars.[11]

Abstract art of this calibre appears to have come full circle in the 20th century as artists seeking to communicate spiritual and mystical themes were bound to use archetypes that had emerged thousands of years earlier in the minds of shamans. Also in this period psychologist Carl Jung was forming his ideas regarding the collective unconsciousness and archetypes, and it's this collective level of the mind that all creative individuals can tap into at any time and in any era. The fascination for ancient, almost lyrical, symbols did not end in the 1920s. In the 1930s and 40s the same age old symbols continued to haunt artists like Joan Miró, Paul Klee and Mark Rothko (1903-1970). In Joan Miró's 23 pieces of work called *Constellations* (1940-41), the stars become atoms or cells, which speak of the microcosm and macrocosm understanding of unseen energies behind the creation of the universe.

ART AS A SEARCH FOR THE FOURTH DIMENSION

Just as light and time fascinated scientists throughout the 19th and 20th centuries, the Cubists revolted against 'perspective' (in 1911), capturing what can be described as a fourth-dimensional perspective. In their work, artists like Pablo Picasso and Umberto Boccioni offer a perfect example of how faces, objects and people can be viewed from multiple perspectives as though they are painted by someone who can see from *outside* this reality – the fourth dimension. Another aspect of fourth-dimensional art is *movement* through time and space, something I constantly attempt to capture in my own work. I am fascinated with the movement of light as energy and the invisible (made tangible) forms occurring in nature because of vibration, or movement. At this level, I am *not* talking about motion in terms of physical speed, but more the movement of (invisible) particles as recorded by astrophysicists. The magnification of galaxies, nebulae and star systems, so that they appear in different forms, also shows us creation consists of microcosmic and macrocosmic invisible levels. Art and image making can have the same impression of discovering something not normally seen, unless we see from an alternative perspective. The more artists access the subconscious levels of their mind, through their imagination, the more likely they will see the multidimensional views of reality. On that note, I sense all artworks create portals into other dimensions while capturing scenes from the past, present, or future memory bank of an immense, creative consciousness! Could art, like astrophysics, be a vehicle for seeing into invisible (parallel) worlds? If so, could art be a tool for seeing into higher dimensions? There are similar concepts in H.G.Wells' work *The Wonderful Visit* (1895), or Lewis Carroll's *Through the Looking Glass* (1871). Art *is* a sacred gift that can help each person discover the many invisible worlds that exist within our *personal* universe.

WINDOWS OF THE SOUL

The Surrealist art movement in the 1930s seems to penetrate the subconscious worlds on different levels, using imagery, in my view, that exposes our 'myopic state.' Surrealist art is an almost natural response to the 'mechanisation' of the human spirit brought about through war and mass industrialisation. Both the Surrealist and Dadais art movements in Paris responded to our loss of soul by attempting to shock the public through their art. Much modern art today doesn't go far enough, in my view, when it comes to reflecting the real spiritual needs of our current time.

Art, in all its forms, if we dig deep enough into the depths of our soul, is a device by which we can inform and cleanse our current civilisation. The Surrealists seem to peel back all rationality, one that fights to accept the insanities of war, death and destruction. The images of Salvador Dali and

René Magritte, for example, illustrate very vividly the confused and broken levels of consciousness, due to conflict and pain caused by two World Wars. On the other hand, the works of artists like Paul Klee and Wassily Kandinsky shows us how by tapping into the subconscious realms, their art is not too dissimilar to native cave art and petroglyphs. Their work is almost poetic, a kind of lyrical symbolic language similar in form to indigenous art. Klee believed childhood to be a period of uncorrupted creativity and he is one of the first artists to publicly recognise the significance of children's art and, through it, our connection with the soul and spirit. Klee's use of phosphenes, which are found in flower shapes, honeycombs, spider webs and such, express a higher dimensional language, one that other artists of this era were trying to capture. French artist Odilon Redon (1840-1916) a precursor of Surrealism also penetrated our reality with drawings of strange beings, spiders, eyes, phosphenes and flower shapes he saw dwelling in the lucid dreamtime (archetypal) worlds of the subconscious. Similar phosphene and geometric shapes are also found in the designs of walls and floors of ancient places like the Palace of Tell el-Amarna in ancient Egypt. Abstract Surrealists, like earlier shamans and Egyptian temple artists, seem to employ a 'language of forms' (the language of the subconscious) to communicate with forces that order our reality.

Pablo Picasso also delved into symbolic territory and even though he only touched the surface, he was communicating with spirit, just like many indigenous cultures that inspired him. The American painter Georgia O'Keeffe in the 1920s certainly places emphasis on natural phenomena found in flora and fauna, as her paintings seem to reflect the 'spirit of nature'. O'Keefe's work has the ability to offer a close-up of a flower and the subtle folds of a rolling hillside simultaneously. Interestingly, the UK *Guardian* newspaper touched on the same ability often expressed by artists, in an article comparing Thomas Moran's 19th-century paintings to the imagery photographed by the Hubble Space Telescope.[12] The article shows how the image of the Eagle nebula (65,000 lights years away) could almost be from Moran's *Cliffs of the Upper Colorado River, Wyoming Territory, 1882*. Even earlier masterpieces, such as the *Creation of Adam* on the ceiling of the Sistine Chapel in the Vatican, show parallels with the structure of the Orion Nebula, a subject I touched on in *Orion's Door*.

In effect, what we really do when we use our imagination through art, music, or dance, is to automatically attune to the myriad archetypes residing within us. These are non-physical aspects of ourselves, existing in each dimension, working directly through the psyche. Sadly the inability to feel other dimensions at work around us or the desire to connect with our higher selves, is evident by society's overly materialistic and scientific preoccupation with only the five physical senses. Seeing beyond the physical conscious

world means looking beyond the limits of duality and the illusion that *is* the physical world. Our imagination can take us beyond the parameters of the mundane 'vegetable glass' of nature (as Blake called it) and into more lucid worlds where our thoughts and dreams connect us to something more real than the material world. All science in its truest form (seeking knowledge) and art, as I have been exploring in this book, have been separated in the human mind. Instead of balancing our lives by acknowledging higher levels of awareness, such as psychic sight, telepathy, and our innate ability to feel at one with creation, we too often choose to limit our experience to the 'realm' of the five senses. All visionary art shows us that there has to be something more than this physical world! From an artistic viewpoint, when we limit our experience only to the norm or comfort zones deemed accept-able by the status quo, then we automatically deny a sight and a process of communication that empowers the visionary within us.

In the final part of the book, I want to focus on the power of the imagina-tion and the capabilities of what Blake calls, the "human form divine."

NOTES

1) Highwater, Jamake: *Primal Mind*, Meridian Books, 1982, p58

2) *Blake*, Tate Gallery Publications, p11

3) Raine, Kathleen: *William Blake*, Oxford University Press, p124

4) See *Through Ancient Eyes*

5) Gibson, Michael: *Symbolism*, Taschen, 1995

6) Eliasson was sponsored by Unilever. For more information visit his website at: *www.olafure-liasson.net/*

7) Arthur, James: *Mushrooms & Mankind. The Impact of Mushrooms on Human Consciousness & Religion*, The Book Tree, p12

8) The *Education Guardian, But is it Science?* Anna Fazackerley reports on Lizzie Burns. 3rd February 2004, p22

9) *The Spiritual in Art: Abstract Painting* 1890-1985, Abeville, p20

10) Clegg, Brian: *Light Years, An Exploration of Mankind's Enduring Fascination with Light*, Piatkus, p210

11) See the exhibition and book, *Cosmos, from the Romanticism to Avant-garde*. The Montreal muse-um of Fine Arts, June to October 1999, published by Prestel 2000

12) Radford, Tim: *From Wild West to Final Frontier, The Guardian*, 19th February 2005, p10

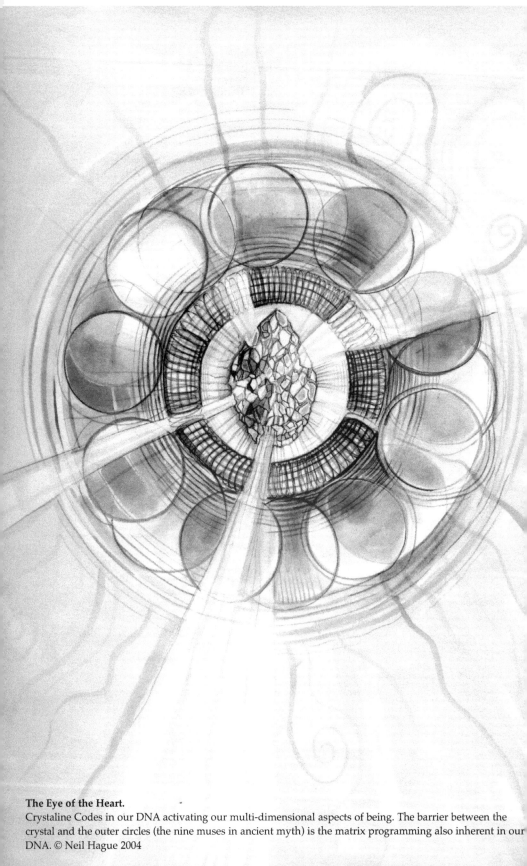

The Eye of the Heart.
Crystaline Codes in our DNA activating our multi-dimensional aspects of being. The barrier between the crystal and the outer circles (the nine muses in ancient myth) is the matrix programming also inherent in our DNA. © Neil Hague 2004

PART FIVE

THE *DREAMING*

& BECOMING

MULTI-DIMENSIONAL

I shall not rest from this great task ...
to open the immortal Eyes of Man inwards

William Blake

Reality Rings & Memory Wheels

Transcending time through art

Imagination has always had powers of resurrection
that no science can match
Ingrid Bengis

The alternative history of art is one that attempts to understand the nature of reality! On a certain level art can be viewed as the 'record' of humanity's desire to penetrate the veils of time, to reveal a higher purpose. My own art has been a process through which I have seen through the illusions of time and the 'construct' we call everyday reality. I like to think my own paintings take the viewer 'beyond the parameters' of reality and into the worlds where higher consciousness (infinite love) and humanity (spirit) are at one with each other. If anything, the journey into alternative levels of consciousness has been the main theme of this book.

The art of the visionary attempts to show us there is more to reality than the physical world and that the 'divine', through images, can open our eyes and our hearts to more mystical, yet increasingly scientific, understandings of how our minds create our reality. All visionary art should, in my view, take the viewer beyond the realms of acceptable thought, the norms, and instead, show us the myriads of forms inside our personal universe. Our ability to daydream, have flights of imagination, dream, and construct mental dialogue with non-human intelligence, are all basic aspects of the visionary capabilities found in all humanity. How we respond to our dreams and visions as individuals depends on our ability to 'see through' the world and anchor our visions within this physical dimension. The subjects covered in this book have illustrated the relevance of our imagination, mythmaking and visionary capabilities throughout history. What all visionary art has in common, both past and present, is the ability to reveal alternative realities, which helps in the formulation of an individual paradigm shift, even reinventing

461

the status quo through a collective response to this vision. Such a philosophy is beautifully captured in the lyrics of Peter Gabriel's song, *Fourteen Black Paintings* (1992), where he states:

From the pain come the dream
From the dream come the vision
From the vision come the people
And from the people come the power
From this power come the change [1]

Our mind is the vehicle through which we can traverse time and be in the past, present, and future simultaneously. Through our thoughts we can change our reality to suit our new level of understanding. Our heart is the place where we need to go, to *feel* the love within as it moves us into states of beauty. It's the responsibility of all of us to *become* visionaries and 'independent free thinkers' if we are to break free of the self-imposed limitations. Such limitations create a lack of abundance, choices, and therefore freedom! In this chapter I want to focus on the connections between visionary art, science, and the knowledge that can open our minds to *much more* than the consensus this-world-is-all-there-is reality!

ASPECTS OF BEING

According to shamanic traditions and parts of the more open-minded scientific establishment today, the Universe is an endless flowing grid of consciousness. Our personal universe connects to a wider web-like consciousness, one that encompasses all life forms. True visionary art is a form of expression that speaks to the heart of anyone willing to see beyond the veil and the constraints of time and our illusory physical reality. As I have shown in the earlier parts of the book, our minds can travel through parallel realities and the places we reach can sometimes be occupied by life forms dubbed as paranormal, supernatural or extraterrestrial. All of my paintings allude to non-local realities, or, in other words, non-physical worlds inhabited by a myriad of alternative life forms. These non-physical personas are multidimensional *aspects* of who we are, and they often come to life through our art.

What I refer to as *aspects* are simply non-physical and express themselves in the types of personas, attitudes, and past (or future) life connections we hold within on a deeper level. The first time I recognised that we have non-local (multidimensional) *aspects* was when David Icke asked me to paint the cover of his book *I am Me, I am Free* (1996). The people surrounding David's naked presence (if you excuse the phrase) are symbolic of *his* non-local aspects as I saw them (see Figure 136). As are the figures portrayed in the

Figure 136:
Non-local aspects of being.
We are not just our physical bodies.
Art can be a channel for our multidi-
mensional *aspects*. © Neil Hague 1996

image on the cover page of *Part Five*. This illustration is meant to be an alternative representation of the *Lovers* card in the Tarot. Relationships (lovers) can also experience 'aspects of being' (through each other), based on past traumas, conflicts, and life patterns which can arrive in dreams, too. Both images are an attempt to convey that we are more than just physical human beings. We have a projected energy 'field' (aura), and within this energy, some people can see our past 'projections', or lives. Whether these non local projections are merely expressions of the illusion (matrix) from a fourth-dimensional (astral) 'intelligence' is hard to know.

THE NON-LOCAL EFFECT

The non-local philosophy, which is more of a scientific understanding put forward by great minds such as Niels Bohr (one of the founding fathers of quantum physics) and David Bohm, a protégé of Einstein, relates to the Universe as a super-hologram. Both have shown through their work that our world and everything in it, from a star to an electron, are images or 'projections' from a level of reality beyond our own – they are literally *beyond* both space and time. The famous Oglala Sioux medicine man Black Elk explained the non-local way of seeing when he said:

> *I saw more than I can tell and I understood more than I saw; for I was seeing in a sacred manner the shapes of all things in the spirit, and the shape of all shapes as they must live together as one being.*

The idea of a holographic (non-local) universe can be seen in the way an image repeats itself on a holographic plate, therefore creating a non-local effect of the same image. The ancients tried to explain this concept through 'macrocosm is the microcosm' (the big is small and the small is big). Visionaries, such as William Blake through to Greek philosophers like Anaximenes, Pythagoras and Plato, also explored the same philosophy. As have scientists and neurophysiologists, such as Karl Pribram at Stanford University, author of *Languages of the Brain* (2003). Pribram shows, through

his research, that the 'non-local mind' and the 'holographic model' of the Universe can explain many so-called mysteries.

The nature photographer and French TV personality Nicola Hualt, has also stumbled across the concept of 'macrocosm is the microcosm' in recent years. His books and television programmes show non-local imagery viewed across microscopic images of plant life, in relation to similar imagery viewed from great heights, such as satellite photographs of parts of the earth. What these photographs show is the holographic nature of reality, they visually illustrate what physicists such as David Bohm and neurophysiologists like Pribram have shown: that every part of a whole image is repeated in smaller parts of a hologram (see page 439). Therefore microcosmic images of a leaf can look like a macrocosmic part of the Earth's surface, and this why a spiral can be seen in a galaxy and in the shape of the double helix of our DNA. All life is connected from a star to the human form, and since the Bible tells us that God made man in his image, we can be certain that no matter how DNA shapes our form, we are all 'light' and are all aspects of infinite consciousness.

Seeing non-local aspects of life was practiced by the shamans through their art and this ability to see both the 'big' and the 'small' is how we see with our 'ancient eyes'. The most important revelation we get from seeing in this manner is that each and every one of us *is* a personal universe. The ability of the human mind to stretch beyond a specific point or location would mean that areas, such as telepathy, psychic abilities and a wide range of phenomena, could be easily explained when we realise that *all* shapes, sizes, colours and people come from one source, the Infinite. Visionaries, in the form of shamans, artists and now scientists, are coming to the same conclusion, that we are *not* our physical bodies or our brain (our ability to 'see with the brain'), instead, we exist in many parallel realities.

THE MIND'S EYE

Imagery passing through the mind's eye is as valid to the visionary as the natural forms we acknowledge through our physical sight. The only difference is that physical forms are images decoded by lenses (our eyes) that pass information to the visual cortex in the brain. However, non-local forms come through the ability to see with our visionary sight, which can be activated by a range of meditation techniques and hallucinogenics - but the most powerful activation is through our imagination. Our dream states, especially daydreaming, are also methods of reaching non-local states of being. William Blake, with whom I feel a great affinity, especially through my art, even went as far as saying: "I know that this world is a world of imagination and vision. I see everything I paint in this world, but everybody does not see alike."

Non-local forms are seen *without* our eyes, rather, they come from our ability to use the imagination to see! The type of images witnessed through our non-local seeing abilities are often dubbed as supernatural, flights of fantasy or extraterrestrial. What we need to appreciate, is that none of the so-called strange phenomena are actually paranormal, but merely another facet of reality that has either been denied bycenturies of mind control (religion especially) or, generally forgotten by humanity. What visionary artists, scientists, writers and their like have consistently pursued, is the truth in relation to reality, and by doing so many have suffered at the hands of a controlling force much invested in sustaining and manipulating the norm – the status quo. "He's mad" or "Shut him up" are the classic off-the-cuff responses awaiting anyone who dares to tread outside the parameters of acceptable thought and behaviour. Even if the acceptable is often insane! In fact, many a visionary, or pioneer of the imagination, has been labelled mad for expressing similar views often found in my art and books covering these subjects. Five hundred years ago, individuals would have been burned at the stake for discussing such subjects! No need for that today, instead, people police each other's thoughts and too often mentally parrot the accepted view, even if it's fundamentally flawed or an outright lie. Too many people accept what they 'see' and they don't 'reflect' or contemplate enough, especially in relation to the quality of information given to them concerning current affairs.

Navigating our way through life via only the five senses, is like relying on a map of the UK to travel around the world! There is more to reality than meets the eye, excuse the pun, and our ability to set our minds free comes with the perception that we are in this world (reality), but not necessarily 'of it'. We are time travellers by nature and our minds can imprison us or set us free. It's all a matter of perception and choice!

As my books and paintings constantly strive to show, our level of imagination is what creates our reality and our state of mind reflects back at us the life we experience daily. The places we travel to, the aspects, creatures, images and information we receive, whether it is from the past or the future, depends on how we learn to access our non-local visionary capabilities. Our memories and flights of fantasy also stimulate our minds through our greatest gift – *our creative imagination*. For many, the imagination is something to rebuke, to fear or even deny. We lack imagination collectively, because we don't value the need for the visionary within each of us. Our imagination is a gift that needs nurturing, because through it we can change our perception and visualise any reality we choose. We can be both big and small, as Jean-Jacques Rousseu said: "Reality has boundaries, imagination is limitless."

BEING SACRAMENTAL

Art is a perfect vehicle for reflecting back at society the inner values of people, whether as individuals or as a collective. The modern world is full of art that goes skin deep, and so-called modern fine art is obsessed with the 'cult of the individual'. This is not a bad thing in itself, but what painters and art students need to see, in my view, is that art exists, as it did in ancient times, as a conduit for 'unseen' forces! Art is a language that offers a thousand words in one image, it is a natural vehicle for the non-local or spiritual levels of reality. The Roman Church know this and that's why religious heirarchy has hijacked art over the past 2,000 years. The last thing those in power want (whether the church or now the political, economic industrial complex), is artists and creative individuals exploring subjects that offer alternative constructs on reality. Artists like Damien Hirst, Tracy Emin and their likes around the world are not 'dangerous' to the status quo, or even pushing the boundaries of thought and perception. These artists are clever, even intellectual when it comes to marketing and placing themselves in today's media machine. Many artists today are reflecting back at Western society, our 'collective' lack of visionary capability. For more proof of this one only has to look at how art and music have become more mediocre and mass-produced, and with it there is a lack of the sacramental, mystical or spiritual in its broadest sense. Fine Art has become a 'profession without a purpose' , as artists follow the 'cult of the individual' and the 'cult of self-expression', trying to achieve media status, in a world that really coudn't care less about sacred art. Figures like Blake or Giordano Bruno, if they were alive today, would certainly ruffle the feathers in our mediocre, often spiritless machine-based society. Music and art can be important tools for telling the truth and opening the hearts and minds of all who come into contact with them. The world desperately needs an outburst of visionaries in every field of the arts and the sciences. So what are we waiting for?

Society, on the whole, fears the unknown and especially anything associated with death and what happens to us after we die. The whole religious-scientific-political structures that have run the world for at least 2,000 years have a lot invested in what I call the 'fear of death culture'. Therefore, it's not surprising that anyone who offers an alternative vision and desires to understand the true nature of reality can find themselves branded as insane or even dangerous to the establishment. Art is hugely controlled and commissioned by the same élite structures and as I have explored in this book, the same élite has feared the visionary and the artist free-thinker throughout history. The fascination for unseen alternative realities, through holistic science, art and the writings (often when art and science are combined), can now be seen in a growing number of visionary individuals. Since the turn of the 20th century

many creative spirits have felt there is more to reality than the physical one we pay homage to through taxes, toil and survival mindsets.

PAST, PRESENT AND FUTURE ALL AT THE SAME 'TIME'

In *Through Ancient Eyes* and *Orion's Door*, I detail the connections between ancient accounts of higher dimensions and more scientific knowledge that has come to light in recent years. Hyperspace theories, including studies into the holographic nature of our Universe (or reality) are subjects that have found their way into the art of the visionary. In fact, it has been the visionary throughout history who has endeavoured to illustrate what true science is now proving that consciousness exists as both matter and spirit, and the higher we travel in terms of dimension, the smaller the particles become. What they become is *one and the same*. These particles have also been described as 'rings or strings' and it is these mini-rings that are said to construct our physical reality. Scientists call these particles 'quarks' and 'leptons', latter of which exist in nature as 'individual' particles whereas quarks cannot. It's these mini-rings, which compose the physical body connecting us to what sages, and in more recent years astrophysicists, call the Infinite. Giordano Bruno summed up this concept when he wrote:

> In all things there is an ordered connection, so that inferior bodies follow median ones, which follow superior ones, hence composed bodies join simple ones, material ones approach spiritual ones, which in turn approach immaterial ones. Thus there is only one body of a universal being.[2]

At the level of subatomic particles *nothing* is fixed or solid and therefore *all* can exist *everywhere* and *nowhere* simultaneously. All life is One!

From my own experiences and research, the dimensions intersecting our physical reality can be visualised as 'rings within rings', with each ring representing a specific vibration, time frame, dimension or state of mind. I see these rings as 'gateways' into many different worlds (levels of knowledge/information), all of which house archetypes, which are found in the myths and religions of the world. The astrophysicist Giuliana Conforto, in her fantastic book *Giordano's Future Science, the Birth of the New Human Being* (2002), says of these mini-rings:

> Mini-rings which compose any physical body, are mini stargates which connect it invisibly to similar invisible parallel, immaterial or rather more subtle bodies. Paradoxically for the human mind, within our own biological body, composed of empty atoms, there might be other similar subtler bodies that we don't see, but we can feel as memories or ways of thinking pertaining to other worlds. Any physical body is therefore the terminal of invisible mini pulsating cables, which are the cos-

mological stairways Bruno and other sages described.[3]

These rings or dimensions are also the home to numberless expressions of consciousness dubbed supernatural, or extraterrestrial. What the visionary in all cultures and eras reveals, is that the language of imagery (our art) is the nearest and most clearest resemblance to the type of knowledge experienced in non-physical states of being.

Figure 137: Nine reality rings.
We are operating in past, present and future worlds. These are connected to our mythmaking, artistic and visionary capabilities. Our humour allows us to not get caught up in the illusion (duality).

The information housed within what I call 'reality rings', usually through encoded imagery, archetypes and symbolism, can also provide the mind with imaginative connections to a timeless wisdom. Our personal connection to these 'reality rings' is through our mind, our imagination and sense of perception (see figure 137). Many artists, visionaries, scientists and sages of yesteryear have been able to access alternative realities through, what the ancients called, *nine* key reality rings.

REALITY RINGS

The nine 'key' rings relate to nine dimensions, numbers and personality types on one level, but as mentioned earlier, they are keys to our multidimensional aspects of being. Our multidimensional aspects are connected to each other just as a crystal and its multifaceted reflections are connected. The rings as shown in figure 137 can be used vertically, horizontally or diagonally as a tool for expressing our creative imagination. The nine reality rings are an integral core 'framework' that translates our multidimensional personas (relections of the crystal) into a tangible language understood in this physical reality as art forms. From this perspective, we exist in all past, present and future lives, narratives or expressions of infinite consciousness. The crystal is the receiver of light or consciousness and at the same time, is part of the original ocean of light, or what the Gnostics call 'watery aeon light'. Through accessing our innerworlds, our higher consciousness, we can heal our outer and inner conflicts.

Philosophers, scientists, and visionaries, such as Plato through to the 16th-century sage Giordano Bruno, also used a similar structure to try and explain how the human imagination can transport us into alien worlds and alterna-

tive realities. Bruno named these rings 'memory wheels', which he believed provided the imagination with both ancient and futuristic imagery simultaneously. Michael Talbot describes these reality rings as 'reality fields' in his book *The Holographic Universe* (1996). In relation to consciousness and the connection to illusory aspects of reality, Talbot writes:

> *Indeed, if the universe is a holodeck, all things that appear stable and eternal, from the laws of physics to the substance of galaxies, would have to be viewed as reality fields, will-o'-the-wisps no more or less real than props in a giant, mutually shared dream. All permanence would have to be looked at as illusory, and only consciousness would be eternal, the consciousness of the living universe.*[4]

These reality fields, or rings, are both the 'circles in our minds' and can be visualised as more expansive 'heavenly' gyres, bringing a finite set of images into ever-changing proximity and juxtapositions with one another. What exists beyond these rings is infinite and unique to all life. A cornucopia of deities associated with the stars, the turning of the heavens, to the events we call history, were considered by the likes of Bruno and other visionaries, to create these 'reality rings'. The religious notion of God's giant notebook, or in more Eastern traditions, the Akashic records, are also an attempt to describe the same myriad of realities humanity can tap into and 'download'. Therefore, what we imagine and believe, will become our physical reality. In films like *The Matrix*, through to ancient legends of Spider Woman and the aboriginal Dreamtime, all of these descriptions of archetypes and their associated imagery relate to realities within realities – rings within rings. Some are fixed, others are fluid, but all are part of *Oneness*. In my view, our task as creators in a world of illusions is to realise our roles as multidimensional beings and use the matrix of worlds to 'liberate' and elevate this physical dimension. We need to expand our understanding of reality and allow our hearts and minds to travel into the worlds beyond this one.

As I said in *Through Ancient Eyes* and explored in this book, we experience *nine* key reality rings, or dimensions, from *within this physical reality*! The solar spectrum is a perfect example of how limiting our notion of reality and light can be, viewed from an earthly physical perspective. Consciousness operating from beyond the spectrum of light made visible through the sun, or from another dimension (from outside looking in), would not necessarily see the same colour structure as we do from our perspective. Colour is merely what we think we see, rainbows are a perfect example of the illusion of colour! Even colour photographs and printed objects at a basic level, are not what they seem. All are made of four colour separations: cyan, magenta, yellow and black, or red, green and blue. When each individual colour is overlaid, they create an image, or print the *effect* of 'full colour'.

The reality rings, or 'gyres' as Bruno described them, are in constant motion, rather like cogs and wheels of a giant 'luminous clock', they are constantly moving the fingers (or surface reality) we call 'time'. The physical world is but a reflection of these rings, and time *is* a construct or product of the mental rings we create and adhere to in this world.

The ancient African Dogon, mentioned in an earlier chapter, also believe that the physical world is a product of a deeper and more fundamental level of reality, one that is perpetually flowing out of, and then streaming back into, this one. Imagery associated with rivers in ancient art also relates to the flowing of time and this is the duality behind reality, or what scientists often refer to as the 'implicate/explicate motion' between 'form' and 'formlessness'. Time is an illusion, just as the dream we had last night, or the memory that came to us in the moment, is an illusion created in the mind. The only difference is that we believe time to have some physical dimension, the use of clocks and calendars as points of reference are examples of this. Outside of these reality rings is an ever-flowing world, where *no time* or *no place* exists. We often venture into this state of mind when we feel at one with the world, meditate, or connect with the beauty in nature. Artists from all eras have tried to capture these moments of *Oneness*, or fluid dreamlike states, by using nature and landscapes as a platform to travel into different dimensions.

THE NINE RINGS (DIMENSIONS) OF HUMANITY

The ancients considered there were nine worlds or dimensions making up Earth, Heaven and Hell. From the Sanskrit *Vedas* of ancient India, to *Paradiso* written by Danté (1265-1321), these multilevels, or realms, have captured the imagination of artists, writers, musicians and now astrophysicists (see *Through Ancient Eyes*). All *three* regions are in fact states of mind, which also have their own reality-associated imagery. J.R.R. Tolkien also used the same symbolism in his inspired book, *The Lord of the Rings*, which I feel, hints at different beings (levels of consciousness) occupying the space, or using the different reality rings. The *nine* (3x3) rings given to the race of men' (or humanity) in Tolkien's masterpiece, are, in my view, the nine realities that can be utilised to access hidden realms and places beyond time.

The associated imagery, knowledge and wisdom that relates to these rings also relates to the nine muses of Greek myth, which are *epic poetry, history, music, dance, lyric poetry, tragedy, comedy, mime* and *astronomy* (see figure 138). According to Greek myth, the nine muses were born to Zeus and the Titaness 'Mnemosyne' (memory), and all are said to inspire artists, writers and musicians. The forms of expression the muses embody, through thought, memory and the vehicle of the arts, in its broadest sense, can open our minds and give us our personal vision. Alternatively, the number nine and these rings are

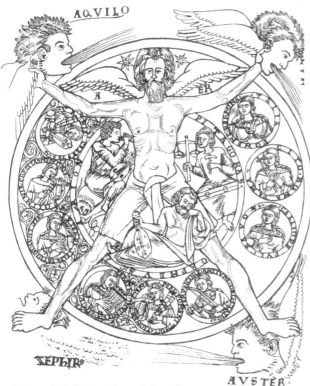

Figure 138: Nine Rings (Muses).
A medieval illustration showing harmony personified in the figure of Air which, like the soul, embraces everything between Heaven and Earth. In the three segments of the cosmic circle are rings depicting the nine muses.

also associated with the 'chains' behind the mechanics of our physical world, through death and birth cycles. Nine can also be considered the furthest number from *Oneness* and for certain occultists and shamanic traditions, it represented the fall of humanity. The number six (nine reversed) on the other hand was said to be the symbol of humanity and the numbers beyond lead to divine perfection.

TIME-SHIP EARTH

All of these rings are tools for liberating the mind and opening our heart. You could visualise these rings as part of a cosmic mainframe structure, one that connects our mind with the mind of an immense infinite consciousness. I see the earth as a 'time-ship' floating in an ocean of infinite consciousness and this ocean flows through all and exists within the cells of *all* life forms. Each individual drop constitutes the ocean, an understanding that may well have been available to more ancient civilisations as shown in some prehistoric art. The author David Icke, describes this time-ship structure as a 'Time Loop' (or matrix) in his book *Tales from the Time Loop* (2003), of which my painting was used as the cover image (see figure 139 overleaf). In this book, Icke connects in great detail the scientific evidence for a holographic (non-local) reality.

The empty space that gives form to the rings (or loops) is also the ocean of consciousness, and even though my illustration is a symbolic one, images of ocean ripples or bottlenecks in a river could, and have, been used to suggest

Figure 139: Time-Ship Earth.
We are operating in past, present and future worlds simultaneously. History repeats
itself when we forget how to travel back in time to change our future, in the present.
Our consciousness expands beyond time, which makes us natural time-travellers.
© Neil Hague 2003

the same philosophy in prehistoric civilisations. At the time of making this
image, I came across a Stone Age carving on a stone in Derbyshire in the UK,
which also seems to suggest similar principles of reality rings forming on the
surface of water. Again, this is symbolic of the fluidity of consciousness and
the separation occurring when we see ourselves apart from the Infinite.
Aboriginal art and Native American petroglyphs from the Bronze Age also
seem to illustrate similar concept of *Oneness* (see Figure 140). So do many
alchemical works of art and texts illustrating the matrix, the divine form, her-
metic concepts and the Fall.

The sea or ocean of consciousness is eternal love, infinite knowledge and
the balance of all-that-exists. The creators of religions and the Myth Makers
highlighted in this book, often gave it other names, which sadly, have been
used to divide and rule the human spirit. Images (symbols) and knowledge
existing within each reality ring, provides a cornucopia of imagery, feelings,
scenarios and life forms, which in essence are timeless. This is why the same
themes and archetypes continually recur through visionary art, both ancient
and modern. The knowledge of who we are and how we traverse time
through our minds has never left us. We've just forgotten our true potential
that's all! The negative side to the time-ship, is that history has a tendency to

Figure 140: Time loops and reality rings.
Rings *within* rings (concentric circles) as seen in water ripples and in Bronze Age art found all over the world are a perfect visual depiction of thoughts creating our reality.

repeat itself! Nothing has really changed when we view the world from 'outside' of the time-ship. To be able to break the cycle we, as co-creators, we need to see ourselves symbolically as the ocean, while making our own individual ripples in the ocean. We need to reconnect with infinite love, and who we truly are. As the classic line from *The Lord of the Rings* epic says: "Even the smallest person can change the course of history." As individual droplets we *are* the ocean of consciousness, we also wield a great power through our ability to remember that we are *Oneness*.

MULTIREALITIES

For scientists such as Bruno and visionary artists like William Blake, reality was merely a reflection of the imagination of ourselves. Memory and thought were the two ingredients by which we, as individual dream machines or time travellers, could access multirealities. Meditation, yoga, painting, love making and such, are all forms of creativity that can aid us in reaching different levels of awareness. Certain rituals, especially the ones performed by ancient brotherhoods such as the Templars and Rosicrucians (which are still performed by the Freemasonic orders today), create a vibrational pact with vibrational fields and the reality rings they exist within. One frequency in particular, the 'lower astral' reality, has played a huge role in the manipulation of world events, by influencing minds in this physical reality (especially by the elité), and this is the reason why history often repeats itself. As I have already illustrated in the earlier part of this book, entities with horns and wings were said to inhabit the lower astral reality and it's said by the ancients that this reality ring, or dimension, sits closely to our 3D physical world. It's also the frequency field, or part of our DNA, where our emotions and

thoughts intersect these fields! It's also the dimension from where the source for images of angels and their opposites (archons/demons) have been captured by artists and shamans since ancient times.

Ancient texts, such as the Egyptian *Book of the Dead* and the *Coffin Texts*, are dedicated to the trials and tribulations of humanity's connection with the lower astral worlds, soul flight and the shadow side (see figure 141). Our ability to traverse time and space, along with our own connection to the mainframe structure (the reality fields), is how we can access knowledge available to us beyond the five senses. Some people can quite naturally access finer vibrations and subtle feelings beyond the usual physical faculties. Others deny their existence, it's all down to mind, imagination and perception. We often call people who see non-physical levels of reality psychics or mediums, but in the ancient world they were called prophets, shamans, oracles, or seers. However, there is always more to know, when it comes to communicating with wider realities or finer vibrations of the one infinite mind!

Figure 141: The lower astral realm.
In Egyptian art, the soul took the form of a bird and the shadow is the dead man caught between two worlds. The lower astral world (dimension) is another ring within a wider realm. Image from the tomb of Tjanefer, Thebes.

Knowledge of reality fields and the realisation that we exist on many levels of creation expands us far beyond "Knock twice if you can hear us, Betty," or talking about family heirlooms with a recently deceased relative. It's quite possible that much communication with so-called spirits (the dead) is actually information fields broadcast from the astral world, an 'intelligence' akin to Amazon's Alexa in our reality. How can we be so sure we are communicating with deceased family, friends or ancestors? The astral Dreamtime worlds are known among other names as 'Barzakh' by Islam and 'Yetzirah' in Judaism and is once again a common thread in religions and ancient cultures. Barzakh means 'limbo, barrier, partition, obstacle, hindrance, separation', and it is this understanding of the lower astral worlds that makes me sceptical of some of the types of communication we recieve via psychics.

The more we allow ourselves to be entertained by our dreams, visions, and, most importantly, our imagination, while integrating what we learn from other levels of reality through our higher conscious self (creative imagina-

tion), the more we expand our awareness beyond the matrix and its illusory constraints.

BEYOND THE GAME & ITS LIMITATIONS

Beyond the limits of the physical and non-physical realms there are also larger reality fields, which fluctuate like ripples on the ocean I've been describing. I am sure that within these realities are 'beings of light' that change shape and lucidity depending on the flow of the ocean of consciousness. In fact, we are those 'beings of light'. Just as a game player controls the console which in turn moves the 'virtual character' in the game world, we can get caught up in the game (the screen world) when we forget our true spiritual origins. We move beyond limitation of the illusion, the game (the screen), when we stop taking the game seriously and go within to find all the answers and methods that can bring us home. So many people are trying to 'win the game', complete the tasks and bob and weave the virtual characters that always seem to crop up at the same point in the game when we repeat certain moves, thoughts or actions. Whether you are a game-boy or girl, life is just like a virtual reality game, and we are both 'in the game' and 'from outside of it'. Consciousness isn't the virtual body, the console, or the hand that moves it; it is the state of mind that 'knows it's only a game'; therefore, we can choose to play another game, or we can create a game of our own making. But before we can do this we need to recognise the visionary within.

Scientists that have studied results concerning OBEs (out-of-body experiences), have recorded numerous accounts of people seeing dazzling lights and beings of light. People who have Near Death Experiences (NDEs) also insist they saw heavenly lights and angelic beings communicating through mental imagery. The 17th-century mystic Emanuel Swedenborg, who was a Leonardo da Vinci figure, recorded detailed accounts of what is often called the 'after-life' realm. He said people from all walks of life have experienced the ability to see, move and continue thinking beyond death and that this state was constantly sought by the shaman in all indigenous cultures. Swedenborg could speak nine languages, was a politician, an astronomer, he built watches and he wrote books on colour theory, amongst many other subjects, and was said to have experienced heavenly worlds. Swedenborg filled almost twenty volumes with his experiences relating to heavenly realms and the nature of reality. He even went as far as saying: "heaven was peopled by spirits from other planets", which was an outstanding assertion for a man who was born three hundred years ago.[5] However, with the understanding of the non-local, holographic nature of our reality, this is not so outstanding now. On one level, we *are* those other people, aliens, angels and beings that exist in different parallel worlds. What connects us all, is the awareness of *Oneness*, or Infinite Consciousness.

Quite often we can sense entities and other phenonema which inhabit the realms nearer to our 'sixth, and seventh senses'. We often call them spectres, ghosts, ghouls, or the supernatural. These are also the gods and goddess figures described by the ancients. In the ring worlds and realities further out from this physical one, we encounter what are described in today's terms as extraterrestrials. The ancients gave them other names, the Maya called them the 'Muxul' and the Hopis call them the 'Chukuon', which they say come in many shapes, sizes and levels of evolution. Our reality or life cycles consist of days, months, and years, from this physical perspective, and are very limited in terms of the wider circles understood by forces *alien* to our perception of time. Yet I feel certain, we are also capable of seeing higher dimensional viewpoints and travelling into the past and future, simultaneously, while being part of the present reality. We can do this through our mind, our memory and our creativity *combined*. I believe we are also of this reality and alien to it, by the fact that we possess imagination and the abilty to perceive mulitple viewpoints. If we were to see our true form, we would be astonished at the amount of 'light' we emit and how far we expand beyond the five-sense frequency range. It's our divine human form that exists beyond time and space. We are like a jewel or crystal with many sides, reflections of the whole. Our 'electromagnetic light' is what attracts other people, places and life experiences to us. It also draws towards us the more predatory levels of consciousness outlined earlier in the book. I have seen these predatory type of creatures attach themselves to individuals, and quite often in our dream states we encounter extraterrestrials, entities and otherworldly beings. In one memorable dream, I was being pursued by birdlike creatures that gave off a repugnant smell, similar to sulpher. I know how mad that sounds, but it happened. To my amazement, these creatures seemed to be interested in my energy field, which when I increased it and shone it at them with a hug gesture, it instantly repelled them. They didn't want to be hugged? Never mind a bedbug, it was a bed hug that made them recoil!

Our minds and memories are capable of traversing 'manufactured time barriers' which hold a one-dimensional perspective at any one time. The three-dimensional world (reality ring) is only one of many rings within rings (realities within realities), yet we are mesmerised by this one, only because we think it is the only one that exists. If we start to imagine, or even see, other possible worlds or life forms, we are automatically dubbed as insane or bad, depending on the level of information one starts to access and assimilate. In truth, when we access other worlds, many doorways of perception open up. Some of these doors lead to future worlds, others seem to go back in time, while others house alien forms and fantastical landscapes. We are all capable of seeing hidden dimensions. Not all people need the 'shaman's brew' or magic mushrooms, the latter of which have now been upgraded to class A

drugs in the UK. Wonder why? It may just be that the those that govern the system on behalf of the predator-matrix mind, don't want the next generation realising that the world is a multifaceted illusion, a virtual reality and that they can change the nature of reality through their thoughts and imagination.

We are all myth makers and masters of the 'reality rings' by the very nature of being human. The myths and legends that seem to be describing ancient worlds are also hinting at positive futuristic ones? The common ground is 'Us' exercising our imagination in the present, to affect the collective reality. In our imagination we are whatever we believe we are, and that's the key to changing the nature of reality. The reality rings I am describing in this chapter, are constantly repositioning themselves, turning to offer possible parallel realities. We don't exist solely in this world, we are also characters in adjacent realities and sometimes in our dreams our different personas come together. The meeting places are the realms beyond night and day, heaven and earth, a zone where time does not exist! Or at least time as we perceive it does not exist outside of our physical reality. We can enter the worlds beyond night and day when we daydream, or go into more relaxed states of being, time carries no meaning. Our imagination gives us the keys to enter into simultaneous realities and it is from inside the circles of our mind that the many common themes, relating to extraterrestrials, archetypal imagery and interdimensional forces, have been acted upon and made into imagery by artists since ancient times.

A SHIFT IN CONSCIOUSNESS IN THE 21ST CENTURY

The more I look at the world today, the more I realise the true human spirit is 'trapped' within a dense vibration – a prison vibration. How we got into this state of mind is a long story, an untold history, beyond the scope of this small book. What I am certain of is the 'light' crystalline software (DNA) which constructs all visible life, via the brain, is going through a tremendous change. Our current level of evolution is moving up a grade, we are, if you like, rewiring the neuron pathways in our brain to match new levels of light reflected by the infinite ocean of consciousness. We have been led to believe that the physical world exists as a separate entity to humanity. This is not true. The earth matrix and time-ship described in this chapter *is* evolving to match rising levels of consciousness emitted from the ocean of light. At some point, the infinite ocean is going to flood the time-ship (as in my image on page 472) and when this happens the world will seem to be in a state of flux. The chaos occurring in the physical world will *seem* catastrophic, but all that is occurring is a 'flood' of energy from non-physical levels, and this will eventually subside to leave a very different earth (matrix), or physical reality.

From this perspective, I've often wondered if the biblical flood, recorded in numerous ancient sources, is a metaphor for the changes brought about when the infinite ocean floods the matrix time-ship? The story of Noah (the bloodline of the offspring of the gods) salvaging the genes for another time-ship (ark), seems to hint at how the world was re-built to reflect a new physical programme (DNA), once consciousness had risen to flood proportions. The flooding and earthquakes occurring globally today are, on one level, also a manifestation of the rising levels of consciousness.

Over the years, I have had many visions alluding to a celebration of humanity, after a new level of awareness has flooded the world. Even though I am not certain if I was seeing non-physical levels of humanity celebrating, or a party in the physical world, or a celebration taking place at a non-local level, the effects will be the same. What these visions seemed to show me was that we had come through a powerful shift and major upheavals on one level, but on another, the switch in vibration from one of 'collective fear' to collective love, was quite overpowering. I was also aware of the most amazing light structures and what looked like floating cities descending from high plateaus, where thousands of humans of all colours, backgrounds and beliefs were united as 'one family'.

THE UNITED COLOURS OF HUMANITY

The emotions felt when I saw this vision were very intense and even though I was fully conscious of the people around me, it was as if I was also 'seeing' from outside of myself - like a reunification of all my other-selves. You could say, that Neil was meeting the many other parts of himself for a celebration in a place beyond time and space! Most of my art seems to express unseen levels of work being done to remove the climate of fear, which is denying humanity its spiritual sovereignty, no matter what beliefs we choose to have. In fact from a Christian viewpoint, you could say we are all the Father, the Son and the Holy Spirit. Christ consciousness, infinite consciousness, does not, in my humble view, recognise divisions. How can it when *we are all each other?*

In recent years, I've often felt the spiritual revolution (one based on freedom for all), which has grown in momentum since 2020. Even if we seem to witness so much fear and horror in the current movie projected out of the 'Time-ship Earth', remember, this film (like all movies) will come to an end! The actors, all of us, will move onto the next script to start the next production, etc. Since the late 80s I have been painting what I see on different levels of reality, and the timelessness I referred to, in this chapter, is reached through meditation, creativity, joy and feeling at *one* with the world. I've also seen forms that exist beyond the physical world when I've been in a timeless-

ness state. I have also seen layers, or inner-frequency levels, of what most are calling the 'matrix' today. The matrix itself was shown to me in 1993 as a 'blocking frequency' encircling the original earth. The blocking frequency is wired to our minds via waveforms coming from an artificial construct. I think holistic science calls this link between humanity and the earth matrix, the *noosphere* and *biosphere*. When I've painted or meditated I often find I enter other layers of this matrix-sphere, and from that perspective, it becomes easier to visualise forms (intelligence) that create our reality. Some of these forms appear in the microcosmic world of insects and sacred geometry, as shown earlier in the book. They are found in ancient art and symbols of what the Aborigines call the *Dreamtime*, which is the astral world, or the fluid non-physical reality existing within the blocking frequency (matrix).

Stilling the mind's chatter and using any artistic process *is* a meditation that can take us out of the reality rings, or blocking frequency, and place us in the ocean of *Oneness*. Painting and drawing takes me into the Dreamtime, where I see the world taking form before it becomes physical. Beyond the Dreamtime is *Oneness*, a place difficult to describe, but felt through knowing that we are loved beyond limitation. A feeling of *Oneness* can come to us at any time, because it has never left us. You know when it comes, because the smile on your face is bigger than the skyline and the feeling in your heart radiates more than any sun in the galaxy. In a fleeting moment you *are* the world around you, you *are* the sky, the trees, the road, the buildings and the people that come across your life path. Once you get this feeling, once you *know* 'who you are', then life becomes one imaginative adventure. The love within each and everyone of us has the ability to pour into the world; it can touch all that we see and meet in life. Our love tells us we have more to offer the world than we often dare to realise. Our creativity, our vision and individual respect for who we are, needs to be nurtured as we move into a new phase of planetary evolution. In truth there is *no* new phase, only a return to love and the wisdom, compassion and peace that comes with our love.

NOTES:

1) Gabriel, Peter: *Fourteen Black Paintings* © 1992
2) Conforto, Giuliana: *Giordano Bruno's Future Science. The Birth of a New Human Being*, Taken from *De Magia*, p100
3) Conforto, Giuliana: *Giordano Bruno's Future Science. The Birth of a New Human Being*, Noesis 2002, p110
4) Talbot, Michael: *The Holographic Universe*, Harper Collins 1996, p159
5) Bruce Greyson & C.P Flynn: *The Near-death Experience* (Chicago C. Thomas, 1984, as quoted in Stanislov Grof, *The Adventure of Self-Discovery*, Albany Press, 1988, pp71-72

The Human Form Divine

Dreaming ourselves back to Oneness

Every created thing is an image of God in a mirror.
Emanuel Swedenborg

The answer is, life is love (Creative Imagination)
and the absence of love is death.
Cecil Collins

The world we think we know so well is merely one of many stage shows, films, images or realities – *all* are projections of Infinite Consciousness. Somewhere in our memory banks, at the core of who we are, I believe that we are expressions of infinite love. This love I am taking about is unconditional and it's the *true* power behind Creation. Humanity in its original form is love and we are all aspects of *One* consciousness. We have tried to describe it and have misunderstood this love as a whole, for so long, that we have forgotten who we really are.

As I've set out to explore in this book, artists, storytellers and visionaries, both ancient and modern, sought divine inspiration through their work. As individuals and as a collective, we are *One* consciousness and our true selves exist beyond the illusion of flesh, bone, time and space.

IN THE BEGINNING THERE WAS THE *ONE*

Somewhere in the timeless ocean of consciousness, an all-encompassing love simultaneously imagined itself into infinite realities. This love was called the *One* and it was the very fabric of the water (consciousness) that brings the ocean into existence. In every life that is born the *One* exists and in every heart it dwells. The *One* exists within every living form – both seen and unseen. It's in all sounds, colours, shapes and forces that exist. The *One* encompasses both light and dark, silence and noise and there is no place or smallest particle that is not part of this divine ocean of consciousness called

the *One*.

In the darkest recesses of silence, a spark of inspiration ignited in the mind of the infinite *One* and instantly, at the speed of thought, all life came into existence. Just as many thoughts occur in our own minds, the *One* imagined infinite realities, possibilities and worlds (see Figure 142). Many of these realities became visible and others remained as ideas, invisible to the life forms taking shape in the mind of the *One*. In an instant, all that was once silent now sang to the sound of life, vibrating, orbiting and cycling. All in motion

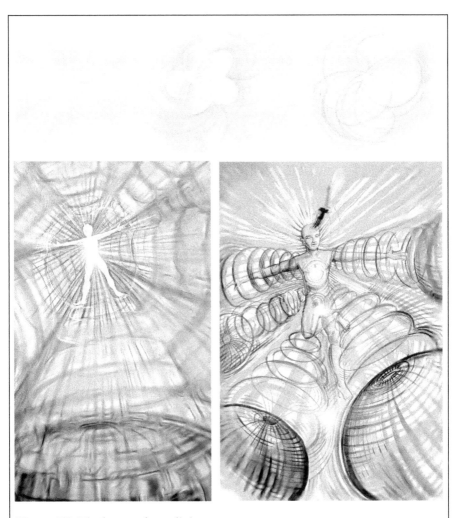

Figure 142: The human form divine.
A sequence of images depicting the divine *giving* form to humanity, who then births doubt, which becomes *fear* of our own creative imagination. The images appeared in London for my retrospective exhibition and were also featured in David Icke's book *Infinite Love is the Only Truth* (2005) © Neil Hague 2004

expanding outwards from the *One*. Everything now vibrated and danced around the centre to the tune that inspired it. The dancers were luminous forms both light and dark, spinning outwards from this place and with this dance came the divine image – a mirror image of the *One*. Its human name was imagination and as it took form, it resembled a flower whose petals took the shape of a star and that star eventually became the 'Human Form Divine'. Nothing physical existed at this 'time', only images, ideas and dreams in the mind of the divine. Every part was a perfect picture of the *One* indivisible whole, both big and small, cell and star system, microcosm and macrocosm– all was a reflection of the mind of infinite *Oneness*.

IMAGINATION CAME FIRST

As the human form took shape in the mind of the *One*, everything that was infinite was also instantly part of the Human Form Divine. Inner space and outer space were the same and imagination became the force through which all realities came into being. What emerged from the centre of *Oneness* became the thinker and creator of all that exists.

Much visionary art, ancient philosophy, alchemy and science, as practiced by the advanced civilisations, expressed an understanding of the Human Form Divine. Robert Fludd, the 17th-century artist and alchemist, called the human body "a vessel of all things." For many 16th and 17th century alchemists like Fludd, Kircher, and von Welling, (all connected to the mystery schools of antiquity), the human form was intersected with invisible spheres. These spheres encompass the soul, the spirit and the imagination and are manifestations of the divine form (see Figure 143). William Blake's poem *The Divine Image*, written as part of a series of poems for children in 1789, express-es a wisdom and compassion that takes us beyond the manufactured illu-sions imposed by our minds. Blake writes:

> *For Mercy has a human heart,*
> *Pity a human face,*
> *And Love, the human form divine,*
> *And Peace, the human dress.*[1]

At the end of the 18th century, Blake spoke openly of a realisation that had been the secret knowledge of a few. He was a true visionary, prophetically inspired, and *The Divine Image* is the quintessence of his message: that God is "in the form of man" and that incarnation is not particular but universal.[2] For the likes of Blake, no form and no world existed before the form of the human was present, and all things and everything that exists only exist through it—the Divine Form. The wisdom and understanding behind the

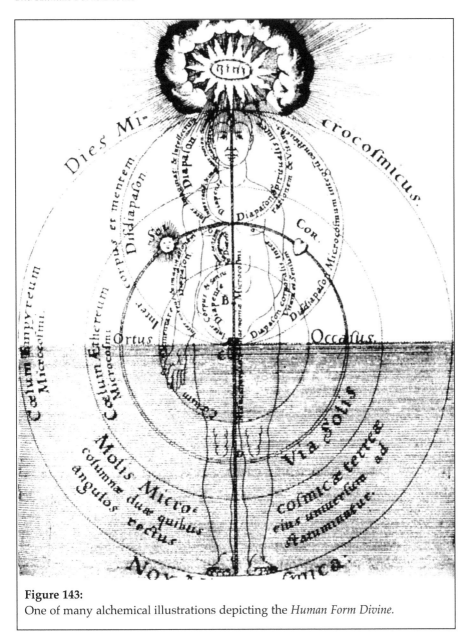

Figure 143:
One of many alchemical illustrations depicting the *Human Form Divine*.

concept of the Human Form Divine cuts through all theological tangles and to the heart of the matter. When Christ affirmed "I and the father are one" and "he who has seen me has seen the Father," his words were deemed blasphemous, and according to the Gospels, led to his condemnation. Blake's genius, under the guise of poetic license, also announces his belief in the Human Form Divine. He constantly declared his was the 'religion of Jesus',

and in Blake's terms, 'the Divine Form' *is* the imagination present in all.

LIVING LIGHT

In light of much scientific discovery in the fields of quantum physics and DNA, the true form of humanity constitutes a beautiful 'light' or what some refer to as 'matter'. Our DNA is crystalline and it both receives and transmits information. Our DNA *is* both physical and spiritual, but, it's the spiritual heart (the core) of our divine form that is able to transcend the illusions of physical reality, of time and space. From a metaphysical view, every part of the human body is epitomised in the brain and, in turn, all-that-is in the brain, is epitomised in the heart.[3] Our hearts are where the light reaches out connecting to *all* living matter (see figure 144). Light *is* the essence of the divine form, and humanity can live in light or darkness, love or fear, when it comes to self-knowledge.

In much esoteric symbolism the human body is often shown divided vertically into two halves, the right being considered light and the left, our darker side. The light half is symbolic of the spiritual heart and the dark, the material mind. Light is considered a symbol of objectivity, darkness a symbol of subjectivity. And as I have shown throughout this book, *light* is a manifestation of *life*. Darkness, blindness, ignorance are the veil, which eternally conceals our true nature, our divine form. The light can also blind us; consider most New Age or Woke philosophies that don't acknowledge their darker aspects. It's our mind and self-imposed limitations of thought that deny our creative imagination, our inner light, and with it, our individual keys to *infinite* potential.

When we live in our head (mind) and forget our heart, then the world we create will reflect this imbalance. The imagination is our key to unlimited potential, and our creativity and our love for each other is what brings forth the divine within. The imagination is also the key to the door marked freedom, it's also the bridge between the mind *and* the heart. Imagination can bring 'new eyes' to any situation. When we trust our own energy, creativity and imagination, we can see beyond any stagnation in our life. Our creativity expressed through our imagination is how we bring art forms into the physical world, but on a higher level, it's also how we open our hearts and minds to our infinite potential and to the beauty that surrounds us. All the ills of this world only exist because of our human ability to limit our imagination and therefore limit our vision. When we access our human form divine, or our *divine Imagination,* it brings out our creativity, which is the supreme passion of Infinite Love. There is not one image or face of love but an infinity of images, an infinity of faces. Our light shines on no matter what we face or how we feel in this life.

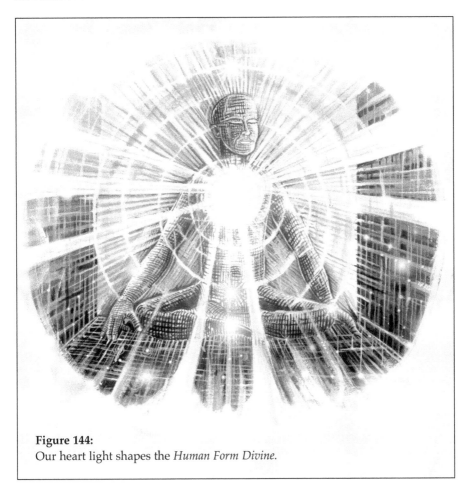

Figure 144:
Our heart light shapes the *Human Form Divine*.

THE DIVINE ARTIST (IMAGINATION)

Everything that is – every tree, bird, star, stone and particle – existed first as a dream in the mind of the divine. The world is a mirror of the divine imagination and to decipher the depths of the world is to receive insights into the heart of the *Infinite*. The divine artist does not recognise a world of separation, too often fueled by duality and imposed upon by the predator-matrix mind. Instead, the divine artist, through imagination, infuses all worlds, dreams, or realities providing humanity with a 'sacred language'. One that communicates directly with our divinity. Great works of art should invite contemplation just as the mystery of the imagination offers surprising invitations into the *Infinite*. As William Blake put it, "This world of Imagination is the world of eternity; it is the divine bosom into which we shall go after death of the vegetated body."

The Divine Imagination is from where all true forms emerge, whereas the 3D natural world is a copy, or 'download'. Limited imagination means we will only focus on the copy, or the illusion, rather than the original source. Art in its highest sense, should be about accessing the 'originality', spontaneity and individuality within each of us. When we use our imagination creatively we can solve problems, enlighten ourselves and change 'dead perceptions'. Deception can dissipate bringing clarity from a shift in perception. When we access *our* Divine Imagination through *our* creativity we become divine. The world around us becomes a manifestation of this divinity. True visionary art, as presented throughout this book, will always head straight for the heart – our individual truths. Through the imagination we learn to know ourselves and also explore the depths of our soul. It can unite our multidimensional aspects of being and offer great insight into what avails us. Through knowing our heart we can learn to love who we are and what we have become in our lives. But more importantly, realising the multifaceted spiritual light in others brings us self-love, innocence, joy and beauty.

MULTIDIMENSIONAL EARTH STARS

Back in the mid 1990s, I had a series of visionary exhibitions in London titled: *Earth Stars - Symbols of Spirit, Earth & Universe*. At that time, I only had the smallest understanding of what I was trying to communicate through my art. Yet, the idea of human 'beings' as 'earth stars', or 'beings of light', struck me profoundly. You could say I was 'star-struck'. As I have touched on in my books and paintings, art *is* a tool for communicating with non-physical (non-local) realities. Therefore, within the realms of the divine 'human' imagination there has to be memories, or reflections, of *what* and *who* we truly are? We are individual sparks of the *Infinite*. Because the imagination has no limitations, rules or borders, and the fact that we possess imagination, means our true divine form also transcends all limitations and control, especially mind control. No one can truly control us, even though much evidence suggests we are heading towards a global fascist superstate, with power in the hands of the elite few. The *Infinite* and the Divine Imagination can (and will) reinvent, remanifest and recreate limitless realities. It has the power to imagine the so-called elite and global fascist state out of existence!

As I have shown throughout the last few chapters, we exist simultaneously in many parallel realities. Just as light, matter and particles exist in different forms at the same time. The idea that all life is born of light from a star to a crystal, tells us that we are all *One*. When we hold a crystal up to the light we see many sides to its surface. Its facets shine offering further character and uniqueness across the crystal's surface. Yet the crystal remains part of the light. It's a symbol of *Oneness*. Art and meditation, in their truest forms, can

also help us discover our multifaceted life – our non-physical aspects. By tapping into our multidimensional aspects through therapy, healing, art and most importantly, our creative imagination, we start to truly know our multidimensional selves. We also start to unlock memories relating to what are often called past lives and future events. But since time does not exist, then how can we have past lives? What often seems like a futuristic dream could easily be placed in a setting that feels ancient, but nothing is set in stone. New Age or Stone Age all are films running in parallel theatres, existing in universal cities of the imagination. When we tap into our multidimensional aspects we are seeing actors, actresses, gods, extraterrestrials, angels and other personalities playing roles simultaneously in mini-films within the Time-Ship Earth (or Loop) illustrated in the last chapter.

What I am describing here is no different from shamanism, and what I've done as part of my meditation collaborations over the years. The role of the shaman/healer/way-shower/artist, helps to heal and unite our divine aspects and bring inner peace, joy and love for ourselves. Such a philosophy can be understood through the following words:

> *Many people are concerned with material possessions to the extent they believe they will only be happy if they are wealthy, successful or powerful and in control. For some, this may continue for a lifetime. For others, however, there is a feeling of dissatisfaction, that money, position or wealth are just mere illusions of happiness. These human beings seek to find the truth, working tirelessly to transcend limitation in order to uncover the meaning of their lives; they look within and enter the silence of inner knowing in order to find their answers. For a few, the integration of their truth and knowledge, alongside a Western Lifestyle, family, and society means a journey fraught with challenges. Whatever path a human being chooses, and all have their place in the cycle of life, true happiness comes from recognition that one has found their own answers and personal vision. This acknowledgement brings the state of grace through acceptance and inner peace.*[4]

As an artist and writer I have learned so much more about who I am through acknowledging my multidimensional projections of the Divine Imagination.

I LOVE YOU UNCONDITIONALLY, THEREFORE I LOVE ME UNCONDITIONALLY!

Visionary art moves us beyond rationality, toil and the struggle we often accept as reality. The ability to open the mind and unlock the imagination through our creativity brings forward two types of visionary – the wounder and the consoler. However, they both have one commonality – they speak to the heart and this is the place we must immerse ouselves in to get back to who we really are. It's simply the *Oneness* felt through our ability to love our-

selves and our ability to love others.

The past few decades have seen much revelation in relation to the scientific 'nature of reality' in astrophysics combined with a spiritual knowledge. The world has also borne testimony to gross global conspiracies and hidden agendas, especially since the Covid era. Yet these are no more than reflections of our individual and collective fears. Fear creates doubt and becomes a barrier to manifesting our hearts' desires. Even though courage can come from fear, it makes us cautious, it can hold us back, and it's the opposite of love. If we listen to our fears for too long they will convince us that our dreams are not worth having. All fear starts in the mind and, in truth, fear is nothing but *fear of itself*. True freedom and global control are mirrors of the amount of control we desire over each other in our daily lives. If we want to remove control, tyranny, war, unnecessary suffering and all of the injustices we see in our world, then we'd better take a hard look at ourselves first. We may need to be ready to feel our own pain, so that our dreams and visions can then come forward into the world. Our creativity and our imagination are crucial in this process of looking at oursleves. Why? Because the mind balanced with the heart, can just as well create beautiful thoughts, inspire works of art, and share our immense joy with those around us. We don't have to see toil and struggle, or live in survival mode, as *everything* in our reality comes down to knowingness and self-love. This does not mean we have to bury our head in the sand when it comes to looking at what is really going in the world. But, fear can be transmuted as can our thoughts and emotions. By pinpointing the cause of our fears, emotions and the thoughts that manifest in our lives, we can work through them in order to release our real creative potential. Recognising the root cause of our inner conflicts, we can heal and not repeat the dramas or experiences that caused the traumas or conflicts in the first place. When we encompass both polarities, love and fear, light and dark, we become *Oneness*.

The more we look within ourselves, the more we are able to deal with real issues manifesting as 'relationships' and 'experiences' in our lives. When we access our Divine Imagination, and open our heart through our creativity and love, the more we learn to *see* love where fear once lived. This love is our natural state of being and gives life to the Divine Form – without it, all would cease to exist! To live love, or *be* love, means we only have to love others because everyone else in our lives is merely a projection of our inner selves. It's the inner child within us that holds a light for the Divine Imagination, and *all* that this child has to give is our unique gift to the world. When we express that gift, through our heart, our creativity and through *our love for life*, we call to us a higher, *Infinite Love*. Through this process we become 'journey makers', 'time travellers' through the *Dreamtime*. Through our love we

become at *One* with the Universe – *our personal universe*. When we love hard, without fear and condition, then we allow our inner child to just *be*. This is important because to 'just be' means to 'be free'. In that moment, beyond physical limitations, beyond time and space, our inner child produces our unique gift to the world. It's the inner child as an artist, a poet, a dancer, a singer or a creative spirit that knows no boundaries. As words attributed to Jesus say:

> *Verily I say unto you, Except ye be converted, and become as little children, ye shall not enter into the kingdom of heaven.Whosoever therefore shall humble him-self as this little child, the same is greatest in the kingdom of heaven ...*
> Matthew 18:3-4 [5]

Heaven, or paradise, *is* a state of mind and heart. It's our ability to love life, be creative and to forgive those who live in fear, which truly frees us. The heart is the place where we feel love. Even though we express our love through our relationships and our creativity on a physical level, *we are loved more than we realise*.

Fellow travellers in the Dreamtime, we all hold a key to the door marked LOVE and COMPASSION. We are that key and as divine human beings, armed with creative imagination and a love so strong, we become living examples of Heaven on Earth.

NOTES:

1) Blake, William: *The Divine Image*, taken from *Songs of Innocence* (part of a collection of poems) 1789.

2) Raine, Kathleen: *The Human Face of God* (from a lecture delivered to L'Université St-Jean de Jérusalem, May 1985. Quoted in *Blake and Swedenborg – Opposite is True Friendship*. The Sources of William Blake's Arts in the Writings of Emanuel Swedenborg. Published by the Swedenborg Foundation 1985, p86

3) Hall, Manley P: *The Secret Teachings of All Ages*, Tarcher Penguin, p230

4) Chatfield, Beverley: *Shamanism – A Way of Being*, 2004

5) Jesus, quoted in Matthew 18:3-4 (KJV).

The Lethargic Sleep (Dream)

For life and death are one, even as the river and the sea are one
Kahlil Gibran

One subject I've been drawn to while completing this book, is how ancient, and often highly evolved 'spiritual' human beings, could have evaded physical death. It's a subject that's hardly been focused on outside of Slavic and Balkan countries, but from time to time, we get a glimpse in the west of what has been termed the 'lethargic sleep'. The more I looked at this subject, the more I realised that a deeper knowledge, or an ancient 'healing magic', connected to the *Dreamtime* themes covered in this book, had been wiped from our memories and our cells!

According to some ancient cultures, humanity *could* evade death through a form of hibernation, or deep dormancy. The Greek word, 'Lethe', which means 'forgetfulness', is also connected to the phenomenon of lethargic sleep. In the old 'Rus', or Russian traditions, it's believed that when one 'sleeps', one can traverse 'other worlds' (or pass beyond the chthonic) and come back alive through a process of full body regeneration. In other words, a living human who goes into an eternal sleep-state, could achieve eternal life through the process of sleeping, or hibernating.

Pagan Slavic peoples believed that the dead could still *feel* for a sustained time after physical death.[1] In other words, some of our ancient ancestors knew very well that physical death *is* just a 'dream state' that is *not the end* but could be the beginning of a *renewed life*. In the 'dreaming' process, or lethargic sleep, the alleged 'dead' human may have been under the influence of priests, priestess, or sages who would facilitate such a 'death-sleep process'. After waking up from a lethargic sleep, a soul would begin to live an eternal renewed life, a form of 'resurrection', no different in some ways to the story of Christ's emergence from the tomb. In fact, the story and power of Christ's resurrection could well have come from ancient Druidic or Slavic knowledge of the lethargic sleep. It's a subject I am merely scratching the surface of here, but will focus on in great detail in a possible future book project.

SLEEPING BEAUTIES
Judging by the number of crypts and dolmens still found in Slavic territories

such as Russia and the Northern Balkans, one could conclude that, until quite recently, our ancestors treated death not as a 'departure' from life but as a 'transformation' into a full body, a 'new life'- renewed by a deep 'sleep state'. Both the 'crypt' and the 'dolmen' seem to have been created with a view to the deceased *returning* to the physical world after a form of suspended animation. The most memorable stories of such a sleep are found in children's literature relating to 'Sleeping Beauty' (originally a Russian fairytale) who is awakened after what is perceived to be her physical death. Some may think the idea of a lethargic sleep is ludicrous, but when we look at ancient rituals and how 'priestly' or 'priestess' clans would 'anoint' and 'prepare' individuals for the 'next world' (at perceived death), one cannot help but see some kind of 'resuscitation' process taking place in crypts, sanctuaries, and later cemeteries of the ancient world. The kiss, or the 'nefesh' found in Judaic and Gnostic teachings (or the 'vital spirit', or 'anima' in the Latin sense) is part of the Sleeping Beauty narrative and relates to awakening from a lethargic sleep. The idea of people returning from perceived physical death after being declared 'dead', would have been a major problem for *all* Orthodox religions when the ability to resurrect was available to all human beings.

A GUARANTEED DEATH

With the advent of Roman Catholicism in places like Russia and the Balkan Peninsula during the rise of the Holy Roman Empire, it was ordered by religious leaders to 'bury the dead' *in the ground*, instead of crypts and earlier ancient dolmens. Placing the deceased in sanctuaries became prohibited by the Orthodox Christian Church and Roman Catholicism. The Orthodox Church 'still' strongly favours burial over cremation due to a belief in the possibility of a 'physical resurrection' of the body, which was/is not good for the doctrines of the Church. Of course, the more dead there were, especially at the time of war, the more mutilated bodies would not have the ability to awaken, and therefore burial was the norm. Despite this, Slavic peoples, especially the 16th-century Cossacks (a word meaning adventurer or free man) continued to leave 'air pipes' for the dead, so the 'resurrected-deceased' could 'call' for help and not suffocate inside their coffins should they awake. Bells were also used in mortuaries across England over the past few centuries as a method for the so-called deceased to communicate with the living if they woke up.

Physical resurrection and 'judgement' in Judaic belief, was followed by 'Paradise' or 'Gehenna' (sometimes a place of punishment). In simple terms, one had to 'stay dead' to receive 'judgement', but there was a hint of eternal paradise *beyond* physical death. Islam also teaches the body resides in the coffin until the day of judgement. This is considered a period of 'trial' where angels (Jinn/archons) question the person about their beliefs and practices

while in the coffin. In this sense, the coffin itself is meant to be a 'place of paradise' for the righteous, whereas for the 'unrighteous' it would be 'torture'. Here we have a ritualistic connection to the astral world through keeping the physical body in a box, forming an attachment to otherworldly forces. Why being in a coffin would be a form of 'torture' will become apparent shortly. Cemeteries, graveyards, mourning and grief (as much as I understand why people would be obviously upset) anchors the death and fear vibration for those attending orthodox religious funerals.

Funerals and their rituals based on the *Vedas* (the *Samhitas*) also deal with the correct performance of funeral rites for the deceased. One of the most famous (or infamous) forms of Buddhist death ritual is the 'Tibetan Sky Burial', or 'Bird Scattering'. With this rite, the deceased (the body) is 'staked out' on a mountain to be eaten by vultures and other scavengers. How grotesque! The general theme across various mainstream religious beliefs when it comes to death and funerals is to make sure the deceased is 'dead' and unable to awaken. The final blow to the notion of humans going into a lethargic sleep was taken by the Catholic Church and State with the onset of autopsies, or 'post-mortems', a word which derives from the Latin, *post* (after) and *mortem*, 'death'. From the late 17th-century autopsies on the dead *guaranteed* 'death', there was no returning to the physical world.

MAKING THE LIVING 'DEAD'

If you look at the entire tradition of funerals, you can come to the conclusion that 'everything' has been done (and continues to be done) so that a person, having recovered from possible suspended animation, could *not* get out of his or her burial place. The religious power structures came up with the idea of 'heavy tombstones', or putting a stone on the grave itself.

However, even with the idea of trapping bodies inside graves, some still managed to get out. Many cultures have stories about people returning from the dead, which may have inspired many legends about ghouls, zombies, and vampires throughout history. Cases relating to the alleged deceased tearing off their nails and fingers trying to scratch their way out of a coffin would have terrified those who heard or saw such events taking place. Nailing a coffin shut was to make sure the alleged deceased could not get out!

The notion of wooden stakes being used to ensure a person would not return from the dead gives a slightly different angle to the vampire stories, too. Driving stakes into the 'heart of living people who were regenerating (in a sleep state), prevented any idea of physical 'life after death' (resurrection) and was fatal for those who knew how to go into a lethargic sleep. The awakened soul who did emerge after death was later presented in books and films as a vampire or wicked entity. I am not saying for a minute that vampires and demons don't exist, they do, but it could be that the lethargic sleep, and the resurrection of human beings, was 'demonised' by the church and state (the

world over), so to prevent generations from understanding how death could be overcome. Those who did wake and return home from cemeteries (some time after death) were mostly persecuted by their communities. Often they were perceived as evil spirits and succumbed to extermination (see the burning of every witch in Christendom). Eventually, all knowledge of lethargic sleep was lost over time, while the church established rules to make sure future graves had heavy slabs to prevent awakened souls from getting out of their death-box in the ground.

ASTRAL ATTACHMENTS *OR* ETERNAL LIFE

Burial in the ground of a 'dead' person creates a connection between the astral body and the deceased. Since the astral body is trying to reanimate the dead body, this creates a *binding* and the soul often *cannot* find peace. Cremation actually severs the ties with the astral body and other forces trying to use it. In some traditions, the astral body does not become the 'guardian' of living relatives (an ancestor spirit) as it is supposed to. In fact, the astral body of the departed can acquire vampiric characteristics and forever roam cemeteries, houses, or buildings located near the grave (or where the body is buried). Such personalities can acquire a demonic orientation and go on to possess other bodies. Such astral attachments become consumers of living energy, and can feed off their relatives and others they encounter over time. The dead can also appear in dreams as ghosts for those who were close to them. Just as holy relics of so-called Saints and priests *cannot* decompose, they get stuck in this world affecting those who make an energetic connection to such relics. Some writers on the subject of astral attachment say pyramids with mummies, graveyards, and cemeteries can 'programme' an entire population to age traditionally and eventually die. But according to ancient Slavic cultures, and the translation of modern Russian literature, *death is not a natural process*. We don't have to live 'three score and ten years', we can live much longer through the lethargic sleep.

The subjects outlined briefly in this appendix need much more research, and I am sure a future project will focus on such subjects, taking me further into this phenomenon.

Some of the research and information relating to lethargic sleep were provided with huge gratitude by the *Slavic Elf*, Ilona Dobrynina. A big thank you.

NOTES:

1) Elizabeth A. Warner. *Russian Myths*. (Austin, Texas: University of Texas Press, 2002).

Bibliography & Recommended Reading

Acharya S; *The Christ Conspiracy, The Greatest Story Never Told.* Advertising Unlimited, Kempton, Illunios. 1999

Ackroyd, Peter; *Blake.* Minerva 1995

Allan, D.S & Delair, J.B; *When the Earth Nearly Died; Compelling Evidence of a Catastrophic World Change 9,500 BC,* Gateway Books 1995

Authur, James; *Mushrooms & Mankind.* The Book Tree 2000

Baigent, Michael; *Ancient Traces.* Penguin Books 1999

Baldwin, Christina: *Calling the Circle.* Gateway Books 1996

Barber, Richard and Riches, Anne: *A Dictionary of Fabulous Beasts.* Boydell 1998

Bauval, Robert: *Secret Chamber.* Arrow Books. 2000

Beinfield, Harriet & Korngold, Efrem: *Between Heaven and Earth.* Ballantine Books. 1991

Bellin F, Harvey & Ruhl, Darrell: *Blake & Swedenborg, Opposition Is True Friendship* Swedenborg Foundation 1985.

Bentor, Janette: *Medieval Mischief, Wit & Humour in the Art of the Middle Ages,* Sutton Publishing 2004

Berger, John: *Ways of Seeing.* Penguin Books 1977

Berlitz, Charles: *Atlantis The Lost Continent Revealed.* Macmillan.1984.

Blake, William: *The Complete Illuminated Books.* Thames and Hudson. 2000

Bord, Janet & Collin. *The Evidence for Bigfoot and Other Man-Beasts.* Aquarian 1984

Bosing, Walter. *The Complete Paintings Bosch.* Midpoint Press. 2001

Broadhurst/Miller, Paul & Hamish. *Sun and the Serpent.* Pendragon Press. 1989

Brewers Book of Myth and Legend. Helicon Publishing. 1993

Burns, Kathy: *Masonic & Occult Symbols Illustrated*

Clegg, Brian: *Light Years, An Exploration of Mankind's Enduring Fascination with Light,* Piatkus

Collins, Cecil. *The Vision of a Fool.* Golgonooza Press 1989

Coleman, Loren: *Bigfoot! The True Story of Apes in America,* Paraview Pocket Books, 2003

Cotterell, Arthur; *The Encyclopedia Of Mythology.* Lorenz Books.

Conforto, Giuliana: *Giordano Bruno's Future Science,* Edizioni Noesis

Cosmos, from the Romanticism to Avant-garde. The Montreal Museum of Fine Arts, June to October 1999, published by Prestel 2000

Daniken, Erich Von: *Arrival of the Gods.* Element 1999

Foister, Susan, Ashok, Roy & Wyld, Martin: *Making & Meaning Holbein's Ambassadors,* National Gallery Company, 2001

Gibson, Michael: *Symbolism.* Taschen 1993.

Gill, DM. *Discovering Art, the Life, Times and work of the Worlds Greatest Artists – Illustrated Manuscripts.* Brockhampton Press. 1996

Hague, Neil: *Orion's Door. Symbols of Consciousness & Blueprints of Control.* Quester 2020

Hall's Dictionary of Subjects and Symbols in Art. John Murray. 1984

Hall, Manley P: *Secret Teachings of All Ages*. The Philosophical Research Society. 1988
Hall, Manley P: *Masonic Orders of Fraternity*. The Philosophical Research Society. 1995
Hancock, Graham: *Fingerprints of the Gods*. Century 2001
Highwater, Jamake: *Primal Mind,Visions & Reality in Indian America*.New American Library 1982
Hurley, Matthew: *The Alien Chronicles*, Quester Publications 2003
Huxley, Francis: *The Eye, the Seer and the Seen*. Thames and Hudson. 1990
Icke, David: *Infinite Love is the Only Truth, Everything Else is Illusion*, Bridge of Love. 2005
Icke, David. *Children of the Matrix*. Bridge of Love Publications 2001
Jenkins, John Major: *Maya Cosmogenesis 2012*, Bear & Company, 1998
Jones, Steve: *In the Blood – God, Genes and Destiny*, Flamingo, 1998
Judson, Sylvia Shaw. *The Quiet Eye, A Way of Looking at Pictures*. Aurum Press 1882
Jung, Carl: *The Collected Works, Volume 10: Civilisation in Transition*, Princeton University Press 1956
Kaku, Michio. *Hyperspace*. Oxford University Press 1994
Kaku, Michio: *Visions*, Oxford University Press 2001
Keel, John: *Our Haunted Planet*. Fawcett Publications, USA 1971
Koestler, Arthur: *Acts of Creation*
Krishnamurti, *Education and the Significance of Life*. Victor Gollanz Ltd. 1992
Leeming, David with Margaret, *A Dictionary of Creation Myths*. Oxford University Press 1994
Lewis William, David: *Mind in the Cave*, Thames & Hudson
May, Rollo. *The Cry For Myth*. Souvenir Press. 1991
Maxwell, Jordan: *Matrix of Power*, The Book Tree 2002
McNiff, Shaun. *Art as Medicine*. Piatkus 1992
Meadows, Kenneth. *Earth Medicine*. Element Books 1989
Moore, Patrick: *Phillips Guide to the Stars and Planets*. Chancellor Press 2001
Narby, Jeremy: *The Cosmic Serpent*. Weidenfeld & Nicholson; New Ed edition (7 Oct. 1999)
Owusu, Heike. Symbols of Native America. Sterling Publishing.1999
Pennick, Nigel: *The Subterranean Kingdom*, Turnstone Press Ltd
Pierre Vedet, Jean: *The King of the Moon and Starry Dream*; *The Sky Order and Chaos*, Thames & Hudson Ltd, 1992.
Pierre, Yvette la. *Native American Rock Art – Messages from the Past*. Tomasson–Grant 1994
Purce, Jill. *The Mystic Spiral (Journey of the Soul)*. Thames & Hudson 1974
Quamman, David: *The Monsters of God*
Rael, Joseph. *The Way of Inspiration*. Council Oak Books 1996
Red Star, Nancy. *Star Ancestors*. Destiny Books 2000
Renault, Dennis & Freke Timothy. *Native American Spirituality*. Thorsons 1996
Roob, Alexander: *The Hermetic Museum, Alchemy & Mysticism*, Taschen 2001
Robb, Dave: *Operation Hollywood. How the Pentagon Censors the Movies*,
Sams, Jamie. *The Thirteen Original Clan Mothers*. Harper Collins 1994
Sitchin, Zecharia: *Divine Encounters*, Avon Books.
Stasisas, Klossowski des Rola. *Alchemy, the Secret Art*. Thames and Hudson. 1973

Street, CE: *Earth Stars*. Hermitage Publishing. London 1990.

Swerdlow, Stewart: *True Blood, Blue Blood: Conflict & Creation* 2000

Stanislov, Grof: *The Adventure of Self-Discovery*, Albany Press, 1988

Tsarion, Michael: *Atlantis, Alien Visitation and Genetic Manipulation,* Angels at Work Publishing

The Plantagenet Chronicles: Greenwich Editions, 2002

Talbot, Michael: *The Holographic Universe,* Harper Collins 1996

Taube, Karl. *Aztec and Maya Myths*. The British Museum Press 1993

Tompkins, Ptolemy. *The Monkey in Art.* Scala Books

Townsend, Richard; *The Ancient Americas: Art From Sacred Landscapes.* The Institute of Chicago - Prestel Verlag, Munich.

Ulansey, David. *The Origins of the Mithraic Mysteries*. Oxford University Press 1989

Walker, Paul Robert. *American Indian Lives–Spiritual Leaders.* Facts on File1994

Wasserman, James. *Art and Symbols of the Occult*. Greenwich Editions 1993

West, John Anthony. *Serpent in the Sky*. Quest Books. 1993

Wild, Stuart. *Miracles*. Hay Publications 1994

Wright, Harry. *Witness to Witchcraft (1957)*

Zöllner, Frank. *Leonardo*. Midpoint Press. 2001

NEIL HAGUE

About the Author

Neil Hague is a UK based author, metaphysical artist, illustrator, book designer, and publisher, originally trained in graphics and publishing. Over the past 25 years, he has developed a 'unique' vision through his distinctive style of art and remarkable creativity. Hague's particular artistic style has been described as both spiritual and 'neo-shamanic' by people who have heard him lecture or who have seen his work.

Since 2005 he has developed a career as a painter of transcendental, alternative art, producing imagery for a niche area in a class by itself.

In his first illustrated story, *Kokoro*, he encapsulates a chronicle of creation within 'themes and signs' unfolding in our reality as we go through a major shift in consciousness. In his second narrative, *Moon Slayer*, and third illustrated story, *Aeon Rising*, he takes the exposition further in terms of 'mythological characters' and the construction of our reality. With his illustrated work appearing in books and global presentations all over the world, his work is pivotal and fitting at this time.

Neil has lectured on alternative history, esoteric symbolism, mythology, the power of the imagination, and now the extraordinary subjects in his books *Through Ancient Eyes* and *Orion's Door*. His highly visual presentations are thought-provoking, speaking directly to the subconscious mind and, more importantly, to the hearts of those who hear his words.

"Neil Hague's work is unique - the language of an open and highly creative mind. You look with your eyes, but he speaks to your heart."

David Icke

Index

THROUGH ANCIENT EYES

SEEING HIDDEN DIMENSIONS
EXPLORING ART & SOUL CONNECTIONS

NEIL HAGUE

neilhaguebooks.com

Now in hardback

Lightning Source UK Ltd.
Milton Keynes UK
UKHW050259301222
414560UK00003B/7